Also by Alex Danchev

Very Special Relationship, 1986

Establishing the Anglo-American Alliance, 1990

International Perspectives on the Falklands Conflict (ed.), 1992

The Franks Report: The Falkland Islands Review (ed.), 1992

Oliver Franks, 1993

International Perspectives on the Gulf Conflict (ed.), 1994

Fin de Siècle: The Meaning of the Twentieth Century (ed.), 1995

International Perspectives on the Yugoslav Conflict (ed.), 1996

On Specialness, 1998

Alchemist of War: A Life of Basil Liddell Hart, 1998

War Diaries: Field Marshal Lord Alanbrooke (ed.), 2001

The Iraq War and Democratic Politics (ed.), 2005

Georges Braque, 2005

Picasso Furioso, 2008

On Art and War and Terror, 2009

100 Artists' Manifestos, 2011

Cézanne

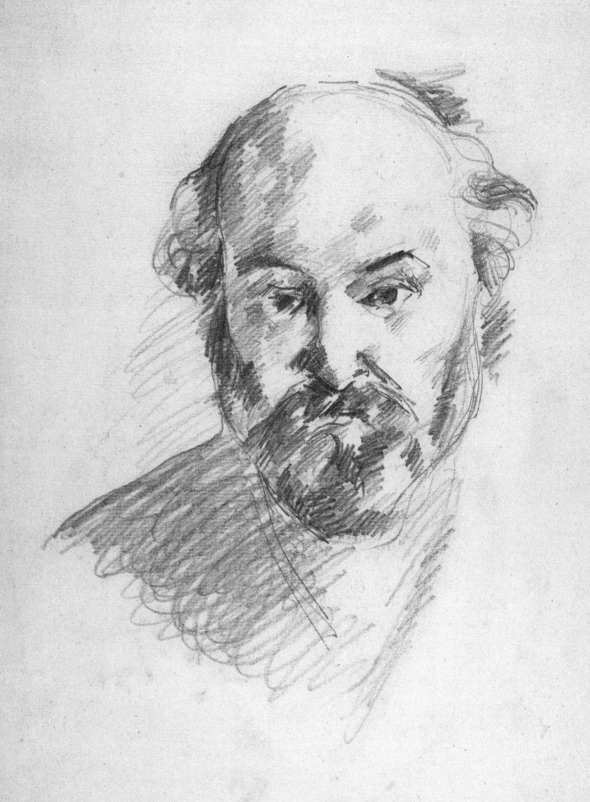

A LIFE

Alex Danchev

Pantheon Books
New York

All rights reserved. Published in the United States by Pantheon
Books, a division of Random House, Inc., New York, and in
Canada by Random House of Canada Limited, Toronto.

Pantheon Books and colophon are registered trademarks
of Random House, Inc.

Library of Congress Cataloging-in-Publication Data

Danchev, Alex.
Cézanne : a life / Alex Danchev.
pages cm
Includes bibliographical references and index.
ISBN 978-0-307-37707-4 (hardback)
1. Cézanne, Paul, 1839–1906. 2. Painters—France—
Biography. I. Title.
ND553.C33D34 2012
759.4—dc23 [B] 2012007182

www.pantheonbooks.com

Jacket image: Self-Portrait by Paul Cézanne, 1879.
Oil on canvas. Oskar Reinhart Collection,
Winterthur, Switzerland. © SuperStock
Jacket design by Peter Mendelsund

Printed in the United States of America

First Edition

9 8 7 6 5 4 3 2 1

For D

Man perceives in the world only what already lies within him; but to perceive what lies within him man needs the world; for this, however, activity and suffering are indispensable.

—Hugo von Hofmannsthal, *Book of Friends* (1922)

The point is to give value to the man, just as he is, whatever he may be.

—Paul Valéry, *Analects* (1926)

Contents

Illustrations

All images are by Cézanne unless otherwise specified. Titles and dates as per his catalogue raisonné (controversies over these matters are raised in the notes).

COLOR INSERT

1. *Portrait of Paul Cézanne* (1862–64). Oil on canvas, 44 x 37 cm, Private Collection. Image courtesy of ESKart, LLC, New York. Self-Portrait 1 in this book.
2. *Self-Portrait* (c. 1866). Oil on canvas, 45 x 41 cm, Private Collection. Image courtesy of Acquavella Galleries, Inc., New York. Self-Portrait 2 in this book.
3. *Self-Portrait with Rose Background* (c. 1875). Oil on canvas, 66 x 55 cm, Musée d'Orsay, Paris/Art Resource, New York. Self-Portrait 3 in this book.
4. *Self-Portrait in a White Bonnet* (1881–82). Oil on canvas, 55.5 x 46 cm, Bayerische Staatsgemäldesammlungen, Munich/The Bridgeman Art Library. Self-Portrait 4 in this book.
5. *Self-Portrait in a Beret* (1898–1900). Oil on canvas, 64 x 53.5 cm, Museum of Fine Arts, Boston, Charles H. Bayley Picture and Painting Fund and Partial Gift of Elizabeth Paine Metcalf/The Bridgeman Art Library. Self-Portrait 5 in this book.
6. *Self-Portrait with a Landscape Background* (c. 1875). Oil on canvas, 64 x 52 cm, Musée d'Orsay, Paris/Giraudon/The Bridgeman Art Library.
7. *Self-Portrait* (c. 1877). Oil on canvas, 26 x 15 cm, Musée d'Orsay, Paris/Giraudon/The Bridgeman Art Library. Once owned by Pissarro.
8. *Self-Portrait* (1878–80). Oil on canvas, 61 x 47 cm, Phillips Collection, Washington, D.C. Corbis.

9. *Self-Portrait with Palette* (c. 1890). Oil on canvas, 92 x 73 cm, Stiftung Sammlung Bührle, Zürich/The Bridgeman Art Library.

10. *Still Life with Bread and Eggs* (1865). Oil on canvas, 59 x 76 cm, Cincinnati Art Museum, Ohio/The Bridgeman Art Library.

11. *The Black Clock* (1867–69). Oil on canvas, 54 x 74 cm, Private Collection/Giraudon/The Bridgeman Art Library.

12. *Portrait of Louis-Auguste Cézanne, Father of the Artist* (c. 1865). Mural transferred to canvas, 167.6 x 114.3 cm, National Gallery, London/Art Resource, New York.

13. *Louis-Auguste Cézanne, Father of the Artist, Reading "L'Événement"* (c. 1866). Oil on canvas, 200 x 120 cm, National Gallery of Art, Washington, D.C. Courtesy of the National Gallery of Art.

14. *Marie Cézanne (The Artist's Sister)* (1866–67). Oil on canvas, 55.9 x 39.4 cm, Saint Louis Art Museum, Museum Purchase 34: 1934. Courtesy of the Saint Louis Art Museum.

15. *Portrait of the Artist's Mother* (1869–70). Oil on canvas, 55.9 x 39.4 cm, Saint Louis Art Museum, Museum Purchase 34: 1934. Courtesy of the Saint Louis Art Museum.

16. *Sugar Bowl, Pears and Blue Cup* (1865–66). Oil on canvas, 30 x 41 cm, Musée Granet, Aix-en-Provence/Giraudon/The Bridgeman Art Library.

17. *Portrait of Antony Valabrègue* (1866). Oil on canvas, 116 x 98 cm, National Gallery of Art, Washington, D.C. Courtesy of the National Gallery of Art.

18. *Marion and Valabrègue Setting Out for the Motif* (1866). Oil on canvas, 39 x 31 cm, Private Collection/Photo © Christie's Images/The Bridgeman Art Library.

19. *The Lawyer (Uncle Dominique)* (1866). Oil on canvas, 62 x 52 cm, Musée d'Orsay, Paris/The Bridgeman Art Library.

20. *The Negro Scipio* (c. 1867). Oil on canvas, 107 x 83 cm, Museu de Arte, São Paulo/Giraudon/The Bridgeman Art Library.

21. *The Abduction* (1867). Oil on canvas, 90.5 x 117 cm, on loan to the Fitzwilliam Museum, Cambridge. Courtesy of the Provost and Fellows of King's College, Cambridge, and the Syndics of the Fitzwilliam Museum.

22. *The Orgy* (c. 1867). Oil on canvas, 130 x 81 cm, Private Collection/The Bridgeman Art Library.

23. *Portrait of the Painter Achille Emperaire* (1867–68). Oil on canvas, 200 x 122 cm, Musée d'Orsay, Paris/Giraudon/The Bridgeman Art Library.

24. *Album Stock* (1870). Musée Carnavalet, Paris. Roger-Viollet/Topfoto.

25. Camille Pissarro, *Portrait of Paul Cézanne* (c. 1874). Oil on canvas, 73 x 59.7 cm, on loan to the National Gallery, London. Courtesy of Graff Diamonds and the National Gallery.

26. Édouard Manet, *Portrait of Émile Zola* (1868). Oil on canvas, 146.5 x 114 cm, Musée d'Orsay, Paris/Giraudon/The Bridgeman Art Library.

27. Jean-Siméon Chardin, *Self-Portrait* (1775). Pastel, 46 x 38 cm, Musée du Louvre, Paris/Giraudon/The Bridgeman Art Library.

28. Camille Pissarro, *Self-Portrait* (1873). Oil on canvas, 56 x 46.7 cm, Musée d'Orsay, Paris/The Bridgeman Art Library.

29. *Portrait of Victor Chocquet* (1876–77). Oil on canvas, 46 x 36 cm, Private Collection/The Bridgeman Art Library.

30. *The Apotheosis of Delacroix* (1890–94). Oil on canvas, 27 x 35 cm, Musée Granet, Aix-en-Provence/Giraudon/The Bridgeman Art Library.

31. *Paul Alexis Reading to Émile Zola* (1869–70). Oil on canvas, 130 x 160 cm, Museu de Arte, São Paulo/Giraudon/The Bridgeman Art Library. Once owned by Zola.

32. *Still Life with Soup Tureen* (1877). Oil on canvas, 65 x 83 cm, Musée d'Orsay, Paris/Giraudon/The Bridgeman Art Library. Once owned by Pissarro.

33. *Madame Cézanne in Striped Skirt* (c. 1877). Oil on canvas, 72.5 x 56 cm, Museum of Fine Arts, Boston, Bequest of Robert Treat Paine II/The Bridgeman Art Library.

34. *Madame Cézanne in a Yellow Armchair* (1888–90). Oil on canvas, 116 x 89 cm, Metropolitan Museum of Art, New York, The Mr. and Mrs. Henry Ittleson Jr. Purchase Fund 1962 (62.45)/Art Resource, New York.

35. *Madame Cézanne with Hortensias* (c. 1885). Pencil and watercolor on white paper, 30.5 x 46 cm, Private Collection.

36. *Madame Cézanne* (c. 1885). Oil on canvas, 46 x 38 cm, Nationalgalerie, Museum Berggruen, Staatliche Museen, Berlin/Art Resource, New York.

37. *Portrait of Madame Cézanne* (1888–90). Oil on canvas, 90 x 71.7 cm, Barnes Foundation, Philadelphia/The Bridgeman Art Library.

38. *Madame Cézanne with Hair Down* (1890–92). Oil on canvas, 62 x 51 cm, Philadelphia Museum of Art/The Bridgeman Art Library.

39. *Madame Cézanne with a Fan* (1886–88). Oil on canvas, 92.5 x 73 cm, Stiftung Sammlung Bührle, Zurich/The Bridgeman Art Library. Once owned by Gertrude Stein.

40. Elizabeth Murray, *Madame Cézanne in a Rocking Chair* (1972). Oil on canvas, 89.5 x 90.2 x 2.9 cm, Collection of Katy Homans and Patterson Sims. Image courtesy of Katherine Sachs, the Philadelphia Museum of Art.

41. Armand Guillaumin, *The Seine at Bercy* (1873–75). Oil on canvas, 56.1 x 72.4 cm, Kunsthalle, Hamburg/The Bridgeman Art Library.

42. *The Seine at Bercy, after Guillaumin* (1876–78). Oil on canvas, 59 x 72 cm, Kunsthalle, Hamburg/The Bridgeman Art Library.

43. Camille Pissarro, *The Small Bridge, Pontoise* (1875). Oil on canvas, 65.5 x 81.5 cm, Kunsthalle, Mannheim/The Bridgeman Art Library.

44. *The Bridge at Maincy* (1879–80). Oil on canvas, 60 x 73 cm, Musée d'Orsay, Paris/Giraudon/ The Bridgeman Art Library.

45. *The House of the Hanged Man* (c. 1873). Oil on canvas, 55 x 66 cm, Musée d'Orsay, Paris/Giraudon/The Bridgeman Art Library.

46. *The Card Players* (1890–92). Oil on canvas, 135 x 181.5 cm, Barnes Foundation, Philadelphia/The Bridgeman Art Library.

47. *Bathers at Rest* (1876–77). Oil on canvas, 79 x 97 cm, Barnes Foundation, Philadelphia/The Bridgeman Art Library.

48. *Three Bathers* (1879–82). Oil on canvas, 52 x 55 cm, Musée de la Ville de Paris, Musée du Petit Palais/Giraudon/The Bridgeman Art Library. Once owned by Matisse.

49. *The Temptation of Saint Anthony* (c. 1870). Oil on canvas, 57 x 76 cm, Stiftung Sammlung Bürhle, Zurich/The Bridgeman Art Library.

50. *Large Bathers* (1896). Color lithograph, 22.9 x 27.9 cm, Barnes Foundation, Philadelphia/The Bridgeman Art Library.

51. *Afternoon in Naples* (1876–77). Oil on canvas, 37 x 45 cm, National Gallery of Australia, Canberra, purchased 1985/The Bridgeman Art Library.

52. *Three Pears* (1888–90). Pencil and watercolor on white paper, 22 x 31 cm, on loan to the Princeton University Art Museum. Courtesy of the Pearlman Collection and the Princeton University Art Museum. Once owned by Degas.

53. *Apples* (c. 1878). Oil on canvas, 19 x 26.7 cm, Fitzwilliam Museum, Cambridge. Courtesy of the Provost and Fellows of King's College, Cambridge, and the Syndics of the Fitzwilliam Museum.

54. *Self-Portrait* (c. 1895). Oil on canvas, 55 x 46 cm, Private Collection. Image courtesy of GFS Management, Chicago.

55. *Self-Portrait* (c. 1895). Pencil and watercolor on white paper, 28.2 x 25.7 cm, Private Collection.

56. *Portrait of Gustave Geffroy* (1895–96). Oil on canvas, 116 x 89 cm, Musée d'Orsay, Paris/The Bridgeman Art Library.

57. *Portrait of Ambroise Vollard* (1899). Oil on canvas, 100 x 82 cm, Musée de la Ville de Paris, Musée du Petit Palais/Giraudon/The Bridgeman Art Library.

58. *Portrait of Henri Gasquet* (1896). Oil on canvas, 56 x 47 cm, McNay Art Museum, San Antonio/Art Resource, New York.

59. *Portrait of Joachim Gasquet* (1896). Oil on canvas, 65 x 54 cm, Národní Galerie, Prague/Giraudon/The Bridgeman Art Library.

60. *Woman with a Coffee Pot* (c. 1895). Oil on canvas, 130.5 x 96.5 cm, Musée d'Orsay, Paris/Giraudon/The Bridgeman Art Library.

61. *Old Woman with a Rosary* (1895–96). Oil on canvas, 85 x 65 cm, National Gallery, London/The Bridgeman Art Library.

62. *Gardanne* (1886). Oil on canvas, 92 x 73 cm, Brooklyn Museum, New York/The Bridgeman Art Library.

63. *Portrait of the Artist's Son* (1881–82?). Oil on canvas, 34 x 37.5 cm, Musée de l'Orangerie, Paris/Giraudon/The Bridgeman Art Library.

64. *Still Life with Plaster Cupid* (c. 1895?). Oil on canvas, 70 x 57 cm, © Samuel Courtauld Trust, Courtauld Institute Galleries, London/The Bridgeman Art Library.

65. *Boy in a Red Waistcoat* (1888–90). Oil on canvas, 79.5 x 64 cm, Stiftung Sammlung Bührle, Zurich/The Bridgeman Art Library.

66. *Lake Annecy* (1896). Oil on canvas, 65 x 81 cm, © Samuel Courtauld Trust, Courtauld Institute Galleries, London/The Bridgeman Art Library.

67. *Rocks at Fontainebleau* (c. 1893). Oil on canvas, 73 x 92 cm, Metropolitan Museum of Art, New York, H. O. Havermeyer Collection, Bequest of Mrs. H. O. Havermeyer, 1929 (29.100.194)/Art Resource, New York.

68. *Mont Sainte-Victoire with Large Pine* (c. 1887). Oil on canvas, 66 x 90 cm, © Samuel Courtauld Trust, Courtauld Institute Galleries, London/The Bridgeman Art Library.

69. *Large Pine and Red Earth* (1890–95). Oil on canvas, 72 x 91 cm, Hermitage Museum, Saint Petersburg/The Bridgeman Art Library.

70. Maurice Denis, *Homage to Cézanne* (1900–01). Oil on canvas, 180 x 240 cm, Musée d'Orsay, Paris/© DACS/ Giraudon/The Bridgeman Art Library.

71. *Still Life with Compotier* (1879–80). Oil on canvas, 46.4 x 54.6 cm, Fractional gift to the Museum of Modern Art, New York, from a private collector. Acc. no: 69.1991, Museum of Modern Art, New York/Scala, Florence.

72. *Man with a Pipe* (c. 1896). Oil on canvas, 73 x 60 cm, © Samuel Cour-tauld Trust, Courtauld Institute Galleries, London/The Bridgeman Art Library.

73. *Large Bathers* (1895–1906). Oil on canvas, 133 x 207 cm, Barnes Foun-dation, Philadelphia/The Bridgeman Art Library.

74. Jasper Johns, *Tracing after Cézanne* (1994). Ink on plastic, 46 x 74.8 cm, collection of the artist. Courtesy of Jasper Johns. Photo: Dorothy Zeidman.

75. Michael Snow, *Paris de jugement Le and/or State of the Arts* (2006). Color photograph on wood stretcher, 183 x 193 x 8 cm, collection of the artist. Courtesy of Michael Snow.

76. *Bathers by a Bridge* (c. 1900). Pencil and watercolor on white paper, 21 x 27.4 cm, Metropolitan Museum of Art, New York, Maria DeWitt Jesup Fund, 1951; acquired from The Museum of Modern Art, New York, Lillie P. Bliss Collection (55.21.2)/Art Resource, New York.

77. *Blue Landscape* (1904–06). Oil on canvas, 102 x 83 cm, Hermitage Museum, Saint Petersburg/The Bridgeman Art Library.

78. Maurice Denis, *Cézanne Painting the Mont Sainte-Victoire* (1906). Oil on canvas, 51 x 64 cm, Private Collection/The Bridgeman Art Library.

79. *The Mont Sainte-Victoire Seen from Les Lauves* (1904–06). Oil on can-vas, 60 x 73 cm, Pushkin Museum, Moscow/Giraudon/The Bridgeman Art Library.

80. *The Mont Sainte-Victoire Seen from Les Lauves* (1904–06). Oil on canvas, 60 x 72 cm, Kunstmuseum, Basel/The Bridgeman Art Library.

81. *Still Life with Carafe, Bottle and Fruit [Bottle of Cognac]* (1906). Pencil and watercolor on white paper, 47 x 62 cm, on loan to the Princeton University Art Museum. Courtesy of the Pearlman Foundation and the Princeton University Art Museum.

82. *Still Life with Milk Jug and Fruit* (c. 1900). Oil on canvas, 46 x 54.9 cm, National Gallery of Art, Washington, D.C. Courtesy of the National Gal-lery of Art.

83. *The Gardener Vallier* (1902–06). Oil on canvas, 107.4 x 74.5 cm, National Gallery of Art, Washington, D.C./The Bridgeman Art Library.

84. *The Gardener Vallier* (1905–06). Oil on canvas, 65.5 x 55 cm, Tate Mod-ern, London/Art Resource, New York.

85. *The Gardener Vallier* (c. 1906). Pencil and watercolor on white paper, 48 x 31.5 cm, Nationalgalerie, Museum Berggruen, Staatliche Museen, Ber-lin/Art Resource, New York.

86. *The Gardener Vallier* (1906). Oil on canvas, 65 x 54 cm, Private Collection. Image courtesy of Stonecroft Associates, LLC, New York.

206 Camille Pissarro, *Portrait of Cézanne in a Felt Hat* (c. 1874). Pencil on paper, 24.2 x 13.0 cm, Musée du Louvre, Paris. Photo: Michèle Bellot. RMN/Art Resource, New York.

207 Camille Pissarro, *Paul Cézanne* (1874). Etching, plate 26.6 x 21.5 cm, sheet 44.5 x 34.6 cm, Musée Bonnat, Bayonne/The Bridgeman Art Library.

212 Pissarro in his studio. Roger-Viollet/Topfoto.

223 Pablo Picasso, *Portrait of Georges Braque* (1909). Private Collection. Archives Charmet/The Bridgeman Art Library.

253 Zola reading (c. 1881–84). Pencil on paper, 21.7 x 12.5 cm, Art Gallery of New South Wales, Sydney, purchased with funds provided by Margaret Olley, 2003/The Bridgeman Art Library.

263 Dornac (Paul François Arnold Cardon), Zola in his study at Médan. Archives Larousse/Giraudon/The Bridgeman Art Library.

280 Gustave Geffroy (c. 1894). Private Collection. Roger-Viollet/The Bridgeman Art Library.

297 Alberto Giacometti, [*After an Egyptian sculpture: Sesostris III; after Cézanne: Self-Portrait*] (undated). Pencil on paper, 32.8 x 25.3 cm, Collection Fondation Giacometti, Paris (inv. 1994–0710). Courtesy of the Fondation Giacometti.

301 Josse Bernheim-Jeune, Cézanne in the garden of his studio at Les Lauves. *The Illustrated London News* Picture Library, London/The Bridgeman Art Library.

319 Émile Bernard, Cézanne at Fontainebleau (1905). Musée d'Orsay, Paris. Repro-photo: René-Gabriel Ojéda. RMN/Art Resource, New York.

324 Gertrude Osthaus, Cézanne on the terrace of the studio at Les Lauves (13 April 1906). Photo Marburg/Art Resource, New York.

325 Studio interior, Les Lauves (1902). Private Collection. Giraudon/The Bridgeman Art Library.

332 Émile Bernard, Cézanne near Aix (1904). Archives Vollard, Musée d'Orsay, Paris. The Granger Collection/Topfoto.

336 Ker-Xavier Roussel, Cézanne painting the Mont Sainte-Victoire (1906). John Rewald Papers, National Gallery of Art, Washington, D.C., Gallery Archives.

345 Émile Bernard, Cézanne in his studio, Les Lauves, in front of the *Large Bathers* (1904). Photo: René-Gabriel Ojéda. RMN/Art Resource, New York.

346 Close-up of Cézanne in his studio, Les Lauves, in front of the *Large Bathers* (1904). Private Collection. Archives Charmet/The Bridgeman Art Library.

Cézanne

Prologue: The Right Eyes

The most consequential exhibition of modern times opened in Paris on 1 October 1907: "Exposition rétrospective d'œuvres de Cézanne," the first posthumous retrospective, a year after his death. It was part of the Salon d'automne. Two rooms of the Grand Palais on the Champs-Élysées were given over to fifty-six Cézannes—more Cézannes than anyone had ever seen.

Everyone went. They went to see and be seen, to marvel, to mock, to argue, to pore over the paintwork, to make up their minds about what they had heard, to investigate what he had been doing, to try to understand how he did it, and perhaps to make use of it if they could. The exhibition ran for three weeks. Some went every day.

In 1907 the Salon d'automne was still short on tradition. Founded in 1903, its primary purpose was to show new work by living artists—in a word, modern art. Its very creation was a calculated act of protest, or insolence, cocking a snook at the existing salon: the Salon national des artistes français, the reactionary institution Cézanne called the Salon de Bouguereau, after the leader of the time-serving Société des artistes français, William Bouguereau. Bouguereau did voluptuary by numbers. He painted ample buttocks on angelic maidens in allegorical poses at astronomical prices. This line had given him everything a man could desire. For a long time he was the last word in the fashionable classical, the epitome of the academy, the embodiment of artistic prowess and social success, and he knew it. In keeping with his station, Bouguereau was a figure of monumental self-importance. Rumor had it that it cost him five francs, by his own reckoning, whenever he stopped painting to relieve himself.

By the turn of the century his authority had been comprehensively undermined, but no one told Bouguereau. Among painters, he and his manner were quietly mocked. Degas and his friends had a word for the chocolate-box effect of any piece of work that looked too slick or too fancy: it was "bouguereaued."

When the Douanier Rousseau was found gazing at a Bouguereau in the Musée du Luxembourg, the old painter was ragged mercilessly by the young Fernand Léger and his avant-garde comrades-in-arms. But the Douanier was not as naïve as his painting. "Look at the highlights on the fingernails," he told them. The fingernails had been bouguereaued. Many an artist appropriated those effects. Meanwhile the power of official patronage remained deeply entrenched. The Salon de Bouguereau never stooped to admit Paul Cézanne.

For living artists, the opportunity to exhibit within the stately portals of the Grand Palais was a welcome change of scene, whatever they might think of the potboilers of salon painting. For the hoi polloi, on the other hand, "new work" meant nothing more than newfangled, and "living artist" was a contradiction in terms. Modern art was not what they were accustomed to seeing, shamelessly displayed in public places. No living artist could enter the Louvre. Museums were for the dead, by definition. The art they contained was meant to conform to certain standards. The technique should be competent, the people recognizable, the plot legible, the skies blue and the trees green. Contemplation of the work should be pleasurable or profitable, or both. By these standards, modern art was an uncouth riddle. The conclusion was clear. If it had to be made, modern art was a matter for consenting adults meeting in private. Even the most consenting found it hard to understand, and on occasion hard to stomach. When André Derain saw the work that became *Les Demoiselles d'Avignon* in Picasso's studio, that same year, he observed mordantly that "painting of this sort was an impasse at the end of which lay only suicide; one fine day we would find Picasso hanging behind his big canvas."

Coming to terms with Cézanne was not easy. The work itself gave ample grounds for offense. On first acquaintance, it ranged from the inexplicable to the intolerable. What is more, it was unfinished, and apparently unfinishable. Cézanne skirted the bounds of the traditional proprieties. He was in many ways a profoundly civilized creature, but he found the forms and trappings of civilization irksome. The feeling was returned in kind. All his days he was characterized as a kind of barbarian. He lived on the margins, beyond the pale. When the writer Jules Renard went to the 1904 Salon d'automne, he discovered works by Carrière, Cézanne, Toulouse-Lautrec, and Renoir. "Carrière, good, but a little too tricksy. Lautrec, vice couched in majesty. Cézanne, barbarian. One would have to like a lot of rubbish to like this carpenter of color. Renoir, perhaps the strongest, and excellent!"[1]

Barbarian painting exhibited every kind of imperfection and distortion. Supporters and detractors alike agreed on a single proposition: Cézanne was

strange. He seemed not to see as others saw, but slant. "Painter by inclination," he said of himself: a Delphic remark, characteristically difficult to interpret. In his pictures, the perpendicular is scorned. Joachim Gasquet's wife told how her husband had often observed Cézanne out painting with his easel at a slope. Does this help to account for the inclination in his work? "It makes no odds," Cézanne would say.[2] The angle of the easel was a matter of indifference to him.

The errors were easy to spot; the effects were difficult to fathom. The story was told of a client who stood amazed before a Cézanne landscape amid the marble and onyx of the Galerie Paul Rosenberg. He had never seen anything like it. Paul Rosenberg put him right. "No, Monsieur," he interposed grandly, "it is not a landscape, it is a cathedral."[3] Stories of this sort were common currency. Apollinaire published a satire on the theme, featuring the president of the Salon d'automne, Frantz Jourdain, selecting works for the retrospective. In this instructive flight of fancy, Jourdain sallies forth from the Grand Palais to the Galerie Bernheim-Jeune to view some Cézannes. He is attended by members of the selection committee, one of whom carries his box of sweets, another his spittoon, a third his handkerchief.

> Upon arriving at Bernheim's, he charged at an admirable painting by Cézanne, a red painting, needless to say: the portrait of Mme. Cézanne. . . . [He] then turned on a landscape. He charged, running like a madman, but that painting of Cézanne's was not a canvas, it *was* a landscape. Frantz Jourdain dived into it and disappeared on the horizon, because of the fact that the earth is round. A young employee of Bernheim's who is a sports enthusiast exclaimed: "He's going to go around the world!"
>
> Luckily that did not happen. Those assembled saw Frantz Jourdain emerge, all red and out of breath. At first, he looked very small against the landscape, but he grew bigger as he approached.
>
> He arrived, a bit embarrassed, and wiped his brow. "What a devil, that Cézanne!" he murmured. "What a devil!"
>
> He stopped before two paintings, one of which was a still life with apples and the other a portrait of an old man.
>
> "Gentlemen," he said, "I defy anyone to say that this is not admirable."
>
> "I will say it, Monsieur," replied Rouault. "That hand is a stump."
>
> And Frantz Jourdain had to remain silent, for there in fact is the chink in his armor. For him, painting is reduced to this question: is a hand a stump or is it not? Whatever he may say or do, he cannot avoid that

stump. But when a man has spent twenty years proclaiming his admiration for Cézanne, he cannot be expected to admit that he does not know why he admires him.[4]

Apollinaire had hit a nerve. Admirers of Cézanne's art have always been extravagant in their admiration, but they have always had difficulty explaining themselves. The painter-theorist Maurice Denis remarked on this phenomenon in an influential appraisal of the artist published just as the retrospective was due to open. "I have never heard an admirer of Cézanne give me a clear and precise reason for his admiration," he began; "and this is true even among those artists who feel most directly the appeal of Cézanne's art. I have heard the words—quality, flavor, importance, interest, classicism, beauty, style . . . Now for Delacroix or Monet, for example, one could put forward a reasoned opinion, briefly stated, easily intelligible. But how difficult it is to be precise on the subject of Cézanne!"[5] As if to prove the point, Roger Fry, who translated and disseminated that article in the august pages of *The Burlington Magazine,* for the edification of the English, concluded his own pioneering study of Cézanne a generation later with a sigh of resignation: "In the last resort we cannot in the least explain why the smallest product of his hand arouses the impression of being a revelation of the highest importance, or what exactly it is that gives it its grave authority."[6]

Back to work, as Cézanne might have said. Frantz Jourdain is continuing his inspection:

Among the dozen Cézannes at Bernheim's, there was a fruit bowl, all lopsided, twisted, and askew. M. Frantz Jourdain had some reservations. Fruit bowls generally look better than that, they stand more upright. M. Bernheim took the trouble to defend the poor fruit bowl, mustering all the graciousness of a man who frequents the most noble salons of the Empire:

"Cézanne was probably standing to the left of the fruit bowl. He was seeing it at an angle. Move a little to the left of the painting, M. Frantz Jourdain. . . . Like this. . . . Now close one eye. Is it not true that in this way the painting makes sense? . . . So you see, there was no error on Cézanne's part."

On the way back to the basement of the Grand Palais, M. Frantz Jourdain was deep in thought; his wrinkled brows attested to the serious-

ness of his preoccupation. Finally, having thought over the battles he had fought, he pronounced the following words with a sincerity that brought tears to the eyes of every member of the jury:

"The dozen Cézannes at Bernheim's are extremely dangerous!" He thought a bit more, then added:

"As for me, I stop at Vuillard."[7]

In the event, the works in the retrospective came not from Bernheim-Jeune but chiefly from two considerable private collectors, Maurice Gangnat and Auguste Pellerin, or straight from Cézanne's son. Making all due allowance for the fantastical, Apollinaire's account was a plausible fiction. Whether or not it had any foundation in fact, he made a point of returning to the fray while the salon was still in progress: "There is no need for us to speak about the art of Cézanne. Let it be known, however, that M. Frantz Jourdain, under the pretext of not wishing to tarnish the glory of that great man and of not displeasing the clientele of his backer, Jansen, deliberately under-represented him at the Salon d'automne."[8]

The members of the Société du salon d'automne were undeniably bold. Even so they had their limits. Article 21 of their statutes decreed that political or religious discussions were strictly forbidden. Their most significant innovation lay in the mounting of regular retrospectives, often of artists still warm. These retrospectives were relatively small-scale—one or two rooms—but they had a huge impact. In 1905, for example, besides the notorious Fauves, or Wild Beasts, with their orgy of raw color, there were retrospectives of Ingres (1780–1867), Manet (1832–83), and Seurat (1859–91), each of them electrifying. In 1906 it was Gauguin (1848–1903). In 1907 came Cézanne (1839–1906) and Berthe Morisot (1841–95). Interestingly enough, it was Morisot who had the bigger build-up and the bigger exhibition. Her work was light and airy; it was well executed; it had a certain delicacy, perhaps even a finesse. There were those who found it preferable. Camille Mauclair, for one, "could not imagine a more striking contrast with the awkward, the effortful Cézanne, where the subtle nuances are constantly betrayed. It's the difference between a laborer and a princess."[9]

Gratifyingly for M. Frantz Jourdain, the salon was packed. The spectators were various. Some came as if on safari, to gawp at the exotic plumage and take potshots at the easy targets. Others came to preen and confirm their prejudices. Apollinaire knew their game only too well.

Wear your best skirt, pretty one,
And put your bonnet on!
We're off to have a lark
With contemporary art
At the Autumn Salon.[10]

Cézanne had been shown at the Salon d'automne before, as Jules Renard had witnessed. In 1904 he was given an individual room, the Salle Cézanne. Puvis de Chavannes (1824–98), Toulouse-Lautrec (1864–1901), and Redon and Renoir (both still living) were similarly honored. This was a modest retrospective of thirty-three paintings, for the most part selected by his dealer, Ambroise Vollard, whose animal cunning and astute hoarding were crucial to Cézanne's rise to world power status. The Salle Cézanne was a luxuriant affair, complete with potted palm, stove, oriental carpet, and velvet sofa. The paint-

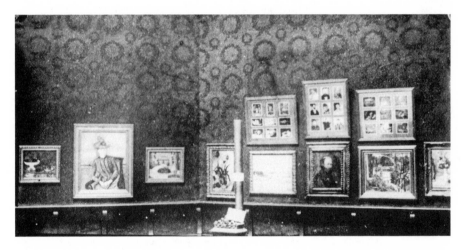

ings were spaciously hung. Unusually, they were topped with several panels of photographs of other works by Cézanne, not in the exhibition: a typical piece of showmanship by the artful Vollard—a trick repeated in the 1907 retrospective, where photographs by Druet showed the artist's youthful rendering of *The Four Seasons* on the walls of the Cézanne family home in Aix-en-Provence. The photographs contributed to the sense of commemoration. They were much remarked, as was the artist's sportive signature, "Ingres."[11]

The Salle Cézanne confirmed his somewhat paradoxical position. He was at once unknown and famous, as one commentator had observed. Among painters, he was an object of fascination. His peers were his earliest collectors. Monet owned fourteen Cézannes. Three of them hung in his bedroom. Pis-

sarro owned twenty-one. Gauguin used to take one of his favorite Cézannes to a nearby restaurant and hold forth on its amazing qualities. They all tried to penetrate his secrets. "How does he do it?" asked Renoir. "He has only to put two strokes of color on the canvas and it's already something."

The path he trod to painting was a tortuous one. As a professional artist, he was remarkably unsuccessful. He did not even qualify to take the examinations for the École des beaux-arts. The "Bozards" joined the Salon de Bouguereau in his periodic raillery against the establishment. "Institutions, pensions and honors are made only for cretins, humbugs and rascals." His first sojourn in Paris in 1861 made him miserable. He was thirty-five before he sold a single painting to anyone other than friends and supporters. He was continually at war with an indifferent world and a domineering father who declared him, aged forty-seven, *sans profession.*

Late in life, after his first one-man show, in 1895, at the age of fifty-six, things began to change. Awestruck young artists would make their way to Aix, as if on a pilgrimage, to seek him out and hear him speak—and if they were very lucky, see him paint. As accounts of these meetings began to leak out, so the word spread. The sayings of Cézanne circulated like the fragments of Heraclitus. In 1904 Émile Bernard published a laudatory article on him in the journal *L'Occident,* complete with a collection of "Cézanne's Opinions," apparently straight from the source. They were avidly consumed. Matisse asked his friend Marquet to buy and send him a copy: "In this issue there is Cézanne's doctrine by Bernard, who often reports Cézanne's own words. . . . It's very interesting."[12] Cézanne had decided opinions. "To paint from nature is not to copy an object; it is to represent its sensations." "Within the painter, there are two things: the eye and the mind; they must serve each other. The artist must work at developing them mutually: the eye for the vision of nature and the mind for the logic of organized sensations, which provide the means of expression." The following year, Charles Camoin published a further selection, taken from his own correspondence with the master.[13] Not to be outdone, Bernard's celebrated "Memories of Paul Cézanne" appeared in two parts in the *Mercure de France* in 1907.[14] Cleverly timed to coincide exactly with the retrospective at the Salon d'automne, these articles were immediately ransacked for their testimony from beyond the grave. There was more to come. Émile Zola's correspondence began to appear that same year. The "letters of his youth" included no fewer than nineteen to his best friend, Paul Cézanne.[15]

Interest in these morsels reflected a certain willful elusiveness on the part of the living, breathing *"primitif du plein air,"* as Camoin called him. In the

art world, and the social world, he remained an outsider, a phantasm. Much speculation and little information gave him a kind of fictional quality. To this unstable mix he added ingredients of his own. He had a temperament, as he often said, or rather a *temmpérammennte* (rolled around the tongue, in his broad Provençal accent).[16] For Cézanne, temperament was a test of character and moral worth, or moral fiber. According to this conception, temperament governed human potential—more exactly, human-being potential. In art, as in life, temperament was the fundamental requirement. "Only original capacity, that is, temperament can carry someone to the objective he should attain," he instructed Camoin.[17] Cézanne thought of himself as seeing nature through a painter's temperament. "With only a little temperament," he told Bernard, "one can be a lot of painter."[18]

At the Salon d'automne, the struggle continued. The novice Maurice Sterne had wandered in the Salle Cézanne in search of enlightenment, without success. In 1905 he returned to the fray. Repeated visits to a group of Cézannes left him baffled as ever. Late one afternoon came a breakthrough by example. "I found two elderly men intently studying the paintings. One, who looked like an ascetic Burmese monk with thick spectacles, was pointing out passages to his companion, murmuring '*magnifique, excellent.*' His eyes seemed very poor, and he was very close to the paintings. I wondered who he could be—probably some poor painter, to judge from his rather shabby old cape."[19] The poor painter was Degas.

Cézanne's death was announced midway through the 1906 salon. Black crêpe was attached to his name in the exhibition room, where ten paintings kept a silent vigil. More than one visitor never forgot the black crêpe.[20] This was the year that the American artist Max Weber had his epiphany. Long afterwards he remembered his first sight of the ten Cézannes, and how he returned again and again to gaze at them. "I said to myself, 'This is the way to paint. This is art *and* nature, reconstructed' . . . I came away bewildered. I even changed the use of my brushes. A certain thoughtful hesitance came into my work, and I constantly looked back upon the creative tenacity, this sculpturesque touch of pigment by this great man in finding form, and how he built up his color to construct the form. . . . When you see a Cézanne, it's like seeing the moon—there's only one moon, there's only one Cézanne."[21]

The following year Weber was back for the retrospective. He went with his friend the Douanier Rousseau. "We came there and found the galleries packed. . . . It was a great event. . . . Rousseau and I walked round, we looked,

and he became quite absorbed, picture after picture. Then he turned to me and he said, '*Oui, Weber, un grand maître,* this is a great artist, *mais, vous savez, je ne vois pas tout ce violet dans la nature,* I don't see so much violet in nature.' Then he looked up at a picture of bathers, probably the largest canvas that Cézanne painted. And, of course, much of the barren paper is visible. . . . So Rousseau found it, of course, an unfinished picture. So he looked up, and he said, 'Ah, Weber, if I had this picture at home—*chez moi*—I could finish it.' "[22]

The Douanier was not the only one to harbor reservations. The American critic James G. Huneker wrote to a friend: "The Autumn Salon must have blistered your eyeballs. Nevertheless Cézanne is a great painter—purely as a painter, one who seizes and expresses *actuality.* This same actuality is always terrifyingly ugly (imagine waking up at night and discovering one of his females on the pillow next to you!). There is the ugly in life as well as the pretty, my dear boy, and for artistic purposes it is often more significant and characteristic. But—ugly is Cézanne. He could paint bad breath."[23] Walter Sickert also recognized a great artist, but came to think he was incomplete and overrated. As two men went by in the Salon d'automne, he was tickled to catch some drollery about overexposure: "They will succeed in killing Cézanne," said one to the other, as if surfeited.[24]

Rilke may have eavesdropped on the same conversation. The ardent young poet experienced something close to a religious conversion. "I'm still going to the Cézanne room," he wrote to his wife on the tenth day. "I again spent two hours in front of particular pictures today; I sense this is somehow useful for me. . . . But it takes a long, long time. When I remember the puzzlement and insecurity of one's first confrontation with his work, along with his name, which was just as new. And then for a long time nothing, and suddenly one has the right eyes"[25]

The next morning he went with the painter Mathilde Vollmoeller. As usual, "Cézanne prevented us from getting to anything else. I notice more and more what an event this is." They settled down with the paintings. After a while, Rilke was startled by his companion's observation: "He sat there in front of it like a dog, just looking, without any nervousness, without any ulterior motive." Vollmoeller was a penetrating student of Cézanne's way of working. " 'Here,' she said, pointing to one spot, 'this he knew, and now he's saying it' (a part of an apple); 'just next to it there's an empty space, because that was something he didn't know yet. He only made what he knew, nothing else.' "[26] He used to say that he wanted to astonish Paris with an apple: another saying

full of meaning.[27] In Cézanne, the empty space is as astonishing as the apple. This was a new concept of painting—not the thing, but the effect it produces, as Mallarmé had it.

Rubbing shoulders with Rilke was the next generation: Picasso, Braque, Matisse, Derain, Dufy, Gris, Léger, Vlaminck, Modigliani, Duchamp—they were all there. Léger fastened on "a canvas representing two working class chaps playing cards": one of the famous *Card Players*. "It cries out with truth and completeness." For Léger, he was the Cézanne-Christ, who had eventually to be denied. His struggle to escape Cézanne's clutches became one of Léger's best stories. It was an epic battle. "Then, one fine day, I said, 'Zut!' " He was free, or so he thought.[28] For Braque, prolonged immersion in Cézanne was a revelation of affinity and a process of anamnesis, a memory of what he did not know he knew. He set about a systematic investigation of Cézanne and the secret something he sensed in the painting. But it was not only the work that seized him; it was the life. "Cézanne! He swept away the idea of mastery in painting. He was not a rebel, Cézanne, but one of the greatest revolutionaries; this will never be sufficiently emphasized. He gave us a taste for risk. His personality is always in play, with his weaknesses and his strengths. With him, we're poles apart from decorum. He melds his life in his work, the work in his life."[29]

Others engaged in front of the works themselves. Conversations could be heard among artists, writers, dealers, collectors, museum directors, critics, and philosophers, in Dutch, English, French, German, Russian, Japanese. Two influential voices from Japan were already there, as an advance guard: Arishima Ikuma, who published a long essay on Cézanne as early as 1910, and Yasui Sotaro, who was said to paint "in the Cézanne style."[30] Gertrude Stein sailed in, escorted by Alice B. Toklas, and found what she was looking for. "And then slowly through all this and looking at many pictures I came to Cézanne and there you were, at least there I was, not all at once but as soon as I got used to it. The landscape looked like a landscape that is to say what is yellow in the landscape looked yellow in the oil painting, and what was blue in the landscape looked blue in the oil painting and if it did not there was still the oil painting, the oil painting by Cézanne."[31]

Insular Englishmen came and went. Philip Wilson Steer, a founder member of the New English Art Club, admired *The Black Clock*, "an early work of exquisite color and no oddity of form," but little else. That painting reappeared some years later in an exhibition at Burlington House, "over against some ridiculously malformed apples, proclaimed by the mystagogues to

achieve rotundity by being irregular polygons, shabby in color as well." Steer was one of the unbelievers. "Determined to bypass the perpetual yapping of the patriarch's name," he and Henry Tonks took to calling him Mr. Harris.[32]

For the rest, it was the Congress of Europe all over again. The Russian collectors were there: Sergei Shchukin, who acquired eight Cézannes between 1904 and 1911, and Ivan Morozov (eighteen between 1907 and 1913), Shchukin indulging his favorite pastime of visiting the Egyptian antiquities in the Louvre, where he found parallels with Cézanne's peasants.[33] The Germans were there, in strength, among them the influential art historian Julius Meier-Graefe, one of the first to write about Cézanne, studying the paintings day after day, like Rilke, in the company of Count Harry Kessler, the well-known patron and collector; Karl Ernst Osthaus, founder of the Folkwang Museum in Hagen (Westphalia), who had visited the artist in his lair in Aix the year before; Hugo von Tschudi, director of the Nationalgalerie in Berlin. Tschudi was a man of taste and discrimination, who bought his first Cézanne in 1897. He seems to have been having fun. Discussing the works with the painter Jacques-Émile Blanche, he went so far as to say that he enjoyed a Cézanne "like a slice of cake, or a piece of Wagnerian polyphony." The Frenchman was stunned. "These Germans are amazing," he reflected. "The sentimental academic style of Böcklin sends them into ecstasy, while they find Carrière inexpressive. . . . But Cézanne!" Surely such a people were incapable of appreciating Cézanne—and yet this particular German evidently shared his passion for the master of the masters. For Blanche, Cézanne was in a class of his own.[34]

Ironically, Blanche himself has been cast by posterity as a kind of foil. Posterity has taken its cue from Pablo Picasso. One of the boldest pronouncements ever made by one artist in homage to another was made by Picasso in homage to Cézanne:

> It is not what the artist does that counts, but what he is. Cézanne wouldn't be of the slightest interest to me if he had lived and thought like Jacques-Émile Blanche, even if the apple he painted had been ten times as beautiful. What is of interest to us is Cézanne's *inquiétude*, that is Cézanne's lesson . . . that is to say, the drama of the man. The rest is false.[35]

For Picasso, as for Braque, it was the man that mattered—"what he is." That pronouncement was made in 1935. It serves to isolate the primary condition with which Cézanne was identified in life and afterlife: *inquiétude*—anxiety,

restlessness. In the sense pervading so many accounts, this was an almost path-ological condition. The philosopher Maurice Merleau-Ponty's celebrated essay "Cézanne's Doubt" (1945) made the same point in slightly different terms. Merleau-Ponty did not shrink from speculating on his morbid symptoms, psy-chological disequilibrium, and "schizoid make-up."[36] *Cézanne* the musical has yet to appear—no one has dared—but the opera, by Daniel Rothman, is *Cézanne's Doubt* (1996).[37]

Who first pinned *inquiétude* on him is difficult to establish with certainty, but by 1907 it was already received wisdom. Maurice Denis spoke of him then as "*perpétuellement inquiet*," Émile Bernard as "tormented." As early as 1873, the Cézanne character in one of Zola's novels had been introduced as "twitch-ing with a habitual nervous *inquiétude*." In 1895, Gustave Geffroy proposed that he was dominated by that very characteristic.[38] Soon Cézanne and *inquié-tude* were almost reflexively associated. *Inquiétude* was his lot, or the cross he bore: his fate, his plight, his tragedy. But it was also the mark of his moral stature. Chronic doubt made for epic struggle. That was the drama of the man: the hard-fought engagement on the battlefield of the interior. The legendary knight Bayard was *sans peur et sans reproche*. The legendary artist Cézanne was just the opposite. Timid or tormented, he was human, all too human. Yet he overcame. He mastered himself and his epoch. He made those paintings.

Significantly, Picasso's propagandists were keen to assert that he, too, "knew *inquiétude*."[39] It was as if he had inherited the condition, or taken on the mantle. *Inquiétude* was no longer a stigma but a badge of honor. Cézanne's struggle became a legend, his journey a quest, his condition an index of great-ness: artistic greatness, to be sure, but something more. "The sublime little grimalkin," D. H. Lawrence's marvelous characterization, attained an unex-pected grandeur.[40] If in the final analysis a great artist is a man who has lived greatly, as Albert Camus proposed, Cézanne seemed to exemplify what was required. Cézanne shows what human beings are capable of. His victory was in the end a moral victory—a victory of temperament, perhaps, over doubt, discouragement, and dismay. His life story is the exemplary life story of the artist-creator in modern times. Countless artists take Cézanne as their model. And not only artists—poets and philosophers, writers and directors, thinkers and dreamers. The sublime little grimalkin created a new world order. His way of seeing radically refashioned our sense of things and our relationship to them. He once said of the mighty *Woman with a Coffee Pot* (color plate 60) that a teaspoon teaches us as much about ourselves and our art as the woman or the coffeepot. The revelations of Cézanne are akin to those of Marx or Freud. The

transformational potential is as great. The impact on our selves and our world is as far-reaching.

Of the successor generation, the one with the most profound understanding of Cézanne's moral valence was Henri Matisse. Matisse felt impelled to buy his first Cézanne on 7 December 1899, at great personal sacrifice, long before he had any success as an artist. *Three Bathers* (color plate 48) became his talisman. He worshipped it in private for thirty-seven years, before parting with it, tenderly, as a gift to the Museum of the City of Paris in 1936. "Yesterday I consigned to your shipper Cézanne's *Bathers*," he wrote to the director of the museum.

> I saw the picture carefully packed and it was supposed to leave that very evening for the Petit Palais. Allow me to tell you that this picture is of the first importance in the work of Cézanne because it is a very dense, very complete realization of a composition that he carefully considered in several canvases which, though now in important collections, are only the studies that culminated in this work.
>
> In the thirty-seven years I have owned this canvas, I have come to know it quite well, though not entirely, I hope; it has sustained me morally in the critical moments of my venture as an artist; I have drawn from it my faith and my perseverance; for this reason, allow me to request that it be placed so that it may be seen to its best advantage. For this it needs both light and adequate space. It is rich in color and surface, and seen at a distance it is possible to appreciate the sweep of its lines and the exceptional sobriety of its relationships.
>
> I know that I do not have to tell you this, but nevertheless I think it is my duty to do so; please accept these remarks as the excusable testimony of my admiration for this work which has grown increasingly greater ever since I have owned it. Allow me to thank you for the care that you will give it, for I hand it over to you with complete confidence.[41]

For Matisse, Cézanne was God. "There are, you see, structural laws in the work of Cézanne which are useful to a young painter. He had, among his great virtues, the merit of wanting the tones to be forces in a painting, giving the highest mission to his painting." On another occasion he added, "Cézanne's paintings have a peculiar construction; reversed, looked at in a mirror for example, they often lose their balance."[42] If that was an insight into the investigation of one master by another, then the emphasis on structure or *architec-*

ture (the word used by Matisse) is surely revealing. What Matisse was trying to discover was what Baudelaire called "the secret architecture" of the work.

The deity appeared at the 1907 retrospective in a solitary self-portrait, painted around 1875, when he was in his mid-thirties (color plate 3). Rilke was fascinated by his gaze: "How great this watching of his was, and how unimpeachably accurate, is almost touchingly confirmed by the fact that, without even remotely interpreting his expression or presuming himself superior to it, he reproduced himself with so much humble objectivity, with the unquestioning, matter-of-fact interest of a dog who sees himself in a mirror and thinks: there's another dog."[43]

1: The Dauber and the Scribbler

The schoolboy Paul Cézanne was a sensitive brute. At thirteen, he was almost full-grown. He entered the Collège Bourbon in Aix as a half-boarder in the sixth grade in 1852. Half-boarders slept at home—in Cézanne's case, a bourgeois house in the center of the town, a fifteen-minute walk away—but spent most of their waking hours at school, from seven in the morning (six in summer) until seven in the evening. Like many Aixois families, the Cézannes took advantage of the opportunity to combine public education and domestic education, as the school prospectus tactfully put it, for a modest three hundred francs per year, dinner and snack included. This arrangement continued for his first four years. For the last two he became a day boy. Whether he was by then sufficiently domesticated must be open to doubt.

Intelligent, spirited, somewhat introverted, he was clever enough and sturdy enough to get by with the other boys. He boasted of translating one hundred Latin verses in no time at all, for the price of two sous. "I was a businessman, by Jove!"[1] It was as commercial as he ever got. His ambitions were inarticulate. Among friends, he was eager for adventure: boys' own pursuits, of a wholesome kind, spiced with poetry. Girls were out of bounds. They could be adored but not accosted. Making love meant serenading the object of one's affections from afar—the ungovernable in search of the unattainable. For Cézanne, romantic fervor and libidinous impulse vied with conventional inhibition. He was unsure of himself, but Aix was his stamping ground. Here, he knew the form. He had the patter, or the patois. He spoke the language.

In the year below was little Émile Zola, a boarder.[2] Émile did not mix well. "My years in school were years of tears," says the hero of his fiercely autobiographical first novel, *La Confession de Claude* (1865). "I had in me the pride of loving natures. I was unloved because I was unknown and I refused to make myself known."[3] Émile did not speak the language. He spoke with a

lisp and a Parisian accent; his name sounded foreign; he was fatherless (Zola *père* died of pleurisy when Émile was six); his mother and grandmother came to visit him every day, in a parlor reserved for the purpose. In the bear pit of the boarders, Zola was a mama's boy. He could not pass for Provençal. He did not care. The insult was cordially returned: they called him *le Franciot* (Frenchy). Among the bourgeois Aixois, Zola was different. They were fat, he was thin. Worse, he was poor. His early writing fairly pulsates with contempt for the good-for-nothing bourgeois. The last lines of the novels are often revealing. The last line of *Le Ventre de Paris* (1873) is the Cézanne character's parting shot—one of the real Cézanne's favorite expressions—a muttered imprecation against the plump of the world: "What bastards respectable people are!"

Zola craved renown and respectability. At the Collège Bourbon, he was deprived of both. He was a *boursier,* a scholarship boy, living on charity. "Beggar!" the other boys taunted him. "Parasite!" Sometimes they beat him up. Sometimes they refused to speak to him altogether. "For the smallest thing, he was put in quarantine," Cézanne remembered. "And really our friendship stemmed from that . . . from a thrashing I got from everyone in the playground, big and small, because I took no notice, I defied the ban, I couldn't help talking to him anyway. . . . A decent sort. The next day, he brought me a big basket of apples."

Recounting this to the young Joachim Gasquet, the son of Cézanne's friend Henri Gasquet, some forty years later, he added with a sly wink, "Cézanne's apples, see, they go back a long way."[4] Apples were not only Cézanne's capital subject, the subject he succeeded in knowing fully, "*all round,*" as D. H. Lawrence aptly said; they were freighted with meaning and complex emotion.[5]

In Zola's novel *Madeleine Ferat* (1868), this story of origins (minus the apples) becomes the tale of Jacques and Guillaume at a local *collège* in Véteuil. The family backgrounds are transposed, and the character sketches jumbled, but the thrust is clear. Guillaume is christened "Bastard" and persecuted by the other boys. He is tearful and wretched, but soon enough he finds his savior.

> Guillaume, however, had one friend at school. As he was about to start his second year, a new pupil entered the same class. He was a big, strong, sturdy boy, who was two or three years older. His name was Jacques Berthier. An orphan, having only an uncle, a lawyer in Véteuil, he had come to the school in that town to complete the humanities course he had begun in Paris. . . . On the very day he arrived, he noticed a big rascally boy bullying Guillaume. He raced over and made the boy under-

stand that he would have to reckon with him if he tormented the others like that. Then he took the arm of the persecuted one and walked with him throughout the break, to the outrage of the other boys who couldn't understand how the Parisian could choose a friend like him. . . . Guillaume . . . developed an ardent friendship for his protector. He loved him as one loves a first mistress, with absolute loyalty and blind devotion. . . . Jacques accepted in good part the adoration of his protégé. He loved to show off his strength and be praised. Besides he was overwhelmed by the fond caresses of this character, puny and proud, who crushed the others with his scorn. During the two years they spent at the school, they were inseparable.[6]

"The Inseparables" became their call sign and caste mark. Like the Musketeers, they were three. Cézanne and Zola were joined by Baptistin Baille, later a distinguished scientist, professor of optics and acoustics at the School of Physics and Chemistry of the City of Paris, an institution he helped to found. Young Baille was a bright spark, and good company. He played host to their schoolboy escapades. The Bailles lived in a large house on the Cours Sextius, near the baths. A big room on the third floor served as the Inseparables' den, laboratory, and workshop. Here they ate the grapes that hung from the ceiling; they risked their lives (so they liked to think) brewing up strange concoctions in chemical retorts; they composed three-act plays.[7] At school, if Zola's fictionalized reminiscence is to be trusted, they were not always little angels. They stole the shoes of Mimi-la-Mort, otherwise known as the Skeleton Day Boy, a spindly youth who used to keep the others supplied with snuff, and burned them in the stove. They stole matches from the chapel to smoke dried chestnut leaves in their homemade pipes. They marched round the pond in a cortège, singing dirges, with sawed-off benches from the playground, pretending they were corpses come to life, and Baille fell in as he tried to fill his cap with water. The young scamp Cézanne seems to have reveled in all this. One day he had the bright idea of roasting some Maybugs in the bottom of his desk, to see if they were good to eat, as people said. The smoke escaping from the desk was so thick and acrid that the supervisor grabbed a jug of water, thinking there was a fire.[8]

These japes must have been welcome distraction. Life at the Collège Bourbon was not an unalloyed pleasure. There was no heating. In winter, the interminable recitations began in clouds of steam. The ground-floor *études*, or study rooms, were depressing places: airless, humid, dimly lit, with the damp

running down the walls. The pond where the boys learned to swim was covered in slime. School uniform was a trial: blue woolen tunic with red border and gold palms on the collar; matching blue trousers; blue *kepi*. School meals were so bad that there were occasional riots. Zola, who liked his food, remembered horrible dishes, "among others, a strange codfish stew that poisoned the mold. . . . We made up for it with bread, we stuffed crusts in our pocket and ate them in class or in the playground. For the six years I was there, I was hungry."[9]

The sick bay was manned by nuns in black habits and white coifs. One sister, whose virginal features were enough to give the older boys palpitations, caused a sensation by running off with Fatty Chops from the rhetoric class, who was so smitten that he used to cut himself with a knife, so that she could dress his wounds.

The masters were dim but not ferocious. A paternal discipline prevailed, "leaving each pupil to his own qualities and vices," according to Paul Alexis, who passed through a few years later and became a lifelong friend of Cézanne's.[10] There was none of the whipping they could have expected at a Jesuit school. Serious punishment might consist of five hundred lines of Boileau—"a eunuch!"—tiresome, but bearable. Cézanne had the measure of Boileau.

> You know that Boileau with a broken shoulder
> Was found last year in a deep gulley,
> And that digging deeper the workmen found
> All his old bones which they took to Paris.
> There, in a museum, this king of the jungle
> Was classified as an old rhinoceros.
> Then these words were carved at the foot of his carcass:
> "Here lies Boileau, the rector of Parnassus."[11]

He remembered the masters almost fondly. There was one who loved poetry, who read them Auguste Barbier's *Iambes,* and encouraged Zola to be a writer; and old Brémond, nicknamed Waif.[12] The boys loved nicknames. The deputy headmaster, Snitcher, had a nose like a cannon, conveniently identifiable at long range. Among the junior masters there was The Grime, who left a mark on the back of the chair where he rubbed his head; Adèle-You-Deceived-Me, the physics master, a notorious cuckold, known to generations of boys by the name of his wife, who had been caught in the act, it was said, with a police

officer; and Rhadamanthus, the judge of the dead in the *Aeneid,* who was never known to smile.

> Here Rhadamanthus rules, and most severe his rule is,
> Trying and chastising wrongdoers, forcing confessions
> From any who, on earth, went gleefully undetected—
> But uselessly, since they have only postponed till death their
> atonement.[13]

Lower down the social scale, there was Spontini, the murderous supervisor, who liked to show off his Corsican dagger, stained with the blood of three cousins; little Songbird, who was so easygoing that he let them smoke when out walking; and Parabola and Parallela, the kitchen boy and the scullery maid, who had a tryst among the potato peelings.[14]

On high days and holidays, Cézanne and Zola wasted no time. At the crack of dawn they were off, into the countryside, in search of the pine tree and the riverbank. They both loved to swim, naked, faunlike, free. Swimming was an essential part of the bond between them. It was celebrated in Cézanne's incorrigible versifying:

Zola nageur	Zola the swimmer
fend sans frayeur	strikes fearlessly
l'onde limpid.	through the limpid water.
Son bras nerveux	His vigorous arms
s'étend joyeux	stretch joyfully
sur le doux fluide.	over the calm fluid.[15]

Bathing and disporting themselves on the riverbank, reciting poetry and howling at the moon: these experiences were packed away inside him, fabulous and unrepeatable, the images engraved on the memory. Cézanne's bathers go back almost as far Cézanne's apples.

Often Baille came with them. If he could not, they went by themselves, or they took one of their other friends, Philippe Solari or Marius Roux, or Baille's younger brother Isidore, who was permitted to carry the knapsack. Zola never tired of conjuring the scene:

> On holidays, on days when we could steal from studying, we escaped on
> wild rambles across the countryside; we needed fresh air, full sun, lost
> paths at the bottom of gullies, which we claimed as conquerors. Oh! the

endless strolls across the hills, the long rests in the green hideaways, close to a little stream, the walk back through the thick dust of the main tracks, which crunched under our feet like fresh snow! In winter, we loved the cold, the ground frozen with ice which cracked merrily, and we would go and eat omelettes in the neighboring villages, reveling in the clear sharp air. In summer, all our meetings were on the river bank, for we had a passion for water; and we would spend all afternoon paddling about, living there, coming out only to lie naked on the fine sand, warmed by the sun. Then, in the autumn, our passion switched, and we became hunters; oh! most harmless hunters, for the chase was for us just an excuse for long strolls. . . . If we fired an occasional volley, it was for the pleasure of making a noise. The hunting party always finished in the shade of a tree, the three of us lying on our backs with our noses in the air, chatting away about our loves.

And our loves, in those days, were above all the poets. We didn't stroll alone. We had books in our pockets and our game bags. For a year, Victor Hugo reigned among us as an absolute monarch. He had captured us with his high style and powerful rhetoric. We knew several works by heart, and when we returned in the evening, at dusk, we walked in time to the beat of his verses, echoing like a trumpet blast. Then, one morning, one of us brought along a volume of Musset. We were very ignorant tucked away in the provinces, teachers were careful not to mention contemporary poets. For us reading Musset was our hearts' awakening. We kept shivering. . . . Our cult of Victor Hugo received a terrible blow; little by little we were seized by coldness, his verses fled from our memories, copies of *Orientales* or *Feuilles d'automne* were no longer to be found among the powder and the cartridge boxes. Alfred de Musset alone was enthroned in our game bags.

What good memories! I can't close my eyes without revisiting the days of that happy age. It was a fine September afternoon, a soft grey afternoon, a blue sky with a gauzy veil; and we lunched in a dip, with tall willows whose fine branches wept over our heads.

Intent on the literature, Zola omits the lunch. It was only to be expected that this, too, was the subject of careful preparation. Baille made a fire and rigged up a makeshift spit, on which they cooked a leg of lamb seasoned with garlic. Zola turned the spit. Cézanne dressed the salad, kept fresh in a damp towel. After the feast, a nap, and then more adventures, weather permitting:

It was a rainy day; we set off anyway, despite the menace of the sky; and we had to shelter in the hollow of a rock, while it poured with rain. It was a windy day, one of those awful winds that toppled the trees; and we went into a village inn, we sat at the back of a little room, we really enjoyed spending the afternoon there. But, everywhere, the great attraction was to have Musset with us; in the dip, in the hollow of the rock, in the little room of the village inn, he accompanied us and was sufficient for our contentment. He compensated for everything, pulled us out of our misery, revealed something new to us on every reading. Sometimes, when a curious bird came and perched at a reasonable distance, we thought we should have a blast at it; fortunately we were appalling shots, and almost every time the bird just flapped away. That hardly interrupted whoever was reading aloud, perhaps for the twentieth time, *Rolla* or the *Nuits*. I can never hear the hunt any other way. As soon as anyone mentions hunting, I dream of long reveries under the sky, of verses that unroll with a great noise of wings. And I see once more the greenery, the scorching plains overcome with the intense heat, the far horizons that hardly contained the proud ambition of our sixteen years.[16]

Alfred de Musset spoke powerfully to sixteen-year-olds. He breathed down their necks; he wrote what they felt; he passed away as they read. Musset liberated them from the shackles of bourgeois convention. "He spoke to us of women with a bitterness and a passion that inflamed us. . . . He was skeptical and ardent like us, full of pride and weakness, confessing his sins with the same fervor that he had put into committing them." They were haunted by Rolla's famous lament, "*Je suis venu trop tard dans un monde trop vieux*" ("I have come too late in a world too old"). They raved about his ballad to the moon, "a gauntlet thrown down by a thoroughbred poet to the romantics as well as the classics, the guffaw of a free spirit recognized as a brother by all our generation."[17]

C'était, dans la nuit brune,	It was, in the dark night,
Sur le clocher jauni,	On the yellowed steeple,
La lune	The moon,
Comme un point sur un i.	Like a dot on an i.
Lune, quel esprit sombre	Moon, what dark spirit
Promène au bout d'un fil,	Walks at the end of a leash

<div style="text-align: center">

Dans l'ombre,	In the shadow,
Ta face et ton profil?	Your face and your profile?[18]

</div>

Cézanne's verses were mock Musset, it transpires, just as Zola's *La Confession de Claude* (a work addressed to Cézanne and Baille) was modeled on Musset's *La Confession d'un enfant du siècle.* Poetry meant something to Cézanne—his own included. His early rhymes reached a wider audience only after his death. He mentioned them very seldom in later years, a shade wistfully. "Woe betide the painter who fights too much with his own talent," he mused in his sixties, to one visitor, "perhaps one who composed some verses in his youth. . . ."[19]

Some of his verses were better than others. For Zola, he composed a juvenile hymn to the *mirliton*—a play on words or connotations. A *mirliton* is a pipe or flute, or a proboscis, but also a young girl or her pudendum—the fingering, therefore, ripe for exploitation. There was some warrant in Virgil, whose first *Eclogue* opens seductively, "Tityrus, here you loll, your slim reed-pipe serenading / The woodland spirit beneath a spread of sheltering beech . . ." In contemporary parlance, *vers de mirliton* was very bad verse, or throwaway lines. Cézanne himself used the word in this sense in thanking Zola for "the affectionate verses [*les affectueux mirlitons*] that we have had the honor to sing." A century later, Samuel Beckett, who studied Cézanne intently and drew deep inspiration from him, was in the habit of composing what he called *mirlitonnades,* "rhymeries" or "versicules," on beer mats, backs of envelopes, or scraps of paper: fragments, full of wordplay and wet-whistle wit.[20] Cézanne's "Unpublished Poem" (1858) was not quite in the same league:

C'était au fond d'un bois	It was deep in the woods
Quand j'entendis sa voix brillante	When I heard a clear voice
Chanter et répéter trois fois	Singing and repeating three times
Une chansonnette charmante	An enchanting little ditty
Sur l'air du mirliton.	With the air of a *mirliton.*
J'aperçus une pucelle,	I spied a budding lass,
Ayant un beau mirliton	With a neat little *mirliton*
En la contemplant si belle	Seeing her so lovely
Je sentis un doux frisson	An ardent shiver shook me
Pour un mirliton, etc.;	In want of a *mirliton,* etc.;
.

Au bout de la jouissance	At the climax of our *jouissance*
Loin de dire: "C'est assez."	Far from saying: "That's enough."
Sentant que je recommence	Sensing that I start over again
Elle me dit: "Enfoncez."	She says to me: "Go deeper."
Gentil mirliton, etc.;	Gentle *mirliton*, etc.;
Je retirai ma sapière,	I took my sapling out,
Après dix ou douze coups	After ten or twelve thrusts
Mais trémoussant du derrière:	But wriggling her derrière:
"Pourquoi vous arrêtez-vous!"	"Why do you stop?"
Dit ce mirliton, etc	Says this *mirliton,* etc.[21]

Verses were the vehicle of their exchange. Cézanne began painting on the side while he was still at school; at eighteen he was serious enough to enroll at the free School of Drawing in Aix. And yet, as a teenager, he was as much poetaster as painter. Poets were real presences in the Cézanne world. They were a source of moral support. "One who is strong is Baudelaire," he told his son at the end, as if passing him on to the next generation, "his *Art romantique* is amazing, and he makes no mistake in the artists he appreciates."[22] Baudelaire's *L'Art romantique* (1868) was one of his favorite books. Among many wonderful things, it contained the celebrated essay "The Painter of Modern Life" and, of greater import for Cézanne, a eulogy on the life and work of Delacroix.[23] Baudelaire replaced Musset in Cézanne's personal pantheon, just as Musset had replaced Victor Hugo. With fitting symmetry, *Les Fleurs du mal* was first published in 1857, the year Musset died, and immediately prosecuted as an outrage to public decency. Cézanne was said to know this scandalous collection by heart, and sometimes to take it with him for a day's work out *sur le motif,* as he would say, meaning a day spent painting outdoors.

He gave a paint-spattered copy to the young poet Léo Larguier, who found on the last page an itemized list of poems, presumably the ones he valued most: "The Beacons," "Don Juan in Hell," "The Giantess," "*Sed non satiata*" ("But not satisfied," a reference to sexual appetite), "A Carcass," "Cats," "The Happy Corpse," and "The Taste for Nothingness."[24] "A Carcass" is strong meat. "Remember, my love, the object we saw / That beautiful morning in June . . . Her legs were spread like a lecherous whore / Sweating out poisonous fumes." The poem seems to have captured Cézanne's imagination. He devoted three sheets of drawings to studies for an illustration of it, in 1866–69, and recited it all from memory to Émile Bernard, without a mistake, forty years

later. "The Beacons" is a paean to certain artists much esteemed by Cézanne (Rubens, Leonardo, Rembrandt, Puget, Watteau, Goya, and Delacroix). Coincidentally or otherwise, the verse on his idol Delacroix yokes the painter's name with an appropriate composer:

Delacroix, lake of blood, the evil angels' haunts,
Shaded within a wood of fir-trees always green;
Under a gloomy sky, strange fanfares pass away
And disappear, like one of Weber's smothered sighs[25]

Weber would become Cézanne's favorite composer; his favorite works were romantic operas. School music lessons were supplemented by violin lessons at home. This was not a success. The tutor was the organist and precentor of the Cathedral of Saint-Sauveur, Henri Poncet, who also taught at the Collège Bourbon. He encountered a recalcitrant pupil. Young Cézanne took no interest whatsoever in the lessons; "often the descent of a violin bow on his fingers bore witness to M. Poncet's displeasure." And yet perhaps something stuck. Fifty years on, he reported to his son: "At Saint-Sauveur, the former choir leader Poncet has been replaced by an idiot of an abbot, who takes charge of the organ and plays out of tune. Such that I can't go to hear mass any more, his way of making music makes me positively ill."[26] Cézanne's taste in music may or may not have run to Wagner, as is often suggested, after the gratuitously titled painting *Young Girl at the Piano—Overture to "Tannhäuser"* (1869–70), but it did not run very far. He cannot have been oblivious to the Paris première of that opera in 1861, and the controversy it generated, if only because of Baudelaire's impassioned plea for the composer to "persist in his destiny." Wagner was *de rigueur* among several of his friends and acquaintances; but there is scant evidence of Cézanne's personal engagement. Not even Joachim Gasquet could tempt him on the subject, in the 1890s, when waxing philosophical:

CÉZANNE: Basically, if you have character, you have talent. I don't say
 that character is enough, that it's enough to be a good fellow to paint
 well. That would be too easy. But I don't believe that a scoundrel can
 have genius.
GASQUET: Wagner?
CÉZANNE: I'm not a musician. And then, let's be clear, a scoundrel,
 that's not having the temperament of a devil, and managing still to

be somebody, with that temperament. . . . Keep your hands clean, I mean. All artists, *parbleu,* more or less, always go a bit off the rails, this way or that. There are some who, in order to make it . . . yes, but I believe those are the very ones who don't have talent. You have to be incorruptible in your art, and to be so your art, you have to train yourself to be so in your life. Remember, Gasquet, old Boileau? "*Le vers se sent toujours des bassesses du cœur.*" ["The verse always smacks of the baseness of the heart."] In short, there is know-how and there is show-how. When you know what you're doing, there is no need for showing off. You can always tell.[27]

Late in life he would sometimes ask Marie Gasquet, an accomplished pianist, to play for him—preferably selections from Weber's *Der Freischütz* (1821) or *Oberon* (1826)—and almost invariably go to sleep. The delicate pianist was accustomed to playing the last few chords *fortissimo* to wake him up and spare him any embarrassment.[28] A touch of the piano took him back to his youth. "It's like in '57," he would exclaim, "I'm young again. Ah! The bohemian life then!"[29]

Some of his friends thought that he had no ear for music, and his dealer used to say that he liked only the barrel organ, but he seems to have heard more than might be expected. Dining at home with him in his last years, the young writer Louis Aurenche was amazed to find that he knew by heart the songs of various operas: Boieldieu's *La Dame blanche,* Hérold's *Le Pré aux clercs,* Meyerbeer's *Robert le diable.* They would sing them lustily over dessert, to the consternation of Cézanne's housekeeper, washed down with a bottle of good Médoc.[30]

An element of fun was important to Cézanne. *Opéra-bouffe* appealed to him; it took him back to the ragtag choir of his schooldays, with the light tenor Baille and the bass Boyer, when they sang their verses aloud together. And then there was the school band. Their classmate Marguery played first cornet, Cézanne second, Zola a tuneless clarinet. They processed through the town, dressed up, behind the rain-bringing saints and the cholera-curing Virgin. Whenever they could get away, the two friends would go and serenade a pretty girl whose pride and joy was a green parrot. Neither girl nor parrot seemed to appreciate the noise they made. "We serenaded the girls of the *quartier,*" Cézanne recalled. "I played the cornet, Zola, more distinguished, the clarinet. What a racket! But we were . . . fifteen. We thought we could swallow the whole world at that age!"[31]

His time at the Collège Bourbon was not devoted only to mayhem and mischief and *mirliton*. He was a prize-winning pupil. At the ceremony at the end of his first year (when he was fourteen), he won first prize for arithmetic, and gained a first honorable mention for Latin translation and a second honorable mention for history and geography, and for calligraphy. The years rolled by in like fashion. In the fifth grade he won second prize for overall excellence (after Baille), first prize for Latin translation, second prize for Greek translation, a first honorable mention for painting, seconds for history and for arithmetic, and a third for religious instruction. In the fourth grade he won second prize for arithmetic and geometry and for Greek translation, a first honorable mention for excellence, and a second for general grammar. In the third grade he won first prize for excellence, for Greek translation, and for geometry and physics, second prize for French narration, a second honorable mention for Greek composition and for Latin verse, and a third for Latin composition. In the second grade he won first prize for excellence, for Greek translation, for chemistry, and for cosmography, second prize for history and geography, a first honorable mention for Latin translation, a second for Latin narration, and a third for Greek composition. In his last year, 1858, he won a first honorable mention for excellence and for Latin conversation.[32]

He had an outstanding record, but not for painting and drawing. Zola was the one who won prizes for drawing, to say nothing of religious instruction and wind instruments, tone deaf as he was in each case. Cézanne the scribbler and Zola the dauber is a curious reversal, or doubling, reinforced by Zola's instinct that Cézanne might have made the better writer—the stronger pulse, the truer feeling. On Zola's side there was a certain sense of inferiority, perhaps, early acknowledged and then long submerged. After leaving school he dreamed of writing a kind of prequel to Jules Michelet's *L'Amour* (1858): "if I consider it worthy of publication, I'll dedicate it to you," he wrote to Cézanne, "who would perhaps do it better, if you were to write it, you whose heart is younger and more affectionate than mine."[33]

Cézanne's relationship with Zola was the main axis of his emotional life from cradle to grave. Theirs was one of the seminal artistic liaisons: as intimate, as vexed, as steadfast, as fascinating, and as fathomless as any in the annals of modernism. The true measure of their connectedness has remained elusive. The terms of the relationship evolved over time, as did its modus operandi; its purposes and consequences are still not well understood; its ultimate duration is a mystery. At bottom was an ineradicable *tendresse*. The two men

loved each other, it is tempting to say, like brothers. They continued to do so, in spite of everything that came between them, even after the publication of *L'Œuvre* (1886), about a failed painter bearing a suspicious resemblance to Paul Cézanne, the novel that is supposed to have caused a fatal rupture. Their feeling for each other was anchored in shared experience, in self-disclosure, in coming of age as artist-creators against the grain, armed with the tools of their trade, the pen and the palette knife, and armored with temperament. Cézanne characterized his own early style as *couillarde*—ballsy—while Zola's first critical writing was collected under the title of *Mes Haines* (*My Hates*).

The relationship was forged in adversity, in the school of hard knocks. It was founded on a basic commonality, a sense of social and cultural exclusion, verging on discrimination. In character, they were poles apart, as Zola later observed, but each nursed an almost willful sense of difference, a feeling of estrangement from the herd, a yearning to achieve himself, to become, as Nietzsche says, that which he is—something personal, distinctive, authentic. "Somehow I too must find some way to make things . . . realities that stem from handcraft," fretted Rilke at a similar juncture. "Somehow I too must discover that smallest basic element, the cell of *my* art, the tangible immaterial means of representation for everything."[34] What that might involve, Cézanne and Zola had no idea.

Perhaps the mighty Flaubert could give them a clue. Zola got to know Flaubert. Cézanne was fascinated by *The Temptation of Saint Anthony* (1874), first serialized in 1856–57 in *L'Artiste*, a periodical read by his mother, and immediately acclaimed by his hero Baudelaire. Cézanne devoted several paintings and drawings to that subject in the 1870s. Perhaps he identified with Anthony. The affinity with Flaubert ran deep. Monet later called him "a Flaubert of painting, a little clumsy, tenacious, unyielding . . . sometimes not getting beyond the trials and errors of a genius who struggled manfully to seize something of himself."[35]

"There is a part of everything that is unexplored," Flaubert told the young Maupassant, "because we are accustomed to using our eyes only in association with the memory of what people before us have thought of the thing we are looking at. Even the smallest thing has something in it which is unknown. We must find it." Here was an admirable prospectus for a great artist. Flaubert proceeded by penetration rather than intuition, as Maupassant put it.[36] The unspoken corollary was the need for application, effort, sheer hard graft. One of Cézanne's earliest letters to Zola begins with a mea culpa and a mock-classical

injunction, "Work, *mon cher, nam labor improbus omnia vincit*" (because hard work overcomes everything), but Cézanne did not really internalize this until later, following the example of Pissarro.[37] The vaulting Zola, by contrast, had a precocious understanding of the toil of art. Not yet twenty-one, he could be found explaining to Cézanne that "in the artist, there are two men, the poet and the worker. One is born a poet, one becomes a worker."[38] The last line of *L'Œuvre* is spoken by the Zola character himself. He has just buried his best friend, he is appropriately distraught, but time is getting on—it is already eleven o'clock: "Let's get to work."

In the beginning they talked unstoppably to each other, about everything, but above all about their yearnings. They talked of love, as if trying it on for size. They exchanged readings and quotations. Both devoured Michelet's *L'Amour*. "Michelet's love, pure love, noble, can exist," Cézanne informed Zola, "but it's very rare, he says." Zola responded with a quotation from Dante's *Inferno*— "Love, that releases no beloved from loving"—and a long disquisition on young love: "Young people above all have this self-esteem, and as love is one of the finest qualities of youth, they hasten to say that they don't love, that they are dragged into the swamp of vice. You've been there and you should know. He who declares a platonic love in school—that is to say, something holy and poetic—wouldn't he be treated as mad?"[39] What they declared, what they exchanged, sealed and defined the relationship. When it came to making things, each made with the other in mind. They took root in each other's imagination; they populated each other's work. Each held up a mirror to the other. But they also did as creative artists do, blending and amending, according to their needs.

Cézanne found solace in reading. As a young man he discovered Stendhal— not only *Le Rouge et le noir* (1830) and *La Chartreuse de Parme* (1839), but also the teeming, captivating *Histoire de la peinture en Italie* (first published anonymously in 1817, but widely available only in 1854)—a key author and a key work, to be read and reread all his life. Stendhal was an author to savor. "I've bought a very curious book," Cézanne wrote to Zola in 1878, "it's a web of observations so subtle that they often escape me, I feel, but what anecdotes and true facts! And the smart people call the author paradoxical. It's a book by Stendhal: *Histoire de la peinture en Italie,* no doubt you've read it, but if not, allow me to alert you to it. I'd read it in 1869, but I'd read it badly; I'm rereading it for the third time."[40] He was a great rereader, of books and paintings, people and nature. In this instance the curiosity lay partly in the work and partly in the author. Stendhal was a marvelous study of pride and vanity, "divided between his immense desire to please and become famous," in Valéry's

words, "and the opposite mania, his delight in being himself, in his own eyes, in his own way. He felt, deeply embedded in his flesh, the spur of literary vanity; but he also felt a little deeper down the strange sharp pricking of an absolute pride, determined to depend on nothing but itself."[41]

It is not too much to believe that Cézanne felt something similar. He was going to find his own way, in his own eyes, in his own time. In due course, he grew an absolute pride like a protective shell; he became financially independent; he cut loose from his contemporaries. He walked by himself. Yet succor of some sort was always vital to him. He had need of moral support. That was how he put it, and how he saw it. What he sought was constancy, the sympathy of the true believer—the believer in Paul Cézanne—and also perhaps someone who would make no demands on him. When he was nearing sixty, he painted Henri Gasquet's portrait (color plate 58). Gasquet was one of his oldest friends; a baker and a pipe smoker, deeply rooted in Aix, the very embodiment of constancy as Cézanne conceived it—*un stable,* as he succinctly said. For Cézanne this still-life stability was at the same time physical and metaphysical: he saw his friend planted in front of him like a rock, or a piece of furniture that would last; he saw also *l'homme intégral,* a principled consistency, an ethical unity. Henri Gasquet was the personification of harmony. Cézanne prized harmony. "I feel all that," he told his friend impulsively, "as I watch you draw on your little pipe." He insisted that the pipe smoker had done him a great service: "You are a support . . . a moral support. . . . I'd like to bring that out, to find the tones, just the right tone to show that. A moral support! That's what I've been looking for all my life."[42]

In the early days Zola was that support—a true believer. "I have faith in you," he insisted, over and over again.[43] Just as he, Zola, could be a great writer, the Balzac of his age, so his friend Paul could be a great painter. So much was implicit in the life they had laid out together in their late teens and early twenties. As the years went by, the purity of that belief began to fray. The choice of forebear was troublesome. Zola could be Balzac. Who could Cézanne be? Surely not Ingres, much caricatured from an early age. "Despite his *estyle* (Aixois pronunciation) and his admirers," said Cézanne, "Ingres is only a very minor painter."[44] Delacroix? Courbet? Later on, Zola suggested as much; but a note of equivocation had crept in. "Such strong and true canvases can make the bourgeois smile," he wrote in 1877, "nonetheless they show the makings of a very great painter. Come the day when M. Paul Cézanne achieves complete self-mastery, he will produce works of indisputable superiority." But the day was forever postponed. Three years later, he offered: "M.

Paul Cézanne, a great painter-temperament who is still struggling with investigations in technique, remains closer to Courbet and Delacroix."[45]

With the passage of time Zola lost faith in Cézanne's capacity for greatness. At around thirty, he latched on to Manet, who painted his portrait, in the style to which he would become accustomed. The intensity of the relationship abated, but the circuits of connectivity remained active. Cézanne continued to turn to Zola, as if the gesture were imprinted, until well into his forties. Zola was his friend and confessor, mentor and motivator, gateman and goad, storm lantern, poste restante, trusted intermediary, and lender of last resort. There were things he withheld, but he bared more of himself to his evil genie (as Zola once put it) than to any other living soul.[46]

And what was Cézanne for Zola? At the outset, a savior, and then a boon companion, an ally, a confidant, a stimulant, a witness, a gauge, and a source of ideas; after a while, a younger-brother figure—reversing their real age, where Cézanne was some fifteen months older—more wayward (or backward), but somewhat like himself; for the established writer, an artistic ideal, at once a source, a cause, and a puzzle; at the end, a dream, and possibly a disappointment.

In 1858 Zola and his mother left Aix for Paris, and he began to communicate with his friend in the best way he knew how: in writing. "Here," he lamented, "there is no ancient pine, no fresh spring from which to replenish the old bottle, no Cézanne with the expansive imagination and the cheerful and racy conversation!"[47] This little elegy was prompted by the memory of a favorite tree, evoked by Cézanne, whose sensory experience of trees approached that of people. "For him a tree is a growing thing, and can only live where it is; each tree has its appointed site. And the tree which he shows as so firmly rooted is not simply an essential type; it is individualized, with a history of its own, unlike any other's."[48] Throughout his life he was primitively attached to certain individual trees. "Do you remember the pine standing on the edge of the Arc," he asked Zola, in a sudden rush of feeling, "which bent its well-thatched head over the chasm that opened at its feet? That pine that protected our bodies with its foliage from the heat of the sun, ah! May the gods preserve it from the fatal blow of the woodcutter's axe!"[49]

After five years of constant companionship, the enforced separation hit them hard. They started an intensive correspondence, by turns playful, doleful, scatological, and confessional. "Since you left Aix, *mon cher,* I've been overwhelmed by a gloomy sorrow: my word, I'm not kidding," Cézanne assured

him lugubriously. "I don't seem myself, I feel heavy, stupid and slow. I'd really like to see you . . . in the meantime, I lament your absence."[50]

The feeling here was genuine enough, but the manner of its expression had a classical model: almost a code. At the Collège Bourbon, Cézanne and Zola wrestled for years with the classics—Livy, Cicero, Horace, Tacitus, Lucan, Apuleius, Ovid, Lucretius, and especially Virgil. In Aix, with its much-mythologized Roman origins in the city of Aquae Sextiae Salluviorum, they were steeped in pastoral psychogeography. For Cézanne, the self-styled "Aquasixtain," classical allusion was second nature.[51] With Zola he could trade Latin tags, butcher Cicero, and quote Horace with impunity. They played Latin word games, and sometimes dropped into a bastard version, as if locked in a private language. "*Mi amice, Carus Cezasinus,*" Zola addressed him, "*tibi in latinam linguam, ne lingua gallica rubescit audiendo quidam rem impudicam, mitto me ardescere et amare virginem pulcherrimam et quae non habet jam masculo membro frui. Haec femina fulva est et sua color est alba et sui oculi caerulei sunt. Vides ergo ut illa est divinitas, simila Ceres quae ad messes presidet. Gaude, gaude Cezasine, vides enim unus litteratus qui latina lingua utitur et qui dicit platitudinas* [to you in Latin not in French, reddening from shame over this shameless thing, I send a beautiful virgin who inflames and incites me and who I have not yet enjoyed with my masculine member. This woman is golden, her skin is white and her eyes are blue. See how divine she is, like Ceres who presides over harvests. Rejoice, Cezasinus, see a true literator who uses the Latin language and utters platitudes]."[52]

Their mutual lamentations were grounded in Virgil. The dialogue they struck up in their letters was deliberately patterned on the dialogue between two shepherds, Meliboeus and Tityrus, in the first of Virgil's *Eclogues*. In the poem, Tityrus ups and leaves his *patria,* the country of his youth, to go to Rome, in order to seek manumission from slavery—to become a free man—or perhaps reprieve from the confiscation of his land. He leaves behind a girl, Amaryllis, and proceeds to display a certain insensitivity to the plight of Meliboeus, his friend. Meliboeus tells him of the pain he has caused, invoking the very touchstones of their existence:

> I used to wonder why Amaryllis called so sadly
> Upon the gods, and let her apple crop go hang.
> Tityrus was not there. The very springs and pine-trees
> Called out, and these very orchards were crying for you, my friend.[53]

Such was Cézanne's predicament. Moreover, Cézanne in Meliboeus mode conveyed exactly the Virgilian conception of the tree. Trees in Virgil do more than provide shade. They offer what the Romans called a *locus amoenus,* a delightful place, in which to read and write; a place of contemplation and consolation; a place to remember and to celebrate. The pine, in particular the umbrella pine, has almost talismanic qualities, serving as a substitute, or marker, for the absent (male) beloved. "If Lycidas only were with me more often," sorrows Thyrsis in the seventh *Eclogue,* "ash-tree and pine would be nothing to me."[54]

The umbrella pine appears in Cézanne's letters in precisely this sense, no more poignantly than in 1882, when he wrote to Paul Alexis:

I must be well behind in thanking you for sending me your biographical work, for I'm in L'Estaque, the land of Sea Urchins. The copy you were kind enough to send me fetched up in Aix, in the unclean hands of my relatives. They took care not to let me know. They took it out of the envelope, cut the pages, went through it in every sense, *while I was waiting under the harmonious pine tree.* But finally I found out. I asked for it back, and here I am in possession, reading.

I want to thank you most warmly for the good feelings you give me in recalling times gone by. What more can I say. I shan't be telling you anything new if I tell you what marvelous stuff there is in the beautiful verses of he who wants very much to continue to be our friend. But you know how much it means to me. Don't tell him. He would say that I'm soft in the head. This is between us and not for broadcast.[55]

The work in question was *Émile Zola, notes d'un ami.* Among the verses was one "To my friend Paul," dated 1858. "The particular scent of pine evokes my entire youth," Zola remarked later.[56]

"With you," Cézanne wrote to Zola, "what subjects could I tackle!—hunting, fishing, swimming, a whole variety right there—and love (*Infandum,* let's not broach that corrupting subject)." *Infandum,* Virgil's unspeakable grief, became one of his favorite tropes. ("*Infandum, Infandum,* le Rhum de sa patrie! / Du vieux troupier français, Ô liqueur si chérie!")[57] Yet he who poured out so much, in print and paint, withheld his translation of Virgil's second *Eclogue.* "Why don't you send it to me?" asked Zola. "Good Lord, I'm not a young girl, and I shan't be shocked." The subject of the second *Eclogue* is the unrequited love of a shepherd, Corydon, for his master's favorite, Alexis.[58]

"You write that you are very sad," Zola responded characteristically to another letter, in 1860: "I will reply that I am very sad, very sad. It is the wind of the century passing over our heads, we should not blame anyone, only ourselves; the fault is in the times in which we live." Then a change of register:

Then you add, if I understood you, that you don't understand yourself. I don't know what you mean by that word "understand." For me, this is how it is: I recognized in you a great goodness of heart and a great imagination, the two highest qualities to which I pay tribute. And that's enough; from that moment I understood you, I appreciated you. Whatever your weaknesses, whatever your erring ways, you will always be the same for me. It's only rocks that don't change, that never depart from their rocky nature. But man is a whole world; anyone who wished to analyze one individual for one day would be overcome by the work. Man is incomprehensible, even to know his slightest thoughts. But what do your apparent contradictions matter to me. I considered you a good man and a poet, and I shall always repeat: "I understood you."[59]

A few months later: "Like the shipwrecked man who clings to the floating plank, I cling to you, *mon vieux* Paul. You understand me, your character was in sympathy with mine; I had found a friend, and I thanked heaven for it. Several times I was afraid of losing you; now that seems impossible. We know each other too well ever to separate." On another occasion a downhearted Zola conjured up a magnificent tribute to his very own Cézanne: "I find myself surrounded by such insignificant, prosaic beings, that I'm delighted to know you, you who are not of our century, you who would invent love, if it were not a very old invention, as yet unrevised and imperfect."[60]

If this was love, it was also declared in unusually public fashion. In 1866, a punchy complement to *Mes Haines* entitled *Mon Salon* came complete with a letter-dedication "To My Friend Paul Cézanne":

It is for you alone that I write these few pages, I know that you will read them with your heart, and that, tomorrow, you will love me even more. . . . I see you in my life like Musset's pale young man. You are all my youth; I remember you in each of my joys and each of my sorrows. Our fraternal natures developed side by side. Today, as we make our debut, we have faith in each other, because we have entered each other body and soul.[61]

Cézanne's school prizes were books: such things as Antoine Caillot's *Abrégé des voyages modernes, réduit aux traits les plus curieux* (1834), Sancerotte's *Avant d'entrer dans le monde* (1847), and Abbé Noël-Antoine Pluche's *Beautés du spectacle de la nature, ou Entretiens sur l'histoire naturelle* (1844). After his death, his books were parceled out among the family. His sister Marie kept some of the school prizes; later they found their way back to his studio.[62] The rest of his library was disposed of by his relatives. The gossip among the neighbors in Aix was that no sooner had the funeral taken place than the studio was picked clean, leaving absolutely nothing worth more than fifty centimes.[63] There appears to be some truth to those tales. A few of his childhood books have been recovered: they include Washington Irving's *Life and Voyages of Christopher Columbus* (1828), translated into French as *Voyages et découvertes des compagnons de Colomb* (1846), and a precious volume inscribed with his mother's maiden name, *Les Incas, ou La Destruction de l'empire du Pérou* (1850), by Jean-François Marmontel. In the back of the latter is a flowery schoolboy signature and a rudimentary drawing, or cartoon, possibly the earliest portrait drawing by Paul Cézanne in existence.[64] It is presumed to represent his parents. "Every time he paints one of his friends," said Antony Valabrègue, who fell victim a few years later, "it seems as though he were revenging himself for some hidden injury."[65] If that was so, revenging himself on his parents began early.

2: *Le Papa*

He did very few portraits of his parents. Or perhaps he did more, and destroyed them. Along with the self-inspecting goes the self-editing. The false starts and failures are often the first to go. Cézanne had at least one bonfire: Cyril Rougier, later his neighbor in Aix, remembered him detaching an enormous quantity of early works from their stretchers and burning them in 1899. He is supposed to have instructed his housekeeper to burn others; the anecdotal evidence suggests that she did so with a will, especially his studies of the female nude. "I can't leave those for the family. What would people say?"[1] Three formal portraits of his father survive, together with a number of informal drawings and sketches. There is indeed a family resemblance to these images of "the author of my days," as Cézanne wryly referred to him.[2] He is usually pictured reading, or snoozing; appropriately for a man who made his way in hats, he always appears in some sort of headgear.

The earliest of the three was originally a mural—almost a household god— in the grand salon of the Jas de Bouffan, the manorial estate just outside Aix that Cézanne's father acquired in 1859, for the considerable sum of 85,000 francs. The Jas de Bouffan would become a kind of sanctuary for Cézanne, but it was always "my father's house." In 1859 it was in a poor state. The family kept their house in the town; that remained their principal residence for some years. In the fullness of time Cézanne was permitted to colonize one of the bedrooms at the top of the Jas as a studio, and alterations were made to give it more light. A high window inserted into the roof afforded a good northern light, at the cost of spoiling the line of the eaves—a liberal gesture on the part of "the parental authority," and in its own way an example of his take-it-or-leave-it attitude, for in the tight confines of Aix-en-Provence the look of the roof was a marker of social status, and the layers of tiles an index of

net worth. Louis-Auguste Cézanne was the very antithesis of Ben Jonson's Sir Politic Would-Be.

Cézanne was also given license to decorate the walls of the salon. What is more, his father agreed to sit for him, possibly on condition that he could read his newspaper at the same time. Thus the first *Portrait of Louis-Auguste Cézanne, Father of the Artist* assumed its rightful place as the centerpiece of the display (color plate 12), attended by *The Four Seasons,* the ones that were playfully signed Ingres, with a variety of other derivations and experimentations ranged around the room.[3] These murals appear to have been done over a period of some ten years, from around 1860 to around 1870, beginning perhaps with *The Four Seasons.* The father of the artist seems to have adopted a remarkably laissez-faire attitude to the festival of images populating the walls. He balked only at a rather intrusive naked rear view. "See here, Paul, what about your sisters; how could you do a nude woman?" To which Cézanne is said to have replied: "But don't my sisters have bottoms like you and me?"[4]

The whole extravaganza, mural and extra-mural, survived in situ only as long as the artist himself. Following the death of his mother, the Jas de Bouffan was sold in 1899 (the occasion for the bonfire). In 1907 the new owner, Louis Granel, proposed to have all of the paintings detached from the wall in order to present them to the state. The idea was that they should go to the Luxembourg Museum in Paris. Faced with this generosity, the director general of national museums, who evidently knew nothing of Cézanne or his works, instructed Léonce Bénédite, curator of the Luxembourg, to visit the Jas de Bouffan and inspect the murals to determine whether or not the offer should be accepted. Bénédite's official report is a masterpiece of the genre:

> The Jas de Bouffan is Cézanne's own house, and the paintings in question are intended as part of the decoration. They are all located, in fact, in the same room, a fine large salon in the style of Louis XIV, which still retains a few delightful traces of the time when this property was a country house belonging to the Maréchal de Villars, a marble medallion of whom crowns the entrance doorway.
>
> At the end opposite the windows this large salon is terminated by a semicircular alcove. This apse is decorated with five tall narrow paintings.
>
> In the middle, a portrait of a man dressed in black, with a cap on his head, seated with his profile turned towards the left, painted in practically two colors only, and executed in an altogether wild [*farouche*] manner. It is Cézanne's father.

Alongside this picture are four panels representing the four seasons.

Spring is symbolized by a young woman, in a red dress, descending the steps of a garden and holding a garland of flowers. In the background is seen a decorative urn under an early-morning sky in graded tones, running from rose to blue.

Summer is a seated woman, a sheaf of wheat on her lap, with a heap of fruit, melons, figs, etc., piled at her feet.

Autumn carries a basket of fruit on her head, and *Winter* is a woman seated before a fire, at night, under a cloudy sky, part of which is sprinkled with stars.

These paintings, awkwardly and immaturely executed, in a conventional manner closer to the detestable imitations *à la* Léopold Robert than to the modern so-called Impressionist tendencies, were painted on the wall at an early date. And the artist, who does not seem to have had any illusions about their value, which is to his credit, has signed them derisively: *Ingres*.

Near the fireplace, to the right, on the wall opposite the entrance, a *scène galante* in the style of Lancret, but of unusual dimensions, entirely fills one panel, an enlargement or interpretation of some old engraving. The figures, half life-size, are seated under a group of trees, near a tall

Le Papa

pedestal supporting the bust of a woman. In the foreground two figures, a man and a woman, appear to be executing a dance step.

To the left of the doorway of the salon—that is, on the wall opposite the fireplace—the panel is completely covered by an immense landscape also in the style of the eighteenth century, great leaning cedars, with excessively thick trunks, painted in the spirit of Boucher's decorative backgrounds. Farther to the left, against a heavy black background, there stands out obtrusively the nude torso of a man, seen from behind, executed in a coarse manner.

To the right of this doorway, also on a blackish background, is a religious scene: Christ bending over a group of kneeling beggars; a scene painted apparently under the influence of El Greco, in whites and greys on a black background. These figures are a little less than life-size. At the bottom of this picture, to the left, two life-size heads representing a bearded man and a woman, which have no connection with the preceding scene. On the right is still another figure, also life-size, in an attitude of prayer.

Finally, beneath the *scène galante* described above, is a large head with long hair, mustaches, a tuft of hair under the lower lip, and a small beard on the chin, which is the portrait of a painter of Aix, a sick little dwarf, of the name of Emperaire, of whom Cézanne painted several other portraits, among them the one exhibited at the last [1907] Salon d'automne.

In addition to this collection of "decorations," I may also mention, in a studio located on the top floor of the villa, a small canvas representing women dressed in the fashion of the Second Empire, out for a walk, which seems to have been painted from some reproduction in an illustrated paper.

With the exception of this last canvas, all of the pictures are painted directly on the walls. But M. Granel, whose generosity is beyond question—for he has been offered a very large price for these pictures: 100,000 francs, he told me, for *The Four Seasons*—M. Granel . . . has offered to have them taken off the walls.

I have dissuaded him from doing so. For I am obliged to decide absolutely against the acceptance of this liberality. I do not wish to discuss here either the talent or the work of Cézanne. Moreover, is he not already represented in the Luxembourg in the Caillebotte bequest?

I abstain therefore from venturing on this ground, but whatever may be one's opinion of the work of this painter, one cannot deny that to rep-

resent him by empty and banal productions which he does not appear to have taken seriously himself, would be a strange way to do him honor.[5]

And so, a month after the 1907 retrospective closed its doors, the offer was refused. The timing was impeccable, and the outcome predictable, for the snakelike Monsieur Bénédite had form: the Caillebotte bequest included five Cézannes, of which the ungrateful authorities grudgingly selected two, in 1896. Bénédite himself had written down their value, putting them at a fraction of the estimated value of works by Degas, Pissarro, and Sisley, to say nothing of Manet, Monet, and Renoir. In other words, he knew exactly where he stood on the talent and the work before he ever set foot in the salon of the Jas de Bouffan. On or off the wall, Cézanne had nothing to recommend him.

Most of the murals were removed in 1912, when Granel began to offer them to Paris dealers, though Roger Fry was delighted to find the head of Emperaire and the other two life-size heads still in place in 1919, especially as no one at the house seemed to know anything about Cézanne, and the gardener had never heard of him. Local people, Fry was told, recalled him with difficulty as *un vieux monsieur qui n'était pas net*—who wasn't all there.[6]

Before the removals, however, the *farouche* Louis-Auguste Cézanne had caught the eye of the *farouche* Augustus John. Many years later he recommended the mural portrait to the American collector John Quinn, who snapped it up. Quinn considered it "a very noble thing," and in due course sold it on.[7] In 1968 it was acquired by the National Gallery in London. Wild or noble, it is a curiosity, and already a statement. "*Le papa,*" said Cézanne, simply, with gruff tenderness, when he showed it to his young friend Joachim Gasquet, thirty years later.[8] *Le papa* is all there, solid against the world, bulging with vitality. He is over sixty, and in rude health. His outfit, the peaked cap in particular, seems vaguely military, but rumpled, like the Good Soldier Schweik. Planted on his chair, he stares down at his newspaper. His hands are mitts. After a fashion—in a way that might well have pleased him—the father of the artist presents his very own *bella figura*. Despite the well-advertised *je-m'en-foutisme*, Louis-Auguste was not without a certain regard for his appearance. The distinctive headgear was all his own, the cut and shape of the peak so pronounced that people would ask, "Have you seen old Cézanne's shovel?"[9] He was familiar with that jibe. So was his son.

There is more to the statement. "Father of the Artist" is a traditional form of words, but in this instance they had a special resonance. In the domestic arena, an artist announces himself.

The most celebrated of the paternal portraits, *Louis-Auguste Cézanne, Father of the Artist, Reading "L'Événement"* (color plate 13), entwines biography and autobiography in an intriguing personal work—a painting kept by the artist all his days, and now in the National Gallery of Art in Washington, D.C. Unlike so many of Cézanne's paintings, this one can be securely dated, to 1866, when the artist was twenty-seven and the father of the artist sixty-eight. In November 1866, Antoine Guillemet wrote to Zola from Aix, "this Athens of the Midi," with some news of their mutual friend Paul. "When he returns to Paris you'll see several pictures that you'll like a lot, among others . . . a portrait of his father in a big armchair, which comes over really well. The painting is light [in tone]; the look is very fine. The father has the air of a pope on his throne, if it weren't for the *Siècle* that he's reading."[10]

The first bit of intrigue surrounds the paternal newspaper. X-ray examination of the painting confirms that it was originally *Le Siècle,* as reported by Guillemet, which was indeed Louis-Auguste's newspaper. *Le Siècle* was the voice of the constitutional opposition; it was republican but not revolutionary. Under the Second Empire (1852–70), the official style of the government of France in the reign of Napoleon III, it was solidly anti-government and fiercely anti-clerical. Cézanne's father tends to be cast in a reactionary light—"the parental authority" plays up to that very notion. The historian E. P. Thompson famously declared his wish "to rescue the poor stockinger, the Luddite cropper and the 'obsolete' hand-loom weaver from the enormous condescension of posterity." Perhaps the rich hatter should be added to the list. In life Louis-Auguste could look after himself, but there is an element of condescension to the way in which posterity has treated him. Politically, he was something of a freethinker, truculently independent, liberal or left-leaning, and staunchly republican. For father and son alike, Napoleon III was "the tyrant."[11] After the fall of the Second Empire, in the wake of the Franco-Prussian War of 1870, Louis-Auguste Cézanne emerged as a figure in the municipal council of Aix in the new republic, a council composed not of the nobility but of lawyers, bankers, traders, and even shoemakers. Typically, he did not give much time to municipal affairs. The Church did not detain him, either. Louis-Auguste was not a man for organized religion. "We're going to lunch a little late today," he joked to a friend. "As it's Sunday, the women have gone to eat the Host." This crack is supposed to have provoked his son to observe, incautiously, "It's easy to see that you read *Le Siècle,* Father, with its wine-merchant politics!"[12]

Le Siècle, therefore, was the natural choice. No less a person than the subject of the portrait was liable to find anything else inauthentic, inappropri-

ate, apparently gratuitous, possibly offensive. Nevertheless Cézanne opted for *L'Événement*. Why?

L'Événement was a short-lived republican rag launched by the director of *Le Figaro*, in search of a wider circulation. It gained notoriety in its day, and the bounty of posterity, for a series of articles by a tyro art critic who first appeared under the threadbare alias of "Claude" and soon revealed himself as Émile Zola. Their ostensible subject was the Salon of 1866.

The usual approach to salon criticism was to consider the art and the artists represented. That was not for Zola. Instead, he began as he meant to go on, with a coruscating piece on the jury. "A salon, these days, is not the work of the artists, it is the work of the jury. So, I concentrate first of all on the jury, the author of those long, cold, pallid rooms where, under the harsh light, all the timid mediocrities and all the stolen reputations stretch out before us." There followed a panegyric to Manet, who did not feature in the salon at all, because his submission had been rejected (along with Renoir's, and of course Cézanne's). Zola was bracingly unequivocal. "Manet's place is marked in the Louvre like Courbet's, like every artist of a strong and original temperament."[13] All of this was too much for *L'Événement* and its readers. After a deluge of protest, Zola's articles were discontinued. Undeterred, he promptly reissued them as a brochure, *Mon Salon* (1866), with the letter-dedication to Cézanne that declared his love and their complicity.

> For ten years we have talked art and literature. We often lived together—do you remember?—and often daybreak surprised us, discussing still, rifling the past, questioning the present, endeavoring to discover the truth and to create for ourselves an infallible, total religion. We shifted horrendous piles of ideas, we examined and rejected all systems, and, after such hard labor, we said to ourselves that beyond the powerful and individual life there is nothing but lies and stupidity.[14]

Cézanne remembered. "By God," he would say, "he really did for them, those buggers."[15]

The choice of *L'Événement* for the portrait was loaded with personal significance. It was a response to Zola—part of a reciprocal history of call and response, deeply embedded in dauber and scribbler alike—and in wider compass a response to his own situation, at once coddled and cramped, in the bosom of his family. "I'm here among my family," he wrote in exasperation to Pissarro at the time, "the foulest people on earth, those who make up my

family, excruciatingly annoying. Let's say no more about it." As he worked on the light portrait his mood darkened. "I'm feeling a bit down," he confessed to Zola, after carrying the letter around in his pocket for several days. "As you know, I don't know what causes it, it comes back every evening when the sun sets, and then it rains. That brings on the gloom."[16]

Among his family, Cézanne felt caged. By 1866 he had been toiling at painting for at least five years. A number of canvases had come to nothing. So far from astonishing Paris, it was as if he were confined to Aix. And the uncomprehending Aixois were getting on his nerves. "They ask to come and see his painting so that they can then rubbish it," noted Guillemet, who cordially approved Cézanne's response: " 'Bugger off,' he says to them, and the ones with no temperament run away, terrified."[17]

L'Événement meant a great deal—more than his father ever realized. The newspaper was nothing if not a paternal attribute. Switching the title was a gesture of defiance, muted and encoded, yet emblazoned on the masthead. The portrait is a kind of cryptogram, like those in the letters he sent to Zola. In a certain sense, it is a letter-dedication in his own idiom, privately shared. Cézanne must have relished that, and relished also the image of his father engrossed, holding in his hands the manifesto of artistic rebellion.

The portrait has another intriguing feature. In this Cézanne is another Cézanne, a painting within a painting, *Sugar Bowl, Pears and Blue Cup* (color plate 16).[18] That little still life, a choice example of the palette-knife technique of his *manière couillarde,* hangs on the wall above his father's head. It is partially obscured by the papal throne; in the hieratic scheme of the composition it is suitably restrained, but it is not to be ignored. It is the only decoration in this austere chamber, but it is no mere decoration. True to its temperament, it registers a powerful and individual presence. It is proudly, unmistakably, his. Cézanne in his mid-twenties had restricted means of self-assertion. Artistically he was coming into his own, though he hardly yet knew it; financially he was bound to the parental authority. As he used to say, "Me, I go as far as to embrace *le papa.*"[19] In the portraits, however, he never looks his father in the eye. *Portrait of Louis-Auguste Cézanne, Father of the Artist, Reading "L'Événement"* is the very opposite of *farouche*. It is a contemplative work, and a form of tribute. It embraces more than *le papa*. Behind the throne, a still life raises a small flag of independence.

Cézanne's father was an archetypical self-made man. His forebears are supposed to have originated from Cesana Torinese in the mountains of Piedmont, migrating a few miles across the border to Briançon some time in the seven-

teenth century. (In the 1850s, when Louis-Auguste was reading it, *Le Siècle* was dubbed "the newspaper of Cavour," the prime minister of Piedmont and champion of the Risorgimento—the movement toward Italian unification.) In the parish registers of Briançon the name evolves through Césane and Cézane to Cézanne. Subsequent migrations are difficult to reconstruct with precision. The earliest mention of a Cézanne (or Sézanne) in Aix dates from the mid–seventeenth century. Honoré Sézanne (c. 1624–1704), Louis-Auguste's great-great-grandfather, was born near Embrun, south of Briançon, but lived in Aix and married Madeleine Boyer there in 1654. Their son Denis Cézanne (1659–1738), Louis-Auguste's great-grandfather, a clerk, secretary to a lawyer in the parish of Sainte-Marie-Madeleine, married Catherine Marguerit (c. 1683–1745) of the parish of Saint-Sauveur in 1700. Their son André Cézanne (1712–64), Louis-Auguste's grandfather, who became a master wigmaker, married Marie Bourgarel around 1754. Their son, christened Thomas François Xavier, was born in Aix, but lived and died in Saint-Zacharie in the Var, northeast of Marseille. Thomas Cézanne (1756–1818), Louis-Auguste's father, a costume tailor, married Rose Rebuffat (1761–1821) in nearby Pourrières in 1785. Louis-Auguste Cézanne (1798–1886), their son, was born in Saint-Zacharie on the 10th Messidor of year VI in the French Revolutionary calendar, which is to say 28 June 1798.

Saint-Zacharie was too small for Louis-Auguste. Eager to escape his large family and get on in the world, he left for Aix as soon as he could, finding work with a wool merchant called Dethès. That was only the beginning. In 1821, aged twenty-two, he was off to Paris and an apprenticeship as a hatmaker and hat salesman, and a liaison with the boss's wife. Four years later he returned to Aix and opened his own business, with two partners, for the sale and export of felt hats, in the local style. The hat trade flourished in Aix in the mid–nineteenth century, and Louis-Auguste was in on the ground floor. By the 1870s, some 470 men and 240 women were employed in hatmaking, and many more in associated activities, the most important of which was rabbit farming. Hatmaking was heavily dependent on rabbit farming: the skin made the felt. In the surrounding countryside the skin collector was a fairy-tale grotesque, at once bogeyman and butcher. "*Peaux de bête, peaux de lapin,*" runs the Provençal rhyme, "*l'estrassaire est un coquin*" (Animal skin, rabbit skin, the rag-and-bone man is a cheeky beggar).[20]

The new establishment, Cézanne and Coupin, had a smart frontage on the Cours. Droll coffee drinkers at the café tables a few doors down might quip that Céz-anne (*seize ânes,* sixteen donkeys) and Coupin made seventeen

old fools (*vieilles bêtes*), but there was money in skins, and Céz-anne was no Céz-asinus. He began in effect to speculate in rabbit skins, lending to the rabbit farmers in lean times, charging interest, buying up when he could. From there it was but a small step to lending more widely, first of all to local businesses, in the fullness of time to enterprises as faraway as Marseille. Debtors were monitored with characteristic rigor, any backsliders likely to find themselves under the personal supervision of the paternal authority. Legend has it that Louis-Auguste installed himself in the house of one spendthrift and proceeded to impose a regime more in keeping with their means, regulating all household expenditure, down to the amount of butter, meat, and potatoes to be consumed. After two years of enforced austerity, he recovered the full amount of his loan, with interest.

For all that, the improvident were let off comparatively lightly. The insolvent were not so lucky. They were dispossessed. Louis-Auguste swallowed them whole, without compunction. In the papal portrait of him there is a telltale splotch of red on his left forefinger: he is red, if not in tooth, in claw. According to the records of "the liquidation of the property of the insolvent debtor Louis Gaspard Jean," for example, when that unfortunate upholsterer went bankrupt, on 5 July 1854, Louis-Auguste Cézanne bought up "all the goods and shop stock comprising various sofas, armchairs, chairs, cradles, canopies, cornices, webbing, bedside rugs, woolen damask fabrics, velvet cloth, canvas, horsehair, elastic fabrics . . . in short all the upholstery and trimmings gathered together in the apartment . . . together with furniture and movable effects comprising table, chairs, looking-glass, desk, linen, clothing and miscellaneous kitchen utensils, all the above from the bankruptcy of M. Jean . . ."[21]

Moneylending bordering on usury was certainly profitable. When Louis-Auguste got married, in 1844, at the age of forty-five, he was identified as a former hatter, now a *rentier,* a man of independent means. The witnesses, "friends of the bride and groom," were Jean François Hyacinthe Perron, bailiff; Jacques Étienne Vieil, independent gentleman; Casimir Pierre Joseph Corse, doctor of medicine; and Jérôme Coupin, hatter (and partner). All signed the marriage certificate, unlike the bride and her mother, "who declared themselves without this skill."[22] Professionally, the father of the artist had gone up in the world. A background in rabbit skins and shady deals was just the thing to set bourgeois tongues wagging at the Collège Bourbon, but Louis-Auguste cared not a fig for that. He was set on going further.

His bride was Anne Élisabeth Honorine Aubert, *sans profession,* according to the marriage certificate, but in fact a former worker at the firm of Cézanne

and Coupin. Élisabeth Aubert (1814–97), Cézanne's mother, had been living with Louis-Auguste for some six years, since the age of about twenty-four. A handsome woman with dark eyes and strong features, she came from much the same social class as him. Her father, Joseph Claude Aubert (1776–1828), a bodger, or chair turner, lived in Aix. In 1813 he married Anne Rose Girard (1789–1851), Cézanne's maternal grandmother, who played an important role in his early upbringing, and told him tall stories of his ancestors; her own father, Antoine Girard, was a former plowman turned saltpeter man from the parish of Notre-Dame-du-Mont in Marseille. The witnesses to Élisabeth's birth, on 24 September 1814, a stable boy and an innkeeper, were illiterate, but her father could sign his name. Thirty years later, according to the marriage contract, she brought as a dowry "the sum of savings she has made up until this day as a worker in the hatmaking trade." Her trousseau was valued at 500 francs; she contributed a further 1,000 francs in ready money, and a future inheritance of another 1,000 francs. This was perfectly respectable, but dwarfed by the burgeoning wealth of her husband.[23]

No sooner did she start living with Louis-Auguste than she became pregnant. Paul, their first child, was born at one in the morning on 19 January 1839, in a charitable institution in the Rue de l'Opéra. His parents were not yet married. That was common enough at the time; no stigma attached to the parents, or the children, so long as they were publicly acknowledged by the father. In this instance the birth certificate is in the form of a recognition of paternity by Louis-Auguste, witnessed by Lucien Coussin, a commercial broker, and Alphonse Martin, a hatter (Louis-Auguste's first business partner). In other words, Paul Cézanne was illegitimate, but recognized. A month later he was baptized in the Church of Sainte-Marie-Madeleine. His godmother was his grandmother Rose; his godfather was his uncle Louis, Élisabeth's brother, also a worker in the hatmaking trade, under the sign of Cézanne and Coupin. As a child he was close to her younger brother, Dominique, a bailiff. Some years later uncle Dominique was prevailed upon to dress up for a series of striking palette-knife portraits.

Soon Paul had a sister, Marie (1841–1921), born in similar circumstances. The two children were formally legitimized by their parents' marriage, on 29 January 1844, at which point Paul had just turned five. After a lengthy intermission, another sister, Rose (1854–1909), completed the family. At one time, rather implausibly, Cézanne thought that his painting of the twelve-year-old Rose reading to her doll was the best thing he had done. He had thoughts of entering it for the Salon of 1866. Unfortunately the painting is lost, perhaps

destroyed by the artist at a later date. Only a taster remains—a sketch and a summary description in a letter to Zola in which he offered his friend this little morsel if he would like it. "My sister Rose is seated in the middle, holding a little book that she's reading; her doll is on a chair, she is in an armchair. Dark background, light head, blue headdress, blue pinafore, dark yellow frock, a bit of still life on the left, a bowl, some children's toys."[24]

Not long after his marriage, when his son was nine, Louis-Auguste Cézanne became a banker, thus regularizing his practice and elevating his status. He achieved this transition by the simple expedient of buying the bank. In the revolutionary year of 1848, Aix's only bank failed. Louis-Auguste seized the day. In association with one of the cashiers, Joseph Cabassol, he took it over. The new bank of Cézanne and Cabassol was inaugurated on 1 June 1848. Louis-Auguste put up all the capital, 100,000 francs, on which he received interest of 5 percent. Cabassol, a sly old dog, contributed his expertise and his address book. According to the partnership agreement, the two men shared the profits equally; they were each entitled to draw 2,000 francs a year for personal expenses. The partnership was established for an initial period of just over five years.

Cézanne and Cabassol were well-matched. Their core business was short-term loans. Their core skill was a canny assessment of creditworthiness. Between them they had an invaluable stock of local knowledge on the financial status of potential borrowers. If Louis-Auguste had reservations about a certain applicant, he would ask, meaningfully, in his habitual Provençal, "Qué n'en pensa Cabassou?" (What do you think, Cabassol?), whereupon the latter would solemnly refuse the loan.[25] In this way, they prospered. The partnership was finally dissolved in 1870, on account of their advancing age (and possibly the Franco-Prussian War), by which time Cézanne and Cabassol were rich men. The dowry drawn up by Louis-Auguste for his younger daughter's marriage to the lawyer Maxime Conil (1853–1940), in 1881, gives some indication of his acumen. Rose Cézanne's trousseau was valued at 6,000 francs; she also contributed one-fifth of a 3,000-franc annuity, two shares in the Paris-Lyon-Mediterranean Railway, and a house in the Rue Émeric-David valued at 16,500 francs. In addition—a sharp reminder of her father's business practices—she came with the sum of 5,000 francs, owed by Mme. Marie Antoinette Delphine de Rollaux de Villans, wife of the marquis de Castellane, in accordance with a debenture dated 10 December 1879. Her father's bantering remark to his wastrel son-in-law was well-remembered in Aix: "Oi! Si donno uno baguo oro! Jeou! Quan mé sicou marrida, avion dous penden—

Paul einé Marie!" (How about that for a gold ring! Me, when I got married, I had two pendants—Paul and Marie!)[26]

The father of the artist lacked in letters but not in sense. In 1873, at the age of seventy-five, he took up his pen to write to Dr. Paul Gachet, who encouraged so many artists, including Cézanne and van Gogh. Writing must have been a painful business.

> I received your sad leter of 19 July last informing me of the grivous loss of a son to your esteemed brother at the age of 19; I am much sadened and beg to beleve that I share in your sorow, you also say that Mdme your wife has just ben delivered of a child after a month of most serious ilness, but that todday she is a litle beter, I trust and hope that this leter finds her improved and fully restored, you say Mr. Paul [Gachet's son] from who I received a leter todday to which I am repling behaved well towards you, he was simply doing his duty. I beg you would convay my respects to you'r honnorable family and beleve me your most humble servant.[27]

Louis-Auguste was a true paterfamilias. He had maxims to live by. "Every time you go out, know where you're going!" "Don't over-excite yourself. Take your time, pace yourself!"[28] He did his best to pass them on to his son, without success. Cézanne and Zola coined more in their correspondence. "Child, child, think of the future," wrote Zola to his friend in 1859, parroting the parental authority. "One dies with genius, and one eats with money!"[29] The fatherless Zola had seen a good deal of Louis-Auguste in Aix as a teenager. Inevitably, he was recruited as a model in the novels. In *La Fortune des Rougon* (1871) he lends himself to the character of Pierre Rougon, a man underestimated by his wife ("She judged him to be more stupid than he was"), whose considered opinion is that "all children are ingrates."[30] More substantially, in *La Conquête de Plassans* (1874), the central character of François Mouret is conceived as "C's father's type, mocking, republican, bourgeois, cold, meticulous, mean; . . . he refuses his wife any luxury, etc. He is a blabbermouth, besides, sustained by his wealth, who mocks everyone; there's talk of him getting on to the Council; in short, he could be the subject of a little Republican reawakening." Elsewhere in Zola's notes is a reminder of Mouret as "C's father, more intelligent . . . common sense, anti-clerical, miserly . . . subscribing to *Le Siècle*."[31] Flaubert himself reveled in the Mouret character: "What a lovely bourgeois is Mouret, with his curiosity, his greed, his resignation and his groveling!"[32]

Zola fancied that Louis-Auguste disapproved of him, or of his influence on Cézanne. He exaggerated, as Cézanne told him, but he knew the family as well as he knew any family. In the saga of the Rougon-Macquarts on which he embarked, "the natural and social history of a family under the Second Empire," Mouret is a bastard Macquart. His wife, Marthe, is a Rougon. "Plassans" is Aix, thinly disguised. (There was a Rougon from Flassans at the Collège Bourbon in their time.) *La Conquête de Plassans* offers a portrait of the marriage, drawn essentially from life, and perhaps a glimpse of the atmosphere as Cézanne was growing up:

Marthe certainly loved her husband and was a good friend to him; except that her affection was mingled with a fear of his jokes, and his continual teasing. She was also hurt by his selfishness, and his neglect; she nursed a vague resentment against him for the peace and quiet which he had constructed around her, for the very tranquility which she said made her happy. When she spoke of her husband, she insisted:

"He keeps us on our toes. You should hear him shout sometimes; it's just that he likes everything to be in order, you see, often taken to a ridiculous extreme. A flowerpot out of place in the garden or a toy lying about on the floor makes him angry. Otherwise, he doesn't bother his head, quite rightly. I know he's not very well thought of, because he's put by some money, and still pulls off some deals now and then, but he only laughs at such talk. People also make fun of him because of me. They say that he's mean, he keeps me in the house, he goes as far as to refuse me a pair of boots. It's not true. I'm absolutely free. No doubt he would rather I were here when he comes home, instead of thinking I'm always walking the streets or paying calls. Besides, he knows my tastes. What would I look for outside?"

When she defended Mouret against the talk of Plassans, her speech took on a sudden sharpness, as if she felt the need to defend him equally against secret accusations made against her; and she would return to that life outside with a kind of restless anxiety. She seemed to take refuge in the small dining room, or the old garden with the tall box trees, seized by a fear of the unknown, doubting her own resources, dreading some catastrophe. Then she would smile at that fearful child, shrug her shoulders, and slowly return to sewing her stockings or mending an old blouse.[33]

Mouret's meanness is a recurring theme. Later it emerges that he does indeed refuse her a pair of boots, on the pretext that the transaction would spoil his accounts. Marthe is far from a spendthrift; still, as a disciplinary measure, he keeps her on a monthly allowance. "Listen, my dear, I will give you 100 francs a month for food. If you really must give charity to girls who don't deserve it, you will take it from the money for your clothes."[34]

The mother of the artist remains fugitive. There is only one extant portrait of her, rediscovered in 1962 under an inexplicable coating of thick black paint (color plate 15), with a portrait of his sister Marie on the reverse (color plate 14). The portrait of Marie seems to have been done first; it looks a little like an amateur El Greco. After studying it at Vollard's, Whistler opined: "If a child of ten had drawn that on his slate, his mother, if she were a good mother, would have whipped him!"[35] She was a constant reference point in his life—she died only nine years before him, in 1897, at the ripe old age of eighty-three—yet we know almost nothing about her. Zola apart, her inner life is a blank. If she was illiterate when she got married, she was able to write her name in a book six years later: *Les Incas,* passed on to her son, is inscribed "H. Aubert 1850." According to her granddaughter Marthe (Rose's oldest daughter, who was fifteen in 1897), she was not in the habit of writing letters, though she could certainly read them—Cézanne wrote to her regularly. She subscribed to the popular review *L'Artiste* and to the *Magasin Pittoresque* (a complete series of the latter, from 1837 to 1892, remains in his studio), both titles an important source of ideas and images for Cézanne, who painted so slowly that the still life rotted, and even the paper flowers faded with time. "Those devilish buggers, they change tone!" he would complain.[36]

She was on good terms with his friends. Zola would visit her every so often. Renoir, who stayed at the Jas de Bouffan in the 1880s, remembered the warmth of her welcome, and her fennel soup. "Those lovely fennel soups that Cézanne's mother used to make for us! I can still hear her giving the recipe, as if it were yesterday: 'You take a stalk of fennel, a little spoon of olive oil . . .' What a fine woman she was!"[37]

She made less noise than her spouse, but she seems to have had remarkable self-possession—more than Marthe Rougon—a necessary virtue, one would think, living with Louis-Auguste. In fact they sometimes lived apart. For many years Élisabeth rented a small house in L'Estaque, on the coast near Marseille, which she used as a summer retreat (and a refuge for Cézanne during the Franco-Prussian War). Even in Aix, they were not always under the same roof,

either in town or at the Jas. A certain separateness, if not separation, obtained; increasingly as the years went by, they tended to live their own lives, or perhaps to negotiate their own spheres of influence. Was the continued use of her maiden name significant? The nature of their relationship is hard to assess. No doubt it changed over nearly half a century. However deferential she may have been, or felt obliged to be, she was plainly no pushover. Her granddaughter was struck by her character (*"très, très fine"*) and her intelligence (*"extrême-ment intelligente"*).[38] In short, the mother of the artist had temperament. Her relations with other members of the family were sometimes strained; especially with Marie, who never married and became increasingly pious and persnick-ety with age. "Paul will be eaten up by painting," Louis-Auguste liked to say, "Marie by the Jesuits."[39] With her domineering husband there were clearly grounds for difference, as Zola's fictionalized portrait might suggest. More-over, there are signs that he had a roving eye, or an eye to the main chance, in maturity as in youth. Cézanne himself thought that Louis-Auguste was mak-ing advances to one of their maids in Aix, while he and his mother were in L'Estaque.[40] Given his father's personality and potency, and the conventions of the time, it would be surprising if something of that sort did not go on. It would be equally surprising if his mother had no inkling of it.

Cézanne and his mother were fundamentally in sympathy. He was her favor-ite. She recognized and encouraged his early interest in painting and drawing, or at least coloring in—another use for the illustrations in the *Magasin Pittor-esque*. (Did Cézanne experience a thrill of recognition when he came to read in Baudelaire's great *éloge* on Delacroix a suggestion of the child as potential colorist?) She knew little enough of art—her favorite picture was her son's faithful copy of Frillié's melodrama, *Kiss of the Muse* (1857), which hung in her room and traveled with her whenever she moved between town and coun-try—but she believed in him as an artist.[41] She qualified as a moral support. A few years after Cézanne's death, Marie Cézanne wrote to her nephew, his son, with some reminiscences of their childhood: "I remember hearing Mamma mention the names of Paul Rembrandt and Paul Rubens, calling our attention to the similarity between the Christian names of these great artists and that of your father. She must have been aware of your father's ambitions; he loved her dearly and no doubt was less afraid of her than of our father, who was not a tyrant but who was unable to understand anybody except people who worked in order to get rich."[42] Marie herself had no interest in art, and no liking for her brother's work. At her death, in 1921, she possessed one paint-ing, a study of Mont Sainte-Victoire. Late in life, when a visitor made bold to

remark on how few Cézannes she had, she replied: "Oh! Monsieur, I have that Sainte-Victoire because my brother forced me to take it, and so as not to upset him! I never understood and I still don't understand anything about my brother's painting! And he used to say to me: Marie, I tell you I'm the greatest painter alive!"[43]

When they were five, Paul and Marie were sent to a little primary school in the Rue des Épinaux, run by Tata Rébory, to learn the three R's. At five, Marie was not one to be trifled with. At sixty, the pursed lip is very evident; we catch the stern tone of moral disapproval. Her reminiscence continued:

> Your father looked after me carefully; he was always very gentle and probably had a sweeter disposition than I, who it seems was not very nice to him; no doubt I provoked him, but as I was the weaker he contented himself with saying: "Shut up, child; if I slapped you I should hurt you."
>
> When he was about ten he was sent as a half-boarder to the École Saint-Joseph, run by a priest, the Abbé Savorin, and his lay brother; it was while he was there, I think, that he took his first communion at the church of Sainte-Madeleine. A quiet and docile student, he worked hard; he had a good mind, but did not manifest any remarkable qualities. He was criticized for his weakness of character; probably he allowed himself to be influenced too easily. The École Saint-Joseph was soon closed; the directors, I believe, did not make a success of it.[44]

Three years at the École Saint-Joseph (1849–52) were followed by the six at the Collège Bourbon (1852–58). Half-boarder or day boy, Cézanne remained close to his mother. With her he could dream aloud. He could unburden himself. She was privy to almost as many of his secrets as Zola. Unexpectedly, perhaps, he found reinforcement in his reading: Thomas Couture's handbook of advice for artists, *Méthode et entretiens d'atelier* (1867), emphasizes the role of the mother. "Yes, in women, above all in your mother, you will find your best counselor."[45] Cézanne took this to heart. Many years later he offered some life lessons to the young painter Charles Camoin: "I congratulate you most sincerely on being with your mother, who will be the most reliable moral support for you in moments of sadness and despondency, and the best source from which to take fresh courage to work at your art, which one must seek to achieve, not limply or halfheartedly, but in a calm and sustained fashion, which cannot but lead to a state of clear-sightedness, very useful in conducting you through life with confidence."[46] Cézanne relied on his mother; and it may be

that in a slightly inchoate fashion she relied on him, to have something to show for his labors. Historically she is mute (unlike the garrulous Louis-Auguste). Almost the only words of hers that have come down to us testify to the conviction that all would be well, since "the little one had something."[47] Her belief in him was adamantine.

From belief to self-belief was a long haul. Cézanne was at once free and unfree. On the one hand, he did not have to work for a living. In this sense he was truly *sans profession*. To be more precise, he was not dependent on selling his paintings in order to live, which was just as well. It would be an exaggeration to say that he could not give them away, but not much of an exaggeration—there were those who refused. On the other hand, he was dependent on a monthly allowance from his father. Cézanne was tied to his father's purse strings, or perhaps his untanned boots (an economy measure, to save on polish).[48] *Le papa* would provide.

Le papa for his part could see no end to subsidy, and Louis-Auguste Cézanne was no almoner. He also wanted the best for his son as he saw it. In these circumstances it was only to be expected that he should seek to exert his influence by flexing his financial muscles. First, however, there was the question of how young Paul should continue his education after the Collège Bourbon, and what profession he should follow. For Louis-Auguste the answer was a foregone conclusion: the boy must study something, and what he must study is Law. Law would be eminently suitable. Anything else would not.

For Cézanne the issue was not so straightforward. He had no interest in Law. He had no better idea of his own. In fact, he did not know what he wanted to do. He dreamt of being an artist, but the dream was like the "Dream of Hannibal" in his poems, far-fetched, high-flown and low-thoughted, as Milton said, being directed to base or vulgar pursuits.[49] Making it come true was beyond him, apparently; he seemed to lack any sense of purpose. When Zola left Aix for Paris, a sort of lassitude set in. As if to signal his distress, he failed his baccalaureate in August 1858, passing at the second attempt with a modest *assez bien* (fair) three months later. Given his track record of scholarship and the nature of the baccalaureate of letters—Latin translation, Latin rhetoric, and oral examinations in logic, history and geography, arithmetic, geometry and physics, a Latin author and a French author—he should have sailed through. His feelings of dislocation can only have been increased by another loss: his best friend from primary school, Philippe Solari, a sweet-natured sculptor from a poor family, won the Prix Granet at the École des beaux-arts in Aix, a bountiful 1,200 francs, which enabled him to go to Paris to learn his trade

and seek his fortune. Solari had done what Cézanne yearned to do. Yearning, indeed, appeared to be his chief preoccupation. Evidently he was in no position to contest his father's wishes. In September 1858 he duly registered with the Faculty of Law at the University of Aix.

The yearning was various. The following spring he fell for "a certain Justine, who is truly *very fine*," as he told Zola, using English for emphasis, "but as I don't have the honor to be *of a great beautiful*, she always turned away." True love did not run smooth.

When I trained my peepers on her, she lowered her eyes and blushed. Now I thought I noticed that when we were in the same street, she executed a half-turn, as one might say, and took off without a backward glance. *Quanto à della donna* I'm not happy, and to think that I risk bumping into her three or four times a day. What is more, *mon cher*, one fine day a young man accosted me, a student in his first year, like me, [Paul] Seymard, whom you know. "*Mon cher*," he said, taking my hand, then clinging on to my arm and continuing to walk towards the Rue d'Italie, "I'm about to show you a sweet little thing whom I love and who loves me." I confess that just then a cloud seemed to pass before my eyes, I had a premonition that my luck had run out, as you might say, and I was not wrong, for just as the clock struck midday, Justine came out of the dressmaker's where she works, and my word, as soon as I saw her in the distance, Seymard indicated, "There she is." From then on I saw no more, my head was spinning, but Seymard dragged me along, I brushed against her dress. . . .

Since then I have seen her nearly every day and often Seymard in her tracks. Ah! What fantasies I built, as mad as can be, but you see, it's like this: I said to myself, if she didn't despise me, we should go to Paris together, there I should become an artist, we should be happy, I dreamt of pictures, a studio on the fourth floor, you with me, how we should have laughed. I did not ask to be rich, you know how I am, me, with a few hundred francs I thought we could live content, but by God, it was a really great dream, that, and now I'm so idle that I'm only content when I've had a drink; I can hardly do anything, I am inert, good for nothing.

My word, *mon vieux*, your cigars are excellent, I'm smoking one as I write; they have a taste of caramel and barley sugar. Ah! But look, look, there she is, it's her, how she glides and sways, yes, that's my little one, how she laughs at me, she floats on the clouds of smoke, look, look, she

goes up, she comes down, she frolics, she rolls, but she laughs at me. Oh Justine, tell me at least that you don't hate me; she laughs. Cruel one, you enjoy making me suffer. Justine, listen to me, but she disappears, she goes up and up and up forever, finally she disappears. The cigar falls from my lips, straightaway I go to sleep. For a moment I thought I was going mad, but thanks to your cigar my spirit has revived, another ten days and I shall think of her no more, or else glimpse her only on the horizon of the past, as a shadow in a dream.[50]

In November 1859 he passed the first round of Law exams. "The examination completed, the outcome of the ballot favored admission of the Candidate with two red balls against one black."[51] Cézanne was an average student (though a better one than Flaubert, who achieved two red against two black balls, and thereby failed). A sheet from one of his exercise books has been preserved, with some notes on the role of bailiffs.[52] After a few lines the notes tail off, and the rest of the page is covered in sketches. Whether or not this was typical, the first round of exams was also the last. Students were required to register every quarter in the Faculty of Law. In January 1860 Cézanne registered as usual for the second quarter of the academic year 1859–60.[53] That was the beginning of the end. There would be no more registrations, whatever his father might say. He gave up Law, definitively, in April 1860—one decision painfully arrived at.

On a different front, he was more active than it first appeared. Since the age of eighteen, in 1857, he had been moonlighting at the École spéciale et gratuite de dessin (the Free School of Drawing), housed in the same building as the Musée d'Aix, now the Musée Granet. Here he encountered a number of those who would become friends or fellow travelers: Jean-Baptiste Chaillan, Joseph Chautard, Numa Coste, Achille Emperaire, Joseph Villevieille, among others. With the exception of Emperaire, whom he considered extraordinary, Cézanne did not have a very high opinion of his classmates as artists, though they were the liveliest thing about the school. Their drawing master was Joseph Gibert, who doubled as curator of the museum. As a teacher, Gibert was a good disciplinarian: he made up in regulation what he lacked in imagination. Figure studies were subject to strict rules as to size, scale, degree of shading, and overall effect. Equally strict rules governed the conduct of the students. They were enjoined to avoid "slang expressions and unnecessary conversation"; they were forbidden absolutely from going to the toilet. Under this hidebound regime Cézanne took classes in figure study from antique sculpture (plaster casts of the usual suspects) and figure study from the live model (male only). Life classes ran in

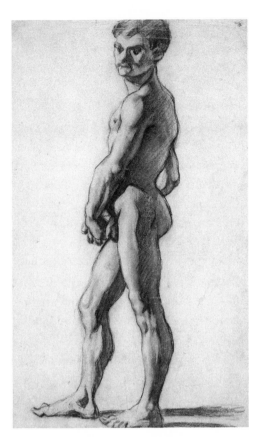

summer from six to eight in the morning and in winter from seven to nine in the evening. In winter the classroom was lit by gas and oil lamps and heated by stoves lit a statutory twenty minutes before the start of the session. The luckless model disrobed and struck a pose as near to the stove as prudence would permit, shivering stoically for one franc per session. Sessions were overseen by the *gardien de service,* wearing his official cap, whose duty it was to maintain order at all costs.

Chaillan was the prize student. In 1859 he took first prize in figure study from the antique, for a bust of Ajax, and another award for a "book of Gothic types." Cézanne was prepared to concede that he had something. Zola met him in Paris the following year: "I spent yesterday with Chaillan. As you said, he's a boy with a certain deposit of poetry: he lacks only direction. . . . He is working *unguibus et rostro* wishing from the bottom of his heart for you as a companion."[54] Cézanne himself toiled away, to modest effect. His efforts at figure study were as static as all the rest, though in August 1859 he won second prize for "a life-size study of a head from the live model painted in oil."[55] Perhaps it helped to embolden him.

In addition to the classes, he was painting out of doors, sitting on the ground, even in the dead of winter; and on at least one occasion he found himself a model (possibly his sister), a cause of much amusement to Zola, who responded with an enticing vision of how it was in Paris. "Chaillan maintains that here the models are drinkable, even if they're not all that fresh. You draw them by day and caress them by night (the word caress is a bit weak). As for the daily pose, so for the nightly one; moreover they are certainly very accommodating, especially during the hours of darkness. As for the fig leaf, it is unknown in the studio; undressing there is totally free, and the love of art veils any over-excitement at all the nudity. Come, and you'll see."[56]

In the course of 1860, when Cézanne was twenty-one, he resolved to become an artist. As he knew full well, two things followed from such a reso-

lution: translation to Paris and confrontation with Papa. Opposition from that quarter was only to be expected. As Kafka wrote to his own father, "Courage, resolution, confidence, delight in this and that, could not last when you were against it or even if your opposition was merely to be assumed; and it was to be assumed in almost everything I did."[57]

Embedded in Zola's famous essay on Manet (first published in 1867) is an impassioned disquisition on a young man's choice of career, and its implications for the bourgeois family, surely colored by his perspective on Cézanne's travails, in which Zola himself invested so much. Cézanne fed his criticism as well as his fiction. Zola treated the young Manet as a kind of exemplar:

> At seventeen, when he left college, he fell in love with painting. What a terrible love that is! Parents will tolerate a mistress or two; close their eyes, if need be, to the license of the heart and the senses. But the arts! Painting for them is the great Corruptor, the Courtesan always hungry for young flesh, who will drink the blood of her children and suffocate them on her insatiable breast. Here is the orgy, the debauched life with no pardon, the spine-chilling specter that sometimes looms out of the family circle and disturbs the peace of domestic life.[58]

True to form, Cézanne himself framed the problem of choice in classical terms. In December 1858 he sent Zola an appreciation of his own predicament, in verse, together with a prospectus for an epic cycle on the adventures of the *Pitot Herculéen*—the Young Hercules—but something more than the Young Hercules. *Pitot* is Provençal for "young man." He and Hercules were deeply rooted in the culture. Hercules had traversed Provence on his way from Spain to Italy and had fought a great battle against two giants on the nearby plain of La Crau. Superstitious householders used to write in large letters above their doors: "The conqueror Hercules dwells within. Let nothing evil enter here!" *Pitot* was rooted also in the shared memory (or mythology) of the Inseparables. "You remember our swimming parties," wrote Zola, "that happy era when, indifferent to the future, one fine evening we devised the tragedy of the celebrated *pitot*; then the great day, there on the riverbank, the radiant sunset, the countryside that perhaps we didn't admire then, but that seems so calm and pleasant in the memory. It has been said—I believe it's Dante—that nothing is more painful than a happy memory in hard times." This particular *pitot* seems to have been a real person: judging from Zola's correspondence, a nickname for a master or a supervisor at the Collège Bourbon.[59]

What Cézanne proposed was "to learn the exploits of master Hercules and convert them into the great deeds of the *pitot*." The conception was at the same time allegorical and ironical. Cézanne imagined himself as the valiant *pitot*—even as he offered a woeful account of his indenture—and as Hercules at the crossroads, with Virtue on his right and Vice on his left, an allegory familiar from school editions of Cicero or Lucian or Xenophon; or from the poetry of Hugo and Musset; or from browsing in back numbers of the *Magasin Pittoresque,* which featured "The Choice of Hercules," from Xenophon's text, complete with suggestive illustration (the youthful Hercules, sporting an impressive club, caressed by the comely Vice).[60] This scheme allowed him to poke fun at all concerned, including himself. It also yielded a satisfying play on the word *droit,* meaning the law, the straight-and-narrow, the right (side), and the righteous path that he must follow: the path to Virtue. The allegory and the wordplay were emphasized in the first line of his verse:

> Alas, I took the tortuous path of Law.
> I took is not the word, I was forced to take
> The Law, the horrible Law, with all equivocations
> Will make my life a misery for three years!
> Muses of Helicon, Pindus, and Parnassus
> Come, I pray you, and soothe my disgrace.
> Have pity on me, an unhappy mortal
> Snatched in spite of himself from your altar.
> The arid problems of the Mathematician,
> His pallid brow furrowed, his lips as white
> As the white shroud of a sullen ghost,
> I know, sisters, they seem frightful to you!
> But he who embraces the career of Law
> Forfeits your trust and Apollo's too.
> Do not cast too scornful an eye on me
> For I am less culpable than miserable.
> Run to my call, relieve my disgrace.
> And in eternity I will render thanks.[61]

Horrible Law held him hostage until he took matters into his own hands and refused to re-register. Until the very last moment, he continued to speak wistfully of his eventual release. "When I'm done with law, perhaps, I'll be free to do what seems good to me," he wrote to Zola in April 1860, as if holding his

breath; "perhaps I'll be able to come and rejoin you."[62] However timorous this might appear, in the circumstances his rebellion is not to be underestimated. He had left the path of virtue. There remained the delicate problem of negotiating the path of vice.

Over the next few months Cézanne's studied vagueness about his future plans in the face of all entreaty from Zola drove his friend to distraction. The litmus test was Paris. Would Louis-Auguste consent to such a venture, as he himself had ventured some forty years before? No one could foretell. More immediately, there was another matter of pressing importance to consider. In February 1860 Cézanne's number had come up in the lottery for the draft of the "class of 1859" (twenty-year-olds eligible for call-up); in May he was declared fit for military service. His father purchased an exemption: a customary procedure for those who could afford it. After the cantonal quota had been met, Cézanne was issued with a certificate of exemption in July. That must have been a great relief all round. The same month Zola heard from Baille that "it is almost certain that Cézanne will go to Paris."[63] This sounded hopeful, but still tantalizingly imprecise. No date had yet been vouchsafed, and the years were slipping by.

Things were moving Cézanne's way; but Louis-Auguste had another card to play. Reasonably enough, he proposed to consult Joseph Gibert, at the School of Drawing, who advised that Cézanne should stay put for the time being. Zola, who had a dim view of the drawing master, thought that "le sieur Gibert" did not want to lose a pupil.[64] Zola may well have been right; and Louis-Auguste may have formed the same opinion. Gibert's advice served perhaps to protract things a little further, but it was not decisive. By October, Baille was assuring Zola that Cézanne would be coming to Paris in March (1861).[65] Slowly, an understanding was emerging.

There was never any prospect of Cézanne going to Paris before 1861. Contrary to popular belief, the issue was not the father of the artist, but the artist himself. Cézanne's letters to Zola over the critical period 1859–62 are lost, but Zola's letters to Cézanne (and Baille) have been preserved. The correspondence was intense. Making all due allowance for Zola the *romancier,* it is clear that Cézanne agonized over his vocation, or his destiny, and indulged in some painful soul searching. "I don't understand myself," he would say; or on another occasion, "I speak without saying anything, for my actions belie my talk." Some of his expressions struck a chord with his friend: "I'm weaned on illusions." Luckily for us, Zola had the habit of playing back his lamentations to him, often in his own words: "I was also painfully struck by another phrase in

your letter. This one: 'Painting, which I love, though I do not succeed,' etc., etc. You!" Frequently he was discouraged in his work; he would write of throwing his brushes at the ceiling, and worse. Zola did his best to reassure and encourage Cézanne, in his own rather self-centered way. "But you, my dreamer, you, my poet, I sigh when I see your thoughts, your beautiful princesses, so poorly clothed. They are strange, these fine ladies, strange like young bohemians with a bizarre look, their feet muddy and the heads garlanded. Oh! For the great poet who has gone, give me a great painter, I beseech you. You who have guided my faltering steps towards Parnassus, you who suddenly abandoned me, make me forget the budding Lamartine for the future Raphael."[66]

The future Raphael was not to be rushed. For Cézanne the classics were a source of practical wisdom and self-knowledge. He consulted Cicero on how to live. Cicero counseled caution, or deliberation. "Let him who meditates entering on any important undertaking, carefully consider, not only whether the undertaking is right, but also whether he has the ability to carry it through; and here he must beware, on the one hand, lest he too readily despair of success from mere want of spirit, or, on the other hand, lest he be over-confident from excessive eagerness. In fine, for all transactions, before you enter into them, you should make diligent preparation." Cicero may well have spoken to him more compellingly than his own father (or his best friend). The nature of the decision as set out in *De Officiis* (*On Duties*) might have been his own. "At the outset, we should determine in what condition we wish to be, in what kind of pursuits . . . a decision the most difficult of all; for it is in early youth, when judgment is weakest, that one chooses some mode of life with which he has become enamored, and thus is involved in a fixed avocation and course before he is capable of judging what is best for him." Not only did Cicero use Hercules as an example, he also made specific mention of being "imbued with the advice of our parents" and thereby "drawn into their manners and habits." As against pressures of that sort, he emphasized the virtue of following one's own individual nature, or temperament, as Cézanne might have said.

But the rarest description is of those who, endowed either with the prestige of surpassing genius, or with pre-eminent culture and learning, or with both, have time to deliberate what course of life they would prefer to follow—in which deliberation the issue should be made to conform to one's own natural bias. For while in the details of conduct what is becoming from a man's native disposition, so in ordering the entire course of life much greater care should be taken that we may be consistent with

ourselves so long as we live, and may not falter in the discharge of any one duty. . . . Let him, then, who refers his entire plan of life to his nature so far as it is unvitiated, go on as he has begun (for this is in the highest degree becoming), unless he be made aware that he was mistaken in his choice.[67]

He consulted Zola on the same subject. A month before his projected departure, he asked if it was possible to work in Paris—an odd question, as his friend could not help remarking. Zola proffered a schedule for a typical day:

From six to eleven you'll go to an atelier and paint from the live model; you'll have lunch, then from midday till four, you'll copy the masterpiece of your choice, either in the Louvre, or in the Luxembourg. That will make nine hours of work; I think that's enough and that, with such a regime, it won't be long before you do something good. You see that that leaves us all evening free, and we can do whatever we like, without impinging at all on our studies. Then on Sundays we'll take off and go to some places around Paris; there are some charming spots, and if so moved you can knock off a little canvas of the trees under which we'll have lunched.[68]

Whether the hint of the harmonious pine stilled his doubts, there were no more questions.

As for *le papa*, he came up trumps. He sanctioned an open-ended stay in Paris, on a monthly allowance of 125 francs, 25 francs more than Zola earned at the Librairie Hachette. At last, the time had come.

Self-Portrait: The Brooder

Cézanne painted some twenty-six self-portraits, over a period of forty years. To these may be added a similar number of self-portrait drawings, mostly from the 1870s and 1880s, to say nothing of other paintings, such as *A Modern Olympia* (1873–74) or *The Apotheosis of Delacroix* (1890–94), in which a Cézanne-like figure appears to be present. Another artist criticized in his own time as a painter of poor likenesses and as "a victim of a pathological obsession with fat paint," Rembrandt, also had a lifelong preoccupation with self-portraiture, characterized as "a necessary process of identity formation or self-definition."[1] Perhaps the same is true of Cézanne.

Portrait of Paul Cézanne (color plate 1) is the first—the first that we know of—painted from a photograph in the early 1860s, when he was in his early twenties.[2] A photographic source is not quite as unusual in Cézanne's work as was originally thought, but he seems to have followed that practice only once more in his self-portraiture, many years later.[3] In this early work, the photographic image has been transformed. The young man in the photograph looks alert but benign. The set of his face is somehow softened by his mustache; half-concealed, his lips do not register. He is sufficiently far removed to feel unthreatening. There is some illumination behind his head. In the painting, by contrast, lifelikeness has been sacrificed for expressiveness. The coloration is vivid, not to say lurid. The look is brooding, almost scowling. The tension has been ratcheted up by extending the forehead and pulling back the hairline towards the upper left—apparently an afterthought. The light has gone and so has the distance. Paul Cézanne looms out of the blackness in ghoulish close-up.

The effect is dramatic, even disturbing. A highly charged work of this sort seems to invite a psychological interpretation. "The intensity of the gaze and the dour, grey modeling, flecked with accents of blood-red at emotionally crucial points [the lips, the corners of the eyes, even the hairline], lead one

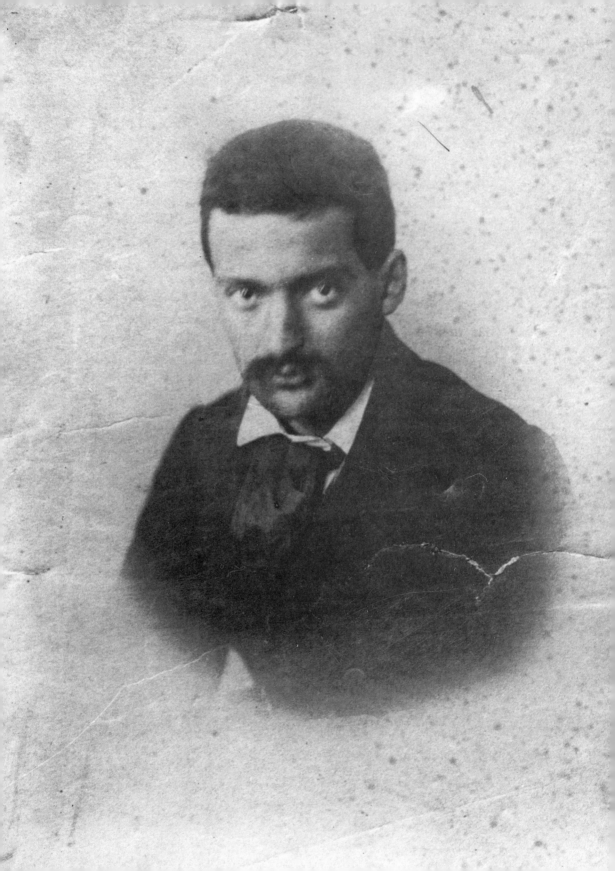

to suspect a critical moment in the young man's fortunes," Lawrence Gowing speculated, "perhaps a crisis in the plans of the artist-to-be or the emergence of a private determination in the face of his father's opposition."[4] If the photograph suggests the conventional pose of a son prepared to acquiesce in his father's wishes, the painting seems to announce that all bets are off. This blood-red youth is capable of anything.

This portrait was acquired by Auguste Pellerin from the artist's son, after Cézanne's death. It is now in a private collection.

3: All Excesses Are Brothers

"'I've seen Paul!!!' I've seen Paul, do you understand that, you," exclaimed Zola, interrupting a letter to Baille; "do you understand the full melody of those three words? He came this morning, Sunday [21 April 1861], to call me several times on my stairs. I was half asleep; I opened my door trembling with joy and we embraced hard. Then he reassured me about his father's antipathy towards me; he maintained that you had exaggerated a little, doubtless over-zealous. Finally he told me that his father asked for me, I must go and see him today or tomorrow. Then we went to lunch together, smoked a good many pipes in a good many public gardens, and I left him. While his father is here, we can see each other only occasionally, but in a month we should be able to take rooms together."[1]

He had finally made it to Paris. He arrived under escort, but Louis-Auguste soon returned to Aix. Cézanne found lodgings at 39 Rue d'Enfer (now Avenue du Général Leclerc), in the Fourteenth Arrondissement, on the way to Montrouge.[2] He had his allowance: he could live. The living was not princely, but it was possible. According to Zola's calculations, there were around one hundred francs of regular expenses each month—twenty francs for the room, sixty francs for food, ten francs for working at an atelier, ten francs for art supplies—leaving twenty-five francs for lighting, laundry, drinks and tobacco, and any other cheap pleasures. Zola reckoned on two francs a day for food, but in fact Cézanne did better than that, managing to eat enough at lunch and dinner for fifteen sous (seventy-five centimes) per meal. "It's not a lot; but what do you expect?" he said, with a faint echo of his father's maxims. "I'm not dying of hunger, after all."[3]

Cézanne was perfectly capable of living frugally. Rich or poor, his requirements were modest. He was the very opposite of acquisitive. In his youth, according to Zola, whenever he had a little money, he spent it before bedtime.

Tackled about this prodigality, he replied: "*Pardieu!* If I should die tonight, would you prefer my parents to inherit?"[4] This exchange may have been tongue-in-cheek, but intimations of mortality and the complexities of inheritance would recur.

His days were spent more or less as Zola had forecast. From six till eleven every morning he worked at the Académie Suisse, on the Île de la Cité. This picturesque establishment, in a dingy building on the Quai des Orfèvres, was free in precisely the sense that the Free School of Drawing in Aix was not. The Académie Suisse was a little like a free university of painting—except that, strictly speaking, there were neither professors nor students, for no instruction or correction was offered, apart from the commentary of one's peers. Anyone could enroll, and work completely unsupervised in the genre or medium of his choice. Live models (male and female) were more favored than antique sculptures, but figure study was not prescribed. Many came to get their hand and eye in. Trial and error were the order of the day. Experimentation was taken for granted. Eccentricity was noted but not censured. The premises were on the second floor, reached by an ancient wooden staircase, dirty and dismal and stained with blood. On the floor below was a dentist—"SABRA, Dentist of the People," his sign proclaimed—renowned for his cheap rates and primitive methods.

This academy was named after Charles Suisse, an elderly model who had served for the big names of yesteryear: David, Gros, Girodet, Vernet, and a host of others. It was a broad church. According to a contemporary account, "Colorists, Ingrists, traffickers in chic, Realists, Impressionists—the word had not yet been invented, but several of the founders of the new school that bore that name were there—everyone was on good terms, with a few rows here and there among the fanatics. The amateur himself had a right to his daubs without facing studio fees. You could spoil the paper or the canvas, without too much fuss, as long as you were careful to pay the monthly charge."[5]

The Suisse had its own traditions. It was more a forum than a finishing school. People gravitated there and became habitués; it was as if they could never leave. There was always a throng in the studio. Artists who never registered as students would drop in to catch up with their friends or to discuss the latest thing. When Zola began his serial assault on the salon, in 1866, the denizens of the Suisse split into two camps, for and against. Young painters would come to see what was cooking—with good reason. Delacroix himself had worked at the Suisse; so too Bonington, Courbet, Isabey. Manet came to draw, while still a pupil in Couture's studio. Chaillan preceded Cézanne, as Zola had informed him. "Every day he takes himself off to old Suisse's place,

from six to eleven. Then, in the afternoon, he goes to the Louvre. He's really got a nerve." Chaillan was almost bound to succeed, thought Zola, because he had no towering ambition; he was basically a simple soul, happy in his skin.[6]

Did Cézanne have a nerve? Was he happy in his skin? Zola was not so sure. Depressed about his own work, and plagued with nameless neuropathological disorders, he kept Baille apprised of the latest developments:

> *Hélas*! It's not like Aix anymore, when we were eighteen, and free and without a care about the future. The pressure of life, working separately, keeps us apart now. In the mornings Paul goes to the Suisse and I stay and write in my room. We lunch at eleven, each to his own. Sometimes at midday I go to his room and he works on my portrait. Then he goes to draw for the rest of the afternoon with Villevieille; he has supper, goes to bed early, and I see him no more. Is this what I'd hoped for? Paul is still that excellent capricious youth I knew in college. As proof that he's lost nothing of his originality, I need only tell you that no sooner had he got here than he was talking of going back to Aix; after struggling for three years to make the journey and seemingly unbothered.

Zola thought this idiotic, and said so, without making much impression. "Convincing Cézanne of something is like persuading the towers of Notre Dame to execute a quadrille."[7]

Cézanne was indeed unsettled. Paris did not welcome him with open arms. Six weeks in, he could be found taking stock in a letter to Joseph Huot, his fellow art student in Aix. The account is revealing.

> Ah! *Brave* Joseph, I've been neglecting you, *morbleu*! And the friends and the *bastidon* [where they used to meet] and your brother and the good wine of Provence; you know the stuff here is dreadful. I don't want to compose an elegy in these few lines, but all the same, I must confess, I'm not feeling very light-hearted. . . .
>
> I thought that when I left Aix I'd leave the ennui that pursues me far behind. All I've done is swap places and the ennui has followed me. I left my parents, my friends, some of my routines, that's it. I have to admit that I wander about aimlessly practically all day. Naive as it sounds, I've seen the Louvre and the Luxembourg and Versailles. You know the potboilers they have in those fine monuments, it's *amazing, overwhelming, breathtaking*. Don't think that I'm becoming a Parisian. I've also seen

the Salon. For a young heart, for a child born for art, who says what he thinks, I believe it's there that the best is truly to be found, because there every taste and every style meet and collide. I could give you some fine descriptions and send you to sleep. Be grateful to me for sparing you. . . .

A thousand respects to your parents; to you, courage, lots of vermouth, little boredom, and farewell.[8]

Huot was not spared a recap in rhyming couplets of salon chic. For Cézanne the highlights were Doré and Meissonier, whose *tartines* of Napoleon's campaigns have been likened to a symphony by Berlioz played without drums, with tin for brass, and whose overfamiliar repertoire made the critics cringe— "little personages, who only know how to read, write, smoke their pipes, play the double bass, and talk between the pear and the cheese." Meissonier is the god of the bourgeoisie who do not like the strong sensations one gets from true works of art, declared Zola, many years later, parroting his painter friend.[9] Cézanne was still using the word "chic" as a term of approbation, long after it had been subjected to a withering attack from Baudelaire himself: " 'Chic,' ghastly, bizarre word of modern coinage . . . which I am obliged to use, because it is accepted by artists as explanation for a modern monstrosity meaning: absence of model and nature. 'Chic' is the abuse of memory; or 'chic' is a memory of the hand rather than the brain, for there are artists gifted with a profound memory for character and form—Delacroix or Daumier—who have nothing to do with 'chic.' "[10]

On this evidence, Cézanne still had a long way to go in matters of taste and discrimination and style. Perhaps he sensed it. There is a whiff of melancholy about the letter to Huot. It speaks of something more than homesickness—an underlying confusion and dislocation. He had done what he had convinced himself he wanted to do: come to Paris to be an artist. The dream of Paris had sustained him. The reality was different. Later on, when he came to read *Jacques Vingtras*, an autobiographical novel by the insurrectionary Jules Vallès, he was stirred by the affecting tale of a young provincial with abusive yet loving parents, who reached the metropolis a few years before him.

Paris, 5 a.m. We've arrived.
What silence! Everything looks pale in the bleak light of morning, and there is a villagey loneliness in this sleeping Paris. It's as melancholy as desertion. Dawn-cold, and the last star blinking stupidly in the bleached blue sky.

I'm scared like a Robinson wrecked on an empty shore, in a country without green trees and red fruit. The houses are tall, mournful, like blind men with their closed shutters and lowered curtains.

The porters hustle the luggage. Here's mine.[11]

Paris was unforgiving, and almost immediately Cézanne must have felt at a loss. Truth be told, he did not know how to be an artist, though he and Zola talked of little else. "Our conversations ramble over everything," Zola reported, "especially painting; our recollections also loom large; as for the future, we touch lightly on it, in passing, either to wish for our complete reunion [that is, the three Inseparables] or to pose for ourselves the terrible question of success."[12] Success, and what might count as success, was a conundrum as yet unsolved.

One way to be an artist was to paint a portrait. Painting Zola's portrait was only natural, and nothing if not convenient. It was Zola's idea: in part

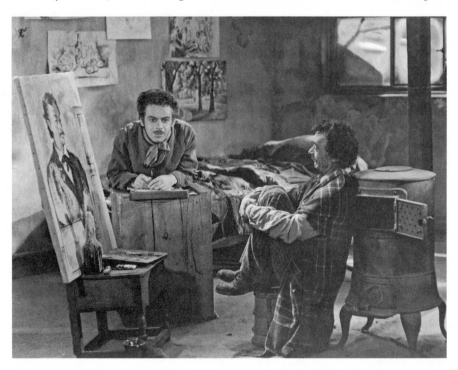

vanity, in part a ruse to keep him going and keep them together, like conspirators in a covert operation. For a while, it worked. The plot was hatched in Cézanne's poky little room. "We are hardly disturbed; a few intruders come from here and there to throw themselves between us; Paul paints on relent-

lessly; I pose like an Egyptian sphinx; and the intruder, quite disconcerted by so much work, perches for a moment without daring to move, and then makes off with a whispered goodbye, gently closing the door." Work began in early June and continued without incident for about a month, though Cézanne was never happy with the results. He started afresh, twice, and then asked for a final sitting. Zola came round the following day to find him stuffing clothes into a suitcase. "I'm leaving tomorrow," he announced calmly. "And my portrait?" "Your portrait," he replied, "I've just torn it up. I wanted to redo it this morning, and as it went from bad to worse, I destroyed it. And I'm leaving." At which point lunch intervened, and after they had talked into the evening Cézanne undertook to stay, at least until September. But this was merely a postponement, as Zola realized well enough. "If he doesn't leave this week, he'll leave the week after. . . . Still I believe he'll do well. Paul may have the genius of a great painter; he will never have the genius to become one."[13] In the midst of his disappointment, the novelist shaped his prose.

And so it seemed he had not arrived after all. He lasted about five months in Paris before the heavily trailed return to Aix and the bosom of his family. The reaction of *le papa* is unrecorded.

"Talent doesn't reveal itself in a moment," said Chardin, his eighteenth-century predecessor, with feeling. "Judgments about one's limitations can't be reached on the basis of first efforts."

> The student is nineteen or twenty when, the palette having fallen from his hands, he finds himself without profession, without resources, without moral character: for to be young and have unadorned nature ceaselessly before one's eyes, and yet exercise restraint, is impossible. What to do? What to make of oneself? One must either take up one of the subsidiary crafts that lead to financial misery or die of hunger. The first course is adopted, and while twenty or so come here [to Paris] every two years to expose themselves to the wild beasts, the others, unknown and perhaps less unfortunate, wear breastplates in guardrooms, or carry rifles over their shoulders in regiments, or dress themselves in theatrical attire and take to the boards. What I've just told you is the life story of Bellecour, Lekain, and Brizart, bad actors out of despair at being bad painters.[14]

And Cézanne? Not yet a bad painter. But an uncommonly bad banker.

In moments of discouragement in Paris, he had spoken of becoming a clerk in a firm.[15] In Aix he became a clerk in a bank—his father's bank—an under-

taking to rival Kafka's employment in an insurance office. Cézanne was not cut out for clerking, or banking. He whiled away the time doodling in the margins of the ledgers and composing occasional rhymes.

My father the banker cannot see without a shudder
A coming painter born under his counter.[16]

Despite recent reversals, the coming painter had not been deterred from his calling. He enrolled once more at the School of Drawing and went on painting expeditions in the countryside with his friend Numa Coste and Coste's dog, Black. He was toughening himself for a second assault on the capital. *Reculer pour mieux sauter.*

After a year of seclusion in Aix, Cézanne returned to Paris in November 1862, unaccompanied. He found himself a room in the Impasse Saint-Dominique d'Enfer (now Royer Collard), and then in the Rue des Feuillantines, in the Fifth Arrondissement, near the Panthéon. He stayed until June 1864. This time he was serious. When he wrote to Coste to give him some news, he included a fragment of verse (a farewell to the poetaster). The poem evokes a private arcadia, as before, but something has changed. There are portents of death and decay—a premonition, perhaps, of the paintings to come.

The day we went to the meadows of the Torse
To eat a good lunch, and with palette in hand,
To trace on the canvas a lush landscape:
Those places where you nearly sprained
Your back, when you lost your footing
You rolled to the bottom of the moist ravine,
And Black, do you remember! But the leaves yellowed
By the breath of winter have lost their freshness.
At the edge of the stream the plants have wilted
And the tree, shaken by the fury of the winds,
Swings in the air like a huge cadaver
Its leafless branches wrenched by the mistral.[17]

He went back to the Suisse. Unlike Manet, who spent a full six years with Couture, Cézanne missed out on apprenticeship. He never experienced the servitude and grandeur of the studio. Couture was a master to be reckoned with. He cut a figure. His *Roman Orgy,* otherwise known as *Romans of the*

Decadence (or *Nero at the Circus*, as Zola had it in *L'Œuvre*), caused a sensation when it was unveiled at the Salon of 1847, and another shiver when it appeared at the 1855 World's Fair. He also had a considerable reputation as a teacher. The story was told of an exchange between preceptor and pupil, in front of a model who had been instructed to adopt a natural pose—clothed. "Do you pay Gilbert not to be nude?" inquired Couture delicately. "Who is responsible for this foolishness?" "I am," said Manet. "Off with you, my poor boy," came the rejoinder, "you will never be anything more than the Daumier of your day."[18] Couture was a true *maître*. "As for me," Cézanne would lament in later life, "if only I'd had a master! People have no idea what Manet owed to Couture."[19]

In Paris he relied first of all on Villevieille and then on Chautard to correct his work.[20] That may have been reassuring, but a cozy arrangement with his compatriots from Aix was no substitute for the discipline of a major artist in a major studio. When he registered as a copyist at the Louvre, in 1863 and again in 1868, he was recorded as a "pupil of Chesneau."[21] Ernest Chesneau was a prolific writer and critic, covering the arts for such journals as *Le Constitutionnel*, *L'Opinion nationale*, and the *Revue des deux mondes*, and producing a stream of books, including *L'Art et l'artistes modernes en France et en Angleterre* (1864), *L'Education de l'artiste* (1880), and *Peintres et statuaires romantiques* (1880). He was an expert on Delacroix; he was a friend and admirer of Ruskin; and he was quick to appreciate the significance of Manet— quick enough to buy one of his paintings in 1864. In the same year he wrote that if current trends continued, he expected soon to see a painting consisting of nothing but two broadly brushed areas of color, a green and a blue. Such a painting would be deficient, he argued, because it would be nothing more than a draft or sketch of the work, and not the work itself; as a painting, it would remain not so much unfinished as unmade. Nevertheless, he was receptive to impressionism, unmade as it might be, reviewing Monet's work sympathetically in 1874, at a time when most critics simply jeered.[22] Chesneau was no lightweight. He was sufficiently well placed for Zola to send him copies of his first books, begging for some publicity. Some of his pronouncements may have stuck: "The great artists have no specialism; all of nature and man belongs to them." His comment on Meissonier, "an eye on the end of a hand," may have been the source or stimulation for Cézanne's famous comment on Monet: "He is only an eye. But my God what an eye!"[23] Nonetheless, Chesneau was not a painter, still less a master in the accepted sense; and there is no sign of Cézanne treating him as such, beyond the formalities of registration.

The customary way to find a master was to go to a school. For the traditionalist (or the conformist), there was only one school: the École impériale et spéciale des beaux-arts. Cézanne had nursed a dream of the Beaux-Arts ever since 1858, if not before. No sooner had the Law course commenced in Aix than he urged Zola to "find out about the competition at the Académie, because I'm sticking to the plan that we made of competing for whatever prize there may be, provided of course it doesn't cost anything."[24] If the proviso smacks of a certain hesitance, then it may be indicative. Nothing came of that preliminary inquiry. Four years later, in 1862, Zola relayed the subject of the annual competition for what he called the painting prize, probably the Prix de Rome, whose lucky winner would spend four years all expenses paid at the Villa Medici. The subject was "Coriolanus Beseeched by His Mother Vituria": a stupid subject, sure to be treated stupidly, in Zola's Flaubertian estimation. We do not know for certain whether Cézanne entered that competition; if he did, we do not know how wholeheartedly. By 1862, he had absorbed the idea of a stifling academicism (and stiff criticism) at the Beaux-Arts; and he had already begun to think in terms of dividing his time between Paris and Provence, a scheme with a purpose—to maximize his freedom, artistic and other. "I fully approve of your idea of coming to work in Paris and then withdrawing to Provence," wrote Zola. "I think that's one way of escaping the influence of the schools and of developing some originality if one has it."[25]

Forty years later, in conversation with two visitors, both reliable witnesses, Cézanne mentioned that he had twice failed to get into the Beaux-Arts. "I am a primitive, I have a lazy eye," he told them, in his characteristic way. "I applied twice to the École, but I can't pull it all together: if a head interests me, I make it too big."[26] The surviving documentation merely records that he was certified by Chautard as being in good standing as an *aspirant* student in February 1863.[27] Vollard repeats a comment made allegedly by one of his examiners: "Cézanne has the temperament of a colorist; unfortunately, he overpaints."[28] It seems that he applied in 1863. He may also have applied in 1862. Perhaps his father encouraged him, or pushed him into it. For Louis-Auguste, the Beaux-Arts was the passport to a profession, to say nothing of remuneration. His son's accession there would have served to vindicate the paternal liberality, demonstrating his wisdom and justifying his boast. "*Moi, Cézanne, je n'ai pu avoir fait un crétin!*" (I couldn't have made a cretin.)[29]

It was not to be. By 1864 the Beaux-Arts had become the "Bozards"; that scornful corruption signaled a regular target of Cézannian vituperation. "As for me, *mon brave*," he wrote sportively to Coste, whose number had come

up in the lottery for military service, "hair and beard are longer than talent. Never mind, no discouragement in the painting, one can make one's own little way, even as a soldier. I've seen those who take anatomy classes at the *école des Bozards*. . . . [Aimable] Lombard paints, draws and pirouettes more than ever; I haven't yet been able to go and see his drawings, which he says he's happy with. I haven't done any more to my taster after Delacroix for two months." From then on the matter was settled: for an artist of temperament, the École was a mistake. Reminiscing about his lifelong friend Solari, Cézanne would say, "I always told him he really screwed up with his École des beaux-arts."[30] Professors were beyond the pale. "Professors are all bastards, eunuchs and jackasses; they have no guts!"[31]

For better or worse, the Académie Suisse was his proving ground—proving himself to himself and to others. It was there that he met some of his closest friends: Armand Guillaumin, Antoine Guillemet, Francisco Oller, Camille Pissarro. Everyone was fascinated by his quirks and foibles: the strong southern accent, the heavy emphasis, the slang (released now from the constraints of Gibert in Aix), the profanity. *Nom de Dieu! Bougre de crétin!* Monet always remembered his habit of placing a black hat and a white handkerchief next to the model to help him gauge the tonal scale.[32]

He used and reused those figure studies all his life, as a substitute or aide-mémoire for the human form. An ambitious early work, *The Abduction,* or *The Rape* (color plate 21), painted for Zola and subsequently owned by Keynes, features a bronzed Herculean *pitot* carrying off a milk-white maiden through a watery glade, with a rudimentary Mont Sainte-Victoire in the background; the dusky seducer, as Lawrence Gowing calls him, bearing some resemblance to *The Negro Scipio* (color plate 20), a model at the Suisse who sat for one of the most powerful works of this period, in which the muscular torso, magnificently elongated, rivets the attention. *Scipio* was later acquired by Monet from Vollard for four hundred francs—"He was only a beginner," said Monet, "who had since made good." It hung in his bedroom at Giverny, together with his other favorites. It was, he confided, *"un morceau de première force."* Monet showed it to his friend Clemenceau, who pronounced it "hair-raising!"[33]

There is eroticism and violence aplenty in this early work, though it is by no means as disturbed or uncontrolled as is sometimes made out. Cézanne's imagination was rich and strange—richer than generally realized, and rather less strange. "Delacroix was passionately in love with passion," wrote Baudelaire in homage at exactly this juncture, "but coolly determined to find the means to

express passion as clearly as possible."[34] A similar judgment might be applied to the young Cézanne. *The Abduction* was not pure fantasy. It had its origins in ancient mythology. It also had autobiographical overtones. The story told in the painting is the legend of Persephone's abduction by Pluto, king of the Underworld.[35] Cézanne's version of it appears to be based on Ovid's *Metamorphoses,* another staple of his reading. Ovid's account of "The Rape of Proserpine" (Persephone) is set in Sicily, with the volcanic Mount Etna as backdrop. The key passage begins with a reference to Henna (Enna), a city in the center of the island with a famous shrine to Ceres, goddess of agriculture and mother of Proserpine:

> Not far from Henna's walls there is a lake,
> Pergus by name, its waters deep and still;
> It hears the music of the choiring swans
> As sweet as on Cayster's gliding stream.
> Woods crown the waters, ringing every side,
> Their leaves like awnings barring the sun's beams.
> The boughs give cooling shade, the watered grass
> Is gay with spangled flowers of every hue,
> And always it is spring.[36]

For Cézanne (and for Zola) this was familiar territory: a classic *locus amoenus,* complete with companionable trees. In his imagination, such enticing scenes transposed easily from legend to lived experience. Mount Etna became Mont Sainte-Victoire; the mythical landscape of Ovid and Virgil became the personal landscape of dauber and scribbler. Provence as the Arcadia of France was a notion embedded in Walter Scott's *Anne of Geierstein,* known in French as *Charles le téméraire* (Charles the Bold), a novel much cherished by Cézanne.[37] Earlier painters and paintings may have been agents of influence in the transmission—Poussin (1594–1665), for example, whose *Shepherds of Arcadia* he first copied in 1864 and recopied twenty-five years later, or Rubens (1577–1640), whose work he studied and restudied all his life.[38]

But there is more to the marks than meets the eye. In the *Metamorphoses,* the *locus amoenus* is not unambiguously delightful. Even the pine is implicated. In a virtuoso passage of "Orpheus and Eurydice," Ovid describes a place where Orpheus charms the trees to gather round and provide shade. "Every tree was there," he says, splendidly, and catalogues them all, concluding with the pines,

high-girdled, in a leafy crest,
The favorite of Cybele, the gods'
Great mother, since in this tree Attis doffed
His human shape and stiffened in its trunk

—or emasculated himself, as Attis did, as Ovid mentions.[39]

The Abduction takes place in a *locus amoenus* that betrays its promise. Proserpine is innocently picking flowers when all of a sudden her play is cut short. Pluto bursts in. What follows is not for the faint-hearted. In Ovid's words, "[He] saw her, loved her, carried her away—love leapt in such a hurry!" That must have been a thrilling despoiling—better than any in Zola's novels.

> . . . Terrified,
> In tears, the goddess called her mother, called
> Her comrades too, but oftenest her mother;
> And, as she'd torn the shoulder of her dress,
> The folds slipped down and out the flowers fell . . .

Taking his cue from Ovid, and no doubt from other paintings on the same theme, Cézanne depicted both mighty figures nude.[40] Proserpine is locked in Pluto's embrace, as if the wrestling is over. She is completely overcome; her torn dress trails behind her like a crumpled shadow. The scene of the action has become the scene of the crime.

It is witnessed by two nymphs, Cyane and Arethusa, who play a significant part in Ovid's narrative and who also feature in Cézanne's painting. He shows Cyane standing knee-deep in the water in which she will soon dissolve, holding "the well-known sash which Proserpine / Had chanced to drop there in the sacred spring." Arethusa, who meets the same fate, reclines nearby; her slightly contorted posture follows a preparatory drawing, which looks very like a figure study from Poussin's *Echo and Narcissus*—another derivation from Ovid, another *locus amoenus,* and another nymph drowning in love and grief.[41]

Cézanne gave *The Abduction* to Zola; he may well have painted it in his friend's house in the Rue La Condamine in Batignolles (near Montmartre). In the circumstances, it is almost inconceivable that they did not talk about it. One wonders what they said. The image stayed with Zola for some time. He seems to have been thinking of the nymphs when describing Claude Lantier's painting *Plein Air* in the Salon des refusés of 1863, a work not only refused but ridiculed, and re-evaluated in an expurgatory act of self-criticism by the trau-

matized Lantier: "In the background, the two little wrestlers, the blond and the brunette, remained too much like a sketch, lacking in solidity, pleasing only to the eye of the artist."[42] Did Zola make a riposte to Cézanne, meanwhile, adding to the history of call and response between them? In *La Conquête de Plassans,* Serge Mouret is goaded by his father to study Law in Paris. Serge lacks temperament; he recoils from this and every other challenge. "Indeed, the young man was of such a nervous disposition that the slightest imprudence would find him upset like a girl, and send him to bed, hurt, for two or three days." His father has high hopes for him nonetheless. "Whenever the boy seemed strong enough, he would schedule his departure for the beginning of the following month; but no sooner was the trunk packed than he would develop a bit of a cough, and the departure would be postponed once more."[43] Allowing for the exchange of roles, the story is curiously reminiscent of Zola's experience with Cézanne. Things come to a head when Serge becomes gravely ill. Drifting between this world and the next, he falls under the spell of the sinister Abbé Faujas, who delivers him to Christ—abduction by other means. In this case the seducer is usually known only by his surname or his religious office. His Christian name is Ovide.[44]

Whatever his fantasies about goddesses, temptresses, sibyls, and sirens, or the accommodating professional, Cézanne never felt at ease with the nude model in his studio.[45] Much has been made of his reported remarks on the subject, though the reports are unreliable and the subject is rife with speculation, and prey to an unedifying mixture of amateur psychology and novelettish fancy. Jean Renoir, the son of the artist, relates what his father recalled of an occasion when Cézanne is supposed to have said: "I paint still lifes. Women models frighten me. The sluts are always watching to catch you off your guard. You've got to be on the defensive all the time, and the motif vanishes."[46]

These remarks were given currency in an essay by Meyer Schapiro, "The Apples of Cézanne" (1968), which has achieved classic status. Schapiro was an art historian of extraordinary virtuosity. Psychobiography was not his forte. His essay offers a psychological interpretation of the apples, or rather the artist, an interpretation that leans heavily on a battery of sexual obsession, repression, sublimation, and frustration. It is replete with tropes like "self-chastening" and "fear of his own impulses," to say nothing of "the unerasable impress of the mother" and "the child's conflicting relations to the parents." It assumes a deeply troubled, neurotic relationship with women. It elides art and life. "Cézanne's pictures of . . . nudes show that he could not convey his feeling for women without anxiety. In his painting of the nude woman . . . he is most

often constrained or violent. There is for him no middle ground of simple enjoyment."[47]

Schapiro quotes Cézanne's remarks to Renoir in support of his thesis. "Sluts" sounds like strong language, and the tenor of the remarks is at once shocking and intriguing. On closer examination, however, Cézanne's words take on a rather different meaning from that imputed by Meyer Schapiro and his followers. Leaving aside the issue of a secondhand report, at a remove of half a century, the standard translation of this notorious outburst is apt to be misleading. Cézanne did not speak of "the sluts" (*les salopes, les putes*). He spoke of "the hussies" or "the buggers" (*les bougresses*), a milder expression, and a habitual turn of phrase. (Of the paper flowers which persisted in fading over time, for example, "*ces sacrées bougresses, elles changent de ton à la longue.*")[48] Moreover, he did not merely say "the motif vanishes." He said "the motif escapes you" (*le motif vous échappe*). The sense of these remarks lies more in professional exasperation than in sexual excitation. It is a conversation, not a confession. Speaking as one artist to another, Cézanne is complaining that models tend to shift off the pose. If you are not careful, they move, in which case the whole setup is compromised and the work is spoiled. Monitoring the model is a distraction—the motif escapes you. Even professional models could not be relied upon to keep still, as Zola heard from Guillemet when he was researching *L'Œuvre*. "The very beautiful girls get paid a lot, pose very badly, and are up and away while the picture is still in progress: the despair of the painter."[49] Amateur models caused problems of their own. Vollard once nodded off while Cézanne was painting his portrait. The artist, normally so polite to his dealer, did not mince his words: "Wretch! You've ruined the pose! I tell you in all seriousness you must hold it like an apple. Does an apple move?" "As soon as he moves," the painter Maurice Denis noted at the time, "Cézanne complains that he's made him lose *the line of concentration.*"[50] Still life came in infinite variety.

The source for so much of the overheated speculation about Cézanne's attitude to nude models and women in general is another fabrication: Claude Lantier, his alter ego in Zola's fiction. *L'Œuvre* is among other things a casebook of Lantier's difficulties with women. "He treated them all like a boy who didn't know or care about them, hiding his painful shyness behind a blustering off-handedness."[51] A woman half-naked under the covers is sufficient to bring on his signature condition, even as he sketches her: "A shiver of nervous anxiety [*inquiétude nerveuse*] ran through him." He is unable to achieve the longed-for *réalisation* with a succession of nude models. His painting, we are to understand, is somehow incomplete. So is he.

Then, he attacked the breast, barely indicated in the study. His excitement mounted, it was the passion of the chaste for women's flesh, a mad passion for nudes desired and never possessed; he was incapable of achieving satisfaction, incapable of creating from that flesh anything like he dreamed of seizing in his frantic grasp. The girls he chased out of his studio he worshipped in his paintings, caressing them and abusing them, driven to tears by his inability to make them sufficiently beautiful, sufficiently alive.[52]

It is but a small step from realization to satisfaction, incapacity to impotence. Zola addressed the issue more directly in his preparatory notes.[53] Just as Lantier's *inquiétude* was established in Zola's earlier work, so too was his fear of women—fear laced with morbid suspicion. Towards the end of *Le Ventre de Paris*, some gentle teasing about a pretty girl provokes him to a famous renunciation: "I don't need women," he declares, "they disturb me too much. I wouldn't even know what to do with one; I've always been afraid to try. . . ."[54]

Zola's Lantier licensed Gasquet's Cézanne. Gasquet plundered *L'Œuvre* to produce a confection of his own lurid imagining and his embroidering on that same suggestive passage in the novel:

Naked flesh made him giddy. He would have leapt at his models; as soon as they came in, he would throw them, half-undressed, onto his mattress. He took everything to extremes. "I'm an intense one, me," he would say, "like Barbey [d'Aurevilly]." A consolation and a new torment remained with him. He had found another way to worship the nudes that he chased out of his studio, he took them to bed in his pictures, he agitated them, he scored them with great colored strokes, driven to tears by his inability to send them to sleep under sufficiently crimson rags and tatters, in kisses, in sufficiently satin-smooth tones.[55]

Embellishments such as these, unwarranted as they may be, took deep root. Cézanne was pathologized, infantilized, melodramatized. The stories were purveyed in the biographies and explicated in the art histories. In *Lot and His Daughters,* a painting whose attribution has been questioned, one authority finds, "beneath its boisterous surface, a mood of dark terror that has explicit roots in both the romantic conjunction of sexuality and violence and aspects of the painter's own, sometimes tortured, sensibility."[56] The moral was drawn accordingly, "for he was morbidly nervous and timid with women all

his life."[57] The library of fictive types grew still further, as if by repetition. An abnormal Cézanne was constructed, with a touch of Melville's Isolato, "not acknowledging the common continent of men," but living in a world of his own.[58] This Saint-Anthony-Cézanne is indeed a kind of hermit. He is outlandish, bizarre, yet in a strange way sanctified. Like Anthony, he is besieged by carnal temptation and philosophical doubt. In *The Temptation of Saint Anthony,* Flaubert writes:

> And he shows him in a grove of bean trees, a Woman, completely naked—on all fours like an animal and covered by a black man holding in each hand a torch. . . .
>
> And he shows him under the shadow of cypresses and rose-trees, another Woman, clad in gauze. Around her lie spades, litters, black hangings, all the paraphernalia of funerals. She smiles. . . .

> ANTHONY: "The horror! I saw nothing! Were it so, my God, then what would remain?"[59]

Saint-Anthony-Cézanne is a remarkable and pitiable creature, and in the end a tragic one. He is also fantastical, a quality he shares with his comic counterpart, Père-Ubu-Cézanne, after Alfred Jarry's monstrous Ubu Roi. Each type bears a similar relation to the original. Saint or sinner, hermit or reprobate, the treatment calls for some vulgarization. It is, in a word, a caricature.

There is a fictional character who may reflect more of the depth and complexity of Cézanne's inner world at this time, without sacrificing anything of the tortured sensibility. All his life he read and reread Balzac, absorbed in the *Comédie humaine.*[60] A collection of the novelist's *Études philosophiques* lay to hand by his bedside. This battered article of faith contained five works: *La Peau de chagrin* (1831), *Le Chef-d'œuvre inconnu* (1831), *Jésus-Christ en Flandre* (1831), *La Recherche de l'absolu* (1834), and *Melmoth réconcilé* (1835).[61] Cézanne was enthralled by Balzac's epic combination of drollery and rhapsody. The megalomaniac philosophizing was fascinating.

> Debauchery is certainly an art like poetry, and requires a stout heart. To grasp the mysteries, to savor the beauties, a man should apply himself, as one might say, to conscientious study. Like all sciences, it is at first repulsive, thorny. Enormous obstacles surround man's great pleasures, not his minor ecstasies, but the systems that habitually govern his most

exquisite sensations, epitomizing and fertilizing them, and creating in him a dramatic life within his life, which necessitates a prompt and inordinate dissipation of his energies. War, Power, Art, are corruptions . . . as profound as debauchery. . . . But once a man has begun the assault on those great mysteries, does he not walk in a new world? . . . All excesses are brothers.[62]

These were flights of imagination to inspire the coming painter. And then there were the descriptions, at once moral and morphological, of everything from bacchanalian feasts to table linen. The profound life of still life pulses in Balzac as it does in Cézanne.[63] "He does his still life, Balzac, but like Veronese," said Cézanne, thumbing through *La Peau de chagrin* for the relevant passage: "A tablecloth . . . 'white as a freshly-fallen coating of snow, on which the place settings stood in array, crowned with little white rolls.' Throughout my youth I wanted to paint that, that tablecloth of fresh snow." When he began his own version of *The Feast*, subsequently known as *The Orgy* (color plate 22), he thought of it as "something like a pendant to the orgy in *La Peau de chagrin.*"[64]

Cézanne followed Balzac in fusing the ordinary with the extraordinary. The still life is as wild as the orgy. All excesses are brothers. Inspiration was there to be found; sensations were there to be organized, as the older and wiser Cézanne tried to explain to the stripling Gasquet:

Now I know that it won't do to want to paint simply "'place settings stood in array" and "little white rolls." If I paint "crowned" I'm screwed. Do you see? And if I truly balance and shade my place settings and my rolls as in nature, you can be sure that the crowns, the snow and the whole caboodle will be there. There are two things in painting: the eye and the brain, and they have to help each other; you have to work on their mutual development, but painter-fashion: the eye, for the vision of nature; the brain, for the logic of organized sensations which give the means of expression.[65]

Famously, he identified with Balzac's Frenhofer, painter or perpetrator of the unknown masterpiece. Identification of that sort came easily to him. It is no surprise that he was also drawn to the young Raphaël de Valentin, in the tragic tale of *La Peau de chagrin*. Raphaël has decided that life is insupport-

able; he will throw himself into the Seine. Before he does so, he wanders into an old curiosity shop on the Quai Voltaire. The shopkeeper shows him an ass's skin with magic properties: *la peau de chagrin*. With this talisman his every wish comes true. He emerges from his artist's garret to play Nebuchadnezzar at the feast; he becomes fabulously rich. For Raphaël, however, success is not what it seems. Each wish shrinks the skin, and with it his existence. He condemns himself to the impossible—to live without desires.

In the company of his friend Émile (a happy coincidence), Raphaël discourses freely on his life, his hopes and dreams, his difficulties and disappointments, in particular with women.

"Its expansion ceaselessly checked, my soul curled up on itself. Entirely frank and natural, I became cold and dissimulating; my father's despotism had undermined all my self-confidence; I was shy and gauche, I didn't believe that my voice was of the slightest consequence, I was annoyed with myself, I found myself ugly, I was ashamed of my looks. Despite the internal voice that must support men of talent in their struggle, that shouted Courage! Forward! despite the sudden revelation of my fortitude all alone, despite the optimism generated by comparing the new works admired by the public with those surging through my head, I suffered childish self-doubt. I was prey to excessive ambition, I believed I was destined for great things, and I felt I was in oblivion. I needed people, and I found I had no friends. I had to make a way for myself in the world, and I was alone, not so much timid as ashamed. . . .

"I was bold, but only in spirit, not in manners. I discovered later that women don't like to be begged; I've seen many I've adored from afar, for whom I would put a heart through any test, a soul torn to pieces, a spirit undaunted by sacrifices or tortures. . . . I lived all the torments with a powerless energy that consumed itself, either for want of audacity or, sometimes, experience. Perhaps I despaired of making myself understood, or feared being understood too well. . . . Oh to feel born for love, to make a woman very happy, and to have never found anyone, not even a brave and noble Marceline [from *The Marriage of Figaro*] or some old marchioness! To carry treasures in a pouch and not to be able to meet a child, some young girl interested in being admired! I often wanted to kill myself in despair."

"Really tragic this evening!" exclaimed Émile.[66]

Raphaël's plaint comes very close to the young Cézanne, give or take the old marchioness, just as Frenhofer's talk sounds uncannily like the elderly one. Yet it, too, was a kind of dramatization—a self-dramatization—as Émile's response reminds us. In fact, Cézanne manifested a degree of formality in his behavior with women, regardless of status or state of undress. It is tempting to think that he maintained this approach, a combination of stiffness and solicitude, even while making love—if a draft love letter may be taken as evidence. Contrary to legend, he was remarkably well behaved. So far from lunging or quaking, he appeared in public and in private as a model of correctness. In youth he was shy, as Justine could testify; in maturity he was almost chivalrous. The American painter Matilda Lewis encountered him at a gathering at Monet's house at Giverny, in 1894, when he was in his fifties. She wrote to her family about the experience:

> Monsieur Cézanne is from Provence and is like the man from the Midi whom [Alphonse] Daudet describes; when I first saw him I thought he looked like a cut-throat with large red eyeballs standing out from his head in a most ferocious manner, a rather fierce-looking pointed beard, quite grey, and an excited way of talking that positively made the dishes rattle. I found later on that I had misjudged his appearance, for far from being fierce or a cut-throat, he has the gentlest nature possible, *comme un enfant* as he would say. His manners at first rather startled me—he scrapes his soup plate, then lifts it and pours the remaining drops in the spoon; he even takes his chop in his fingers and pulls the meat from the bone. He eats with his knife and accompanies every gesture, every movement of his hand, with that implement, which he grasps firmly when he commences his meal and never puts down until he leaves the table. Yet in spite of the total disregard of the dictionary of manners, he shows a politeness towards us that no other man here would have shown. He will not allow Louise to serve him before us in the usual order of succession at the table; he is even deferential to that stupid maid, and he pulls off the old tam-o'-shanter, which he wears to protect his bald head, when he enters the room. . . .
>
> The conversation at lunch and at dinner is principally on art and cooking. Cézanne is one of the most liberal artists I have ever seen. He prefaces every remark with: *Pour moi* it is so and so, but grants that everyone may be as honest and as true to nature from their convictions; he doesn't believe that everyone should see alike.[67]

His table manners might have raised eyebrows in polite society in the United States, where even the piano legs were clothed, but in France they were commonplace. Deference to the maid was typical Cézanne. He rarely went to Vollard's famous cellar dinners, but on one occasion he dined alone with the dealer, who was telling him about an item in the newspaper. Cézanne stopped him with a gesture of the hand. When the maid had gone out, he said, "I stopped you because it wasn't proper for a young girl to hear." "What young girl?" "Why, your maid." "But she knows all about that sort of thing! You may even be sure she knows more than we do." "That may be," replied Cézanne. "But I prefer to think she doesn't."[68]

Among painters, his society was overwhelmingly male, with one fleeting exception. Around 1889–90, he took the young Joseph Ravaisou to paint side-by-side with him at the Château Noir, near Aix, one of his favorite spots. Ravaisou shared a studio with Louise Germain, a painter of animals. She came too. When they stopped for lunch, Germain, reprising the Baille role, would get out the food that Cézanne's sister had prepared for him and reheat it on a spirit stove. While he ate, Cézanne would discuss painting with Ravaisou. He did not address a word to Germain. "It was as if I wasn't there." [69] But she did not go unnoticed. One day, without telling her, he bought an example of her work from a gallery in the town: a little picture of ducks. Ducks, it is safe to say, were not Cézanne's *tasse de thé*.

If some of this behavior suggests a certain inhibition, it also conforms to social convention. Cézanne was not easy to read. His speech acts were as difficult to interpret as his antics, as Monet and others observed at the time.[70] His presentation must have often seemed exorbitant; his closest friends recognized his erratic sociability; he was prone to mood swings, and inclined to be suspicious of ulterior motives. He had temperament, to excess, but he was also *faible dans la vie,* as he liked to say. Hence the need for moral support. "I who am not practical in life, I lean on my sister, who leans on her adviser, a Jesuit (those people are very strong), who leans on Rome." In another variant, at the hour for vespers, Cézanne excuses himself. "Oh! Vespers, I go to please my wife. My wife is in the hands of the curate, the curate is in the hands of the Jesuits, the Jesuits in the hands of the Pope, there's no end to it."[71]

Was this account of the moral or spiritual hierarchy entirely serious? Perhaps it was. Yet Cézanne was a practiced ironist, with a sharper wit and a keener intelligence than most of his interlocutors. As he grew older he dug deeper into himself and achieved a profound self-knowledge. He felt strong, but also vulnerable. He was always on the lookout for predators—those who

might want to get their hooks into him ("*Le bougre, il voulait me mettre le grappin dessus!*")—but he did not know how to recognize them. Men as well as women were a risk; *les bougres* joined *les bougresses* as objects of suspicion. This was not a case of misogyny, or a certifiable neurosis. With the passage of time the shyness left him, but not the reserve. The mood swings continued, later exacerbated by the onset of diabetes. If he was weaned on illusions, as he said, he lived on sensations and projections. Cézanne was as prophetic as he was prickly—like a hedgehog, said Renoir. He did not mellow, or learn better. In behavioral terms, he never learned. He immatured with age, as his friends remarked, becoming less self-conscious and more disinhibited as the years went by. There was a sort of simplicity to him; but the simplicity was matched by a subtlety, an interiority, a dramatic life within a life, as Balzac wrote, that cannot be reduced to the salivating of a sociopath.

His understanding of his own situation, and of the very possibilities of painting, took a great leap forward at the Salon des refusés of 1863. The regular salon was then biennial; Cézanne had seen nothing comparable since the chic of 1861. In 1863 a draconian jury rejected nearly three thousand of some five thousand works submitted. No one could remember a bigger cull. The roll call of the rejected included Bracquemond, Cazin, Fantin-Latour, Gautier, Harpignies, Jongkind, Legros, Manet, Pissarro, and Whistler, though Manet had received an honorable mention only two years before. Despite being hors concours (not subject to jury decision), Courbet had a painting rejected for "moral reasons." The artists and their supporters were outraged. Complaints flew in all directions. So great was the brouhaha that the emperor himself descended on the Palais de l'industrie on the Champs-Élysées to sample the rejected work. The director general of museums (who also happened to be president of the jury), Count Nieuwerkerke, was summoned, and a diplomatic compromise was reached. The jury's verdict would stand, but provision was made for an exhibition of the rejected works in another part of the building—the annex, as it was rather indelicately styled—opening two weeks after the main event. This extraordinary exhibition was elective: all the rejected artists could participate, as of right, unless they chose to withdraw their work. In other words, this alternative salon, the "Salon des refusés," would show every last painting (with the exception of the proscribed Courbet). It was a significant concession. Cézanne was prepared to admit that the emperor was not such a bad bugger after all.[72] But for many artists it was a mixed blessing. The Salon des refusés was parodied as the Comedy Show. Ernest Chesneau called it the Salon of the Vanquished.

The public flocked to the annex in their thousands, agog to see what all the fuss was about. At the center of attention was a painting listed innocuously enough as *Le Bain,* by Édouard Manet. *Le Bain,* better known as *Le Déjeuner sur l'herbe,* was exactly what everyone except perhaps the artist himself hoped and feared: a scandal. Many of those who went to gawp burst out laughing. Many more were deeply offended. The emperor went so far as to call it "immodest," and it was indeed an offense against modesty or *pudeur.* Not only was there a naked woman sitting on the grass, calm as you please, practically entwined with two men, both of them overdressed; *la bourgresse* was looking out of the picture, almost absentmindedly meeting the spectator's gaze, while the men continued with their conversation. The brazen "facingness" of the painting was disconcerting, yet it was all flat, emotionally and pictorially, as if the figures had been stuck onto a backdrop. "I search in vain for any meaning to this uncouth riddle," Louis Étienne concluded, and he may have touched on a basic objection.[73] *Le Déjeuner sur l'herbe* was worse than a crime, it was a mistake. It was obviously indecent, and completely incomprehensible. Like much of Manet's best work, it yielded no plausible or acceptable story line. There was no safe inference to draw (*Reclining Nude*) or stock narrative to complete (*Woman Reading a Letter*). There was merely an arresting mise-en-scène and the debris of a picnic. It was at once affectless and shameless, deadpan and cocksure, rigorous and outrageous, classical and unconventional. It achieved instant notoriety.

Surely Manet had a nerve. His conception was as bold as his execution. The classical undertone was not fortuitous: the scene was stolen. *Le Déjeuner sur l'herbe* involved the appropriation of a detail from Marcantonio Raimondi's engraving after Raphael's *Judgment of Paris* (c. 1510–20). Manet's was an artful art; he specialized in quotation and paraphrase. His uncouth riddle paraphrased Giorgione's *Concert champêtre* (c. 1510), as a few sophisticates noticed at the time. The man himself was far from a joker. He was deadly serious and conspicuously refined, a pillar of café society, a maker of bons mots, a fascinator of writers and painters alike, Mallarmé prominent among them. Manet was a magnifico, "*un gentleman,*" as his French friends said. He was unimpeachable; he even fought a duel. And this was by no means his last word. At the Salon of 1865 he unveiled *Olympia,* a work submitted at Baudelaire's insistence. The wan, wasted courtesan with the cool stare and the electrified black cat was too much for the critics, who went into paroxysms of disgust over everything from the skin color to the paw marks.[74] "It's like the Queen of Hearts after a bath," Courbet is supposed to have said.[75] Others knew better.

Henceforth, Manet could not be avoided. "*They mock you*; the *raillery* annoys you; they don't do you justice, etc., etc. Do you think that you're the first to be treated so? Are you a greater genius than Chateaubriand or Wagner? . . . And so as not to fill you with too much pride, I will tell you that those men are models, each in his genre . . . and that you, *you are but the first in the decrepitude of your art,*" wrote Baudelaire, to cheer him up.[76]

The younger generation worshipped the ground he walked on. "With Courbet, it was still the tradition," said Renoir; "with Manet, it was a new era in painting."[77] Duranty, who once found himself on the wrong end of the artist's épée, observed in 1870 that "in any exhibition, at a distance of 200 paces, there is only one painting that stands apart from the others; it is always a painting by Manet."[78] Degas, who was nothing if not difficult to please—"Yes, no doubt what he does is very good," he would say of Fantin-Latour, "but what a pity that it's a little *rive gauche*"—this same Degas admired and envied Manet's assurance, records Valéry, who adds: "There is in Manet a decisive force, a sort of strategic instinct for the pictorial action. In his best canvases, he achieves *poetry,* that is to say the artistic supreme, through what I may be permitted to call . . . *the resonance of the execution.* But how to talk about painting?"[79]

Cézanne and Zola went round the Salon des refusés together, contemplated *Le Déjeuner sur l'herbe,* and engaged in endless talk about painting. Cézanne studied Manet as carefully as he did the Old Masters. He was vastly impressed, first of all by the mark making, and then by the total effect. He absorbed the power of the *réalisation.* Manet made paintings (*tableaux*), not pieces (*morceaux*), said Cézanne, picking up the distinction that was made at the time. He had an enviable virtuosity. "He splotches the tones!" Cézanne rejoined, later, in answer to a question from Vollard; and to a fellow painter, the young Maurice Denis, who ventured to ask what had led him from the hot temper of his early work to the patient application of separate strokes, he replied, "It's because I can't capture my sensation at the first go; so, I lay in some color, I lay it in as I can. But when I start, I always try to paint with a thick impasto like Manet, giving form with the brush."[80] Cézanne was not in the habit of burdening Vollard with technical explanation; instead he made cracks and gnomic comments, as the dealer noted. Whatever he meant by splotching the tones (probably the bold staccato touches of bright color), he took due note of "the rightness" of Manet's tones, as Zola put it in a pen portrait that owed a good deal to his friend's talk: "The rightness of the tones establishes the planes, lets the canvas breathe, gives each thing its strength." Zola's analysis also sug-

gested that Manet had managed what Cézanne had hardly begun. "Édouard Manet had found his way, or, more precisely, found himself: he could see with his own eyes, in each of his canvases he could give us a translation of nature in that original language that he found deep within himself."[81]

Cézanne set store by the master painter's good opinion. Manet had seen some of his early still lifes at Guillemet's. "He found them forcefully handled," reported Valabrègue to their friends. "Cézanne took great pleasure in this, though he does not go on about it or make much of it, as usual."[82] His reaction was replayed in *L'Œuvre,* when Bongrand, the felicitously named Manet character, encounters Lantier among the baying hordes at the Salon des refusés and passes him a compliment on his painting in that exhibition. The compliment is as handsome as it is unexpected:

> "You, my good man, you are famous. Listen! They think I'm pretty sharp, but I would give ten years of my life to have painted your great strumpet of a woman."
>
> This praise, coming out of that mouth, moved the young painter to tears. At last, he had had a success! He couldn't find a word of gratitude; he spoke brusquely of something else, wanting to hide his emotion.

Lantier casts himself in the role of devoted follower: "Your pupils are coming along," he tells Bongrand humbly: the struggle continues. The expression he used, *"vos élèves poussent,"* was an echo of Cézanne's own expression *"pousse-toi de l'agrément!"*—shun convention![83]

They first met in the flesh in 1866, in Manet's studio. The encounter was cordial, it appears, but the conversation stilted. On home ground Manet was formidable. Cézanne would have been busy sizing him up, and no doubt a little awed. In one of his dialogues Plato's hero Socrates admits that "there is one being whom I respect above all. Parmenides himself is in my eyes, as Homer says, a 'reverend and awful' figure. I met him when I was quite young and he quite elderly, and I thought there was a sort of depth in him that was altogether noble."[84] So it was with Manet, reverend and awful, until Cézanne discovered how to take his measure. There was only seven years between them in age, but the gulf in achievement was enormous. Over time, this was rectified, and Cézanne came to think that Manet was perhaps too *bon grand*—too good to be true. Thirty years later, contemplating Giorgione's *Concert champêtre* in the Louvre, he ruminated: "Let us feast our imagination on a great carnal dream. But let us soak ourselves in nature. Not extract nature from our imagi-

nation. If we can't, too bad. You see, in *Le Déjeuner sur l'herbe* Manet should have added—I don't know—a frisson of that nobility, that je ne sais quoi, that elevates all the senses." Evidently there was something missing. "He lacks harmony," Cézanne confided to Vollard at length, "and temperament."[85]

Zola went the same way. After a period of intoxication greater than Cezanne's, and a certain reciprocal self-regard—*Édouard Manet, étude biographique et critique* (1867), a brief life and work, begat *Portrait d'Émile Zola* (1868), a kind of official portrait (color plate 26)—disappointment set in. In fact, an interesting parallelism could be observed. By the 1880s, Zola's doubts about Manet began to compare with his doubts about Cézanne. Claude Lantier owed something to both of them. "I haven't mentioned Édouard Manet, who was the leader of the group of impressionist painters," wrote Zola, in an extraordinary passage on the Salon of 1879:

He has continued the movement after Courbet [who died in 1877], thanks to his perceptive eye, so good at discerning the right tones. His long struggle against the incomprehension of the general public can be explained by the difficulty he faces in execution, by which I mean that his hand is not the equal of his eye. He has not been able to construct a technique for himself; he has remained the eager schoolboy who always sees exactly what is happening in nature but who does not have the power to convey his impressions in a complete and definitive fashion. That is why, when he sets out, it is impossible to tell how he will arrive at his destination, or even if he will arrive at all. It remains to be seen. When he succeeds with a painting, it is something else: absolutely true and immensely skillful; but he has begun to lose his way, and so his canvases are imperfect and uneven. In short, over the last fifteen years no painter has been more subjective. If the technical side of his work matched the sharpness of his perceptions, he would be the greatest painter of the second half of the nineteenth century.[86]

A few months after the revelation of the Salon des refusés, in August 1863, Delacroix died. Baudelaire's epic homage, "The Life and Work of Eugène Delacroix," ran in serial form in *L'Opinion nationale* from September to November. In December, Cézanne began his own homage—a faithful copy of *Dante and Virgil Crossing the Styx* (1822) in the Luxembourg—the taster after Delacroix that he mentioned to Coste.[87] In the 1930s Arshile Gorky was in the habit of saying that he was *with* Cézanne for a long time.[88] Cézanne was

with Delacroix for even longer. Death brings artists closer together. After the death of Delacroix and the birth of Manet, his own situation was beginning to clarify. The stakes had been raised. When they met in the publicity department of Hachette in the early 1860s, Jules Vallès was taken aback to be asked point-blank by Zola, "Do you consider yourself a force to be reckoned with?" Zola answered matter-of-factly for himself: "I am."[89] This was just the sort of thing that he and Cézanne discussed together; it bore directly on the question of success. By the middle of the decade Cézanne could have returned the same answer. Paul Valéry's empathic understanding of the young Baudelaire's situation serves to illuminate his thinking:

> Baudelaire's problem must have posed itself in these terms: "How to be a great poet, but neither a Lamartine, nor a Hugo, nor a Musset." I do not say that this was a conscious aim, but it was a necessary one, even an essential one, for Baudelaire. It was his *raison d'État*. In the field of creation, which is also the field of pride, the need for self-differentiation is inseparable from life itself. Baudelaire wrote of his project in the preface to *The Flowers of Evil*: "For a long time illustrious poets have shared the most flowery parts of the poetic field. So I will do something else."[90]

Cézanne, too, would do something else. His problem must have posed itself in analogous terms: how to be a great painter, but neither a Delacroix, nor a Courbet, nor a Manet. The project of self-definition and self-differentiation started here.

In the mid-1860s, at the age of about twenty-five, Cézanne set about becoming Cézanne. This had ramifications beyond painting. When he arrived at the Café Guerbois, the favored watering hole of Manet and his band, "he threw a suspicious glance at the assembled company," Monet recalled. "Then, opening his jacket, with a movement of the hips worthy of a zinc-worker he hitched up his pants, and ostentatiously readjusted the red sash round his waist. After that he shook hands all round." The ceremony was not over yet. In the presence of the capo himself, Cézanne removed his hat, smiled his smile, and in nasal tones announced: "I won't offer you my hand, Monsieur Manet, I haven't washed for a week."[91]

4: I Dare

The red sash was a Provençal *taillole*—something more than a fashion state-
ment. Cézanne was not much taken with the Café Guerbois and its denizens.
He told Guillemet, who had taken him there, "That lot are all bastards! They're
decked out like lawyers!" He who relished a play on words could not abide the
mannered wit and cultivated repartee that was the form in that coterie. Cote-
ries were not his style. "Parisian wit bores me rigid," he would say. "Forgive
me. I'm only a painter."[1]

The simple painter and his sash found their way into *Le Ventre de Paris*.
Here, Claude Lantier is introduced as "a big-boned, scrawny youth with a
large head, bearded, with a delicate nose and small bright eyes." He wears a
black felt hat, from his father's surplus stock, perhaps, that has become shape-
less and discolored with age. He is wrapped in an enormous greatcoat, once
a delicate shade of brown, now streaked green from the rain. He is a little
stooped, and rather twitchy, in the usual way ("*agité d'un frisson d'inquiétude
nerveuse*"). Nervy he may be—like his mother, he is given to outbursts of hys-
teria—but he stands his ground as if planted, in big lace-up boots. His trousers
are too short, exposing his blue socks.[2]

Such is the stock figure of the young Cézanne—part clown, part vagrant,
part bumpkin. An uncoordinated figure, in more senses than one. Traces of
this description leach through the literature like the rain. Reliable alternatives
are rare. Most of the firsthand accounts date from the last ten years of his
life, c. 1896–1906; they are out of the mouths of babes and sucklings. They
tend to describe a living idol, a man grown prematurely old, and conscious
of encroaching death. One of the very few to redress the balance is Georges
Rivière, who evokes him at thirty, in 1869, as a big, solid youth, long-legged
and lanky.

He walked with an even step, with his head held high, as if looking at the horizon. His noble face, surrounded by a curly black beard, recalled the features of Assyrian gods. Big eyes, with a brilliant sparkle and tremendous liveliness, dominating a delicate, slightly curved nose, tended to give him an oriental mien. He generally had a serious air, but when he spoke, he became more animated and his expressive features matched his powerful, beautifully resonant voice, with a strong Provençal accent lending it a particular savor.[3]

The colorful fiction has eclipsed the direct observation. Over time, a process of transference has been effected, or a sleight of hand. The living, breathing Cézanne flits through the past like a ghost, or an Assyrian god, lacking all substantiality; he gains credence, and a kind of corporeal verisimilitude, from the concoction that is Lantier, who blithely fills his boots. The transference, however, was not one-way. In his outrageous phase—his purple period—it was as if the man himself were bent on living up to the legend. "If this is of any interest to you," Duranty wrote to Zola in 1877, "Cézanne appeared recently at the little café on the Place Pigalle [La Nouvelle-Athènes, successor to the Café Guerbois] in one of his costumes of olden times: blue dungarees, a white linen jacket covered with the marks of brushes and other implements, battered old hat. He had a certain success. But these are dangerous demonstrations."[4]

Duranty had been shrewd enough to keep him under close observation for over a decade. As early as 1867 he published a fictionalized portrait, "The Painter Marsabiel." In the course of serial revisions and republications over the next few years, Marsabiel mutated into Maillobert, but retained his peculiar identity. This painter enjoyed a reputation as "a very strange being," with a strong Mediterranean accent, and a talking parrot. One fine day the narrator calls on him at his studio:

I was completely stunned by the place and the person. Dust, dirt, shards of pots, rags, debris, clay from dried sculptures, piled up as if it were the rag-and-bone man's shed. The smell of mould made your heart sink. The painter—bald, with a huge beard and protruding front teeth, looking at once old and young—was himself; like the symbolic deity of the studio, he was sordid, indescribable. He gave me a bow, accompanied by an inscrutable smile, either mocking or stupid.

At the same time, I was struck by the sight of so many enormous canvases hanging all around and in such dreadful colors that I was frozen to the spot.

"Ah! Ah!" said Maillobert, in a nasal voice, with a drawling *hyper-Marseillais* accent, "Monsieur is a lover of painting (*peinn-turrre*)." "Here are my little palette droppings," he added, indicating the most gigantic canvases.

At that moment, the parrot exclaimed: "*Maillobert is a great painter!*" . . .

"That's my art critic!" said the painter with an unsettling smile. . . .

A series of portraits caught my attention next, portraits without faces, for the heads were a mass of blotches in which it was no longer possible to make out any features; but on each frame a name was inscribed, often as strange as the painting. Thus I read: Cabladours [Cabaner?], Ispara [Pissarro], Valadéguy [Valabrègue], Apollin [Emperaire], all disciples of this master.

"You see," Maillobert resumed, "painting can only be done with temperament." (Pronounced *temmpérammennte*.)

So saying, he brandished a kind of wooden cooking spoon, with a long handle and a beveled end. I wondered if by temperament he meant what is generally meant by that word, or if it was the spoon that he called *temmpérammennte*. . . .

He dipped the spoon into one of the pharmaceutical pots and brought out a veritable trowelful of green, which he applied to a canvas on which a few lines indicated a landscape; he rotated the spoon and at a pinch you could see a meadow in his daubs. I noticed then that the paint on his canvases was about a centimeter thick, and formed hills and valleys like a relief map. Evidently Maillobert believed that a kilo of green was greener than a gram of the same color.[5]

In the original version of this story, the doctrine of temperament was taken one stage further. The conversation turns to a painting called *La Sole frite, ou Le Crépuscule dans les Abruzzes* (*The Fried Sole, or Twilight in Abruzzo*), a spoof of a painting of Cézanne's, dubbed by Guillemet *Le Grog au vin, ou L'Après-midi de Naples* (*The Toddy, or Afternoon in Naples*). As might be expected, it is a painting of drunkenness and debauchery, with an appropriate measure of naked flesh (color plate 51). For all this the painter makes no apology. Unabashed, he offers a rousing justification: "It's because the nude

is much more beautiful, and because all that upends society. I'm a democrat. Nature is bourgeois! I give it temperament!"[6]

Duranty's stories were widely read. Among the readers was Cézanne. What did he learn? Ballsy painting, apparently, was done not with the palette knife but the cooking spoon; and the work of art was not so much a corner of nature but more of a relief map seen through a temperament—the application of the paint akin to the process of geological sedimentation. These were suggestive metaphors. Painting as a blend of alchemy and cookery was a sympathetic notion. "You must like Delacroix," hazards the narrator. "*Peuh!*" snorts Maillobert disdainfully. "Delacroix is egg white."[7] Stirring the pot like that is exactly what Cézanne was about. This was also the period in which he was accused of painting not only with a knife but also a gun, a charge that must have given him considerable satisfaction. *Peinture au pistolet* (pistol painting, or spraying it on) was by implication the strange practice of a strange person.[8] Whatever the implement, the mixture was fundamental. It had to have a certain density, in order for the work to reach a certain solidity. For the Cézanne of the 1860s, solidity had to do with the manner of application, and more specifically with the resulting thickness (*épais*). It was a question of the paintwork. In keeping with this philosophy, the paint was worked very hard. In Duranty's story, Maillobert's *puissance,* his prowess as a painter or paint worker, and as a man, is explicitly linked to his ability to apply the mixture in such a way as to achieve the requisite thickness. To succeed in that is true *réalisation*. Thickness, therefore, is the challenge and the gauge. Painting is like mountaineering; scaling the peaks requires skill, and balls. "*Modern painting does not know how to do thickness,*" screeches Maillobert's parrot. Following Cézanne, who classified painting into that which was *bien couillarde* and "the rest" (*les autres,* pronounced *les otttres*), "the master of the spoon" lays it on with a trowel.[9]

The geological metaphor was no less apt. Cézanne's friend Fortuné Marion was a brilliant scholar whose passion was the rocks and soil and the flora and fauna of Provence. A precocious Darwinist (recognized by Darwin himself), a renowned professor of zoology, and later the director of the Museum of Natural History in Marseille, Marion attended the Collège Bourbon a few years after Cézanne. He was steeped in the geology and paleontology of the ammonite-rich area around Aix, in particular the Mont Sainte-Victoire. He made his reputation at the age of twenty, in 1866, when he discovered a Neolithic cave settlement in the hills of Saint-Marc, on the western slopes of the mountain, complete with human skulls, bones, and flint utensils. Marion was something of a Provençal patriot. He also liked to paint. Borrowing the palette

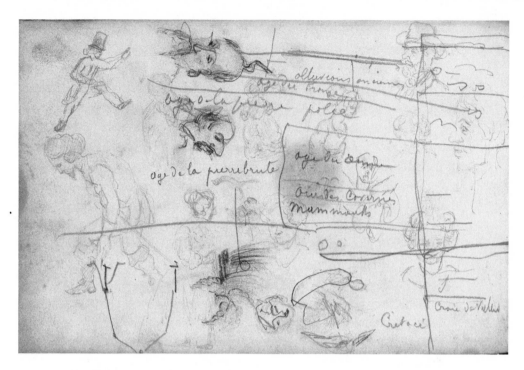

knife, he executed a *View of Aix,* now in the Fitzwilliam Museum, Cambridge, which has been taken for a Cézanne.

Cézanne labeled him, rather as he labeled his own specimens, "geologist and painter." The two of them discovered a shared excitement in the fervor of their quest and in a Paleolithic love of their native soil. On several pages of Cézanne's early sketchbook, the cartoonish studies of soldiers and greybeards and men in top hats are overlaid with diagrams of geological eras, annotated in Marion's hand—Triassic, Permian, Cambrian, Carboniferous, and the rest— together with some appealing terms of art: *âge de la pierre brute* (Paleolithic), *âge de la pierre polie* (Neolithic), etc. This sketchbook exchange must have been part of the freewheeling discussions and the painting expeditions they shared between 1866 and 1868: a real intellectual affinity. The lesson stuck: many years later, Cézanne recalled Marion on "the psychology of the earth" for Joachim Gasquet.[10] "As for young Marion, who you know by reputation," their mutual friend Guillemet wrote to Zola from a sojourn with Cézanne in Aix, "he cherishes the hope that he will be appointed to a chair in geology. He is excavating steadily, and tries to demonstrate to us with each snail fossil he finds that God never existed and that it's a put-up job to believe in Him. This is of little concern to us, as it's not *painting.*"[11]

Cézanne's practice was increasingly geological. Renoir recounted an experience that became an essential part of the Cézanne legend: "It was an unforget-

table sight," he told Geffroy, "Cézanne at his easel, painting, looking at the countryside: he was truly alone in the world, ardent, focused, alert, respectful. He would return the following day, and every day, building on his efforts, and sometimes coming away disappointed, returning without his canvas, which he'd leave on a rock or on the grass, at the mercy of the wind or the rain or the sun, swallowed by the earth, the painted landscape reclaimed by the natural environment."[12] The legend had substance. In 1913 the Marseillais painter Charles Vivès-Apy discovered the remains of a canvas in the Tholonet area near Aix, one of the artist's favorite sites.[13] The Cézannian period left rich deposits.

Zola for his part knew Marion very well, not as a geologist, but as a naturalist. Zola reviewed his book *Les Végétaux merveilleux* in *L'Événement*. (By way of thanks, Marion named a newly discovered marine organism after him, *Thoracostoma Zolae*.) They entered into an intensive correspondence on the subject of heredity, with which the novelist had become obsessed in working out the "natural history" of the Rougon-Macquart family for his projected series. Marion fed this obsession, and gave it his personal imprimatur. "We shall talk all about the strange phenomena of heredity," he wrote. "Therein lies the whole philosophy of natural history: reverting to type from our grandparents, atavism, recurrent development."[14] Meanwhile Zola was reading voraciously, as always, stockpiling notes for the novels to come. He worked his way

through two volumes of Prosper Lucas's *Traité philosophique et physiologique de l'hérédité naturelle* (1847 and 1850) and, closer to home, Émile Deschanel's *Physiologie des écrivains et des artistes, ou Essai de critique naturelle* (1864).[15] He sent Marion his plan for *Madeleine Ferat,* the test bed for some of these ideas, and then for the entire Rougon-Macquart cycle; Marion cordially approved. Zola's schematization laid a heavy emphasis on fate and fatalism, "the fatalities of life, the fatalities of temperament and environment." "I don't want to paint contemporary society," he reflected, in a characteristic note on "differences between Balzac and myself," "but a single family, showing the play of race modified by environment. . . . My big thing is to be a pure naturalist, a pure physiologist."[16]

What all this might mean for poor Claude Lantier began to emerge in an outline of the cycle as conceived in the late 1860s:

> A novel that has as its frame the artistic world and as its hero Claude Lantier, another child of a working-class family.
>
> The remarkable effect of heredity transmitting genius to a son of illiterate parents. Influence of the mother's nerves. Claude has unstoppable and unrestrained intellectual appetites, just as certain members of his family have physical appetites.
>
> The violence with which he tries to satisfy his mental passions makes him impotent. A picture of the temperature of the art of the age, of what has been called decadence, which is nothing but the mad activity of the mind. Harrowing physiology of the artistic temperament of our time, and terrible tragedy of a mind that devours itself.[17]

According to this conception, Claude Lantier never really stood a chance. Genius or no—in *L'Œuvre,* the question is moot—his fate was determined by his temperament: overdetermined, one might say. It was sealed by heredity. For Zola, heredity *is* fate, with scientific icing. Lantier's forebears distinguish themselves in idleness, drunkenness, and madness. His mother, Gervaise, is born lame. Throughout the novel Zola plays with the idea of a defective gene. Lantier is the victim of biological imperatives; he is tormented by the mystery of heredity. "Was it a lesion to his eye that prevented him from seeing straight?"[18] He has a defect of his own, it seems, and in the vital organ—Valéry's organ of asking—the eye. Cézanne was taxed with the same thing ("retinal maladies"); in later life he feared losing his sight, or his mind.

In the world of fiction, the implication is clear: Lantier is crippled from

birth, as man and artist, physiologically and psychologically. He is not merely uncoordinated; he is unstable. "Influence of his mother's nerves" is ominous indeed. His mother wends her doomed way through *L'Assommoir* (1877), whose original title was *The Simple Life of Gervaise Macquart,* descending into a kind of animalization. Half-starved and half-crazed, she rots to death, as the neighbors say, like a rat in a trap. "One morning there was a bad smell in the corridor and people remembered that she hadn't been seen for two days; they found her in her hole, already green."[19] Heredity had a lot to answer for.

Temperament remained the driving force. In this foggy zone, Zola's reading and understanding converged with Cézanne's. Fundamentally, thinking about temperament had made scarcely any advance on the ancients. Contemporary authorities resolved it into a classification of "types" based on the four bodily humors: the sanguine (blood), the melancholic (black bile), the phlegmatic (phlegm), and the choleric (yellow bile). The literature was dry as dust—even Deschanel. For any artist, however, there was one shining exception. Embedded in Stendhal's enchanting *Histoire de la peinture en Italie* was a bravura treatment of "six classes of men," six marked temperaments, touted by the author as a user's guide to artistic adventure and behavior.[20] The six temperaments were little more than an elaboration of the humors of old—the sanguine, the melancholic, the phlegmatic, the choleric, the nervous, and the athletic—but in Stendhal's hands each temperament yielded its own "moral character." Herein lay the fascination.

On first reading, Cézanne seems to have identified himself as choleric (*bilieux*), along with Saint Dominic, Julius II, Gaius Marius, Charles V, and Cromwell—men of action, as Stendhal underlined. It cannot have escaped his attention that "almost always the stimulating effects of the bile coincide with those of the seminal humor."[21] *Bilieux* was ballsy by another name. His moral character was revealed to him as follows:

Intense sensations, abrupt and impetuous actions, swift and change-able impressions (as swift and changeable as the sanguine); but, as each impression has a slightly greater strength, it is for the moment dominant. The flame that devours the choleric produces more uncompromising, singular and fickle ideas and feelings.

It also gives him a feeling of almost habitual *inquiétude*. He is a stranger to the casual well-being of the sanguine; he finds a little peace only in inordinate activity. This man feels the joy of life only in great deeds, when the risk or the difficulty absorbs all his energy, and when he

experiences each moment to the full. The choleric man is compelled to great things by his bodily state.[22]

For the skeptically inclined, humors may not be so far removed from horoscopes, but for the artist in search of himself (or a plausible construction) Stendhal's moral characters were well-nigh irresistible. Cézanne was very attached to this work. He told Zola that he first read it in 1869, at the age of thirty, but it is entirely possible that he absorbed some of the ideas before that. Stendhal's book had been widely available since the mid-1850s. A new edition was published in 1854; it was reprinted in 1860 and 1868. Baudelaire's homage to Delacroix, which Cézanne would have read when it first appeared in 1863, is full of Stendhal. Moreover, the message of *Histoire de la peinture en Italie* was telegraphed in the Goncourt brothers' *Comédie humaine* of painting, *Manette Salomon* (1867), a novel that in some respects anticipated *L'Œuvre*. For Cézanne, *Manette* contained at least three unmissable items. The relationship between Naz de Coriolis from Provence, originally from Italy, and his only friend, Anatole Bazoche, may have seemed vaguely familiar—pure coincidence—especially in the extracts from their youthful correspondence. The damnation of Delacroix, his body still warm, was arresting. His temperament was traduced ("a bag of nerves, a sick man, an agitated man"), and his art subjected to a torrent of abuse, culminating in a magnificent dismissal: "Delacroix! Delacroix! A great master? Yes, for our time. . . . But at bottom, this great master? The dregs of Rubens!"[23]

Most spectacularly, there was a marvelous tirade against the Prix de Rome and the very idea of "schools." The moral drawn was irrefutable: the true school is the self, in spite of all.

Originality, which the individual carries in himself . . . Well, that faculty, that tendency of the personality not always to redo Pérugin, Raphael, Dominiquin, with a kind of Chinese piety, in the way they have today . . . that ability to put into what you're doing something of the design that you and only you have discovered and perceived, in the lines of life; the strength, even the courage to see with your Western, Parisian, nineteenth-century vision, with your own eyes . . . I don't know . . . with your Presbyterian, brown or blue eyes . . .

In short, what you can muster to be *yourself,* that is to say a lot, or a little different from the others. . . .

Well, *mon cher,* you'll see what you'll be left with, what with the

preaching, the little torments, the persecutions! But they'll point you out! You'll have against you the director, your friends, strangers, the atmosphere of the Villa Medici, memories, examples, twenty-year-old calculations that they redo at the École, the Vatican, the stones of the past, the conspiracy of individuals, things, those who talk, advise, rebuke, oppress with memory, tradition, veneration, prejudice. . . .[24]

The Goncourts were not the only ones. The moral ground was occupied by Hippolyte Taine and expounded in his own inimitable fashion in *Philosophie de l'art* (1865), an assemblage of his lectures as professor of aesthetics at the École des beaux-arts. Taine was a phenomenon—one of the most fertile and formidable intellectuals of the age. Despite his position, or perhaps because of it, he wrote on practically everything. As the Goncourts observed, "Taine has the admirable ability to teach others today what he did not know himself yesterday."[25] His doctoral thesis, *Essai sur les fables de La Fontaine,* was already a celebrated work. Here as elsewhere, there are parallels with the omnivorous Walter Benjamin.

Taine was inspirational and unavoidable. Asked in later life which books had had the most influence on him, Zola replied: Musset's poetry, Flaubert's *Madame Bovary* (1857), and Taine's writings. As a young man, Zola tackled Stendhal when Taine tackled Stendhal (in an essay of 1864). His early work as a critic is a dialogue with Taine, often silent, sometimes loud. *Mes Haines* opens with a Tainian flourish: "Like Stendhal, I prefer a villain to a cretin." Belying its title, one of its subjects is "M. H. Taine, artiste," taking up Taine's lapidary remark to his students at the Beaux-Arts, that only two precepts had so far been discovered. "The first counsels being born with genius: that is your parents' affair, not mine. The second counsels working very hard, in order to gain a thorough mastery of your art: that is your affair, and not mine either." The great man simply needs to train; as Zola put it, "he carries his masterpiece inside him."[26] The early novels, too, have Tainian traces. The epigraph to the second edition of *Thérèse Raquin* (1868) is Taine's notorious statement that "vice and virtue are products like vitriol and sugar."

Cézanne meanwhile digested Taine's *Voyage en Italie* (1866). There he found extensive analysis of painting and painters, in particular the Venetians and the Florentines, a counterpart to Stendhal. Many years later, perambulating in the Louvre with Joachim Gasquet, he confessed that he very rarely visited "the primitives," citing Cimabue, Fra Angelico, and Uccello. "There's no flesh on those ideas. I leave all that to Puvis [de Chavannes]. I like mus-

cles, beautiful tones, blood. I'm with Taine, and what's more, I'm a painter. I'm a sensualist. . . . You don't paint souls. You paint bodies; and when the bodies are well-painted, dammit, the soul—if they have one—the soul shines through all over the place." Continuing their tour, they come upon *La Source* (1856), by Ingres, a knock-kneed nude hoisting an urn of water. She is soul-

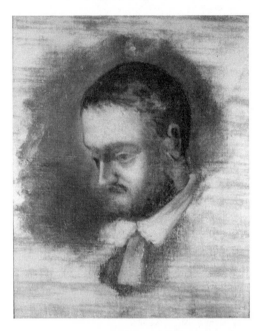

ful, yet soulless; forlorn, but pasty. "Ingres is just the same, *parbleu,* bloodless. He's a draftsman. The primitives were drafts-men. They illustrated. They made great big illuminated missals. Painting, painting worthy of the name, only began with the Venetians. Taine tells us that in Florence all the painters started out as goldsmiths. They were draftsmen. Like Ingres."[27]

Cézanne and Zola talked more about art and ideas than is often realized. They surely talked temperament. Zola's famous definition "a work of art is a corner of nature seen through a temperament" is part Cézanne, part Taine, with a dash of Zola, a little like the characters in his novels. "*Voilà un tempérament!*" Zola hailed Monet in *Mon Salon,* as he practiced his rhetoric. "There is a man in a crowd of eunuchs."[28] For Delacroix, the temperament was the *vis poetica,* which would surely have pleased them.[29] Did they talk Taine? It seems they did. Zola and Taine were colleagues; as authors, they were in the same stable at Hachette. In January 1865 Zola sent Taine a copy of his newly published stories, *Contes à Ninon,* with a fulsome covering letter, and a special request. "One of my friends," he wrote guardedly, "a painter, who is not on the course at the École des beaux-arts, would like to join your classes in aesthetics. Is a pass required for entry, and if so, would you be so kind as to obtain one for me? If my request is in any way inappropriate, please ignore it."[30] Nothing came of this *politesse,* but there is no mistaking the identity of the painter friend. Cézanne always retained a certain ambivalence towards the Salon de Bouguereau. Perhaps the same applied to the Bozards.

Taine would have made quite a master. As it turned out, the bulk of his lectures on aesthetics appeared later that year, together with a collection of essays, among them a glorious celebration of Balzac. Taine's idea of the artist

was equally glorious. It went without saying that the artist was *homme séri-eux*; more particularly, he was *homme moral*—an exemplary figure, enlarging our conception of the world and demonstrating what it means to be human. It followed that "a certain moral temperature is needed for certain talents to develop; in its absence, they fail."[31] For Cézanne, this was a significant finding; but its significance did not register at the time. In his thirties, Cézanne was not ready. Taine, like Stendhal, required rereading.

What did register was Taine's remarkable vision of what an artist could be:

Balzac, like Shakespeare, painted villains of every species: worldly and bohemian, from the penal colony and the spy ring, from banking and politics. Like Shakespeare, he depicted monomanias of every stripe: debauchery and avarice, ambition and science, art, paternal love, love itself. You suffer from one just as you suffer from any other. We are not at all in the realm of a practical or moral life, but an imaginary and ideal one. Their characters are not models but spectacles; greatness is always uplifting, even in the midst of misfortune or crime. No one invites you to approve or to follow; you are asked only to look and to marvel. In open country I would rather meet a sheep than a lion; but behind the bars of a cage I would rather see a lion than a sheep. Art is exactly that sort of cage; by removing the terror, it preserves the interest. Hence, safely and painlessly, we may contemplate the glorious passions, the heartbreaks, the titanic struggles, all the sound and fury of human nature elevated by remorseless battles and unrestrained desires. And surely then it has the power to move and to stir. It takes us out of ourselves; we leave the commonplace in which we're mired by the weakness of our faculties and the timidity of our instincts. The spectacle and the repercussions enlarge the soul; we feel as if we are in front of Michelangelo's wrestlers, tremendous statues whose immense muscles and tendons threaten to crush the pygmy people who look on them; and we understand how in the end these two great artists live in a realm of their own, far from the public domain, in the land of art.[32]

How was this vision to be realized? Taine had equally remarkable things to say about that, too, things that spoke directly to Cézanne's growing sense of himself as different—if not quite as different as the lion and the sheep, then as different as the hare and the rabbit, as Renoir had it.[33] Taine's thrilling theorizing explained and validated that sense of difference. His philosophy

of art offered aid and comfort; strange to relate, Taine was a moral support. More than that, he was an incitement. Taine helped to refine the project of self-differentiation. In effect he underwrote it. If the heart of the matter was the artist's individual sensibility, then a felt sense of difference was a blessing, not a curse. In Taine's quasi-scientific scheme of things, the distinguishing feature was the *sensation originale*. The trick lay in getting it to ripen; hence the importance of the moral temperature. Artists, he proclaimed, had to have their own way of feeling, inventing, producing—their own way of being—otherwise they were nothing more than copyists, or hired hands. In Voltaire's terms, they must cultivate their garden. In Taine's terms, they must cultivate their microclimate.

> In the presence of things, they must have a *sensation originale*; some aspect of the object has struck them, and the shock effect leaves a powerful and distinctive impression. In other words, when a man is born with talent, his perceptions, at least his perceptions of a certain kind, are swift and refined; he naturally grasps and untangles the nuances and connections with a sure touch, be it the plaintive or heroic feeling of a sound sequence, be it an attitude of pride or a sense of languishing, be it the richness or the sobriety of two complementary or contiguous tones; with this faculty he understands objects from the inside and seems more perceptive than other men. And this *sensation,* so vital and so personal, does not remain passive; the whole thinking and feeling machine receives it, reverberates with it. . . . Under a powerful and primitive impulsion, the brain works to rethink and transform the object, sometimes to illuminate and elevate, sometimes to twist and distort.[34]

Here was a philosophy to cherish, a philosophy consistent with his moral character. Originality implied individuality, even eccentricity. Defects of all sorts, psychological, physiological, and perceptual, were cause for celebration, not shame. Seeing slant might be a virtue. Sensations mandated distortions; temperament mandated devilment. Cézanne could follow his star. Better still, he could act up. Not for the choleric a life of Chinese piety. True to his temperament, he began to perform. Performing Cézanne became one of his best turns. This was not a jape: the Cézanne that emerged in the late 1860s was in every way a serious artist. Even the performance was serious. For the first time there was an element of calculation, or premeditation. The campaign strategy may have lacked something in sophistication, but it got him painting—and it got him noticed.

First he cut his beard, "and consecrated the tufts on the altar of Venus victorious," as Zola reported to Valabrègue in 1864. Then he grew it again. "Paul looks superb this year," recorded Marion in 1866, "with his hair thin on top and extremely long, and his revolutionary beard." "His person is rather smartened-up," Guillemet informed Zola. "His hair is long. His complexion is blooming and his very turn-out causes a sensation in the Cours [later the Cours Mirabeau, the grand boulevard of Aix]. So you see all is calm on that front. Though always in turmoil, his morale shows a slight improvement . . . in short, 'for now the sky of the future seems less black' "—poking fun at Cézanne's habitual refrain whenever things were not going well with the work, "The sky of the future looks very black for me," an expression much cherished by his friends.[35]

The revolutionary beard was not completely fanciful. According to regulations promulgated by the Ministry of Public Instruction, long hair, untrimmed beards and mustaches were proscribed as "anarchic." Anarchic, in fact, would have been a useful addition to the types of temperament. Marion's letters to his musical friend Heinrich Morstatt are full of references to the turmoil of Cézanne's temperament, his bid to make the most of it, and his struggle to master it—and Marion's belief in him, regardless of the buffetings and the turbulence. "He is growing in stature. I truly believe that his temperament will be the strongest and the best."[36] Temperament as well as sediment must have figured in their discussions. Marion's reactions to the stratagems of the new philosophy are similarly revealing. The biggest stratagem of all involved submissions to the salon.

Cézanne made his first submission to the Salon of 1865, in the company of his friend Francisco Oller. He was then in a fourth-floor apartment, under the eaves, at 22 Rue Beautreillis in the Fourth Arrondissement, near the Place des Vosges; Oller lived at the same address. An affectionate portrait of his stove may represent the interior of the studio. "Copy your stovepipe," he would advise beginners.[37] For weeks he had been meditating his offensive. He wrote to Pissarro: "On Saturday [18 March 1865] we're going to the shack on the Champs-Élysées [the Palais de l'industrie], carrying our canvases, which will turn the Institute red with rage and despair." If Cézanne was familiar with Stendhal's letters, recently published, he may well have recalled a good line about Delacroix and the Salon of 1839: "Eugène Delacroix, whose three pictures were refused by those animals at the Institute, through envy: the swine!"[38] Whatever the reaction of their descendants at the Institut de France, the jury were unimpressed. Cézanne's canvases were rejected. So began a twenty-year

war of attrition. Every year he would submit his canvases; every year, without fail, they were rejected. Exceptionally, in 1882, a single painting was slipped through, masquerading as a "pupil of Guillemet," when his good friend was a member of the jury, who were then entitled to exercise their discretion in selecting a work by one of their pupils—their "charity." The loophole was closed the following year.

In the absence of any systematic record, it is often difficult to know which works Cézanne submitted in any given year. The quota was two, though artists could choose to submit only one. In 1865 it seems reasonably clear that one of his canvases was a lowly still life, *Bread and Eggs* (color plate 10), his first significant venture in that genre, and a rare example of a signed and dated Cézanne.[39] Rilke wrote later of Cézanne still lifes "hoarded by darkness." In *Bread and Eggs* the sky of the future looks very black indeed, though the bread and the eggs look good enough to eat. A white tablecloth rucks and funnels energetically in the foreground. A black knife, suggestively angled, spans the cloth and the bread; its blackness passing strange, or sinister. The contrasting tones are reminiscent of the black hat and white handkerchief of the Suisse. If this was one of the still lifes that Manet saw at Guillemet's, it justified his approval.

The knife reappeared, as things in Cézanne are wont to do, in *Still Life with Green Pot and Pewter Jug*.[40] This painting had the distinction of being bought and sold by the great Russian collector Sergei Shchukin by 1900, in which year it reached a record 7,000 francs at auction. Six years later, it had the further distinction of converting Roger Fry to Cézanne, of whom he then knew virtually nothing, at the Exhibition of the International Society at the New Gallery in London. Virginia Woolf relates in her biography of Fry, first published in 1940:

As usual, he felt his way along the walls conscientiously, noting first the sculpture. There was Rodin; there were two important works by M. Bartholomé; there was an excellent statuette by Mr. Wells, and Mr. Stirling Lee's portrait head was admirable as a treatment of marble, "though a little wanting in the sense of style." And then at last he came to the Bertheim [Bernheim] collection in the North Room. There was a still life by Cézanne. In view of what he was to write later about that great master, this first glimpse may be given in full:

"Here, indeed, certain aspects of the Impressionist School are seen as never before in London. There were, it is true, a few of M. Cézanne's works at the Durand-Ruel exhibition in the Grafton Gallery [in 1905],

but nothing which gave so definite an idea of his peculiar genius as the *Nature Morte* [still life] and the *Paysage* [landscape] in this gallery. From the *Nature Morte* one gathers that Cézanne goes back to Manet, developing one side of his art to the furthest limits. Manet himself had more than a little of the primitive about him, and in his early work, so far from diluting local color by exaggerating its accidents, he tended to state it with a frankness and force that remind one of the elder Breughel. His *Tête de Femme* [*Head of a Woman*] in this gallery is an example of such a method, and Cézanne's *Nature Morte* pushes it further. The white of the napkin and the delicious grey of the pewter have as much the quality of positive and intense local color as the vivid green of the earthenware; and the whole is treated with insistence on the decorative value of these oppositions. Light and shade are subordinated entirely to this aim. Where the pattern requires it, the shadows of white are painted black, with total indifference to those laws of appearance which the scientific theory of the Impressionistic School has pronounced to be essential. . . . We confess to having been hitherto skeptical about Cézanne's genius, but these two pieces reveal a power which is entirely distinct and personal, and though the artist's appeal is limited, and touches none of the finer issues of the imaginative life, it is none the less complete."

One is reminded of a passage in his letters in which he describes how on his honeymoon he had dug up the head of a column in the sand at Carthage, with a bit of potsherd and his nails. There for a moment Cézanne is seen still half-covered in the sand.[41]

In fact, *Still Life with Green Pot and Pewter Jug* was done more in dialogue with Pissarro than with Manet—a sign of things to come—in particular a palette-knife *Still Life with Carafe of Wine* (1867).[42]

"Grappling directly with objects," as Cézanne put it later, became an essential part of his practice. "They buoy us up. A sugar bowl teaches us as much about ourselves and our art as a Chardin or a Monticelli." Objects lived full lives. They were sentient, recalcitrant, changeable. "People think a sugar bowl has no physiognomy, no soul. But that changes every day, too [as with people]. You have to know how to take them, coax them, those fellows."[43] It was as Wallace Stevens wrote,

An object the sum of its complications, seen
And unseen.[44]

Coaxing things, the *sensation originale* kicked in. It was a sugar bowl that led the charge for independence in the small still life surmounting the throne of *le papa*. Cézanne knew his vessels, as Morandi in his Cézannian way knew his bottles. He communed with them; he understood them from the inside. "Cézanne made a living thing out of a teacup," wrote Kandinsky in his influential manifesto *On the Spiritual in Art* (1912), "or rather in a teacup he realized the existence of something alive. He raised still life to such a point that it ceased to be inanimate. He painted these things as he painted human beings, because he was endowed with the gift of divining the inner life in everything. His color and form are alike suitable to the spiritual harmony. A man, a tree, an apple, all were used by Cézanne in the creation of something he called a 'picture,' and which is a piece of true inward and artistic harmony."[45]

He sided with things, in the felicitous expression of Francis Ponge. In a larger work on display in Zola's dining room—not put away in the attic like most of his Cézannes—he sided with a black clock. *The Black Clock* (color plate 11) is almost surreal. The clock in question has no hands. The still life on the table is dwarfed by an enormous conch shell, flagrantly sexual, with carmine lips. The tablecloth hangs in great slabs, like a rock formation. Each dimension is hard to define. Space and mirror-space, as Rilke puts it, are vast, yet claustrophobic. Everything is motionless, including the clock. The painting trades in a kind of quotidian exoticism. It may be no coincidence that its subsequent purchasers reflect a certain exoticism of their own. In the twentieth century *The Black Clock* passed through the hands of the film star Edward G. Robinson and the shipping magnate Stavros Niarchos, among others.

"The beautiful is always *bizarre*," said Baudelaire.[46] In Cézanne's still lifes there is a hint of the uncanny. *The Black Clock* marks the start of that tradition. At the 1907 retrospective Rilke was taken above all by the use of color:

> The frequently used white cloth, for one, which has a peculiar way of soaking up the predominant local color, and the things placed upon it now adding their statements and comments, each with its whole heart. The use of white as a color was natural to him from the start: together with black, it defined the two limits of his wide-open palette, and in the very beautiful ensemble of a black stone mantelpiece with a pendulum clock, black and white . . . behave perfectly colorlike next to the other colors, their equal in every way, as if long acclimatized. . . . Brightly confronting each other on the white cloth are a coffee cup with a heavy dark blue stripe on the edge, a fresh, ripe lemon, a cut crystal chalice with a

sharply scalloped edge, and, way over on the left, a large, baroque triton shell—eccentric and singular in appearance, with its smooth, red orifice facing the front. Its inward carmine bulging out into brightness provokes the wall behind to a kind of thunderstorm blue, which is then repeated, more deeply and spaciously, by the adjoining gold-framed mantelpiece mirror; here, in the mirror image, it again meets with a contradiction: the milky rose of a glass vase which . . . asserts its contrast twice (first in reality, then, a little more yieldingly, in reflection). Space and mirror-space are definitively indicated and distinguished—musically, as it were—by this double stroke; the picture contains them the way a basket contains fruit and leaves: as if all this were just as easy to grasp and to give.[47]

For the benefit of the salon jury, Cézanne rang the changes. According to legend, when Manet asked him what he was preparing for the Salon of 1866, he responded: "A crock of shit."[48] What he submitted was his *Portrait of Antony Valabrègue* (color plate 17), the work which caused one benighted juror to make the quip about painting with a pistol. No doubt the painting was provoking. The blatancy of the palette-knifework was deliberately provoking. The clotted oils were disgusting. The colors were outrageous. "The highlight on the nose is pure vermilion!" Cézanne boasted to Guillemet.[49] An impudent mustard squiggle on the front of the shirt was enough to induce a shudder in anyone with a little delicacy of feeling. Looking at the portrait demanded a strong constitution. The eye traveled down from the plowed field of the forehead past the muddy black torso to the butcher's-shop fists; the flesh worked up almost to orange. And this was no mere study, to be hung out of sight, "in the catacombs," as Corot used to say, or over a high doorway: Antony Valabrègue sat proud, over one meter tall.

Cézanne was courting rejection. According to Marion, he was actually hoping for rejection, and a public demonstration was planned in his support. On the final day for submissions, he made a last-minute appearance at the Palais de l'industrie. His canvases arrived in a wheelbarrow, pushed by his friends. He ceremoniously removed each work from the wheelbarrow, unveiled the portrait, and exhibited it to the crowd of onlookers, before handing it over to the bemused attendants.[50] Zola wrote afterwards that Cézanne had been rejected, "of course," along with Solari and others, and that they fully expected that it would be another ten years before they gained acceptance. Apparently Daubigny had tried to intervene on his behalf with the other jurors, expressing a preference for "paintings brimming with daring to the nullities welcomed

at every salon," without success.[51] The model himself was disappointed but phlegmatic (by temperament). A few months later he was pressed into service once more, for a double portrait, *Marion and Valabrègue Setting Out for the Motif* (color plate 18). "We are arm in arm," Valabrègue wrote to Zola, "and have hideous shapes. Paul is a horrible painter as regards the poses he gives people, in the midst of his riots of color." Valabrègue then had to pose alone. "Paul made me sit yesterday for the study of a head. Flesh: fire red with scrapings of white; the painting of a mason. I am colored so strongly that I am reminded of the statue of the Curé of Champfleury when it was coated with crushed blackberries."[52]

If there was an element of bravado to the talk of hoped-for rejection, there was unquestionably a planned campaign. Cézanne's next move, coordinated with Zola, was a petition to the grand panjandrum himself, Count Nieuwerkerke, with a request that the Salon des refusés be re-established, and the public be allowed to judge, as the emperor himself had proclaimed in 1863. He received no reply, so he wrote again.

Monsieur

I had the honor to write to you recently on the subject of two canvases of mine that the jury has just rejected.

Since you have not yet replied, I feel I must emphasize my purpose in writing to you. Given that you have certainly received my letter, there is no need for me to repeat here the arguments that I thought necessary to submit to you. I will confine myself to reiterating that I cannot accept the illegitimate verdict of colleagues who have no authority from me to assess my work. [The jury was elected by salon medal holders.]

I am therefore writing to insist on my petition. I wish to appeal to the public and to be exhibited nonetheless. My wish does not seem to me to be at all unreasonable, and if you were to question all the artists who find themselves in my position, they would all tell you that they disavow the jury and that they would wish to participate in one way or another in an exhibition that is perforce open to all serious workers.

So let the Salon des refusés be re-established. Even if I were the only one in it [Manet and Renoir had also been rejected, as Cézanne must have heard], I would still want the public to know that I have no wish to have anything to do with those gentlemen of the jury, any more than they appear to wish to have anything to do with me.

I trust, Monsieur, that you will not continue to keep silent. It seems to me that every appropriate letter deserves a reply.

On the same day, Zola introduced his articles on the salon with an open letter to the editor of *L'Événement*. Dramatically titled "A Suicide," it dealt with a painter who had shot himself after his submission had been rejected by the jury (a macabre twist to *peinture au pistolet*). "Of course," he added, "I am not saying that the jury's rejection was the deciding factor in the death of this poor wretch. . . ."[53]

Cézanne's petition fared no better than all his other submissions. The mighty Nieuwerkerke was a fastidious man, and self-righteous. For years he had swallowed his disgust at crude painters like Courbet or Millet who demonstrated such a conspicuous lack of taste and refinement. Democrats, he called them, who don't change their linen. This Cézanne was no better. The *Portrait of Valabrègue* was proof of that, if proof were needed. His scribbled annotation across the top of the letter left no room for doubt as to the tenor of the reply: "What he asks is impossible, everyone recognizes how inappropriate was the exhibition of the Refusés to the dignity of art, and it will not be re-established."[54]

Cézanne was unappeased. If anything, he was further liberated. The following year he was back for more. In April 1867 *Le Figaro* published an item by a certain Arnold Mortier, who had heard tell of "two rejected paintings by M. Sesame (not of the *Arabian Nights*), the one who provoked general hilarity in 1863 at the Salon des refusés—still!—with a picture of two crossed pig's trotters. This time M. Sesame sent in two compositions, if not quite as bizarre, then also deserving of exclusion from the salon. These compositions are entitled *Le Grog au vin* [*The Toddy*] and represent, in one case, a nude man being brought a toddy by a woman dolled up to the nines; in the other, a nude woman and a man dressed as a *lazzarone* [a Neapolitan good-for-nothing, a scoundrel]: here the toddy is spilt." This sally provoked Zola, who replied with some asperity that his *camarade de collège* M. Paul Cézanne was not to be confused with M. Sesame, that his two paintings were in fact *Le Grog au vin* and *Ivresse* (*Drunkenness*), and that he was in good company.[55]

Le Grog au vin, otherwise known as *Afternoon in Naples* (color plate 51), the painting satirized by Duranty, is the subject of a droll tale by Vollard, who had it from Guillemet, who was there—but who may have improved it in the telling.

The model who posed for this study was a fine specimen of a cesspit emptier, whose wife ran a little *crémerie,* where she served a beef soup much appreciated by her clientele of young daubers. One day, Cézanne, who had gained the confidence of the waste collector, asked him to pose. The man spoke of his work [as a reason for not posing]. "But you work at night; during the day you don't do anything!" The cesspit emptier explained that during the day he slept. "Well, I'll paint you in bed!" The good man started off under the covers, with a nightcap on his head, in the painter's honor; but, since there was no need to stand on ceremony among friends, he first removed the nightcap, then threw off the covers, and finally posed entirely naked; his wife figured in the painting, with a bowl of mulled wine that she offered to her husband.[56]

So much for the prosaic story behind the prosaic title of *The Toddy. Afternoon in Naples,* however, suggests something rather different—an assignation, or a romp, in a bedroom or a cabinet particulier of a brothel or a cabaret which provided rooms for that very purpose. It is safe to say that when Cézanne returned to this theme ten years later, around 1876–77, a wifely bowl of mulled wine was not what was uppermost in his mind.

Posing for Cézanne was no small undertaking. Valabrègue escaped lightly. "Fortunately, I only posed for one day. The uncle is more often the model," he reported from Aix, in November 1866. "Every afternoon, a portrait of him appears, while Guillemet kept up a stream of droll comments."[57] Uncle Dominique had found his place in the sun.

Dominique Aubert turned out to be one of Cézanne's best models. Ten portraits appeared in quick succession: Uncle Dominique as lawyer, Uncle Dominique as monk, Uncle Dominique as artisan, Uncle Dominique as citizen, Uncle Dominique in a cap, Uncle Dominique in a turban, Uncle Dominique in a bonnet, Uncle Dominique in profile, Uncle Dominique full-face, Uncle Dominique every which way.[58] Uncle Dominique was an obliging person. He did not mind dressing up. In each disguise, he remained instantly recognizable and utterly himself. The uncle had presence. The father of the artist might have to look to his laurels.

These paintings were a gallery of *physiognomies,* exercises in style, in an established tradition. They showed what he could do. The technique was impressive; but it was not mere technique. Manifestly, also, they showed off. The portraits maintain their innocence—Dominique keeps a straight face—but

the question of how to take them mirrors the question of how to take the artist himself. Portraits ape speech acts. In one of these portraits, *L'Avocat* (*The Lawyer*), he is caught in the act, finger raised, pontificating—or advocating (color plate 19).[59] Cézanne was fond of puns, verbal and visual. For the *avocat* to advocate may have pleased him almost as much as making Dominique a Dominican. Lawrence Gowing thought he detected a slight look of facetiousness about some of them; perhaps they are letting us in on the secret.[60] Painter and sitter (and audience) are enjoying themselves, as Valabrègue's report underlines. Moral turmoil was not the only thing Cézanne knew. With Uncle Dominique he had fun. He was also generous to his sitter. Thirty years later, Dominique Aubert sold twelve Cézannes to the dealer Vollard for 1,150 francs.

As usual, Zola asked for bulletins of Cézanne from mutual friends in Aix. One of the most intriguing he received was from Marius Roux, who saw a lot of Cézanne at this time, and put that knowledge to good use a few years later in a novel, *The Substance and the Shadow* (1878), whose central character, Germain Rambert, is a thinly disguised portrait of Paul Cézanne—more thinly disguised than Uncle Dominique. "To me Paul is a veritable sphinx," Roux told Zola.

> I went to see him as soon as I got here. I found him at home, we talked for quite a while. A few days ago he came with me to the country, where we stayed a night. We had all that time for talking.
>
> Well! All I can tell you about him is . . . that he's well.
>
> However, I haven't forgotten our conversations; I'll relay them to you out loud and you'll be able to do the translation. As for me, I don't have the power to translate. You see: I haven't become sufficiently close to Paul to understand the exact meaning of his words.
>
> Nonetheless (if I may hazard an opinion), I believe he has retained a religious fervor for painting. He is not beaten yet; but without having the same enthusiasm for Aix as for painting, I also think he'll still prefer the life he leads here [in Aix] to the life he leads in Paris. He is beaten by that Gomardian existence and he has a holy respect for the paternal vermicelli.
>
> Is he fooling himself? Does he believe he's been beaten by Gomard rather than by Nieuwerkerke? That's what I can't tell and what you'll be able to tell when I recount our interviews at greater length.[61]

Some of this is suitably Delphic. If Zola the novelist is to be believed, Gomard was a wine merchant in the Rue de la Femme-sans-Tête (now the Rue Le

Regrattier), on the Île Saint-Louis, under the sign "Au Chien de Montargis." It is the place where Claude Lantier has his lunch. The sign interested him, says Zola, and the locale is clearly meant to interest us, as a site of almost spiritual significance for a tormented soul. For Lantier, it is a place of refuge; a haven from the world of ceaseless wandering.

> The stonemasons were there at the table, in their workers' overalls, spattered with plaster; and like them, with them, he ate his "usual," for eight sous, the soup in a bowl, in which he dunked some bread, and the slice of boiled meat, served with beans, on a plate damp from the washing-up. It was still too good for a brute who did not know his métier: when a study had failed, he abased himself, he placed himself lower than the laborers whose huge arms at least did their job. For an hour, he lingered, mindlessly absorbed in the conversations of the neighboring tables. And then, outside, he resumed his slow, aimless walk.[62]

Reading back to Roux's account, "Gomard" was a kind of shorthand, and the "Gomardian existence" was freighted with meaning. At its starkest, it meant artistic failure, wrapped up in self-respect. No self-respecting artist lacked a métier; as Cézanne knew full well, to be a painter was to have mastered the craft. Was there also an implication of character failure, of lacking moral fiber (found wanting in resolution, sunk in dissolution)? More mundanely, it meant a life of penury. Eking out an existence on an eight-sous lunch, at le papa's pleasure, was not Cézanne's idea of self-fulfillment. In Aix, to all intents and purposes, he had a much more comfortable existence. He was not free, but he ate well.

"The paternal vermicelli" was a phrase and an idea—a recipe—that caught on, in a curious intermingling of art and life. L'Assommoir features not only Lantier's mother but also his father. Auguste Lantier wears the trademark black felt hat. He is small, dark, and good-looking. He likes his food, though he is no gourmet. He has a signature dish. "His great treat was a certain soup, very thick, of vermicelli boiled in water, into which he tipped half a bottle of oil. Only he and Gervaise would eat this, because the others, the Parisians, had been sick as dogs when they'd risked trying it one day." The soup, like the sash, makes a point. The Provençals can take their oil; the Parisians cannot. Thickness of a kind is realized here by cookery alone. Cookery, moreover, had its converts. Over a year after that novel came out, Cézanne wrote to Zola from L'Estaque: "I got your letter at the very moment when I was making a

vermicelli soup with oil, so dear to Lantier."[63] The paternal vermicelli became an in-joke between them. Given that Claude Lantier had already been introduced to the world, it is further evidence that Cézanne was perfectly capable of recognizing and accepting his fictional selves, and their families. He went so far as to borrow their recipes.

In reality, Cézanne was not beaten by Gomard or Nieuwerkerke. He was cooking up something quite new for the Salon of 1870. In that momentous year he submitted a larger-than-life reclining nude (lost, presumed destroyed), bearing a suspicious resemblance to an aged *Olympia*—a daunting proposition. It appears that this painting was owned at one time by Gauguin, an avid collector and imitator of Cézanne, who may have acquired it from the color merchant and backroom dealer Julien "Père" Tanguy, a heroic figure, and in his own modest way a tremendous moral and practical support to the embattled painter. Gauguin's collection formed the nucleus of an exhibition of impressionist paintings in Copenhagen in 1889. On that occasion, a Danish critic took particular note of a reclining nude by Cézanne:

A large picture of an elderly naked woman, painted larger than life by Cézanne, has not been hung in the exhibition, in due respect to Copenhagen's state of absolute innocence. It is neither a particularly attractive nor a particularly good picture, and its absence cannot be described as a loss. The elderly woman displays the sad ruins of her charms on a dazzling white sheet, one hand grasping a folded fan; cloth of a dull vermilion is draped over a chair; in a corner on the black wall hangs a small picture, which seems to be an undoubtedly genuine *Image d'Épinal* [a highly colored popular print]. The color of the figure is reminiscent of the dregs of a bad claret, the highlights are chalky white; the colors of the picture are thus no more enchanting than the being it represents. The painting is remarkable only in its brushwork, which with its violent energy and rough swirling contours seeks to give the impression of the greatness and force of a master hand . . . such as Frans Hals . . . and many of the old Spanish masters. The picture's extraction is clear enough. Both in color and in treatment it is modeled on Manet, and like his works displays . . . reminiscences of Ribera, el Greco, and Goya.[64]

Cézanne's other offering did come from the hand of a master: *Portrait of the Painter Achille Emperaire* (color plate 23), the most ambitious painting yet to leave his studio.

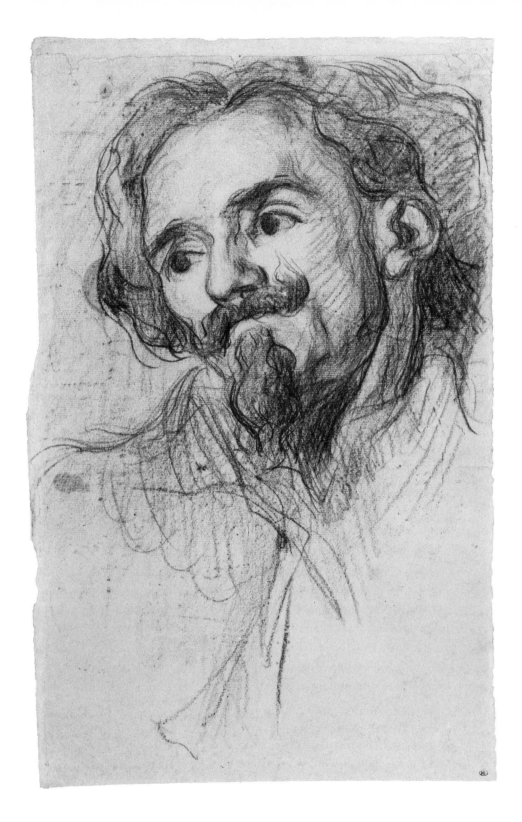

Cézanne's friend Emperaire was a dwarf with a misshapen body, spindly legs, eloquent hands, and skeletal extremities. All this was as nothing when compared to his head: a Van Dyck head, musketeer's hair, saffron-dyed mustache with the ends twirled, sometimes up, sometimes down, and a Louis XIII goatee. His big eyes were pools of melancholy and mad fantasy. Emperaire dreamed of glory. He, too, wished to enter the Salon de Bouguereau. Furthermore, he planned to enlist Victor Hugo in his cause. "I am going to see the great Victor," he announced, "to submit my portfolio and to ask him to select two subjects for the salon. . . . The sight of the giant does not frighten me—and I go to him with a moist eye and a firm step."[65] It was not to be. The great Victor and the small Achille never met. Delusions of grandeur were all the more poignant in one so afflicted, and there was no denying the adversity he faced. Emperaire the indomitable had suffered. What ailed him was poverty: all his life he was nearly destitute. He was said to keep himself alive on fifteen centimes a day.

Cézanne was always fond of him. Emperaire was *très fort*—high praise. According to Gasquet, Cézanne went so far as to say that he had a little of Frenhofer in him. The two of them argued art and artists in many a museum. "There was nothing he didn't know about the art of the Venetians," Cézanne told Émile Bernard admiringly.[66] When it came to studying him on paper, it was the head that captured his imagination. Two majestic charcoal drawings are all head; they exude something of Emperaire in repose, or in visions.[67] The full portrait is six feet tall—truly larger than life—the same dimensions as the portrait of his father reading *L'Événement,* in the same chair, which his father has just vacated, as it would seem. In more ways than one, therefore, the Emperaire is on his throne; and Cézanne surely relished the imperial incongruities of the image he created. His title, ACHILLE EMPERAIRE PEINTRE, appears in bold red lettering above the throne: perhaps a tribute to IACOBUS TENTORETUS PICTOR VEN(E)TI(AN)US, the inscription that appears across the top of a self-portrait by Tintoretto, possibly the greatest of the Venetians, in Cézanne's book.[68]

This Emperaire is pictured fresh from his morning bath. (He was said by some wags to be completing his toilette, enthroned on a commode.) He is wearing a blue dressing gown, open to reveal unprepossessing purplish drawers. His long feet rest on what appears to be a footstool but is in fact a foot warmer; without it, his legs would dangle. His bony hands are elongated, the fingers like combs. His head, slightly enlarged, is beautiful and expressive, as Bernard says; his gaze is pensive, perhaps a shade wistful. He is serene, but frail; enthroned, but vulnerable.

To the jurors of the salon he must have appeared as a grotesque travesty of *Napoleon I on His Imperial Throne* (1806), by Ingres, known to some as the Emperor Napoleon of Art. Once again, death had a hand in the association. Ingres died in 1867. An enormous commemorative exhibition was immediately organized at the École des beaux-arts. There Cézanne would have renewed his acquaintance with *Jupiter and Thetis,* from Aix, the painting that had prompted him to sign *The Four Seasons,* his wall panel at the Jas de Bouffan, "Ingres, 1811"; and also with *Napoleon on His Throne.* Worse, in the climate of the time, any suggestion of a dwarf Napoleon, a pygmy Napoleon, or even a little Napoleon was bound to be interpreted as an attack on the current Napoleon, the emperor, his nephew. A cartoon of "Le petit et le grand Napoléon," the uncle as a giant, the nephew as a miniature replica, lived in the memory. It was captioned "La Grenouille et le bœuf," from La Fontaine's fable of the frog and the ox, in which the frog strains to puff itself up to the size of the ox, and explodes. The great Victor himself had written an anti-imperial pamphlet, *Napoléon le petit,* which concluded: "He will never be anything but the pygmy tyrant of a great people. The stature of the individual is entirely incompatible with greatness, even in infamy. As a dictator he is a buffoon; as an emperor he will be a grotesque." Members of the Senate were vilified in his verse as "grand Chinese mandarins worshipping the Tartar."[69] The grand Chinese mandarins of the salon drew their own conclusion. ACHILLE EMPERAIRE PEINTRE was the frog made flesh. Cézanne's submission was rejected, of course.

The portrait of Emperaire was in every way a challenging work, not to say a confrontational one. The life of the painting is a parable of the life or after-life of the painter (and incidentally a kind of redemption for the sitter, who never did realize his dreams, and ended his days selling pornographic prints to the students of Aix). After its submission to the salon, the portrait disappeared from view. Cézanne consigned it to Père Tanguy, who buried it in his back room, afraid that the artist might take it into his head to destroy it, as he did several other works, including perhaps the reclining nude. The young Émile Bernard discovered it there, "under a pile of very mediocre canvases," sometime during the late 1880s. He was astounded: this was a Cézanne of a kind he had never seen before. According to Tanguy, the artist did indeed have designs on it.[70] A few years later, when Tanguy was in dire straits, Bernard urged his friend Eugène Boch to buy it. Boch was a Belgian painter, a member of the avant-garde group Les XX. At Bernard's instigation, he bought it for 800 francs in 1892. After Cézanne's death it was exhibited in the 1907 retrospective. The following year Boch decided to dispose of it, and offered it to the Galerie

Bernheim-Jeune in Paris for 30,000 francs. The asking price was too high; the deal fell through. Two years later he tried again. Bernheim-Jeune were pleased to advise as follows: "We would like to be seriously involved in the sale of your large Cézanne *Portrait of Emperaire,* but for a work so 'difficult,' perhaps the most 'difficult' Cézanne has painted, the price that you have indicated, 50,000 francs, seems prohibitive to us. Recall that two years ago you asked 30,000 francs. At that time, this price was too high. Today, it's practical. Why not adopt it again?" Twelve days later the portrait was acquired by the munificent Auguste Pellerin for 45,000 francs, much to the delight of Boch's sister, who wrote to her brother, "I congratulate you with all my heart on the sale of your frightful M. Emperaire! This nasty man got on my nerves in your studio."[71]

In 1964 Pellerin's daughter and granddaughter gave the portrait to the Jeu de Paume in Paris. It now resides in the Musée d'Orsay. Having traversed disgust, disdain, difficulty and delight, in the course of a century the frog became a prince.

It was the artist and not the jury who had the last word. On 20 March 1870, in the antechamber of the Palais de l'industrie, Cézanne was interviewed by Stock, a popular caricaturist, for the weekly *Album Stock* (color plate 24). The caricature featured the artist in a revolutionary liberty bonnet, with a Jacobin earring, brandishing a palette and a long, pike-like hatpin. By way of a pendant, there hung a version of the reclining nude, with pot belly, mountainous old bones, and flipper feet. The long-haired revolutionary held aloft a passable imitation of the portrait of Emperaire. The accompanying text was everything Cézanne might have hoped:

> Artists and critics who found themselves at the Palais de l'industrie on 20 March, the last day for the submission of paintings, will remember the ovation given to two works of a new kind. Now Courbet, Manet, Monet, and you others who paint with a knife, a brush, a broom or any other instrument, you have been outdone!
>
> I have the honor to introduce to you your new master: M. Cézanne. Cézanne comes to us from Aix-en-Provence. He is a realist painter and what is more, a convinced one. Listen to him tell me, in his pronounced Provençal accent: "Yes, my dear Monsieur Stock, I paint as I see, as I feel—and I have very strong sensations. The others, too, see and feel like me, but they do not dare. They produce salon paintings. Me, I dare, Monsieur Stock, I dare. I have the courage of my convictions—and he who laughs last laughs longest."[72]

Self-Portrait: The Desperado

This portrait (color plate 2) is usually dated 1866, when Cézanne was twenty-seven. It was owned by Zola—a memento of their brotherly insurgency. When it appeared at the Zola sale, in 1903, it was singled out by Henri Rochefort in a politically motivated attack on both of them: "The crowd was particularly amused by the head of a man, dark and bearded, whose cheeks were sculpted with a trowel and who seemed to be the victim of eczema."[1]

Rochefort was right in one respect: the portrait was indeed sculpted, with a trowel or palette knife. It is a classic example of Cézanne's *manière couillarde,* the ballsy technique that he made his own in that daredevil period. This is a dangerous man; there is an air almost of menace. The revolutionary beard is in full flow.

It is tempting to think that at this stage, his primary interest lay in what effect he might produce on the spectator. The same may be true of the first self-portrait, "The Brooder." For some, it misfired. "Poor Cézanne," wrote D. H. Lawrence (a devotee), "there he is in his self-portraits, even the early showy ones, peeping out like a mouse and saying: I *am* a man of flesh, am I not?"[2] Others were convinced, as if by the brute force of the caked paint: here, surely, is someone who has not washed for a week.

Cézanne and Zola were then in league together. Cézanne's virile painter is the very picture of Zola's artistic ideal, as conveyed to the readers of *Mon Salon* that same year: "What I ask of the artist is not to give me delicate views or dreadful nightmares," wrote Zola, "but to lay himself bare, heart and flesh, to register a strong and distinctive spirit. . . . I have the profoundest respect for individual works, those that flow from a powerful and unique hand."[3]

The effect is powerful indeed. Yet it is somehow incomplete. If there is know-how and show-how, as Cézanne himself said, the latter wins out. "When you know what you're doing, there is no need for showing off. You can always

tell." At twenty-seven, he was still showing off. Perhaps it was as Wallace Stevens wrote,

> I cannot bring a world quite round,
> Although I patch it as I can.
> I sing a hero's head, large eye
> And bearded bronze, but not a man,
> Although I patch him as I can
> And reach through him almost to man.[4]

This portrait was bought by Auguste Pellerin at the Zola sale for 950 francs. It is now in a private collection.

5: Anarchist Painting

Cézanne gave copies of the caricature to his friends and relations. "You will have heard my news from Emperaire . . . and lately from my uncle [Dominique?] who promised me to see you and give you a copy of the caricature that Stock did," he wrote to the cabinetmaker Justin Gabet in Aix. "So I was rejected as before, but I'm none the worse for it. Needless to say I'm still painting, and for the moment I'm fine."[1] Meanwhile the hullabaloo at the shack on the Champs-Élysées had reached the ears of Théodore Duret, a cultivated republican of progressive tastes and deep pockets, who combined the lives of critic and collector. "I hear tell of a painter called Cézanne, I think, or something like that, apparently from Aix and whose paintings have been rejected by the jury," he wrote to Zola. "I seem to remember that you have spoken to me in the past of a painter from Aix who is completely eccentric. Would he be this year's reject? If so, would you be kind enough to give me his address and a word of recommendation, so that I may go and make the acquaintance of the painter and his painting?" To this exquisite overture Zola replied by return: "I cannot give you the address of the painter of whom you speak. He is very much withdrawn, he is going through a period of experimentation, and, to my mind, he is right not to allow anyone into his studio. Wait until he is able to find himself."[2]

Zola the moralizer had become Zola the gatekeeper. The role of guardian angel came easily to him; it flattered his ego. So did some of their friends. "How long will they go on rejecting Paul?" bemoaned Valabrègue, on hearing the verdict of 1867.

> On the other hand, I learned with pleasure of the forceful way you answered for him [over the mockery of "M. Sesame" and the *Arabian Nights*]. You are destined to torture his enemies. You cannot be con-

gratulated enough on this fine role. Paul is the child ignorant of life; you are the guardian and the guide. You watch over him; he walks by your side, always sure of being defended. A defensive alliance has been signed between you, which will even take the offensive if need be. You are his thinking soul; his fate is to make paintings, just as yours is to make his life![3]

On this reading, the balance of power in the alliance had changed: at the Collège Bourbon, Cézanne acted as Zola's protector; in the school of life, roles were reversed. Zola had been transformed from weakling to worldly. So far from finding himself, Cézanne at thirty was a little boy lost without him.

To all outward appearances, that was a plausible account of how things stood. In the matter of appearances Zola needed no coaching; he was a master of conspicuous display. Manet's consummate *Portrait of Émile Zola* (color plate 26) is all display. The writer is at his desk. He is grave, poised, formally attired. The portrait is full of still life, not excluding the sitter. Zola gazes manfully into the distance. He is thinking. He has in his hands an illustrated book, almost certainly one of Charles Blanc's multivolume *Histoires des peintres de toutes les écoles,* which Cézanne and Manet used to raid as a kind of image bank.[4] The attributes of art and its rewards, as Chardin might have put it, include the booklet on Édouard Manet, by Émile Zola, prominently placed on the desk (the title doubling cleverly as the artist's signature); the monster ceramic inkwell that makes an anonymous appearance in Cézanne's *Black Clock*; the Oriental screen; the peacock feathers; the Japanese color woodcut of *The Wrestler Onaruto Nadaemon of Awa Province,* by Kuniako II, a later Ukiyo-e master; and the reproduction of *Olympia,* who is contemplating her gallant defender. The self-referential loop of the work was completed by the sitter's favorable assessment of it in a contemporary article on the artist:

I was thinking the whole time [while posing] of the destiny of individual artists who are made to live apart, alone with their talent. Around me, on the walls of the studio, hung those powerful and characteristic canvases that the public does not want to understand. To become a monster, you need only to be different. You are accused of not knowing your art, of mocking common sense, precisely because the knowledge of your eye, the pressure of your temperament lead you to singular results. If you do not follow the mediocrity of the majority, the idiots stone you, treating you as mad or arrogant.[5]

There was more to come. Fantin-Latour's group portrait *A Studio in Batignolles* (1870), which could have been called *Homage to Manet* and which was caricatured as *Jesus Christ and His Disciples,* featured the man himself at the easel, attended by a cenacle including the German painter Otto Scholderer, Renoir ("a painter who will get himself talked about," according to Fantin, placed near Manet, apparently at the latter's express wish), Zacharie Astruc ("a whimsical poet"), Zola ("a realistic novelist, great defender of Manet in the newspapers"), Rapha Maître ("a highly refined mind, amateur musician"), Bazille ("manifesting talent"), and Monet. Zola strikes a pose, as if on a pedestal. Evidently he had earned a little veneration in this company. Duranty also figured in the original composition, only to be discarded later. Pissarro was unaccountably excluded. Cézanne was never considered.[6]

Manet's portrait of Zola was exhibited at the Salon of 1868, Fantin-Latour's at the Salon of 1870. The great defender had gained admission, in a manner of speaking. Zola had arrived. Cézanne had not. "Well, they can go to hell for eternity with all the more persistence," he wrote to Marion after the rejection of 1868.[7] Cézanne may have been *faible dans la vie,* as Valabrègue suggested, but he had resources undreamt of in that quarter. Plainly he did not belong in the studio in Batignolles, where the celebrants were indeed decked out like lawyers, nor in a painting by Fantin-Latour. ("The bugger, he already knew how to do the folds in clothing!")[8] As for Zola, if he had arrived, he had not yet settled in. On the contrary, he was profoundly insecure. Security meant a lot to Zola. Financial security continued to elude him, despite the prodigious work rate. As the Salon of 1868 was about to open, he touched Manet for a loan of 600 francs.[9] Émile Zola was a proud man. The begging letter must have cost him dear.

Théodore Duret waited three years. In 1873 he tried again. This time he directed his inquiry to Pissarro. He also tried a different approach. "In painting," he wrote, "I'm looking more than ever for the five-legged sheep." The approach was well judged. Pissarro responded in like fashion. "If it's five-legged sheep you're after, I believe Cézanne will appeal to you, for he has some extremely strange studies and views of a unique kind."[10] So it proved. Duret acquired a small flock of five-legged sheep, and after omitting Cézanne from his early *Histoire des peintres impressionistes* (1878), he gave him a chapter to himself in subsequent editions. Duret's Cézanne was an anarchist in art and a capitalist in life. That, too, appealed to him.[11]

Duret's inquiries bracketed a small revolution. Between the seclusion of 1870 and the distinction of 1873, Cézanne's world turned. By the end of the

decade he had found himself sufficiently to feel that he understood what it was to be an artist, at last, and to sense that some part of that being was singular, inimitable. Almost imperceptibly, he had become the most extraordinary artist of his generation. He did not know it yet, and neither did they. The critics had heard of him; the general public had not. News of the Cézanne phenomenon spread by word of mouth among his fellow artists. Pissarro was the one who had the earliest insight into that phenomenon, and the deepest understanding of it. Guillemet was shrewd enough to see it coming. Sending Oller the latest news, in 1866, he reported: "Cézanne is in Aix where he has done a good painting. He's the one who says so, and he's extremely hard on himself. . . . Courbet is becoming a classic. He's done some superb things, [but] beside Manet it's all part of the tradition, and Manet beside Cézanne will become the same in his turn."[12] Guillemet was close to Cézanne for several years. He was the deep throat for Zola's *L'Œuvre* and Vollard's *Cézanne* (1914), in effect the first biography, masquerading as a kind of celebrity memoir. He was a major source but a minor artist. Of those in the front rank, Degas, Gauguin, Monet, Pissarro, and Renoir, all kept an eagle eye on Cézanne. All found him in varying degrees fascinating and disconcerting. (When things were going badly for her husband, Madame Monet felt the urge to cover up the Cézannes.) All copied him, at one time or another. And all collected him, discriminatingly, well in advance of most of their fellow men.[13]

Gauguin owned six Cézannes, including the famous *Still Life with Compotier* (color plate 71), which he used to take to a nearby restaurant, where he would hold forth on the artist's amazing qualities. "Ripe grapes overflow the edges of a shallow dish: on the cloth bright green and violet-red apples are mingled. The whites are blue and the blues are white. A devil of a painter, this Cézanne!"[14] In 1900, Maurice Denis, who heard that performance, made the painting the centerpiece of his *Homage to Cézanne* (color plate 70), a work bought by André Gide, impressed by its *vertu*.[15]

Monet owned fourteen. Three hung in his bedroom: a great late *Château Noir,* a *View of L'Estaque,* and a *Bathers*. In 1899 he paid 6,750 francs at auction for *Snow Melting at Fontainebleau* (1879–80)—the highest price ever recorded for a Cézanne, a price so unexpected that the buyer was compelled to identify himself in the sale room, to dispel any suspicion of sharp practice.[16] Pissarro himself told the story of Degas and Renoir drawing lots to decide who would get the watercolor they both coveted at Vollard's famous Cézanne exhibition of 1895: a still life, of three pears (color plate 52). Degas won.[17]

Cantankerous in all things, Degas was a cantankerous collector. In three

years, 1895–97, he acquired seven Cézannes for an outlay of just 1,430 francs. These works were small, but they packed a punch. Degas was so taken with Cézanne's *Portrait of Victor Chocquet* (1877) that he tried to buy another. Chocquet was at that time Cézanne's most important patron, and also his friend; Degas described the painting that slipped through his fingers as "the portrait of one madman by another."[18] Like many artists, painters and sculptors alike (Bonnard, Matisse, Giacometti, Henry Moore, Jasper Johns), he was bewitched by Cézanne's bathers. In 1877 he made two copies of the central figure of *Bathers at Rest* (1876–77), probably from memory; according to one authority, the copies were deliberately crude. This was the cantankerous copyist at work, perhaps, though Cézanne thought that something more basic was lacking. " 'Degas isn't enough of a painter, he hasn't enough of *that*!' and with a vigorous gesture he imitated the turn of the hand of the Italian muralists." As he well knew, the standard criticism was that he himself had alto-

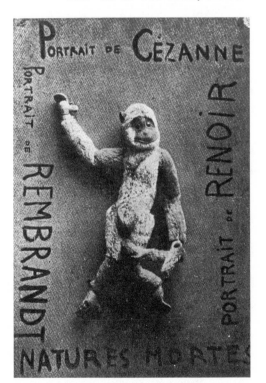

gether too much of *that*.[19] Twenty years after he made his copies, Degas acquired an iconic *Bather with Outstretched Arms* (1877–78), a painting that now hangs above the fireplace in Jasper Johns's living room, where it is joined by a fine collection of Cézanne drawings. This particular bather motif clearly meant a lot to the artist. There are more versions of it than any other, and it is the only one that always appears alone—"less a bather than a sleep-walker absorbed in his dream"—an enigmatic figure ripe for identification, or projection.[20]

Degas also bought some apples. Cézanne the fruit merchant was a conceit of Francis Picabia, in his Dadaist phase, popularized by André Breton, who affected a contemptuous dismissal—"Cézanne, about whom I personally could not care less and whose human attitudes and artistic ambitions, despite what his boosters say, I have always considered imbecilic." Breton recounted an anecdote that was said to have come from Picabia: "One day a friend of his, Mr. S. S., of high Persian nobility, had gone to see an art exhibit in Lausanne, after which the young

man, who had fortunately remained alien to our 'culture,' said, 'Really, all these artists are just beginners; they're still copying apples and melons and jam jars,' and, at the remark that it was beautifully painted, 'The truly beautiful thing is to paint an *invention* as well. This gentleman—Cézanne, as you call him—has the mind of a greengrocer.' "[21]

It was the greengrocer who appealed to Degas. He cherished the fruit, the apples as much as the pears. After his death, the sale of his collection in Paris in 1918 attracted international attention. It was attended by the director of the National Gallery in London, Charles Holmes, and the economist Maynard Keynes, who had persuaded the British government to allocate £20,000 for the purchase of art for the nation: an opportunity for Britain to acquire painting and France to acquire sterling, both much needed at that moment. Holmes appeared in disguise, in order that this most genteel of ransackings might go unobserved. They acquired a Corot, a Gauguin, a Rousseau, two Delacroix, two Manets, four Ingres, and several drawings; to Keynes's intense frustration, Holmes would not countenance Cézanne. Keynes bought one for himself, and returned to London. Offered a lift to Charleston by the chancellor of the exchequer, he deposited his bags and baggage in the hedge at the bottom of the lane and made his way, exhausted, to the house.

Retrieved posthaste from the hedge, the Cézanne was revealed as a pint-size still life, *Apples,* the first in a British private collection (color plate 53). *Apples* had a rapturous reception among the Bloomsberries. Roger Fry wanted to copy it, so it was taken to London by Vanessa Bell. Her sister, Virginia Woolf, was there:

> Nessa left the room and reappeared with a small parcel about the size of a large slab of chocolate. On one side are painted six [actually seven] apples by Cézanne. Roger very nearly lost his senses. I've never seen such a sight of intoxication. He was like a bee on a sunflower. Imagine snow falling outside, a wind like there is in the Tube [the London Underground], an atmosphere of yellow grains of dust, and us all gloating upon these apples. They really are very superb. The longer one looks the larger and heavier and greener and redder they become. The artists amused me very much, discussing whether he'd use viridian or emerald green, and Roger knowing the day, practically the hour, they were done by some brush mark in the background.[22]

Fry's conversion was complete.

Renoir was fascinated by Cézanne. He exchanged paintings with him; he made a distinguished-looking pastel portrait of him (which Cézanne copied); he introduced Victor Chocquet to him; he made a generous selection of his work for the third impressionist exhibition of 1877; he sought him out to work with him, for short periods in 1882, 1885, 1888, and 1889; he recorded his speech like an anthropologist in a strange tribe; and he was later prepared to say that Cézanne was unique among painters. His wife even had one of Cézanne's recipes, for baked tomatoes. She would tell the cook to be "a little more generous with the olive oil."[23] Evidently he did not follow Lantier all the way.

Renoir was an acute observer. He noted Cézanne's immense pride, matched by his deep humility; his intense focus on the task at hand, and his corresponding lack of interest in the work he had already made—an indifference bordering on the careless, which led him to shed paintings whenever they had served their purpose, casting them off like old clothes. He appreciated what baffled the slower Monet: the "half-serious, half-joking" quality of Cézanne's talk. All of this was well illustrated in his story of Cézanne complaining about a wealthy member of the Aixois bourgeoisie, who had a picture by Besnard in his living room—"*ce pompier qui prend feu*," a play on *pompier,* a fireman or a piece of hack work, each in its own way catching fire—and who also had the temerity to stand next to Cézanne at vespers and sing out of tune. Renoir, amused, reminded him that all Christians are brothers. "After all, both of you will be together in heaven for eternity." "No," came the swift retort. "In heaven they know very well that I am Cézanne!" Then he added: "I am not even capable of working out the volumes properly. I am nothing." Renoir also enjoyed repeating an apocryphal remark in similar vein: "I will go to heaven," said Cézanne, "but my heaven will not be the same as my gardener, who is a bad gardener and doesn't know how to grow a single bean."[24]

Renoir had an extravagant admiration for Cézanne's work. It spoke to him of structure and solidity, and an almost uncanny sense of pictorial order. "How does he do it?" Renoir asked Denis. "He can't put two strokes of color on a canvas without it already being very good."[25] On one of several visits to Vollard's exhibition, he remarked that the Cézannes bore a certain resemblance to the frescoes of Pompeii, a curiously apt comparison, as Pissarro noted at the time.[26] For all that, the relationship did not catch fire. In truth it was not so much a relationship as a pursuit. The element of reciprocity was missing. Renoir's admiration was tinged with self-interest. He sought out Cézanne for a purpose, to watch and to learn. Cézanne seems to have liked him well

enough—he was surprisingly hospitable, indoors and out—but there is no sense that Renoir really mattered to him. Renoir is usually accorded some respect (though in one outburst of temper, Zola was "a phrasemonger," Monet "a crook," and Renoir "a whore"), but he hardly figures in Cézanne's letters or conversation, either as a moral support or as a point of reference. "Renoir is skillful," he told Gasquet. "Pissarro is a peasant." Little doubt which he preferred. "Renoir painted on porcelain, you know. There's still a certain pearly quality to his immense talent. What pieces he has assembled even so. I don't like his landscapes. His vision is fuzzy."[27] Temperamentally, they were out of phase. They differed on Baudelaire: Renoir hated *The Flowers of Evil*; much to his disgust, he was made to endure a recital of "The Carcass" (Cézanne's favorite) at a reception one evening. They differed on Corot, and by implication on Delacroix: Renoir considered Corot the greatest modern artist; Cézanne had his doubts. "Your Corot," he would say to Guillemet, "don't you find that he lacks a little *temmpérammennte?*" He enjoyed ribbing Zola, as he told Vollard, with suitable emphasis: "*Émile* said that he would have really let himself go in his appreciation of Corot if he had populated his woods with peasants instead of nymphs. *Bougre de crétin!*" "Forgive me," he added, "I'm so fond of Zola!"[28]

Fundamentally, Cézanne and Renoir differed on Pissarro.

Pissarro was an anarchist—a real one—a dedicated follower of Proudhon and Kropotkin, whose books he read and whose language he spoke. He recommended Kropotkin's *Les Paroles d'un révolté* (1885) to his niece Esther, writing naturally of capitalism, speculation, emancipation, and the working classes (*les classes travailleuses*); he made for her a series of caricatural denunciations of capitalist society, *Turpitudes sociales* (1889). For his son Lucien, he recommended Proudhon's *La Justice dans la révolution et dans l'église* (1858), underlining its relevance to the political upheavals of the 1890s. "The Republic, of course, defends its capitalists, that is understandable. It is easy to see that a real revolution is about to break out—it threatens on every side. Ideas don't stop!"[29] Ideas, and ideals, were for the whole family. Anarchism was not to be reduced to bomb throwing for boys. Declining Octave Mirbeau's invitation to write an article on his political convictions, Pissarro could not help offering a glimpse of what it might have contained:

> Write an article, good God, are you serious? To say that with complete freedom, with the certainty of experience, with the capitalist nightmare, speculation, the École des beaux-arts, the Institute, and all the horrors of

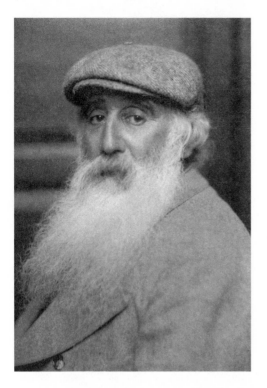

stupid civilization, one is an artist once one has learned what it takes to make art, *parbleu,* that is absolutely true and logical, but to say it neatly is an altogether different matter.

It's up to you, my good Mirbeau, to do one of those articles full of fire and enthusiasm, you who wield so well that subtle implement [the pen]; in your hands there will be no room for doubt, you'll win the day.

Pissarro was all of a piece. As he used to say, neatly, "I felt that my conscience was liberated from the day my eye was liberated."[30]

For Renoir, anarchism was detestable. Even more detestable, however, Pissarro was a Jew. Renoir was a reactionary anti-Semite. He was not as virulently anti-Semitic as Degas, but few men were. He always tended to patronize Pissarro. Walking with Vollard in the woods of Louveciennes, a landscape that Pissarro had made his own, Renoir remarked: "Those trees, that sky . . . I know only three painters who could have captured that: Claude Lorrain, Corot, and Cézanne." When he was angry, the sin of omission paled into insignificance. In the course of the protracted wrangling over another impressionist exhibition in 1882, he wrote to the dealer Paul Durand-Ruel: "To exhibit with Pissarro, Gauguin and Guillaumin would be like exhibiting with some collective. Next, Pissarro will be inviting the Russian Lavrof [the populist Peter Lavrov] or some other revolutionary. The public does not like the smell of politics and as for me, at my age I have no desire to be a revolutionary. Leave the revolution to the Jew Pissarro."[31]

Cézanne would have none of this. Around 1903 he was visited in Aix by a young archaeologist, Jules Borély, who managed to get him talking in the course of a long afternoon:

"Zola speaks openly of your genius; did you know him in Paris?"

"In Paris! No, Zola was my childhood friend: we studied at the college in Aix. In the second year he had the good fortune to have a teacher who loved poetry (I remember he read us *Les Iambes*); he already had

a marvelous talent for story-telling. One day when he did his French homework in verse, our teacher returned it saying, 'You are going to be a writer.' It's a cliché, isn't it? Nevertheless, that academic stimulated the genius of that writer. But I'm speaking to you of Zola . . . are you offended?"

"No, why?"

"Because of his escapade. Do you like Baudelaire?"

"Yes."

"I didn't know Baudelaire, but I knew Manet. As for old Pissarro, he was like a father to me. He was a man to go to for advice, and something like *le bon Dieu*."

"Was he Jewish?"

"Yes, he was Jewish. Above all get yourself a good artistic education. Do you like Degas?"

"Certainly! But it's still cabinet painting, if I may say so."

"I know what you mean."[32]

Zola's "escapade" appears to be a reference to his part in the Dreyfus case—one of the very rare occasions on which Cézanne brought it up. Captain Alfred Dreyfus was a Jewish officer on the French General Staff, court-martialed for treason and sentenced to imprisonment on Devil's Island in 1894. The evidence consisted of military intelligence, allegedly in Dreyfus's handwriting, intended for the Germans. Two years later, a new chief of intelligence discovered that the espionage continued, and in the same handwriting. The traitor was in fact Major Ferdinand Walsin-Esterhazy, a descendant of the powerful Austro-Hungarian Esterházy family via a bastard, expatriate line—a twist reminiscent of one of Zola's plots—and a sociopath to boot. In 1897 Dreyfus's brother publicly denounced Walsin-Esterhazy, who was promptly acquitted by a military court. The chief of intelligence was transferred to Tunisia for his pains. On 13 January 1898, a new daily newspaper, *L'Aurore,* splashed on its front page an incendiary "Letter to the President of the Republic" from none other than Émile Zola. Better known as "J'accuse," a title extracted from its litany of indictments by Georges Clemenceau (co-director of the paper), the letter took up the cause of Alfred Dreyfus. Zola accused various high officials of judicial error, suppression of evidence, fraud, deceit, conspiracy, and cover-up, to say nothing of "deliberately acquitting a guilty man, on orders from above," and scornfully invited them to prosecute him in open court.[33]

"J'accuse" electrified France. Dreyfusard and anti-Dreyfusard opinion hard-

ened, as did the underlying prejudices. Zola himself offered a predictable target. "Just who is this Monsieur Zola?" asked Maurice Barrès, who had been accustomed to dine with him the year before. "The man is not French. . . . Émile Zola thinks quite naturally with the thoughts of an uprooted Venetian." Zola was sentenced to a year in prison. He appealed, lost, and fled the country for a brief exile in England. Dreyfus was retried in 1899. Bizarrely, he was found "guilty with extenuating circumstances," but pardoned. That was not good enough for Dreyfus or for the Dreyfusards. In 1906 the court-martial verdict was finally quashed; Dreyfus was readmitted to the army, promoted, and awarded the Legion of Honor. He gave distinguished service to his country in the Great War.

The *affaire,* as it was known, divided friends, families, and fraternities. Among writers, Mallarmé and Proust expressed their admiration for the stand taken by Zola. Many others did not. Of those in his own circle, only Paul Alexis remained loyal. Edmond de Goncourt and Huysmans turned into raving anti-Semites. Among painters, Monet and Pissarro were staunch Dreyfusards. Degas and Renoir were natural anti-Dreyfusards. Both had known Pissarro well for over thirty years; both cut him dead. In private, the atmosphere was poisonous. Even Degas's friends found his company unbearable. At the home of Julie Manet, the artist's niece, "Renoir let fly on the subject of Pissarro, 'a Jew,' whose sons are natives of no country, and who do their military service nowhere. 'It's tenacious, the Jewish race. Pissarro's wife isn't one, yet all the children are, even more so than their father.' " Jean-Louis Forain did a drawing in which Zola was represented as a German Jew. Guillaumin was heard to say that "had Dreyfus been shot at once, we wouldn't be in this mess."[34]

It was not all black and white. There were spots of grey: individual idiosyncrasies, multiple loyalties, personal friendships across the divide. Neither camp was monolithic. Zola's son-in-law, Maurice LeBlond, was a virulent anti-Semite. Allegiances formed and re-formed over time; reasons varied. Gauguin kept his own counsel until 1902, and then declared himself against Renoir and Degas, in favor of Pissarro and Cézanne:

Divine Renoir, who cannot draw. Following the principle of this enlightened critic, it is illogical to admire these two artists: he doesn't like Bouguereau, of course, but he admires Claude Monet. Admiring Monet, he drags Pissarro through the mud, or at least he attempts to make him look a ridiculous artist.

One wonders what all this is supposed to mean, in the realm of human

reason. For if you examine Pissarro's art as a whole, despite its fluctuations . . . you find not only an inordinate artistic control that never falters, but also an essentially intuitive art, from fine stock. However far away that haystack on the top of the hill, Pissarro takes the trouble to make a detour and examine it.

He has looked at everybody, you say! Why not? Everybody has looked at him, too, but disowns him. He was one of my masters and I don't disown him. . . .

A sharp comment. Pissarro provoked a pretty description from the spiritual Degas. Have you seen Pissarro's gouaches, he says: peasant women selling green vegetables in the market. One would think them little virgins manufacturing poison.

Look here, Mr. Critic, Pissarro is a virgin who has had many children and who has always remained a virgin despite the temptation of money and fame.

He is Jewish! It's true. But today there are so many honest Jews who are superior men.

You don't claim to have discovered Cézanne. Today you admire him. Admiring him (which requires understanding) you say that Cézanne is monochrome. You could have said polychrome or even polyphone.

An eye and an ear!!

Cézanne descends from no one: he is content to be Cézanne. If it were otherwise, he would not be the painter he is. He knows Virgil; he has looked at Rembrandt and Poussin with understanding.

Apples: Rembrandt? Yes. Rembrandt: Apples.[35]

Not all anti-Dreyfusards were dolts or bigots. Valéry was anti-Dreyfusard. So was Cézanne.

Cézanne had nothing to say about the *affaire,* which he observed as from a distance. When the young painter Louis Le Bail asked him about Zola's part in it, in 1898, he is supposed to have laughed and said enigmatically, "They've been pulling his leg," apparently suggesting or jesting that Zola had been duped. This may have been intended as some sort of excuse—another case of extenuating circumstances—or a further dig at his friend's posturing (or grandstanding). There were others who saw Zola's intervention as a form of exhibitionism. It is possible that Cézanne attended to his pronouncements on the *affaire* rather more carefully than is often supposed. Zola was immediately struck by the resemblance to his own novels: he was roused first by its

dramatic potential. "It's thrilling! It's horrible!" he exclaimed. "It's a frightful drama. But it's also a drama on a grand scale!" He did not shrink from expressing such sentiments publicly (to his subsequent embarrassment). In a piece in *Le Figaro* the year before "J'accuse," he began, "What a poignant drama, and what superb characters! Faced with documents of such tragic beauty . . . my novelist's heart leaps with passionate admiration."[36] Even as he became more closely engaged, working himself up to his final indictment, he continued to talk in terms of acts and dramas (and vice and virtue). Cézanne could have read his interventions in *Le Figaro* and drawn his own conclusions. Hence, perhaps, his suggestion to Vollard that Zola's involvement had more to do with self-regard or self-promotion. Nevertheless, the comment to Le Bail does him little credit.[37]

In the climate of the time, however, what he did not say may be just as significant. The tenor of his conversation with Borély is noteworthy. Cézanne refused to rise to the bait on the subject of Pissarro ("Was he Jewish?"), in private, on his own home ground. There would be no anti-Semitic insinuation, none of the usual raillery, even when he seems to have been offered an opportunity to indulge in it. On another occasion, in one of his conversations with Émile Bernard, "we spoke of Zola," says Bernard, ambiguously, "whom the Dreyfus affair had made *the man of the hour*." There follows only some fantastic talk of Zola as "a detestable friend," surely garbled or invented by Bernard.[38]

One explanation for his silence on the subject of the *affaire* is that Cézanne was preoccupied with other things—last things. His mother died in 1897, a catastrophe which led to the forced sale of the Jas de Bouffan and the final abandonment of his father's house two years later. The explanation for his loyalty to Pissarro is more simple. For Cézanne, Pissarro was without compare. Among painters, Pissarro was the first, and the most wholehearted. His immediate recognition and unconditional embrace of the tyro Cézanne had no parallel among their peers. Pissarro owned twenty-one Cézannes, half of them given to him (or left with him) by his friend, as well as a number of drawings.[39] For two decades, from the 1860s to the 1880s, they were as close as could be, as close as any two artists in the modern era, until Braque and Picasso began to cook up cubism together in the years before the Great War. Cézanne had no better painter friend; nor perhaps anyone who understood him so well as an artist. His magnificent tribute to "the humble and colossal Pissarro" was heartfelt.[40] He remained loyal to the memory of their relationship until his dying day—a loyalty often demonstrated, at the very time when

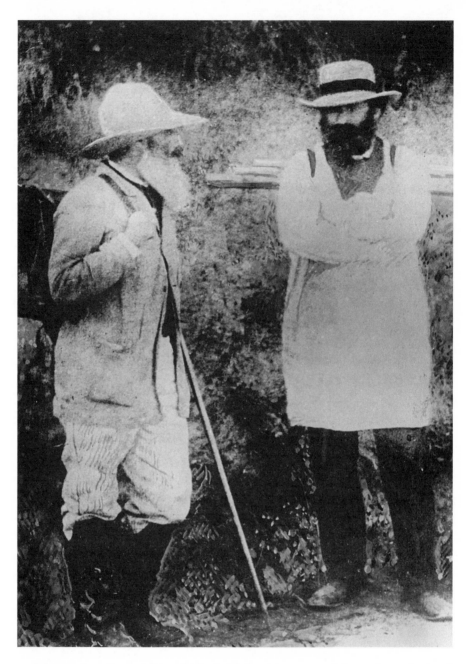

a piping nationalism and a reflexive anti-Semitism spread throughout the land. Never one to yield to his contemporaries, when he took part in the fourth exhibition of the Société des amis des arts in Aix, in 1902, just as Degas and Renoir were shunning Pissarro in the street, he appeared in the catalogue as a "pupil of Pissarro." At the next exhibition, in 1906, the formula was repeated, in posthumous acclaim.

They met at the Suisse. At the time of Cézanne's triumphant exhibition of 1895, Pissarro allowed himself a moment of self-congratulation in a letter to his son: "How far-sighted I was in 1861 when I went with Oller to see this curious Provençal at the atelier Suisse where Cézanne was doing figure studies ridiculed by all those impotents from the schools, among them the great Jacquet [a pupil of Bouguereau], long since mired in prettiness, whose works fetch a gold ransom! Most amusing, this reawakening of old battles."[41] Renoir had a fanciful account of meeting them together at the time of the Salon des refusés, in 1863, when Bazille brought them to the studio—"I've brought you two great recruits!"[42]

By 1866 they were firm friends. When Cézanne wrote to Pissarro to tell him about his submission for the Salon of 1865 (the one that would turn the Institute red with rage and despair), he commiserated over the death of Pissarro's father, and inquired after his friend's submission, concluding with the cryptic thought: "I hope that you'll have done some beautiful landscape." When Pissarro wrote to Oller a few months later, it was to urge him to do something similar: "All three of us [Cézanne, Guillemet, and Pissarro] are counting on a beautiful painting from you, and above all nothing Jesuit."[43]

They had begun to evolve their own dialect, or doctrine. In this idiom, "beautiful" did not mean beautiful, according to the canon, Bouguereau-beautiful, but almost the opposite: it meant shocking, audacious, *superb*. Of Cézanne, for example, "he's done some superbly audacious studies," Guillemet told Oller. "Manet looks like Ingres by comparison."[44] What they were after was pictorial *harmony*. (What Manet lacked in the end, according to Cézanne, was harmony.) "When I start a painting," said Pissarro, "the first thing I strive to catch is its harmonic form. Between this sky and this ground and this water there is necessarily a link. It can only be a set of harmonies, and that is the ultimate test of painting. . . . The big problem to solve is to bring everything, even the smallest details of the painting, to an integral whole, that is to say harmony." That "art is a harmony parallel to nature" became one of Cézanne's fundamental truths. The art of painting entailed finding equivalents in material color for visual (or experiential) *sensations*: art paralleled nature; it did not slavishly copy it. Young Lucien Pissarro remembered endless discussions between his father and Cézanne and an amateur painter from Pontoise, capped by Cézanne's expostulation: "We're not painting a figure, we're creating harmonies!"[45]

Harmony was immanent, but difficult to isolate, or rather to *realize*. Nevertheless, the realization should be simple rather than complex, and need not

entail a finished work of the conventional kind. The very idea of "the finished work" was a misconception; "finish" and "style" were equally to be deplored—hence the mockery of Ingres. Harmony, like beauty, was being redefined. Lack of finish could be every bit as harmonious, perhaps more so. Two strokes might do the trick, as Renoir suggested: more precisely, two tones in juxtaposition, provided that they were the right ones. The *rightness* of the tones was crucial; this much Zola learned from Cézanne. For both Cézanne and Pissarro the two-tone criterion became a kind of painterly ideal. Pissarro held that Cézanne eventually achieved it. Returning again and again to the exhibition of 1895, he mused on how rare it was to find "a true painter," one who knows "how to set two tones in harmony." His letters to Lucien convey his excitement: "There are exquisite things, still lifes with an irreproachable finish, others heavily worked but abandoned, yet even more beautiful than the first, landscapes, nudes, heads unfinished yet truly imposing, and so painterly, so fluid . . . why? They have the *sensation*!" At around the same time, in a passionate avowal in front of Veronese's *Marriage Feast at Cana* and *Jesus in the Pharisee's House* in the Louvre, both of which he idolized, Cézanne was trying to explain to Joachim Gasquet what it meant to be a painter. "His psychology, it's the juxtaposition of two tones. That's where his heart is. That's it, his story, his truth, his depth, himself. For he is a painter, you see, and not a poet or a philosopher."[46]

They painted in *strokes* (*touches*)—but differently. According to legend, the difference was apparent to the uninitiated. They were a familiar sight to the local inhabitants, out painting *sur le motif*. Famously, Cézanne was said to *daub*, Pissarro to *dab*.[47]

They saw in *patches* (*taches*). Seeing in patches or stains of color seems to have come naturally to Cézanne, in particular, but there was also something programmatic about it. The basic principle was formulated early on, developed significantly over time, and never surrendered. "Seeing in patches, the metier is nothing, thickness and rightness: that is the aim to pursue," Oller was instructed in 1866. "A beautiful patch, all the same!" said Cézanne in his gnomic way, of Manet's *Olympia*, before trying to trump that particular card with his own *Modern Olympia* (1873–74). "I see only patches," affirmed Pissarro in 1903, as if to endorse Cézanne, in the last interview he ever gave.[48] In its final form, the *locus classicus* is the sixth of Cézanne's celebrated "opinions," as purveyed by Émile Bernard in 1904: "To read nature is to see it beneath the veil of interpretation as colored patches succeeding one another according to a

law of harmony. These major hues are thus analyzed through modulations. To paint is to register one's color sensations."[49]

Patches lived interesting lives. They had a history. The Old Masters as well as the moderns were preoccupied with patches, according to some, even if they were not called that; modern interest dated back almost half a century. A popular artists' manual of 1827 had described a method of landscape painting in what was called *hachures,* akin to hatching in drawing, by stabbing on the paint with a thick brush.[50] Plainly, this ran counter to the "well-licked" surface finish of the salon painting. As *hachures* turned into *taches,* their ideological underpinning assumed greater prominence. Inasmuch as they served to discipline sensations, they exercised a kind of policing function: the patch organized the painting. But they were also subversive, like free radicals within the frame. Patches were no respecters of persons or conventions. They promoted "a sort of pantheism which gives a head no higher value than a pair of trousers," as one critic put it.[51] They subverted the established order, pictorial and social; they undermined the very foundations of the traditional composition. "The more the artist attends impartially to the detail, the more anarchy gains," wrote Baudelaire in "The Painter of Modern Life." "Whether he is myopic or presbyopic, hierarchy and subordination disappear completely."[52]

Subordination gave place to democratization. In patches, all people are equal. The snobberies of genre are nugatory. Still life looks like indoor landscape; landscape looks like outdoor still life. The rules of perspective are broken; conventional expectations are laid to rest. In the landscape, the horizon slips, like a TV screen on the blink. Blue trees invade blue skies. Seeing blue outdid seeing red. Huysmans made fun of Pissarro's "blue mania," and the impressionists' fixation on that color, as another case of retinal malady.[53] Rilke's *Letters on Cézanne* is a paean to his blues. Blue could be all things to all men, and all classes, but it could also be construed as a proletarian color. Paul Adam's novel *Soi* (1886) boasted a radical impressionist with a mania for color, a beard like a prophet, and a strange name—Vibrac—a composite of Pissarro and Signac, in consonant disguise. "People are color," he proclaims. "They're the only social class in which there is so much blue and white. The overalls of the very poor workers are a dead blue, a worn-out, faded blue, with extraordinary greenish shadows. You might care for those hues, in plush, to make curtains."[54] In this way, seeing in patches was a continuation of anarchism by other means: the patch was the building block of "anarchist painting."[55]

Anarchist art is an elusive concept. Very often it is merely a label, or a

term of abuse. Pissarro himself believed firmly that his art was an expression of his political philosophy. "Our modern philosophy is absolutely social, anti-authoritarian, anti-mystical," he wrote, as if in rebuttal of Renoir, and it may well be that his paintings testify to these virtues. Yet on the question of the label he maintained a certain caution. "Is there an anarchist art? What? It certainly isn't understood. All art is anarchist when it is beautiful and good! That's what I think." And he was not above a little mockery, or self-mockery, of his own earnest propaganda of the word, finding Degas "such an anarchist! In art, of course, and without realizing it!" Zola's love-letter dedication to *Mon Salon* (1866), "To my friend Paul Cézanne," used the same form of words, in all seriousness. "Did you know that we were revolutionaries without realizing it?"[56]

Getting to know Pissarro transformed Cézanne's attitude to his craft. "I lived like a bohemian until I was forty," he told Bernard, with pardonable exaggeration. "I wasted my life. It was only later, when I knew Pissarro, who was indefatigable, that I got a taste for work." "Work" meant execution, and production, but also a felt need to push oneself—to stretch—and at the same time to push a painting to the limit, in Cézanne's parlance.[57] "All the great artists have been great workers," as Nietzsche said, "tireless not only in invention but also in rejecting, sifting, transforming, ordering."[58] If paintings were experiments with a view to improvements, then it was important to make the most of them. Cézanne discovered what the philosopher R. G. Collingwood apprehended from his own artistic upbringing: "I learned to think of a picture not as a finished product exposed for the benefit of virtuosi, but as a visible record . . . of an attempt to solve a definite problem in painting, so far as the attempt had gone."[59]

The taste for work embraced what we might now call personal growth, or professional development. It was not a question of growing like a mushroom, as Cézanne once said, but of study and practice. "The Louvre is the book from which we learn to read. However, we should not be content with memorizing the beautiful formulas of our illustrious predecessors. We have seen a dictionary, as Delacroix used to say, where we will find all the words. Let us go out. Let us study nature in all its beauty, let us try and grasp its spirit, let us seek to express ourselves according to our individual temperament. Besides, time and reflection modify our vision, little by little, and finally understanding comes." In a letter to Bernard he added: "Study modifies our vision to such an extent that the humble and colossal Pissarro finds his anarchist theories substantiated."[60] In other words, study of this sort leads to emancipation. He was also

taking issue with something that Bernard had written. Artists are not iconoclasts, Bernard maintained. "The best painters, whether they are called Courbet, Manet, or Monet, are not out to make us forget Michelangelo, Raphael, Leonardo. . . . They are nothing like anarchists who want to start the world all over again and date it from themselves." Cézanne was not so sure. As Proust knew, the world is not created once and for all but as often as the original artist is born.[61] If this required a deal of utopianism, so be it. Study for Cézanne meant a school of a different kind: a school of self-realization, in a class of two, with no timetable and no teachers. Anarchy rules, under the benevolent eye of *le bon Dieu*. Pissarro dignified the work.

The work was done by *the workers*—the serious workers, as Cézanne put it in his famous letter to Nieuwerkerke. It was no coincidence that Zola used exactly the same expression in his article on the salon jury a few days later. The ideologically loaded usage resurfaced in the protests that marked the emergence of a group of independent artists, soon known as the impressionists, in the early 1870s. A suggestive article by Paul Alexis, recalling earlier discussions in the Café Guerbois, sketched the future of a new collectivity—not a sect but an association, as he wrote, uniting interests not systems, and soliciting the support of all the workers who aligned themselves with such a cause. Here was the beginning of a manifesto: an impressionist manifesto. The central message was unmistakable: unite! The serious workers were organizing. They had nothing to lose but their chains. They had a world to win.[62] Curiously, Pissarro himself seems to have made no mention of Marx, but he did contribute a mini-manifesto or credo of his own. Sending a copy of Duranty's brochure *La Nouvelle Peinture* (1876) to the dealer Eugène Murer, he emphasized: "Nothing to do with personality; only this in view: a group of artists are united to get their work on view because the juries systematically prevent the showing of paintings to amateurs and to the public. As a matter of principle, *we want no school*; we like Delacroix, Courbet, Daumier and all those who have some fire in their belly, and nature, the open air, the various impressions that we experience, these are our concerns. We reject every factitious theory."[63]

Cézanne admired Pissarro first of all as a human being. He envied him his biography. "Responsibility to take over one's own biography," says the philosopher Habermas, "means to get clear about who one wants to be."[64] Camille Pissarro was quite clear about who he wanted to be, and he stuck to it to the end. This free radical was nine years older than Cézanne, a seafarer, a rover, an exotic. The provincial Aquasixtain met his first magus. Pissarro was no stranger to metropolitan France, and yet he was an outsider, an

uprooted cosmopolitan. He was born in the Virgin Islands, in what was then the little Danish colony of Saint Thomas. The Pissarros were Sephardic Jews of French-Portuguese stock; Camille was Danish by birth, and all his life a Danish national. The port of Charlotte Amalie, where he grew up, had a polyglot mix of European settlers and a sizeable indigenous population; he spoke French, Spanish, and English. At the age of twelve he was sent to boarding school in Paris. Five years later he returned to Saint Thomas to work in the family haberdashery and hardware business, but he was no more capable of being a haberdasher than was Cézanne a banker. He was determined to become an artist. "I was in Saint Thomas in [18]52, a well-paid shop clerk," he wrote to Murer, long afterwards, in 1878. "But I couldn't stand it, so without giving it a thought I dropped everything and ran off to Caracas, to cut the mooring that tied me to bourgeois life. I suffered unbelievably, of course, but I lived."[65] He found his way back to Paris in 1855, at the age of twenty-five, ravenous for painting. After the West Indies and Venezuela, he saw fresh France, as Derek Walcott puts it in his poetic reflection on Pissarro's quest:

> O, the exclamation of white roses, of a wet
> grey day of glazed pavements, the towers
> in haze of Notre Dame's silhouette
> in the Easter drizzle, lines banked with flowers
> and umbrellas flowering, then bobbing like mushrooms
> in the soup-steaming fog! Paris looked edible:
> salads of parks, a bouillabaisse of fumes
> from its steaming trees in the incredible
> fragrance of April; and all this would pass
> into mist, even cherishable mud, the delicate
> entrance of tentative leaves and the grass
> renewed when the sun opened its gate.
> The Renaissance, brightening, had painted altars,
> ceilings, cupolas, feasts with an arched dog,
> this city's painters, the guild in her ateliers
> made her sublime and secular as fog.[66]

So began the long march to make a living. Pissarro's autobiographical letter to Murer continued: "What I suffer now is dreadful, even worse than when I was young, filled with enthusiasm and ardor, for I'm convinced that I am lost for the future. Yet I have the feeling I would not hesitate to follow the same

path if I had to start over again." In 1857, unhappy with the academic teaching he was receiving in private classes with teachers from the Beaux-Arts, he began to frequent the Suisse, where he struck up a friendship with Oller, and where a little later he met Monet, Guillaumin, and Guillemet. He also went to call on Corot, who had been giving informal lessons to a small group of pupils since the early 1850s; he is reported to have finished some of the master's skies. Papa Corot gave him encouragement and advice, and even a drawing. "Go into the fields! The muse is in the woods!" Corot's outdoorsmanship was an example to the younger generation. Cézanne and Pissarro would have heard the story of his being accosted while out painting *en plein air*: "But where, Monsieur, do you see that splendid tree you've put there?" To which idiotic question Corot makes no reply, but takes his pipe from between his teeth, and without turning round, points with the stem at an oak behind them.[67]

By 1860 the entire Pissarro family had cut its ties with Saint Thomas and returned or relocated to France. Establishing themselves in Paris, his parents engaged a young woman called Julie Vellay as a kitchen maid. Julie was a Catholic, the daughter of a vineyard laborer from Burgundy. Pissarro began an affair with her. In the face of strong parental disapproval, Julie left their employ. She and Pissarro set up house together—a rock-solid relationship that would last forty years, despite all the privations. Lucien, their firstborn, arrived in 1863. He was followed by seven more children, three of whom died young. They did not get married until 1871—still without the consent of Pissarro's mother—in London, where they took refuge during the Franco-Prussian War. Neither family was present.

Pissarro began to set out his stall. He had a painting in the Salon of 1859, a diminutive *Donkey in Front of a Farm, Montmorency*. "Conversation between a donkey, a green door, and an apple tree," wrote Zacharie Astruc. "This vignette will make you think of [Laurence] Sterne. It is skillfully rendered." He had three paintings in the Salon des refusés. "Corot's manner seems to please him," observed Jules Castagnary. "He is a good master, monsieur, but certainly not one to be imitated." His two landscapes—not beautiful enough—were accepted for the Salon of 1865. "Does not lack a bright, clear temperament," observed another critic, sympathetically. "Does not shirk difficulties, overcomes them, or is knocked for six by them. All of which is good and proper for a young man in search of knowledge and still finding his way. He is not far off the right track of truth, if only he will stop clutching at the apron strings of his good nanny, Mama Corot."[68]

By the time he got acquainted with Cézanne, Pissarro had lived. He must

have related a good deal of this to his newfound friend. "He was lucky enough to be born in the Antilles," Cézanne recalled, "there he learned to draw without a master. He told me all about it."[69] Pissarro's talk was intoxicating. Guillemet parroted some of it in 1866:

> We're painting on a volcano. The [17]93 of painting will ring its death knell. The Louvre will burn, museums and antiquities will disappear, and as Proudhon said, from the ashes of the old civilization a new art will arise. Fever burns in us; today is a century away from tomorrow. Today's gods are not tomorrow's, to arms, let us seize the insurrectionary knife in a feverish hand, let us destroy and build again (*et monumentum exegi aere perennius*) [I have built a monument more lasting than bronze]. Courage, brother. Let us close ranks; we are too few not to make common cause. They are throwing us out; we will shut the damned door in their face. The classics are stumbling. Nieuwerkerke is falling off his perch. Let us mount an assault and bring down that loathsome creature. . . . Build, paint thick, and dance on the belly of the horrified bourgeois. We too will have our turn.

This was a spoof. Pissarro was nothing if not a man for deliberation (and a pacifist); his fervor was balanced by his rigor, as Georges Bataille said. But Cézanne never forgot the revolutionary rhetoric. "Pissarro wasn't wrong," he told his son forty years later; "he went a bit far, however, when he said that we should burn the necropolises of art."[70]

Cézanne introduced Pissarro to Zola, who sang his praises in his salon criticism, borrowed the idea of patches, and seasoned his profile of Taine with a soupçon of anarchism. "Schools die, even if masters remain with us. A school is only a halt on the march of art, just as a monarchy is often a halt on the march of society."[71] Schools and masters were much on their mind in this period. Cézanne's remark that Pissarro had learned his trade without a master was a half-truth that may conceal a deeper understanding. Early exhibition catalogues show Pissarro as a "pupil of A. Melbye and Corot." Not one but two, apparently, and a key to a half-buried connection. The Danish artist Anton Melbye had a studio in Paris, where Pissarro worked briefly to earn a little money finishing some more skies. Anton was the older brother and teacher of Fritz Melbye, a landscape artist, now forgotten. Fritz was an intrepid traveler who roamed the world painting exotic scenes likely to appeal to European collectors. Pissarro met him on the docks in Saint Thomas. They began to

work together. In 1850 they made a short trip to the Dominican Republic and Haiti; in 1852 they left for Venezuela, Melbye reminding Pissarro to take colors, canvas, pencils, and paper, in case such things were in short supply in their new home. Caracas was not quite the Conradian leap that it was subsequently made to appear; it was a joint operation, carefully planned. There they shared a studio and made a go of it as professional artists.

It transpires that Pissarro had lived even more than is generally allowed. By the time he got to Paris in 1855 he was already a painter. He had tried his hand at almost every subject; he had experimented with the insurrectionary knife, and with all manner of other implements; he had learned to work closely with another artist, in a kind of extended dialogue, the form of relationship at which he excelled. It is true that he had no master in the Couture mould, but he did have a mentor, as he himself would mentor others over the years. He also had a body of work. In oil on canvas he was doing highly accomplished landscapes, difficult to tell apart from those of Fritz Melbye. In pencil on paper he was doing drawings of vegetation that were even more impressive, with bunched parallel lines that seem to prefigure Cézanne's innovation of the 1870s, his "constructive stroke." What exactly Cézanne saw of this Pissarro-before-Pissarro is impossible to reconstruct with certainty. Some of the early work may have disappeared during the war, when Prussian troops occupied his studio and used the canvases to cover the floor. Some may have been buried elsewhere; a sketchbook containing 112 unpublished drawings has only recently been rediscovered.[72] Nonetheless, great artists have memories like elephants. Is it significant that Cézanne's recollection turned to Pissarro's drawing? Does his knowledge of the early work put a different complexion on his celebrated observation that, if Pissarro had continued to paint as he had until 1870, "he would have been the strongest of us all"?[73]

Pissarro's extended dialogue with Cézanne was unsurpassed. There was an element of mentorship in their relationship, as Cézanne himself freely acknowledged. Pissarro brought to it a fine humanity and a well-integrated personality ("*esprit clair et honnête*," Cézanne told Denis); he dignified the artist as he dignified the work. He lent some of that dignity to Cézanne, fortifying and stabilizing him. "They were the Academy's outcasts," writes Derek Walcott, "its niggers/ from barbarous colonies, a contentious people!"[74] They could face the opprobrium together: "When two together go / They are better able both to see an opportunity and to take it."[75]

For Pissarro, dialogue was indivisible: there were no walls between art and life. He was a man to go to for advice, as Cézanne said, as amply attested in his

correspondence (over two thousand extant letters, filling five substantial volumes). In these circumstances it is hard to believe that Pissarro did not make some impression on Cézanne's attitudes and outlook, however stubborn the latter might have been. William Empson said of T. S. Eliot, "I do not know for certain how much of my own mind he invented." Cézanne might have said the same. Reinforcement, perhaps, rather than conversion; principle, not proselytism, was the order of the day. Pissarro was an anarchist, not a dogmatist, but his principles were strongly held. On the death of Manet, in 1883, he wrote to his son: "Manet, great painter that he was, had a petty side, he craved recognition by the duly constituted authorities; he believed in official recognition; he longed for honors. He died without achieving them." Pissarro was anxious about posterity, but he had no time for bowing and scraping, and no love for baubles. The folderol of official honors was beneath contempt; chasing after them was a base pursuit. His condemnation spared no one, however humble their station; not even Mirbeau's gardener, though in this instance cheerfulness kept breaking in:

> Is your gardener Lucien a little touched by his status as medal-winner? Is he hooked on the glory? Oh! One shouldn't rely on the Official, my friend. Pursuing this new feeling, next year will bring superhuman efforts in this artist of his genre, and we're going to see the sudden appearance of extraordinary flowerbeds, flowers unknown in any corner of paradise, vegetable fantasies in amazing borders; in the middle of all this efflorescence, multi-colored, plumed fowl, cats that slink like tigers! These echoes of the agricultural chorus, medals, banquet, envoy, Arc de Triomphe, medal-winners' quarrels, prefect, bourgeois, oh! the calves' heads of the banquet![76]

Cézanne and Pissarro exchanged books and authors. In poetry they were agreed on Baudelaire, and also on Verlaine.[77] Sending a copy of *Les Fleurs du mal* and a volume of Verlaine to Lucien in England, Pissarro observed:

> I do not believe these works can be appreciated by anyone who comes to them with the prejudice of English or (especially) bourgeois tradition. Not that I am completely in favor of the contents of these books; I am no more for them than for Zola, whom I find a bit too photographic, but I recognize their superiority as works of art, and from the standpoint of certain ideas of modern criticism, I find them valuable. Besides it is clear

that from now on the novel must be critical; sentiment, or rather senti-mentality, cannot be tolerated without danger in a rotten society ready to fall apart.

Cézanne lent Pissarro a copy of Huysmans's *En ménage* (1881), which he gob-bled up.[78] Together they went to visit Robert Caze and his salon of avant-garde poets, novelists, and critics, a short-lived groupuscule which included Adam, Alexis, Huysmans, and Signac. They had a warm reception. "The young are very enthusiastic about our work," wrote Pissarro, gratified. "They tore Zola's *L'Œuvre* to pieces. . . . But they are very enthusiastic about Flaubert. There I agree! They are right! They consider *Bouvard et Pécuchet* a masterpiece."[79]

For Cézanne and Pissarro alike, Flaubert was an exemplary artist. His char-acter and his struggle invite comparison with Cézanne's, as the painter himself may have noticed.[80] Like Cézanne, he had given up on Law. His self-description as an *homme-plume* (not so much a "penman" as a "manpen") must have been profoundly sympathetic to the *homme-peintre*. Writing was his life. His life was writing. He spoke of "the humiliations that adjectives inflict on me, the cruel ravages of relative pronouns." He lived and died by the word. "May I die like a dog," he told a correspondent, "rather than try to rush through even one sentence before it is properly ripe." He had temperament to spare; he too was *bilieux*. The control of his microclimate was faulty. "I pass from exasperation to prostration, then I rise from annihilation to rage, so that my mean emo-tional temperature is a state of annoyance." The targets of his annoyance were the *bougres de crétins* so regularly invoked by Cézanne. Stupidity was the bane of his life. "The bottomlessness of human stupidity" never ceased to amaze him. The stupidity of his countrymen exasperated him. *Bouvard et Pécuchet* (1881) was the book in which "I shall try to puke up my bile over my con-temporaries." "All my compatriots are arseholes beside me," said Cézanne at the end.[81] Stupidity about art, wrote Flaubert, comes less from the public than from "(1) the government, (2) theater managers, (3) publishers, (4) newspaper editors, and (5) official critics—in short, from holders of power, because power is essentially stupid," a sentiment that might almost have been expressed by Cézanne. "Talking about art is almost useless," he wrote to Bernard, in Flau-bertian mode. "Work which realizes some progress in one's own craft is suf-ficient compensation for not being understood by imbeciles."[82] For both men, progress was a hard slog. Goncourt mocked Flaubert as the "one-word-a-day book-constructor." Much the same was said of the mythical interval between Cézanne's every brushstroke.

For Flaubert the sky of the future was black most of the time, but he was used to that. He was at once funny and pessimistic, sustained by "sacrosanct literature" (his one true church) and by his animus against the bourgeoisie. ("Axiom: hatred of the bourgeois is the beginning of virtue.") Like Cézanne, he loved his mother and hated Switzerland. Like Cézanne, he sought to repel the inquisitive. "I have no biography," he responded magisterially when asked for personal details. "Giving the public details about oneself," he wrote to a friend six months before he died, "is a bourgeois temptation I have always resisted." "I thought that one could do good painting without attracting attention to one's private life," said Cézanne. "Certainly an artist wishes to improve himself intellectually as much as possible, but the man should remain obscure."[83] Obscurely enough, Flaubert was estranged from his famously inseparable "left testicle," Louis Bouilhet, three years before the latter's death in 1869. Flaubert's cherished theme of the elective fraternal couple would not have escaped Cézanne; the long years of quasi-fraternal exchange suggest an analogy with Zola. Over time, however, something went wrong. After half a lifetime as moral support and intellectual compass, Bouilhet abandoned Flaubert, as he said, changing "in mood, personality and ideas" and developing "all the moral symptoms of old age." In effect Flaubert accused his friend of the sin of *embourgeoisement*—a failure of temperament and a betrayal of artistic principles—a kind of abdication.

Flaubert was for Cézanne a star of the firmament—an honorary Venetian. While he painted Henri Gasquet's portrait in 1896, with Joachim Gasquet looking on (and butting in), he delivered himself of a declaration of faith, by reference to his precursors and to Flaubert, with a nod to Pissarro's views on photography. The results are revealing:

> CÉZANNE: Well! Rembrandt, Rubens and Titian knew at once how to merge their whole personality in all that flesh that they had before their eyes, in a sublime compromise, to animate it with their passion and with the likeness, to glorify their dream or their sadness. They did it exactly. I can't do that . . .
>
> JOACHIM GASQUET: It's because you're too fond of other people . . .
>
> C: It's because I want to be truthful. Like Flaubert. To extract the truth from everything. To submit myself . . .
>
> JG: Perhaps it's impossible.
>
> C: It's very difficult. By putting some part of myself in your father, I would have my ensemble. . . . I would come close to reality. I want

it whole. . . . Rubens attempted it with his wife and children, you
know, the phenomenal *Hélène Fourment* in the Louvre, all russet-
colored, in her hat, with her naked child . . . and Titian, with his
Paul III between his two nephews, in the Naples museum, a page of
Shakespeare.

J G : And Velázquez?

C : Ah! Velázquez, that's another story. He took his revenge. You see,
that man, he was painting away in his corner, getting ready to give us
the forges of Vulcan and the triumphs of Bacchus to cover the walls
of every palace in Spain. Some imbecile, to do him a favor, talks
about him, drags him along to see the king. In those days they had
not invented photography. Do my portrait, on foot, on horseback,
my wife, my daughter, this madman, this beggar, this one, that
one . . . Velázquez became the king's photographer, the plaything
of the unhinged. Then, he kept everything bottled up, his work, his
great soul. He was in prison. It was impossible to escape. He took a
terrible revenge. He painted them with all their blemishes, their vices,
their decadence. His hatred and his objectivity were one and the
same. He painted his king and his jesters like Flaubert his Homais
and his Bournisien [in *Madame Bovary*]. He bears no resemblance to
the portraits that he painted, but look how Rubens and Rembrandt
are always there, you can always recognize them under all the
faces. . . .[84]

The allusion to Flaubert's characters Homais and Bournisien begins to sound a
little like Gasquet over-egging the pudding. And yet, a few years later, Cézanne
spoke in similar terms to Maurice Denis, who wrote it down in his diary. This
time the point of reference is not *Madame Bovary* (1857) but *Salammbô* (1862).
Especially given his fascination with Saint Anthony, there is every reason to
believe that Cézanne was steeped in Flaubert. He mentioned rereading him in
1896. Serial rereading was in itself something they had in common, as Cézanne
would have discovered from his letters, first published in 1887. As Cézanne
reread Stendhal, so Flaubert reread Spinoza (three times). Always wary of the
snare of "literature" in painting—"only Baudelaire has talked properly about
Delacroix and Constantin Guys"—Cézanne liked the way Flaubert refused
to prate about an art whose technique he did not understand. "That's him all
over."[85]

Cézanne talked also of a lesser-known work, *Par les champs et par les*

grèves [*Over Strand and Field*] (1886), Flaubert's account of his travels in Brittany with his friend Maxime Du Camp. "You remember . . . that burial he describes, and the old woman whose tears fell like rain. Every time I reread that I think of Courbet. The same emotion, the same artistry." Cézanne is thinking of *A Burial at Ornans* (1849), to which he pays characteristic tribute in the Louvre. "Look at that dog. Velázquez! Velázquez! Philip's dog is less of a dog, royal dog though he was. . . . And the choirboy, with his chubby red cheeks. . . . Only Courbet knows how to slap on a black, without making a hole in the canvas."[86]

Despite the pitfalls, therefore, it was clearly possible to associate one art with another. According to Gasquet, Cézanne himself had this experience in his own painting:

> You know that when Flaubert was writing *Salammbô* he said that he saw purple. Well! When I was painting my *Old Woman with a Rosary* [1895–96], I saw a Flaubert tone, an atmosphere, something indefinable, a bluish russet color that's given off, it seemed to me, by *Madame Bovary*. For a while I was afraid that this obsession might be dangerous, too literary. I tried reading Apuleius. Nothing would do it. That great blue russet fell upon me, sang to me in my soul. I bathed in it completely. . . . I scrutinized all the details of the clothing, the cap, the folds of the apron; I deciphered the shifty expression. It was only much later that I realized the face was reddish brown, the apron bluish, just as it was only after the picture was finished that I remembered the description of the old servant at the agricultural show.[87]

Old Woman with a Rosary (color plate 61) was much exhibited: at the 1907 retrospective, at the first postimpressionist exhibition in London in 1910–11, and at the famous Armory Show in New York in 1913, lent by the Paris dealer Eugène Druet, who was asking $48,600 for it, by far the highest price listed for any work in the show. Most of the Cézannes at the Armory Show were judged to be "difficult"—too difficult for most of the visitors—but it is reported that President Theodore Roosevelt contemplated this one with equanimity for some time.

"Whatever else happens," said Flaubert at the outbreak of the Franco-Prussian War, "we shall remain stupid." The French declaration of war soon proved his point. The main French army was forced to capitulate at Sedan in September 1870; the emperor himself was taken prisoner. Another French army

surrendered at Metz a few weeks later. Paris endured a grim four-month siege. Food shortages became acute. Cats began to disappear; dogs' heads were sold at the butchers; Philippe Solari and his family were tempted by rat pie.[88] In March 1871 France accepted humiliating peace terms, ceding Alsace and most of Lorraine, and paying an indemnity of five billion francs. A German army of occupation would remain until the indemnity was paid. In Paris, feelings were running high against those who had brought about this debacle. Rioters in Montmartre refused to surrender their weapons to French troops; they seized and hanged the two generals commanding them. All French forces were withdrawn. In March the vacuum was filled by a central committee, calling itself the Commune, in emulation of the Jacobin Assembly of 1793. So began the brief and bloody history of the Paris Commune. In May the French army retook the city, street by street, in a week of vicious fighting. Neither side gave any quarter. The Communards shot hostages, including the archbishop of Paris. The troops skewered anyone who got in their way. The suppression of the Commune left more people dead than the Terror of the French Revolution.

Two decades later, Vollard asked Cézanne what he did in the war. He replied: "Listen, Monsieur Vollard! During the war, I worked a lot *sur le motif* at L'Estaque." Cézanne was a draft dodger. He was trying to elude the authorities, civil and paternal.

He had embarked on a secret life. He was living with a woman.

6: La Boule

Her name was Hortense Fiquet. They met in Paris in 1869, when Cézanne was thirty and Hortense barely nineteen. They began to live together the following year. In 1872 they had a son, also christened Paul. Cézanne acknowledged paternity, like his father before him. Paul was truly the apple of his father's eye. He doted on his son. "Paul is my orient."[1] After the excitement of encounter, the joy and perhaps the surprise of acceptance, his feelings for Hortense were more complicated. Through force of circumstance, their first experience of life together was a kind of incubation, cooped up in cramped quarters, in Paris, testing patience and hatching Paul. Such intensity was impossible to sustain. Something like harmony existed for a year in Auvers in 1873, with the Pissarros as neighbors. Thereafter it was more evanescent. Lengthy separations became the norm, in keeping with Cézanne's seasonal migration between Paris and Aix.

Even when they were in the same place, they were not always under the same roof. The Jas de Bouffan was effectively out of bounds to Hortense. The exchanges between them were at once attenuated and concentrated. Cézanne painted at least twenty-four oil portraits of Hortense, over a period of twenty years. She continued to sit for him long after they had ceased to live together all the time. However convenient it may have been to avail himself of his wife as a model—in the circumstances, the convenience has perhaps been overplayed— repeated sitting was a pledge of allegiance, on both sides. Paintbrush in hand, he paid more attention to her than to anyone else, except himself. Hortense was immortalized. She was also silenced: sitters are seen but not heard. But she was something more than dumb matter, or a changeable ensemble of color patches. Absent or present, she was a permanent fixture. No one ever took her place.

Their relationship was at first clandestine and then arm's-length—neither

of them was cut out for joint housekeeping. For many years it was strictly unmentionable. Cézanne made every effort to conceal it from his father, for fear of paternal disapproval and disinheritance. Surprising as it may seem, Hortense was not openly avowed, nor Paul formally legitimized, until 1886, when they were eventually married. Until well into his forties, Cézanne had a secret family, or a semi-secret family, kept out of sight and hidden from *le papa*. His friends were privy to their existence, and so was his mother; inevitably, his father had his suspicions. "It appears that I have *grandchildren* in Paris," he was heard to say; "one day I must go and visit them!"[2]

Six months after the wedding, his father died. Cézanne had this in common with the nameless protagonist of Samuel Beckett's "First Love": "I associate, rightly or wrongly, my marriage with the death of my father, in time. That other links exist, on other levels, between these two affairs, is not impossible. I have enough trouble as it is in trying to say what I think I know."[3] For Cézanne, 1886 was a year of solemnizations and ratifications.

Marie Hortense Fiquet (1850–1922) was born on 22 April 1850 in the village of Saligney, near Besançon, in the Jura. She was the elder daughter of Claude Antoine Fiquet (1807–89), a farmer, and Marie Catherine Déprez, or Déprey (1821–67), whose father was a blacksmith. In the late 1850s or early 1860s the Fiquets migrated to Paris to start a new life. The new life must have been every bit as hard as the old one. Hortense's sister Eugénie died young, and so did her mother, on 23 July 1867, when Hortense was seventeen. Her father returned to the Jura and the thirty-nine acres of vines left by his wife. Hortense stayed on, alone. How she made ends meet is not entirely clear. She is said to have worked as a seamstress. One suggestion is that she did some dressmaking, a sideline which continued after she met Cézanne.[4] Another is that she worked in a bookbinder's, sewing handmade books.[5] That is certainly possible, but it may equally derive from a portrait drawing by Cézanne, an ambitious composition on an unusually large scale, selected by Vollard to illustrate the title page of his book on the artist, published in 1914. Vollard himself entitled the drawing *The Seamstress*. Hortense is absorbed in what appears to be needlework, though the needle and thread are not shown, and the nature of the work is difficult to determine because the heart of the action, the center of the drawing, is boldly left blank. Among the furnishings, there are indications of a bedpost, a cabinet or table with a familiar drawer, and a pile of books.[6]

She is also said to have done some modeling.[7] That would have been quite normal. Sewing paid badly; modeling would have helped. Whether modeling covered other activities often associated with that line of work is impossible

to ascertain, but Hortense was not known as a woman of easy virtue. There seems to have been no gossip about her past, though her situation might well have invited it. As to her future, she was not welcomed with open arms by the Cézanne family—they called her "La Reine Hortense" (Queen Hortense)—but her offense was cupidity, and vulgarity, rather than promiscuity: she was suspected of wanting to get her hands on his money. Put crudely, they thought she was a gold digger, and common with it. Modeling and the mores of the demimonde were the least of their concerns. According to Philippe Cézanne, the artist's great-grandson, it was generally assumed that "Hortense had her adventures," and in view of the life she led it might be more remarkable if she had not. Cézanne himself intimated to Zola that Hortense "had a little adventure" in Paris in 1878. "I won't entrust it to paper, I'll tell you about it on my return, besides it's no big thing."[8] The nature of the adventure remains obscure, but apparently it did not cause him much concern. No other indiscretions of that sort have come to light.

Understandably, given her early experience, Hortense developed a taste for the good life. "My wife likes only Switzerland and lemonade," said Cézanne, half-seriously. The list could have been expanded. The principal interests of Voltaire's paramour Madame du Châtelet are supposed to have been books, diamonds, algebra, astronomy, and underwear, all of them keenly appreciated by Voltaire. Hortense was not averse to diamonds, or underwear, but her priorities were different. She liked to talk—but not about painting. She liked to dress in the latest fashions. She liked to travel. And as she got older, and richer, she liked to gamble. At the gaming tables of the casinos, at Monte Carlo and elsewhere, she played cards or roulette. At home, she played patience.[9]

She indulged herself to the full after Cézanne's death, once she had sold some paintings. Before that, any extravagance caused friction. Whether or not Hortense had regal airs and graces, or spending habits, she did have a will of her own, and frugality was not her forte. Not surprisingly, she preferred Paris to Aix; like Cézanne, she objected to being under surveillance. In Paris she could let herself go, which was precisely the worry. For many years money was tight. Getting and spending was fraught with tension. To some extent, no doubt, that was unavoidable. Only after his father's death in 1886 did Cézanne become a free man, as it were, disposing of a significant income. Until then, times were hard, from Hortense's point of view. The monthly allowance was closely rationed, twice over, by father and then son; and her churchmouse spouse was under the paternal thumb, as she could not fail to observe. In April 1878, at the age of thirty-nine, Cézanne was compelled to walk from Marseille

to Aix, a distance of some twenty miles, when summoned to present himself for dinner with his parents. The summons was indicative of a crisis long fore-seen and long evaded. Suddenly, it exploded.

Louis-Auguste had opened a letter addressed to his son—as was his custom, as Cézanne well knew—in which he read of "Madame Cézanne and little Paul." His suspicions were confirmed. Action was called for. Louis-Auguste was outraged. Plainly, his son had been suckered; moreover, he, Louis-Auguste Cézanne, had been deceived. That would not do. There was an obvious solution: he told his son that he wanted to be rid of them. By way of encouragement, he halved his son's allowance. There was a long moment when Cézanne feared he would be cut off altogether.[10]

Cézanne was left with a monthly allowance of one hundred francs, less than he received when he was just starting out, almost twenty years before. In desperation, he turned to Zola and asked him to send sixty francs to Hortense. He renewed the request every month for the next five months—"my monthly prayer." Zola responded immediately, without question. With his father, meanwhile, there was a sort of standoff. Blindly committed, both to his family and to his untruth, Cézanne continued to deny everything; lacking conclusive proof, Louis-Auguste appeared reluctant to pursue it any further. Corroborative evidence continued to mount. Louis-Auguste met Cézanne's painter-mentor Ville-vieille in the street. "You know, I'm a grandfather!" exclaimed Louis-Auguste. "But Paul isn't married!" replied Villevieille, aghast. "He was seen coming out of a shop with a wooden horse and other toys," rejoined Louis-Auguste. "You're not going to tell me that they're for him."

In July 1878, things took an almost comic turn for the worse. Cézanne received a letter from his landlord in Paris, informing him that strangers had been staying in his apartment. Louis-Auguste read this letter, too, and leapt to the conclusion that Cézanne was keeping women in his rooms. The truth was more banal: the "strangers" were friends of the cobbler round the corner, with whom he had left the key. "This begins to take on the air of a vaudeville farce," Cézanne wrote to Zola.[11]

Louis-Auguste, riled, cannot have been easy to get on terms with. Especially with a child to support, the forty-year-old Cézanne must have felt acutely vulnerable. Confronted directly with his subterfuge, he could think of nothing better than brazen denial and further dissimulation. Whether a more rational discussion would have been possible or profitable is difficult to say; in any event it was never tried. Cézanne was chronically ill at ease dealing with his father, man-to-man, face-to-face. Painting him was one thing, besting him in

argument quite another. Was he intimidated? It would have been only natural. Did he have a similar feeling to Kafka, at a similar age, about his father on his throne? "You had worked your way up by your energies alone, and as a result you had unbounded confidence in your opinion. That was not yet so dazzling for me as a child as later for the boy growing up. From your armchair you ruled the world. Your opinion was correct, every other was mad, wild, *meshugge,* not normal. . . . For me you took on the enigmatic quality that all tyrants have whose rights are based on their person and not on reason. At least so it seemed to me." Hence, perhaps, the indirect approach: the well-pondered portrait, the carefully drafted letter (the eye that fashions, the hand that ponders). Kafka wrote his father a famous letter, which he gave to his mother to deliver. It echoes uncannily of Cézanne.

Dearest Father

You asked me recently why I maintain that I am afraid of you. As usual, I was unable to think of any answer to your question, partly for the very reason that I am afraid of you, and partly because an explanation of the grounds for this fear would mean going into far more details than I could even approximately keep in mind while talking. And if I now try to give you an answer in writing, it will still be very incomplete, because, even in writing, this fear and its consequences hamper me in relation to you and because the magnitude of the subject goes far beyond the scope of my memory and power of reasoning.

To you the matter always seemed very simple, at least insofar as you talked about it in front of me, and indiscriminately in front of many other people. It looked to you more or less as follows: you have worked hard all your life, have sacrificed everything for your children, above all for me, consequently I have lived high and handsome, have been completely at liberty to learn whatever I wanted, and have had no cause for material worries, which means worries of any kind at all. You have not expected any gratitude for this, knowing what "children's gratitude" is like, but have expected at least some sort of obligingness, some sign of sympathy. Instead I have always hidden from you, in my room among my books, with crazy friends, or with extravagant ideas. I have never talked to you frankly . . . I have never taken any interest in the business or your other concerns. . . . If you sum up your judgment of me, the result you get is that, although you don't charge me with anything

downright improper or wicked (with the exception perhaps of my latest marriage plan), you do charge me with coldness, estrangement, and ingratitude. And, what is more, you charge me with it in such a way as to make it seem my fault, as though I might have been able, with something like a touch on the steering wheel, to make everything quite different, while you aren't in the slightest to blame, unless it be for having been too good to me.

This, your usual way of representing it, I regard as accurate only insofar as I too believe you are entirely blameless in the matter of our estrangement. But I am equally entirely blameless. If I could get you to acknowledge this, then what would be possible is—not, I think, a new life, we are both much too old for that—but still, a kind of peace; no cessation, but still, a diminution of your unceasing reproaches.[12]

In September 1878 there was a further contretemps and a diminution, or perhaps an exhaustion. A letter to Hortense from her father, addressed to "Madame Cézanne," was forwarded to the Jas de Bouffan and duly opened. Hortense was not mentioned by name; Cézanne persisted in his denials. To his amazement, his father seemed either to relent or to lose interest. "*Nota-Bene*: Papa gave me 300 francs this month," he wrote to Zola. "Incredible. I believe he's making eyes at a charming little maid we have in Aix; mother and I are in L'Estaque. What a turn-up."[13]

After this melee, peace of a kind descended. More accurately, cold war resumed. Cézanne asked Zola for a further subvention of one hundred francs for Hortense in November, but that seems to have been an extraordinary request to meet a particular need, not prompted by any renewed offensive on the part of the paternal authority.[14] Louis-Auguste was nothing if not a pragmatist; however unreconciled, he may well have concluded that there was little to be gained from more recrimination. For all his growling and his greed, when it came to the point he was not ungenerous, as he continued to demonstrate. If his son was set on this particular madame, as unsuitable as she might be, and there was indeed a little Paul, then perhaps they had need of him after all. *Le papa* had his pride. He was not a man to be taken for a ride; nor was he a man to shirk his responsibilities—and he knew a thing or two about dependents.

Cézanne's family were not the only ones to treat Hortense with a degree of contempt. Among his friends, particularly his literary friends, her nickname was La Boule (the Ball, or the Dumpling). Like Cézanne, Hortense did not have the honor to be "a great beautiful." In middle age she grew rather stout, but as

a younger woman she would assuredly have passed muster, as her portraits go to show; and she was certainly not fat, especially by the standards of the day. She may have been seen as round-faced, but the nickname seems to suggest something more. Here the portraits are of little help, for Cézanne saw her variously; indeed, the remarkable variation in his images of her is one of the most intriguing things about them, and one of the most unsettling. Cézanne himself appears not to have used the nickname, though he must have been aware of it. In some of his drawings he seems to emphasize the roundness of her head, and to associate her with round objects, including the knob of the bedpost in *The Seamstress,* and some enigmatic fruit; but everyone he loved is associated with fruit, sooner or later, and there is at least one Old Masterly *Self-Portrait and Apple,* with a striking affinity between bald head and solitary apple.[15] Cézanne had a tendency towards the concentric. "In order to make progress, there is only nature, and the eye educates itself by contact with nature," he told Émile Bernard. "It becomes concentric by looking and working. What I mean is that, in an orange, an apple, a ball, a head, there is a culminating point; and this point is always—despite the tremendous effect: light and shadow, *sensations colorantes*—the closest to our eye."[16] With Hortense, moreover, shape is

shifting; in almost all the portraits, she is more oval than round, and distinctly un-dumpling.

In the circumstances, it is tempting to look for literary derivations. The one that leaps out is *Boule de suif,* by Maupassant, first published in *Les Soirées de Medan* (1880), a collaborative volume by the writers in Zola's circle. *Boule de suif* might be translated as ball of suet, or lump of lard, though the soubriquet was by no means a simple insult. Maupassant's description of the title character, a prostitute, is mouthwatering, not to say salacious, but it came too late. The nickname was employed as early as 1870. Baudelaire plays with *la boule* in a poem called "Voyaging," in *The Flowers of Evil,* but there is no obvious connection to be made. Musset may answer. In his "Ballad to the Moon," which so captivated the sixteen-year-old scribblers, there is a suggestive verse:

> Are you nothing but a ball?
> Nothing but a big fat bug
> That rolls,
> Without arms and legs?

Little Paul was Le Boulet (the Little Dumpling), which also carries the association of ball and chain and good-for-nothing, as well as sounding pleasingly diminutive. This seems to reinforce the lumpen connotation, and to emphasize the notion of a drag or a burden. Whatever the precise signification, Hortense's nickname conveyed the very opposite of delectable or desirable: La Boule was not La Goulue (the Glutton), the former flower seller who became a panting attraction at the Moulin Rouge soon after it opened in 1889. Panting after Hortense Fiquet, it suggests, there was only Paul Cézanne—and even he lost heart.

The usage may have been jocular, but it was clearly not complimentary. In 1891 Paul Alexis was still sending Zola news of Cézanne from Aix:

> He is furious with the Dumpling, who, after a year in Paris, last summer inflicted on him five months of Switzerland and hotels, where the only sympathetic presence he encountered was a Prussian. After Switzerland, the Dumpling returned to Paris, escorted by her bourgeois son. But, by halving her competence, she has been driven to come home to Aix. At seven yesterday evening, Paul left us to go and meet them at the station: her, his brat of a son, and the removal man from Paris, hired for 400 francs. Paul plans to set them up in a rented place in the Rue de la Mon-

naie [now Rue Frédéric-Mistral] where he'll pay for their keep. (He even said to his kid: "Whatever idiocies you might get up to, I'll never forget that I'm your father!") Nevertheless, he himself doesn't plan to leave his mother and elder sister [Marie], where he is settled out of town [at the Jas], where he feels fine, and which he definitely prefers to his wife! Now, if the Dumpling and the brat take root here, as he hopes, nothing will stop him going from time to time to spend six months in Paris. "Long live sunshine and liberty!" he cries.

Money worries were a thing of the past, except for the division of the spoils. For that, Cézanne had a system. "First he divides his income into twelve monthly portions; then, each portion is subdivided into three: For the Dumpling! For the Little Dumpling! And for him! Except that the Dumpling, who is apparently none too scrupulous, continually tends to spend more than her share. Now, backed by his mother and his sister—who have a special hatred for her—he feels he has the strength to resist."[17]

A few days later Zola received another report, this time from their mutual friend Numa Coste:

> How to explain that a tough and rapacious banker could give birth to a being like our poor Cézanne who I saw recently? He looks well and physically there's no deterioration. But he's become timid and unsophisticated and younger than ever.
>
> He is living at the Jas de Bouffan with his mother who has incidentally quarreled with the Dumpling, who isn't on good terms with her sisters-in-law, who don't get on with each other either. The upshot is that Paul lives on one side and his wife on the other. And in my experience one of the most moving things is to see that good lad preserve the innocence of youth, forget the disappointments of the struggle and, resigned to suffering, throw himself into the pursuit of a work which he can't deliver.

Evidently there was ample scope for conflict in the family without any assistance from Hortense. A few years later, Coste resumed the tale: "His wife must have led him a merry dance. He is obliged to go to Paris or to come back according to the orders that she gives him. To get some peace, he has been forced to sell some of his assets, and according to the confidences that he's let slip, that only leaves him with an income of about 100 francs a month. He has

rented a cabin in the [Bibémus] quarry [a few miles east of Aix], and spends most of his time there."[18]

These reports should be taken with a pinch of salt. Cézanne knew his Balzac: "The wife of an artist is always an honest woman."[19] But it is interesting to find him imitating his father's tactic, in an effort to gain leverage, and also his father's generosity, over the allowance. "My father was a man of genius," he would say, in his ironic mask. "He left me an income of 25,000 francs."[20]

Zola knew Hortense from the outset, just as Cézanne knew Alexandrine Meley, the future Madame Zola. Alexandrine (formerly Gabrielle) had a somewhat similar background to Hortense's. Her resourcefulness matched her aspirations. She wanted family, respectability, society. Decorum was all; Alexandrine had a strict sense of propriety. Cézanne conspicuously failed that test, but the upwardly mobile Zola could be brought into compliance. Once upon a time, Gabrielle had posed for Cézanne; he is said to have introduced her to Zola. The more lubricious version is that he was the one who slept with her first, which seems highly unlikely.[21] Together with Alexis, Roux, and Solari—the gang from Aix—he was a witness at their wedding, in Paris, in April 1870. Hortense must have been there too. A few months later, after the exodus of the Franco-Prussian War, Alexandrine wrote to her husband from Marseille: "Marie [Roux's companion] saw the Dumpling go past the window three days ago, and we heard from women in L'Estaque that Paul [Cézanne] isn't living there anymore; we think that they're hiding in Marseille. Naïs asked for news about them, as if something extraordinary had happened. As for us, we haven't seen them again, those two pretty ones, him and her. How rude they are! We worry about these people, when really they should mean nothing to us now."[22] The prescriptive Madame Zola did not care for the presumptive Madame Cézanne.

The accounts of Cézanne's friends are all about what Cézanne had to put up with. Historically, Hortense lacks allies who wrote letters. Biographically, she seems immune to treatment. Until very recently she was completely ignored. The vogue for the "significant other" passed her by. On the contrary, by omission or commission, Hortense became the insignificant other. Cézanne's biographers evinced no interest in the woman who was his life partner and the mother of his son, regardless of the importance he attached to mothers, and sons, not to mention portraits.[23] In a disputatious arena, the prevailing attitude towards Hortense remained more or less uniform and unquestioned: it betrayed a fundamental lack of sympathy. It took its cue from the founding

father of Cézanne studies, John Rewald, who delivered a kind of anathema on Hortense in the 1930s and saw no reason to recant over the next fifty years. The final edition of his biography of Cézanne appeared in 1986. It dismisses her in a paragraph:

> Cézanne returned to Paris at the beginning of 1869. It is about this time that he met a young model, Hortense Fiquet, who was then nineteen. She was born in Salign[e]y in the Jura and had lived in Paris with her mother until the latter's death. Nothing is known of her father except that he was a landowner [in Lantenne] in the department of Doubs around 1886. Hortense Fiquet was a tall and handsome brunette with large black eyes and a sallow complexion. Cézanne, eleven years older than she, fell in love with her and persuaded her to live with him. Thus he was no longer alone, but he kept his affair secret from his parents, or rather from his father. This change in Cézanne's emotional life does not appear to have influenced either his art or his relationship to his friends.[24]

That damning verdict was the death knell for Hortense Fiquet. On this account, all those portraits counted for nothing. Rewald was not alone in cutting her out of Cézanne's life—the well-connected Georges Rivière, whose daughter Renée married little Paul in 1913, published *Le Maître Paul Cézanne* the year after she died, without mentioning her—but his animus towards her is striking, and it leaks into the work. Rewald was a combative figure. "He could indeed become most aggressive if anyone trespassed onto his territory," as Walter Feilchenfeldt has observed. His opinion of Hortense was aired in an open letter to another scholar, intended to controvert a deviant interpretation. Rewald considered her "a coarse and superficial person, who never did anything for Cézanne, except to sit for him (for which she was well paid or looked after), in life or after."[25] These charges stuck. Hortense became a stock character: the scatterbrain, the scold, the sullen sitter—not so much an apple as a sack of potatoes—a parasite. In marginally less personal terms, the charges were driven home in the conclusion of Rewald's biography, with the story of the artist's death.

When Cézanne died, a few days after collapsing in a thunderstorm out *sur le motif*, Hortense and Paul were in Paris. "Gossip had it," Rewald relates, "that his wife didn't make it in time to Aix because she was unwilling to cancel a fitting at her dressmaker's." The story of the end, endlessly repeated, is not always qualified as gossip or rumor; it has become an essential part of the

martyrology—and a stick with which to beat Hortense, faithless or feckless, according to taste.[26]

The gossip is malicious, and conveniently ignores the part played by Cézanne's sister. The earliest notification of his collapse was a letter sent (too late) by Marie, addressed to his son alone. Marie was concerned to convey the message that Paul's presence was necessary, because the housekeeper could not look after Cézanne by herself. She was equally concerned to convey that Hortense's presence was not required. "Madame Brémond particularly wishes me to tell you that your father is using your mother's dressing room as his studio, and that he doesn't intend to move out of it for the present," she wrote meaningly; "she wants your mother to know this detail, and since the two of you were not expected back here for another month, your mother can remain in Paris for some time longer; by then perhaps your father will have changed studio."[27] Marie, who passed much of her life in devout disapproval, strongly disapproved of Hortense.

Rewald closes his book on an almost vindictive note:

It seems superfluous to add that since Cézanne's death his fame has never stopped increasing and his position as "the father of modern art" has been steadily fortified. The saddest epitaph for him was provided—not too surprisingly—by his widow, who once told Henri Matisse . . . :

"You know, Cézanne didn't know what he was doing. He didn't know how to finish his pictures. Renoir and Monet, they knew their craft as painters."[28]

Is that the authentic voice of Hortense Fiquet? Possibly. It may well be true that she had scant regard for him as a painter. She certainly seems to have regarded the paintings themselves as little more than gambling chips, to be cashed in as the need arose; if for no other reason, it would be futile to hold on to them. No special tenderness attached to the portraits of herself or her son. They were sold, sooner or later, like all the rest. Yet her views as expressed to Matisse were no more than the received wisdom at the time she formed them (or adopted them); she could have picked up opinions of that sort from gatherings at Zola's house almost any night of the week—even from Zola himself. The life of the artist is often a trial to the wife of the artist, as Matisse himself remarked: "As for me, I remain an old fool, as Madame Paul Cézanne called her husband. They tell me that Madame Pissaro said the same of her husband. These women of humble origins had served their husbands according to their

lights, judging their heroes as if they were simple carpenters who had taken it into their heads to make tables with legs in the air."[29] Matisse was right. Even the humble and colossal Pissarro was accused of being a pie-in-the-sky fantasist by the long-suffering and stout-hearted Julie. Hortense was in good company, company not confined to women of humble origins. Such views were commonplace in the Cézanne family, all of whom proceeded to disembarrass themselves of his paintings at the earliest possible opportunity. Nor did they spare his feelings. "Look, Paul," said Marie, as he began to draw his father on his deathbed, "this isn't the time to play games; if we want to capture the look of your dear father, we need a proper painter." That story, too, may be apocryphal: it could easily have been ascribed to Hortense, who spoke with similar directness of Cézanne's bloodshot eyes "popping out of his head" in the herculean effort to see.[30]

It may also be true that she was well looked after. But that does not capture the full range of her experience or her feelings in the matter. Hortense was patient indeed, as the Cézannes themselves acknowledged. She had a long wait before the relationship was recognized. "Seventeen years of concubinage, and in secret!"[31] Did she come to feel a sense of entitlement, or perhaps of just deserts? She was not slow to remonstrate, it seems, yet not given to making scenes. However, after the death of Cézanne's mother and the subsequent sale of the Jas de Bouffan, in 1899, a telling little drama was acted out between them. As Maurice Denis heard from his friend André Gide:

> Having lost his beloved mother, Cézanne dedicated a room to her memory in his apartment: there he kept the bibelots that reminded him of her, and often shut himself away inside. One fine day, his jealous wife destroyed these mementos. Accustomed to his wife's foolishness, Cézanne came home, found everything gone, took off, and stayed away for several days in the countryside. His wife joyfully told a friend: "Do you know what! I burned everything." "And what did he say?" "He went wandering in the countryside: he's an eccentric."[32]

Hortense the harpy was not the only permutation. In reality, Madame Cézanne had several voices, some of them difficult to catch. Only two letters in her own hand have survived. Neither conforms to the stock character.

One is addressed to Marie Chocquet, the wife of Cézanne's patron and friend. This was a significant relationship for Cézanne; it helps to explain the letter. Victor Chocquet (1821–91) was a customs official and a born collector.

In his own unemphatic but enthusiastic fashion, he was one of the most important private collectors of the nineteenth century. His idol was Delacroix. In 1862 he had made bold to write to the master in the hope that he would accept a commission for a portrait of Madame Chocquet. Delacroix declined; eye trouble had compelled him to give up portraiture altogether. In 1863 he died. The following year Chocquet attended the auction of the contents of his studio and bought an oil painting, *Bouquet of Flowers,* for 880 francs—much more than he was accustomed to paying. A magnificent watercolor on a similar theme eluded him; it went for 2,000 francs to the executor of the estate. Delacroix himself evidently attached great importance to this work, singling it out in his will: "It is my express wish that a large brown frame representing flowers placed as if at random against a grey background be included in the sale." Happily, the executor died the very next year, enabling Chocquet to acquire it for only 300 francs. Cézanne was a fervent admirer of this watercolor, which he was able to study firsthand at Chocquet's homes at Yvetot and Hattenville, in Normandy. Chocquet would lay out the works on the living-room floor, for them to pore over at leisure. Rivière reports that, one day, "on their knees, these two super-sensitive beings, bent over the sheets of yellowed paper which for them were so many relics, began to weep."[33]

Chocquet died in 1891, leaving his wife as sole heir; after her death, his collection was sold at auction in 1899. Cézanne was painting Vollard's portrait at the time. The sitter was enjoined to silence, and still-life immobility, but the painter would prattle away as the mood took him. Cézanne discoursed freely on the importance of the *line of concentration* (which was lost if the sitter moved); his own want of *optical skill*; his inability to *realize* like the Old Masters (citing Poussin and Veronese, and also Delacroix and Courbet); his belief in his own *sensations*; his perennial optimism that circumstances would be conducive to his being able to *see,* tomorrow, a sentiment straight out of *Waiting for Godot*; his abomination of dogs, especially dogs that barked, and his corresponding veneration of the prefect of police, who was reported to have given an order to arrest every one of them (when next distracted by a barking dog: "*le bougre,* he's escaped!"); above all, the need for a *grey day.*[34]

He also spoke of the Chocquet sale, telling Vollard, "You must go and see the [works by] Delacroix in the Chocquet collection," and apprising him of the watercolor, and the clause in the will.[35] Suitably primed, Vollard attended the sale and made three purchases. By far the most expensive was a certain watercolor on grey paper by Delacroix, *Bouquet of Flowers* (1848–50), which cost him 1,325 francs. A little later he presented it to Cézanne. Émile Bernard saw

it in the artist's bedroom in Aix, kept within reach, its face carefully turned to the wall, to prevent it from fading. There was a palpable sense of transmission. The watercolor by which Delacroix set such store joined a select company: Cézanne made a copy of it.[36] If Picasso Picassified everything he touched, Cézanne Cézannized—even Delacroix—one of his most important lessons.

Cézanne and Chocquet struck up a wonderful friendship. Renoir introduced them but it was Delacroix who brought them together. "Renoir tells me that you like Delacroix?" hazarded Cézanne. "I adore Delacroix," replied Chocquet. "We'll look together at what I have of him." What he had eventually amounted to over eighty paintings, drawings, and watercolors. They met in 1876: it was love at first sight. Indeed, even before. In the ramshackle back room of Père Tanguy's paint shop the previous year, Chocquet had picked up a small Cézanne, *Three Bathers,* for fifty francs.[37] He was delighted with his purchase. "How well it will go between a Delacroix and a Courbet!" On the doorstep, there was a scintilla of doubt. What would his wife say? *Three Bathers* was small but difficult—the bathers looked awkward and otherworldly. Chocquet persuaded Renoir to pretend that it was his, and that he had unaccountably left it with them. In this way Madame Chocquet would have a chance to get used to it; the truth and the painting would be easier to accept. No one knows how long this ruse was maintained. Renoir eventually put an end to it by telling all to Marie Chocquet, advising her that she would make her husband very happy if she acted as if she knew nothing. So it proved. Marie, it seems, was never as enamored of Cézanne's work as was her husband. Cézanne painted no fewer than six portraits of Victor Chocquet, but there would be no commission for a portrait of Madame.[38]

Cézanne's portraits of Chocquet are works of arresting originality, as attested by no less an authority than Degas, who owned one and coveted another ("the portrait of one madman by another"). The maddest one of all was shown at the third impressionist exhibition of 1877; as if to echo Degas, it was greeted as an example of "artistic insanity" (color plate 29). It is a portrait of a noble head. The collector and the inspector find common ground in a work worthy of their hero: a work that has been compared with Delacroix's idealized portrait of Chopin. On this occasion Chocquet is inspected in close-up ("If a head interests me, I make it too big"). His elongated, leonine head is alive with brushstrokes and color; he has a grey-green mane. He is endowed with a stately dignity, a certain melancholy, a swirling vibrancy, an incandescence. *Portrait of Victor Chocquet* is a small painting of such grandeur and gravity

and riveting unorthodoxy that it quite eclipsed a refined little Renoir of the same subject, and brought down a torrent of abuse on the *Head of a Man,* as it was originally titled. "It's a worker in a blue smock, whose face—long, long, as if passed through a wringer, and yellow, yellow, like that of a dyer who specialized in ocher—is framed by blue hair bristling from the top of his head," wrote one critic.[39] A contemporaneous work, which might have been called *Portrait of Victor Chocquet in a Louis XVI Chair with Sawn-off Legs,* offers another remarkable image of the collector, collected, in angular repose, the face out of focus, the figure out of joint, torqued in the intricate tapestry of his well-upholstered world, at the same time dignified and detached from the fray.[40]

Can we see in *Head of a Man* something more than the sitter? "In the portrait of his admirer," suggested Meyer Schapiro, "Cézanne speaks also of himself." Lawrence Gowing went even further, proposing that he "remodeled his own self-image" on his portrait of Chocquet.[41] Portraiture is a reflexive process, and a mutual reckoning. Cézanne cared about his own singularity as much as he did about the singularity of his subjects. As he measured Chocquet for the frame, surely he measured himself. His portraits were searching examinations. Searching and self-searching were more or less inseparable. In the nature of his relationship with Victor Chocquet, he was led to compare their lot. That relationship was sealed by the first portrait: *Head of a Man* and its laughable reception had the force of a treaty between them. "You yourself feel that each brushstroke I make is a little of my blood mixed with a little of your father's blood," as he put it to Joachim Gasquet, "and that there's a mysterious exchange which he isn't aware of, which goes from his soul to my eye, which recreates it, and in which he will recognize himself. . . . We must live in harmony, my model, my colors, and me, and together catch the same passing moment."[42] For Cézanne, the portrait was a blood pact.

Chocquet was committed. In fifteen years he amassed an outstanding collection of thirty-three Cézannes. Zola knew him, or knew of him. Chocquet, alias Hue, has a cameo in *L'Œuvre:* "M. Hue, a former chief clerk, was unfortunately not rich enough to buy all the time, and he could only lament the blindness of the public, who once again allowed the genius to die of hunger; convinced by the grace of God from the very first glance, he himself had selected the most difficult works, which he hung next to his Delacroix, prophesying for them equal renown."[43] The cameo was true to life. Chocquet was almost as quick as Pissarro to appreciate Cézanne. As was only fitting, Cézanne paid him characteristic homage in *The Apotheosis of Delacroix* (color plate

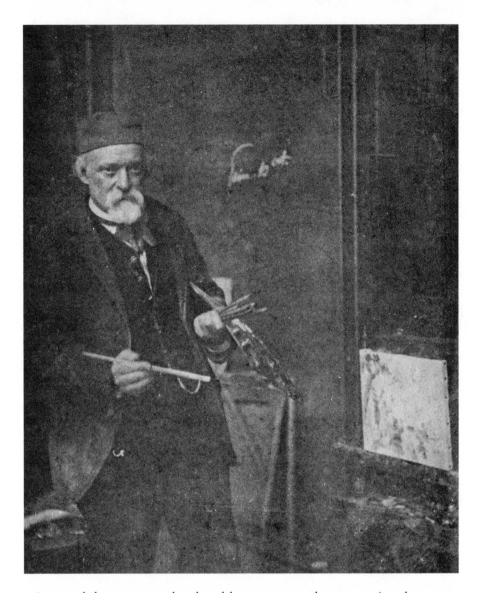

30), a work long contemplated and long postponed, representing the master ascending to heaven, borne up by angels, one of whom carries his palette and brushes. Among the worshippers below are Pissarro at his easel, Monet under an umbrella, Cézanne himself with walking stick and painting paraphernalia on his back, a barking dog (symbol of envy, according to the artist), and the unmistakable figure of Chocquet, applauding, under a tree.[44]

On the back of an earlier sketch for that work, Bernard stumbled upon another of Cézanne's verses, a fragment of imitation Baudelarian. The original drawing has been dated to the middle or late 1870s; Cézanne took it up again

twenty years later and added some watercolor. If the verse is contemporaneous with the sketch, then it appears that he continued to fight his talent for even longer than is generally realized—or else that elusive muse made an unscheduled return. However that may be, the versicule is not completely ridicule.

> Here is the young woman with the curvaceous buttocks.
> How well she flaunts herself in the setting of the meadow
> Her supple form, splendid blossoming;
> No serpent has greater suppleness
> And the sun obligingly shines
> Some golden rays on that flesh.[45]

Like Pissarro, Chocquet was the older man; old enough to earn the honorific Père Chocquet from the painters. He too joined a select company: not only did he discuss Cézanne's painting with him, and effectively commission work—from an artist who almost never took commissions—he also became a moral support. Did Cézanne see him as his Maecenas, like Horace and the original Maecenas in ancient Rome? He even painted two panels, *The Peacock Basin* and *The Barque and the Bathers,* for Chocquet's property in Paris, an eighteenth-century *hôtel particulier* in the Rue Monsigny, tucked between the Opéra and the Bourse.[46]

The friendship between Cézanne and Chocquet had another novel feature: their wives were included.[47] The Chocquets were enlightened enough to embrace the Cézannes as a couple, or rather as a family unit, for Le Boulet could not be detached from his mother. Ironically, the author of the letter that precipitated the crisis with Cézanne's father, with its innocent reference to "Madame Cézanne and little Paul," was Victor Chocquet. From time to time, therefore, Madame Cézanne had an opportunity to socialize with her husband in the tasteful surroundings of the Chocquet family home—and to make a friend of Marie Chocquet, a woman with "expectations," as the French say: expectations of coming into a substantial inheritance in her own right. If Cézanne compared his lot to Chocquet's, Hortense could hardly resist comparing hers to Marie's.

Hortense's father died in December 1889, leaving the same thirty-nine acres, now fallow. The following summer she and Cézanne traveled to the Jura to settle the will. They rented a house in nearby Emagny, not far from the Swiss border. From there, Hortense wrote to Marie Chocquet:

Dear Madame and friend

You must be back from Paris, so I am sending you my letter. We are going to leave on Thursday or Friday for Switzerland where we expect to end the season. It is very good weather and we are hoping that continues.

[Little] Paul and I have already spent ten days in Switzerland and we found the country so beautiful that we came back eager to return. We saw Vevey where Courbet did the lovely painting that you own.

I hope, dear Madame, that you and Monsieur Chocquet and little Marie are well.

You must be very busy with your *hôtel* for it is no small matter to restore and furnish four floors. I hope that it will be finished promptly and that you will be able to settle in soon. I think that you will like it there and that you will not much regret any trouble caused.

We are fine. I feel better than when I left, and I am hoping that my trip to Switzerland will put me right completely. We plan to look for somewhere to stay and to spend the summer there. My husband has been working pretty well; unfortunately he was disturbed by the bad weather that we had until 10 July. Still he continues to apply himself to the landscape with a tenacity deserving of a better fate.

Monsieur Chocquet must be very busy with all his paintings, furniture and lovely bibelots. We hope that next year we shall have the pleasure of seeing you in Switzerland. You will not have the disruption of this year and I can assure that you will find the country superb; I've never seen anything so beautiful and it is so refreshing in the woods and on the lakes, and it would give us so much pleasure to have you.

My husband and Paul join me in sending you our best wishes and beg you to recall our great friendship for Monsieur Chocquet. . . .

For you, dear Madame and friend, I embrace you with all my heart and am your affectionate

Hortense Cézanne
P.S.: My mother-in-law and sister-in-law Marie are reconciled, I am in heaven. Once we are established in Switzerland I will send you our address.[48]

Contrary to popular belief, Hortense was no dumb brunette. She could talk, and she could write. (Her signature on the marriage certificate is notably con-

fident, even stylish.) The tone here is perhaps a little stilted, and some of the phrasing over-rehearsed; the preoccupations may appear rather narrow, and the sentiments rather trite. But that is an ungenerous reading. Hortense did not have the benefit of Cézanne's classical education. She was not his intellectual equal; there too she was in good company. Her letter writing lacked polish, but this was evidently not an easy letter to write. It is part bread-and-butter, part cultivation, part gossip. The mix of affection and affectation is carried off reasonably well; and there are flashes of genuine feeling, including the postscript. If Marie Chocquet was not exactly a bosom friend, she was clearly something of a confidante.

The other letter is even more unexpected. It was written to Émile Bernard in September 1905:

Dear Monsieur Bernard

I enclose the requested authorization. I hope that it is in the desired form? But my husband says that you have absolutely no need for it in Holland. One can reproduce whatever one wants, there is no law for the protection of artworks—nor books—no one can make any complaint on that subject. And since my husband is a doctor of law (he did his studies before becoming a painter) he should know!

Nevertheless I am writing this evening to the "Wereldbibliotheek" [publishing house in Amsterdam] which has the folios to send us an authorization. However, if they do not do it, do not worry—it is an indication that you do not need one. . . .

You saw from my previous letter that the drawings are at [illegible]. I hope those twenty-five drawings are enough for you? With the others that makes a reasonable total and as I said, I can *categorically* promise the others. The choice is yours—that is all I can do. You have no idea how much trouble this causes me all the time. Now they are asking me for more exhibitions for November. I had only two months' rest this summer and I really needed them because I am worn out! In any event good luck with your book. I shall be very glad to have a copy of your South of France!

All the best to you.

MHC
Good wishes from my husband and son. . . .[49]

Here are snatches of a different voice: Hortense transacting business on behalf of her husband. It has been assumed that the business, like the art, was not her province—that she was rigorously excluded, or that she effectively excluded herself, on grounds almost of diminished responsibility. Towards the end of his life Cézanne used his son as an intermediary with dealers, with Vollard in particular. That his wife may have played an active part in his affairs comes as a surprise. Yet it seems to be so. And the signs are that it was a continuing one, at least on a relatively small scale. They seem to have discussed this together. What is more, the business is transacted with some aplomb, and even a dash of wit. Cézanne as doctor of law is a nice touch.

Hortense was always "delicate," and often unwell; she preferred to live in Paris for health reasons.[50] This may also explain why she was so attached to Switzerland, where she spent much of her old age. And there is circumstantial evidence to support it. When they were apart, Cézanne's son evidently sent him regular bulletins on Hortense's health; in one of his last letters Cézanne replied, "I cannot but deplore the state your mother is in, take as much care of her as possible, look out for her well-being, coolness, and diversions appropriate to the circumstances."[51] When they were together, it may be that their movements were governed by just these considerations. In 1896, for example, Cézanne spent a month at the Hôtel Molière in Vichy; La Boule and Le Boulet were with him. He was not there for the good of his health—"you can eat well here," he reported puckishly. Perhaps it was for the good of hers. After that, regardless of his preferences, they proceeded to spend a summer in the Haute-Savoie, at the Hôtel de l'Abbaye in Talloires, on the shores of Lake Annecy, where Cézanne staved off boredom by eating well and painting a majestic picture of the view across the lake, customized and Cézannized to suit his purpose. "To relieve my boredom, I'm painting," he wrote to Solari, "it's not much fun, but the lake is very good with the big hills all around, 2,000 meters, I'm told, not much in our country, though truth to tell it's fine. But when you're born down there [in Provence], that's it, there's nothing more to be said. One must eat well, drink well—do you remember Pierre's 'the vine is the mother of the wine'?—and by the way I'll be getting back to Paris at the end of August. When shall I see you again?" For Cézanne, the scenery was irredeemably second-rate; in the Haute-Savoie, nature itself left something to be desired.

Maxime Du Camp used to say that Flaubert's preferred form of travel was to lie on a divan and have the scenery carried past him. Something of the same was true of Cézanne. In another letter, to Joachim Gasquet, he poked fun at his own predicament: "Here I am far from our Provence for a while. After much

toing and froing, my family, in whose hands I find myself for the moment, have decided to attach me for the time being to the spot where I now find myself. It is a temperate zone. The altitude of the surrounding hills is fairly considerable. Narrowed here by two tongues of land, the lake seems to lend itself to the linear exercises of young misses. It's still nature, certainly, but rather as we have learned to see it in the travel albums of young ladies."[52]

If those toings and froings were dictated in whole or in part by Hortense's health, it puts a slightly different complexion on her remarks to Marie Chocquet ("I feel better than when I left") and to Émile Bernard ("I am worn out"). Inasmuch as that casts her frailties and her asperities in a new light, it may temper our judgment. It may also alter our conception of Hortense herself. The sybarite does not consort well with the valetudinarian. The life of the lotus eater leaves little time for taking the waters. Prone to debility, the high roller of Monte Carlo tangles with the patience player of Vichy. In this light, she appears less high-and-mighty and more needy, less imperious and more exposed. So far from being solid, stolid, fat, and placid, La Boule begins to look curiously fragile, just as she does in some of Cézanne's variations, which become at once more understanding and more penetrating than we ever realized. All those portraits take on a new aspect. *Madame Cézanne in a Red Dress* or *Madame Cézanne with Her Head Lowered* assimilate the fragility, as if to say *Madame Cézanne, Delicate*—no longer lumpen, but strangely weightless (and ageless, and placeless), leavened with that new knowledge. For Hortense Fiquet, then, a kind of makeover: not shallow but sentient, not flighty but constant, not the Dumpling but the Crock.

As so often, Rilke intuited something of this at the 1907 retrospective, which included two of those portraits, *Madame Cézanne in a Striped Skirt* (color plate 33) and *Madame Cézanne in a Yellow Armchair* (color plate 34). The young poet watched people milling about in the Cézanne rooms, "amused, ironically irritated, annoyed, indignant," and noted their bafflement.

> And when they finally arrive at some concluding remark, there they stand, these Monsieurs, in the middle of this world, affecting a note of pathetic despair, and you hear them saying: *il n'y a absolument rien, rien, rien* [there's absolutely nothing in it, nothing, nothing]. And the women, how beautiful they appear to themselves as they pass by; they recall that just a little while ago they saw their reflections in the glass doors as they stepped in, with complete satisfaction, and now, with their mirror image in mind, they plant themselves for a moment, without looking, next to

one of those touchingly tentative portraits of Madame Cézanne, so as to exploit the hideousness of this painting for a comparison which they believe is so favorable to themselves.[53]

Rilke was enraptured by *Madame Cézanne in a Striped Skirt* (also known as *Madame Cézanne in a Red Armchair*). When he could adore it no more, he was bereft. "The Salon is closing today," he wrote to his wife.

And already, as I'm leaving it, on the way home for the last time, I want to go back to look up a violet, a green, or certain blue tones which I believe I should have seen better, more unforgettably. Already, even after standing with such unremitting attention in front of the great color scheme of the woman in the red armchair, it is becoming as irretrievable in my memory as a figure with many digits. And yet I memorized it, digit by digit. In my feeling, the consciousness of their presence has become a heightening which I can feel even in my sleep; my blood describes it within me, but the naming of it passes by somewhere outside and is not called in. Did I write about it? A red, upholstered low armchair has been placed in front of an earthy-green wall in which a cobalt-blue pattern . . . is very sparingly repeated; the round bulging back curves and slopes forward and down to the armrests (which are sewn up like the sleeve-stump of an armless man). The left armrest and the tassel that hangs from it full of vermilion no longer have the wall behind them but instead, near the lower edge, a broad stripe of greenish blue, against which they clash in loud contradiction. Seated in this red armchair, which is a personality in its own right, is a woman, her hands in the lap of a dress with broad vertical stripes that are very lightly indicated by small, loosely distributed flecks of green yellows and yellow greens, up to the edge of blue-grey jacket, which is held together in front by a blue, greenly scintillating silk bow. In the brightness of the face, the proximity of all these colors has been exploited for a simple modeling of form and features: even the brown of the hair roundly pinned up above the temples and the smooth brown of the eyes has to express itself against its surroundings. *It's as if every part were aware of all the others*—it participates that much; that much adjustment and recognition is happening in it; that's how each daub plays its part in maintaining equilibrium and in producing it: just as the whole picture finally keeps reality in equilibrium. For if one says, this is a red armchair (and it is the first and ultimate red armchair in the

history of painting): it is that only because it contains latently within itself an experienced sum of color which, whatever it may be, reinforces and confirms it in this red. To reach the peak of its expression, it is very strongly painted around the light human figure, so that a kind of waxy surface develops; and yet the color does not preponderate over the object, which seems so perfectly translated into its painterly equivalents that, while it is fully achieved and given as an object, its bourgeois reality at the same time relinquishes all its heaviness to a final and definitive picture-existence. Everything . . . has become an affair that's settled among the colors themselves.[54]

Almost a century later, the American painter Elizabeth Murray responded to *Madame Cézanne in a Yellow Armchair,* also known as *Madame Cézanne in a Red Dress* (color plate 34), with a rapture of her own. "I am fascinated by what he must have thought of Hortense, and how much you can tell from looking at this picture," she said to the critic Michael Kimmelman, as they stood in front of it, in the Metropolitan Museum in New York. For Murray, it suggests a mixture of fear and love.

She's not really sitting in the chair, and sometimes it seems as if she weighs about five hundred pounds and other times she looks like a hollow dress with arms and a head sticking out of it. You can't really tell whether she's standing or whether she's sitting because she is so stiff, though she's tilting. The image seems to be all about uncertainty, the deliberate way nothing ever quite comes together. Like the hands: they're there and not there at the same time. They're formed and holding something, like a handkerchief or a flower, maybe, I'm not sure, but then the longer you look the more they decompose. From a distance you'd think those hands are flesh-toned, but when you get close up they turn into a multitude of different colors coming together to make this highly abstract form. . . . I mean, this is very complex stuff: clearly, Hortense is regarding her husband, not with disdain, but as if she's saying, "You old fool." And all this emotion, this angst, this frustration is in the picture.[55]

The red dress and the radical uncertainty recur. Also the old fool. Cézanne painted four portraits of Hortense in that outfit, three of them in that chair— not really sitting, but levitating, almost floating off the furniture (and in the fourth, completely free-standing, adrift in space: *Madame Cézanne, Ascendant,*

nimbed in yellow).[56] But for the dress, and the parting, and the decomposing hands, the four Hortenses are barely recognizable as the same woman. In the one that fired Elizabeth Murray's imagination, the right eye acts as a kind of marker. The prominent eyebrow arches like a circumflex; the expression is hard to read, as always, but the eyebrow lends her a skeptical or quizzical air—this woman has seen a lot, and is unlikely to be taken in. The eye itself is more focused than usual; the inspection is mutual. Anomalously, a patch of paleness creates a faceting effect around it—not a black eye but a white one—especially below, as if that eye alone bears witness to an unsuccessful experiment with clown makeup. This feature is not present in the other variants, though one of them displays something akin to it: a Hortense of rare modesty, whose features are more delicate than her state of health, has a different coloration, but a vestige of the same whitening, with heavier outlining; in this case the effect is more like eyepieces or goggles. Juan Gris painted a cubistic version of it.[57]

Every Hortense is startling, or disquieting, in her way. Some are severe and unbending, some tender and vulnerable, some clenched and remote, some uncomfortable and dissatisfied, some contemplative, some dreamy, some spirited, some disappointed. All share a certain irresolution. These portraits capture an uneasy psychology rather than a complete physiognomy. They are neither flattering nor reassuring. They are often appealing but never alluring. They are infinitely more emotional and expressive than is generally allowed, but there is also a sphinxian quality to them, a reserve, a refusal to ingratiate, in the art historian Susan Sidlauskas's phrase. Hortense does not endear herself to us; neither do the portraits. The sitter, like the painter, offers no comfort to the viewer. If she was exposed, she was also well defended. In spite of the dressmaking, and the fashion sense, "she seems stubbornly resistant to the usual markers of femininity," as Sidlauskas says. In a number of the portraits, "Madame Cézanne is rendered in mannish lines." Opinion differs—one man's mannish is another man's "broad and handsome brow, small, elegant ear, and wonderfully modulated jawline." More often than not, however, the locus of intimacy is elsewhere. It is to be found in "that passionate rifling of detail—the articulation of a wrist, the juncture of a head and neck, the quality of a hairline—that conveys so much of Cézanne's eros." A hundred years after the portraits were painted, we are still taking the measure of the exploratory nature of the work.[58]

In truth she is not so much defeminized as defamiliarized. She is *Madame Cézanne Made Strange*. Did the long fixation, the fanatic attention, allow Cézanne to achieve a certain distance? Fascinated by Felice Bauer, who became

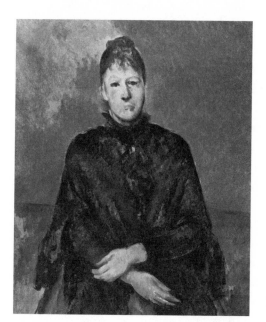

his fiancée, Kafka recorded in his diary: "I alienate myself from her a little by inspecting her so closely."[59] Hortense's manifold strangeness is often distancing, and more often disconcerting; it has probably encouraged the purloining of her image. In his study *Cézanne's Composition*, first published in 1943, Erle Loran employed an outline diagram of a *Portrait of Madame Cézanne* to explain how he did it. Twenty years later, the pop artist Roy Lichtenstein reproduced the same diagram, life-size, in paint on canvas, and called it *Portrait of Madame Cézanne*. Loran was outraged (as outraged as the original critics) and brought charges of plagiarism; others may well have felt that a cartoon of a diagram of *Madame Cézanne as Motif*, as one philosopher puts it, was an apt comment on Cézanne's pictorial purpose.[60] Ten years on, Elizabeth Murray herself made *Madame Cézanne in a Rocking Chair* (1972), a kind of semi-abstract comic strip, arranged as a grid (color plate 40).[61] Madame Cézanne, a stick figure in a silent comedy, sits under a window; a moonbeam of yellow light falls on her. In one sequence the beam pulls her straight through the window; in another it puts her to sleep, and she tumbles headfirst, in a pratfall, from her chair. It is surely no coincidence that all these effigies or specters treat Madame Cézanne as multiple ("I'm always true to you, Cézanne," joked Murray).[62] The original portraits have an element of the identikit: a sense that the witness assists in producing the likeness, and that the likeness produced is the one that the witness requires.

Hortense is a haunting presence. When Gertrude Stein bought *Madame Cézanne with a Fan* (color plate 39) from Vollard in 1904, the dealer appears

to have conceded something to mannishness, or possibly to strangeness. "Vollard said of course ordinarily a portrait of a woman is more expensive than a portrait of a man but, said he looking at the picture very carefully, I suppose with Cézanne it does not make any difference." The portrait hung above Stein's favorite chair. It inspired her own art, she said, and it haunted Picasso as he tried to find a way to resolve his *Portrait of Gertrude Stein* (1905–06). There is a remarkable consonance between the solution he found and the painting she liked so much, "a portrait of a woman with a long face and a fan."[63]

She has a face—sometimes long, sometimes round, sometimes oval—and a gaze. The face is a battleground, a beaten zone. Painter and sitter fight for possession: self-possession. His sensations war with hers. Every so often he seems to overwhelm her defenses. The face falls, the mouth turns down, the lips are bruised and spoiled, like overripe fruit.[64] Self-possession is skin-deep. Fragility wells up from within as if by capillary action. Hortense's face is suffused with feeling. The feeling may be acid green, pale coral, alizarin crimson, green blue, yellow ocher. "God help them," exclaimed Cézanne, of ignoramuses everywhere, "if they cannot imagine how you can make a mouth look sad or a cheek smile by blending a fine shade of green with a red."

Out of this struggle something deeper emerges, something of the hidden self, the personality and its suffering, its manifold restraints, its tender spots, its spiky privacy. This may help to explain how the face can appear masklike, but also exquisitely alive, while the gaze is frequently lost. The blank stare that Picasso purloined for himself (and Gertrude Stein) was characteristic. Samuel Beckett's favorite actor, Billie Whitelaw, once asked him which way she should look onstage. Beckett thought for a moment and then replied, "Inward."[65] Marooned onstage, Hortense looks inward.

Nietzsche thought that "one builds one's philosophy like a beaver, one is forced to and does not know it." Perhaps the same is true of paintings, and portraits. Painting inwardness is a tall order; the body parts are built, beaver-fashion, and the special effects—the torsion, the tension, the tilt. Cézanne was a painter by inclination, as he liked to say. Hortense, posed, was inclined to be intractable. Cézanne expected nothing less: in this respect, he was not disappointed. "If you think it's easy to do a portrait . . . " he muttered, as he tried to explain to Henri Gasquet:

Between you and me, Henri, I mean between what makes up your personality and mine, there is the world, the sun, what's going on, what we see in common. Our clothes, our bodies, the play of light, I have to dig

through all that. That's where the slightest misplaced brushstroke spoils everything. If I'm purely emotional about it, I slap your eye on sideways. If I weave around your expression the entire network of little bits of blue and brown that are there, that combine there, I'll get you to look as you look, on my canvas. One stroke after the other, one after the other. And if I'm unemotional, if I draw and paint as they do in the schools, I'll no longer see anything. A mouth, a nose, by the book, always the same, with no soul, no mystery, no passion. Every time I'm at the easel I'm a different man, and always Cézanne.

He turned to Gasquet's son:

Look, Gasquet, your father, he's sitting there, isn't he? He's smoking his pipe. He's listening with only one ear. He's thinking—what about? Besides, he's buffeted by sensations. His eye is not the same. An infinitesimal proportion, an atom of light, has changed, from within, and has met the unchanging or almost unchanging curtain in the window. So you see how this tiny little minuscule tone which darkens under the eyelid has shifted. Good. I correct it. But then my light green next to it, I can see it's too strong. I moderate it. . . . I continue, with almost invisible touches, all over. The eye looks better. But then, there's the other one. To me, it squints. It's looking, looking at me. Whereas this one is looking at his life, his past, you, I don't know what, something which is not me, not us . . .

HG: I was thinking of the trump I held until the third trick yesterday.
CÉZANNE: You see![66]

The human face was for Cézanne, as for Proust, "like the face of the God of some oriental theogony, a whole cluster of faces juxtaposed on different planes so that one does not see them all at once."[67] He never saw Hortense all at once. She was every time a different woman, and always Hortense. In fact, she is always recognizable. Through the gusts of sensation and the myriad disguises, one part of her held constant: the upper lip. The soul of Madame Cézanne is encoded in the upper lip.

Self-Portrait: The Dogged

This portrait (color plate 3) is usually dated around 1875, when Cézanne was thirty-six. The pose, the poise, the pyramidal shape, the physiognomy, and the hirsute integrity recall a magnificent self-portrait by Pissarro (color plate 28), which Cézanne must have seen, while the features and the set of the face bear some resemblance to Pissarro's comradely *Portrait of Paul Cézanne* (color plate 25) of 1874.[1]

Rilke saw it at the 1907 Salon d'automne and was fascinated:

His right profile is turned by a quarter in the direction of the viewer, looking. The dense dark hair is bunched together at the back of the head and lies above the ears so that the whole contour of the skull is exposed; it is drawn with eminent assurance, hard and yet round, the brow sloping down and of one piece, its firmness prevailing even where, dissolved into form and surface, it is merely the outermost contour containing a thousand others. The strong structure of this skull which seems hammered and sculpted from within is reinforced by the ridges of the eyebrows; but from there, pushed forward toward the bottom, shoed out, as it were, by the closely bearded chin, hangs the face, hangs as if every feature had been suspended individually, unbelievably intensified and yet reduced to utter primitivity, yielding that expression of uncontrolled amazement in which children and country people can lose themselves— except that the gazeless stupor of their absorption has been replaced by an animal alertness which entertains an untiring, objective wakefulness in the unblinking eyes. And how great this watching of his was, and how unimpeachably accurate, is almost touchingly confirmed by the fact that, without even remotely interpreting his expression or presuming himself superior to it, he reproduced himself with so much humble objectivity,

with the unquestioning, matter-of-fact interest of a dog who sees himself in a mirror and thinks: there's another dog.[2]

The doggedness carried. A century on, another poet ponderered the man Cézanne—his Cézanne—and his own poetic tribute. Seamus Heaney took up where Rilke left off:

I love the thought of his anger.
His obstinacy against the rock, his coercion
 of the substance from green apples.
The way he was a dog barking
at the image of himself barking.
And his hatred of his own embrace
of working as the only thing that worked—
the vulgarity of expecting ever
gratitude or admiration, which
 would mean a stealing from him.
The way his fortitude held and hardened
because he did what he knew.
His forehead like a hurled *boule*
traveling unpainted space
 behind the apple and behind the mountain.[3]

He is all there, yet in a strange way half-camouflaged against the background. His head seems to merge with the wallpaper, almost as if the pattern is replicated on his domed forehead, like a passing cloud. Some of Cézanne's remarks might suggest that he was not enamored of his own appearance, in particular his premature baldness. Whether this has anything to do with his adoption of a hat in eight of the self-portraits, more often than not he does not shrink from bravura painting of that very spot. Here, the figure is solid, the gaze is level, the face is mobile, and the cranium extraordinarily animated. "Already in his early thirties he was bald on top," observed Adrian Stokes laconically. "It is difficult when considering the wonderful volume he always achieved for the dome of his skull not to feel that this was very fortunate for the artist."[4]

Cézanne painted a family of self-portraits at around this time. One of them was owned by Degas (front of dust jacket), another by Pissarro (color plate 7).[5] A third was later acquired by Duncan Phillips for the Phillips Collection in

Washington, D.C. (color plate 8). When it was exhibited at the 1904 Salon d'automne, the critics excelled themselves. "M. Cézannes [*sic*] sends his portrait! A worthy man! He's a worker given to dreaming. Why doesn't he just stick to still life, since he knows nothing about the rest?"[6]

Fifty years later, Kurt Badt felt that the Phillips portrait, in particular, "shows a man who has acquired a seeing eye through resignation, through *humilitas*, with features grown calm, with penetrating glance, i.e., a glance which sees beneath the surface, and is directed in relaxed fashion towards the world of earthly things which unveils itself to him in its true significance."

> Both the features of this prematurely aged man (Cézanne was not yet forty years old) and the lapels and folds of his jacket have here lost all trace of the way in which time has affected them and made them its victim. The whole person apprehended as an architectural structure, the parts of which—related to, supporting and carrying one another—seem to assure a spiritual existence or, more correctly, to signify its preservation. Here the features have actually become completely spirit and soul.[7]

Against this monument to piety may be set Lawrence Gowing's tribute to impiety: "The sly, faun-like glint betrays that Cézanne himself remains detached. He secretes the independence, even the wit, to examine the shape which is himself."[8]

Around 1937, at almost exactly the same age, Alberto Giacometti copied the head in this self-portrait. Giacometti was similarly dogged. He had an obsessive interest in Cézanne's head, and indeed in his work as a whole, including his revolutionary treatment of the head.[9]

Inevitably, it was owned at one time by Auguste Pellerin, and later by another prodigious collector, Ernst Beyeler. It is now in the Musée d'Orsay in Paris.

7: The Lizard

Soon after they got together, they eloped to L'Estaque. There they sat out the Franco-Prussian War, the siege of Paris, the Commune, and the establishment of the Third Republic, while Cézanne worked *sur le motif,* as he told Vollard, and made occasional forays to the Jas to see his mother. By his own account, this tumultuous period was remarkably uneventful.

In an outpouring of republican fervor, the citizens of Aix elected the chemist as acting mayor, with a lawyer and a doctor as his deputies. Then they proceeded to destroy all graven images of the emperor, whose bust was detached from its pedestal, kicked out of the council chamber, and thrown into a fountain. Cézanne's father and his friends Baille and Valabrègue were elected to the new, temporary town council. Louis-Auguste was appointed to the finance committee, Baille to the committee for public works, Valabrègue to the committee overseeing the organization of the police, Baille and Valabrègue both to the body responsible for the registration of the national guard. The younger members took their responsibilities very seriously, perhaps overseriously. Marius Roux wrote sardonically of being bored, "watching the revolution go by. In the crowd are the admirable Baille and Valabrègue. They are rejoicing; they hail me loudly. Fancy those two basket-weavers from Paris coming here and getting mixed up in the town council and voting for resistance. Let us march as one man, they proclaim. Let us march! They are fine ones to talk."[1] Louis-Auguste, by contrast, could not be accused of excessive zeal. Out of forty-seven meetings of the temporary town council, he attended only two.

Cézanne was elected in absentia to the supervisory committee of the School of Drawing, surprisingly enough at the head of the list, with fifteen votes out of twenty. (Baille, who was present, secured only four in the first round and eight in the second.) This committee was formally constituted in December

1870 and dissolved in April 1871, having produced one report. Cézanne did not put in an appearance.

In the meantime his whereabouts had become a matter of official concern. In January 1871 Zola, then in Bordeaux, received news from Roux in Aix of the mobilization of the national guard:

> The unpleasant news is that Paul C . . . is being actively sought and I'm very much afraid that he will not escape being found, if it is true, as his mother says, that he is still in L'Estaque. Paul, who in the early days did not fully realize what would happen, was seen a lot in Aix. He went there quite often, in fact, and stayed one or two or three days or more. It is also said that he got drunk in the company of gentlemen of his acquaintance. He certainly must have made known his place of residence since the gentlemen in question (who must be jealous of him for not having to earn his living) made haste to denounce him and to give all necessary information for him to be found.
>
> These same gentlemen (here is the astonishing news) to whom Paul said that he was living in L'Estaque with you—not realizing that you've since been able to leave that hole, and not knowing whether you were married or single—at the same time gave your name as a draft dodger. On the evening of 2 January my father took me aside and told me: "I've just heard a conscript who said this: 'There are four of us, with Corporal So-and-So, who have to go to Marseille to bring back draft dodgers.' (He gave the names.) Among them, I remember those of Paul Cézanne and Zola. 'Those two,' added the conscript, 'are hiding in Saint-Henri [a neighboring village].' "
>
> I told my father to turn a deaf ear and to take no part in any conversation of this kind; for myself, I did my business and next morning hurried to the town hall. There I have complete access, and was shown the list of draft dodgers. Your name wasn't on it. I told Ferand, a reliable person and devoted to me, what was being said. He replied: "They must have spoken of Zola only because of Cézanne, who is being diligently sought; but if your friend's name was mentioned, it must have been before information was obtained, because Zola doesn't come from Aix and besides he's married."
>
> At the town hall, nothing official, and among the crowd that knows Cézanne's name, I never heard yours.[2]

Apparently the gendarmes went to the Jas de Bouffan, where Cézanne's mother cordially invited them to search the house. "He left two or three days ago," she assured them. "When I find out where he is, I'll let you know."[3] Monsieur Sesame had vanished into thin air. In later life his brother-in-law Maxime Conil was fond of recounting a dramatic version of this escapade, more or less heroic, according to taste: Cézanne was at the Jas at the time; he told his mother to open all the doors and let the gendarmes look round; knowing every nook and cranny, he hid; and they left emptyhanded. "That night Cézanne packed up a few things and tramped over the hills to L'Estaque. . . . And there he remained for the duration of the war." Élie Faure published another variant in 1914, at the time of the next war, and a few years later Maurice Denis told André Gide of the story he had heard, which involved the artist jumping out of the window to avoid capture.[4] The story improved in the telling, and the question of Cézanne's reputation as a draft dodger rumbled on throughout the interwar period, until overtaken by the pervasive issues of occupation and collaboration in the Second World War.

The gendarmes never did find him. How hard they looked, and how far afield, is open to question. In any event Cézanne continued to paint, unmolested. After several months of silence, Zola was getting worried. Alexis was dispatched to his lair in L'Estaque. "No Cézanne!" he reported. "I had a long conversation with Monsieur Giraud [his landlord], known as *lou gus* [the tramp]. The two birds have flown . . . a month ago! The nest is empty, and locked up. 'They left for Lyon,' Monsieur *lou gus* told me, 'to wait until Paris *stops burning*!' " Zola did not fall for this. "What you say about Cézanne's flight to Lyon is an obvious fairy story. Our friend simply wanted to throw Sieur Giraud off the scent. He's hiding in Marseille or at the bottom of some valley. And I must find him as soon as possible, because I'm worried."[5] Zola entrusted Alexis with the mission of calling at the Jas, in order to speak privately to Cézanne's mother, or failing that, asking Emperaire if he had an address for their friend. The scheme worked. Cézanne's mother evidently knew where to find him. Cézanne wrote to Zola, who replied immediately.

I was very glad to get your letter, as I was beginning to worry about you. It's now four months since we heard from one another. Around the middle of last month I wrote to you in L'Estaque, then I found out that you'd left and that my letter might have gone astray. I was having great difficulty finding you when you helped me out. You ask for my news. Here is my story in a few words. I wrote to you, I think, just before I left for

Bordeaux, promising another letter as soon as I returned to Paris. I got to Paris on 14 March [1871]. Four days later, on the 18th, the insurrection broke out [meaning the Commune], postal services were suspended, I no longer thought of giving you any sign of life. For two months I lived in the furnace: cannon fire day and night, and towards the end shells flying over my head in my garden. Finally, on 10 May, I was threatened with arrest as a hostage; with the help of a Prussian passport I fled and went to Bonnières [northwest of Paris] to spend the worst days there. Today I'm living quietly in Batignolles, as though waking from a bad dream. My pavilion is the same, my garden hasn't moved, not a single piece of furniture or plant has suffered, and I could almost believe that the two sieges were bad jokes invented to frighten the children.

What makes these bad memories more fleeting for me is that I haven't stopped working for a minute. Since I left Marseille, I've been earning a good living. . . . I tell you this so that you won't feel sorry for me. I've never been more hopeful or keen to work. Paris is reborn. As I've often told you, our reign has begun!

My novel *La Fortune des Rougon* is being published. You wouldn't believe the pleasure I've taken once more in correcting the proofs. It's as if my first book is appearing. . . . I do feel a little sorry to see that all the imbeciles aren't dead, but I console myself with the thought that none of us has gone. We can resume the fight.

I'm a bit rushed, I'm writing in haste only to reassure you about my situation. Another time I'll tell you at greater length. But you who have all the long day ahead of you, don't wait for months to reply. Now you know that I'm in Batignolles and your letters won't go astray, write to me without fear. Give me the details. I'm almost as alone as you and your letters help me a lot to live.[6]

This letter, with its echoes of their younger days, its solipsism, its extravagance, its badgering, its blithe assumption and its brotherly embrace, seems to have made a strong impression on Cézanne, an impression interestingly shaded. It must also have stirred memories of painting Alexis reading to Zola in that pavilion (with the time-serving black clock on the mantelpiece) and in that garden, the writer sitting cross-legged on the grass, robed for the part of "the morose pasha of realism," receiving the reading like a tribute (color plate 31).[7] When Vollard asked him about his war, Cézanne launched immediately into a reminiscence of Zola and his letter:

I haven't really got anything extraordinary to tell you about the years 70–71. I divided my time between the landscape and the studio. But if I didn't have any adventures during that troubled epoch, it wasn't the same at all for my friend Zola, who had all sorts of misadventures, especially after his final return to Paris from Bordeaux. He had promised me to write when he got to Paris. Only after four long months could he keep his promise!

Faced with the refusal of the Bordeaux government to make use of his services, Zola decided to go back to Paris. The poor man arrived in the middle of March 1871; a few days later, the insurrection broke out. [There follows a recapitulation, almost a paraphrase, of that part of Zola's letter.]

Monsieur Vollard, I regret not having kept that letter. I would have shown you a passage where Zola lamented that all the imbeciles were not dead!

Poor Zola! He would have been the first to be sorry if all the imbeciles were dead. In fact, I reminded him just recently of that phrase in his letter, for a laugh, on one of the last evenings that I saw him. He told me that he was going to dine with a big cheese to whom he'd been introduced by Monsieur Frantz Jourdain. All the same, I couldn't help saying, if all the imbeciles were gone, you'd be forced to eat the rest of your casserole at home, tête-à-tête with your bourgeois! Well, would you believe that our old friend looked none too happy?

Surely, Monsieur Vollard, one can have a little joke when one has worn out our trousers on the same school bench. . . .

Zola ended his letter by urging me to return, too. "A new Paris is in the process of being born," he explained to me, "it's our reign that's coming!" Our reign that's coming! I thought that Zola was exaggerating a little, at least in relation to me. But, all the same, that told me to return to Paris. It had been too long since I'd seen the Louvre! It's just that, you understand, Monsieur Vollard, at that moment I had a landscape that wasn't going well. So I stayed a while longer in Aix, to study *sur le motif*.[8]

Very little survives of that period of study. The vestiges fire the imagination. *Melting Snow at L'Estaque* has been wonderfully described by Lawrence Gowing as "the fearful image of a world dissolved, sliding downhill in a sickeningly precipitous diagonal between the curling pines which are themselves almost threateningly unstable and Baroque, painted with a wholly appropriate slip-

ping wetness and a soiled non-color unique in his work." In this world there is no foothold for the spectator, as Meyer Schapiro remarked; the trees are tormented, and so are we. By contrast, an elliptical drawing, *Landscape at L'Estaque,* evokes a roof, a wall, and the branches of an isolated tree, "which takes on the grace and elegance of a Japanese fan," in Henri Loyrette's deft observation.[9] In the studio, Cézanne worked from a variety of sources, among them—incongruously—fashion plates from *La Mode illustrée.* He copied at least three: *Two Women and Child in an Interior,* from a plate published on 3 July 1870, shortly before war was declared; *The Conversation,* from a plate published on 31 July 1870, shortly after; and *The Walk,* from a plate published on 7 May 1871, at the height of the Paris Commune, two weeks before its bloody suppression.[10] The paintings retained much of the original composition of the plates (and the costumes) while at the same time wrenching them into something more physically present and psychologically charged. Even the fashion plate was Cézannized. Overt political commentary had no part in this procedure. Nonetheless, a cryptic tricolor has been added to *The Conversation.* It flies unobtrusively in the background; it is studiously ignored.

One more tricolor made an unscheduled appearance. *Allegory of the Republic,* in pencil and watercolor, depicts a (naked) woman brandishing a sword and carrying a flag, surrounded by vanquished men. In the background is a sketchy mountaintop. Images of this sort were common currency in the French press after the Franco-Prussian War and its insurrectionary aftermath. When her flag is red, the woman personifies the Commune; here the flag is a tricolor, presumably representing the Republic. This small study, equally vigorous and anomalous, was once a page in Cézanne's sketchbook. Adding to the mystery, experts are divided on whether the drawing on the verso represents Saint Anthony keeping temptation at bay by repelling a woman, or a libertine beckoning one on.[11]

In the latter part of 1871, when Paris had cooled, Cézanne returned. He lodged for a while with Solari, and then found an apartment for himself and Hortense on the second floor of 45 Rue Jussieu, in the Fifth Arrondissement, opposite what was then the Halle aux Vins, known to Cézanne as the wine port.[12] In these cramped quarters, amid the din of deliveries and the raucous sound of barrels rolling over pavements, Hortense gave birth to Paul, on 4 January 1872. Emperaire came and went, unable to understand how Cézanne could live or breathe in such a space; needful as he was, Emperaire's unassailable vainglory swept all before him. His ingratitude knew no bounds. "I'm leaving Cézanne's. I must. Otherwise I could not escape the fate of the others. I

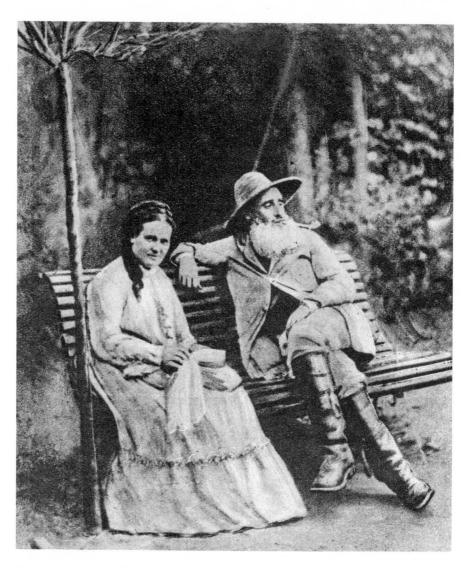

found him deserted by everyone. He no longer has a single intelligent or affectionate friend. The Zolas, the Solaris, all the others, they no longer figure. He's the most amazing article imaginable."[13]

Cézanne painted on regardless, producing a work known as *The Quai de Bercy,* in fact *The Wine Port,* a view from his window, and a kind of companion piece to *Melting Snow at L'Estaque:* a painting vehemently out of joint yet in tune with the times, at once realistic and splenetic-poetic, in which the painter, like Pluvius, "pours / Mortality in gloomy district streets."[14]

Whatever Emperaire might say, he was not without friends. The intelligent and affectionate Pissarro wrote to Guillemet: "Our Cézanne gives us hope, and I've seen some paintings; I have at home one of remarkable vigor and

power [most probably *The Quai de Bercy*]. If, as I hope, he remains for a while in Auvers, where he's going to live, he'll astonish a lot of artists who were too quick to condemn him."[15] After the turmoil of 1870–71, the Pissarros had made their home in Pontoise, northwest of Paris. In the summer of 1872 the Cézannes upped sticks and joined them, settling in nearby Auvers-sur-Oise, where the artists' friend Dr. Gachet lived. They remained until early in 1874. There was important work to be done.

In concert with Pissarro, Cézanne began a campaign of sustained experimentation and self-examination, as satisfying an endeavor as anything he had ever undertaken as an artist. He would walk from Auvers to Pontoise; often he would eat and sleep at Pissarro's house, becoming almost part of the family. "I take up Lucien's pen," he wrote once when Pissarro was in Paris, "at an hour when the railway should be transporting me to my *penates* [home]. That's a roundabout way of saying that I've missed the train. Needless to add that I'm your guest until tomorrow, Wednesday. Now then, Madame Pissarro requests you to bring back from Paris milk powder for little Georges. And Lucien's shirts which are with his aunt Felicity. I bid you good evening." He returned the pen to young Lucien (aged nine), who added: "My dear Papa, Maman wants you to know that the door is broken so come quick because robbers could come. Please bring me a box of paints. Minette [his little sister] wants you to bring her a bathing costume. I am not writing well because I don't feel like it."[16] The children liked Cézanne; he enjoyed teasing them. To Lucien, who had a schoolmaster called Rouleau: "Hey Lucien, have you been rolled over [*roulé*] today?"[17] Julie in her straightforward way liked him too: the feeling was mutual. She sat for him, stalwart and compassionate, in a compact pencil portrait.[18] He was very respectful of them both—she was always "Madame Pissarro"—though he was not above making a little polite mischief. Ever anxious about her husband's commercial prospects, Julie identified some local collectors and invited them to dinner, which she served in her best silk frock. Halfway through, Cézanne arrived, still in his paint-spattered work clothes, scratching himself all over. "Don't take any notice, Madame Pissarro, it's only a flea."[19]

Whether polite mischief turned into ribald mischief in Pissarro's case is matter for speculation, but one authority has called attention to "an equivocal interpretation of a trouser fold" in Cézanne's drawing of Pissarro going off to paint, from a contemporary photograph. There is perhaps an analogous "interpretation" in Cézanne's second version of *A Modern Olympia* (1873), a mischief-making work of its own, dubbed by one critic "a voluptuous vision,

sustained by hashish." In this instance, the offending article belongs to the onlooker or client: a self-portrait.[20]

Cézanne and Pissarro embarked on an intensive study of each other's work. Cézanne would have known what Delacroix said of Raphael: "He surpassed himself in the research on the perfection of forms by redoing the models and the ideas of other artists with a skillful and inexhaustible creative force."[21] Soon

after he arrived, as an earnest of intent, Cézanne borrowed Pissarro's masterly landscape, *Louveciennes* (1871), expressly to copy it. Cézanne wanted to analyze his procedures, the better to understand his precepts. Pissarro's teachings have come down to us from notes taken by the young Louis Le Bail, who knew both artists. They go to the heart of the impressionist project.

Look for the kind of nature that suits your temperament. The *motif* should be observed more for shape and color than for drawing. There is no need to tighten the form which can be obtained without that. Precise drawing is dry and hampers the impression of the whole, it destroys all *sensations*. Do not define too closely the outlines of things; it is the brushstroke of the right value and color which should produce the drawing. In a mass, the greatest difficulty is not to give the contour in detail, but to paint what is within. Paint the essential character of things, try to convey it by any means whatsoever, without bothering about technique. When painting, make a choice of subject, see what is lying at the right and at the left, then work on everything simultaneously. Don't work bit by bit, but paint everything at once by placing tones everywhere, with brushstrokes of the right color and value, while noticing what is alongside. Use small brushstrokes and try to put down your perceptions immediately. The eye should not be fixed on one point, but should take in everything, while observing the reflections which the colors produce on their surroundings. Work at the same

time upon sky, water, branches, ground, keeping everything going on an equal basis and unceasingly rework until you have got it. Cover the canvas at the first go, then work at it until you can see nothing more to add. Observe the aerial perspective well, from the foreground to the horizon, the reflections of sky, of foliage. Don't be afraid of putting on color, refine the work little by little. Don't proceed according to rules and principles, but paint what you observe and feel. Paint generously and unhesitatingly, for it is best not to lose the first impression. Don't be timid in front of nature: one must be bold, at the risk of being deceived and making mistakes. One must have only one master—nature; she is the one always to be consulted.[22]

Cézanne produced a faithful copy, but a different painting. He redid the model and the ideas. The overall effect is to simplify and intensify, to strengthen and tighten. *The Seine at Bercy, after Guillaumin* underwent a similar transformation a few years later (color plates 41 and 42).[23] Pissarro's *Louveciennes* is like the man himself, all of a piece. Cézanne's *Louveciennes, after Pissarro* is rather smaller, and less spacious. It seems to propose a sequence of events, or scenes, framed by trees. As a pleinairist Cézanne was not so much a topographer as a psycho-geographer, not so much a landscapist as a geologist, or perhaps an archaeologist. His landscapes are increasingly structured, almost preordained. His version of a place is his vision of a place. In his version of Pissarro's vision, the composition is more compacted, the contrasts are more pronounced, the colors are more intense, the brushstrokes are bigger, broader, bolder—not quite splotching, but incipient daubing, rather than persistent dabbing.[24]

The figures in these landscapes are also prototypical. Pissarro's landscapes are populated. People, often working people, naturally find their place. They strain with effort; they bear their burdens. Cézanne's landscapes are depopulated. Neither peasants nor nymphs make an appearance. Bathers apart—the bathers inhabit a world of their own—the biped is banished. "Unfortunately what is called progress is nothing but the invasion of the bipeds," he wrote to his niece in 1902, "who do not rest until they have turned everything into hideous *quais* with gas lamps and—even worse—electric lights. What times we live in!" If progress meant newfangled ways of illumination, Cézanne was against it. He deplored the despoiling of landscape and cityscape; principally, he deplored the bipeds who wrought it. "We live at the mercy of the borough surveyors," he remarked, as he walked the streets of Aix with Joachim Gas-

quet. "It's the reign of the engineer, the republic of straight lines. I ask you, is there a single straight line in nature? They apply a ruler to everything, in the town as in the country. Where is Aix, the old Aix of Zola and Baille, the fine streets of the old area, the grass growing between the cobblestones, the oil lamps. Yes, oil lighting, *li fanau,* instead of your crude electricity which destroys the mystery, whereas our old lamps embellished it, nurtured it, lived it, à la Rembrandt."[25]

In his *Louveciennes,* the figures are ghosts. In *Turning Road, Auvers-sur-Oise,* ten years on, a spectral person accompanies a nondescript animal down the road, as if truly absorbed in the ground.[26] Once he is gone, there is no one.

So began an extended artistic dialogue, one of the richest of modern times— a shining example of open conversation or intersubjective understanding— whereby Cézanne and Pissarro went out into the countryside around Pontoise, selected a *motif,* painted it, and compared the results, or, more to the point, the process. They seem to have done this, at intervals, on at least four occasions over the next ten years: in 1873 they painted the Rue de la Citadelle; in 1875, the Maison des Mathurins; in 1877, the Jardin de Maubuisson; in 1882, the hills at Le Chou.[27] But that is only the tip of the iceberg. During Cézanne's sojourn in Auvers, in 1872–74, they saw each other nearly every day—like Braque and Picasso a generation later, they were practically cohabiting—yet they did not need to paint side by side to be together. Painting side by side may be a misnomer, in any case, given Cézanne's aversion to being watched as he worked. There are some indications that they set up their easels in staggered formation, a little apart. Cézanne evidently had the opportunity to watch Pissarro at work: in one sketch he is seen from behind.[28] Be that as it may, painting their "pairs" was like taking their bearings.

In addition to those set-piece exercises in style, they were painting and drawing dozens of similar views and similar subjects in different places at different times. They might be only a few fields apart; they might be somewhere entirely different. Years could go by between these thought experiments in paint: the passing of time did not diminish the felt sense of connection. Thus Cézanne's *Bridge at Maincy, near Melun* of 1879 or 1880 (color plate 44) summons Pissarro's *Small Bridge, Pontoise* of 1875 (color plate 43). Cézanne's *Jalais Hill, Pontoise* (1879–81) evokes Pissarro's *Jalais Hill, Pontoise* (1867), though it is not the same hill, just as Cézanne's *Mill on the Couleuvre, Pontoise* (c. 1881) evokes Pissarro's *Hills at L'Hermitage, Pontoise* (1867), the two-meter canvas that lived in his memory for over a decade.[29] Out *sur le motif* in the early 1880s, Cézanne was not thinking of what Pissarro was doing at that moment,

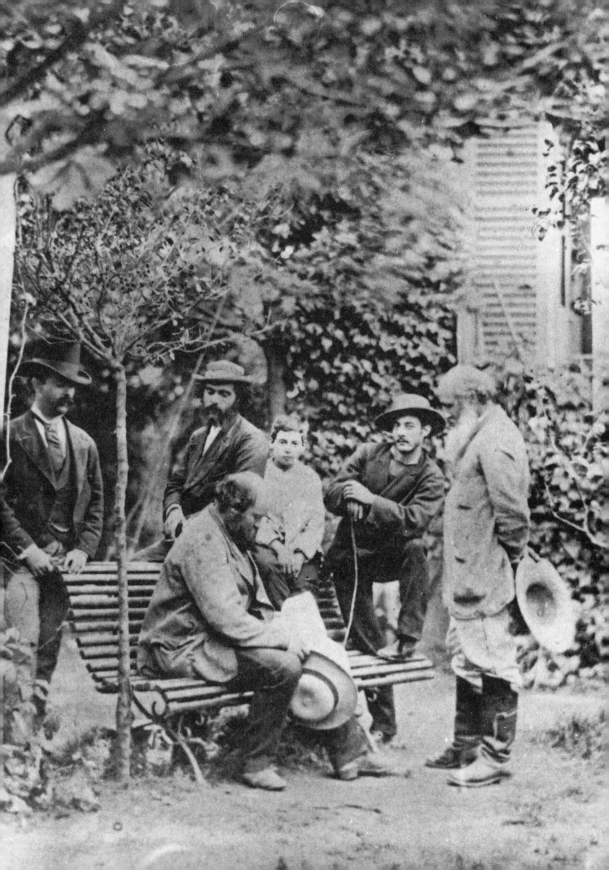

but of what he had done before the war ("If he had continued to paint as he had until 1870, he would have been the strongest of us all"). In Cézanne's eyes, 1867 was Pissarro's *annus mirabilis,* not only for the landscapes, but also for the vertiginous *Still Life with Wine Carafe,* a work of tremendous physical and emotional power. The point has been nicely made by Richard Brettell: "Cézanne developed his personal manner as a painter of structured landscape by becoming the painter he wished Pissarro might have been."[30]

They both adhered to the same fundamental principle. In Pissarro's injunction to Lucien, when he was a little older, "Don't bother trying to look for something *new*: you won't find novelty in the subject matter, but in the way you express it."[31] As comrades and collaborators Cézanne and Pissarro were profoundly intertwined, over a much longer period than is generally realized, and the impress of that experience remained with them to the end. Stylistically they grew apart; spiritually they were inseparable. When Pissarro had an exhibition of recent work in Paris in 1896, he vacillated over whether to include a view of Rouen Cathedral which he half-expected to be compared unfavorably with Monet's *Cathedrals* series (also of Rouen), exhibited and acclaimed the previous year. Finally he wrote to Lucien: "What the hell! It is so different from Monet that I hope our friends won't see any malice in it on my part. It's really only Cézanne who could find fault, and I don't much care. Each of us does what he can." Cézanne was still the gauge. Ten years later, in 1906, Cézanne concluded one of his last letters to his son with a moving envoi: "Greetings to Maman and to everyone who still remembers me. Greetings to Madame Pissarro—how distant it all seems already and yet so close."[32] Pissarro was a real presence, three years after his death.

The question of influence is not a simple one, as Pissarro himself reflected in the wake of Cézanne's breakthrough exhibition of 1895:

There is no doubt that Cézanne had influences like all of us and that in total that doesn't detract in the least from his qualities; people don't know that Cézanne was first of all under the influence of Delacroix, Courbet, Manet, and even Ingres, like all of us; he was under my influence at Pontoise as I was under his. You'll remember the sorties by Zola and [Édouard] Béliard on that issue; they believed that one invents painting from scratch and that one is original when one doesn't resemble anyone else. What is interesting is that in this Cézanne exhibition at Vollard's you can see the similarity that exists between certain landscapes of Auvers, Pontoise and mine. *Parbleu,* we were always together! But what is cer-

tain is that each retained the only thing that counts, *la sensation* . . . that would be easy to demonstrate (are they that stupid!).[33]

It was a union in independence, as Braque said of his own relationship with Picasso.[34] They painted for each other, but remained inalienably themselves. In Charles Tomlinson's words:

> Who painted these pictures that take in
> The whole curvature of the visual hemisphere,
> Where the gables and the roofs appear
> As if they were minims and the blocks
> Of an entire universe that freezes, flows
> And then recomposes itself beneath
> A different light? The humble and colossal
> Pissarro—the adjectives are Cézanne's,
> Who painted side by side with this man
> Of humbler gifts, "to learn from him."[35]

Cézanne openly acknowledged Pissarro's influence, in the context of a celebrated statement on impressionism and his own relationship to it. Reminiscing with Joachim Gasquet:

> I too was an impressionist, I won't hide it. Pissarro had an enormous influence on me. *But I wanted to make of impressionism something solid and enduring like the art of museums.* I said as much to Maurice Denis. . . . But, listen, a green patch is enough to give us a landscape, just as a flesh tone translates into a face, or gives us a human figure. Which means that all of us perhaps come out of Pissarro. . . . Already in [18]65 he had eliminated black, bitumen, sienna and the ochers [from his palette]. That's a fact. Paint only with the three primary colors and their immediate derivatives, he told me. He was the first impressionist.[36]

In Pissarro's company, Cézanne relaxed. His palette lightened; his mood too. Harmonically and psychologically, the sky of the future began to look a little less black. He did not stick rigidly to Pissarro's advice about the primary colors: neither did Pissarro. Cézanne often used a more extensive palette, though in this period it was generally limited to "bright" colors. For *The House of the Hanged Man* (1873), for example, he had eleven or twelve colors, all of them

bright. Significantly, there were multiple blues, greens, and yellows: cobalt blue, ultramarine blue, cerulean blue (pure and mixed with azurite), viridian, verdigris, emerald green, yellow ocher (or Mars yellow), chrome yellow, and vermilion; white would have been there, too, but there were no dark earths (no browns), nor any blacks—a marked change from the shockers of the salon juries. Pissarro's palette for *Kitchen at Piette's House, Montfoucault* (1874) was more restricted, consisting of ultramarine blue, cadmium yellow, red lead (a strong orange-red), alizarin crimson, cobalt green, and lead white; both the red and the green pigment were unusual choices.[37]

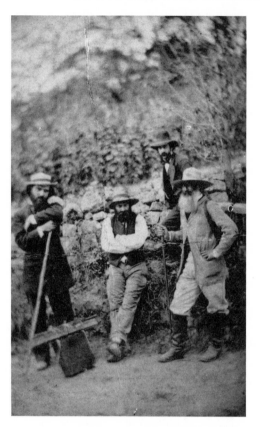

Cézanne's thinking about color naturally developed over time, though his technique changed more than his palette. Thirty years after his experiments in Pontoise, he examined Émile Bernard's palette—prepared with chrome yellow, vermilion, ultramarine blue, madder lake, and lead white—and found it wanting. "You paint only with that?" "Yes indeed." "But where is your Naples yellow? Where is your peach black, your sienna, your cobalt blue, your burnt crimson lake?" He named at least twenty colors that the luckless Bernard had never used. By this time, it seems, his own palette had evolved into a strict array of yellows, reds, greens, and blues: brilliant yellow, Naples yellow, chrome yellow, yellow ocher, raw sienna, vermilion, Indian red (red earth), burnt sienna, madder lake, carmine lake, burnt crimson lake, Veronese green (viridian), emerald green, green earth, cobalt blue, ultramarine blue, Prussian blue, peach black. Recent technical studies tend to confirm Bernard's account. Analysis of the Cézannes in the Courtauld Gallery in London, works dating from the mid-1870s to the mid-1890s, found evidence of the following pigments: emerald green, viridian, cobalt blue, ultramarine, Prussian blue, chrome yellow, cadmium yellow, vermilion, and at least two organic reds.[38] The colors he created in the paintings are the result of subtle variation in the

proportions of these pigments in a matrix of white (most often lead white), with the addition of small quantities of earths and carbon black. Individual strokes of paint examined in cross-section are generally composed of three to five pigments. Contrary to Bernard's observation, colors rarely comprise unmixed pigments straight from the tube. Occasionally there are purer patches of green or red, but even these are usually modified by a greyish stroke.[39]

Cézanne's mark-making required a prodigious effort. Painting was a moral act. This was his ethics. Hence the intense concentration, the deep ponderation, the mythical interval between strokes—twenty minutes, according to Gasquet—though recent studies show conclusively that he was often painting "wet-in-wet," that is, considerably faster than the Cézanne of legend.[40] Pierre Bonnard, another artist who owned a regulation small *Bather,* argued

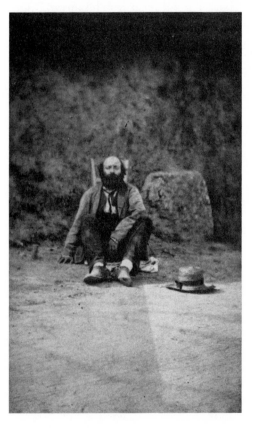

that there are painters who are able to work from the *motif* because they know how to defend themselves against nature. Cézanne was one. "He used to remain there, lizard-like, warming himself in the sun, not even touching a brush. He would wait until things had once again become as they were when he conceived them."[41] Cézanne spoke to Roger Marx of having "a temperament of a painter and an ideal of art, that is to say a conception of nature. . . ." At heart, perhaps, he was more a sensationist than an impressionist.[42] True impressionists could not wait.

Given his temperament, it was only to be expected that he was not a good impressionist, just as he was not a good Catholic. Denominations were not his style. Impressionism could not contain him; no movement could. The "ism" was too doctrinaire, too programmatic, too collective. Cézanne made a restless bedfellow. In fact he would not have been included in the Société anonyme coopérative des artistes peintres, sculpteurs, graveurs, etc., soon dubbed the impressionists, but for Pissarro's advocacy. He was too wayward; he was bound to attract the

wrong kind of attention. His work was extraordinary, but suspect. There still lingered something of the distaste Manet once expressed to Guillemet. "How can you like that filthy painting?"[43]

According to Matisse, Pissarro regarded Sisley's painting as typical of impressionism, remarking later that Cézanne painted the same painting all his life, be it bathers or mountains or apples. This led Matisse to comment that "a Cézanne is a moment of the artist [whereas] a Sisley is a moment of nature." In other words, Cézanne's ultimate goal was to remain true to himself: "truth-to-self" was his hallmark. It was that combination of individuality and authenticity, making for such originality, that Pissarro prized in Cézanne, and before him in Courbet. "I've just seen some Courbet landscapes," he wrote to Lucien in 1898. "They're far superior [to Legros's] and so much himself, Courbet! And Cézanne, having such character, does that stop him from being himself?"[44] What we see is not what we see, said Fernando Pessoa, but who we are. In Maurice Denis's formulation: "Cézanne's three apples are one Cézanne, that is to say an expression of the man Cézanne, the 'subject' Cézanne." Truth-to-self meant truth-to-sensations, and Cézanne's sensations were incommensurable with the impressions of Monet, Renoir, and the rest. Cézanne was a great colorist. For all the bright colors, however, he usually conducted operations in a grey light, rather than sunshine and shadow, as Pissarro pointed out.[45] Cézanne stared at the sun, perhaps too long, but sunrise was not his subject.

The strongest impression he made in Pontoise was of a man at peace with the world. In the Hôtel du Grand Cerf, still in his painting gear, he interrupted a lecture on Virgil to correct the lecturer and give the audience the benefit of a short recitation from memory. In the market square, leaning on his staff observing the proceedings, and looking a little like a bandit, he attracted the attention of a local gendarme.

GENDARME: Do you have your papers?
CÉZANNE: No.
GENDARME: Where do you live?
CÉZANNE: In Auvers.
GENDARME: But I don't know you.
CÉZANNE: I'm *sorr-ry.* ["Je le *re-gret*-te," enunciated with the full force of the *hyper-Marseillais* accent.]

Out *sur le motif,* one of their favorite memories was of Pissarro painting industriously, while Cézanne sat, lizard-like, on the grass behind him. A

passer-by took in the scene, went up to Pissarro and said: "Your assistant's not exactly straining himself."[46]

Those works and days were liberating. For the first time, he glimpsed what a true partnership might be, not with Zola, nor with Hortense, but with Pissarro, the poet-logician, as Gauguin called him. For Cézanne, he was more Hesiod, the former merchant sailor turned temporary shepherd, who became a poet, he claimed, following a visitation from the muses themselves on his mountainside. Hesiod's *Works and Days* offered moral and practical instruction for a life of honest toil, illuminating society, ethics, superstition, and the very soul of things. Pissarro as Hesiod would have appealed enormously to Cézanne. As for himself, he may have been tempted by the shadow identity Zola once suggested for him: Theocritus, Virgil's master, who wrote bucolic verse in the third century B.C. As the artist surely knew, Virgil's *Eclogues* took their inspiration from Theocritus's *Idylls*. Virgil himself had influences. Cézanne's beloved *Eclogues* have a strong Theocritean flavor:

> When I commenced poet, my Muse was not ashamed
> To live in the woods and dally with lightweight pastoral verse.
> Next, kings and wars possessed me; but Apollo tweaked my ear,
> Telling me, "Tityrus, a countryman should be
> Concerned to put flesh on his sheep and keep his poetry spare."[47]

Here was an apt résumé of Cézanne's works and days. In the company of his Hesiod, this is what he was about: putting flesh on his sheep and keeping his poetry spare.

In 1874 three of those sheep were sent to market, or ritual slaughter. For the first impressionist exhibition of 1874, the first public exhibition of his work, Cézanne entered *The House of the Hanged Man*; another landscape of Auvers, probably *The House of Père Lacroix*; and—a gesture of defiance—*A Modern Olympia (Sketch),* as it was listed in the catalogue, voluptuous vision, equivocal interpretation and all, lent by Dr. Gachet. By comparison, Pissarro's entry was more conventional, and also more representative of the new association: *Hoar Frost at Ennery*; *Cabbage Field, Pontoise*; *The Municipal Garden, Pontoise*; *Morning in June, Saint-Ouen-l'Aumône*; and *Chestnut Trees at Osny*. When the exhibition opened, at Félix Nadar's studios on the Boulevard des Capucines, Cézanne's paintings attracted the usual opprobrium. Predictably, *A Modern Olympia* was the cynosure. In a famous review for *Le Charivari,* Louis Leroy declared Manet's *Olympia* "a masterpiece of drawing, decency

and polish compared with M. Cézanne's." His description of the work gives a flavor of the proceedings: "A woman bent double, from whom a negress removes a final veil to offer her hideous charms to the enraptured gaze of a dark-skinned martinet." The reviewer for *L'Artiste* professed to like *A Modern Olympia* better than the landscapes, concluding, "M. Cézanne appears to be nothing more than a kind of lunatic, painting under the effects of delirium tremens."[48] The day after *Le Charivari* appeared, the painter Louis Latouche did a stint of guard duty at the exhibition. He wrote to Gachet: "I'm keeping an eye on your Cézanne. I can't answer for its safety, I'm very much afraid that it will be returned to you with a gash in it."[49]

Cézanne was pleased with himself. He wrote a jubilant letter to his mother in L'Estaque:

My dear Mother

I must first of all thank you very much for thinking of me. For some days now the weather has been bad and very cold. But I'm not suffering in any way, and I'm making a good fire.

I shall be pleased to receive the promised parcel, you can always address it to 120 Rue de Vaugirard, I have to be there until January.

Pissarro has not been in Paris for about a month and a half, he is in Brittany, but I know that he has a good opinion of me, and I have a good opinion of myself. I am beginning to consider myself stronger than all those around me, and you know that I hold that good opinion advisedly. I have to work all the time, but not to achieve the finish that earns the admiration of imbeciles. And that thing that is so widely valued is nothing more than a workman's craft, and makes all the resulting work inartistic and common. I must only strive for completion for the satisfaction of becoming truer and wiser. And believe you me, there always comes a time when one asserts oneself, and one has admirers much more fervent and more convinced than those who are attracted only by mere surface.

It is a very bad moment for sales, all the bourgeois balk at parting with their sous, but that will end. . . .

My dear Mother, remember me to my sisters.

Greetings to Monsieur and Madame Giraud and my thanks.

Ever yours, your son.[50]

1. *Portrait of Paul Cézanne* (1862–64)

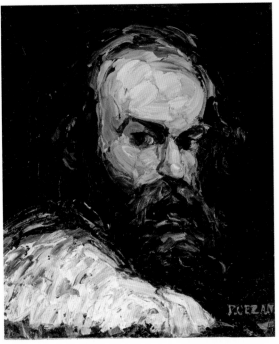

2. *Self-Portrait* (c. 1866)

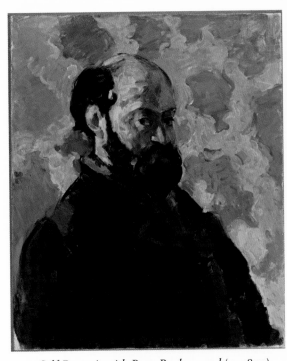

3. *Self-Portrait with Rose Background* (c. 1875)

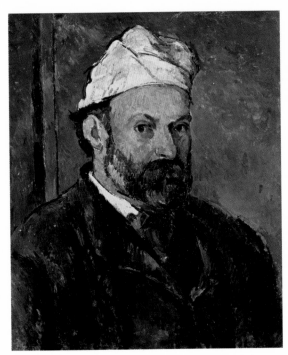

4. *Self-Portrait in White Bonnet* (1881–82)

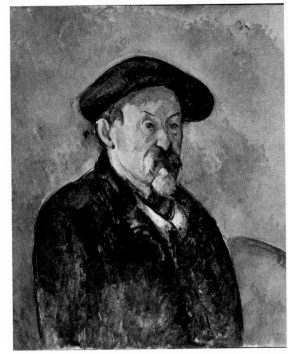

5. *Self-Portrait in a Beret* (1898–1900)

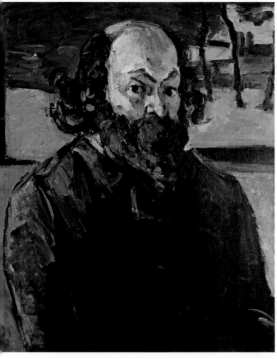

6. *Self-Portrait with a Landscape Background* (c. 1875)

7. *Self-Portrait* (c. 1877)

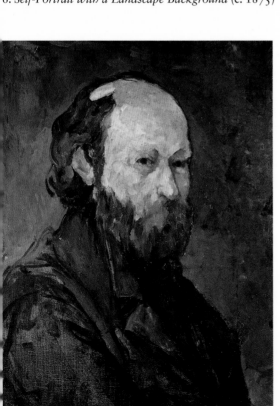

8. *Self-Portrait* (c. 1878–80)

9. *Self-Portrait with Palette* (c. 1890)

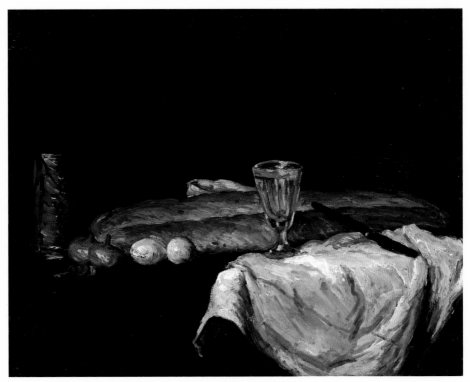

10. *Still Life with Bread and Eggs* (1865)

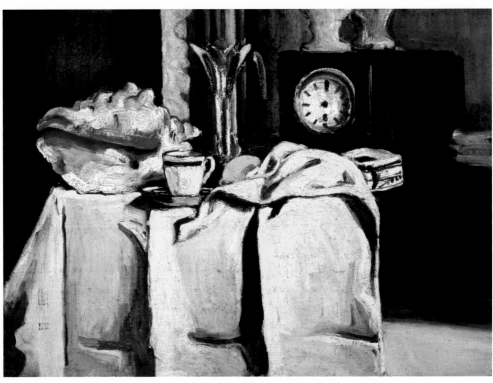

11. *The Black Clock* (1867–69)

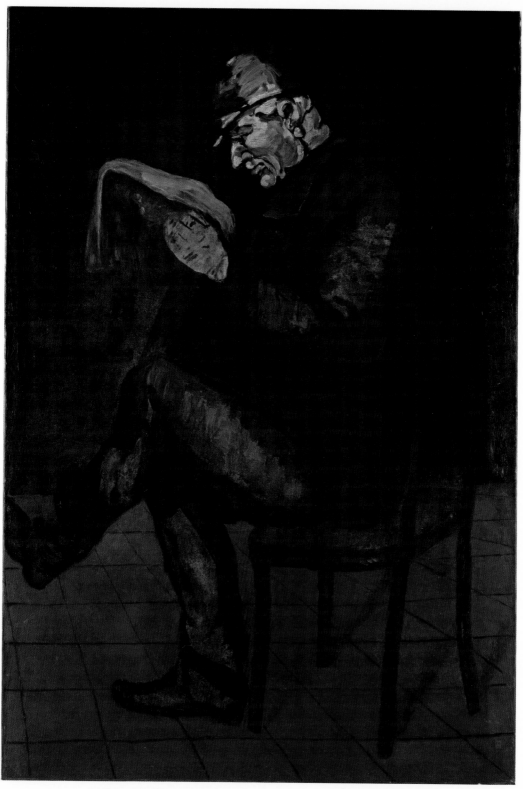

12. *Portrait of Louis-Auguste Cézanne, Father of the Artist* (c. 1865)

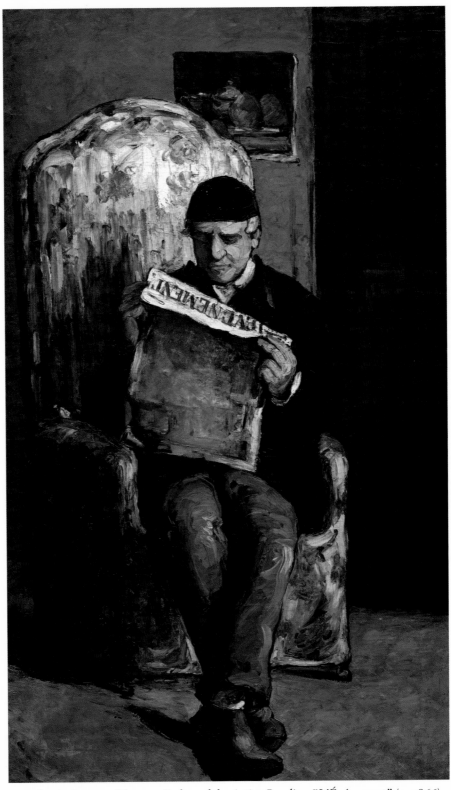

13. *Louis-Auguste Cézanne, Father of the Artist, Reading "L'Événement"* (c. 1866)

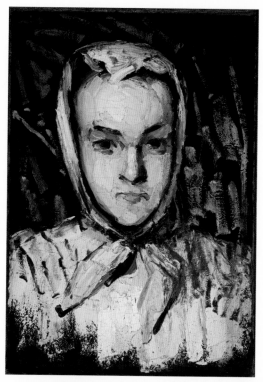
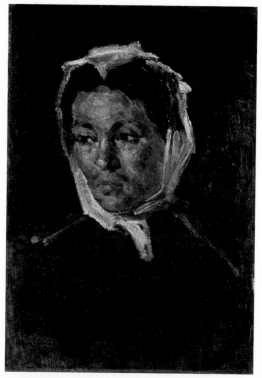

14. *Marie Cézanne (The Artist's Sister) (1866–67)* 15. *Portrait of the Artist's Mother (1869–70)*

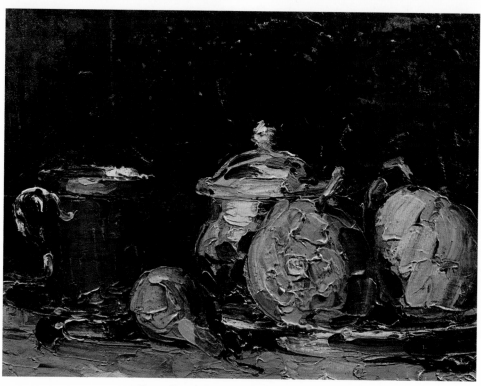

16. *Sugar Bowl, Pears and Blue Cup (1865–66)*

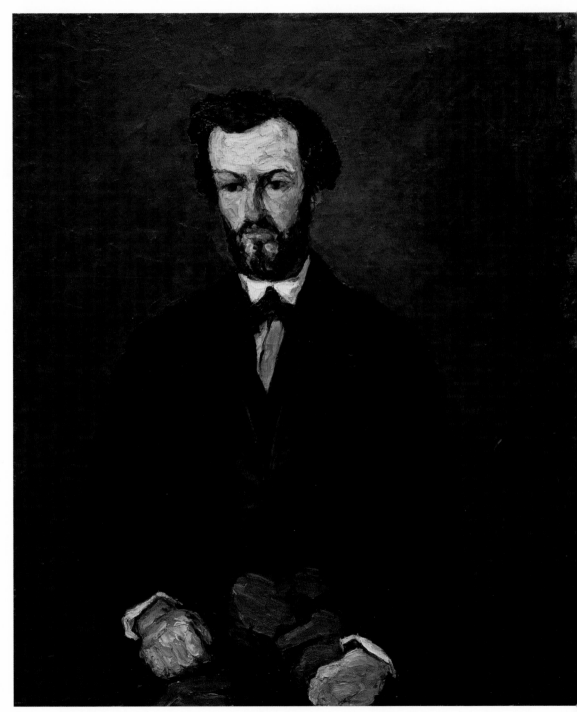

17. *Portrait of Antony Valabrègue* (1866)

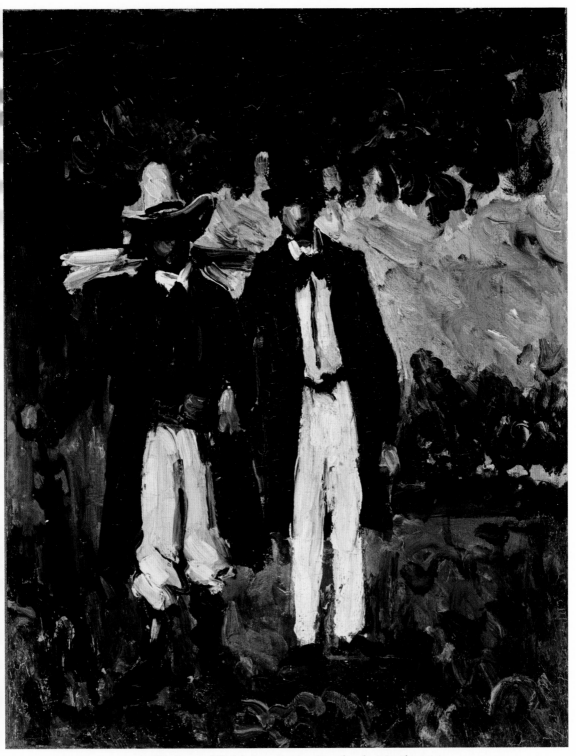

18. *Marion and Valabrègue Setting Out for the Motif* (1866)

19. *The Lawyer (Uncle Dominique)* (1866)

20. *The Negro Scipio* (c. 1867)

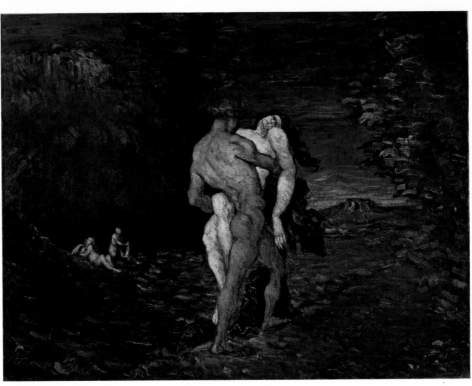

21. *The Abduction* (1867)

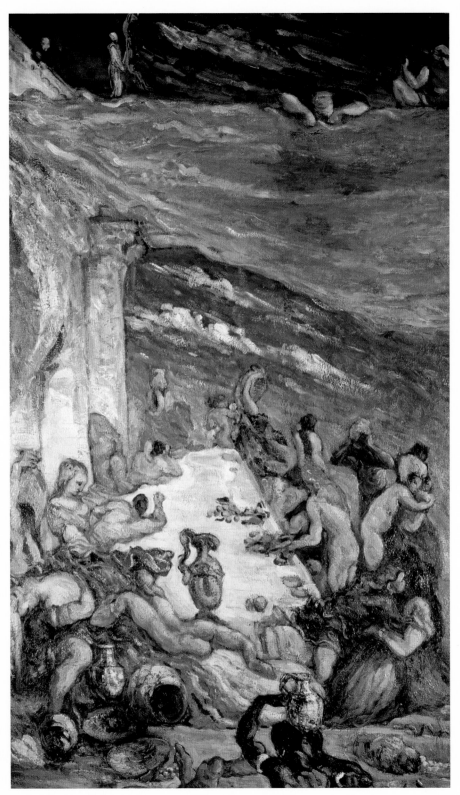

22. *The Orgy* (c. 1867)

23. *Portrait of the Painter Achille
Emperaire* (1867–68)

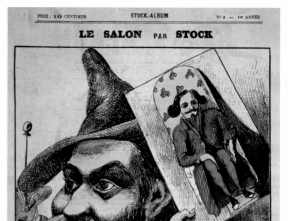

24. *Album Stock* (1870)

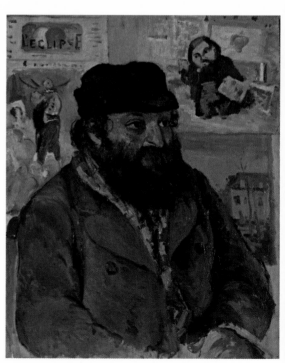

25. Camille Pissarro, *Portrait of
Paul Cézanne* (c. 1874)

26. Édouard Manet, *Portrait of Émile Zola* (1868)

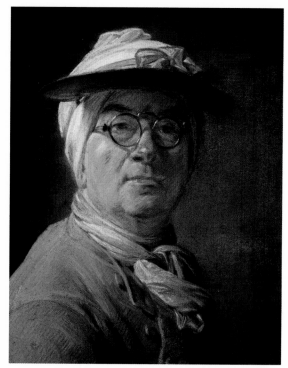

27. Jean-Siméon Chardin, *Self-Portrait* (1775)

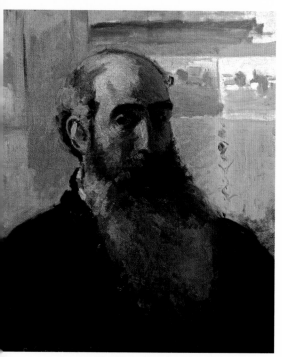

28. Camille Pissarro, *Self-Portrait* (1873)

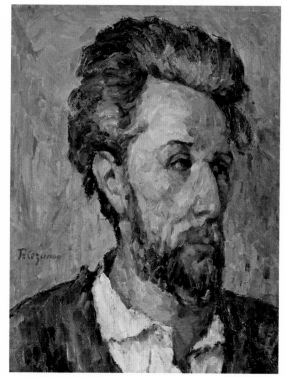

29. *Portrait of Victor Chocquet* (1876–77)

30. *The Apotheosis of Delacroix* (1890–94)

31. *Paul Alexis Reading to Émile Zola* (1869–70)

32. *Still Life with Soup Tureen* (1877)

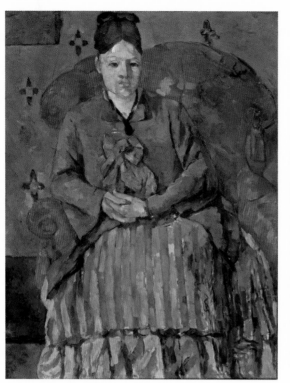

33. Madame Cézanne in Striped Skirt (c. 1877)

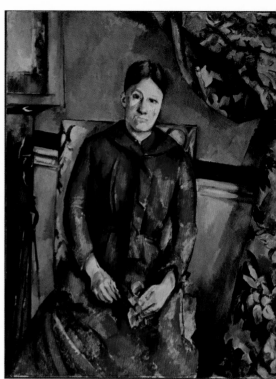

34. Madame Cézanne in a Yellow Armchair (1888–90)

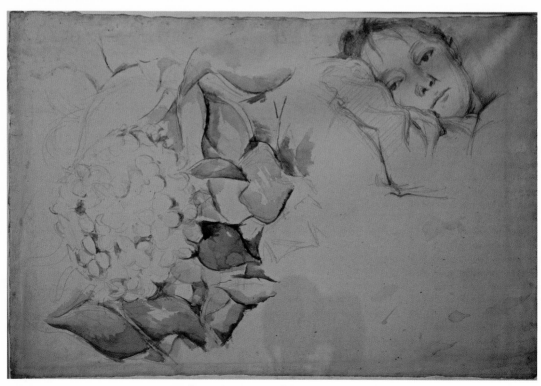

35. Madame Cézanne with Hortensias (c. 1885)

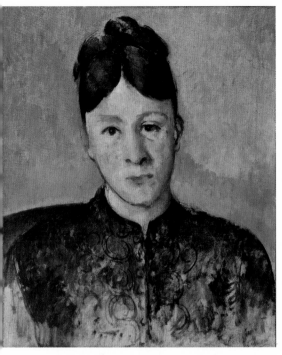

36. *Madame Cézanne* (c. 1885)

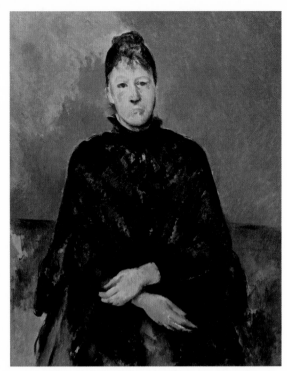

37. *Portrait of Madame Cézanne* (1888–90)

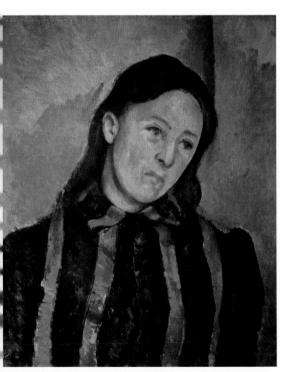

38. *Madame Cézanne with Hair Down* (1890–92)

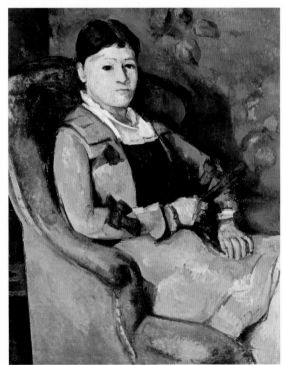

39. *Madame Cézanne with a Fan* (1886–88)

40. Elizabeth Murray, *Madame Cézanne in a Rocking Chair* (1972)

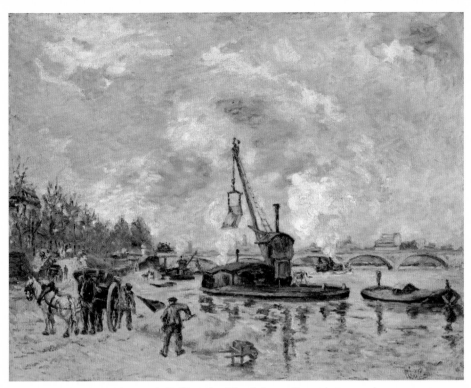

41. Armand Guillaumin, *The Seine at Bercy* (1873–75)

42. *The Seine at Bercy, after Guillaumin* (1876–78)

43. Camille Pissarro, *The Small Bridge, Pontoise* (1875)

44. *The Bridge at Maincy* (1879–80)

45. *The House of the Hanged Man* (c. 1873)

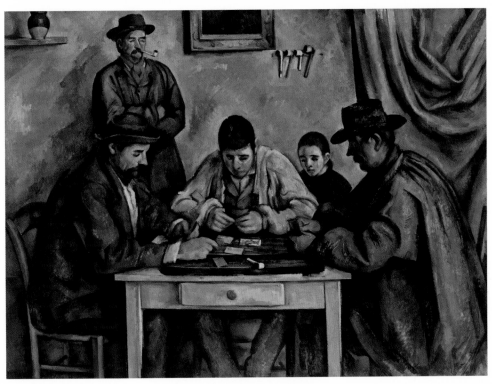

46. *The Card Players* (1890–92)

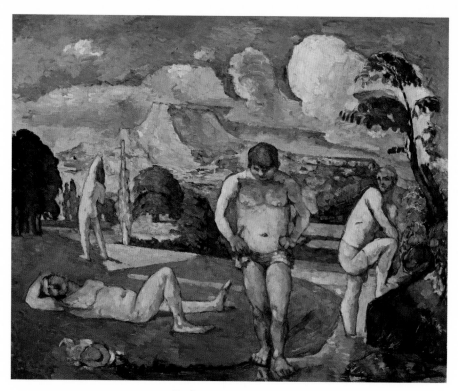

47. *Bathers at Rest* (1876–77)

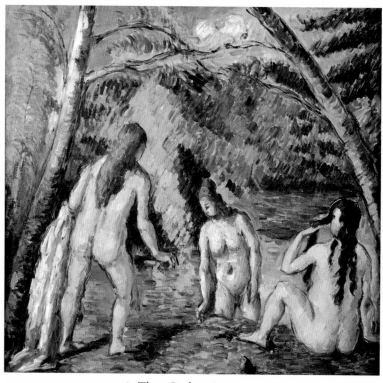

48. *Three Bathers* (1879–82)

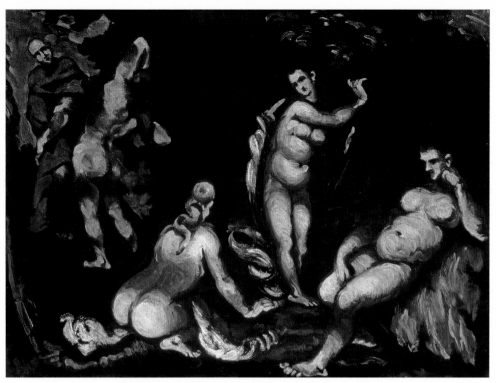

49. *The Temptation of Saint Anthony* (c. 1870)

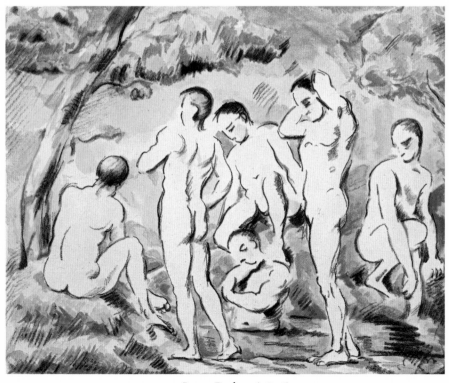

50. *Large Bathers* (1896)

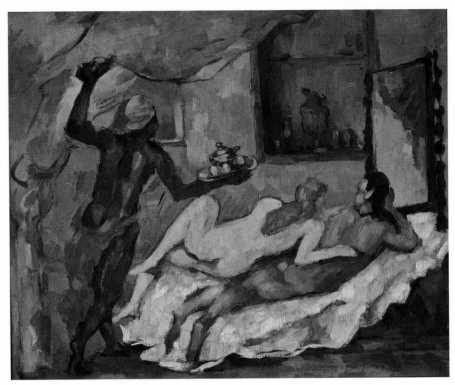

51. *Afternoon in Naples* (1876–77)

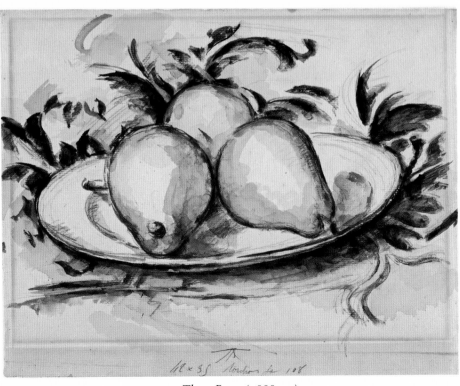

52. *Three Pears* (1888–90)

For once, he was content with his work—and with a sale. *The House of the Hanged Man* (color plate 45), one of his personal favorites, was bought by Count Armand Doria. Fifteen years later, when Victor Chocquet arranged for Cézanne to be represented at the Exposition universelle of 1889, they turned to Doria for the loan of that painting. Chocquet was so besotted with it that he persuaded Doria to part with it in exchange for *Snow Melting at Fontainebleau.* No sooner had Chocquet taken delivery than Cézanne was invited by Octave Maus to exhibit with Les XX in Brussels. The good-natured Chocquet agreed to lend it even before the frame was ready. At the Chocquet sale in 1899 it was bought for 6,200 francs (a record for the sale) by Count Isaac Camondo, with Monet's encouragement. "Well, yes, I bought this painting which isn't accepted yet by everyone!" said Camondo. "But I'm covered: I have a signed letter from Claude Monet, who has given me his word of honor that this canvas is destined to become famous. If you come to my house one day, I'll show you that letter. I keep it in a little pocket pinned to the back of the canvas, at the disposal of the malicious, who think I am soft in the head with my *House of the Hanged Man.*"[51] In 1908 Camondo left his collection to the French state, on condition that it was exhibited in specially designated rooms in the Louvre for fifty years. Unlike Caillebotte's, Camondo's donation was accepted. *The House of the Hanged Man* has been on view ever since, together with four other Cézannes. Monet knew his onions.

That painting has the habit of provoking intriguing reflections. "I am very surprised that anyone can wonder whether the lesson of the painter of *The House of the Hanged Man* and *The Card Players* is good or bad," Matisse told an interviewer in 1925. "If you only knew the moral strength, the encouragement that his remarkable example gave me all my life! In moments of doubt, when I was still searching for myself, frightened sometimes by my discoveries, I thought: 'If Cézanne is right, I am right.' And I knew that Cézanne had made no mistake."[52] The comparison he made with *The Card Players* (color plate 46) is at first sight surprising: a work painted some twenty years later, associated with Aix rather than Auvers (the south rather than the north), a study of personages rather than houses, an interior scene rather than an exterior one.[53] Matisse was intrigued by their structure or *architecture,* to use his word, and it is immediately apparent that both paintings are structured with great care. Each is anchored in a central V shape, formed in one case by the walls of the buildings and in the other by the legs of the card players; the construction of *The House of the Hanged Man* is indeed most peculiar. Moreover, buildings

and card players alike have a monumental gravity and resistance, in Roger Fry's phrase, the card players if anything more than the buildings.[54]

Perhaps they also have a certain atmosphere. Allen Ginsberg discovered in *The Card Players* "all sorts of sinister symbols, like there's one guy leaning against the wall with a stolid expression on his face, that he doesn't want to get involved; and then there's two guys who are peasants, who are looking as if they've just been dealt Death cards; and then the dealer you look at and he turns out to be a city slicker with big blue cloak and almost rouge doll-like cheeks and a fat-faced Kafkian-agent impression about him, like he's a card-sharp, he's a cosmic cardsharp dealing out Fate to all these people."[55] André Breton might well have agreed. Abandoning his scornful attitude, the Pope of Surrealism inserted in *L'Amour fou* (1937) a typically contrary digression on the true Cézanne:

> Against the grain of current interpretation, I think that Cézanne was not a painter of apples above all, but in fact the painter of *The House of the Hanged Man*. I mean that the preoccupation with technique, on which it is convenient to dwell in his case, tends too systematically to obscure the concern he demonstrated time and again to give his subjects an *aura*, from *The Murder* of 1870, which testifies vividly to that concern, to *The Card Players* of 1892, around whom there swirls an air of menace, part-tragic, part-clownish, just like the atmosphere in the card game in the Chaplin film *A Dog's Life* [1918], not forgetting [Cézanne's] *Boy with Skull* of 1890—in conception apparently ultra-romantic, but in execution far removed from any romanticism: the metaphysical anxiety falling over the painting *from the folds in the curtain*. *The House of the Hanged Man*, in particular, always seemed to me ... to be handled in such a way as to convey something quite different from its exterior as a house, from the most suspect angle: the horizontal black mark over the window, the deterioration of the wall on the first floor, towards the left. This is not a question of anecdote: for painting, for example, it is a question of the need to explain the connection that cannot but exist between the fall of a human body, a rope around its neck, in the void and the very spot where this drama took place, a spot which it is incidentally in the nature of man to go and inspect. Cézanne's consciousness of this connection is sufficient explanation for me as to why he has pushed back the right of the building as if partly to hide it and then to make it seem *taller*. I readily concede that, through his particular skill at discerning these

auras and concentrating his attention on them, Cézanne has been led to take them as the immediate object of study and to examine their most basic structure. . . . In the final analysis everything turns on the effects of light. . . . It all takes place as if one were in the presence of a particular refraction, in which the non-transparent medium is constituted by the spirit of man.[56]

For Breton, in his nontransparent prose, *The House of the Hanged Man* was full of associations and connotations, anticipating not only *The Card Players,* menaced as they may be, but also other houses in other places, in various states of metaphysical decay—*The Abandoned House, The Cracked House* (a tantalizing title: the French word for "crack," *lézarde,* looks remarkably like the word for "lizard," *lézard*).[57] In Cézanne's vision, "the crack in the teacup opens / A lane to the land of the dead."[58]

The other link made by Breton was equally inspired. *Boy with Skull* was another of Cézanne's personal favorites, one of the few that he would talk about after he had finished working on it. That painting is also a favorite of Jasper Johns, whose method of investigation is more physical. Standing next to him in front of it, Roberta Bernstein was the privileged observer of a form of mime:

> He raised and bent his right arm to follow the diagonal running from the fold in the hanging cloth, along the boy's head and shoulders, and across the top of the chair. He then turned his arm to align it vertically with the back of the chair and then, again, to follow the horizontals of the seat and trousers. As I watched Johns respond to the picture, I sensed that he was not ignoring the painting's expressive content, but rather responding to the way the content was intrinsically connected to the picture's composition. This aspect of Cézanne's art—the unity of meaning and structure—is at the core of the longstanding, ongoing creative dialogue Johns has held with Cézanne's work.[59]

Johns owns a *Bather with Outstretched Arms*. He has nominated another *Bather,* arms akimbo, as one of the works of modern art that have meant most to him, and described that painting as having "a synesthetic quality that gives it a great sensuality—it makes looking equivalent to touching." His own *Divers*, with their outstretched arms, have obvious progenitors, as if in an evolutionary chain.[60] Cézanne delves deep.

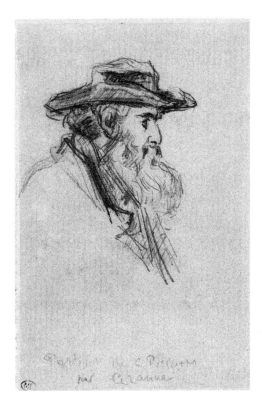

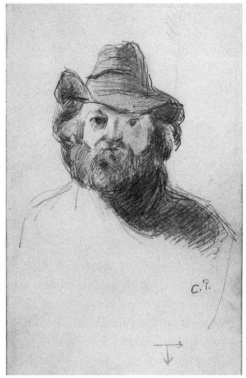

Breton's speculations on *The House of the Hanged Man* proceeded in part from its spine-chilling title. Cézanne himself appeared to suggest at one stage that the title was not his (which would not be unusual); he offered Octave Maus a more prosaic alternative, *A Cottage in Auvers*.[61] Whether or not the title was foisted on him, there is no known hanged man. On the other hand, there is a well-known etching—one of only five—*Guillaumin with the Hanged Man,* produced on Dr. Gachet's printing press in 1873, as he worked on the painting. Cézanne's etchings were rudimentary affairs, characterized by the "extraordinary violence" with which he attacked the plate.[62] The one of Guillaumin is an informal portrait of his friend as a footless or footloose biped, snatched from life. It has a jauntiness of a kind, though it is altogether outfaced by a powerful portrait head, a drawing, from the same period. Gachet encouraged all the artists in the little colony around him to experiment with printmaking, and apparently also to adopt an emblematic signature or mark. For this etching alone, Cézanne chose a hanged man on a gallows—possibly an in-joke.[63] Guillaumin returned the compliment with an etching of Cézanne and the mark of a cat.[64]

Portraiture was an integral part of the camaraderie between Cézanne and Pissarro. They exchanged raffish portrait drawings, hats and beards to the

fore.[65] One of Pissarro's most accomplished etchings is a portrait of Cézanne in a more formal pose, less raffish than hawkish—almost beaked—later reproduced on the cover of *Les Hommes d'aujourd'hui* (1891), a brochure on Cézanne by Émile Bernard, singularly ill-informed, or deliberately misleading, as Pissarro complained at the time.[66] But the pièce de résistance was Pissarro's *Portrait of Paul Cézanne* (color plate 25), a painting kept by Pissarro in his studio all his life, and later owned by the British Rail Pension Fund, before

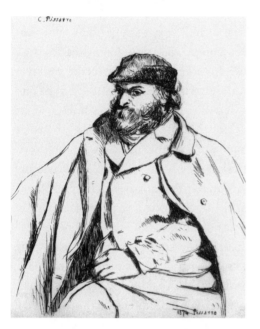

its acquisition by Graff Diamonds, who loaned it to the National Gallery in London, a history that might have provoked a wry smile from the old anarchist.[67]

Pissarro's portrait of Cézanne is a heartfelt *hommage*. It is probably the most benign image of the artist ever made. In spirit and style it is the antithesis of Manet's portrait of Zola, to which it bears some compositional resemblance. Manet's treatment is cool, cerebral, formal, respectful; restrained even in its cleverness. Pissarro's treatment is warm and tender. Cézanne is posed but human, muffled in coat and hat. He has stature, but looks unassuming, almost endearing: bushy, solid, weathered. Manet's Zola is polished and distant. Pissarro's Cézanne is scruffy and tactile. What he lacks in polish he makes up in texture. He is endowed with common dignity. *Portrait of Paul Cézanne* testifies to the profound sympathy between painter and sitter.

Like the Manet, it is chock-full of other images, covering the wall behind (the wall of Pissarro's studio). The most immediately recognizable is a caricature of Courbet, with a mug of beer in one hand and a palette in the other, saluting Cézanne from his vantage point in the upper right of the picture, a little like a portly conscience, or a pipe-smoking guardian angel. Pissarro has adjusted the direction of Courbet's gaze, as Manet adjusted Olympia's, so that Cézanne is indeed the focus of his attention; his girth, his beard, and even his attire all seem somehow congruent with his hirsute successor. The connection was a natural one to make. Cézanne and Pissarro admired Courbet as an artist and a free spirit. The caricature appropriated by Pissarro had appeared originally on the cover of the satirical journal *Le Hanneton*, in June 1867,

over a short text in the artist's handwriting: "I have always thought it was supremely ridiculous that I should be asked permission to publish my portrait, whatever form that request takes. My mask belongs to everyone, which is why I authorize *Le Hanneton* to publish it—provided they do not omit to frame it with a beautiful aura."[68] This was a protest against censorship and other reactionary tendencies under the Second Empire, and a characteristic blast of self-promotion (and also perhaps the origin of André Breton's preoccupation with the aura).

Courbet was prodigious in all things, including self-belief. That same year, he had decided not to submit any of his work to the salon, but instead to organize his own one-man show. For those who were plotting to make a similar declaration of independence, this was an inspiring precedent. By 1873, he had become something of a national hero, at least to those of a radical disposition. Courbet was a Communard. He was president of the Federation of Artists and an elected member of the Commune itself. In this role he was implicated in the destruction of the Vendôme Column, symbol of Napoleonic tyranny, which was pulled down in May 1871. The controversy over that episode was to plague him for the rest of his life. In July 1873 he fled to Switzerland, in order to avoid imprisonment. For Gustave Courbet, the Paris Commune was the fulfillment of a dream—all too briefly—a dream of a Proudhonian utopia of social justice. Pissarro for one understood precisely what that meant.

The suspicion remains that Cézanne did not, or that he understood only too well, and that his sympathies were disengaged, if indeed they did not run in the opposite direction. Much has been made of the apolitical Cézanne, not least by Cézanne himself. ("Listen, Monsieur Vollard! During the war I worked a lot *sur la motif* at L'Estaque!") Vollard's report of his reading conservative newspapers like *La Croix* (*The Cross*) and *Le Pèlerin* (*The Pilgrim*) has been duly noted—a far cry from *Le Hanneton* or its successor *L'Éclipse*.[69] But *La Croix* and *Le Pèlerin* came later, in the 1890s, and in any event Cézanne's reading was always more omnivorous and his outlook more heterogeneous than he usually vouchsafed. The comedic Cézanne portrayed by Vollard has encouraged a tendency to underestimate his intellectual restlessness, to say nothing of his moral seriousness; his own antics and practiced irony have only added to the mystification, as he intended.

His taste in novels and poetry was catholic indeed, embracing such dubious types as Jean Richepin and Jules Vallès, hot for the barricades, and periodicals from across the political spectrum (*Gil Blas, Le Grognon provençal, La Revue de Paris, Le Voltaire*). Zola's work, of which he had a personal col-

lection, added to the mix. "I bought an illustrated *L'Assommoir* at Lambert, the Democrat library," he told the author, adding, "*L'Égalité* of Marseille has issued it as a feuilleton." He argued with his old drawing master Gibert about Richepin—the same Richepin who said that he had never had so much fun as in Paris in April 1871, in the delirious days of the Commune.[70] In 1878 he offered Zola a kind of allegory-in-miniature of the capitalist system and its consequences for the heart and soul (and even the face) of humanity: "Marseille is the oil capital of France, as Paris is for butter: you have no idea of the presumptuousness of this fierce people, they have but one instinct, that is for money; it is said that they earn a lot, but they are very ugly—their modes of communication are wiping out the distinguishing features of the different types. In a few centuries it will be quite futile to be alive, everything will be flattened out. But the little that remains is still close to the heart and eye."[71]

In the 1860s and 1870s, partly under the sway of Pissarro, Cézanne was tackling all manner of radical and satirical sheets. Characteristically, he joked about it. "Imagine," he wrote to Pissarro in 1876, "I'm reading *La Lanterne de Marseille,* and I'm about to subscribe to *La Religion laïque.* How about that!" At the same time he could be found speculating on the political complexion of the government in the Senate.[72] Already in 1868 he was writing to Coste about Henri Rochefort's pocket-size political weekly, *La Lanterne,* whose flaming-red cover announced an incendiary combination of anti-monarchical, anti-clerical, and anti-bourgeois polemic; and about a new "satirical journal of the Midi," *Le Galoubet.* Sharing a garlic meal with Marion and Valabrègue— Marion, the cook, had put in twelve or fifteen cloves—he poked fun at "Citizen Valabrègue," who called garlic "the truffle of the proletariat." (Cézanne would have remembered Horace's squib "If any man with impious hands has broken / his aged father's neck, / let him eat garlic. It is worse than hemlock. / Peasants must have guts of brass.")[73] As early as 1865, Citizen Valabrègue reported to Zola, "I often see Paul in the afternoon. He is still the best of friends. But he, too, has changed, for he speaks, he who seemed your silent shadow. He expounds theories, builds up doctrines; crime of crimes, he even suffers one to talk politics with him (theories, I mean) and replies by saying terrible things about the tyrant [Napoleon III]."[74] There was much more to his political engagement than flaccid reaction.

Morally and politically, nothing could have pleased Cézanne and Pissarro more than Courbet's celebrated action of June 1870: he refused the Legion of Honor. Not content with that, he published his letter of refusal in *Le Siècle.* "Honor," he instructed the minister of fine arts, "is neither in a title nor a rib-

bon, it is in the act and the motive for the act. The state is incompetent in the matter of art. I decline the honor that you believed you did me. I am fifty years old and I have always lived as a free man; let me end my days free. When I am dead, they will say of me: that man never belonged to any school, any church, any institution, any academy, above all any regime, if it was not the regime of liberty."[75] That man was a man after their own heart. A few years later, in thanking Zola for a copy of his latest work, Cézanne wrote: "It's not for me to praise your book, for you can respond like Courbet that the conscious artist awards himself higher praise than that which is bestowed upon him from outside."[76]

In the upper left of the portrait of Cézanne is another caricature, of Adolphe Thiers, recently president of the Republic. Thiers is holding up a newborn baby bundled in a sack of money. This caricature had appeared on the cover of *L'Éclipse* in August 1872, captioned "*La Délivrance.*" It symbolized the deliverance of France from Prussian oppression, after paying the reparations due, in record time. The government had requested a loan, in order to meet the country's obligations; over forty billion francs had been pledged within twenty-four hours, a staggering response. Thiers had been instrumental in that national effort. His position in the opposite corner to Courbet effectively mirrored their political stance and historical experience: Thiers had also been instrumental in the suppression of the Commune. And yet their relations were more complicated than that brute fact might suggest. Thiers was in his fashion an art lover, with a collection of his own. Though he found Courbet's painting as objectionable as his politics, he had protected the artist from excessive reprisals; Courbet for his part had rescued much of Thiers's collection from destruction during the Commune. Courbet's exile was precipitated by Thiers's resignation, in May 1873: he had lost his protection. Their fates were intertwined.

Adding to the richness of association, the original caricaturist of Thiers was André Gill, a figure in his own right, and a close friend and political ally of Courbet's. During the Commune, Gill served as curator of the Luxembourg; he was one of the most active members of the Federation of Artists. When Courbet refused the Legion of Honor, he marked the occasion with another caricature in *L'Éclipse,* captioned "*Courbet avant la lettre*" (a play on words, and on the famous letter), showing the rollicking artist, bursting with self-importance, wickedly lighting his pipe with what looks very like a length of ribbon.

This crowded history would have been well known to Cézanne and Pissarro, and much savored. There may be still more in the portrait. In Pissarro's composition, Thiers appears to be offering the sack of money as a tribute to

Cézanne, whose back is turned, oblivious. Is there a veiled suggestion here of France's indebtedness to the artist—a riposte, or a reversal of the official position as enunciated by Nieuwerkerke? Perhaps there is also a pun that would have appealed to Cézanne, announced by the title *L'Éclipse* (clearly legible above his head), inasmuch as the midget Thiers and even the corpulent Courbet are well and truly eclipsed by his own massive presence.

The other image in the portrait, at Cézanne's elbow, is one of Pissarro's own landscapes, *Route de Gisors, the House of Père Gallien, Pontoise* (1873), a favorite subject, and evidently a favorite painting. This small Pissarro serves as a marker of mutual esteem. It may also be a clue to another form of exchange. The same painting, more faithfully reproduced, appears in a contemporaneous work by Cézanne, *Still Life with Soup Tureen* (color plate 32), a present for Pissarro.[77]

If Pissarro's portrait was a kind of *Homage to Cézanne,* then Cézanne's still life was a kind of *Homage to Pissarro.* Cézanne returned the compliment in kind. The still life was a continuation of the portrait by other means. At once a representation and an extension of the communal life, *Still Life with Soup Tureen* is also an encapsulation and celebration of the good life. It, too, was painted in Pissarro's studio. Madame Pissarro's red shawl was pressed into service as a tablecloth. The table is more densely populated than the landscape. Everything here is humble and colossal—the soup tureen, the wine bottle, the ripe red and yellow apples spilling out of their basket. Pissarro must have been delighted with it. It soon found its place on his studio wall.[78]

Communal life came to an end in 1874. The Cézannes left Auvers for Paris, where they moved into an apartment at 120 Rue de Vaugirard, in the Sixth Arrondissement, near the Luxembourg. Cézanne and Pissarro painted together again, if not exactly side by side, then back to back, as it were, for short stints in 1875, 1876, 1877, 1881, probably 1882, and possibly 1885; but the full-blown experience of 1872–74 was never repeated. Perhaps it was unrepeatable. Yet Cézanne hoped for more.

He did not linger in the metropolis but headed south, leaving La Boule and Le Boulet to the fleshpots of Paris. His parents and his place of birth were calling him home. From Aix he wrote to Pissarro: a letter notable for its frankness, about his feelings for his son and his battles with his father. There were no secrets from *le bon Dieu.*

I thank you for having thought of me while I was so far away, and for not being angry with me for not keeping my promise to pop in to see you

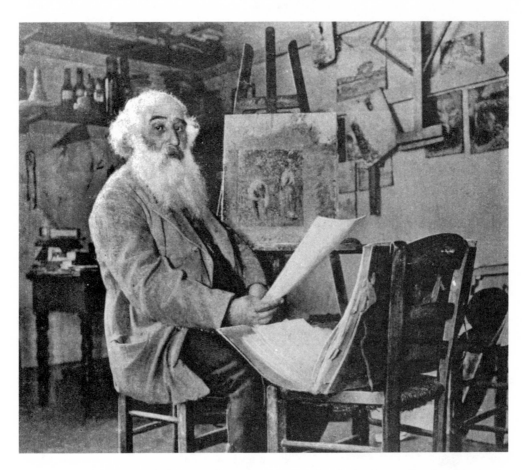

at Pontoise before my departure. I started painting immediately after my arrival. . . . And I understand all the troubles you must be going through. It's really unlucky—always illness at home; however I hope that when this letter finds you, little Georges will be well again.

But what do you think about the climate of the country you're living in? Aren't you afraid that it affects the health of the children? I'm sorry that new circumstances still keep you from your studies, for I know very well how hard it is for a painter to be unable to paint. Now that I see this country again, I believe it would satisfy you completely, for it's amazingly reminiscent of your study of the railway crossing in full sunlight in the middle of summer.

For some weeks I had no news of my little one and I was very worried, but Valabrègue has just arrived from Paris and . . . he brought me a letter from Hortense, from which I learned that he's not doing too badly. . . .

When the time comes, I'll let you know about my return, and what I've

been able to get out of my father, but he'll let me return to Paris. That's already a lot.

Two years later, in 1876, he was still trying to tempt Pissarro to come south. This letter may give some idea of the conversations they had when they were together, painter to painter, working things out between them:

I'm obliged to reply to the charm of your magic pencil with an iron point (that's to say a metal pen). If I dared, I should say that your letter is imprinted with sadness. The picture business isn't going well; I fear that your morale may be colored a little grey, but I'm sure that it's only a passing phase.

I'd much rather not speak about impossibilities, however I'm always making plans which are impossible to realize. I imagine that you would be delighted with the country where I am now. There are great annoyances, but I believe they're purely accidental. This year, it's rained for two days every week. That's astounding in the Midi. It's unheard of.

I must tell you that your letter surprised me in L'Estaque, by the sea. I haven't been in Aix for a month. I've started two little *motifs* of the sea, for Monsieur Chocquet, who talked to me about it. *It's like a playing card*. Red roofs against the blue sea. If the weather turns favorable perhaps I'll be able to push them right to the end. So far I've done nothing. But there are *motifs* that would need three or four months' work, which could be done, as the vegetation doesn't change here. There are the olive trees and the pines that always keep their leaves. The sun is so fierce that it seems to me as if objects are silhouetted, not only in black or white, but in blue, red, brown, violet. I may be wrong, but it seems to me that this is the very opposite of modeling. How happy the gentle landscapists of Auvers would be here, and that [bastard?] Guillemet. As soon as I can, I'll spend at least a month in these parts, as one must do canvases of two meters at least, like that one of yours that was sold to Faure.[79]

"The very opposite of modeling" meant roughly that they would lay down one plane or patch of color next to another, without any "modeling" or shading between them, so that it looked as if each component part of the painting could be picked up from the canvas a little like a playing card from the table. In the canvas that made such an impact on Cézanne, the one that was sold to the

opera singer Jean-Baptiste Faure, *The Hills at L'Hermitage, Pontoise* (1867), the houses on the hills give just that illusion. In time, this letter became one of Cézanne's most celebrated, and the playing-card analogy entered the culture. "Music is not a 'playing card,' to adapt Cézanne's remark on painting," wrote Pierre Boulez almost a century later; " 'depth,' 'perspective,' 'relief' have an important part to play."[80]

Thirty years after he related these perceptions to Pissarro, Cézanne tried once again to explain himself to Émile Bernard—to explain that, old as he felt, failing as he feared, he obstinately pursued his goal: "the realization of that part of nature which, falling before our eyes, gives us the painting." This letter concluded with a characteristic reference to his own circumstances, and another of his famous declarations, later taken up by Jacques Derrida and others. "The difficulties of getting settled have placed me entirely at the disposal of my family, who make use of this for their own convenience, forgetting me a little. That's life, at my age I should have more experience and use it for the general good. *I owe you the truth in painting, and I shall tell it to you.*"[81]

Cézanne and Pissarro told each other the truth in painting. That is a rare distinction, and they knew it. Theocritus tried for ten years to lure Hesiod to the country of his muses and the mountain he made his own.[82] Pissarro was immovable. For Cézanne, that must have come as a bitter disappointment. The relationship did not fail; but from now on, except for brief interludes, it would be conducted at a distance. Voluntarily or involuntarily, Cézanne pushed on alone. A pattern of sorts was beginning to emerge.

8: *Semper Virens*

Cézanne showed in strength at the third impressionist exhibition of 1877—fourteen paintings and three watercolors, in pride of place, including the mad head of Victor Chocquet and the baffling *Bathers at Rest*—and then stopped.[1] The annual ritual of submission and rejection at the salon continued as before; otherwise, he ceased to show his work. He was non grata, as Walt Whitman once said—not welcome in the world. He explained later to Octave Maus: "On this matter I must tell you that the numerous studies to which I devoted myself having produced only negative results, and dreading criticism that is only too justified, I had resolved to work in silence, until the day when I should feel capable of defending theoretically the results of my endeavors."[2] No Cézannes would be seen on public display in Paris for more than ten years, until *The House of the Hanged Man* reappeared, ghostlike, at the Exposition universelle of 1889. His first one-man show had to wait until 1895, at the Galerie Vollard, when he was already fifty-six.

Bathers at Rest: Study, project for a painting (color plate 47), as it was listed in the catalogue of the impressionist exhibition, became for a generation his most famous work.[3] Much mocked by the crowds and the critics, it was robustly defended by Georges Rivière, and by an outraged Chocquet writing anonymously as "one of his friends."

> In his works M. Cézanne is a Greek of the belle époque; his canvases have the calm, heroic serenity of classical paintings and terracotta, and the ignoramuses who laugh in front of the *Bathers,* for example, remind me of barbarians criticizing the Parthenon.
>
> M. Cézanne is a painter and a great painter. Those who have never held a brush or a pencil have said that he can't draw, and they have

reproached him for "imperfections" that are only a refinement born of extensive knowledge. . . .

One of my friends has written to me [of the *Bathers*]: "I do not know what qualities could be added to this painting to make it more moving, more passionate, and I look in vain for the defects for which he is criticized. The painter of the *Bathers* belongs to the race of giants. Since he eludes all comparison, people find it convenient to repudiate him; yet there are other cases, and if the present does not do him justice, the future will know how to rate him among his peers beside the demigods of art."[4]

Critics inclined to question Cézanne's sanity would no doubt have been reinforced in their prejudices if they had heard the story of the painting's first owner, as told by Jean Renoir:

[Cézanne] came to the studio Renoir shared with Monet, radiant. "I have an *amateur*!" He had found him in the Rue de La Rochefoucauld. Cézanne was returning on foot from the Gare Saint-Lazare, having been out "*sur le motif*" at Saint-Nom-la-Bretèche [near Versailles], carrying his landscape under his arm. A young man had stopped him and asked to see the painting. Cézanne had propped the canvas against the wall of a house, well shaded to avoid reflections. The stranger was in ecstasies, especially over the green of the trees. "You can smell the freshness!" Cézanne promptly replied: "If you like my trees, you can have them." "I can't afford them." Cézanne had insisted and the admirer went off with the canvas under his arm, leaving the painter as happy as he was himself.

It was a musician called Cabaner. He played piano in the cafés and never had a sou to his name. His insistence on playing his own compositions meant that he was thrown out every time. My father thought that he had a lot of talent: "The trouble with him is that he was born fifty years too soon."[5]

This story may have been embellished, like many of Renoir's stories; unlikely as it may seem, in essence it was true. Cézanne's quixotic gesture speaks of his humility (and the paucity of such *amateurs*, penniless as they might be). In this instance, moreover, it symbolizes a relationship of curiosities. When Cabaner accosted him, Cézanne did not know who he was. Afterwards, they became friends. Apparently they met at the salons of Nina de Villars, "the Princess of Bohemia," where artists, writers, and musicians would dine, surrounded by

her cats, dogs, parrots, squirrel, and monkey. One of these soirées was evoked in a novel by Cézanne's compatriot Paul Alexis, *Madame Meuriot* (1890), featuring the hostess Eva de Pommeuse and thinly veiled portraits of Manet, Mallarmé, and "Kabaner." Cézanne appears as Poldex (Paul d'Aix)—"a kind of colossus, gauche and bald, an old child, naïf, inspired, at once timid and violent, the only one who really understood Kabaner." Alexis highlighted Poldex's temperament, his awkwardness, and his struggle. "Engrossed in the problems of his art, everything he could never capture, the miseries of the metier, banging his fist on the wall, he repeated endlessly, '*Nom de Dieu! Nom de Dieu!*'"[6] Cézanne and the social whirl sounds implausible, but it too was founded in fact, as the artist later confirmed to his son.[7]

Ernest Cabaner was not only a musician but a poet, a painter, a pauper, and something of a philosopher. He came from Perpignan to study at the Paris Conservatoire and never left, claiming that he was allergic to the countryside. He lived, after a fashion, by playing barroom piano for soldiers and prostitutes. In his spare time he collected old shoes to use as flowerpots. He had come to the notice of the prefect of police, who kept a file on him: "Eccentric musician, mad composer, one of the most fervent devotees of the caste"—a euphemism for homosexuals.[8] As an eccentric, he out-Cézanned Cézanne. He was cadaverous, lugubrious, consumptive. He seemed to be permanently in the final stages of tuberculosis, surviving on a diet of milk, honey, rice, kippers, and alcohol. Verlaine described him as "Jesus Christ after ten years of absinthe and two weeks in the grave." He was also a close friend of Rimbaud, "the pederast assassin," hailed by the Renoir character in a contemporary roman à clef as "the greatest poet on earth."[9] Friendship with Rimbaud was not easy to sustain. In Cabaner's case it lasted until the great poet's final disappearance from Paris, despite Rimbaud's periodic chants of "Cabaner must be killed!" and various other torments and provocations. One winter, Cabaner moved into a freezing hovel: Rimbaud removed all the window panes with a glass cutter. On another occasion, when Cabaner was out, Rimbaud found his daily glass of milk and neatly ejaculated into it.

Their friendship produced a classic of the avant-garde: Rimbaud's sonnet "Vowels."

A black, E white, I red, U green, O blue—vowels,
One day I will recount your latent births:
A—a furry black corset of spectacular flies
That thrum around the savage smells;

Gulfs of shade. E—whitenesses of steam and tents,
Proud glaciers' lances, white kings, quivering umbels.
I—purples, expectorated blood, the laugh of lovely lips
In anger or in the ecstasies of penitence.

U—eons, divine vibrations of viridian seas,
The peace of animal-strewn pastures and of furrows
That alchemy imprints on broad studious brows.
O—the final trump of strange and strident sounds,
Silences traversed by Worlds and Angels:
O—Omega, the violet ray of His Eyes![10]

Cabaner's part in this was the inspiration. He had been teaching Rimbaud to play the piano. His method was unconventional: he stuck little pieces of colored paper to the piano keys. He believed that each note of the octave corresponded to a particular color. "Once these correlations of sound and color have been discovered, it will be possible to translate landscapes and medallions into music." The idea of some sort of synesthesia, "hearing" color or "seeing" sound, was deeply embedded in the culture. Vowels figured large. For Victor Hugo, A and I were white, O red, and U black. The composer Scriabin associated E-flat major with red-purple; his colleague Rimsky-Korsakov insisted it was blue. A common rebus for "virtue" was a green U (*vertU*), which would have appealed to Cézanne. Baudelaire rings in Rimbaud's sonnet; Cézanne could have recited "Correspondences" from *The Flowers of Evil*:

As the long echoes, shadowy, profound,
Heard from afar, blend in a unity,
Vast as the night, as sunlight's clarity,
So perfumes, colors, sounds may correspond.

Cabaner must have talked to Cézanne about his metaphysics of sound and color. His talk was enchanting, his droll one-liners justly celebrated. "My father was something of the Napoleon type," he would say, "but less stupid." Asked if he could express silence in music, he replied unhesitatingly, "For that I should need at least three military bands." Observing with interest a shell landing not far away, during the siege of Paris, he asked his friend François Coppée, "Where are those cannonballs coming from?"

COPPÉE: Apparently the besiegers are sending them over to us.

CABANER (after a silence): Still the Prussians?

COPPÉE: Who else would it be?

CABANER: I don't know. Some other tribe?[11]

Cézanne seems to have taken to him, enjoying his company and listening intently to his bizarre interpretation of the opening scene of Zola's novel *L'Assommoir* (1877), as the workers descend from the heights of Montmartre and La Chapelle to the center of Paris. Perhaps he found something in common with this strange metaphysician, as he described him, "who really ought to have written some conspicuous work, for he had several theoretical insights, truly bizarre and paradoxical, that did not lack a certain savor."[12]

Cézanne was susceptible to synesthesia. He noted that Flaubert saw purple when writing *Salammbô*; as we know, he himself saw "a Flaubert color," a bluish russet, given off by *Madame Bovary*. Out *sur le motif* one day, when things were going well, he asked Gasquet playfully what scent was given off by his landscape-in-progress. The scent of pine, replied Gasquet, a little too quickly. Cézanne reproved him for his limited response. "You say that because of the two great pines swaying in the foreground. But that's a visual sensation. Besides, the pure blue scent of pine, which is sharp in the sun, must blend with the fresh green scent of the fields in the morning, and with the scent of stones, and the perfume of the distant marble of the Sainte-Victoire. . . . The turmoil of the world is resolved, deep down in the brain, into the same movement sensed by the eyes, the ears, the mouth and the nose, each with its own poetry."[13]

Cabaner hung the *Bathers* over his bed. But he was not long for this world. Cézanne helped him out, as he helped Emperaire; he asked his friends to do the same. His appeal to Marius Roux on Cabaner's behalf is a characteristic epistle, carefully drafted, a little like the requests to his father. It was sent shortly after Roux published *La Proie et l'ombre* (*The Substance and the Shadow*), the novel whose principal character, Germain Rambert, was modeled on Paul Cézanne—as the model himself was well aware.

Mon cher compatriote

Although our friendly relations haven't been very well kept up, in the sense that I haven't often knocked at your hospitable door, nevertheless I don't hesitate to write to you today. I hope that you will be able

to separate my small personality as Impressionist painter from the man, and that you will only want to remember the comrade. So it's not at all as the author of *L'Ombre et la proie* [*sic*] that I'm calling on you, but as the *Aquasixtain*, under whose sun I too first saw the light of day, and I take the liberty of introducing you to my eminent friend and musician Cabaner. I beg you to look favorably on his request, and at the same time I commend myself to you in case the day of the salon ever dawns for me. . . .

P. Cézanne
Pictor semper virens[14]

The valediction from this comrade *pictor* (painter) was a favorite expression and a calculated riposte: *semper virens* (evergreen), that is to say still vigorous or still game, as Cézanne explained in a letter to Numa Coste, which was precisely what his fictional alter ego was not.[15] In Roux's novel, Germain Rambert ends his days a ruined man. He is rumored to have committed suicide; in the closing pages of the work he is found lurking, deranged, in the precincts of the Louvre. In more ways than one, Cézanne was contesting his fate. No doubt there were also multiple ironies in his "small personality" as impressionist painter. With similar irony Cézanne once told Maurice Denis, "I should like to do decorative landscapes like Hugo d'Alési [who designed colorful posters for railway companies], yes, with my small sensibility."[16] This was another favorite trope, borrowed perhaps from Delacroix, who was given to inspecting his own "small emotions" in his journal; perhaps from Horace, in the *Odes*:

My style is like the bees
That gather patiently from here and there
Pollen (in the woods and on both sides
Of the Tiber, thyme perfumes the air);
Humbly I shape my careful little odes.[17]

In April 1881 Cézanne helped to organize a benefit for the ailing Cabaner, with paintings donated by Degas, Manet, and Pissarro, among others, including "your humble servant," as he wrote to Zola, soliciting a preface for the catalogue.[18] Five months later the mad composer was dead.

Bathers at Rest was bought by the venturesome Gustave Caillebotte for 300 francs: a substantial sum. He too had only a short time in which to enjoy it. Caillebotte died in 1894, leaving a magnificent collection of modern art to the

state. Walled in the past, the state did not want it. After prolonged negotiations, the director of the Beaux-Arts, Henri Roujon, and the curator of the Luxembourg, Léonce Bénédite (who would later refuse the gift of the murals at the Jas de Bouffan), eventually accepted around half the works—despite Caillebotte's stated wish that the collection should be kept whole: two out of four Manets, eight out of sixteen Monets, seven out of eighteen Pissarros, six out of eight Renoirs, and, at the very bottom of the barrel, two out of five Cézannes. As one of Caillebotte's executors, it fell to Renoir to negotiate with Roujon, a dispiriting experience.

> The only canvas of mine that he was prepared to accept without question was *Moulin de la Galette,* because [Henri] Gervex was in it. He regarded the presence of a member of the Institute among the models as a kind of moral guarantee. For the rest, without going overboard, he was somewhat inclined to sample Monet, Sisley and Pissarro, who had begun to be accepted by the "*amateurs.*" But when he got to the Cézannes! Those *Landscape*s that have the balance of Poussin's, those paintings of *Bathers* in which the colors seem to have been taken from ancient earthenware, in a word all that supremely wise art. . . . I can still hear Roujon: "That one, for example, he had no idea what painting was!"[19]

The *Bathers* were rejected.

In the meantime they had gained in notoriety. In 1883 Huysmans published a study of *L'Art moderne,* with a notable omission. Pissarro wrote to remonstrate. "How come you don't say a word about Cézanne, who all of us acknowledge as one of the most astounding temperaments, the most interesting of our age, and who has had a very great influence on modern art?" Huysmans replied: "Look, I find Cézanne's personality very appealing, for I know from Zola his struggles, his setbacks, his defeats as he tries to get a work going. Yes, a temperament, an artist, but if I exclude a few still lifes which hold up, the rest (in my opinion) are just not viable. Interesting, curious, stimulating, but there is a definite eye-case, as he says himself, I understand. . . ."[20] Stung, nonetheless, Huysmans proceeded to write a diverting pen portrait of the temperament and his works. It was reprinted in a renowned collection, *Certains* (1889):

> And hitherto-bypassed truths become discernible, tones that are strange yet real, blots of singular authenticity, nuances of linen, vassal-like shad-

ows strewn along the turning edges of the fruit and scattered with pos-
sible, charming bluish tones that make these canvases works of initiation,
when one compares them to customary still lifes set off by bitumen,
against unintelligible backgrounds.

Then some oil sketches of *plein-air* landscapes, efforts still in limbo,
attempts at freshness spoiled by retouching, and, finally, baffling imbal-
ances: houses tilted to one side as if drunk, skewed fruit in besotted pot-
tery, nude bathers defined by lines that are demented but throbbing—to
the greater glory of the eye—with the ardor of a Delacroix without refine-
ment and without delicacy of touch, whipped into a fever of botched col-
ors, shrieking in relief, on canvas so loaded it sags!

In short, a revelatory colorist, who contributed more than the late
Manet to the Impressionist movement, an artist with diseased retinas,
who in his exasperated visual perceptions discovered the premonitory
symptoms of a new art, so might we sum up this too-neglected painter,
Cézanne.[21]

The nude bathers evoked by Huysmans were the *Bathers at Rest*. As if to
make his point, he mistook (or misremembered) the men for women. A few
years later, in another portrait, much appreciated by Cézanne, Geffroy used
the same painting as an example of the artist's particular strengths. For Geffroy
it was at once coagulated and luminous; he praised its "ingenious grandeur,"
pointing out the Michelangelesque quality of the figures in their awkwardness.
Like Renoir, he was struck by the resemblance to classical earthenware.[22]

For the exhibition of 1895, the wily Vollard put *Bathers at Rest* in his shop
window, delighting in the offense it caused to all and sundry. Shortly afterwards,
he suggested the idea of making a lithograph of it. Cézanne made a grand
total of three lithographs in this period—even fewer than his etchings—but he
seems to have responded well to Vollard's suggestion. What he produced was
a sizeable work, confusingly known as the *Large Bathers* (color plate 50).[23] At
least three impressions were heightened with watercolor, specially applied by
the artist. In 1905 one of these was acquired by the young Picasso, who car-
ried it off to his studio, to penetrate its secrets. Cézanne's bathers took root in
his imagination; they were one of the stimuli for the *Demoiselles d'Avignon*
(1907) and related experiments of that fire-eating period. The lithograph itself
is not much noticed in this context, but it has found a place in the annals of the
cubist revolution. Picasso was among other things a keen photographer. In the
exuberant phase of their relationship, he and Braque photographed each other,

rather as Cézanne and Pissarro sketched each other, as brothers-in-arms. In the first known portrait photograph taken in Picasso's studio on the Boulevard de Clichy, in 1909, Braque models one of his famous suits, "Singapores" as they called them, much fancied for their "American" style. The young Braque was something of a dandy. He sports a Javanese bamboo cane. He is carefully posed amid the bric-a-Braque of the studio. His cane points towards the

Cézanne lithograph. On his other side is Picasso's gouache *Nude with Raised Arms* (1908). He has everything to hand. This *Portrait of Georges Braque* might have been entitled *The Attributes of Cubism*.

Bathers at Rest was further disseminated via a pen-and-ink drawing with watercolor, or a watercolor with pen-and-ink drawing, which seems to date from the same time as the paintings (1875–77). The watercolor was sold by Vollard as early as 1896. In the 1920s it was one of the first Cézannes to be seen live in Japan, a prime site for Cézanne worship, where it subsequently migrated, and where it now resides.[24]

Around the same time, Roger Fry turned his attention to the original painting, in a bravura study of Cézanne's development, characterizing it as "another desperate and heroic attempt at the construction of one of those *poésies* which had so constantly attracted and tormented his spirit"—a salutary failure, perhaps, as Montaigne might have said.

> It has none of the impetuous rush of the earlier Baroque works. Cézanne does not rely here on the impetus of sweeping contours and violent movement. The design is based on rectangular directions, parallelograms and pyramids. And these forms are situated in the picture-space with the impressive definiteness, that imperturbable repose of which Cézanne had discovered the secret. One suspects, however, that an endless search was needed to discover exactly the significant position of each volume in the space—a research in which the figures have become ungainly and improbable. At any moment the demand of the total construction for some vehement assertion of a rectilinear direction may do violence to anatomy, or the difficulty of finding the exactly right position of a contour may lead to incessant repainting and an unheard-of accumulation of pigment, as has happened, for instance, in the crucially important contour of the great cumulus cloud to the right, and the building of the pyramidal reminiscence of Mont Sainte-Victoire to the left. But the very desperation of the artist's sincerity has its effect on the mind, and I doubt if any picture of modern times has so nearly approached to the lyrical intensity of Giorgione's mood. I would not suggest here any direct hint at Giorgione's design, though I suspect Cézanne of always having entertained the ambition of creating a new *Fête champêtre* on modern lines.[25]

Fry did not miss his guess. Cézanne adored Giorgione's *Concert champêtre* (c. 1510). It hung in the Louvre, where he would often go and immerse himself

in it. He considered that Giorgione had achieved what Manet had not, in his scandalous variation, the *Déjeuner sur l'herbe*. The Giorgione had the je ne sais quoi that transports the senses. "Look at the golden flow of the tall woman, the back of the other," Cézanne urged Gasquet, on one visit. "They're alive, and they're divine. The whole landscape in its russet glow is like a supernatural eclogue, a moment of balance in the universe perceived in its eternity, in its most human joy. And we're part of it, we miss nothing of its life."[26]

If the *Bathers* were indeed personal meditations on the past and the future, rather than observations *en plein air,* then this little burst of them may be linked with a bout of introspection. In 1878, Cézanne read Stendhal's *Histoire de la peinture en Italie,* for the third time. He returned once more to the fascinating section on temperament and moral character. He concluded that he had been mistaken in his earlier self-identification—he had read it badly, as he said to Zola. This time, he seems to have decided that he was not choleric, after all, but melancholic.

His moral character, therefore, was not as he had believed. It was as follows:

Quick impulses, decisive action betray the choleric at work. Awkward movements, decisions full of hesitations and reservations reveal the melancholic. His feelings are always studied, he seems to gain his ends only in a roundabout manner. If he enters a room, he clings to the walls. (Passionate shyness is one of the clearest hallmarks of the talent of great artists. A vain person, lively, often tingling with envy, such as the French, is the opposite.) . . .

Often the real aim seems to be completely forgotten. There is a powerful drive towards an object, and the melancholic proceeds in a different direction; he believes himself to be weak [*faible*]. This curious being is above all interesting to observe in love. Love is always a serious matter for him. . . .

If you know a particular drawing of *Parnassus* by Raphael in the Vatican, look for the figure of Ovid. . . . In Ovid's beautiful eyes you will see very clearly that the beauty counters the miserable expression. For the rest, that head shows the character of the melancholic very well; it has two principal traits, the prominent lower jaw, and *the extremely thin upper lip,* which is the mark of timidity.[27]

Among Stendhal's melancholics are numbered Tiberius and Louis XI. What distinguishes them, he emphasizes, is *the search for solitude.*[28]

Armed with this new realization, Cézanne did some stocktaking; more accurately, some rummaging through attitudes and affections, informed consciously or unconsciously by his reading. In the spirit of self-examination he examined his friends. Some were found wanting. In Marseille he caught sight of Fortuné Marion, with whom he had explored the strata and substrata of Mont Sainte-Victoire. He wrote to Zola, in Stendhalian tones, "I saw from afar Monsieur Marion, on the steps of the Faculty of Sciences. (Shall I go and see him—that will take a while to decide.) He does not appear to be sincere in art, in spite of himself, perhaps."[29] Joseph Huot, his fellow student at the School of Drawing in Aix, elicited a similar reaction. "I met one Huot, architect, who sang the praises of your entire Rougon-Macquart [series], and told me that it is much respected among those in the know. He asked me if I saw you: I said: sometimes—if you wrote to me: I said: recently. Stupefaction, and I rose in his estimation. He gave me his card, with an invitation to go and see him. So you see that it counts for something to have friends, and they won't say of me what the oak said to the reed, 'Now, had you the luck to be born in my shadow,' etc."

This last sally was a reference to the fable of "The Oak and the Reed," by La Fontaine, in which the overmighty oak offers protection (or humiliation) to the wretched reed, who politely declines:

"It's kind of you to be so sore chagrined
On my account. I thank you. But, no need!
I fear the winds far less than you, my friend.
You see, I never break; I merely bend."

And so it comes to pass: a great wind whips up, and arrogance gets its comeuppance.

Oak holds . . . Reed bends . . . Wind blows . . . Then more and more,
Till it uproots the one who, just before,
Had risen heavenward with lofty head,
Whose feet had reached the empire of the dead.[30]

There was also the case of Antony Valabrègue. "I should have nothing to tell you," Cézanne wrote to Zola, "if, having been in L'Estaque these last few days, I had not received a signed letter from the *brave* Valabrègue, Antony, informing me of his presence in Aix, whither I rushed off immediately yesterday, and where I had the pleasure of shaking his hand this morning. . . . We

went round the town together. We recalled some of the people we had known. But how far apart we are in *sensation*!"[31]

Sensation was contaminated by alienation. "I always seem to have the feeling that I would be better off where I am not," wrote Baudelaire in the prose poem "Anywhere out of the world." Cézanne was prone to the same feeling. He had been aware of this from the beginning, in Paris in 1861. ("I thought that when I left Aix I'd leave the ennui that pursues me far behind. All I've done is swap places and the ennui has followed me.") In the Haute-Savoie thirty years later he wrote to Solari: "When I was in Aix, it seemed to me that I'd be better off somewhere else; now that I'm here, I miss Aix. For me life takes on a sepulchral monotony."[32] This was Baudelaire's complaint. "Ah, my dear Michel, how bored I am here! How bored I am! I truly believe that no matter which country one finds oneself in, only work can prevent boredom." So it was with Cézanne. The restless, itching soul was an integral part of the temperament. The answer to the itch was work. Hard work overcomes everything, Cézanne had instructed Zola, at nineteen, quoting Virgil. Twenty years later, he offered his friend a similar thought, by way of consolation: "I hope you soon recover your usual self in work, which is I think, despite all the alternatives, the only refuge where one can find true happiness in oneself."[33]

Cézanne dwelled on restlessness, on refuge, and at bottom, on solitude. He was singular. Was he solitary? What then would become of him? Some of these thoughts may have been another kind of dialogue with Delacroix. The master frequently confided to the pages of his journal his reflections on solitude— "that inevitable solitude to which the heart is condemned," as he recorded, at the age of twenty-five. In middle age, he found that there was a good deal to be said for it. "I was thinking while getting up of the impossibility of doing the slightest thing about the situation in which I find myself. Only solitude, and the safety in solitude, permits of undertaking and achieving." There was a certain grandeur to Delacroix, even in reflection, but also a rich vein of self-scrutiny, and a will to self-mastery: "Tired from my journey and my small emotions of yesterday. Suffering all day: poor state of body and mind. Agitation or torpor, are those the inevitable conditions? No, if I remember thousands of moments in my life over the years when I've escaped from the abyss. On many occasions I savored the pleasurable feeling of freedom and self-possession, which must be the sole good to which I must aspire."[34]

This notion of "safety in solitude," reiterated in the journal, would have interested Cézanne, not only because it came from Delacroix, but also because the Delacroix of the journal revealed himself so candidly in the matter of tem-

perament. "Day of work without interruption. Delicious feeling of solitude and tranquility, and of the profound well-being they provide. No man is more sociable than I . . . [yet] that singular disposition must give a false idea of my character. . . . I attribute to my nervous and irritable constitution this singular passion for solitude. . . . My nervous temperament makes me dread the exhaustion of every social encounter; I'm like the Gascon who said when going into action: 'I tremble at the perils that will expose my courage.' "[35]

The heart has its reasons, as Pascal said, that reason does not know. At the age of forty-six, Cézanne was imperiled by reason of the heart. An agitated letter to Zola of 14 May 1885 signaled his distress:

> I'm writing to ask if you would be kind enough to answer me. I should be much obliged if you would do me some service, which is I think tiny for you and vast for me. It would be to receive some letters for me, and to forward them by post to the address that I'll send you later. Either I am mad or I am sane, *Trahit sua quemque voluptas!* [Each towed by his own fancy!] I appeal to you and I beg your forgiveness, happy are the wise, don't refuse me this service, I don't know where to turn. . . .
>
> I am weak and can do you no service, as I shall leave this world before you, I will put in a good word with the Almighty to find you a good place.[36]

The quotation he reached for was from Virgil's second *Eclogue*—the one that he himself had translated and withheld from Zola so long ago:

> A shepherd, Corydon, burned with love for his master's favorite,
> Handsome Alexis. Little reason had he for hope;
> But he was always going into the beech plantation
> Under whose spires and shades, alone with his futile passion,
> He poured forth words like these, piecemeal, to wood and hill: . . .
> Fierce lioness goes after wolf, wolf after goat,
> The wanton goat goes after the flowering clover, and I
> Go after you, Alexis—each towed by his own fancy.

Cézanne had fallen for a woman—another woman. Like Corydon, he burned with love, and poured forth words.

Her identity has always been a mystery. Indeed, the only thing about this so-called affair of which we can be certain is that he was bold enough to kiss her,

and that he drafted a letter to her—a declaration of his feelings. For him, this was an emotional tempest. For several months he was in such a state of agitation that he could hardly paint. His feelings and his movements can be tracked through his letters to Zola, which are full of telegraphic anguish, and leave a great deal unexplained. As for her, we simply do not know. Speculation has centered on a young maid at the Jas de Bouffan, by the name of Fanny.[37] That is superficially plausible, yet highly unlikely. Fanny had left Aix the year before. The tone of Cézanne's letter does not suggest that he was writing to a young girl, and a servant to boot; and he appears to have had every expectation that she would write back. Moreover, while there is no legislating for fancy, Cézanne's attitude to domestic servants, his own and other people's, displayed a remarkable consistency: all his life he treated them with the utmost respect, with a correctness bordering on prudishness. He disapproved of his father's dalliances, and it is clear that he found it increasingly difficult to cope with the trappings of success in Zola's country house at Médan, once the writer had achieved a commercial breakthrough. This was largely a matter of conspicuous consumption, and the company he kept, but there was also something of the droit du seigneur that Cézanne found almost offensive. In a revealing aside, he told Gasquet later that "a smile exchanged between a maid and Zola at the top of the stairs, one day when [Zola] returned late, laden with packages, his hat battered, drove [Cézanne] away from Médan forever."[38]

The draft of his letter to the unknown woman is on the back of a landscape. It begins with a jolt of recognition—*I saw you*—for Cézanne, the fundamental requirement. It ends abruptly at the foot of the page.

I saw you, and you let me kiss you, from that moment I have had no peace from profound turmoil. You will forgive the liberty that a soul tormented by anxiety takes in writing to you. I do not know how to describe to you that liberty that you may find so great, but how could I remain oppressed by this dejection? Is it not better to give expression to an emotion than to conceal it?

Why, I ask myself, be silent about my torment? Is it not a relief from suffering to be permitted to express it? And if physical pain seems to find some relief in the cries of the afflicted, is it not natural, Madame, that psychological suffering seeks some respite in the confession made to the object of adoration?

I quite realize that this letter, sent hastily and prematurely, may appear indiscreet, has nothing to recommend me to you but the goodness of—[39]

After sending the letter, he embarked on an ill-starred and increasingly erratic odyssey. The Cézannes had an invitation to stay *en famille* with the Renoirs at La Roche-Guyon. Cézanne went first to Paris and dined with Zola. The next day he picked up Hortense and Paul, and off they went to La Roche-Guyon, a picture of domestic harmony. Cézanne arranged for letters to be delivered to a poste restante in the town, notified Zola, and waited in a fever of impatience for any word to arrive. Days passed. He began a painting, *The Turning Road at La Roche-Guyon,* but could not settle, and soon found his circumstances unbearable. He beseeched Zola to let him come and stay at Médan, some forty miles away. More days passed; still no letter from any quarter. Cézanne was so disturbed that he had forgotten to go to the poste restante. Zola, who showed considerable forbearance throughout, had responded immediately and sympathetically but could not accommodate him straightaway. His postscript punctured Cézanne's hopes: "I haven't received anything for you for some time."[40] It appears that his inamorata did reply, as he must have implored, but perhaps only once.

Cézanne could not stay put. He quit La Roche, leaving the unfinished painting with Renoir, tried unsuccessfully to find a hotel room near Médan, reversed course, and cooled his heels in Vernon. No sooner had he determined to return to Aix (alone) than he heard again from Zola, who suggested he come to Médan. He did so, still vacillating over his next move. "I should have liked to get on with painting, but I was in a state of the greatest perplexity, for as I must go down to the Midi, I decided that it might be the sooner the better. On the other hand, perhaps it would be better if I waited a little longer. I'm in a state of indecision. Perhaps I'll get out of it."[41] He stayed with Zola for a few days, started another painting, unburdened himself to his friend, and finally made his way back to Aix. He never did return to *Médan, Château and Village.*[42]

Four months had gone by. Installed once again at the Jas de Bouffan, Cézanne was out of sorts. Love is always a serious matter for him, as Stendhal had observed of the melancholic moral character. As in the past, when he was down, he procrastinated. "I received the news you sent me about your address last Saturday," he told Zola. "I should have replied immediately, but I've been distracted by the molehills under my feet, which are like mountains to me." A few days later he wrote again:

So, for me, complete isolation. The brothel in town, or some other, but nothing more. I pay, the word is dirty, but I need some peace, and at this price I ought to get it. . . .

I thank you and beg you to forgive me.

I'm beginning to paint, but [only] because I'm more or less worry-free. I'm going every day to Gardanne, and coming back each evening to the countryside in Aix [to the Jas].

If only I had had an indifferent family, everything would have been for the best.[43]

The affair, such as it was, had come to nothing. Shaken, Cézanne sought fresh guidance on how to live. Virgil was already ringing in his ears. As he knew full well, the *Eclogues* and the *Georgics* contained awful warnings about the lengths to which any pitiable creature might be driven by sexual passion. Virgil was haunted by the theme of the destructive power of passion. Passion, he argued, must be eliminated for the sake of peaceful and ethical works and days. For Cézanne, this argument was bound to recall the great denunciation of irrational sexual passion in Lucretius, another of his classical interlocutors, in *De rerum natura* (*On the Nature of Things*), a sympathetic title. Cézanne found in Lucretius a man after his own heart.

Lawyers argue their cases and make laws
Generals fight battle leading troops to war,
Sailors pursue their struggles with the wind,
And I ply my own task and seek the nature of things
Always, and tell them in our native tongue.

This apostle of moral life and molecular vision also traffics in sensation, not to mention sex, cosmology, meteorology, and geology. Lucretius was a fount of wisdom. "Take my advice," he says, "and keep your fancy free."[44] Cézanne's confessional letter to Zola ("I pay") was at once paraphrase and enactment of his epic poem:

For if what you love is absent, none the less
Its images are there, and the sweet name
Sounds in your ears. Ah, cursed images!
Flee them you must and all the food of love
Reject, and turn the mind away, and throw
The pent-up fluid into other bodies,
And let it go, not with one single love
Straitjacketed, not storing in your heart

The certainty of endless cares and pain.
For feeding quickens the sore and strengthens it,
And day by day the madness grows and woe
Is heaped on woe, unless the first wounds by new blows
Are deadened and while the wound's still fresh you cure it
By wandering with Venus of the streets,
Or to some newer purpose turn your mind.[45]

Cézanne turned his mind to some newer purpose. Working at Gardanne, and tramping to and fro, helped to restore his equilibrium. For Cézanne as for Rousseau, contemplation was a deliverance from the memory of suffering, "compensation for human joys." In *Reveries of a Solitary Walker* (1776) the dejected Rousseau had written of a Cézanne-like attentiveness to nature, a retrained attentiveness, tempered by experience (or misfortune): "It was even to be feared that my imagination, alarmed by my misfortunes, might end by filling my reveries with them, and the continual consciousness of my sufferings might gradually come to oppress and crush me finally under their weight. In these circumstances an instinct that is natural to me averted my eyes from every depressing thought, silenced my imagination and, fixing my attention on the objects surrounding me, made me look closely for the first time at the details of the great pageant of nature."[46] For Cézanne, it was always the first time.

Gardanne was then a picturesque little place, about eight miles away, looking very much like an Italian hilltop village. Cézanne's interest in the pyramidal shape of the settlement and the cubic cast of the houses makes for an unavoidable association with the cubist landscapes that came twenty years later—not so much landscapes traditionally conceived as variations on the idea of landscape, each element nested in context, but the sense of place increasingly evanescent, or interchangeable. In time, Cézanne's Gardanne would become Braque's La Roche-Guyon, Picasso's Horta de Ebro, and after another twenty years, Gorky's Staten Island. For the cubists, the discovery of Cézanne was decisive. For Braque, in particular, deep immersion in Cézanne was a revelation of affinity and a kind of anamnesis, a memory of what he did not know he knew. "The discovery of his work overturned everything," he told one of his intimates, in old age. "I had to rethink everything. I wasn't alone in suffering from shock. There was a battle to be fought against much of what we knew, what we had tended to respect, admire, or love. In Cézanne's works we should see not only a new pictorial construction but also—too often forgotten—a new

moral suggestion of space." Studying the results, Matisse observed acutely that Braque's houses (or rather the signs used to represent them) were employed formally, "to let them stand out in the ensemble of the landscape," and at the same time morally, "to develop the idea of humanity which they stood for."[47]

Cézanne's depiction of Gardanne is somewhere near the beginning of that metamorphosis (color plate 62). Reinforcing the association, he painted the village three times, at three different times of day, from three different angles, as if surrounding it. One of these compositions, possibly the first, is horizontal; the other two are vertical—though in one case the initial conception was horizontal. Cézanne changed his mind, but allowed traces of his thinking to show through, as though showing the working, or the passage of time, or the process of indecision. The same canvas was left provocatively unfinished.[48]

Gardanne was also a site of reconciliation and, perhaps, restitution. That autumn, Cézanne took a house in the village. Hortense and Paul came to join him. Paul, now thirteen, was sent to the village school. In his spare time he posed for a full-length portrait drawing. *The Artist's Son* stands proud, and a little self-conscious; his stance seems to anticipate that of *The Boy in the Red Waistcoat* a few years later. Cézanne also captured him writing and sleeping.[49]

Hortense sat for at least two portraits, of the same dimensions, in the same outfit, against the same wall.[50] Both portraits are masterly accounts of mixed feelings—studies in disclosure and concealment. In one (subsequently owned by Matisse), Hortense has a long face and a stiff upper lip. She has turned to the left, and gazes impassively into the middle distance. The open flank of her right cheek compels our attention: it is delicate, expansive, a palette of color patches. The other cheek, by contrast, is hardly more than a sliver, darkened, abbreviated, closed. The face is a mask imposed on the neck, attached at the ear, a surface that discloses no interiority or self-reflection, a locus of pictorial effects. *Madame Cézanne Inscrutable* keeps the world at bay. She may be many things, but she is not comfortable in her skin.

Her counterpart is quite different: the embodiment of "changing, shimmering matter," as Cézanne once put it (color plate 36).[51] She is almost pretty, as Ruth Butler has observed. *Madame Cézanne Labile* is shown full face. It is the very picture of uneasy psychology. The mask has been peeled off, revealing the underlying volatility. She engages us directly, with her right eye—the left eye is blanker, narrower, more heavy-lidded, almost recessive. The hair, the face, and the dress all have a kind of parting in the middle, a subtle bisection, slightly misaligned, which makes this portrait so fascinating. The painted face is alive with feeling; color chases pallor across the features. The expression hinges on

the curvature of the upper lip, which seems extraordinarily labile. It could change at any moment; eruptions are unpredictable. There is a powerful sense of emotional presence—emotional pressure—precariously held in check.

Their pact was renewed. As if to seal it, Cézanne produced an image of heart-stopping tenderness (color plate 35): a drawing of Hortense with a water-color of hortensias—hydrangeas.[52] Here is *Madame Cézanne Relaxed,* neither watchful nor remote, but direct and unspoiled, sleepy and delicious. Snug in a corner of the sheet, Hortense is not pretty; she is beautiful. And he is playful. The felt sense of connection scorches the paper like love. "Sketches generally possess a warmth that pictures do not," said Diderot. "They represent a state of ardor and pure verve on the artist's part, with no admixture of the affected elaboration introduced by thought: through the sketch the painter's very soul is poured forth on the canvas."[53] The doomed letter poured forth words; the delicate sketch poured forth soul. This portrait, with its characteristic verbal and visual puns, has been seen as a valentine: my funny valentine. It was surely a gift of some sort. Perhaps it was a wedding gift.

The following spring, on 28 April 1886, Paul Cézanne, *artiste-peintre,* and Hortense Fiquet, *sans profession,* were married in the Town Hall in Aix. Cézanne's father and mother were present; both signed their names, effortlessly. Hortense's father was recorded as "absent but consenting." The witnesses were Maxime Conil, Cézanne's brother-in-law; Jules Richaud, clerk; Louis Barret, ropemaker; and Jules Peyron, excise clerk, a resident of Gardanne, who had the distinction of having his portrait painted, twice, by his friend the groom.[54] According to Conil, Cézanne took the witnesses to lunch, while his parents escorted his wife to the Jas de Bouffan. No more of the hole-and-corner for Hortense. The years of concubinage were over at last.

The next day the marriage was solemnized at the Church of Saint-Jean-Baptiste, the parish church of the Jas de Bouffan, in the presence of Marie Cézanne and Maxime Conil. Far away, a fervent admirer of Cézanne's heard the news: Vincent van Gogh, who never met him, but who made a careful study of his work. Vincent wrote to Émile Bernard, as if to bastardize Lucre-tius, "Cézanne is precisely a man in a middle-class marriage just like the old Dutchmen; if he gets a hard-on in his work, it's because he hasn't wasted him-self on his wedding night."[55]

The deed was done. Why? And why now? Given the sequence of events, it is difficult to believe that the timing of the wedding was not connected in some way with the "affair" or the fallout from it. Not surprisingly, Cézanne vouchsafed nothing directly on the subject. Neither did Hortense. Did she

know, or suspect?[56] She must have realized that something was the matter when Cézanne left La Roche-Guyon in such a state. Did she ask? Did he tell?

On the question of marriage, at least two members of his family suggest themselves as agents of influence. His mother knew all about the secret family. She wanted her son to be happy; she also wanted to see more of her grandson. She tried her best to act as an emollient if she thought that things were not going well between Cézanne and Hortense. She is unlikely to have missed the signs of recent disturbance, even if she was not privy to the details. His sister Marie also knew about the secret family. She evidently wished her brother to regularize the situation in the eyes of the Lord, whatever Hortense's shortcomings—"Marry her, why don't you marry her!" was her constant refrain. Marie is said to have known of the affair. Whether she regarded it as an omen of more philandering to come, or a sign that Cézanne might jettison Hortense in the not-too-distant future, she was all in favor of marriage as soon as it could be arranged.

If Cézanne was indeed belabored in this fashion by his mother, or his sister, or both, it might explain his weary remark to Zola: "If only I had had an indifferent family. . . ." The attitude of his father, previously all-important, no longer seems to have been a prime consideration. Plainly he had dropped his objection; for all practical purposes he may have dropped it some time ago. He always wanted the best for his son, according to his lights. At this late stage it is conceivable that he, too, may have come to think it preferable for Cézanne to regularize the situation, if not in the eyes of the Lord, then in the eyes of the law, especially with regard to any pendants. As it turned out, Louis-Auguste himself had only six months to live. He is said to have been senile at the end. How far and how fast he had weakened, it is impossible to say. In the matter of the wedding, it was as if he had faded out of the frame. For once in his life there was no argument.

Whether or not Louis-Auguste came eventually to accept his son's vocation, in one significant respect he had already eased his passage. When he made provision for Rose's dowry, in 1881, he also made an initial division of his assets among all three children, giving each 26,000 francs. This unexpected largesse encouraged Cézanne to make his will. He turned as usual to Zola.

> I've decided to make my will, because it appears that I can. The annuities on which I receive interest are in my name. So I'm writing to ask your advice. Could you tell me the form of words to be used when drawing it up? In the event of my death, I wish to leave half of my income to my

mother and the other half to the little one. If you know anything of this, would you tell me about it? For if I were to die in the near future, my sisters would inherit from me, and I believe my mother would be deprived, and I think the little one (*being recognized,* when I notified the town hall) would still be entitled to half of my estate, but perhaps not without contestation.[57]

A few months later, he sent a further bulletin: "After a good deal of back and forth, this is what happened. My mother and I went to a solicitor in Marseille, who advised a holograph will [written, dated and signed by the testator], and, if I so desired, my mother as sole legatee. So that is what I did. When I'm back in Paris, if you could come with me to a solicitor, I'll make another appointment and redo my will, and then I'll explain to you in person what led me to this." Zola sent him a reassuring reply—"The idea of making your mother sole legatee seems to me a good one, since you trust her"—but Cézanne was still uneasy. "Now that I know you're at Médan, I'll send you the document in question, of which my mother has a copy. But I fear that all this makes little odds, for these wills are so easily attacked and annulled. A firm agreement before the civil authorities would be better should the need arise."[58]

He trusted his mother, it seems, but not his sisters. There is no indication that Rose was especially acquisitive; but if she merely went along with her husband (a lawyer), that would have been enough for Cézanne, who regarded his brother-in-law as mercenary and untrustworthy. Marie for her part could be exasperating, with her meddling and her piety. Cézanne was usually prepared to indulge her; he believed she meant well. Marie was a hardy soul, and a spinster, but there were those who had got their hooks into her, as Cézanne would have said. She was in thrall to the Jesuits, and he suspected that they had designs on the estate—most nefariously, on his father's house. He talked darkly of "disarming the Jesuits who insinuated themselves with his elderly sister and coveted the Jas."[59]

As he saw it, there were good reasons for protecting his interests, and his mother. Conspicuous by her absence from these calculations was Hortense. On the face of it, she was cut out altogether. And yet when Cézanne came into his full inheritance, after his father's death, he took great pains to make provision for her—generous provision—on an equal footing. ("For the Dumpling! For the Little Dumpling! And for me!") To his dying day he was solicitous of her needs and her well-being. In later life she was effectively in the care of their son (and a paid female companion); as the years went by, Cézanne entrusted

her increasingly to Paul—he who was wise in the ways of the world, as his father liked to think. Doubtless there was an element of convenience to this, but it was also a kind of contract, and an imperishable bond between them. For father and son, for Cézanne in particular, Hortense was that most precious of beings, a mother. There could be no question of cutting her adrift. She must be looked after.

Marriage itself was a form of looking after. Whether it was also a way of making amends, we may never know. If so, it was surely a way she understood. It was late in coming; but whatever the sense of obligation or contrition, it was a handsome gesture. Financially, it meant that Hortense would inherit half of his estate, as of right, regardless of any other provision he might make. Her future was secure. La Boule, too, had expectations of a kind. Twenty years later they were amply fulfilled. When Cézanne died, in 1906, Hortense's half-share amounted to 223,000 francs.

If the marriage came as a surprise, Cézanne had surprised himself. He had leapt: then he had drawn back. (Why go and stay with Renoir at that juncture?) As like as not, he had also been rebuffed. However that may be, he had done something that he had not dreamt of doing since the age of eighteen. He had lost his head—but not entirely. He emerged, if not exactly unscathed, then confirmed in his temperament, à la Stendhal. His conduct was a textbook demonstration of awkward movements. In matters of the heart, passionate timidity was Cézanne all over. He may well have been alarmed by his own emotions. Abortive as it proved, the passage with the unknown woman served as a reminder "of what a narrow ridge of normality we all inhabit," as the neurologist Oliver Sacks has underlined, "with the abysses of mania and depression yawning to either side."[60] A few years later, Cézanne was much taken with a collection of stories by Gustave Geffroy, *Le Cœur et l'esprit* (1894), dedicated to him by the author. His favorite was "Le Sentiment de l'impossible" (the title alone would have appealed to him), about a young girl who falls in love with the portrait of a young man, a deceased relative, "destiny having willed it thus, for him, born too soon, and for her, born too late." It ends: "And so it was that, in the fever and the mirage, she came to know the sorrow of the irreparable, the feeling of the impossible."[61]

In search of quietude, he decided to get married. Delacroix had given up on the idea of a marriage of equals; so would Cézanne.[62] It was his decision. If there was a trace of acquiescence in the hand dealt by fate, he was not only melancholic but phlegmatic. "I could have done with other loves perhaps. But there it is, either you love or you don't."[63]

He was prompted to reflect on all this, almost involuntarily, by a letter of congratulation from Victor Chocquet. Cézanne was deeply moved by this missive. He responded with a poignant self-assessment, measuring himself as so often against the other man.

Now, I should not like to weigh too heavily on you, morally I mean, but since Delacroix served as an intermediary between us, I will permit myself to say this: that I should have liked to have your stable outlook which allows you to reach the desired end with certainty. Your good letter, enclosed with that of Madame Chocquet, testifies to a great balance of human faculties. And so, as I am struck by this requirement, I am discussing it with you. Fate has not endowed me with an equal stability, that is the only regret that I have about the things of this earth. As for the rest, I have nothing to complain about. The sky, the bounty of nature, still attract me, and offer me the opportunity to look with pleasure.

When it comes to the realization of wishes for the simplest of things, which ought really to come about by themselves, for example, it would seem that my unhappy lot is for success to be spoiled, for I had a few vines, but untimely frosts came and cut the thread of hope. And my wish would have been, on the contrary, to see them flourish, just as I can only wish for you success in what you have planted and a fine growth of vegetation: green being one of the most cheerful colors, which does the eyes most good. To conclude, I must tell you that I am still occupied with painting and that there are treasures to be carried away from this country, which has not yet found an interpreter to match the nobility of the riches displayed.[64]

There was a brief, matter-of-fact postscript: "The little one is at school and his mother is well."

And a silent, defiant valediction: *Pictor semper virens.*

Self-Portrait: The Plasterer

This portrait (color plate 4) is usually dated 1881–82, when Cézanne was in his early forties. Its most immediately distinctive feature is his eccentric headgear. This turban-like arrangement has been seen as a nightcap or (more likely) a plasterer's cap, fashioned out of a napkin or a small towel.[1] Mindful of the paternal example, perhaps, Cézanne selected a variety of hats for his self-portraits: over a twenty-year period, from the late 1870s to the late 1890s, he appears in a peaked cap, a straw hat, a black wide-brimmed hat, a Kronstadt hat (a flat-topped bowler or derby with a curly brim), a brown soft hat, and a beret.[2]

Michael Fried's poem "Cézanne" catches his usual outfit and his proverbial disposition:

Returning home
from a day spent looking at paintings
I'm as exhausted
as I would be if I had dug a trench
Returning home
from a day spent digging trenches
the painter pulls the brim of his derby
low over his eyes
Passing each other
on a narrow road
I nod to him in my friendliest manner
he glares at me with what's left of his face[3]

It is tempting to link the plasterer with a celebrated self-portrait by Chardin (color plate 27), a late work of 1775, which Cézanne studied in the Louvre.

Chardin is decked out in a fading pink Madras scarf, worn as a neckerchief, steel spectacles, green eyeshade, and white nightcap, secured by a pink ribbon tied in a bow. "Each detail of this amazingly casual dress," wrote Proust in homage, "seems to be just as much a challenge to convention as an indication of taste." What's left of his face is hard to read.

> When you look more closely at Chardin's face in this pastel portrait you will pause; the uncertainty of the expression will disturb you, daring you to smile, or to make an excuse, or to weep. . . .
>
> Does Chardin look at us with the bravado of an elderly person who does not take himself too seriously, exaggerating (either to entertain us or to show us that he is not easily fooled) the merriment of his continuing good health, his unabated sense of humor: "Aha! You young people think that you are the only ones that count?" Or has our own youth brought home to him his loss of vigor, is he staging a passionate, ineffectual display of defiance which is painful to behold?[4]

Chardin was a crafty one, as Cézanne said.[5] Throughout the 1880s, and beyond, Cézanne took his measure. When he copied *The Skate*—a gutted skate with a human face, surrounded by oysters, carp, spring onions, attacking cat, protruding knife, still life, and tablecloth—he omitted the skate, the oysters, the carp, the onions, the cat, and the knife, concentrating on the still life and the tablecloth.[6]

By the time he came to this self-portrait he had achieved a certain mastery, reflected in the painting. Cézanne mixed pride and humility. He communed with the past masters. "To my mind one does not substitute for the past," he told Roger Marx, "one only adds a new link."[7] A sheet of drawings from the same period juxtaposes his own self-portrait head (bare) with Goya's self-portrait head (in top hat), and a trademark apple.[8] The Freudian reading was hammered home by Meyer Schapiro: "The virile head of Goya represents an ideal of confident and redoubtable masculinity—perhaps a father image— for the shy, troubled painter."[9] The man in the white cap does not look much troubled.

Cézanne would have been aware of other headgear. Rembrandt, too, was given to dressing up. A self-portrait in a beret was donated to the museum in Aix in 1860. In other self-portraits he appears in a white cap; one of them is in the Louvre. It has been suggested that Rembrandt is always in performance. "The self-portraits in fancy dress have nothing to do with self-disclosure," says

Harry Berger, in a study of those works. "What they portray is not the sitter's status, soul, personality, visual particularity, or state of mind, but the act of self-portrayal he performs for the benefit of the painter, the observer, and himself."[10] The young Cézanne is performing Cézanne, perhaps, but the mature Cézanne? The look belies it.

This painting was part of the famous *Tschudi-Spende*. Appointed director of the Nationalgalerie in Berlin in 1895, Hugo von Tschudi built up the first comprehensive public collection of French nineteenth-century paintings anywhere in the world. No public funds were available for such acquisitions, so he arranged for the works to be presented to the museum by various patrons—in the teeth of objections from the meddlesome Kaiser. Tschudi naturally made his way to the 1907 Salon d'automne, where he lingered in the Cézanne retrospective, and shocked Jacques-Émile Blanche by telling him he enjoyed a Cézanne "like a slice of cake, or a piece of Wagnerian polyphony." On 10 January 1908 he bought the *Self-Portrait in White Cap* from the Galerie Druet in Paris for 10,000 francs. Before it could be accessioned, however, he was removed from his post. In 1909 he became director of the Königliche Pinakotheken in Munich. He took the self-portrait with him. In 1912 it entered the collection as a gift of Eduard Arnhold and Robert von Mendelssohn. It is now in the Bayerische Staatsgemäldesammlungen, Munich.

9: *L'Œuvre*

When Cézanne sought refuge at Médan, in the midst of his emotional crisis over the unknown woman, Zola was immersed in the fourteenth of the Rougon-Macquart series, *L'Œuvre*, meaning literally "The Work," but known in English as *The Masterpiece*. *L'Œuvre* retrieves Claude Lantier from *Le Ventre de Paris* (the third of the series), places him center stage, and tells his life story from cradle to grave. The novel has a pronounced autobiographical, even confessional, strain. Zola's unbeatable credentials as privileged participant-observer find expression in the character of Lantier's childhood friend Pierre Sandoz, a thinly disguised self-portrait. *L'Œuvre* is the arc of their lives, dramatized, as if told by Emperaire, tutored by Cabaner.

> The break between Claude and his old friends had slowly widened. His painting they found so disturbing, and were so conscious of the disintegration of their youthful admiration that little by little they had begun to fall away, and now not one of them ever dropped in to see him. . . .
>
> Sandoz was the only one of the group who still appeared to know the way to the Rue Tourlaque. He used to go there for the sake of little Jacques, his godson, and of poor, wretched Christine, whose passion among so much squalor moved him very deeply, for he saw in her a woman in love he would have liked to portray in his books. He used to go there especially because his sympathy for Claude as a brother-artist had increased since he realized that Claude had somehow lost his foothold and, so far as his art was concerned, was slipping deeper and deeper into madness, heroic madness. At first he had been amazed, for he had had greater faith in his friend than in himself; ever since their schooldays he had considered himself inferior to Claude, whom he had looked up to as one of the masters who would revolutionize the art of a whole epoch.

Then his heart had been wrung by the spectacle of failing genius, and surprise had given way to bitter compassion for the unspeakable torments of impotence. Was it ever possible, in art, to say where madness lay? Failure always moved him to tears and the more a book or a painting inclined towards aberration, the more grotesque and lamentable the artist's effort, the more he tended to radiate charity, the greater was his urge to put the stricken soul respectfully to sleep among all the wild extravagance of its dreams.[1]

Claude Lantier's life story is a tragedy. His fate is foretold in a remark by the sardonic master Bongrand: "If only we could have the courage to hang ourselves in front of our last masterpiece!"

Fate is cruel. One gray day—the kind of day Cézanne used to wish for—Lantier's wife, Christine, finds him in the studio.

Claude had hanged himself from the big ladder in front of his unfinished, unfinishable masterpiece. He had simply taken one of the ropes he used to attach the frame to the wall, climbed up the ladder to attach it to the big oak beam he had fitted up one day to strengthen the uprights, and then jumped off. And there he hung, in his shirt, barefooted, an agonizing sight, his tongue blackened and his eyes bloodshot and starting from their sockets, stiff, motionless, looking taller than ever. His face was turned towards the picture and quite close to the Woman whose sex blossomed as a mystic rose, as if his soul had passed into her with his last dying breath and he was still gazing on her with his fixed and lifeless eyes.

Christine stood terror-stricken, as grief and fear and wrath surged up within her, filling her whole body and finding expression in one long, uninterrupted howl. Turning to the picture, she lifted both her arms and cried as she shook her fists: "Oh Claude! Oh Claude! . . . She took you back! She killed you, the bitch! She killed you, killed you, killed you!"

Her legs gave way beneath her and, as she turned away, she crashed to the ground. Excess of suffering had drawn all the blood from her heart, and she lay in a dead faint, white and limp, pitiful to look on, a woman defeated, crushed by the tyrannical sovereignty of Art. Above her, in triumph, radiant with all the symbolic splendor of an idol, stood the painted Woman. Painting had won in the end, deathless and defiant even in its own madness.[2]

Lantier himself had become the hanged man, *le pendu*. His epitaph is brief; it is almost as if he has been expunged from the record. "He had a hero's capacity for work," says Sandoz. "He was a brilliant observer with a brain packed with knowledge and the temperament of a great and gifted artist . . . and yet he has nothing to show." "Nothing at all," confirms Bongrand, who has been through the contents of the studio. "Not a single canvas; nothing, so far as I know, but a few notes and sketches that every artist turns out and are not meant for the public. No doubt about it, the man we're burying today is a dead man; dead in the fullest sense of the word!"[3] The burial plot is next to the children's cemetery. In death as in life he is a child of nature.

L'Œuvre is a melodrama and Lantier a fiction—and an amalgam. When it came to the saga, Zola's great exemplar was Balzac. He always remembered the preface to *La Comédie humaine,* in which Balzac had declared that people form "social species" which the novelist classifies like a naturalist classifying members of the animal kingdom. *Les Rougon-Macquart,* Zola's *histoire naturelle et sociale,* followed a similar principle. He insisted that his characters were not portraits of this or that person; they were "types" and not "individuals." In conception, he saw Lantier as "a Manet, a Cézanne dramatized; closer to Cézanne"—with a dash of Zola. Lantier, too, has elements of self-portraiture. Gustave Geffroy, for one, noted the affinity between Zola and Lantier in a contemporary review. "Do they not complement each other, Claude [Lantier] who seeks himself and Sandoz who explains himself? Passionately devoted to their tasks, furious in their desire to create, devastated by results, they are both *les damnés de l'art*—art's damned souls. Are Sandoz's laments not as painful as Claude's miscarriages? Is Zola, who called himself, astonishingly, 'a perpetual beginner,' not as sad, as disillusioned as the suicide he portrays?"[4] Even in this most autobiographical of novels, where the novelist drew avowedly on people he knew, many of the characters are amalgams: Bongrand is a Manet, with a flavoring of Courbet, Daubigny, Delacroix, and Millet; the dissipated painter Fagerolles is a mixture of Gervex and Guillemet; the minor sculptor Mahoudeau is a mixture of Solari and Valabrègue; and so on. Furthermore, this *histoire* is a story and not a history, nor for that matter a prophecy. Zola made it up. He himself spoke of his hypertrophied imagination, of jumping off the springboard of observation into the unknown, of strict veracity taking wing to become some sort of symbolic truth.[5]

Given its provenance, the novel has been plundered for intelligence on Cézanne, at once an open source and a roman à clef. So pervasive is this practice, so accumulative the appropriation, that a certain slippage may be

observed, whereby Claude Lantier substitutes for Paul Cézanne, rather like a body double. And in fact the effect is enhanced, the substitution made more plausible, by the physical resemblance. Corporeally, Lantier was modeled on Cézanne. His description in *L'Œuvre* answers to his description in *Le Ventre de Paris*. At first sight, Christine finds him alarming. "She was afraid of this gaunt young man with a beard and bony knuckles, who might have been a brigand in a story with his big black hat and his old brown jacket weathered to a dingy green."[6] Various other characteristics also match. Lantier is given to the expostulation "*Nom de Dieu! Nom de Dieu!*" He has fits of rage, and moods of black despair; he destroys canvases that do not satisfy him. He is mocked, and his bizarrerie derided. According to the current witticism, his painting looks as if it has been done "by a drunk with a broom."[7]

More insidious is the reading of his mental state: reading across from Lantier to Cézanne. This psychic transference was present from the very outset. Like other fictionalized Cézanne characters—the protagonist of Duranty's mystery story "La Double Vue de Louis Séguin" reverts to the name Paul as soon as it gets under way—Zola's preparatory notes slide inconsequentially between "Claude" and "Paul."[8] "Don't forget Paul's despairs," Zola reminded himself.

Complete discouragement, once ready to give up everything; then a masterpiece, just a fragment, done quickly, which saves him from despondency. The problem is to know what renders him unable to achieve any satisfaction: he himself, above all, his physiology, his ancestry, the wound to his eye; but I should also like our modern art to count for something here, our feverish desire for everything, our impatience to shake off tradition, in a word, our disequilibrium. What satisfies G. [Gervex?] doesn't satisfy *him* at all; he goes further, and spoils everything. It's genius incomplete, never fully realized: he doesn't lack much; physiologically he's a bit here and there; and I'm adding that he's produced some absolutely marvelous pieces.[9]

The novel's account of Lantier's stunted sociability has entered the biographical bloodstream, so contaminating Cézanne's psychology (or pathology) that it has become something like received wisdom. The phobic Cézanne, the sociopath, the emotional cripple, the *grand enfant,* as Zola put it, living in dread of what life itself holds in store, chronically suspicious of those who want to get their hooks into him, sublimating like crazy, and ceasing altogether to love his wife after the first fine careless rapture: all that is rooted in *L'Œuvre*.[10] It

pertains to Lantier. Yet it has been grafted onto Cézanne. In other words, the novel is the seedbed or breeding ground of the Cézanne of legend.

The lure of the legend is very strong. Sometimes conscious, sometimes almost unconscious, as sources merge and citations jumble, the temptation is especially marked in the emotional sphere: his lack of stability, his compromised relations with others. His relations with women in general and with his wife in particular have been framed by this fiction for more than a century. The passage below, for example, is ripe for exploitation. It begins with Christine's sense of shame when posing (nude) for her husband and ends with Lantier's disrespect, if not disdain, rapt in his deluded quest for the absolute, "the mad desire which could never be satisfied":

> The following morning, however, she had to undress once more in the icy blasts and unforgiving light of the studio. Was it not her job, after all? How could she possibly refuse now that it had become a routine? She would never have done anything to hurt Claude, so every day she took up her position afresh in what, for her burning, humiliated body, was a losing battle. Claude never even mentioned it now; his carnal passion had transferred itself to his work and the painted lovers he created for himself. They were the only women now who could send his blood pulsing through his body, the women whose every limb was the product of his own efforts. Back there in the country, when his passion was at its height, he thought happiness was achieved when he possessed a real woman and held her in his arms. He knew now that that had been nothing more than the old, old illusion, since they were still strangers to each other; so he preferred the illusion he found in his art, the everlasting pursuit of unattainable beauty, the mad desire which could never be satisfied. He wanted all women, but he wanted them created according to his dreams: bosoms of satin, amber-colored hips, and downy virgin loins. He wanted to love them only for the beauty of their coloring; he wanted to feel them perpetually beyond his grasp! Christine was reality, the aim which the hand could reach, and Claude had wearied of her in a season. He was, as Sandoz often jokingly called him, "the knight of the uncreated."[11]

Zola was nothing if not a phrase monger, as Cézanne used to say. The steamy fantasy is infectious. The throwaway lines lodge in the memory. "Claude had wearied of her in a season" is a phrase that became an axiom. Transferred

to Cézanne and embedded in the biographical constructions of the 1930s, it turned into an essential part of the received wisdom. Lying somewhere between symbolic truth and classic distortion, that inadequate understanding has governed perceptions ever since.

At first, the purported resemblance between Lantier and Cézanne went unremarked. *L'Œuvre* was serialized in the magazine *Gil Blas,* in eighty installments, from 23 December 1885 to 27 March 1886. The book was published on 31 March 1886. In artistic and literary circles it was required reading. Zola was by this time a household name, and the advance publicity had been building over a long period. In those circles the immediate reaction was distinctly unfavorable. When Cézanne and Pissarro visited Robert Caze's salon in January 1886, while the serialization was in full spate, they found the young artists and writers militantly anti-Zola and pro-Flaubert. "They tore Zola's *L'Œuvre* to pieces," Pissarro reported to Lucien, a little shocked; "it seems to be completely worthless—they are very severe. I promised to read it when it appears." When he did so, Pissarro was disappointed. "I'm halfway through Zola's book," he informed Monet. "No! It doesn't work, it's a romantic book; I've no idea how it ends, it doesn't matter, it's not that. Claude is not very well thought-out, Sandoz is better, you can see that he's understood him. As for doing us harm, I don't think so; it's not a very accomplished novel for the author of *L'Assommoir* and *Germinal,* and that's all there is to it."[12] Monet was much troubled by the book, fearing that it would be used against the impressionists, to damage their cause. He was not reassured by Pissarro's assessment, but decided to address himself directly to the author: "You have taken deliberate care that none of your characters resemble any one of us," he wrote cautiously to Zola, "but even so I fear that our enemies in the press and the public will utter the names of Manet or even one of us to make us out to be failures, which I don't believe is what you had in mind. Forgive me for saying so. It is not a criticism; I have read *L'Œuvre* with great pleasure, finding memories on every page. Apart from that you know of my fanatical admiration for your talent. No; but I have been struggling for quite a long time and I am afraid that, on the threshold of success, the enemy may make use of your book to crush us."[13]

A few weeks after the book came out, Pissarro dined with Duret, Huysmans, Mallarmé, Monet, and others. "I had a long talk with Huysmans," he told Lucien. "He is very conversant with the new art and keen to break a lance for us. We spoke about *L'Œuvre*; he fully agrees with me. Apparently he has

had a row with Zola, who is very worried. Guillemet too has written to him [Zola], furious, but to complain about the transparency of the character of Fagerolles."[14] Guillemet had taken umbrage because he believed that everyone would recognize him as the model for that weak character. But he put a wider point to Zola. "As for the friends who fill your Thursdays, do you think that they'll end as badly—I mean as courageously? Alas, no. Our *brave* Paul is fattening himself in the sun of the Midi, and Solari is hacking away at his gods; neither thinks of hanging himself, mercifully. Let us hope, my God, that the little gang, as Madame Zola calls them, do not try to recognize themselves in your heroes who are so uninteresting, and on top of that, malicious."[15]

More generally, "transparency" was not the issue, even among insiders. Inasmuch as readers sought a model for Lantier, the name that came instantly to mind was Manet (now dead), who was indeed far more of a name than Cézanne. Edmond de Goncourt thought Lantier was Manet, though he did not think much of the portrait. (He also told Zola to his face that he had made a mistake in introducing himself into the novel in the characters of both Lantier and Sandoz. "Zola fell silent," he recorded, "his face turned slightly grey, and we parted.")[16] Soon the identification was made public. Reporters on *Le Figaro* touted or outed Lantier as Manet. Van Gogh, an avid reader of Zola's novels, made the same connection. Zola himself said little. When cornered, he too adverted first to Manet, but only to deny any painter the palm. A dinner-party discussion "as to whether Claude Lantier was or was not a man of talent" became heated when Zola was sufficiently provoked to assert that "he had gifted Claude Lantier with infinitely larger qualities than those which nature had bestowed upon Édouard Manet." How this was to be interpreted vis-à-vis his "brother artist" was never explored. Once roused, he proceeded to defend "the theory of his book—namely that no painter working in the modern movement had achieved a result equivalent to that which had been achieved by at least three or four writers working in the same movement, inspired by the same ideas, animated by the same aestheticism." None of the assembled company had the temerity to proffer the name of Cézanne. When someone mentioned Degas, Zola retorted: "I cannot accept a man who shuts himself up all his life to draw a ballet girl as ranking co-equal in dignity and power with Flaubert, Daudet or Goncourt"—or, by inference, Zola.[17]

Cézanne, too, said little. Zola sent him a signed copy, as usual, on publication. From Gardanne, on 4 April 1886, he replied:

Mon cher Émile

I've just received *L'Œuvre* which you were kind enough to send me. I thank the author of the Rougon-Macquart for this kind token of remembrance, and ask him to allow me to shake his hand thinking of years gone by.

Tout-à-toi
with the feeling of time passing,
Paul Cézanne[18]

As far as we know, that was the last letter ever to pass between them.

So it is that *L'Œuvre* is widely held to be the cause of a rupture in the relationship between Cézanne and Zola—a relationship which had lasted for over thirty years, from their early teens to their mid-forties, but which then seems to come to an end, abruptly and definitively, never to be restored. Zola died sixteen years later, in 1902. Apparently the two men had no direct contact throughout that period.

The legend of *L'Œuvre* stoked the legend of Cézanne. Fifty years after the fact, in 1936, Georges Braque went to the great Cézanne retrospective at the Orangerie in Paris. On his way back he bumped into the photographer Brassaï, who had a studio nearby. They fell into conversation about the revered master. "Cézanne was alone for so long, so misunderstood," mused Braque. "He needed a rare strength of character to persevere. Even Émile Zola, his boyhood friend, was to abandon him, betray him. He came to regard him as the prototype of the failed and impotent painter. Cézanne realized this when he read his friend's novel *L'Œuvre*. Fortunately, his faith in his own art was unshakable."[19]

Cézanne's words have been combed for any hint of telltale emotion—offense, anger, antagonism, rancor, shock, sorrow, bitterness, or merely coolness—as if the letter might contain the key to the rift. This exercise in rune craft has yielded remarkably little, except for wildly varying assessments of those few lines, and a tendency to read back into them the knowledge of what came later. Frustrating as it may be, it is well-nigh impossible to infer from the letter any fundamental change, still less to detect signs of an unprecedented upheaval. It is true that some of the expressions are rather formal, or formulaic, but that was not at all unusual in Cézanne's letters, even to close friends; in fact, the formalities are often more elaborate than this.

There is no indication that he is writing in anger. A few years later, he

did take offense at the behavior of his old stablemate at the Suisse, Francisco Oller. The letter he wrote to Oller, from the Jas de Bouffan, stands in marked contrast:

Monsieur

The officious tone that you have adopted towards me of late and the rather offhand manner you permitted yourself to use towards me on departure are not calculated to please me.

I have determined not to receive you in my father's house.

The lessons that you take the liberty of giving me have thus borne all of their fruit.

Farewell.

P. Cézanne[20]

Plainly he could have written in very different terms to Zola, had he been so minded. Even if that chilly missive to Oller is set aside, as an aberration, it is difficult to discern any calculated riposte in the letter to Zola, of the kind that he delivered to Marius Roux soon after reading another novel with a Cézannian central character. His message to Roux was clear: *Pictor semper virens*—he was still in business. His message to Zola lacks that sting.

There is no hint of remonstrance. Possibly there is a trace of regret. The letter is cast in retrospection, a remembrance of things past. It has been said that it is all past and no future, but that begins to sound a little too knowing. *L'Œuvre* itself was an act of remembrance: it may have seemed only natural to acknowledge that. Cézanne was not given to dissembling. The sentiments he expressed are very likely to be a reflection of his feelings. According to Gasquet, he was deeply moved by the early chapters of the book, in which he rediscovered his youth—their youth. He felt that these had been accomplished with great fidelity to the truth and the minimum of novelization.[21] If he was writing in sorrow, then, it was not simply for a life traduced. Is there a tinge of sadness, a tincture of melancholia in what he wrote? There is certainly a risk of overinterpretation. Of itself, the letter departs scarcely at all from many of his other letters. It was quite normal for him to thank his friend for remembering him, to hark back, to strike a wistful note. Perhaps there was something a little melancholic in this—regret for a world irretrievably lost, no matter how many madeleines we eat—but it did not foreclose the future.

A letter to Numa Coste, written three years earlier, has some common features:

Mon cher Coste

I think it's to you that I owe the delivery of the paper *L'Art libre*. I read it with the keenest interest, and for good reason. So I wish to thank you and to tell you how much I appreciate the generous spirit with which you take up the defense of a cause to which I remain far from indifferent.

I am, with gratitude, your compatriot and, if I may say, your colleague.

Paul Cézanne[22]

That appears to be the last letter he ever wrote to Coste. Again, it would be difficult to point to any internal evidence of that fact. The letter is by no means as natural or as playful as some of his earlier traffic with Coste, but it hardly speaks of a fixed determination to have nothing more to do with him. Any such inference would be entirely unwarranted—not least because they continued to get together in Aix throughout the 1890s. Coste was one of Zola's best informants.[23]

The timing of the letter to Zola has also come in for some scrutiny. Cézanne must have written very soon after receiving the book, as indicated in his opening sentence. The speculation is that he was deliberately avoiding an obligation to comment on it; or, if the letter is adjudged to be innocent after all, that he had not yet read it, and was still unaware of what was in store. Neither of these alternatives seems very plausible. Cézanne usually acknowledged Zola's books straightaway. He did not always offer an appraisal as he received them; it would have been odd if he had, and there was no expectation that he should. More to the point, in the case of *L'Œuvre*, it is almost inconceivable that he was unaware of the contents. Cézanne was a mighty reader. He read far more than is generally realized. One of the periodicals he read was *Gil Blas* (as Zola knew full well). He could scarcely have missed the serialization, especially after the evening spent with the young Turks who tore it to pieces. In other words, it is most unlikely that he was shocked or surprised when he opened his copy. It is much more likely that he was fully prepared.

What did he think?

He was already familiar with his familiar: he knew Claude Lantier of old.

He had read *Le Ventre de Paris* when it first came out, in 1873. Cézanne was well versed in Zola's fictional world. After reading *L'Assommoir*, in 1877, he began to make vermicelli soup, the signature dish of Lantier père, a joke shared with Zola. Moreover, Lantier was not the only one. Cézannian characters were multiplying all the time. Cézanne also knew Duranty's Marsabiel-turned-Maillobert (the one with the thick mix and the talking parrot) and Roux's Rambert, another case of a painter broken by "his impotence to produce the paintings he envisaged." Soon he became acquainted with Alexis's Poldex. Others followed. *L'Œuvre* had a context; and Lantier was not alone in his fate. Cézannian characters often came to a bad end. "It's a suicide worse than the others," says Rambert's brother, "a moral suicide."[24] Cézanne swallowed all this without difficulty. Not only was he capable of recognizing and accepting his fictional selves; he was also capable of distinguishing between art and life—"separating my small personality of impressionist painter from the man," as he put it to Roux. He understood perfectly well that Zola was not writing his memoirs, but rather a cycle of novels, diligently planned and remorselessly plotted.[25]

For Cézanne, the existential struggle was an old story. He had lived it and relived it for years. Baudelaire's confession of artistic impotence in "A Phantom" was imprinted on his memory:

> I am an artist that a mocking God
> Condemns, alas! to paint the gloom itself;
> Where like a cook with ghoulish appetite
> I boil and devour my own heart,
> Sometimes there sprawls, and stretches out, and glows
> A splendid ghost, of a surpassing charm,
> And when this vision growing in my sight
> In oriental languor, like a dream,
> Is fully formed, I know the phantom's name:
> Yes, it is She! though black, yet full of light.[26]

He was also familiar with Flaubert: "Masterpieces are stupid: they have placid faces like the very products of nature, like big animals and mountains."[27]

Cézanne read and reread with passion and discrimination. He was powerfully affected by his reading, as witness Stendhal and temperament, to say nothing of Virgil and fancy. He seems to have identified with certain fictional characters, possibly also with some personages in history or mythology. Law-

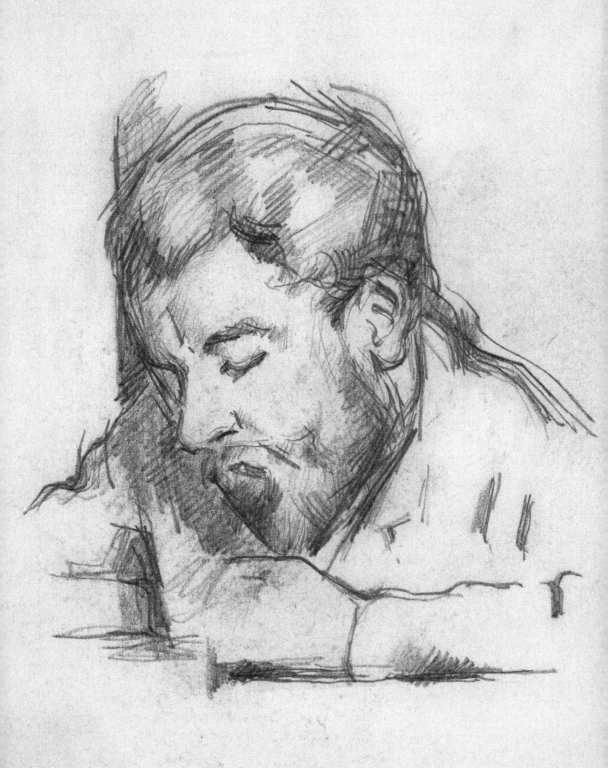

rence Gowing called this latter tendency projection, or self-projection, and it may be that the prime contender was not Theocritus or Moses or Saint Anthony, but one of those closest to him, the gardener Vallier, the subject of his last portraits. In the realm of fiction, by contrast, the most celebrated case was disclosed in his "Confidences." To the question about which character in a novel or the theater he most admired, he answered: Frenhofer.[28]

Frenhofer was the central character of *Le Chef-d'œuvre inconnu* (*The Unknown Masterpiece*), by Balzac, published in his *Études philosophiques* in 1837. As the title might suggest, there is a connection to be made between *L'Œuvre* and *Le Chef-d'œuvre*—what Rilke called Balzac's "unbelievable visions of future evolutions"—a narrative thread, and a presumptive lineage, philosophical and suicidal. Balzac, too, mixed fact and fiction, or at any rate historical characters and imaginary creations. His story is set in Paris in 1612. The legendary master Frenhofer has been working for ten years on a life-size portrait of his mistress. This portrait is to be the ultimate portrait. "Never will painter, paintbrush, color, canvas, or light succeed in creating a rival to *Catherine Lescault.*" He is visited by two other painters, both drawn from life: the Flemish portraitist Franz Pourbus (Gallicized "Porbus") and the young prodigy Nicolas Poussin ("Nick" to Balzac, irreverent as always). Frenhofer feels that he cannot finally realize his masterpiece because he lacks a suitable model. Porbus tells him that Poussin's mistress is an incomparable beauty, and cunningly tempts the old artist with a bargain freighted with meaning—in exchange for allowing him to use her as the model, he must permit Porbus and Poussin to see the portrait, that is, to see Catherine, presumably naked, and moreover unfinished. Frenhofer is in a dilemma. "My painting is not a painting, but a feeling, passion!" he tells them. "Born in my studio, it must remain here as a virgin and not leave if not covered." In spite of himself, however, he cannot resist. He agrees to show them the painting.

In the studio Frenhofer ceremoniously unveils *Catherine Lescault.* Confronted with the unknown masterpiece, the two visitors are dumbstruck. "Do you see anything?" Poussin whispers to Porbus. "No. Do you?" "Nothing." They peer at the canvas from all angles. "The old fraud's pulling our leg," murmurs Poussin. "All I can see are colors daubed one on top of the other and contained by a mass of strange lines forming a wall of paint." "We must be missing something," insists Porbus. All of sudden, they glimpse a foot. "They stood stock still with admiration before this fragment which had escaped from an incredible, slow, and advancing destruction. That foot appeared there like

the torso of some Parian marble Venus rising out of the ruins of a city burned to ashes."

Gauging their reaction, Frenhofer seems fleetingly to recognize the truth about his masterpiece, only to relapse into self-delusion and accuse Porbus and Poussin of an elaborate deception, in order to steal her away from him.

> Frenhofer again draped a green serge cloth over his Catherine, with the intent composure of a jeweler locking his velvet trays, imagining he is in the company of clever thieves. He cast a sly glance, full of suspicion and scorn, at the two painters, and without a word led them to his studio door. Then, at the bottom of the stairs, on the threshold of his house, he said to them, "Farewell, my little friends."
>
> That farewell made the two painters' blood run cold. The next day, a worried Porbus visited Frenhofer again and was told that he had died during the night, after burning his canvases.[29]

So it ends.

The legend of Frenhofer lived on in the culture. He has been called the archetypical artist. In the novel, the young Poussin is totally captivated:

> The old man sank into a profound reverie, his eyes fixed and his fingers toying mechanically with his knife.
>
> "Now he's in conversation with his *genius*," Porbus whispered.
>
> At this word, Nicolas Poussin was seized by an inexplicable curiosity—an artist's curiosity. This old man with his blank stare, fixed and comatose, had become more than human in the youth's eyes: a kind of fantastic genie inhabiting an unknown sphere, rousing a thousand vague ideas in his soul. The moral phenomenon of such fascination can no more be defined than we can translate into words the emotion produced by a song reminding an exile of his homeland. The scorn the old man affected for the noble endeavors of art, his wealth, his odd manners, Porbus's deference toward him, his supreme work of art kept secret for so long—a work of patience, doubtless of genius, judging by the head of the Virgin which young Poussin had so candidly admired and which, still beautiful even beside Mabuse's *Adam*, evidenced the imperial mastery of one of the princes of art: everything about this old man transcended the limits of human nature. What Nicolas Poussin's fervent imagination

could apprehend, what now became quite clear to him from his intercourse with this supernatural being, was a consummate image of the artist's nature, that wild nature to which so many powers are entrusted, and which all too often abuses them, leading cold reason, the bourgeois public, and even some connoisseurs down a myriad barren paths, precisely where this capricious white-winged sprite discovers castles, epics, works of art! A nature sometimes mocking, sometimes kind, at once fertile and desolate! So for the enthusiastic Poussin, this old man had become, by a sudden transfiguration, Art itself, art with all its secrets, its passions, its reveries.[30]

If Poussin's conception of old Frenhofer as Art itself bears some resemblance to a certain conception of Cézanne—a family resemblance, conspicuously present in the accounts of the ardent young men who went to visit the legendary master of Aix in his last years—that is precisely how it seemed to Cézanne. In one of the great set pieces of Cézannian idolatry, Émile Bernard's "Memories of Paul Cézanne" (1907) relates how "one evening, when I spoke to him of *Le Chef-d'œuvre inconnu* and Frenhofer, the hero of Balzac's tragedy, he got up from the table, stood before me, and striking his chest with his index finger, confessed wordlessly by this repeated gesture that he was the very character in the novel. He was so moved that his eyes filled with tears. One of his predecessors, who had a prophetic soul, had understood him. Ah! What a gulf between Frenhofer, impotent from genius, and Claude [Lantier], impotent from birth, that Zola had seen so inopportunely in Cézanne himself!" Bernard also contributed another profile, "Paul Cézanne" (1904), read by its subject, with an epigraph from Balzac: "Frenhofer's a man in love with our art, a man who sees higher and farther than other painters."[31]

Cézanne seems to have shown a similar tendency to identify with Frenhofer in his conversations with Joachim Gasquet in the late 1890s. Gasquet's *Cézanne* was first published in 1921 and much reprinted. "Tell me, am I a little crazy?" asked Cézanne, out *sur le motif* one day. "This fixation on painting . . . Frenhofer . . . Balthasar Claës . . . sometimes, you know, I wonder."[32] Balthasar Claës was the Frenhofer figure in *La Recherche de l'absolu* (*The Search for the Absolute*), another of the stories in Balzac's *Études philosophiques,* a chemist in search of the absolute element. These stories were Cézanne's bedside reading. He must have relished *Le Chef-d'œuvre inconnu* all the more for the introduction of the Poussin character. Cézanne greatly admired Poussin—the real Poussin—who was the inspiration for another of his famous statements,

to the effect that he had tried simply "to bring Poussin back to life by way of nature" (*vivifier Poussin sur nature*).[33] Like many of Cézanne's statements, this one is rather cryptic, in English and in French. Poussin had been dead for two centuries; Balzac had brought him back to life in the novel.

Cézanne seems to have imagined himself in dialogue with Poussin, à la Frenhofer, on the question of classical style and individual sensation. On his first recorded outing as a copyist in the Louvre, on 19 April 1864, he began a copy of *Shepherds of Arcadia*. He was still studying details from it thirty years later.[34] He had a reproduction of *Et in Arcadia Ego* in his studio, purchased sometime in the 1890s. "He liked Poussin," two visitors recorded in 1905, "in whom reason made up for what he lacked in facility."[35] According to Gasquet, "his greatest joy was going once a week to look at the Poussins in the Louvre, remaining a whole afternoon in ecstasy before *Ruth and Boaz* or *The Spies with the Grapes of the Promised Land*." He advised young artists to do the same. "Go to the Louvre," he counseled Charles Camoin, "but having seen the great masters who rest there, we must make haste to go out and revive in ourselves, in contact with nature, the instincts, the sensations of art that live within us."[36] He may have come close to explaining himself in one of his conversations with Gasquet. As reconstructed, Cézanne's train of thought owes something to his interlocutor's hyperactive imagination (and weakness for literary allusion), but allowing for the fact that the basic propositions were filched from Cézanne's letters to Bernard, and from Bernard's "Memories," the sentiments expressed may be genuine enough. Gasquet asked him what exactly he meant by "classical." Cézanne thought for a moment and then offered the best-known variant of his statement on Poussin, as Bernard originally recorded it: "Imagine Poussin completely redone from nature, that's what I call classical."[37] In Gasquet's account, Cézanne continued:

What I don't accept is a classicism that confines you. I want to be in touch with a master who restores me to myself. Every time I come away from Poussin, I know better what I am. . . . He is a piece of French soil completely realized, a *Discourse on Method* in action, a twenty- or fifty-year period of our national life set down on canvas, with abundant reason and truth. And what's more, and above all, it's *painting*. He went to Rome, didn't he? He saw it all, loved it all, understood it all. Well, he made that antiquity French, without losing anything of its freshness or its innate quality. He calmly continued the succession, everything that he found beautiful before his own time. Me, I'd like to continue in the same way

from him, returning him to his own time, without spoiling him, or me, if I were classical, if I could become classical. But you never know. Study modifies our vision to such an extent that the humble and colossal Pissarro finds himself justified in his anarchist theories. Me, I proceed very slowly, as you can tell. Nature appears to me so complicated. There are constant improvements to be made, without getting mixed up in a dream of reason. *Parbleu!* Poussin of Provence, that would fit me like a glove. Time and again I've wanted to redo *Ruth and Boaz sur le motif.* I'd like to link the curve of women's bodies with the shoulders of hills, as in *The Triumph of Flora,* or give a fruit-picker the delicacy of an Olympian plant and the heavenly ease of a Virgilian verse, as in *Autumn.* . . . I'd like to mix melancholy and sunshine. There's a sadness to Provence that no one has captured, that Poussin would have got leaning on some tomb, under the poplars of Les Alyscamps. I'd like to put reason in the grass and tears in the sky, like Poussin. But you have to content yourself. . . . You really have to see your model and sense it exactly, and then if I express myself with distinction and force, there's my Poussin, my own classicism. There is taste. Taste is the best judge. It is rare.[38]

Balzac spoke of his *Études* as fictional exercises in which "the ravages of thought are depicted." The ravages are terrible indeed. Frenhofer dies, presumably by his own hand, in a final act of self-immolation; Balthasar Claës's wife fears that his all-consuming quest is driving him mad. Hortense entertained the same thought. Jean Cocteau said of Victor Hugo that he was a madman who believed he was Victor Hugo. It would be too easy to say that Cézanne was a madman who believed he was Frenhofer, but there are times when Frenhofer sounds uncannily like Cézanne. "Unlike that pack of dabblers who suppose they're drawing correctly because their work is so painstakingly sleek, I never surround my figures with the sort of dry outlines that emphasize every little anatomical detail," he tells Porbus and Poussin:

—the human body isn't bounded by lines! In this regard, sculptors come closer to the truth than we painters ever can. Nature consists of a series of shapes that melt into one another. Strictly speaking, there's no such thing as drawing! . . . Line is the means by which man accounts for the effect of light on objects, but in nature there are no lines—in nature everything is continuous and whole. . . . Hence I never fix an outline; I spread a cloud of warm blond halftones over the contours—you can

never put your finger right where the contours blend into the backgrounds. At close range, such labors look blurred and seem to lack precision, but at two paces everything congeals, solidifies, stands out; the body turns, the forms project, you feel the air circulating round them. Yet I'm still not satisfied—I have doubts. Perhaps it's wrong to draw a single line: Wouldn't it be better to deal with a figure from the center, concentrating first on the projecting parts which take the light most readily, then proceeding to the darker portions? Isn't that the method of the sun, the divine painter of the universe? Oh nature, nature! Who has ever plumbed your secrets? There's no escaping it; too much knowledge, like too much ignorance, leads to a negation. My work is . . . my doubt![39]

Frenhofer's doubt seems to echo Cézanne's. Frenhofer's precepts also. "There are no lines," begins the seventh of Cézanne's opinions, as recorded by Bernard. "Shadow is a color as light is, but less bright," runs the ninth; "light and shadow are nothing more than a rapport between two tones." "Drawing and color are not separate at all," continues the eleventh; "insofar as you paint, you draw. The more the color harmonizes, the more exact the drawing becomes. When the color is at its richest, the form attains its fullness."[40]

Frenhofer's practice chimes with Cézanne's. Ten years' work on the same woman was about right for the *Large Bathers* of c. 1895–1906. "What are ten short years when you're contending with nature?" asks Frenhofer, Cézanne-like. Matisse's suggestion that there came a time when Cézanne ceaselessly redid the same painting, that he "always painted the same canvas of the *Bathers*," applies also to the black clock, the blue jug, the plaster Cupid, the apple, the mountain, the wife.[41] It is as Proust says: "You can see that they're all fragments of a single world, that it is always, whatever the genius re-creating it, the same table, the same carpet, the same woman, the same new and unique beauty, a complete enigma at this period when there is nothing else like it, nothing to explain it, unless one tries to relate him to other painters by his choice of subjects, while recognizing the particular, personal impression made by his color."[42]

Cézanne did not identify with Claude Lantier. But he made no complaint. There is some anonymous tittle-tattle, remarkably mild. He is supposed to have described Zola's talent as "lumpen" (*pataud*); and to have said to his friends, "If I wanted to do the same to him, when he next asks me to do his portrait, I'll paint him as a . . . "[43] More seriously, the criticism he is alleged to have voiced does not ring true: it reads as if manufactured by the author in

question. According to Bernard, Cézanne spoke to him very freely about Zola. "He was a very mediocre mind," says Cézanne in Bernard's account, "and a detestable friend. He was completely self-centered. Thus *L'Œuvre*, in which he claimed to portray me, is nothing but a hideous distortion, a lie purely for self-glorification." None of this sounds authentic, but it fueled the legend—the dialogue was appropriated by Irving Stone for a fictitious exchange between Cézanne and van Gogh in *Lust for Life* (1934).[44] In similar vein, Gasquet has him observing that Zola "stabbed him in the back" (which may be the source of Braque's story of "betrayal"), and on another occasion, "the harm Proudhon did to Courbet, Zola would have done to me," which sounds very much like Gasquet himself, showing off. The comparison he makes between *Le Chef-d'œuvre inconnu* and *L'Œuvre* sounds equally forced: "a great book, if I may say so, more poignant, more profound than *L'Œuvre*, a book that every painter should reread at least once a year."[45]

Typically, Vollard created a dramatic scene of their exchange:

> Cézanne stopped talking for a moment, gripped by the past. He continued:
> "One can't ask of a man who knows nothing that he should say sensible things about the art of painting; but *nom de Dieu*"—and Cézanne began to drum on the table like a deaf man—"how dare he say that a painter would kill himself because he's done a bad painting? When a painting isn't realized, you chuck it on the fire and start another!"
> While he was speaking, Cézanne paced to and fro in the studio, like a caged animal. Suddenly, grabbing a self-portrait, he tried to tear it up; but as his hands were shaking and he didn't have his palette knife, he rolled up the canvas, broke it on his knee, and tossed it into the fireplace.[46]

Contrary to this gaudy embroidery, Cézanne had virtually nothing to say about the book. He seems never to have discussed it with Pissarro, or with Philippe Solari, with whom he remained very close in Aix, and who might well have had grounds for complaint about his own character, Mahoudeau. In sober truth, neither of them had any thought of taking offense. *L'Œuvre* was not the cause of the break. At an earlier stage of his work on Cézanne, Gasquet went so far as to say that "he always insisted, and he never lied, that the book played no part in the falling-out with his old companion."[47] Their relationship was not to be reduced to a character in a novel, or the scribbler's bafflement at the dauber's project. "A quarrel is nothing," wrote Jean-Paul Sartre of himself and Albert Camus, "just another way of living *together*, without losing sight

of one another in the narrow little world in which it is our lot to live. It didn't stop me thinking about him, feeling his eyes fixed on the page of a book, or on the newspaper that I was reading, and wondering: 'What has he to say about that? What is he saying about it *now*?' "[48]

Cézanne and Zola never lost sight of one another. They kept up via mutual friends: Alexis, Coste, Solari. Cézanne continued to read Zola, and to respond to what he read. His card players have been plausibly seen as a repudiation of the vision of the lower orders in Zola's *La Terre* (1887): Zola's peasants are the wretched of the earth, violent, drunken, and uncouth; Cézanne's card players are the model of dignity, abstinence, and contemplation—a company of stoics playing a kind of collective solitaire, in Meyer Schapiro's phrase.[49] Cézanne also continued to joke about Zola, even after his death. On one occasion, in 1905, Vollard visited Aix to find him painting some skulls. Cézanne was in high spirits. "How beautiful it is to paint a skull!" he exclaimed. "Look, Monsieur Vollard! You know, I'm on the verge of realization!" After a silence: "So, in Paris they think what I'm doing is good? Ah! If only Zola were here, now that I'm splotching a chef d'oeuvre!"[50]

Zola for his part continued to collect reports of Cézanne, as he had always done, until the end. Ten years after the commotion of *L'Œuvre*, in 1896, he published an oracular farewell to painting, and painters, later described by Geffroy as "a kind of victory fanfare played as a funeral march." It contained a curious and ambiguous reference to the painter who mattered most, at once a reiteration and, perhaps, a stifled recantation. "I had grown up almost in the same cradle as my friend, my brother, Paul Cézanne, in whom one begins to realize only today the touches of genius of a great painter come to nothing."[51] Zola was also fingered as the source of some loose talk of Cézanne as "a failure." Whether that was anything more than gossip, and whether it came from Zola's own lips, it is difficult to be sure. If Vollard is to be believed, one such story was repeated by Cézanne himself:

"Later when I was in Aix, I heard that Zola had recently arrived. I truly thought that he didn't dare come to see me. You understand, Monsieur Vollard, my dear Zola was in Aix! I forgot everything, *L'Œuvre* and many other things besides, like that damned bitch of a housekeeper who looked daggers at me while I wiped my feet on the mat before entering Zola's salon. At that moment I was *sur le motif*; I had a study that wasn't going too badly; but I said bugger the study: Zola was in Aix! Without even taking the time to pack my things, I raced to the hotel where he was

staying; but a comrade I bumped into on the way told me that someone had said in front of him the night before to Zola: 'Are you going to break bread with Cézanne?' and that Zola had replied: 'What is the point of seeing that failure again?' So I went back to the *motif*."

Cézanne's eyes were full of tears. He blew his nose to hide his emotion, then:

"You see, Monsieur Vollard, Zola wasn't a wicked man, but he lived under the influence of events!"[52]

Both parties denied that they had quarreled. Plainly something had changed. They had grown apart. They were the Inseparables, inseparable still, but estranged. Cézanne for his part seems to have concluded that a certain distance was desirable. Proximity was not necessary to Cézanne's conduct of relationships. It has been said that Flaubert had a penchant for "remote intimacy."[53] It was a penchant shared by Cézanne. His devotion to *le grand Pissarro* never wavered, though they met only once (by accident) over the last twenty years of their lives. Neither of them appears to have considered this cause for remark. In the case of Zola, proximity tended towards aggravation. The fraternal ties had frayed.

The memory of wiping his feet on the mat may be indicative. Zola had gone up in the world—not least in his own estimation. It was as if he had grown into the portrait that Manet had painted of him twenty years earlier. He was determined that his lifestyle should reflect his commercial success. Médan, in particular, was designed to fulfill that dream. The property itself was undistinguished—"I caught a glimpse of a feudal-looking building which seemed to be standing in a cabbage patch," wrote Edmond Goncourt cattily. "You go up to the first floor by a staircase which is a mill ladder, and you have to do something like a horizontal leap in a Deburau pantomime to get into the lavatory, which has a buffet-type door." Daudet, Flaubert, Maupassant, and Turgenev were among those invited to dinner. At a housewarming party in 1878 the guests were given the full tour. Goncourt recorded: "A study in which the young master works on a massive Portuguese throne in Brazilian rosewood, a bedroom with a carved four-poster bed and twelfth-century stained glass in the window, tapestries showing greenish saints on the walls and ceilings, altar frontals over the doors, a whole houseful of ecclesiastical bric-à-brac. . . . He gave us a very choice, very tasty dinner, a real gourmet's dinner, including some grouse whose scented flesh Daudet compared to an old courtesan's flesh marinaded in a bidet." Feeding was important to Zola. He remembered the

bread crusts of the Collège Bourbon. He had always been a gourmand; now he would be a gourmet. Another evening the menu might be green corn soup, reindeer tongue from Lapland, mullet Provençale, and truffled guinea fowl. Sourcing delicacies became almost an obsession. Fine dining was an orgiastic pleasure and a conspicuous display. For the plump *maître* it was at once an assuagement and a point of honor.

Apart from the dining table, the study was his pride and joy. Ten meters long, nine meters wide, six meters high, this vast emporium could not but remind some visitors of a painter's studio. At one end, there was an enormous divan; at the other, a monumental desk. Everything was outsize. "It is tall and spacious," noted Goncourt, "but spoilt by a collection of appalling knick-knacks. There are suits of armor, a whole set of Romantic bric-à-brac, Balzac's motto, *Nulla dies sine linea* [No day without a line], over the fireplace, and in one corner a harmonium with a *vox angelica* which the author of *L'Assommoir* plays at nightfall."[54]

The châtelaine of Médan was in her element. Alexandrine loved to entertain; but it was important to entertain the right people. The hoi polloi did not figure on her guest list. Hortense was still beyond the pale. Cézanne himself was in a category apart: a pariah from the past, impossible to excommunicate. She tolerated him for her husband's sake, but she did not care for his opinions, his manners, or his personal hygiene. Their social expectations clashed. Cézanne was averse to extravagance, of regimen or person; opulence repelled him. Like others, he must have noticed the tastelessness of the trappings—and the absence of Cézannes on the walls. At the housewarming dinner, Flaubert had treated the company to one of his party pieces: "Flaubert, stimulated by the food and a little drunk, reeled off, to the accompaniment of oaths and obscenities, the whole series of his ferocious, truculent truisms about the *bôrgeois*. And while he was speaking," Goncourt noticed, "I saw an expression of melancholy surprise on the face of my neighbor, Mme. Daudet, who seemed pained, upset, and at the same time disillusioned by the man's gross, intemperate unbuttoning of his nature."[55] Cézanne felt much the same about the bourgeois at play, and Alexandrine felt much the same about Cézanne at Médan. With the exception of Nina de Villars', where he could talk to Cabaner, the salon was not his natural habitat. "I was often invited to Monsieur and Madame X's," he recalled, "but what would I do in their salon, I keep saying *nom de Dieu*!"[56] Renoir encountered him once at the house of the publisher Charpentier, with Zola. "But the place was too worldly for him to feel at ease." Towards the end of the evening, Zola approached Renoir, who had spoken up for Cézanne in the course of the conversation. "It is kind of you to speak well of my old comrade; but, between ourselves, isn't he a failure?" To Renoir's protestations, Zola responded, "After all, as you well know, painting is not my business!"[57]

At the Zolas', Cézanne encountered just the sort of pampered pomposity that made him uncomfortable. He reacted badly to the deep pile and the distin-

guished company. Important people discomforted him. On one occasion when staying near Giverny, to visit Monet, he went on to Médan to see Zola. To Monet's surprise, he returned almost immediately. "A grand personage arrived while I was there, Monsieur Monet. Monsieur Busnach arrived! Compared to such a great man, one is a nobody, *n'est-ce pas*? So I came back."[58] William Busnach was a stockbroker turned playwright, known for his light-opera libretti, who adapted Zola's novels for the stage, making a great deal of money for them both. Busnach was harmless enough, though he managed to lose at baccarat all the German royalties for *Nana*, a total of nearly nine thousand francs. All this was of consuming interest to Zola, but not to Cézanne. The higher literary repartee was equally alienating. Competitive talk of print runs or deluxe editions bored him; the scented flesh of salon wit appealed to him no more than the bons mots of café society. His usual question about a new book, "Is there any analysis in it?" fell on stony ground.[59] Conversational gambits sounded as if they were being tried out for future use. Zola himself could be heard condescending to Jules Vallès and the work that Cézanne liked so much, *Le Bachelier*: "For me, Vallès is nothing more than a grain of seed . . . nothing more than a grain of seed." Cézanne could hold his own at this if he wanted to—Camoin remembered him saying that Anatole France was a sub-Mérimée, who was himself a sub-Stendhal—but he felt increasingly out of place in that setting.[60] He explained to Vollard:

> There never was any quarrel between us. It was I who first stopped going to see Zola. I no longer felt at ease at his house, with the rugs on the floor, the servants, and "the other" who now worked at a sculpted wooden desk. In the end it made me feel as if I was paying a call on a minister. He had become (pardon me, Monsieur Vollard, I say it without malice) *un sale bourgeois*. . . .
>
> There were a lot of people there, it's true, but it was bloody annoying, what you heard said. One day I wanted to talk about Baudelaire: that name didn't interest anybody. . . .
>
> So I went only rarely, for it pained me very much to see him become so silly, and one day the servant told me that her master was not at home for anyone. I didn't believe that the instruction applied particularly to me; but I reduced the frequency of my visits accordingly. . . .
>
> Listen, Monsieur Vollard, I must tell you! I stopped going to Zola's, but I could never get used to the idea that our friendship was a thing of the past.[61]

Zola's daughter subsequently concluded that "Cézanne was not avoiding Zola, but rather the apartment and the house at Médan, residences too sumptuous for the painter smitten by nature, who knew nothing of the complications of a meticulously organized existence." If there was a suggestion here of the painter as noble savage, it was linked to an explanation based on different trajectories and experiences, and Cézanne's famous doubt. "Zola knew glory, Cézanne did not foresee his own; it was the doubt that erected a barrier between them, that was the only culprit."[62] They had grown apart; but this seems too schematic, or telescopic, to be wholly convincing. In 1886, glory was difficult to foresee. In 1896, or 1906, it began to look rather different. There was always doubt. Towards the end, however, doubt mingled with hope.

There was a further development. Later that year, on 23 October 1886, Louis-Auguste died, at the age of eighty-eight, and Cézanne came into a substantial inheritance. There is no sign that he envied Zola his glory, or his wealth, but complete financial security must have come as a profound relief to him. To all outward appearances life went on as before, but in this respect his situation was transformed. From now on, there would be no more financial panics, no frantic need to find a means of supplementing his precarious allowance, no call on Zola for maintenance support for Hortense. The "monthly prayer" was a thing of the past. Their relationship was hardly a mercenary one, but the changed circumstances may have served to bolster a sense of independence, financial and otherwise—a sense that, at long last, it was only fitting to stand on his own two feet. Their womenfolk would have expected nothing less.

In some quarters, doubt was not the only culprit. Asked why Cézanne and Zola stopped seeing each other, without explanation, Alexandrine would reply, "You didn't know Cézanne, nothing could make him change his mind," an echo of Zola's youthful exasperation ("Convincing Cézanne of something is like persuading the towers of Notre Dame to execute a quadrille"). Nevertheless, she tried to make posthumous amends. When it came to the publication of Zola's *Lettres de jeunesse,* in 1907, she wrote to the publisher to request that the early correspondence with Cézanne should have pride of place: "The good relations that always existed between my dear Émile and Cézanne mean that it would be preferable if those [letters] were at the beginning of the volume. . . . For my mother-in-law and for me, he [Cézanne] was loved as if he were our own."[63] Her request was ignored. The book opened with the letters to Baille.

If *L'Œuvre* was not the cause, it was perhaps the moment of crystallization. The novel itself invited such a reassessment. The evocation of their youth that

Cézanne found so moving—the pranks, the picnics, the potshots, the pines, the rambles along the riverbank—

They had been happy days, and the memory of them always brought them to the verge of tears amid their laughter. Just now the studio walls happened to be covered with a series of sketches Claude had made on a recent visit to the haunts of their boyhood. It made them feel that they had all around them the well-known landscapes, the bright blue sky above the rust-red earth. One sketch showed a stretch of plain with wave after wave of little grey olive trees rolling back to their irregular line of rosy hills on the skyline. Another showed the dried-up bed of the Viorne [the Arc] crossed by an ancient bridge white with dust, joining two sun-baked hillsides red as terra-cotta, on which all green things had withered in the drought. Farther along there was the Gorge des Infernets, a yawning chasm in the heart of a vast wilderness of shattered rocks, a stony, awe-inspiring desert stretching away to infinity. There was a host of other well-known places, too; the deep shady "Valley of Repentance," fresh as a bunch of flowers among the burnt-up meadows; the "Wood of the Three Gods," where the pine trees, green and glossy as varnish, shed tears of resin in the blazing sun; the Jas de Bouffan, white as an oriental mosque in the center of its enormous fields that looked like lakes of blood. There were glimpses of dazzling white roads, of gullies where the heat seemed to raise blisters on the very pebbles, strips of thirsty sand greedily drinking up the last drops of the river, molehills, goat tracks, hills against the sky.[64]

That was the past they shared. The melancholic Cézanne had a Proustian streak. "The places we have known do not belong only to the world of space on which we map them for our own convenience. None of them was ever more than a thin slice, held between the contiguous impressions that composed our life at that time; the memory of a particular image is but regret for a particular moment; and houses, roads, avenues are as fugitive, alas, as the years."[65]

The memory of a particular image held him in thrall. Zola the swimmer had become Zola the minister. The *pauvre boursier* had turned into the *sale bourgeois*. Claude Lantier's parting shot in *Le Ventre de Paris* came back to haunt him: "What bastards respectable people are!" Ever since they began to make their way in the world, Cézanne had never taken entirely seriously Zola's thirst

for respectability, his political windbaggery, his shallow social commentary—the vaporings about the war doing for all the imbeciles, the dearth of peasants in Corot, the dramatic possibilities of Captain Dreyfus. Cézanne's ideal Zola was the Zola of *Mes Haines,* the courageous comrade-in-arms, the original brother-artist. "If you ask me what I am going to do in the world, me, an artist, I will answer you: 'I am going to live out loud.' "[66] In the cenacle of Médan the artist seemed to shrink into the careerist.

The ideal Zola existed in an earlier era, an era of oil lamps and cobblestones, a geological time period predating "events." Zola the apple bringer, Zola the morale booster, belonged to the space mapped as Aix and re-created as Plassans. No one could know the joy he had experienced with his friend in that prelapsarian place. "Regarding certain things he had enjoyed he was rather reserved; he kept them to himself, and guarded fiercely the memories of happy moments," Gasquet observed acutely. "Anything to do with friendship always seemed to him to be marvelous and profound, with something jealously guarded about it that must not be tarnished. I learned, for example, that he had an old friend in the Rue Ballu in Paris, a cobbler with whom he spent long silent hours, and evidently helped out in difficult circumstances, but he never breathed a word about him. You would sometimes catch him in the grimy shop, sitting there, keeping an affectionate eye on the wretched labor of his friend, as if lost in contemplation of the old lasts and the patched boots; but he made a great mystery of it and hid if you went to look for him." He had the misanthropy of those who like people too much, as Élie Faure once said.[67]

In the early hours of 29 September 1902, the real Zola died a horrible death of carbon monoxide poisoning, asphyxiated by the fumes of the coal fire in the bedroom of his Paris residence. Alexandrine was found unconscious; she pulled through. Amid widespread rumors that he had been assassinated by fanatical nationalists, or had committed suicide for reasons unknown, an inquest was unavoidable. Toxicological tests were conducted, the chimney flue was dismantled, but investigators found no evidence of foul play. Outside, the Dreyfus affair rumbled on. Fearing the political repercussions of an open verdict, the coroner declared death by natural causes. So the matter stood for half a century. In 1954, quite unexpectedly, new evidence came to light. It transpired that a certain stove fitter, an anti-Dreyfusard, had made a deathbed confession, in 1927, to the effect that Zola had been deliberately suffocated. According to the stove fitter's testimony, he and his men stopped up the chimney while doing repairs on the neighboring roof. Early the next morning they unstopped it.

Their activities went completely unnoticed. The evidence is not conclusive, but one thing is clear: "natural causes" can no longer be considered a safe verdict.

News of Zola's death reached Aix via *Le Petit Marseillais*. A laborer at the Jas, Alexandre Paulin, who had served as a model for a card player and a smoker, brought the paper to Cézanne. Paulin burst in on his master as he was preparing his palette. "Monsieur Paul, Monsieur Paul, Zola is dead!"[68]

Cézanne shut himself in his room and wept. No one dared to go in. For hours, the gardener could hear him howl. Later he wandered in the country-side, alone, just as he did when Hortense made a bonfire of his mother's effects. In the evening he went to see Mahoudeau: his old friend Solari, the sculptor, the only person who might begin to understand.

10: *Homo Sum*

Six months after Zola's death, in 1903, a sale was held at the Hôtel Drouot in Paris of "artworks and furnishings, pottery and porcelain, various Japanese and European objects, wooden carvings, marble, glass, antique sculptures, armor, bronzes, clocks, musical instruments, furniture, antique tapestries, fabrics, carpets, ancient and modern paintings, watercolors, drawings, engravings, books and manuscripts, everything belonging to the estate of M. Émile Zola."[1] Nine Cézannes were listed in the catalogue, all dating from the 1860s. Each was described as a "work of early youth"—a lowering description, one might think, but also a recapitulation of that period of their life together. Among them were old favorites such as *Sugar Bowl, Pears and Blue Cup,* the ballsy little still life that appeared in the portrait of his father on his throne; *The Black Clock; The Stove in the Studio; The Abduction;* and *Paul Alexis Reading at Émile Zola's Home.* Evocative as they were, this list did not account for all the paintings that he had given to Zola over the years (or left with him at one time or another), as Cézanne cannot have failed to notice. One or two more were included in the sale, it appears, *hors catalogue.*[2] If he ever dreamt that anything remaining was too precious to part with, he was sadly misled. Another version of Alexis reading to Zola was discovered in the attic at Médan as late as 1927, after Alexandrine's death.

The sale afforded Cézanne the dubious pleasure of being smeared by Henri Rochefort, the radical tribune turned reactionary zealot, who published a poisonous attack in *L'Intransigeant* on Zola and his art—spearheaded by "an ultra-impressionist named Cézanne"—insinuating that "Dreyfusard" painting was not only laughable but treasonable. "We have often stated that there were Dreyfusards long before the Dreyfus affair. All the sick minds, the perverted souls, the twisters, the distorters, are ready for the coming of the Messiah of Treason. When you see nature as interpreted by Zola and his ordinary paint-

ers it is quite simply that patriotism and honor appear to you in the form of an officer handing over to the enemy the plans for the country's defense. The love of physical and moral ugliness is a passion like any other." Copies of this article were distributed all over Aix; evidently there were some who took some pleasure in it. When his son offered to send him one from Paris, Cézanne assured him that there was no need: "Every day I find one under my door, not to mention copies of *L'Intransigeant* that arrive in the post." After that, his housekeeper remembered his hands trembling slightly as he opened the papers from Paris.[3] Nonetheless, Cézanne's persecution at the hands of the philistine Aixois seems to have been overdone. The wild-looking bohemian was the target of abuse from some pupils of Villevieille's in the 1870s; Bernard claims that in his last years children would mock him and taunt him, and even throw stones at him, as a kind of bogeyman. Tales of this sort may be exaggerated, though he did place wire mesh against the big window of his studio to protect against stone throwing.[4] On the whole, however, he was left in peace. "For the bourgeois of Aix," a fellow painter concluded, "Cézanne passed willingly for mad."[5]

Of the nine listed works, six were bought by the margarine magnate Auguste Pellerin, at very modest prices (between 600 and 1,050 francs).[6] In 1903 Pellerin was only just beginning to amass the largest collection of Cézannes ever assembled, larger even than the stupendous holdings of Dr. Albert C. Barnes in the United States. Pellerin had practically unlimited resources at his disposal, but he was not interested in simple accumulation: he liked to live with the fruits of his enthusiasm. Previously he had collected Corot. Corot gave place to Manet. Manet gave place to Cézanne. In 1910 Bernheim-Jeune held an exhibition of thirty-five Manets, all from Pellerin, and all for sale. Pellerin was nothing if not an active manager of his collection; he bought and sold and (increasingly) exchanged as it pleased him. His Cézanne period lasted for about a quarter of a century. At once eclectic and discriminating, he must have owned around 150 Cézannes, of all ages, at one time or another. At his death in 1929, he left a grand total of ninety-two, divided equally between his son and his daughter.

Fittingly, his first purchase at auction was *Farm in Normandy, Hattenville*, at the Chocquet sale in 1899. If this symbolized a passing of the baton from Chocquet to Pellerin, it was a fortuitous conjuncture. Pellerin did not have a direct personal relationship with Cézanne, as Chocquet did, but his effect on the artist's life, or afterlife, was profound. Half of the paintings at the epoch-making 1907 retrospective came from the Pellerin collection. Posthu-

mously, he was also the principal lender to the major exhibitions of 1936 and 1954 at the Orangerie, through his children. He left three important works to the Louvre, among them *Still Life with Soup Tureen*, the homage that Cézanne paid to Pissarro; nine more were to go to the Musée d'Orsay.[7] Roger Fry's landmark text, *Cézanne: A Study of His Development* (1927), was originally written in French and published in the magazine *L'Amour de l'art* in 1926 as an introduction to the Cézannes in the Pellerin collection. Fry's treatment of the paintings came as a revelation to many readers, as Cézanne had to the author himself; the terms of reference he set down are now part of the accepted wisdom. Most striking was his elevation of the still lifes, coupled with the intriguing proposition that "it is in the still life that we frequently catch the purest self-revelation of the artist." After remarking on Goya's ability to give, "even to the still life, a kind of dramatic significance," Fry drew an arresting comparison:

> Cézanne at one time might well have had similar aims, but by the period which we are considering [the 1870s and '80s] he had definitely abandoned them. He eagerly accepts the most ordinary situations, the arrangement of objects which result from everyday life. But though he had no dramatic purpose, though it would be absurd to speak of the drama of his fruit dishes, his baskets of vegetables, his apples spilt upon the kitchen table, none the less these scenes in his hands leave upon us the impression of grave events. If the words tragic, menacing, noble or lyrical seem out of place before Cézanne's still lifes, one feels none the less that the emotions they arouse are curiously analogous to these states of mind. It is not from lack of emotion that these pictures are not dramatic, lyric, etc., but rather by reason of a process of elimination and concentration. They are, so to speak, dramas deprived of all dramatic incident. One may wonder whether painting has ever aroused graver, more powerful, more massive emotions than those to which we are compelled by some of Cézanne's masterpieces in this genre.[8]

In one way or another, we have come to Cézanne through Pellerin, more often than we know. For two generations at least, Auguste Pellerin's sensibility (or, more brutally, his selection) was a prime determinant of the Cézannes it was possible to see, especially in quantity, at the *hommages* and retrospectives. Our Cézanne is Pellerin's Cézanne. He was not merely a collector; he was an educator—a tastemaker.

Once he started a collection, there was no stopping him. By the turn of the century Cézanne was his mission in life. Inevitably, he dealt with Vollard; business was brisk. In February 1900 Vollard bought a *Landscape on the Banks of the Oise* from the artist Édouard Béliard for 300 francs and promptly sold it to Pellerin for 7,500; in July 1904 Pellerin bought a *Portrait of Madame Cézanne* from Vollard and Bernheim-Jeune jointly; in October 1911 he exchanged those two Cézannes for another two, *Landscape Near Aix* and *Bibémus,* throwing in some cash to sweeten the deal. On 7 July 1904 he bought seven from Bernheim-Jeune in a single day, including *Madame Cézanne in a Yellow Armchair* and the monumental *Woman with a Coffee Pot*—the painting in which a teaspoon teaches us as much about ourselves and our art as the woman or the coffeepot—paying cash for the lot.[9] Between 1907 and 1912 he bought another twenty-nine from Bernheim-Jeune alone, including the seditious portrait of Emperaire. If Pellerin set his heart on a work, he was not to be denied. His moves were bold and his taste remarkably untrammeled by the conventional pieties; his preferences are sometimes surprising. In concert with Octave Mirbeau, he bought up Pissarro's collection. Soon after Cézanne's death he acquired the masterly *Portrait of Gustave Geffroy,* from Geffroy, for cash. As early as 1907, he was dealing directly with Cézanne's son, exchanging two Manets for one of the *Large Bathers*—the young Henry Moore had his Cézanne epiphany when he saw it in the Pellerin collection some years later.[10] In 1908 he picked up *A Modern Olympia,* also from Cézanne's son, in exchange for a large Renoir flower piece and a payment in cash. In 1911 he secured *The House of the Hanged Man* from Vollard, in exchange for two small Cézannes, a Berthe Morisot pastel, and some cash. In 1912 he acquired the *View of Louveciennes, after Pissarro* from Gachet, in exchange for a significant late work, *Young Italian Woman Leaning on Her Elbow* (one of the seven he had bought in 1904), another landscape, and more cash.

His last documented purchase was the first version of *Large Pine and Red Earth* at the Gangnat sale in 1925, for the record price of 528,000 francs. This painting was first owned by the writer Félicien Champsaur, author of *Dinah Samuel* (1882), the roman à clef featuring Cabaner, Rimbaud, and others; then by the dealer Père Thomas, who sold it to the painter Émile Schuffenecker, a friend of Gauguin's, for 120 francs. Schuffenecker finished it—as he later confessed—by filling in the unpainted sections and applying a light "glaze" of Veronese green to a small tree on the left of the picture. That done, he sold it to Vollard—who was not always scrupulous in such matters—who sold it on to Bernheim-Jeune, retaining a half-share. The collector Maurice Gangnat

acquired it from Bernheim-Jeune, reportedly for 5,000 francs. If Schuffenecker is to be believed, *Large Pine and Red Earth* was not the only Cézanne he retouched.[11]

It is perhaps just as well that he never got his hands on Gauguin's pride and joy, *Still Life with Compotier.* Knowing of his friend's straitened circumstances, Schuffenecker offered to buy it in 1888. Gauguin replied: "The Cézanne you asked me for is an exceptional pearl and I've already refused 300 francs for it; it's the apple of my eye and unless there's an absolute necessity I would part with it only after my last shirt."[12] In 1897 the moment arrived. In need of money for hospital treatment, Gauguin was compelled to sell. *Still Life with Compotier* was bought by the collector Georges Viau for 600 francs. Ten years later, it went to the Prince de Wagram for 19,000 francs. Eventually it found its way into the Pellerin collection, to become the subject of a firework display by Fry, a disquisition running to nine pages, complete with authorial confession and rhetorical deflation ("this tiresome analysis of a single picture"). Among other things, he turned his attention to the vexed question of Cézanne's distortions or "deformations." Fry delivered a magisterial rebuke to the detractors:

> It is probable that Cézanne was himself ignorant of these deformations. I doubt if he deliberately calculated them; they came almost as an unconscious response to a need for the most evident formal harmony. We have seen many similar deformations since Cézanne's day, sometimes justified and sometimes mere responses to the demands of fashion, than which nothing more tiresome can be imagined. A deformation which is not an imaginative and harmonic necessity is only a piece of snobbish orthodoxy. The snobbists of the eighties were not likely to be tender to the "ill-drawn" *Compotier* of Cézanne.[13]

Pellerin's interest was quickened by the noise about Cézanne in the 1890s, which contrived to bring him to the attention of a somewhat wider audience, at least among the cognoscenti. Surveying the scene of contemporary art, Georges Lecomte remarked on "the constant invocation of this tutelary name."[14] The noise reached a crescendo with a one-man show, "Paul Cézanne," at the Galerie Vollard, a boutique in the Rue Laffitte, off the Boulevard Haussmann, where some 150 works were displayed in rotation, hugger-mugger in the confined space, in November–December 1895. Perhaps the most extraordinary aspect of this eye-opening exhibition was that the artist himself played no direct part in it. Legend has it that he stole in one day, incognito, with his son,

and that when they came away Cézanne marveled, "And to think that they are all framed!"[15] In fact, he was in Aix throughout the winter. He never saw it.

As the exhibition opened, Vollard had not yet met Cézanne and was not yet his dealer. In a curious way they were made for each other. Cézanne was looking for Vollard, though he did not know it; Vollard was looking for Cézanne, with a pertinacity and an ingenuity, a sense of timing and a sense of theater, that left his rivals standing. Ever since the early 1870s, Cézanne had consigned paintings to Père Tanguy, the paint supplier, who would show them to devotees, and sell them if he could. Tanguy was a Communard, lucky to escape with his life, and a true believer in progressive causes and progressive artists. Perennially impoverished, he gave Cézanne credit on painting materials, to the tune of 2,174 francs in 1878, rising to 4,015 francs in 1885, with scant prospect of recouping anything much in the way of sales.[16] At bottom, he was not interested in sales. Tanguy was not so much a dealer as a defender, and in his humble way a connoisseur. "Papa Cézanne is never content with what he's done," he would tell awed visitors avid for any scrap of information on the legendary master. "He always stops before it's finished. When he moves, he takes care to forget the canvases in the house he's leaving; when he paints outdoors, he leaves them in the countryside. He works very slowly. The smallest thing costs him great effort. He leaves nothing to chance. Cézanne goes to the Louvre every morning."[17] Tanguy was a saint. He died, penniless, in February 1894. His stock contained nothing later than the mid-1880s; with Émile Bernard's assistance, he had managed to sell the portrait of Emperaire, but it seems that he had not been entrusted with any recent work. Whether or not this was deliberate forgetfulness, Cézanne began to look elsewhere, prompted perhaps by his son, now twenty-two and domiciled in Paris, without profession or prospects, but with a keen eye on the market, and his portion. In December 1894 Cézanne asked the sympathetic Octave Mirbeau if he could put him in touch with a dealer.[18]

In the meantime, the go-getting Ambroise Vollard was becoming interested in the painter so fervently admired by all the other painters of his acquaintance. "Cézanne was the great romance of Vollard's life," as Gertrude Stein said.[19] Tanguy had introduced them from beyond the grave. Vollard bought his first Cézannes at the Tanguy sale in June 1894, at absurdly low prices (between 95 and 215 francs). He sold them within a year, turning a profit of 1,000 francs. In the early days, he operated as a kind of privateer, cruising and pillaging as the opportunity arose, rarely holding on to any of his plunder for very long. Soon he could stockpile with impunity. For about a decade, coinciding with

the last ten years of Cézanne's life, Vollard acquired an effective monopoly on his work. According to the catalogue raisonné of his paintings, no fewer than 678, more than two-thirds of his lifetime production, passed through Vollard's hands—almost certainly a significant underestimate, given the prevalence of off-the-record transactions and the impenetrable character of the dealer's books.[20] Vollard seized his chance. He emptied the artist's studio of a huge cache of oil paintings and watercolors, snapped up any unconsidered trifles, propositioned every Cézanne owner ("Vollard comes to buy my Cézannes," recorded Signac in 1898; "I refuse to sell him the largest"), and established a remarkably close relationship first with Cézanne's son and then with Cézanne himself—a relationship never broken.[21] In time, this relationship made Vollard's fortune and Cézanne's reputation. The fortune came first. At his death in 1939, Ambroise Vollard must have been one of the richest men on earth.

Like all the great dealers, Vollard paid careful attention to what artists told him. In the course of 1894 he had at least two long conversations with Pissarro, who exchanged a work of his own for a sketch by Manet at one of Vollard's earliest exhibitions. Pissarro was impressed. He wrote to Lucien: "A young man I used to see at [the painter] John Lewis Brown's, and who has been warmly recommended to me by Monsieur Viau, has opened a little shop in the Rue Laffitte. He has nothing but canvases by young painters: there are some very beautiful early Gauguins, two beautiful things by Guillaumin, Sisley, Redon. . . . I believe this little dealer is the one we have been looking for; he only likes things by our school or comparable in terms of talent. He's very enthusiastic and knows his stuff; he has already stirred the interest of certain collectors who like to rummage around."[22] Pissarro was not alone. Maurice Denis's *Homage to Cézanne* (color plate 70) was also a homage to Vollard, and the ever-present cat that shared his name. The painting is set in Vollard's shop. Cézanne's *Still Life with Compotier* is on the easel. Gathered round it are Redon, Vuillard, Mellerio, Vollard, Denis himself, Sérusier, Ranson, Roussel, and Bonnard. Sérusier is holding forth; Redon is cleaning his glasses, the better to see his point. In a corner Marthe Denis, the painter's wife, looks out knowingly from behind a veil. Vollard, head and shoulders above the rest, seems almost to ascend the upright of the easel. Ambroise crouches at its base, a malevolent look in his eye, as if about to pounce on Sérusier's foot, to quiet him.

The homage was merited. Vollard's shop was an Aladdin's cave. Here Braque had his first intimation of Cézanne's seismic consequences. "I had been impressed by Cézanne, the paintings by him that I'd seen at Vollard's," he told an interviewer half a century later. "I sensed that there was something more

secret in that painting."[23] Here, too, Matisse found the small Cézanne that became his talisman: *Three Bathers* (color plate 48).[24] Matisse had first of all admired a van Gogh, *L'Arlésienne*; he tried and failed to persuade his brother to buy it, but his brother had more sense. He preferred to spend his savings on a chainless bicycle. Matisse returned to Vollard's intending to buy another van Gogh, *Les Alyscamps*. Then he noticed the Cézanne on the wall, and he was lost. He resisted buying it for a week, before asking his friend Albert Marquet to make an offer. Vollard had sold *Three Bathers* to the young artist Georges Linaret the previous year, 1898, for 300 francs. But Linaret had overreached; he was compelled to return it. Vollard bought it back for 75 francs and immediately resold it to Matisse for 1,500, at the same time buying twelve Matisses for 1,000—a deal made after much haggling. Matisse could ill afford even 500 francs; at this stage he was barely able to feed his family. He raised the down payment only by pawning his wife's emerald ring: a wedding present, and one of her prize possessions.

If there was a ruthless streak to Vollard's dealmaking, his sales technique was eccentric in the extreme, as Gertrude Stein and her brother Leo discovered. "The first visit to Vollard has left an indelible impression on Gertrude Stein," she wrote in *The Autobiography of Alice B. Toklas*:

> It was an incredible place. It did not look like a picture gallery. Inside there were a couple of canvases turned to the wall, in one corner was a small pile of big and little canvases thrown pell mell on top of one another, in the center of the room stood a huge dark man glooming. This was Vollard cheerful. When he was really cheerless he put his huge frame against the glass door that led to the street, his arms above his head, his hand on each upper corner of the portal and gloomed darkly into the street. Nobody thought then of trying to come in. . . .
>
> They told Monsieur Vollard that they wanted to see some Cézanne landscapes, they had been sent to him by Mr. [Charles] Loeser of Florence. Oh yes, said Vollard looking quite cheerful and he began moving about the room, finally he disappeared behind a partition in the back and was heard heavily mounting steps. After quite a long wait he came down again and had in his hand a tiny picture of an apple with most of the canvas unpainted. They all looked at this thoroughly, then they said, yes but you see what we wanted to see was a landscape. Ah, yes, sighed Vollard and he looked even more cheerful, after a moment he disappeared and this time came back with a painting of a back, it was a beautiful

painting there is no doubt about that but the brother and sister were not yet up to a full appreciation of Cézanne nudes and so they returned to the attack. They wanted to see a landscape. This time after even a longer wait he came back with a very large canvas and a very little fragment of a landscape painted on it. Yes that was it, they said, a landscape but what they wanted was a smaller canvas but one all covered. They said, they thought they would like to see one like that. By this time the early winter evening of Paris was closing in and just at this moment a very aged charwoman came down the same back stairs, mumbled, bon soir monsieur et madame, and quietly went out of the door, after a moment another old charwoman came down the same stairs, murmured, bon soir messieurs et mesdames and went quietly out of the door. Gertrude Stein began to laugh and said to her brother, it is all nonsense, there is no Cézanne. Vollard goes upstairs and tells these old women what to paint and he does not understand us and they do not understand him and they paint something and he brings it down and it is a Cézanne. They both began to laugh uncontrollably. Then they recovered and once more explained about the landscape. They said that what they wanted was one of those marvelously yellow sunny Aix landscapes of which Loeser had several examples. Once more Vollard went off and this time he came back with a wonderful small green landscape. It was lovely, it covered all the canvas, it did not cost much and they bought it. Later on Vollard explained to everyone that he had been visited by two crazy Americans and they laughed and he had been much annoyed but gradually he found out that when they laughed most they usually bought something so of course he waited for them to laugh.

From that time on they went to Vollard's all the time.[25]

Vollard was cunning, like a python.

He pumped Pissarro and Renoir for intelligence on other artists. Both were keen to tell him about Cézanne. Vollard later said that Pissarro's recommendation, reinforced by Émile Bernard and Maurice Denis, had been decisive. He formed the idea of an exhibition that would be in the nature of a retrospective. In order to realize it, he needed Cézanne's consent—and Cézanne's Cézannes. But the artist was nowhere to be found. He was said to be painting *sur le motif* in Fontainebleau; Vollard went to Fontainebleau, only to discover that Cézanne had returned to Paris. Vollard eventually tracked down an address in Paris, too late. Cézanne had left for Aix. The dealer did succeed in

making contact with his son, however, who received the proposal for an exhibition and undertook to convey it to his father. Cézanne cordially approved. What is more, according to Vollard, he dispatched nearly 150 canvases from Aix to Paris for the purpose, many of them apparently unfinished, and all of them rolled up. Like other episodes in Vollard's ornamental account, this story of the bumper bundle of rolled Cézannes has been dismissed as fanciful, but recent research into the pattern of cracking on the surface of the paintings seems to confirm its veracity.

The reaction to the exhibition in Vollard's shop was surprisingly favorable. Naturally, doubters and equivocators remained. Arsène Alexandre's review in *Le Figaro,* entitled "Claude Lantier," found that he was, "in short, an artist without issue but not without utility." Thadée Natanson, by contrast, entertained no such reservations in a lengthy panegyric in *La Revue blanche*:

> Paul Cézanne can lay claim to more than the title of precursor.
> He deserves another.
> He can already lay claim to being the French school's new master of still life. . . . For the love he has put into painting them, and for the way in which he has made them encapsulate all his gifts, he is and will remain the painter of apples—smooth apples, round apples, fresh apples, heavy apples, sparkling apples, apples in which the color rules, not only those one would wish to eat, where the *trompe l'œil* detains the gourmands, but where the forms delight. . . . He has made apples his own. . . .
> But because he painted with love and would have done so from pure inclination, would have followed his penchant regardless of personal advantage or anything else, some very young people to whom he doubtless never gave a moment's thought pause respectfully in front of his despised canvases, seeking strength from the traces of his audacity. And his contemporaries, old like himself, are moved on seeing his efforts gathered together and respectfully bow down before his œuvre.[26]

Natanson's emphasis on the impact of the exhibition on Cézanne's fellow artists, of all ages, was perhaps the cardinal point to make. As Pissarro rhapsodized, and Degas and Renoir squabbled over a still life, so word spread, like the ripples on a pond, to the dealers and collectors who were willing to rummage around—or knew their own minds. According to Vollard, Auguste Pellerin bought his first Cézanne from that exhibition: *Leda and the Swan.*[27]

The first substantial article on the legendary Cézanne appeared the year

before the exhibition, in 1894. Ostensibly a piece on the Duret sale (which included several Cézannes), it turned into a profile, by the writer and critic Gustave Geffroy. The two men had not met, but the article testified to an unusual sympathy, as Cézanne himself recognized; he read it the day it appeared in *Le Journal,* and wrote to express his appreciation.[28] Geffroy had done his homework. He had talked to Monet and Renoir, and doubtless to

others. He identified Cézanne as a character at once unknown and famous—a neat encapsulation—a phantom, a truth seeker, a revelator, a precursor, a kind of gauge; a man who had no desire to cut a figure or seek a role but who had nonetheless achieved a strange renown. In a word, he was fabled. "Surely this man has lived and lives a fine interior novel," Geffroy concluded, "and he is haunted by the demon of art."[29]

Over the next few years Geffroy continued to write insightful articles on Cézanne. At the same time he was working on a sympathetic biography of the socialist revolutionary Auguste Blanqui. Whether Cézanne infected Blanqui, or vice versa, by the end of the book it was almost as if the two had merged into one. Blanqui, "condemned to the extraordinary interior life which was his," achieves a sort of grandeur. "He wished neither to be consoled nor recompensed. He accepted his fate loftily without hope of gain. He was a new Hero, at one with the century, at one with humanity."[30]

Some months after the first article was published, Monet organized a lunch at Giverny for Cézanne to meet Geffroy. He invited three other friends to join them: the radical politician Georges Clemenceau, whose caustic tongue won him the soubriquet "the Tiger"; the writer Octave Mirbeau, who was also friendly with Pissarro, and shared his anarchist convictions; and the sculptor Auguste Rodin, another failure in the competition for the Beaux-Arts, who was already a prominent figure, commissioned to produce monuments to Victor Hugo and Balzac. Giverny was a nest of free-thinkers and atheists. Cézanne was due to stay at an inn nearby, to do some painting in the vicinity. Monet was anxious about the arrangements. "It's all set for Wednesday," he wrote to Geffroy. "I hope that Cézanne will already be here and that he will join us, but he is so peculiar, so fearful of seeing new faces, that I am afraid he may let us down, despite his wish to meet you. What a pity that this man has not had more support in his life! He is a true artist who suffers too much self-doubt. He needs to be cheered up: and he much appreciated your article!"[31]

Cézanne did not let them down. In some respects he exceeded expectations. Geffroy's account of the proceedings has entered the literature:

He struck us all immediately as a peculiar character, timid and violent, emotional in the extreme. Among other things, he gave evidence of the extent of his innocence or his confusion by taking Mirbeau and I aside to tell us, with tears in his eyes: "He's not proud, Monsieur Rodin, he shook my hand! A decorated man!!!" Better still, after lunch, he knelt before Rodin, in the middle of the path, to thank him again for shaking his hand. Hearing things like this, one could only feel sympathy for the primitive soul of Cézanne, who was that moment as sociable as he could be, and demonstrated with his laughter and his sallies that he was enjoying himself in our company. Clemenceau, with whom he found himself later on, had a particular talent for putting him at his ease, regaling him with witticisms. He did tell me one day that he could not support Clemenceau, though I had not asked him to. He gave me this astonishing reason: "It's because I'm too weak! And Clemenceau could not protect me! Only the Church can protect me!"[32]

This account is reminiscent of Matilda Lewis's wide-eyed amazement at Cézanne's table manners and general deportment. Gustave Geffroy was more worldly-wise than Matilda Lewis, but he was not well versed in Cézannian performance, or in Cézannian irony; like Monet, he could not always tell when

Cézanne was hamming and when he was not. Moreover, Geffroy's account has the flavor of a set piece, inspired perhaps by other set pieces. The famous description of Cézanne as at once "timid and violent" had appeared before, in a novel by Paul Alexis, and in an article by Émile Bernard, which stages a fictitious encounter between Cézanne and van Gogh in Père Tanguy's paint shop, where van Gogh is supposed to have shown Cézanne his work and asked for his opinion. "After inspecting it all, Cézanne, whose character was timid but violent, said to him: 'Truly, you paint like a madman!' "[33]

Cézanne may have been unusually excitable or emotional that day, in that company, but it seems clear that there was a strong element of playing to the gallery in his behavior at Giverny. Mirbeau remembered him at lunch, over the dessert, complaining of being plagiarized by Gauguin: "That Gauguin! I had one little *sensation*," he said, plaintively, "and he stole it from me. He took it to Brittany, Martinique, Tahiti, that's right, on all the steamships! That Gauguin!"[34] "That Gauguin" was part of his comic routine. (Other artists, past and present, might also figure. Gros, famous for his battle paintings and his official commissions: "I'm very fond of Baron Gros," he said to Geffroy, "but how can I be expected to take those jokes seriously?")[35] Similarly, the patter about Clemenceau and protection meshed with a well-practiced routine on the Church and his relation to it ("I lean on my sister, who leans on her advisor . . . who leans on Rome").[36] Perhaps Monet was nearer the mark when he reflected later on Cézanne's persona as "the country bumpkin," masking his pride by appearing as "a sort of puppet figure, testy, naïve, ridiculous."[37]

Was he hamming with Rodin? He was acutely sensitive to the forms of *politesse*. On another occasion at Giverny, Monet had no sooner embarked on a few gracious words of welcome than Cézanne stalked off, muttering imprecations, apparently thinking that he was being made fun of, his parting shot to the assembled company ringing in their ears: "You, too, you can bugger off!"[38] Still it is hard to believe that the byplay with Rodin should be taken straight, or that he was entirely serious about the handshake and the decoration. Rodin himself was none the wiser. When he heard the name Cézanne, he would shrug his shoulders, as if excusing himself: "This one I do not understand!"[39] Cézanne might have been intimidated by the sculptor's reputation, though that would have been uncharacteristic. Rodin was his contemporary; they were not personally acquainted, though they had more in common than might be supposed—a love of the baroque sculptor Pierre Puget, a passion for Baudelaire, a similar attitude to work. "He works incessantly," observed Rilke, who served for a while as Rodin's secretary. "His life passes like a single work-

ing day." There was an affinity of outlook. "I simply apply myself to copying nature," said Rodin. "I interpret it as I see it, according to my temperament, my sensibility, the feelings that it evokes in me." And even a certain congruence of experience. "Finally, after years of solitary work, he decided to make his appearance with one of his works," wrote Rilke.

It was a question put to the public. The public answered in the negative. And Rodin retired within himself again for thirteen years. These were the years during which, still unknown, he ripened into maturity and gained complete mastery over his own medium, working, thinking, experimenting unceasingly, indifferent to a generation which was indifferent to him. . . . New associations linked him more closely with the past of his art. That past and its greatness, under which others had labored as if under some heavy burden, lent wings to him, bearing him aloft. For if, at this period, he ever received encouragement and confirmation of his aim and of his quest, it came from the works of the ancients and from out of the soft darkness of the cathedrals. Men did not speak to him. Stones spoke.[40]

Stones spoke to Rodin as apples did to Cézanne.

A few years later he took Joachim Gasquet to see Rodin's *Balzac*. "Look . . . tradition! I'm more traditional than people think. It's like Rodin. No one really knows what he's like, deep down. He's a man of the Middle Ages who makes admirable pieces, but who doesn't see the whole. . . . Listen, I don't want to belittle Rodin. . . . I like him, I admire him a great deal, but he is very much of his time, as we all are. We make pieces. We no longer know how to compose."[41]

In April 1895, after a further exchange of letters and a reading of the stories collected in *Le Cœur et l'esprit* (including "Le Sentiment de l'impossible"), Cézanne sent Geffroy a perky little note with a veiled proposition:

The days are getting longer, the weather is turning milder. I am unoccupied every morning until the hour when civilized man sits down at table. I intend to come up to Belleville to shake your hand and submit to you a plan which I have now embraced, now abandoned, and to which I sometimes revert. Very cordially yours,

Paul Cézanne, painter by inclination[42]

The plan was to paint his portrait. Geffroy readily agreed. Cézanne had given up his ritual joust with the Salon de Bouguereau, but he had not altogether lost hope—unless he was joking when he told Geffroy that with this work he might finally gain admission, "and perhaps win a medal!" He remained ambivalent to the end. When he heard (mistakenly) that *Bathers at Rest* was to be shown at the Luxembourg, as part of the Caillebotte bequest, he is said to have exclaimed in triumph, "Bugger Bouguereau!"—a sentiment that traveled well in Parisian circles.[43]

Portrait and portraitist advanced slowly, as was his custom. Such an enterprise was not to be undertaken lightly, by anyone involved. "Ah! One thing that I didn't enjoy at all was the posing!" recalled Cézanne's son. "At least if he had talked during it, but no, he didn't say a word all the time he worked, and the slightest movement would drive him mad."[44] Several of the laborers and their offspring sat for Cézanne. With workers and peasants he was always affable and *bon enfant,* as they used to say. His familiars in Aix were all traditional craftsmen of one sort or another: the baker Gasquet, the locksmith Rougier, the winemaker Houchart, the stonecutter Barnier, the carpenter Cauvet, the gardener Vallier; even the sculptor Solari could be assimilated into this company. With these men there was never any acting up or acting out; there was only a scrupulous courtesy, an utter lack of pretension, and a sense of solidarity. Some of them he had known all his life—Solari, Gasquet, Houchart.[45] "Today everything is changing," he told one young visitor, "but not for me. I live in the town of my boyhood, and I rediscover the past in the faces of the people of my own age. What I like most of all is the look of people who have grown old without drastically changing their habits, who obey the rules of time; I deplore the efforts of those who try to insulate themselves from that process. Look at that old café owner sitting in front of his door under that spindle tree, what style! Then look at that shop girl in the square, certainly she's nice, one shouldn't speak ill of her. But that hair, those clothes, how flashy!"[46]

Rougier, latterly his neighbor in the Rue Boulegon, was also an amateur painter. (In Aix, so the story goes, even the grocers are painters.) His memories of Cézanne are refreshingly direct:

A lot of nonsense has been talked about Cézanne. Monsieur [Gustave] Coquiot [the writer] has told how the children made fun of him and followed him down the street, which is completely untrue: certainly he was considered to be an eccentric, and his painting was hardly appreciated

at all, but it was respected and everyone had a high regard for him. He was a very fine man, very unaffected, but he lost his temper very easily, so for example he couldn't stand anyone watching him paint; if someone came and stood behind him when he was *sur le motif,* he would stop, grumbling, pack his things and be off. I ran into him a lot, but I very rarely saw him at work. On the other hand he often talked to me about painting and what he said had so much force that often I could barely follow it.[47]

The faithful Vallier's only complaint was that he had no time to get on with the gardening, so long and frequent were the sittings.

Geffroy lived with his mother and sister. In order to work on the portrait, Cézanne visited them almost every day for two months. At the civilized hour they lunched contentedly together, en famille, or Geffroy took him to a restaurant. During the sittings, Cézanne kept up a lively commentary on painters and painting, munching his words through his mustache, as the sitter remembered. According to Geffroy, he was very critical of his contemporaries, with the exception of Monet, "the strongest of us all"—"Monet! I put him in the Louvre!"—and vehemently anti-Gauguin. Cézanne was not in the habit of tailoring his opinions to his audience, or telling people what they wanted to hear, but part of his own politesse was a courtesy towards his interlocutor, in correspondence and in person. A famous letter to Émile Bernard urged him to "treat nature in terms of the cylinder, the sphere and the cone, everything placed in perspective, so that each side of an object, of a plane, leads to a central point. Lines parallel to the horizon give breadth, be it a section of nature, or, if you prefer, of the Spectacle that Pater Omnipotens Aeterne Deus spreads before our eyes. Lines perpendicular to this horizon give depth."[48] The invocation of the deity was another piece of politesse: a nod to Bernard's religiosity, rather than an indication of Cézanne's. Cézanne spoke of nature. "Pater Omnipotens" was for Bernard's benefit.

Similarly, when he was visited by Karl and Gertrude Osthaus, founders of the Folkwang Museum in Germany, notable for its holdings of the French impressionists, he questioned them on the museum's collection, and then declared, "But Holbein, no one can touch him. That's why I stick to Poussin." This statement stunned Osthaus, who stopped to wonder whether Holbein had been given pride of place "out of courtesy for his German visitors," but noted that "he did it with such force that one would never have doubted his conviction." Cézanne went on to praise Courbet with equal vigor—"as

great as Michelangelo," except that "he lacks elevation." Coming to his contemporaries, he assumed a Ciceronian pose, finger upraised, and proclaimed: "Monet and Pissarro, the two great masters, the only two."[49] With Geffroy, the same courtesy was observed. Monet was Geffroy's friend.

The animus against Gauguin was genuine, and in one sense undeserved. For all his jesting, Gauguin revered Cézanne. Pissarro was his mentor, but Cézanne was his exemplar. Gauguin was too clever by half; his obiter dicta are as outlandish as they are astute. In a letter to his friend Schuffenecker he produced a memorable characterization:

> Consider the misunderstood Césanne [*sic*], whose essential nature is a mystic of the East (he looks like an old man of the Levant): in questions of form, he goes in for mystery, for the deep peacefulness of the man lying down to dream; his color is grave like the character of the Oriental. A man of the Midi, he spends whole days on mountaintops reading Virgil and looking at the sky; his horizons are elevated, his blues very deep, and his red has an astonishing vibration. Like Virgil, who has several meanings and who you can interpret as you wish, the literature of his paintings has a kind of parabolic meaning at both ends; his grounds are as imaginative as they are real. In sum, when you see one of his paintings, you exclaim, Strange, but it is madness.

All this was very apt. Some of it was as if to echo Cézanne himself. When the mystic of the East lost his temper with Oller (the occasion of the chilly letter), he apparently let fly against the world—"Pissarro is an old fool, Monet a wily bird, they have no guts . . . only I have temperament, only I know how to do a red!!"[50]

Cézanne had no time for "the Gauguin maids / In the banyan shades." Worse, Gauguin had trespassed, somehow, possibly by flaunting himself "after Cézanne," possibly by making supercilious remarks about Cézanne's discovery of the formula for producing the perfect painting. "Has Monsieur Césanne found the exact *formula* for a work acceptable to all?" he asked Pissarro. "If he finds the recipe for compressing all his exaggerated sensations into a single unique process, please try to make him talk in his sleep by administering one of those mysterious homeopathic drugs, and then come to Paris as soon as possible to tell us about it."[51] Cézanne was not amused. Finding a formula was a serious matter. "The Louvre is the book where we learn to read," he instructed Bernard. "However, we should not be content to rest on the beauti-

ful formulas of our illustrious predecessors. Let us go out to study beautiful nature, let us try to capture its spirit, let us try to express ourselves according to our individual temperament." These were his bedrock beliefs. But that did not preclude a formula of one's own. He may well have known Rimbaud's prose poem "Vagabonds," which insisted on the need to find "the place and the formula." To the question "What, according to you, is the ideal of earthly happiness?" Cézanne responded: "To have a beautiful formula."[52]

In between sittings, he would go and consult the book of the Louvre, to sketch or to look up something arising from his conversations with Geffroy, such as the silvery effect in Vermeer's *Lacemaker*. He seemed almost relaxed. And then, something changed. Geffroy recalled:

> During this period he worked on a painting which is one of his beautiful works, even though it is unfinished [color plate 56]. The library, the papers on the table, the little Rodin plaster sculpture, the artificial rose that he brought at the beginning of the sessions, everything is of the first rank, and of course there is also a character in this scene, which is painted with meticulous care, with a richness and an incomparable harmony of tones. He only sketched in the face, however, always saying: "Perhaps I'll leave that for the end." Alas, the end never came. One fine day, Cézanne sent for his easel, brushes and paints, writing to me that the project was clearly beyond him, he had been wrong to undertake it, and apologizing for abandoning it. I insisted that he come back, telling him what I thought, that he had started a very fine work and that he should finish it. He came back, and for a week he seemed to work, adding thin films of color, as only he knew how, always retaining the freshness and sparkle of the painting. But his heart was no longer in it. He left for Aix, once again sending for his painting materials a year later, on 3 April 1896, leaving behind the portrait as he had left so many other paintings, things of wonderful vision and realization.[53]

Cézanne evidently felt that some explanation was due to Monet, who had taken the trouble to bring them together:

> I had to abandon for the time being the study that I undertook at Geffroy's, who placed himself so generously at my disposal, and I'm a little embarrassed at the meager results I obtained, especially after so many sittings, and successive bursts of enthusiasm and discouragement. So I've

landed up here [again] in the Midi, which I should perhaps have never left to launch myself into the chimerical pursuit of art.

To conclude, may I say how happy I was about the moral support that I encountered with you, which served as a stimulus for my painting. Until my return to Paris, then, where I must go to continue my task, as I promised Geffroy.[54]

Cézanne had an exalted conception of his task. "The end result of art," he said, "is the figure." He was often dissatisfied with the portraits he undertook. A few years later, in 1899, he abruptly stopped work on a majestic portrait of Vollard (color plate 57), after marathon sittings, and withdrew once again to Aix, conceding that "he was not unhappy with the front of the shirt."[55] What governed these interruptions (or terminations)? Sometimes, it seems, he would call a halt when he lost his concentration, which could happen at almost any stage, after several hours or several weeks; sometimes when he succumbed to fatigue, or possibly when he felt that his model had succumbed to fatigue, in which case the pact was broken. Plainly he was more committed to some portraits, or sitters, than to others. When Vollard dozed off, he was given a chance to redeem himself. When Marie Gasquet fell asleep while posing, he abandoned the portrait, even though she was the beauty queen of Provence.[56] Every sitter lost the pose, sooner or later. Most were berated ("Wretch!") and forgiven; but when Alexandrine Zola dropped a careful pose at the tea table, by turning round to laugh at one of Guillemet's jokes, Cézanne left in high dudgeon. These were minor mishaps. A major portrait cost him dear. He admitted that two sittings a day left him feeling exhausted. Yet if the conditions were right he was always tempted by another sitting. One day, after a grueling morning's work, he said to his son: "The sky is turning a clear grey. Time to have a bite to eat, run over to Vollard's, and bring him to me!" "But aren't you worried about tiring out Vollard?" "What does that matter, since it's a clear grey day?" "But if you overtire him today, maybe he won't be able to pose tomorrow?" "You're right, son, one must molly-coddle the model! You, you've got commonsense."[57]

Many of his finest portraits are "unfinished"—not fully realized, as he might have said—Geffroy, Vollard, Vallier, Gasquet (father and son). Cézanne's successors toiled in his shadow. "It's impossible to paint a portrait," Giacometti would say. "Ingres could do it. He could finish a portrait." A sitter observed that Cézanne had painted some pretty good ones. "But he never finished them," Giacometti pointed out. "He never really finished anything. He went as far as

he could, and then abandoned the job. That's the terrible thing: the more one works on a picture, the more impossible it becomes to finish it."[58] Perhaps Cézanne had an instinct for how far he should go. He certainly had a strong sense of when he had achieved something: there may have come a point of diminishing returns. "I've made some progress, up to here," he said to Vollard as he was leaving.[59] In Cézanne's terms, that was saying a lot; "some progress" was about as much as he ever allowed. "I think the idea of a 'finished' picture is a fiction," reflected Barnett Newman. "I think a man spends his whole lifetime painting one picture or working on one piece of sculpture. The question of stopping is really a decision of moral considerations. To what extent are you intoxicated by the actual act, so that you are beguiled by it? To what extent are you charmed by its inner life? And to what extent do you then really approach the intention or desire that is really outside of it? The decision is always made when the piece has something in it that you wanted."[60] Cézanne was strong on moral considerations.

With Vollard, as with Geffroy, he indicated that he would resume work on the portrait when he returned to Paris—he even asked Vollard to leave the shirt and the suit in the studio—but he never did. In Geffroy's case, the situation was further complicated by a cooling on Cézanne's part, which baffled everyone, including Geffroy. As early as April 1896, only a year after he had worked so amicably on the portrait that he himself had instigated, Cézanne could be found cursing "the Geffroys and the other scoundrels who have drawn the attention of the public to me, for the price of a fifty-franc article." This smacks of betrayal; and Gasquet goes so far as to speak of Cézanne's frequently expressed "loathing" of Geffroy, which sounds as if it might be an exaggeration, but for a letter to Vollard, written in such strong language that it was in effect censored by the dealer—deleted from the public record—until very recently. "Geffroy wrote a volume *Le Cœur et l'esprit* where there are very fine things, among others 'Le Sentiment de l'impossible.' How has such a distinguished critic reached such a complete castration of feeling? He's become a businessman."[61]

Clearly Geffroy had strayed from the path of virtue to the path of vice (or the other way round) and was now beyond the pale. What accounts for the change in Cézanne's attitude towards him remains a mystery, only deepened by the knowledge that the artist continued to treasure his writing. Cézanne was transported by his description of the Egyptian sarcophagi in the Louvre, where he would prowl, reading and rereading the passages that he knew almost by heart. The Russian collector Shchukin was in the habit of doing the same thing:

whenever he was in Paris, he would visit the Egyptian antiquities in the Louvre, where he would discover parallels to Cézanne's peasants.[62] Geffroy's evocation of the sarcophagus is also reminiscent of Cézanne: "We cannot go back in time, and the artists of today are condemned to practice their art as a profession, to publicize their thought. Even so, does it not seem that this publicity is overdone, that there are too many shops, too much commerce, and that sometimes the men of today would do well to go and cast a respectful eye on the inside of that touching sarcophagus?"[63]

Geffroy's writings on Cézanne himself would appear to be unexceptionable. He published a long and laudatory review of the exhibition of 1895, recognizing its significance, and concluding unequivocally, "He is going to the Louvre." He wrote in similar vein when Denis's *Homage to Cézanne* was exhibited at the Salon of 1901. These pieces dwell rather more on the personality or psychology of the artist than did the original article, making use of some scraps of private information; they were hardly revelatory, but they were more widely discussed. They seem harmless enough. Nevertheless Cézanne may have felt that they were too personal, or too intrusive. Just as Gauguin stole his sensation, Geffroy appropriated his inclination. " 'Painter by inclination,' says Cézanne of himself, half-seriously, half-jokingly, above all seriously." Geffroy also emphasized his *inquiétude,* which may have been a step too far, though he was careful to give it a context. "Search well, look hard, and you will find that Cézanne is, on the one hand, a traditionalist, seized by those he regards as his masters, and on the other hand a scrupulous observer, like a primitive seeker after truth."[64] Cézanne had been on the receiving end of much worse than this.

It has been suggested that the root of the coolness lies in their interaction during the sittings themselves—the suggestion being that Cézanne was put off or offended by Geffroy's unconscionable beliefs, or simply by something he said. Attention focuses on Clemenceau, a hero to Geffroy but apparently not to Cézanne. According to Vollard, when he asked Cézanne why he no longer saw Geffroy, the conversation went as follows: "You see," said Cézanne, "Geffroy is a fine man, who is very talented; but he talked all the time of Clemenceau; so, I fled to Aix!" "So Clemenceau is not the man for you?" "Listen, Monsieur Vollard! He has *temmpérammennte,* but, for someone like me who is weak in life, it's better to rely on Rome."[65] Leaving aside the doubtful authenticity of the dialogue, this explanation, such as it is, seems highly unconvincing. It was categorically rejected by Geffroy himself. It does not square with two months of concerted effort (and companionable lunches). It fails to address the charges in Cézanne's letters. It is inconsistent with his close rapport with Mirbeau,

who ought to have been as suspect as the others. On the contrary, Cézanne considered him the foremost writer of the period—may even have identified with some of his characters—and continued to value his moral support, not to mention his patronage. For Mirbeau, Cézanne was *le plus peintre des peintres.* His thirteen Cézannes were the pride of his collection.[66]

In truth, Clemenceau is a red herring. The explanation is less an explanation than a repetition of a sort of dogma. It is predicated on the assumption of a fundamental ideological schism between a progressive unbeliever like Geffroy and a reactionary old codger like Cézanne, his nose buried in *La Croix,* his faith a rock, his church a haven, his politics an instinctual mix of blood and soil and chauvinism. That is roughly the line peddled by Vollard, and later by others. It constructs a helpless, almost childlike Cézanne in his dotage, a political simpleton, a preconscious pilgrim, clinging to *le bon droit* in all its forms—the Church, the State, the Army—even the Boers.[67] It seems oblivious to any contradictions: the lifelong insistence on *le sale bourgeois,* for example, to say nothing of *le sale abbé* Roux ("he's a leech"). It is tone deaf, to wit and wisdom. "I'm going to get my helping of the Middle Ages," he would whisper, mischievously, near the font. "To be a Catholic," he told his son, near the end, "I think one has to be devoid of all sense of fairness, but to keep an eye on one's own interests."[68]

As for the chauvinism, it is supposed to have been quickened by his association with Joachim Gasquet, who hymned "the blood of Provence," and who evolved into a rightist, a royalist, and in his high-flown way something of a racist. He wrote rapturously of Cézanne's *Old Woman with a Rosary* (color plate 61) as a Provençal racial symbol, and did his best to represent the artist as a kind of penitent Dostoevsky. This effort was doomed to failure. Gasquet spun a fantastic tale of the old woman's pitiable provenance as a renegade nun, homeless and destitute, taken in by a charitable Cézanne; the artist himself stated plainly that she was a former servant of the lawyer Jean-Marie Demolins, Gasquet's friend and collaborator on the literary journal he created as a mouthpiece for his views, *Les Mois dorés.*[69] No symbols where none intended, as Cézanne might have said.[70] Provençal revivalism had a visceral appeal, and Cézanne was not immune to a little lionizing. Gasquet had a certain allure. He may have reminded Cézanne of his youth, with Zola; they revisited some of his old haunts. He may have conjured a brighter image of his son, ensconced in Paris, irrevocable. "My son has read your review, with the greatest interest," he told Gasquet. "He is young; he cannot but share your hopes." Gasquet was twenty-three when they met, two years younger than Paul, but more vivid,

more accomplished, more intelligent. Much as Cézanne doted on his son (and encouraged him unstintingly by letter), he was not blind to his shortcomings. He wrote more frankly to Camoin: "My son, now in Paris, is a *great philosopher*. By that I don't mean the equal or the emulator of Diderot, Voltaire or Rousseau . . . he is rather touchy, incurious, but a good boy."[71]

But there were limits. Cézanne admired intellectual seriousness (and passion), but any hint of preciousness repelled him. Gasquet was preciousness personified, at once superior and ingratiating.[72] His program was little more than a glorification of a bygone age—"it embalms Provence," wrote Cézanne, passing him a characteristic compliment—and essentially narcissistic. Cézanne may have lived in the past, as he said, but he was not backward-looking. There was work to be done. After a wave of enthusiasm—"Vive la Provence!"— Cézanne disengaged. People would not get their hooks into him.[73] He became as wary of Gasquet as he was of Geffroy. "I live alone," he wrote to Vollard in January 1903, "the Gasquets, the Demolins are priceless, the clan of intellectuals, good God, they're all the same."[74] Even in the best of times, when consorting with Gasquet and his gang, the public image went awry. "Who were you out with the other day?" asked a friend of Louis Aurenche's from Marseille, after a night out at the Café Clément on the Cours Mirabeau. "People say Gasquet is an anarchist, and as for the painter, here they have him down as crazy!"[75] Crazy or not, he was unrepentant. Expressions of patriotic fervor were not always to be taken straight: "I learn with great patriotic satisfaction that the venerable statesman who presides over the political destinies of France is going to honor our country with a visit; for the people of Southern France, their cup runneth over," he wrote to Paul. "Jo [Gasquet], where will you be? Is it the artificial and conventional things in the course of life on earth that lead to the surest success, or is it a series of happy coincidences that bring our efforts to fruition?"[76]

Cézanne was miscast as a simpleton. Stupidity was not his forte. The One True Church (whichever it might be) could not contain him; followership was one of the many things he could never quite bring himself to believe in. "All my compatriots are arseholes beside me." These were very nearly his last words to his son. The sentiment was not quite the sweeping condemnation it might seem, but rather the final nail in the coffin of Jo and his collaborators; "compatriot" in Cézanne's language was a man of the Midi, "our country." The unreconstructed Catholic reactionary is a myth. Whatever the cause of his disillusion with Geffroy, there was no ideological schism. "*Homo sum*," Cézanne

quoted splendidly to Aurenche: "*nihil humani a me,* etc." I am a man: nothing human is foreign to me.[77]

How did Cézanne see Geffroy as he sat for him?

"Today our sight is a little tired," said Cézanne to Jules Borély, when the young archaeologist visited him in 1903, "abused by the memory of a thousand images. And the museums, and the paintings in the museums! And the exhibitions! We no longer see nature; we see paintings, over and over again. To see the work of God! That's what I apply myself to. But am I what they call a realist or an idealist, or just a painter, a draftsman? I'm afraid of being compromised, my situation is very serious; nevertheless I'm a recognized painter, aren't I?"[78]

The recognized painter had a way with portraiture. A Cézanne portrait is more a thereness than a likeness. The mature Cézanne scorned mere likeness. He once asked Vollard what the *amateurs* thought of Rosa Bonheur. Vollard replied that her *Plowing in the Nivernais* was generally considered to be very powerful. "Yes," Cézanne shot back, "it's horribly lifelike." The portraits he preferred were the ones that showed temperament, where the blood pact came through. He relished Corot's portrait of Daumier, because it expressed something of the bond between them. "And as for Corot, what a portrait he did of Daumier! Both their hearts are beating in it. But just look how Ingres, yes, in spite of himself, flatters and transfigures his model. Compare it with his other portraits, those flops like himself."[79]

In his own portraits, the sitter is not projected as a *character,* as the critic David Sylvester puts it.

> Not being distracted by the temptation to define character allowed Cézanne to concentrate all his attention on achieving the most precise and complete sensation of a human *presence,* of the way someone in reality appears in space. He achieves it more, I think, than Rembrandt or Velázquez, partly because he was also undistracted by an interest in virtuoso illusionism, partly because he was supreme in dealing with the problem of re-creating the density that people seem to have as we look at them. Rembrandt tends to make them too heavy, Velázquez tends to make them too light. Cézanne gets the weight of their presence right.[80]

Gauging the weight of things was one of his magical properties. The American painter Brice Marden believed that Cézanne had gauged the weight of the sea

in *The Gulf of Marseille Seen from L'Estaque,* the catalyst for some work of his own.[81]

Much of this weighing and assaying was done with color. "It's as if they were placed on a scale," said Rilke's friend Mathilde Vollmoeller, herself a painter, as they studied the works in the 1907 retrospective: "here the thing, there the color; never more, never less than is needed for perfect balance."[82]

The portrait of Gustave Geffroy obeys this principle. It is not very lifelike, but it is Geffroy by the pound. It conveys the weight of his presence in his world: the world of books and attributes, carefully staged, including the curiously vivacious artificial rose. It is an architectonic tour de force, "a complete artistic education in itself," according to Félix Vallotton. "Observe the expressiveness of the color, the stylishness of the knickknacks on the table, the blue papers, and the beautiful drawing of the head."[83] Not everyone agreed. The color is expressive, but the stone-faced sitter is not. For the throng at the 1907 retrospective, where the portrait was first exhibited, Geffroy was more an absence than a presence, a sitter without a character—a man without qualities. His left hand is something very like a stump.

Hands had a sort of mnemonic power. In the portrait of Vollard, there are two blank spots on the right hand—two of the most celebrated spots in modern art—as if to confirm Renoir's dictum in reverse ("He has only to put two strokes of color on a canvas and it's already something"). "I don't know how to do anything at all," despaired Giacometti, as he wrestled with a portrait of James Lord in 1964. "If only Cézanne were here, he would set everything right with two brush strokes."[84] That was the twelfth of eighteen sittings. Vollard claimed 115. Schuffenecker could have finished it in a trice, no doubt, but not Cézanne. When Vollard made bold to point out the blank spots, as the work was still in progress, Cézanne replied: "If my session at the Louvre this afternoon goes well, perhaps tomorrow I'll find the right tone to fill in those blanks. You see, Monsieur Vollard, if I were to put something there at random, I'd have to redo all of my painting starting in that place!"[85] The dealer shrewdly parlayed the experience into the legend. "Cézanne often does not finish his paintings," Vollard told the collector Harry Kessler, "because he cannot find the tones for a spot in the picture, and therefore leaves a white 'hole' there."[86]

The hands were important. So was the overall conception. The card players have somewhat similar blank spots, which are also highlights.[87] The painter himself was a hand worker—an alliance of the hand that ponders and the eye that fashions, as the poet Jacques Dupin once said—and Cézanne seems often to have pondered his painting in this way. "I get to grips with my *motif,*" he

said to Gasquet one day, surveying the scene from the top of a hill, under a tall pine tree. He clasped his hands together. "A *motif,* you see, is this." Gasquet describes him repeating the gesture, holding his hands apart, his fingers spread wide, bringing them slowly, slowly together again, then clasping and clenching and interlocking the fingers. The poet Edmond Jaloux first met him at Gasquet's house. Cézanne came to call as they were finishing lunch. "We were having dessert; on the table he noticed some peaches and apricots arranged in a dish, in bright sunlight. He held out his old man's hands in a gesture of rapture and said: 'Look how the sun loves the apricots so tenderly, it envelops them, it enters their flesh, it lights them up from all sides. Yet look how miserly it is with the peaches, it illuminates only half the fruit!' "[88] Cézanne's *touch* had manifold meaning; it was an intensely physical experience. In painting, he linked physical consciousness with material substance. Something painted was something captured—enraptured—in his *sensations,* optical and tactile. (According to Vollard, one of his earliest collectors was blind from birth. Did he run his fingers over the painting, reading it like Braille?)[89] Cézanne's basic criterion for evaluating the work of others was the turn of the hand—whether they had enough of *that.* Delacroix did. Degas did not. Enough said.

Two of Cézanne's most sympathetic observers both intuited something about his hands. Robert Walser ends his elliptical "Thoughts on Cézanne" with reflections of bewitching simplicity:

> All the things he grasped became intermarried, and if we find it proper to speak of his musicality, it was from the plenitude of his observation that it sprang, and from his asking each object if it might agree to give him a revelation of its essence, and most pre-eminently from his placing in the same "temple" things both large and small. The things he contemplated became eloquent, and the things to which he gave shape looked back at him as if they had been pleased, and that is how they look at us still.
>
> One could justly insist that he made the most extensive use, bordering on the inexhaustible, of the suppleness and compliance of his hands.

In similar vein, one of Rilke's *Letters on Cézanne* contains a remarkable passage on his hands, and his handiwork. It proceeds from the idea of the artist as a kind of pauper.

And what progress in poverty since Verlaine . . . who wrote under "Mon testament": *Je ne donne rien aux pauvres parce que je suis un pauvre*

moi-même [I don't give anything to the poor because I am poor myself], and whose work is almost entirely marked by this not-giving, this embittered holding out of empty hands, something for which Cézanne, during his last thirty years, had no time. When could he have shown his hands? Malicious looks certainly found them whenever he left the house, lewdly uncovering their indigence; but all we can learn of these hands from his work is how massively and how genuinely they labored unto the end.

"It is this limitless objectivity, refusing any kind of meddling in an alien unity, that strikes people as so offensive and comical in Cézanne's portraits," concluded Rilke—a perception matched twenty years later by Fry, who argued that "even in the least successful of these works [of early youth] he showed the authenticity of his inspirations and the exigence of his artistic conscience. We have to recognize his heroic, his almost contemptuous candor, and the desperate sincerity of his work."[90]

It was the limitless objectivity and the desperate sincerity that riveted Giacometti, perhaps the most Cézannian of his successors, who copied his portraits of Chocquet and Vollard, among others, including countless self-portraits. He was obsessed with Cézanne's scrutiny and self-scrutiny. For Giacometti, Cézanne was responsible for the greatest revolution in painting—in scrutinizing—since the Renaissance: a revolution in our way of seeing. He was first of all an Egyptian, just as Sergei Shchukin had always suspected. The lesson that Giacometti learned from Cézanne was profoundly important. As he explained in an interview in 1957:

Cézanne revolutionized the representation of the exterior world. Until then, one valid conception reigned, since the Renaissance, since Giotto, to be precise. Since that time, there had been no fundamental alteration in the way of seeing a head, for example. The change between Giotto and the Byzantines was greater than that between Giotto and the Renaissance. After all, Ingres's way of seeing was almost a continuation.

Cézanne blew sky high that way of seeing by painting a head as an object. He said as much: "I paint a head like a door, like anything else." As he painted the left ear, he established a greater rapport between the ear and the background than between the left ear and the right ear, a greater rapport between the color of the hair and the color of the sweater than between the ear and the structure of the skull—and because what he himself wanted was still to achieve a whole head, he completely shattered

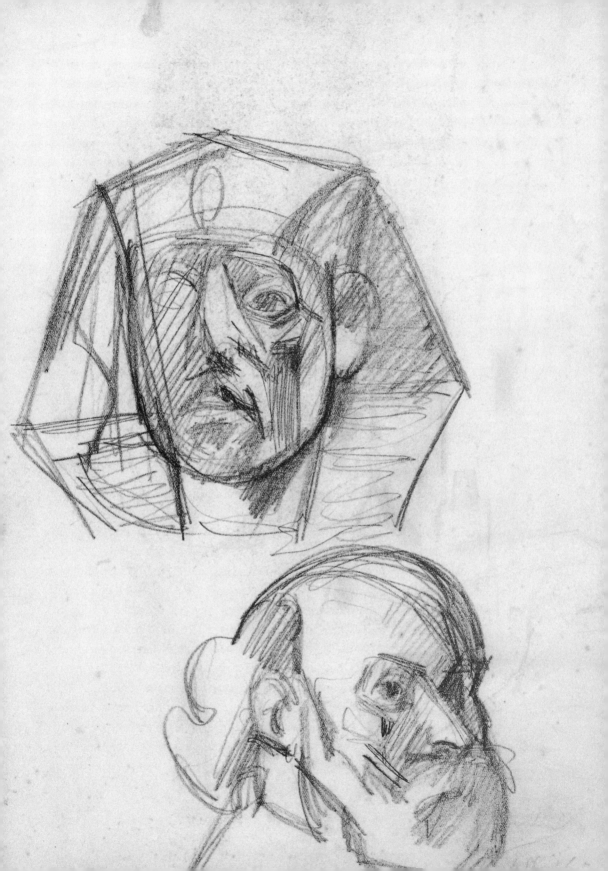

the idea that we had before of the whole, the unity of the head. He completely shattered the bloc, so completely that first of all we pretended that the head had become a pretext, and that, in consequence, painting had become abstract. Today, every representation that seeks to return to the previous way of seeing, that is to say the Renaissance way of seeing, is no longer believable. A head whose integrity would have to be respected would no longer be a head. It would be a museum piece.[91]

The remark about the head as object testified to another of Cézanne's lessons for his successors: no hierarchy of genre or subject or patch of paint. *"Equality of all things,"* as the director Robert Bresson put it in his famous *Notes on the Cinematographer* (1975). "Cézanne painting with the same eye and the same soul a fruit dish, his son, the Mont Sainte-Victoire."[92]

About the head, Giacometti was right. Cézanne wanted a whole head, as he saw it, but he also wanted a museum piece ("to make of impressionism something solid and enduring like the art of museums"). Moreover, he did not always keep it intact. Things were solid and enduring, yet increasingly unstable, permeable, mutable. For Cézanne it was not the center but the contour that could not hold. "You see, Monsieur Vollard, the outline eluded me!"[93] In the portrait of Vollard the exploded head and the evanescent left ear can be glimpsed, as if for the first time. In *Man with a Pipe* (color plate 72), a dignified portrait of Alexandre Paulin, the rapport between the ear and the background is exactly as Giacometti described. In *Seated Peasant,* the instability is such that the figure has become enmeshed in the ground, so that the left ear has been supplanted by the lozenge pattern on the wallpaper behind. Variations on this treatment abound. In *Woman in a Red Striped Dress* it is the socket of the left eye that has a rapport with the background; here, too, the outline is elusive.[94] Cézanne's encapsulation for Bernard of the essence of the enterprise was "to give the image of what we see, forgetting everything that has appeared before us." He was remembering and forgetting and transforming. If his paintings were memories of museums, as he told Renoir, they were also detonators of the material world.[95]

On 7 November 1895 he went on an excursion. Cézanne, Emperaire, and Solari set off for a walk in the countryside around Aix, like the Inseparables reincarnated. Solari's son Émile went with them. "Cézanne, tall, with white hair, and Emperaire, small and deformed, made a weird combination. One might have imagined a dwarf Mephisto in the company of an aged Faust."

They went first to Bibémus, the abandoned quarry haunted by Cézanne. "Farther on," Émile remembered,

> after having traversed a considerable stretch of ground planted with small trees, we found ourselves suddenly face-to-face with an unforgettable landscape with Sainte-Victoire in the background, and on the right the receding planes of Montraiguet and the Marseilles hills. It was huge and at the same time intimate. Down below, the dam of the Zola canal with its greenish waters. We lunched at Saint-Marc under a fig tree on provisions obtained from a road-menders' canteen. That night we dined at Tholonet after a walk over the stony hillsides. We returned in high spirits, marred only by Emperaire's tumble; he was a little drunk and bruised himself painfully. We took him home.

That was a long walk, but Cézanne and Solari decided to go for something even more ambitious: an ascent of the Sainte-Victoire. On this occasion they left Emperaire behind. They established base camp in the village of Vauvenargues, where they slept in a room full of smoked hams hanging from the rafters. At daybreak they started up the mountain, accompanied by Émile Solari. "Cézanne appeared to be surprised and almost chagrined when I innocently pointed out that the green bushes along the path looked blue in the morning light. 'The rascal!' he said. 'He notices at a glance, when he's only twenty, what it has taken me thirty years to discover!' " When they reached the top, "we had lunch in the ruins of the chapel of Calmaldules, the site of an episode in Walter Scott's *Charles le Téméraire* [*Anne of Geierstein*]. We did not go down into the Gouffre du Garagaï (a bottomless pit near the summit), which is also mentioned in that novel. But Cézanne and my father spoke of it and recalled the memories of their youth. There was a terrific wind blowing up there that day."

On the way down, Cézanne tried to prove to himself that he was as young and agile as ever by climbing a small pine tree. But the day's walking had tired him, and the attempt was not very successful. "And yet, Philippe, do you remember? We used to be able to do that so easily!"[96]

He was just beginning the greatest period of late painting since Rembrandt. He had better things to do than attend his own exhibition at the Galerie Vollard. There were mountains to climb, and small pine trees.

Self-Portrait: The Inscrutable

This portrait (color plate 5) is usually dated 1898–1900, when Cézanne was about sixty. It is the last self-portrait he ever painted. The self-scrutiny was displaced into the portraits of the gardener Vallier, on which he worked to the end.

"His meagre eyebrows have a strangely Oriental slant," observed John Rewald.[1] Cézanne often fastened on the eyebrows. In an earlier self-portrait, the artist's massive presence is topped with startling, circumflex-like eyebrows, raised theatrically as if to call the whole enterprise into question. In another one, an angular eyelid is surmounted by an S-shaped eyebrow, leaving a quizzical trace.[2]

The Oriental eyebrows, and the visage as a whole, may be seen to advantage in a contemporary photograph taken by Josse Bernheim-Jeune in the garden of Cézanne's studio at Les Lauves. In the painting, the seeing eye is blank, yet curiously effective. For Pavel Machotka, "he appears shrunken and turned inward." This begins to sound defeatist, which was surely not the case, though it is a common enough perception. Discovering a slightly earlier self-portrait in a private collection in Germany in the 1950s, Beckett found it "overwhelmingly sad. A blind old broken man."[3] For Peter Gay,

Cézanne's most important self-portraits, largely concentrated in the two decades from the mid-1870s to the mid-1890s, seem if anything even more consciously, almost desperately, reserved. He subordinated everything—shapes, colors, his bald head and broad shoulders—to his overall design. . . . He laid on the colors with short, visible parallel strokes to proclaim the presence of a painting far more than of a person. And he painted his eyes, which the ancient truism has it are the windows of the soul, as opaque, impenetrable. For all that, the blank stares that Cézanne bestowed on the viewer were accomplices to an irresistible indiscre-

tion. His self-portraits betray the very secret he aimed to keep: he was a man who all his life tried to impose order on an unruly, perhaps chaotic self. . . .

Whatever the reasons, in his last years Cézanne, feeling defeated and solitary, stopped doing self-portraits altogether, only showing that indiscretion can take many forms, including silence.[4]

As so often in Cézanne, the back wall is an integral part of the composition, painted as fervently as the subject himself, giving the beret and the body as a whole a kind of blue aura. The wall does its bit, "attaining its own perplexing spatiality."[5] The otherworldly red incursion at the bottom right is part of the upholstered armchair that appears in various portraits of Hortense. Armchair or no armchair, the painting is almost abstract. Adding to the ethereality, the paint is applied very thinly, especially in the area of the artist's coat. Rewald found that the brushwork in the face is closely related to that in the portrait of Joachim Gasquet (color plate 59).[6]

In a masterly appreciation, Lionello Venturi noted the disinterestedness with which Cézanne surveyed himself in his self-portraits—making the comparison with Rembrandt—and underlining the *finesse morale* of the expression.[7] With advancing age, Cézanne moved beyond performance. The late self-portraits are the unvarnished truth. The man in the beret stands before us, *semper virens,* but the self-examination is searching. *Homo sum, nihil humani a me,* etc.

This painting passed through Vollard's hands to Egisto Fabbri in Florence, Paul Rosenberg in Paris, and Robert Treat Paine in Boston, where it remained. It was acquired by Thomas N. Metcalf and his descendants, who facilitated its passage into the Museum of Fine Arts in that city.

11: A Scarecrow

"You are an old man plodding along a narrow country road. You have been out since the break of day and now it is evening. Sole sound in the silence your footfalls." Like Beckett, Cézanne walked enormously. The habit of walking filled his late works as it filled one of Beckett's, the Cézannian *Company* (1980), in which a solitary hearer lying in the darkness calls up images from a distant past, not ceasing "till hearing cease."[1] Cézanne was unceasing. The itinerary of his walks was the orbit of his world. His happiest memories were of the hills of Saint-Marc, a few miles to the east of Aix, in the general direction of Mont Sainte-Victoire.[2] This was his country. It was here that he had frolicked as a youth, with Zola and Baille; it was here that he repaired, forty years later, to capture the spirit of nature, and to express himself according to his individual temperament.

If he was pleased with his exhibition and the interest it generated, he did not show it. Numa Coste found him "very low and often prey to gloomy thoughts. Still he can find some satisfaction in his own self-esteem, and his work has sold well and he's not used to that."[3] Evidently the interest had registered. He received Vollard very cordially in Aix a few months later, attended by his son, now effectively his agent, who was deputed to rescue a still life from a cherry tree, after Cézanne had thrown the canvas out of the window. ("Son, we must get down the *Apples*. I shall try and get on with that study!") This sounds far-fetched, but his sister Marie's gardener, Auguste Blanc, remembered canvases in the olive trees in the grounds of his last studio, left for seasons on end before being harvested by the artist.[4]

Otherwise, visitors were discouraged. The well-intentioned and the well-connected alike met with an elegantly formulated impenetrability. In response to an overture from the collector Egisto Fabbri, who owned sixteen Cézannes and who wrote respectfully of their "aristocratic and austere beauty,"

the artist seemed to assent with good grace to the idea of a meeting, only to add: "The anxiety of falling short of what is expected of a person presumed to be on top of every situation is doubtless the excuse for the obligation to live apart."[5] No meeting took place. Cézanne turned his back on the world of affairs, on blandishment and self-advertisement. He rented a *bastidon*, a small, two-story stone dwelling, at Bibémus. The abandoned quarry became his stamping ground and source of inspiration.[6] There he was alone; neither Hortense nor Paul had any part in his quarry life. He also rented a room in the Château Noir, a Provençal country house in the hills nearby, where he could store painting equipment; and another in a modest abode easier of access, lower down the slopes, where he lodged with a peasant named Eugène Couton.[7] He reread Flaubert. It was as if he wanted to escape from the stupidity and cupidity of men.

In private, he remained entirely himself. Couton, his landlord, found him very gentle and polite, and always willing to talk after the day's work was done,

> but oo la la, you didn't dare come near him when he was painting, he would give you such a vicious look that you would be frightened to death. But you couldn't understand his painting anyway, I couldn't make head or tail of it. He made a lot of them, dauby looking things, big ones too. . . . He started a big one of the Sainte-Victoire from the side of the hill over there, just blocked in a little bit, but you could tell it was the Sainte-Victoire even so. Well, one day he was looking at it and you could tell by the look in his eye that he wasn't satisfied with it, he seemed to be all out of sorts. And, *coquing de bong diou* [goddamn it], do you know what he did? He picked up a big rock and threw it right through the middle of the canvas!

At the end of his stay, he gave Couton a small painting, as a memento. The peasant was delighted to find that it was a recognizable image of the *bastidon*, with the Sainte-Victoire in the background. He pretended it wasn't much ("*c'est una petita bêtisa*"), and he kept it in the attic, Zola-like, but nothing would induce him to part with it—not even Cézanne's son, who came to call after his father died and apparently tried to take it away from him. Couton led him to the *bastidon*, which was emptied as efficiently as the studio and the apartment, but the *petita bêtisa* stayed put. "He had a right to take everything else but he couldn't get the one that his father gave to me."[8]

Contrary to legend, he was amenable to taking young painters with him out

sur le motif. He painted side by side (or in staggered formation) with Joseph Ravaisou at the Château Noir, forewarning the owner: "Don't be afraid, I'm bringing you an anarchist." Perhaps these expeditions brought back memories of lizard days with Pissarro, though none of the so-called *petits maîtres* of Aix was in Pissarro's class. "Sonny, why do you see it so far away, the Sainte-Victoire?" he reproached Édouard Ducros.[9] "The main thing in a painting," he would say, "is finding the right distance." That was one of his constant preoccupations, "conveying a feeling of the real distance between the eye and the object."[10] But the real distance was a movable feast, and the means of conveying such a feeling were themselves problematic. Cézanne had almost given up on traditional perspective, the standard vanishing-point procedures of the schools (the perspective of the railway lines that "vanish" to a point far away). John Berger has observed that perspective is not a science but a hope. In this sense Cézanne had lost hope. "There it is," he said to another visitor, gesturing to the Sainte-Victoire. "It is quite a distance from us, in itself it is rather massive. Of course, at the Beaux-Arts you learn the rules of perspective, but you never see that depth results from the conjunction of vertical and horizontal surfaces, and that's exactly what perspective is."[11] Cézanne set himself to pursue the problems of near and far, as the painter Bridget Riley puts it. The results were disconcerting. The philosopher Henri Maldiney speaks of "an inversion and contamination of near and far. . . . The sky collapses along with the earth in a whirling. Man is no longer a center, and space not a place."[12]

As Braque and Picasso came to recognize, Cézanne initiated another break with Renaissance tradition. Often, the horizontal collapsed into the vertical; color was called upon to do the work of linear perspective. "Color had to express all the ruptures in depth."[13] In *Lake Annecy* ("which seems to lend itself to the linear drawing exercises of young ladies"), there are topographical markers which suggest recession into space, yet the rules have been abandoned (color plate 66). It is as if the surface of the lake becomes a wall—a marine version of the *mur végétal,* full of visual interest, complete with distorted reflections—on top of which sits the Château de Duingt, in itself rather massive (and appearing much closer than in life, or in the albums of young ladies). Such radical departures were not confined to landscape. In *Still Life with Plaster Cupid* (color plate 64), perhaps the most disorientating still life ever painted, traditional perspective is so thoroughly subverted as to call into question all manner of pictorial illusion, especially the illusion of depth. The vertiginous world inhabited by the *Plaster Cupid* proposes a new kind of depth, a depth that opens when the ground gives way beneath one's feet.[14]

In public, his behavior became more erratic. Cézanne had always been elusive, changing his address, withholding the details, going perpetually to and fro between Aix and Paris. ("Was it then another journey *from,* like so many," Beckett asked himself, or a journey *to?*)[15] Now he began actively to avoid people—even people he knew well—ignoring them, or indicating that they should ignore him, if their paths happened to cross. Apparently Monet had this experience; Guillaumin and Signac too. Signac never forgot how, as a young man, he was walking one day along the Seine with his master Guillaumin. They caught sight of Cézanne coming towards them. They were about to offer him a warm greeting, but as they approached he began gesticulating emphatically for them to carry on by. Startled, and strangely moved, they crossed the road and went on in silence.[16] "In all profound minds some hidden virtue is perpetually at work creating a recluse," writes Valéry.

> When brought into contact with or reminded from time to time of other people, they become conscious of a peculiar sensation that pierces with a sudden sharp pain, making them withdraw at once into some indefinable inward island. This is an attack of inhumanity, a reflex of invincible antipathy that may end in madness, as befell the emperor who wished that the human race had only one head which could be cut off at a single blow. But with people who are less brutal by nature and more contemplative, this violent feeling, this obsession of the man with himself, can give birth to ideas and works.[17]

His avoidance tactics were not confined to sign language, but extended also to letters. On first meeting Cézanne, in 1896, Joachim Gasquet waxed lyrical about the *Mont Sainte-Victoire with Large Pine* (color plate 68) that he had seen in a recent exhibition of the Société des amis des arts in Aix. Impulsively, Cézanne made him a present of it, just as he had done with the lamented Cabaner. Gasquet then received a note to the effect that he was about to leave for Paris. Shortly afterwards they bumped into each other in Aix. That evening Cézanne composed another letter, unburdening himself to his young admirer:

Cher Monsieur Gasquet

I met you this evening at the bottom of the Cours, you were accompanied by Madame Gasquet. If I am not mistaken, you appeared to be extremely angry with me. If you could but see inside me, the man

within, you would not be. You do not see, then, the sad state to which I am reduced. No longer my own master, a man who does not exist. Yet you, who would be a philosopher, want to finish me off? But I curse the Geffroys and the other scoundrels who, for a fifty-franc article, have drawn the attention of the public to me. All my life, I have worked to be able to earn my living, but I thought that one could do good painting without attracting attention to one's private life. Certainly an artist wishes to improve himself intellectually as much as possible, but the man should remain obscure. The pleasure must be found in the study. If it had been left to me, I should have stayed in my corner with a few friends from the studio with whom one could go out for a drink. I still have a good friend from that time [Emperaire?], well, he has not been successful, which does not prevent him from being a damn sight better painter than those good-for-nothings with their medals and decorations which bring one out in a sweat. Do you want me to believe in anything at my age? Besides I am as good as dead. You are young, and I understand that you would like to succeed. But for me, what is there left to do in my situation but keep my head down; and if I were not so fond of the lie of the land, I should not be here.

But I have bored you enough as it is, and after I have explained my situation, I hope that you will no longer look on me as if I had somehow threatened your safety.[18]

For all its gloom and doom and hyperbole, this letter demonstrated a strong measure of self-awareness. First of all, it was a reasonably accurate appreciation of his situation as reflected in the attitudes of society at large. In a certain sense he was neither dead nor alive, like the hunter Gracchus in Kafka's story: "Nobody knows of me, and if anyone knew he would not know where I could be found, and if he knew where I could be found he would not know how to deal with me, he would not know how to help me."[19] "Cézanne appears to be a fantasy," declared the critic André Mellerio (who was soon to appear in the *Homage to Cézanne*) at precisely that moment. "Still living, he is spoken of as if he were dead." As if to make his point, a survey conducted in the prestigious *Mercure de France* on "Current Trends in the Plastic Arts" posed a number of questions to a cross-section of contemporary artists:

1. Do you feel that art today is going in new directions?
2. Is impressionism finished? Can it renew itself?

3. Whistler, Gauguin, Fantin-Latour . . . What do these dead painters matter? What do they leave us?
4. What do you make of Cézanne?
5. According to you, should the artist rely completely on nature, or merely ask of it the artistic means of expressing the thought that is within himself?[20]

Responses to the Cézanne question varied wildly. "Cézanne? Why Cézanne?" (Piet). "Cézanne? A fine fruit that leaves a nasty taste in the mouth" (Besnard). "Nothing to say about the paintings of Cézanne. The painting of a drunken cesspit emptier" (Binet). "What do I make of Cézanne? What the pagans and the heretics make of a dogma that is in their eyes completely incomprehensible" (Monod). "Cézanne's evident sincerity appeals to me; his clumsiness astonishes me" (Hamm). "Cézanne is a great artist lacking in education; his work is that of a man of genius, brutal and vulgar" (de la Quintinie). "Cézanne can apply thousands of the right tones—value and color—on a fruit, around a fruit, and it is with tones that he designs. In front of the nude, said a friend, *he sees crooked*" (Ouvré). "He is a very great master for whom a sympathetic group of artists profess the veneration due to the Originator" (La Rochefoucauld). "From the novelty and the importance of his contribution Cézanne is a genius. He is one of those who determine evolution" (Camoin). "A Cézanne still life . . . is just as beautiful a painting as the *Mona Lisa* or the two-hundred-meter *Paradise* of Tintoretto" (Signac).[21] Prinet's response constituted a lively summary:

Cézanne is the model battle painter, not the battle that he joins himself, but that which rages around his head among painters, critics, and dealers. A god to many of the young, the devil to the old; a powerful personality which dominates despite itself, and which crushes all its neighbors, a little like the rock crushing the statue. His best works are full of holes, his worst (they are execrable) never leave us indifferent. His breadth of form, his brightness of color impress, even when they tend towards the barbaric, which is often the case; when he catches a glimpse of beauty, that beauty is very real, but it is only intermittent, lapsing almost immediately into brutality. Nonetheless this is a demonstration of art that always remains great, even when that greatness is clumsily expressed. For some, that is all; for others, that is a lot, but they demand taste and judgment too; for the rest, in the end, it is nothing.

Cézanne is the most striking example of a gifted temperament and eye, at the service of an unskilled hand. An instinctive synthesis alone guides that hand. If he seduces so many of the young, it is because they like to take account of nothing but the gift; the old painters are too proud of their skills to like or understand him. He leaves behind him some powerful landscapes, a few figures, and some very beautiful falls of apples.[22]

The survey was widely noticed. Whenever they got together, Maurice Denis and Paul Sérusier used to raise a glass to the "drunken cesspit emptier."[23] Cézanne himself must have read it, if only because it was excerpted in his local paper, *Le Mémorial d'Aix,* with a note of congratulation to their native son, "too little known in Aix, too often underrated." Still living, he held his tongue. One year later, a postscript to his last letter to his son offered something very like a concluding reflection: "I think the young painters much more intelligent than the others; the old can only see in me a disastrous rival."[24]

His letter to Gasquet discloses something more—it has a strong affinity with one of the odes of Horace. This comes over most clearly in its sense of rectitude and renunciation, deeply felt, in tune with Horace's fundamental tenet: "I knew what I was doing . . . when I maintained my own low profile," he told his friend and patron Maecenas. He had declined an invitation from the emperor himself, to "come away from your table, where he accepts your favors gratis," as Augustus wrote to Maecenas, "to my palatial board and aid me in my correspondence." Refusing the emperor cannot have been easy, but Horace kept his distance. He abstained, as he said, spurning privilege and cosseting in order to continue working patiently on his odes, gathering from nature "like the bees."[25] Cézanne knew his Horace. He was "half my own soul," as Horace said of Virgil. His sympathetic appraisal of Zola's *Une Page d'amour* (1878) came complete with Horace's precept "*Qualis ab incepto processerit, et sibi constet*" (Let him proceed as he began, and so be consistent), a tribute to the characterization; and a number of witnesses testify to his quoting Horace by the yard.[26] The odes were part of his culture.[27] Resistance to the emperor was something Cézanne understood only too well; being cosseted was anathema to him. He was in many ways an exemplary Horatian, attending to the world as a surgery and not a party, as one commentator puts it, and learning its hard lessons—what cannot be had, what must be let go, the whole economy of desire and power. Was he thinking of Horace as he wrote his screed to Gasquet?

. . . Unarmed myself, I must
Desert the moneyed ranks to join the poor
Camp of the richly satisfied,

To be a lord of more than one who buys
And hoards the grain—the grain the peasant worked
So hard to cultivate—then stands alone,
A scarecrow, amid fertility.[28]

Gasquet read the letter in a state of bewilderment. Stricken, he dashed to the Jas. He found Cézanne keen to make amends. "Let's say no more about it. I'm an old fool. Sit yourself down. I'm going to paint your portrait [color plate 59]."[29]

Gasquet's consternation is easy to understand. Cézanne's letter seethes with emotion. Some of the expressions are heart-wrenching. One of the most poignant, "no longer my own master," was no mere form of words. Around 1890, Cézanne was diagnosed with diabetes. What exactly this meant for him is difficult to determine with precision. The first textbook in English on the subject, *On the Nature and Treatment of Diabetes* (1862), was produced by Frederick William Pavy, a physician at Guy's Hospital in London. Pavy saw hundreds of patients in private practice. He set about documenting the range of conditions associated with the disease. In 1885 he offered a description of diabetic neuropathy or nerve damage that is still cited with approval today:

The usual account given by these patients of their condition is that they cannot feel properly in their legs, that their feet are numb, that their legs seem too heavy—as one patient expressed it, "as if he had twenty-pound weights on his legs and a feeling as if his boots were a great deal too large for his feet." Darting or "lightning" pains are often complained of. Or there may be hyperaesthesia, so that a mere pinching of the skin gives rise to great pain; or it may be the patient is unable to bear the contact of the seam of the dress against the skin on account of the suffering it causes. Not infrequently there is deep-seated pain, located, as the patient describes it, in the marrow of the bones which are tender on being grasped, and I have noticed that these pains are generally worse at night.[30]

Pavy and other nineteenth-century physicians also described impotence as a common symptom, often the presenting one; and by 1890 a number of other

conditions were widely recognized. Diabetic nephropathy or nephritis (inflammation of the kidneys) was regarded as part and parcel of the disease. Diabetic retinopathy, which can lead to various forms of color blindness (notably blue-green) was also well-known, though opinion was divided on its etiology, some ophthalmologists claiming that it could be found in most people who had diabetes for ten years or more, others that it was virtually confined to older patients with arteriosclerosis (hardening of the arteries).

Whether Cézanne suffered from any of these conditions is highly speculative. No medical records survive, and he himself said very little about his diabetes, as such, though he certainly made no secret of it. He did mention "neuralgic pain" (as early as 1885), and a "much weakened nervous system" (as late as 1906), but his habitual complaint throughout the last years of his life was of "brain trouble" (*troubles cérébraux*), often linked to the heat of the day, which he found increasingly hard to bear.[31] This he experienced as disabling, or at least disorientating, insofar as it interfered with his *sensations,* especially the all-important *sensations colorantes*—a key phrase in his lexicon—and therefore interrupted his painting.[32] It was as if the signals to the internal (neural) receiving station were jammed. These transmission faults were intensely frustrating. They recurred; but they passed, and they very rarely stopped him working. Sometimes, it seems, he could work through them. Once he complained of "the state of his nerves," which prevented him from writing a long letter to his son, but not from going out *sur le motif* that afternoon. "I received your esteemed [letter] of . . . which I left in the country," he wrote to Bernard on another occasion. "If I delayed replying, it's because I find myself in the grip of brain trouble which prevents me from advancing freely. I remain in the grip of *sensations,* and, in spite of my age, committed to painting."[33] The commitment was absolute: it was the thing that sustained him. In the final analysis, painting was his greatest moral support.

He also lamented the failings of his sight. But the defects of which he complained were not necessarily diabetic; nor were they definite indications of a progressive deterioration. "I see overlapping planes," he told Bernard, "and sometimes straight lines seem to me to fall." Cézanne himself was tempted to link failing health or failing sight with failing work, meaning failing *réalisation,* or incompleteness. Revealingly, he talked in terms of his *optique* and its shortcomings—even its moral failings, *des vices de mon optique*—the retinopathy of vice and virtue. The eye, too, was in need of moral support. Sight was intimately related to self-mastery; for the artist, a good eye was essential to a good life.

Incontestably—I am very sure—a *sensation optique* is produced in our visual organ which makes us classify the planes represented by *sensations colorantes* as highlight, half-tone and quarter-tone. (Light itself does not exist, therefore, for the painter.) So long as you [we] pass inevitably from black to white, the first of these abstractions being a little like a support for the eye as much as for the brain, we flounder; we do not gain mastery—nor self-possession. During this period . . . we look to the admirable works that have come down to us through the ages, for comfort and support, like the plank for the bather.

Black is a color, as Braque once said, and peach black found its place on Cézanne's palette, but seeing or representing in black and white was the work of the devil.

So, old as I am, around seventy [actually sixty-six], the *sensations colorantes* that create light are the cause of abstractions that do not allow me to cover my canvas, nor to pursue the delimitation of objects when their points of contact are subtle, delicate; the result of which is that my image or painting is incomplete. On the other hand the planes fall on top of one another, from which comes the neo-impressionism that outlines [everything] in black, a defect that must be resisted with all one's might. But consulting nature gives us the means of achieving this goal.[34]

Bernard for one was inclined to regard such "failings" as willful negligence—willful ineptitude, as it has been called—and any attempt to correlate defective vision with defective painting seems utterly futile. The famous distortions cannot be explained away as a by-product of the diabetes. Nevertheless, knowledge of the diabetes was grist to the mill of "retinal maladies," Huysmans's pet theory. "A definite eye-case," he had said to Pissarro, a case of what he called "the monomanic eye."[35] Huysmans suggested knowingly that Cézanne himself admitted as much; and it is true that the onset or perhaps the diagnosis of the diabetes gave him fresh cause to worry about his sight and his way of seeing. One indicator of that concern was his preoccupation with a celebrated self-portrait by an illustrious predecessor, which he studied in the Louvre—peering at it myopically, perhaps. "Do you remember the beautiful pastel by Chardin, equipped with a pair of spectacles with a visor shading his eyes [color plate 27]? He's a crafty one, that painter. Have you noticed how, by allowing a plane of light to cross his nose at a slight angle, the values adapt

much better to the eye? Take a close look and tell me if I am not right."[36] He often spoke of crafty old Chardin, with his spectacles and his visor and his values, but he eschewed those props just as he scorned those remedies.

He submitted to the usual treatments of that pre-insulin age: dieting, massage, a battery of homeopathic remedies. Most importantly, he kept going. "One must carry on."[37] He carried on walking, and climbing, and crawling. When he took Bernard for a walk in the countryside around the Château Noir, in 1904, the younger man was amazed to find how agile he was among the rocks. In difficult spots, he would get down on his hands and knees, chatting away as he crawled.

Scientifically minded physicians could now measure the amount of glucose in the urine, which enabled them to monitor different treatments, specifically, different dietary regimes. According to the intensive testing done by Pavy, the only thing that cleared the glucose was "an animal diet" with little or no carbohydrate. Strict dieting for the diabetic was apt to be a dismal affair of gluten bread, bran muffins, or (Pavy's pride and joy) almond biscuits. Not surprisingly, Cézanne's dieting was rather more hit and miss in practice, despite the best efforts of his housekeeper to take him in hand. But he did go without bread. When the young poet Léo Larguier dined with him while on military service in Aix in 1901, Madame Brémond brought them some warm pâtés as a starter, from the renowned pâtissier in the town. It was explained to Larguier that on account of his diabetes Cézanne was not permitted the bread that was on the table; instead he had "a sort of diet cake, which was nothing more than a thin crust and which looked a little like a fragile piece of glazed pottery."[38] This he crumbled in a bowl of clear soup and ate with a spoon. Then they had chicken fricassée with mushrooms and olives, washed down with some *vin ordinaire*—a little too *ordinaire* for Larguier's eager palate. The old Médoc that sometimes made an appearance at dessert was evidently not on the menu on this occasion.

Unusually, Larguier was able to return the hospitality: in 1902 the Cézannes (all three of them) went to stay at his father's house in the mountains of the Cévennes. "It was the hunting season," Larguier remembered, "and the wild mushrooms, brown and orange-crimson, with their round, perfumed caps circled the ancient chestnut trees. At that time we had a local woman who knew how to prepare the game and to fry the mushrooms just right in smooth, rich olive oil."[39] Cézanne was in his element. Larguier dedicated some of the poems in his collection *La Maison du poète* (1903) to this Virgilian figure, with his luminous canvases, his high forehead, and his rustic clothes. The

solitary master poet leading his flock of disciples in "Le Maître" is easily recognizable.

> He dreams—smiling—that the divine Virgil,
> Satisfied with his work,
> Has come to pay him a visit.[40]

Larguier's surmise that Cézanne attached little importance to what he ate or drank was unwarranted. He ate and drank in character. The very idea of eating well at a spa (Vichy) pleased him inordinately. Ordering "a Château" from the wine waiter in a restaurant never failed to amuse him: a vintage Château-Lafite would be accepted with alacrity. Here was another routine. ("And now, a real Château!") Even as he painted the Château de Duingt on the opposite shore of Lake Annecy, he wrote to Gasquet that "it would take the descriptive pen of Chateau to give you an idea of the old convent where I'm staying."[41] This was his usual shorthand for Chateaubriand, whose *Mémoires d'outre-tombe* (*Memoirs from Beyond the Grave*) he knew well. He also relished the steak.

There were no airs and graces at table. In this respect Larguier was right. Chicken or preferably duck with olives was one of his chief delights. "Your father is coming to eat a duck with me next Sunday," he wrote cheerily to Émile Solari. "Done with olives (the duck, I mean). What a pity you can't be with us!"[42] The duck would be had at the Restaurant Berne, in Le Tholonet, a hamlet near Bibémus and the Château Noir, where Cézanne was a regular. (Someone from the restaurant would bring him lunch out *sur le motif*.) Madame Berne knew his tastes: duck, *bœuf en daube,* the first olives of the season. Cézanne loved olives, especially his own. They were harvested by Auguste Blanc, sent round for the purpose. When the harvest was good, a quantity would go to the Berne olive press; otherwise Blanc would hand them over to Madame Brémond, who would prepare them and dispatch some to Hortense and Paul in Paris. There was also the fennel soup and the baked tomatoes. Cézanne had simple tastes. Diet or no diet, his favorite dish was potatoes in oil. This was a far cry from Zola's palatial table.

The homeopathic remedies included Bryonia and nux vomica, both still in use. Cézanne seems also to have frequented the Maison Raspail in the Rue du Temple in Paris, purveyors of the renowned Bain sédatif de Raspail, the ingredients for which are itemized in one of his sketchbooks (ammoniac, camphorated alcohol, grey sea salt). Homeopathy was common enough in Cézanne's circle. Dr. Gachet favored such treatments. Pissarro kept a kind of homeopathic

bible in the house, often consulted; he and his children used the same remedies as Cézanne. During the last twenty years of his life Pissarro himself suffered from chronic infection of the tear sac of his right eye. One of the specialists he consulted was Daniel Parenteau, a leading figure in homeopathic therapy, whose *Leçons de clinique ophtalmologique* (1881) became a standard work.

Cézanne also had regular massages, to relieve the pain or to help the feeling in the legs. "Vallier massages me," he wrote to his son during the baking-hot summer of 1906, "the kidneys are a little better, Madame Brémond says that the foot is better. I'm following Boissy's treatment, it's horrible." A few days later:

I received your good letters of various dates fairly close together. If I didn't reply immediately, the reason is the prevailing oppressive heat. It considerably depresses the brain and prevents me from thinking. I get up in the morning, and it's only between five and eight that I live my own life. At that hour it becomes stupefying, and exerts such a strong cerebral depression that I can't think any more about painting. I've been obliged to call Dr. Guillaumont for I've been struck by an attack of bronchitis; I've given up homeopathy for a syrup mixture from an ancient school. I've been coughing a lot, Mother Brémond applied some cotton wool soaked in iodine, and it felt soothing. I regret my advanced age, for my *sensations colorantes*.[43]

So it seems that he did have kidney trouble of some sort, and apparently a painful, swollen right foot.

The tender facts of the massaging and the swabbing coexist with one of the most tumultuous tales of the legendary Cézanne: that he could not bear to be touched. Soon after they met, in 1904, Bernard had an experience which in some ways paralleled Gasquet's. Out walking one day, Cézanne lost his footing and fell backwards; Bernard tried to catch him. Cézanne flew into a rage, pushed him away, and ran off as if he had been molested. On their return, a puzzled Bernard attempted to apologize. Cézanne exploded. "No one will touch me . . . no one will get his hooks into me. Never! Never!" With that, he stormed into the studio and slammed the door. The refrain of "hooks into me" could be heard from within for some time. Bernard withdrew in confusion. Later that evening, as he was getting into bed, there was a knock on the door. It was Cézanne. He had come to see if Bernard's earache was better. He seemed to have forgotten the events of the day.

After a sleepless night, Bernard went to the studio at around eleven o'clock, Cézanne's lunchtime. He called up to the housekeeper to ask if the artist wished to see him, but before she could reply Cézanne himself shouted out, "Come, come, Émile Bernard!" Cézanne got up from the table to welcome him, saying, "Don't pay any attention, these things happen to me in spite of myself. I can't bear anyone to touch me; it goes back a long way."[44] According to Bernard, his explanation for this phobia was that he had once been kicked from behind by a boy sliding down the banister; since then he had become obsessed with the idea that no one should ever again commit such an outrage. If this account is to be trusted, one wonders if the tenderness associated with diabetic nerve damage was itself a contributory factor.

What to make of his talk of depression? Clinically, there is a well-established link between diabetes and depression. Having diabetes is depressing, especially if it ushers in other debilitating conditions. Managing diabetes is further depressing—the diet, the medicaments, the restrictions and prohibitions. Be that as it may, to infer that Cézanne was clinically depressed is quite another matter. Some of the gloomy thoughts and reclusive habits of the 1890s might suggest depressive tendencies, or simply moods or phases of the kind that he had come to terms with thirty years before. The sky of the future darkened periodically, as his friends used to remind him: he adjusted to that as he adjusted to changes in the weather. The diabetes and the ensuing complications may have made him more anxious or fractious, but these were passing clouds. Diabetic *inquiétude* is not a condition known to medical science. It might conceivably be an appropriate connection to make in Cézanne's case, if only to account for some of the heavy emphasis on that ineffable quality in various characterizations of him, but the suspicion remains that the *inquiétude* has been misunderstood. Cézanne was said to be *inquiet* rather than *névrose*: anxious rather than neurotic. *Névrose* was the term applied to the kind of psychiatric conditions being described by Freud (at that very moment); it was already in use in literary circles—*Les Névroses* (1883), a collection of poems by Maurice Rollinat, a disciple of Baudelaire, struck a chord with many artists. It was not a term applied to Cézanne.

Other terms were applied to him, willy-nilly, in these years. They were all variations on a theme. The kindest way of putting it was that he was not responsible for his actions. The most dramatic was that he had gone mad. As early as 1890—roughly coincident with the diagnosis of the diabetes—Pissarro heard from Murer who had heard from Guillaumin that Cézanne was in a madhouse. In 1896, after his contretemps with Oller, their mutual friend Aiguar, speak-

ing as a doctor, assured Oller that Cézanne was unwell, if not unhinged. Even Pissarro seemed to credit some of this. "What a shame that a man endowed with such a beautiful temperament should be so lacking in stability!" Lucien reminded him that Tanguy used to say that Cézanne was crazy, and that at the time they had put this down to Tanguy's lack of sophistication—perhaps he was right after all.[45] Clearly there was a good deal of gossip.

In fact he was not so much anxious as restless, temperamentally and intellectually.[46] Questing, perhaps, would be a better way of capturing it, or normalizing it; for he was more normal and less pathological than the traffickers in *inquiétude* are wont to imply. The eccentricity has been overdone. Too much has been made of Cézanne *outlaw,* as Edmond Jaloux put it.[47] Whatever the gossips might say, he was neither demented nor depressed. The salient thing about his condition was that he had purpose—moral purpose—he was *inquiet de vérité,* in Geffroy's phrase: hot for truth. "He is *inquiet,*" wrote Charles Morice, who conducted the survey of artists, "but only to know if his values are true, and the humanity in his paintings rests on the value of a value"—a pun on moral values and color values.[48] Cézanne was a Nietzschean revaluer of all values. It was entirely characteristic of him to write to Émile Bernard that he owed him the truth in painting, and that he would tell it to him; or to Charles Camoin that he would speak to him about painting more truly than *anyone,* and that *in art* he had nothing to hide.[49] Cézanne the revelator could do no other. His statements were a kind of gospel—"I am the way, the truth, and the life . . . "—the hottest gospel of the modern period.[50] Painting was truth telling or it was nothing. That was his quest. The only medicine he really took was a kind of truth serum. Cézanne's truth may be more important than Cézanne's doubt.

His emblematic words have exercised their own fascination. "The truth in painting is signed Cézanne," observed Derrida cleverly, in a work entitled *The Truth in Painting.* "Did Cézanne *promise, truly* promise, promise to *say,* to say *the truth,* to say *in painting* the truth *in painting*?" he asked, sounding a little like Gertrude Stein.[51] Rilke said that he did not paint "look at me" but "here it is." Truth telling meant *saying* rather than *judging.*

> What if we're here just for saying: *house,*
> *bridge, fountain, gate, jug, fruit tree, window*—
> at most: *column, tower . . .* but for *saying,* understand,
> oh for such saying as the things themselves
> ever hoped so intensely to be.[52]

Cézanne's truth was not to everybody's taste. "Take *The Boy in the Red Waistcoat* [color plate 65]," said Giacometti: "the proportion between the head and arm, which looks too long to some people, is nearer to the proportions in Byzantine painting than in all the painting since the Renaissance. You've only to look at it. It seems odd, you think it's elongated, as you think Byzantine paintings are elongated. But to my mind it is more real than any other painting." The characteristic clodhopper bather in "the compositions of big nudes" (the *Large Bathers*) reminded Giacometti of the Romanesque tympana in French cathedrals; he found them more "like" than the well-proportioned wenches of the schools.[53] Giacometti was not the only one. Modigliani kept a reproduction of *The Boy in the Red Waistcoat* in his pocket, producing it with a flourish in the course of an argument.[54]

Giacometti was a Cézannian by conviction. Samuel Beckett was another. After Cézanne's death Gasquet sold *The Mont Sainte-Victoire with Large Pine* to Bernheim-Jeune, for a handsome 12,000 francs. Some years later it found its way into the Courtauld collection. In 1934 it was on loan to the National Gallery in London, where Beckett saw it. "What a relief the Mont Ste. Victoire after all the anthropomorphized landscape," he wrote to his friend Thomas McGreevy.

Cézanne seems to have been the first to see landscape & state it as material of a strictly peculiar order, incommensurable with all human expressions whatsoever. Atomistic landscape with no human velleities of vitalism, landscape with personality *à la rigueur,* but personality in its own terms. . . . [Unlike] Ruysdael's *Entrance to the Forest*—there is no entrance anymore nor any commerce with the forest, its dimensions are its secret & it has no communications to make. Cézanne leaves landscape *maison[s] d'aliénés* [lunatic asylums] & a better understanding of the term "natural" for idiot.

A week later he pushed the insight further. "I do not see any possibility of relationship, friendly or unfriendly, with the unintelligible, and what I feel in Cézanne is precisely the absence of a rapport that was all right for Rosa or Ruysdael for whom the animizing mode was valid, but would have been false for him, because he had a sense of his own incommensurability not only with life of such a different order as landscape but even with the life of his own order, even with the life . . . operative in himself." Beckett was trying to understand what he hoped to achieve and how art could help him. Cézanne was the

route to self-knowledge, as J. M. Coetzee has underlined. "Herewith the first authentic note of Beckett's mature, post-humanist phase is struck." Beckett became Beckett by arguing with Cézanne from beyond the grave: Cézanne *d'outre-tombe,* as he might have said.[55]

Psychologically and meteorologically, Cézanne always had his eye fixed on the morrow. Every evening, he would go to the window and consult Madame Brémond (in Provençal) about the weather: "*Hé, demain, qué temps?*" Often he would get up in the middle of the night to have another look. Sometimes he had difficulty getting back to sleep; hence the nocturnal hand of cards with Hortense. His day began early. Getting up after five was indicative of sloth, as he wrote regretfully to his son. Despite the heat, and the brain trouble, he remained fully functioning throughout. He was never incapacitated, except for a fortnight in bed with the flu in January 1897.[56] He pushed on to the end, as he prescribed.

His search for solitude led him deep into his kingdom, yielding some of his most compelling work. Baudelaire wrote to his mother of the "good solitude" of Versailles and Les Trianons.[57] Cézanne might have said the same of Bibémus and Fontainebleau. The abandoned quarry enabled him to maintain his own low profile while he explored the structure of the landscape from within, as if descending into the underworld, during the campaigning seasons of the late 1890s. The rocks of the forest of Fontainebleau may have tempted him for similar reasons on his visits to Paris throughout that decade, and as late as 1905. Bibémus, in particular, inspired paintings rich and strange—none more so than the looming *Red Rock.* They have been interpreted, perhaps overinterpreted, as evidence of his preoccupation with mortality. *Mont Sainte-Victoire Seen from Bibémus,* another meditation on the near and the far, has prompted T. J. Clark to observe that "the view from Bibémus is at one level a view from the tomb." Following Clark, the

rock formations have been seen as a kind of funeral vault, or an evocation of "self-entombment."[58] On this reading, they are paintings of first and last things. They speak of a sense of failure—failure to find either a place or a formula.

If not mortality, then, melancholy: the invisible subject of these works is Cézanne himself, it is proposed, no longer Saint Anthony but Saint Jerome in the wilderness, like the Titian he admired so much. "Titian's *Saint Jerome* [1550–60] in Milan, with all his animals, his snail, his teeming rocks, is he an ascetic, a stoic, a philosopher, a saint? We don't know. He is a man. A venerable, white-haired man with a stone in his hand, all set to crack the secret, to strike a spark of truth out of the mysterious flint. That truth issues out of the whole russet color scheme of that clumsy painting. . . . There's a painter for you."[59] Contemplating *Rocks at Fontainebleau* (color plate 67), Meyer Schapiro asked the same question of Cézanne and answered: an ascetic. "This cavern space is the vision of a hermit in despair."[60] Schapiro borrowed suggestively from Flaubert; Cézanne was rereading Flaubert at the time. The evocation of the rocks and trees of Fontainebleau in *L'Éducation sentimentale* (1869) must have exercised a powerful appeal:

The track zigzags among stocky pines and beneath jagged rocks; this whole corner of the forest has something wild, oppressive and brooding about it; it makes you think of hermits, accompanied by giant stags bearing a fiery cross between their antlers, kneeling in front of their caves and welcoming the good old kings of France with a fatherly smile. . . .

In their diversity the trees offered an ever-changing scene: the smooth white-barked beeches with their round, interlacing, leafy tops; the gently flexing sea-blue branches of the ash trees; the bushy hollies standing like bronze figures in coppices of hornbeam; a row of slender silver birches drooping in elegiac poses; and the constantly swaying pines, as symmetrical as organ pipes, seemed to be singing. Huge rugged oaks writhed as they strained upwards from the earth, clasped together, rock-steady on their torso-like trunks, their bare arms hurling despairing appeals and furious threats at each other like a group of Titans frozen in anger. Over the stagnant pools hemmed in by brambles, there hovered something more oppressive, a sickly miasma; their lichen-covered banks where wolves come to drink were a sulphurous yellow, as though scorched by witches' footsteps; the endless croaking of frogs echoed the cawing crows circling overhead. Finally, they'd drive through monotonous clearings planted with the occasional sapling. There was a clanging of steel on

rock. Halfway up the slope a gang of quarrymen were battering away at boulders. More and more of them appeared, until in the end the whole landscape was nothing but rocks, cube-shaped like houses or as flat as flagstones, propped up against each other, blending together or overhanging one another like monstrous, chaotic ruins of some vanished city no longer recognizable; but their very wildness suggested, rather, volcanoes, floods and huge unknown cataclysms. Frédéric would say that they had been there since the beginning of time and would remain like that until it came to an end; and Rosanette would turn away declaring "this would drive her out of her mind."[61]

Could he paint that? Perhaps he could.

Chaos and cataclysm in these works may have been overplayed, but melancholy and mortality were not far away. His mother was dying.

After abandoning the portrait of Geffroy and returning to Aix, in July 1895, Cézanne wrote to Monet: "I am with my mother who is growing old, and she seems frail and alone."[62] He spoke no more than the truth. His mother was a shadow of her former self. In 1895 she turned eighty-one. She seemed to have shrunk; she could hardly walk; she was increasingly isolated. Cézanne adjusted his routine accordingly. He would work at Bibémus or the Château Noir by day, setting off at the crack of dawn, coming back in the evening to have supper with his mother at her house in the Cours Mirabeau. He organized outings for her by horse-drawn carriage; he would take her to sit in the sun at the Jas, or to watch the world go by along the *petite route* to Le Tholonet. Their coachman, Baptistin Curnier, remembered him picking her up, delicately, carrying her from the house to the carriage, and from the carriage to her chair. He ministered to her with great patience, keeping her amused with a fund of little stories. He made a tender drawing of her, sleeping peacefully in an armchair with a suggestion of his father's papal throne, attended by apples.[63]

She died on 25 October 1897. The deathbed portrait was done by Ville-vieille.[64] Two days later the funeral service was held at the Church of Saint-Jean-de-Malte. Cézanne was not present for the interment. He had returned to the solitude of his *motif*. "That pierced me like an arrow," confessed Rilke, "like a flaming arrow."[65]

At her death, Anne Élisabeth Honorine Cézanne, née Aubert, appears to have left nothing in her own name. No date was set for any *déclaration de succession*. A certificate indicating that the deceased possessed no property was issued on 24 June 1899. The succession was still governed by the disposi-

tions made by Louis-Auguste and ratified after his death in 1886. In particular, the Jas de Bouffan remained *indivisum*, jointly owned by his three children. While Élisabeth was alive, this arrangement could not be disturbed. After her death, latent tensions quickly surfaced. By all accounts it was Rose Cézanne's husband, Maxime Conil, who insisted on putting an end to joint ownership, effectively forcing a sale, in order to realize his share of the estate. On 8 September 1899 a deed drawn up by the family notary, Maître Mouravit, terminated the agreement. Ten days later the Jas was sold at auction to Louis Granel, for 60,000 francs. In a further twist, Granel was overbid by Marie Cézanne, a maneuver formally denounced by her brother and sister. The sale was rerun. On 6 November 1899 Granel eventually succeeded in buying it, for 75,000 francs. The following month Conil supplemented his share of the proceeds by selling a couple of Cézannes on the side: two views of his own property (strictly speaking, his wife's property), *House and Pigeon Tower at Bellevue* and *The Pigeon Tower at Bellevue,* given to him by the artist. He offered them to Vollard, who coolly informed him that he did not consider them very polished, and that in any event he preferred still lifes and flower pieces. In the circumstances, however, he would be prepared to take them off his hands for 600 francs. Conil had met his match. The deal was done.[66]

The disposal of his father's house (and with it his murals) was a traumatic experience. According to Rougier, who knew Cézanne well, "when the Jas de Bouffan was sold at the insistence of his brother-in-law who wanted the estate to be settled—Paul was very upset by the sale—he removed the frames and burned all the canvases [stored there]: a huge quantity, mostly early work, painted with the knife. . . . Perhaps he burned them because he was afraid that he'd find them in the market selling for thirty sous, as had happened several times before with the sketches that his brother-in-law had first used to decorate his apartment, and then sold."[67] Joachim Gasquet recalled another bonfire:

> When he had to agree to the sale of the Jas, a family arrangement, agreed by his sisters, I remember his uncertainty, his struggles and his despair. Above all I remember his pitiful arrival, one evening, his mute expression, the sobs that prevented him from speaking, and the sudden tears that brought relief. Without warning, at dusk that day, while he was painting, they had stupidly burned the old furniture that had been religiously preserved in his father's room.
>
> "I would have taken them, you know. They didn't dare sell them, they

had a problem. Dust traps, worthless things! So they burned them, in the back garden . . . in the back garden!"

In spite of himself he reconstructed the scene in his mind's eye.

"And I, who treasured them like nothing else in the world. . . . That armchair in which Papa had his nap. That table, at which he did his accounts all his life. Ah! He didn't miss a trick, not him, to provide me with an income. Tell me, what would have become of me, without that? You see what they do to me. Yes, yes, as I told Henri, your father, when you have a son who is an artist, you must provide him with an income. You must love your father. Ah! I shall never love enough the memory of mine. I didn't show him enough. . . . And now they've burned all that was left to me of him."

"His portraits? At least his portrait remains."

"Ah yes . . . his portrait. . . ."

And he made that gesture of supreme indifference that ennobled him with such magnificent humility, whenever anyone spoke of his canvases.[68]

The story of the immolation of his father's effects by his sisters bears some resemblance to the story of the immolation of his mother's effects by his wife, both precipitated by the sale of the Jas. "If only I had an indifferent family, everything would have been for the best." His perennial cry.[69]

Cézanne was a displaced person, though not exactly a homeless one. He found an apartment on the upper floors of a house in the Rue Boulegon in Aix, once the address of his father's bank. Hortense and Paul would stay there for a few weeks at a time, before decamping to Paris.[70] In that modest abode he built a small attic studio, which may have reminded him of his setup at the Jas. This served well enough for a while, especially when he was out and about *sur le motif,* but it was by no means ideal. On 16 November 1901 he purchased from Louis Bouquier, for 2,000 francs, "a small rural property partly enclosed by walls, located within the bounds of Aix, in the district called Les Capucins or Les Resquihado or the Hospital, comprising an old building with some land laid out in orchards, olive trees and fruit trees, the whole covering a surface area of approximately 6,000 square yards [1.2 acres], bounded to the east by the Chemin des Lauves [now the Avenue Paul-Cézanne], to the north by Girard, to the south and west by the Canal du Verdon."[71]

The property was on a hill north of the town, known as Les Lauves. In Cézanne's day it still had a rural air. The olive trees were then the main

plantation—eighty of them, killed by the great frost of 1956. Bouquier used to shoot birds and lay traps. Cézanne would allow no such thing, forswearing the hunter-gatherer games of his youth. His relations with his neighbor Séraphin Girard were very cordial, even when Cézanne took a detour through Girard's land to reach his own, climbing over the boundary wall, whenever he forgot the key to his front gate (a frequent occurrence). They spoke in Provençal. Cézanne appeared "rather withdrawn and *toujours inquiet*." He kept to himself and did not attract much attention; according to Erle Loran, who knew him, Girard thought Cézanne was "unbalanced." Through the pine grove he could see the artist at work in the studio. He was never invited in.[72]

The sheltered, south-facing hillside afforded a fine view of Aix, dominated by the Cathedral of Saint-Sauveur, and beyond it a panorama of the country he called his own. It was here that he built his last studio, the Atelier des Lauves, a redoubt, a workshop, and a place of pilgrimage.

Cézanne had a certain idea of what he wanted. "I've had a studio built on a little plot that I bought with that in mind," he told Vollard in April 1902. "So I'm pursuing my researches, and will keep you apprised of the results, as soon as my work offers me a trace of satisfaction."[73] He engaged an architect, Mourgues, and a master mason, Viguier. The architect apparently proposed a building with more refinements or embellishments than the artist was prepared to accept. An ornate balcony with French windows came to nothing; manufactured clay moldings and various other appurtenances were removed by Viguier at Cézanne's behest. Together with the planting, the landscaping, and the terracing, the cost of the project has been put at 30,000 francs (an unreliable estimate). The building itself was insured for 12,000 francs in January 1902.[74] What emerged was a functional design and a classical look, with simple pediments, Provençal roof tiles, local stone, and exterior walls the color of Bibémus sandstone.

On the ground floor was a little entrance hall, two medium-sized rooms, a toilet, a kitchen, a cramped pantry. One of the rooms served as a bedroom, the

other as a dining room. Most of the upper floor was taken up by the studio itself, a large, airy room eight meters by seven (twenty-six by twenty-three feet), and over seven meters from floor to cornice. Its walls were painted pale gray; it had a plain pine floor. Two south-facing windows looked out over the lower garden, and beyond. The north-facing studio window was a great glass wall, three meters high and five meters wide (ten by sixteen feet). The terracing of the hillside brought the olive grove in the upper garden to the level of the windowsill; Cézanne complained of the green reflections. "You can no longer get anyone to do anything right. I had this built here at my expense and the architect would never do what I wanted. I'm a shy person, a bohemian. They mock me. I haven't got the strength to resist. Isolation, that's all I'm fit for. At least that way no one would get his hooks into me." He also complained

of the red reflections from the tall chimney of the house opposite in the Rue Boulegon.[75] Distracting reflections were like barking dogs: *les sacrés bougres.*

Next to the studio window, unobtrusive in a corner, was the most intriguing feature: a narrow slot in the wall, some three meters tall, equipped with a metal shutter, a little like a giant, vertical letter box, allowed huge canvases to be passed through—and posted to the world. Great artists live their lives in long cycles. Cézanne had dreamed of painting on a grand scale for thirty years.[76] In the construction of the Atelier des Lauves, ambition was woven into the fabric of the building.

The studio was his sanctuary. To be invited in was a rare privilege. One of the first to see it was Jules Borély, the young archaeologist who succeeded in drawing him out on everything from Monet's eye to Zola's escapade, and even his own versifying.

We arrived at the house. He pushed open the door and offered me one of the white wooden chairs left on the terrace under the pale acacias. He put down his bag, his paint box and his canvas, and came to sit near me looking out at the view. Beyond a mass of olives and withered trees, the town of Aix appeared, in the mauve light, framed by the surrounding hills, cerulean, floating. Cézanne stretched out his arm to measure the bell tower of the Cathedral between thumb and index finger. "How little it takes to distort this thing," he said, "I try my best and it's quite a struggle. Monet has that abundant talent, he looks and, straightaway, draws in proportion. He takes it from here and puts it there; that's what Rubens did."

We went up to the studio, as I had begged. I found a high, wide room with bare walls, devoid of life, its picture window opening onto an olive grove. There, like sad captives, were two easel paintings. A band of young nudes, white bodies against lunar blues. A peasant's head under a poacher's cap: the face yellow, with ultramarine eyes.

We came back out into the garden. In the hall I noticed in passing among twenty watercolors, blue and green, thrown carelessly on the floor, the study that Cézanne had just brought back. You could see a sky streaked with apple green. . . .

We sat down to talk some more of Monet, Renoir and Sisley.

"Unlike Monet," said Cézanne, "Renoir doesn't have a consistent aesthetic; his genius makes it difficult for him to find a way of working. Monet sticks to a single vision of things; he gets where he's going and

stays there. Yes, a man like Monet is fortunate; he reaches his beautiful destiny. Woe betide the painter who fights too much with his talent: perhaps one who composed some verses in his youth. . . . "

Saying this, he sighed, then began to laugh, looking out over the valley, and completed my confusion by adding: "Painting is a funny business." Then he turned and got up, and said softly, "I lose myself in strange thoughts." He pulled himself together and said, "I'm going to take the chairs in, because the damp at night ruins the straw. Do you ever catch yourself thinking how foolish it is to squander what we have?"[77]

After his father, and then his mother, there was no end to the departed—Emperaire in 1898, Marion and Valabrègue in 1900, Alexis in 1901, Roux and Zola in 1902, Pissarro in 1903. "My heart is becoming a necropolis," wrote Flaubert. Nevertheless, until the last few months of his life, Cézanne was not totally bereft of old friends. Solari's passing in January 1906 must have been a heavy blow. Henri Gasquet followed two months later, leaving only his portrait (retained by the artist). Meanwhile the intelligent young filled a gap. In the heyday of their association, Joachim Gasquet had the privilege of accompanying him as he revisited old haunts and old memories. Gasquet, too, dined at Le Tholonet, while Cézanne reminisced. "What beans and potatoes we've eaten in this dugout!"[78] He still identified with Meliboeus, the deserted shepherd in Virgil's *Eclogues,* who was eventually reunited with his soul mate, Tityrus, after a long separation; but only for one last meal.

Yet surely you could rest with me tonight and sleep
On a bed of green leaves here? You're welcome to taste my mellow
Apples, my floury chestnuts, my ample stock of cheese.
Look over there—smoke rises already from the rooftops
And longer fall the shadows cast by the mountain heights.[79]

His soul mate was on his mind. "He used to go there in the old days with Zola. It was the country of *La Faute de l'Abbé Mouret,* sparkling soil, red mounds of earth, the marble quarries of Les Infernets, the old Roman dam near the Château de Galifet, 'the little sea,' as they called it in Aix, where the engineer François Zola [Émile's father] had collected the water for his canal, the length of a huge wall enclosing an entire valley. The mountain, now massive and overwhelming, now fluid and crystalline, gilded by the setting sun, dominating everything."[80]

But Zola was gone. Did he yearn for a substitute or successor? Possibly there was a moment when he thought that Gasquet might serve. "Ah! If only I'd known you in Paris," Cézanne said to him once. "But when I had need of you, you were in the process of being born." A few years later he may have entertained similar thoughts about Bernard or Camoin or Larguier. "It's a man like you that I need," he would say to Camoin, repeatedly, without elaboration.[81] As late as 1906, he ended a letter to his son with a "bonjour to Maman and to anyone who still remembers me. Bonjour to Madame Pissarro—how far away it all seems and yet how near."[82] The problems of the near and the far were not confined to the canvas.

For want of men, there were trees. According to Gasquet, "he had no real friends except trees." Rilke spoke to his condition:

And so I check myself and swallow the luring call
of dark sobs. Alas, whom can we turn to
in our need? Not angels, not humans,
and the sly animals see at once
how little at home we are
in the interpreted world. That leaves us
some tree on a hillside, on which our eyes fasten
day after day; leaves us yesterday's street
and the coddled loyalty of an old habit
that liked it here, stayed on, and never left.[83]

After his death, Ravaisou composed a perceptive tribute, drawing on his own experience of watching Cézanne at work and listening to him talk:

Cézanne is perhaps the most precise and realistic of contemporary painters. The intermittent romanticism of his style is a splendid garment he uses to dress up the nakedness of his impressions. He makes use of very simple notations. Instead of breaking down the harmonies of the light values that give the sky its blue color and depth, for example, he contents himself with pinning down, without analyzing it, what he calls a blue sensation, and this sensation is transferred through his brush without losing any of its liveliness or power. He preserves what is immaterial of the atmosphere, thus carrying further than any other plein-air painter the art of expressing abstractions. But these abstractions reside in the character of the represented objects, and, in this case, by character one can only

mean the amount of truth that the artist's eye has extracted from these objects. Thus there is only an apparent contradiction between the word abstraction and the word realism; it is actually impossible for a painting to be truthful if it seeks only to imitate the model. To copy nature is foolish; we do not copy air or movement or light or life. That was Cézanne's opinion. His portraits, landscapes, still lifes, and nude studies also attest as much to the stability of his style as to the constancy of his sincerity.

In other respects, he was a sensualist in art. He loved nature with a passion, perhaps to the exclusion of all else; he painted in order to prolong within himself the joy of living among the trees.[84]

There would be other trees, but his first love was the pine. For Cézanne, the pine itself was a *lieu de mémoire,* a memory place, redolent with mythology, packed with history, and charged with feeling. It had functioned as such in his earliest correspondence with Zola ("Do you remember the pine standing at the edge of the Arc . . . ?"); it is summoned again in his late work. Here again, perhaps, there was an element of projection. Just as he envied the equilibrium of Victor Chocquet, so he identified with the grandeur of the Large Pine of Bellevue. He first painted this tree around 1885, the painting "finished" by Schuffenecker. He returned to it some ten years later to create an intensely compelling work.

This *Large Pine and Red Earth* (color plate 69) is more than a tree: it is a personality. It is also a vision. Cézanne painted the treeness of the tree, as Kandinsky said. The branches are twisted or contorted; the foliage shimmers; the trunk itself has a tremendous presence—and a blue sensation, with a white plane as an appendage, organizing everything around it, as if in defiance of the interpreted world. The tree is at once well earthed and extraterrestrial, rising up out of the undergrowth of colored patches, which seem to float free across the canvas. Foreground, middle ground, and background blur; color ferries us near and far, here and there, without prejudice. In Cézanne's late landscapes, wrote Lawrence, "we are fascinated by the mysterious *shiftiness* of the scene under our eyes; it shifts about as we watch it. And we realize, with a sort of transport, how intuitively *true* this is of landscape. It is *not* still. It has its own weird anima, and to our wide-eyed perception it changes like a living animal under our gaze." Bridget Riley described it with a painter's eye: "The substance of form is dematerialized. Bushes, shrubs and undergrowth disintegrate—the blue of the sky comes down into the foreground as reflected light; earthy orange-yellows appear in the crown of trees; reds pull up a dis-

tant house, push down a patch of foreground. A whole new pictorial order is created."[85]

The Large Pine is untamed and untamable. The red earth moves. The vision is at once disturbing and alluring. Cézanne's pine is a painting to outdo Courbet's *Oak of Flagey* (1864).[86] Its boldness, its abstractness, and its expressiveness transfixed several generations. The discriminating Russian collector Ivan Morozov bought it from Vollard for 15,000 francs in 1908. Matisse's *Trivaux Pond* (1916 or 1917) is a homage to it. Ellsworth Kelly's *Meschers* (1951), depicting sky and water seen through the pine trees near the town of that name, on the banks of the Gironde, is an echo of it. *Meschers* is completely abstract, save for a single recognizable leaf, but there is a felt sense of affinity.[87]

At the studio, an olive tree became his friend. "When he had had a good session in his studio at Les Lauves," reported Gasquet, "he would go down at nightfall to stand outside his front door, watching the day and the town go to sleep."

The olive tree was waiting for him. He had noticed it immediately, on his first visit there, before buying the land. While the building was being done, he had a little wall put up around it, to protect it from any possible damage. And now the old twilit tree had an air of vigor and fragrance. He would touch it. He would talk to it. When he parted from it at night he would sometimes embrace it. . . . The wisdom of the tree entered his heart.

"It's a living being," he said to me one day. "I love it like an old friend. It knows everything about my life and gives me excellent advice. I should like to be buried at its feet."[88]

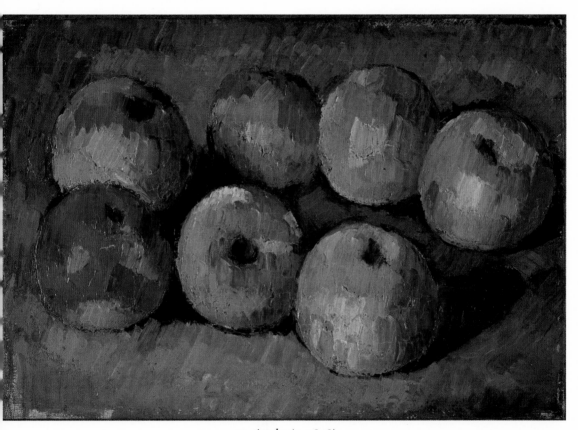

53. *Apples* (c. 1878)

54. *Self-Portrait* (c. 1895)

55. *Self-Portrait* (c. 1895)

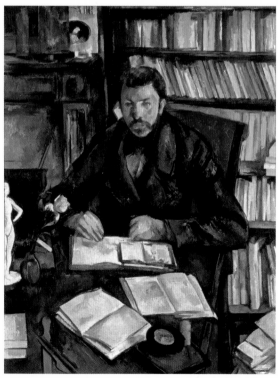

56. *Portrait of Gustave Geffroy* (1895–96)

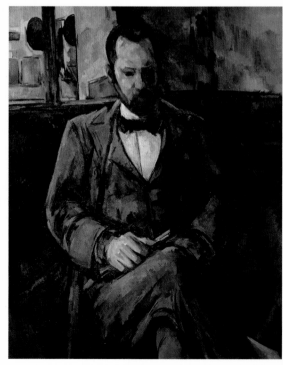

57. *Portrait of Ambroise Vollard* (1899)

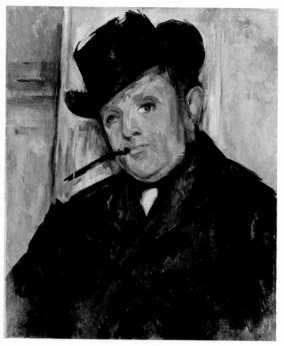

58. *Portrait of Henri Gasquet* (1896)

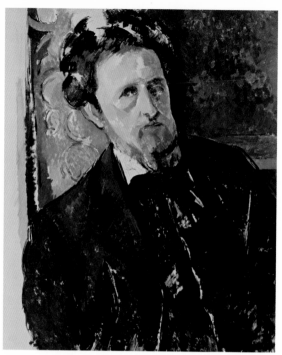

59. *Portrait of Joachim Gasquet* (1896)

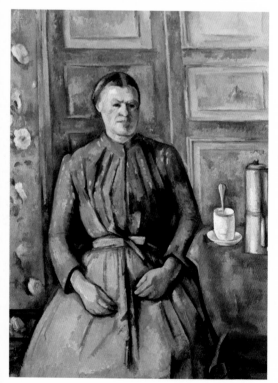

60. *Woman with a Coffee Pot* (c. 1895)

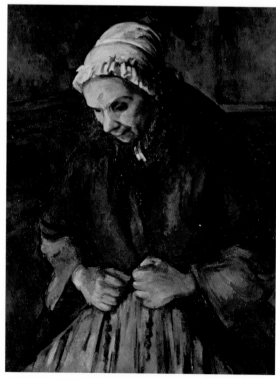

61. *Old Woman with a Rosary* (1895–96)

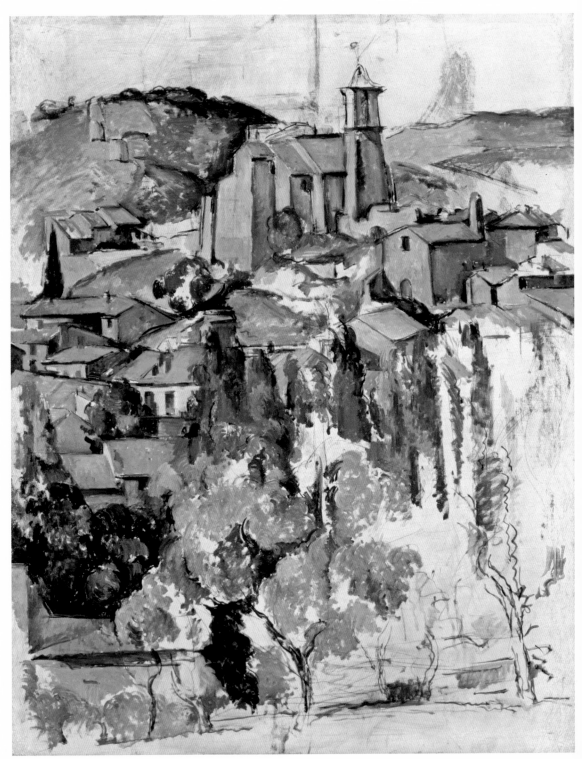

62. *Gardanne* (1886)

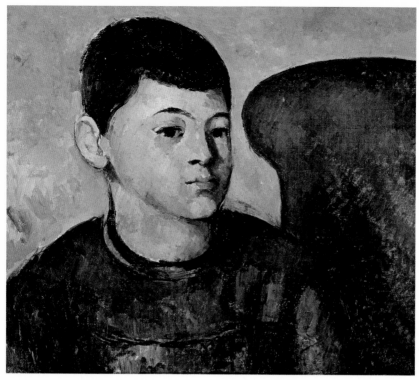

63. *Portrait of the Artist's Son* (1881–82?)

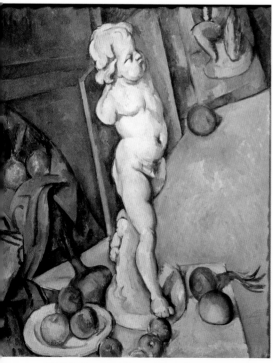

64. *Still Life with Plaster Cupid* (c. 1895?)

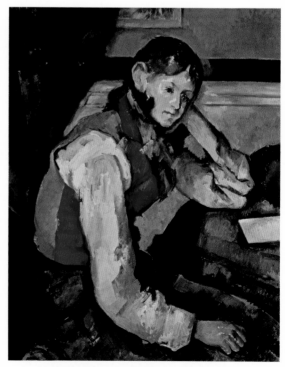

65. *Boy in a Red Waistcoat* (1888–90)

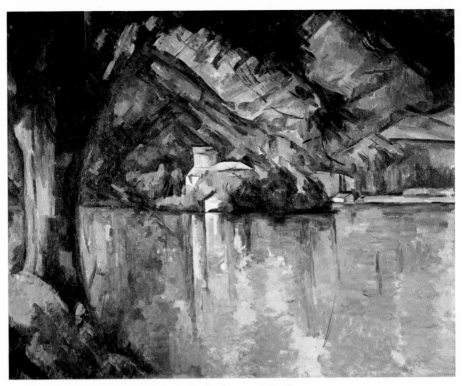

66. Lake Annecy (1896)

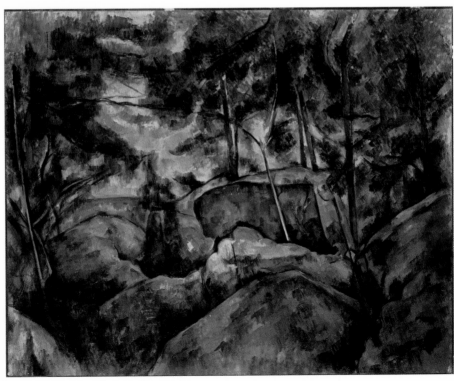

67. Rocks at Fontainebleau (c. 1893)

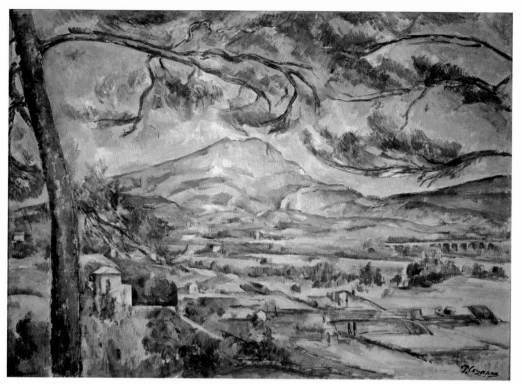

68. *Mont Sainte-Victoire with Large Pine* (c. 1887)

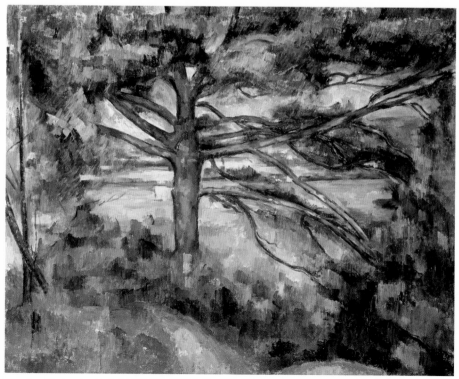

69. *Large Pine and Red Earth* (1890–95)

70. Maurice Denis, *Homage to Cézanne* (1900–01)

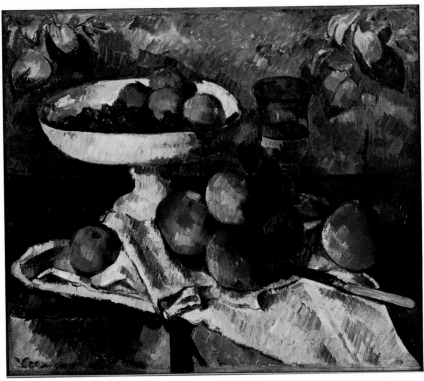

71. *Still Life with Compotier* (1879–80)

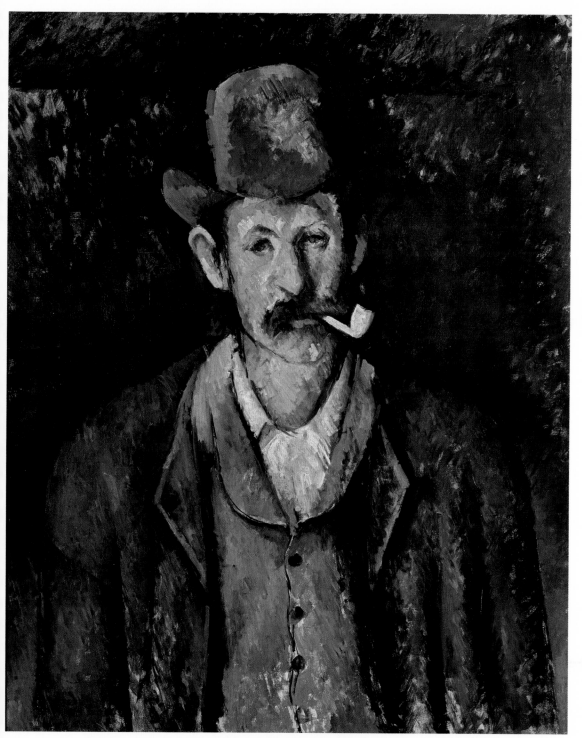

72. *Man with a Pipe* (c. 1896)

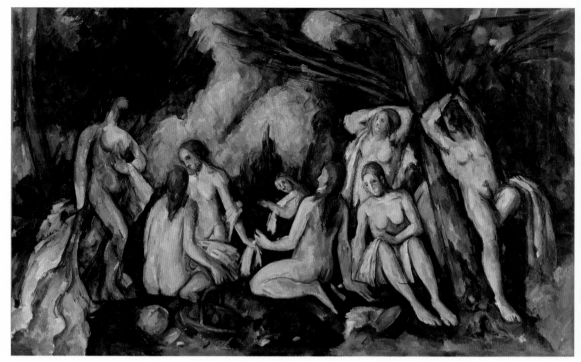

73. *Large Bathers* (1895–1906)

74. Jasper Johns, *Tracing after Cézanne* (1994)

75. Michael Snow, *Paris de jugement Le and/or State of the Arts* (2006)

76. *Bathers by a Bridge* (c. 1900)

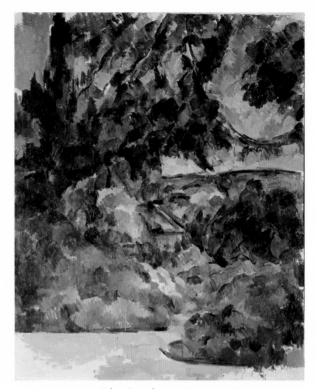

77. *Blue Landscape* (1904–06)

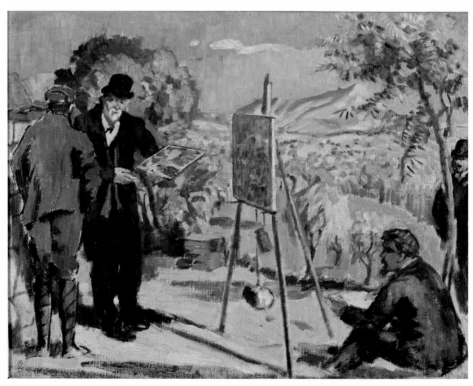

78. Maurice Denis, *Cézanne Painting the Mont Sainte-Victoire* (1906)

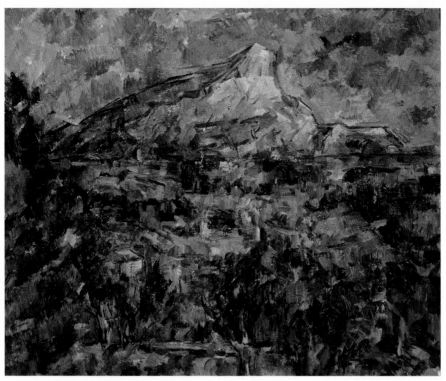

79. *The Mont Sainte-Victoire Seen from Les Lauves* (1904–06) [Moscow]

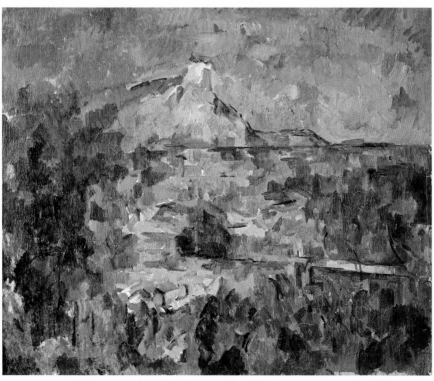

80. *The Mont Sainte-Victoire Seen from Les Lauves* (1904–06) [Basel]

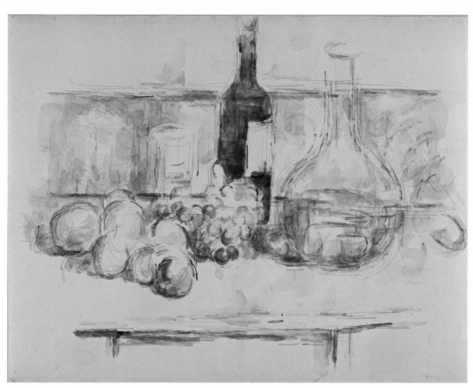

81. *Still Life with Carafe, Bottle and Fruit [Bottle of Cognac]* (1906)

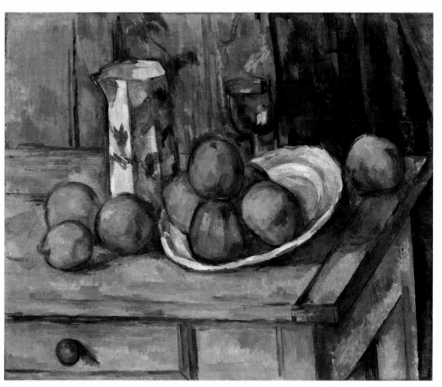

82. *Still Life with Milk Jug and Fruit* (c. 1900)

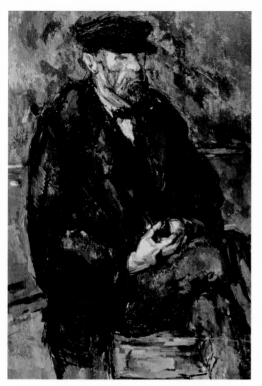

83. *The Gardener Vallier* (1902–06)

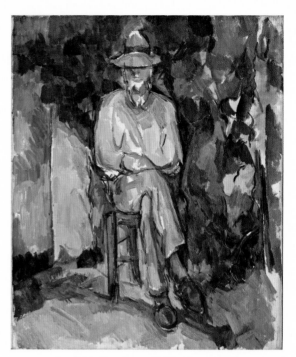

84. *The Gardener Vallier* (1905–06)

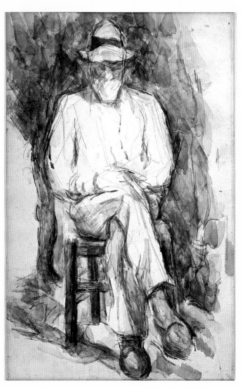

85. *The Gardener Vallier* (c. 1906)

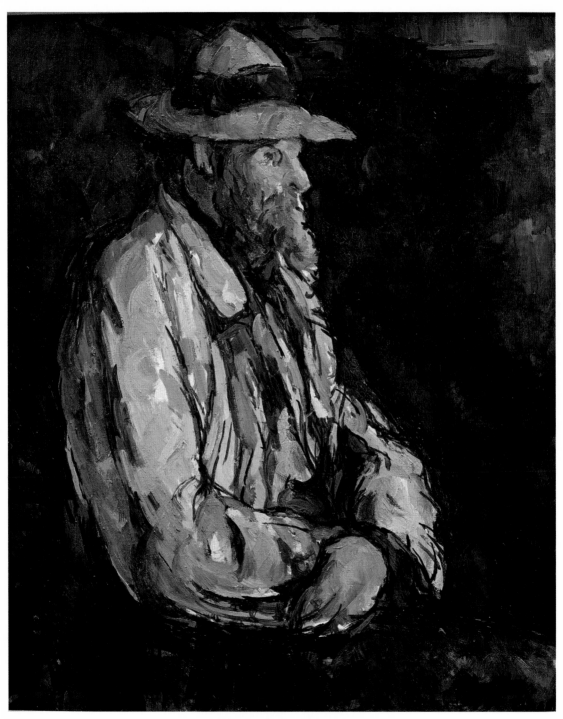

86. *The Gardener Vallier* (1906)

12: *Non Finito*

The new studio was a tonic. "I work tenaciously," he informed Vollard in January 1903, "I glimpse the Promised Land. Will I be like the great leader of the Hebrews, or will I be able to enter? . . . I have a big studio in the country, I'm working, I'm better off there than in town. I've made some progress. Why so late and so laboriously? Is Art really a priesthood that requires the pure in heart, who completely surrender themselves to it? I regret the distance that separates us, for more than once I would have turned to you for moral support."[1]

So emerged another projection or identification: the Moses syndrome, as Lawrence Gowing called it, "itself a feat of insight and consolation."[2] In his more pessimistic moods, Cézanne himself expressed it differently. "I remain the primitive of the way I've discovered," he would say, meaning the pioneer, the original.[3] In these moods he was too old, or time-expired, to complete the task. Such reflections may have been linked to the brain trouble, but they told also of a sense of dislocation, even alienation. In the best Nietzschean sense of the word, Cézanne was untimely. All his life, he seemed to bear a rather tenuous relation to his own time. In some respects he might have felt more at home in the classical period. Much of his work could have been made yesterday. Some of it is even now difficult to imagine. In the last ten years of his life he cut loose from his contemporaries with an almost ruthless abandon.

He appeared to live in a world of his own, yet he was painfully conscious of time running on and running out, and "the fruit merchant" could not but be aware of the idea of ripe time. "Time, by the way, is like the medlar," says F. M. Cornford; "it has the trick of going rotten before it is ripe."[4] This seems to speak to Cézanne's predicament. "I have perhaps come too soon," he remarked to one of Joachim Gasquet's circle. "I was the painter of your gen-

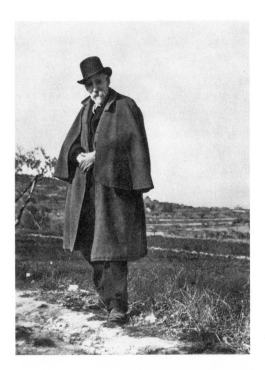

eration more than my own. You are young, you have vitality. . . . As for me, I'm getting old. I won't have time to express myself. . . . Let's get to work."[5]

Too soon or too late, he led the way. When he was persuaded to play the parlor game of "Confidences," his response to the final question about a phrase or saying that appealed to him was a quotation from Vigny's *Moses* (1828):

Lord, you have made me powerful and solitary.
Let me sleep the sleep of the earth.[6]

"If isolation causes the strong to falter," he reflected, "it is a real stumbling block to the waverers." But he was not ready to give up the ghost. "I confess that it is always dispiriting to give up life while we are on earth. Morally in solidarity with you," he wrote to Gasquet, "I shall hold out to the bitter end." Whatever happened, there would be no going quietly. "Painting to the end," he told Maurice Denis.[7]

That was the theme. "After all," wrote Rilke as he followed Cézanne's tracks,

works of art are always the result of one's having been in danger, of having gone through an experience all the way to the end, to where no one can go any further. The further one goes, the more private, the more personal, the more singular an experience becomes, and the thing one is making is, finally, the necessary, irrepressible, and, as nearly as possible, definitive utterance of this singularity. . . . Therein lies the enormous aid the work of art brings to the life of the one who must make it: that it is his epitome; the knot in the rosary at which his life says a prayer, the everreturning proof to himself of his unity and genuineness, which presents itself only to him while appearing anonymous to the outside, nameless, as mere necessity, as reality, as existence.[8]

Painting was the stuff of life. He sent Émile Bernard a magnificent last letter:

Mon cher Bernard

I find myself in such a state of brain trouble, trouble so great that I fear my feeble reason may desert me at any moment. After the terrible heat we've been enduring, a more clement temperature has brought a little calm to our spirits, and not a moment too soon; now it seems to me that I'm seeing better and thinking more clearly about the direction of my studies. Will I reach the goal which I've sought so hard and pursued for so long? I hope so, but while it is unattained, a vague state of disquiet remains, which can only disperse once I've reached the harbor, that is to say when I've realized something that develops better than in the past, and thus becomes proof of theories which, of themselves, are always easy; it is only demonstrating proof of what one thinks that presents serious obstacles. So I continue my studies. . . .

I always study from nature, and it seems to me that I'm making slow progress. I should have liked you beside me, for the loneliness always weighs on me a little. But I am old, and ill, and I have vowed to die painting, rather than sink into the degrading senility that threatens old people who let themselves be ruled by passions that dull the senses. . . .

Warm regards from the pig-headed old macrobite who cordially shakes your hand.[9]

Virgil's lessons on the destructive power of passion had been well learned. Plainly, feeble reason had not quit the scene. Nor yet wit—a playful valediction was always a sign that Cézanne was in good heart. Another letter was signed "*P. Cézanne, bête noire de Roujon.*" Octave Mirbeau had taken it upon himself to raise with the director of the Beaux-Arts, Henri Roujon, the question of a decoration for Cézanne: the Legion of Honor. On his own testimony, Mirbeau broached the matter with the utmost discretion. To no avail. Roujon became apoplectic:

"Cézanne? You said Cézanne?"

"Yes indeed. What do you think?"

"What do I think? What do I think?"

M. Henri Roujon, who would not manage to recover from such a dreadful shock, got up, banged his desk—a magnificent Louis XIV desk—and marched uncontrollably around the room, as if on the point of an epileptic fit, repeating:

"What do I think? You ask what do I think? Well, I think . . . what I would prefer . . . you understand . . . yes, what I would prefer . . . would be to decorate the assassin of Bourg-la-Reine [a certain Soleilland, condemned to death] . . . if I had known him. And how I regret at this moment not knowing him! Cézanne! Ah! Ah! Ah! Cézanne! Come on, out with it! Don't be embarrassed! You mean burning the Louvre, don't you?"[10]

"So institutes, pensions, and honors are only for cretins, jokers, and rascals," concluded Cézanne.[11]

Melancholic, diabetic, dogmatic, splenetic he may have been: nothing would stop him painting. The stubborn incantations of his last letters sound an increasingly Beckettian note. "You must go on, I can't go on, I'll go on."[12]

Moses went marching on. There was no letup in the ceaseless questing. "One is so alone in life that from time to time one feels the need to make something people like," Braque confided once to a discreet acquaintance.[13] Not Cézanne.

In January 1906 two more of the intelligent young, the painters Maurice Denis and Ker-Xavier Roussel, made the pilgrimage to Aix. They went first to the Jas, to worship at the source. Denis recorded in his diary: "At the Jas de Bouffan. Ornamental pond often painted by Cézanne, a magnificent salon, gilt furniture, consoles, Chinese objects, a Veronese, and, on the wall, some Cézannes, fiery, youthful, without much depth, the Christ (after Navar[r]ete) black, white and red, the Lancret severe and airless, a portrait of an emperor [Emperaire], two spirited heads. I thought of the ideas of Claude [Lantier] in Zola's L'Œuvre."[14]

From there they went to call on the artist in his apartment in the Rue Boulegon. It was a Sunday; he was at mass at Saint-Sauveur. They arrived at the cathedral just as he was coming out, clad in a gray-green coat and a paint-spattered suit, Lantier to the life, his hands dirty, his head bare. They introduced themselves. Denis was gratified to find that Cézanne remembered writing to him (to thank him for his *Homage,* when it was exhibited five years earlier), remembered even his affiliation to the journal *L'Occident* ("I read *L'Occident*!") and his address. They wanted to give some coins to a beggar. "*Satis* [enough]!" exclaimed Cézanne. "He's a drunkard. Drunkenness has its merits, but one shouldn't overdo it." Having had his weekly helping of the Middle Ages, he was evidently in the mood to talk.

Ah! The Middle Ages. Cathedrals have everything. I too liked Veronese and Zurbarán, but the seventeenth century, that's perfection! You were at the Jas de Bouffan. It's not much, but in the end it's painting. . . .

I look for the light—the cylinder and the sphere; I want to make black and white with color, to recapture the confusion of sensations. *La sensation* above all. . . .

For the painter, pride is everything. Even [Flaubert's] Mathô in *Salammbô* and the others don't compare. You have to have pride and not let it show too much, you have to be decent. But Gauguin had too much, he amazed me. Ah! Renoir? He's too stiff.

You have to have a method. My father, who was a fine man, people attacked him! My father would say: you have to play games. That's what I look for in painting. . . .

I am a milestone [*un jalon*], others will come who. . . . At my age, you dream of eternity.[15]

To their delight, he arranged to meet them again after lunch, out *sur le motif*. The rendezvous turned out to be a favorite spot, known locally as Les Marguerites, but subsumed under the general description of Les Lauves, about a half mile farther on (and farther up) from his studio. It commanded a magnificent view of the Sainte-Victoire. From the town, Cézanne would usually go there by carriage; from the studio, on foot.

So it was that Denis and Roussel had the extraordinary privilege of watching him paint. What is more, they were able to document the experience. Denis sketched the scene, later converting the drawing into a painting (color plate 78).[16] Roussel snapped him at the easel—a series of action shots, or rather suspension shots, unique in the record. Three of them have been published; they feature in the documentary film made by Jean-Marie Straub and Danièle Huillet, *Cézanne: Conversation with Joachim Gasquet* (1989), commissioned by the Musée d'Orsay, and then rejected as too idiosyncratic for their purpose.[17] In fact there are at least six. One of them shows Cézanne materializing out of the wall behind, in a felicitous double exposure. He organizes his brushes; he picks up his canvas, to position it on the easel; he attends to his palette; he considers the work in progress. The moment of truth has arrived. The next image captures him, palette in hand, brush poised (delicately fingered), body tensed, leaning into the task, looking intently at the world, before making his mark on the canvas, which leans forward to meet him, eager to converse.[18]

Non Finito

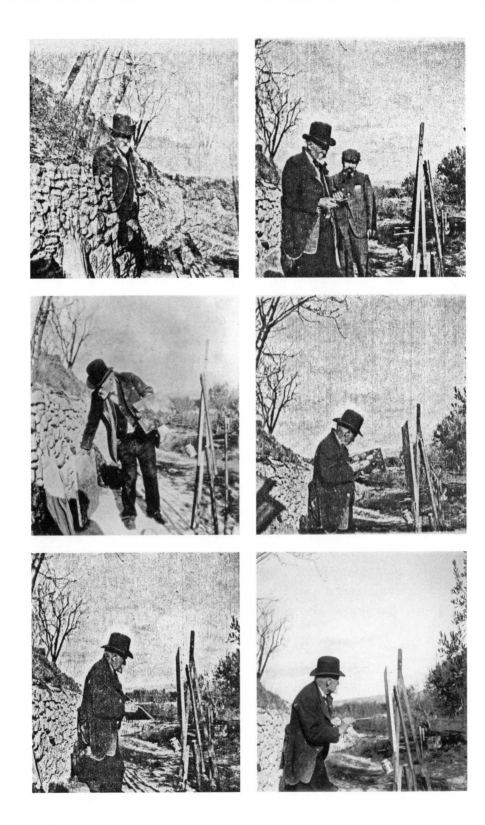

Sartorially, a slight change may be observed. The artist is dressed for work. He has taken off his coat and put on his Kronstadt hat; the paint-spattered jacket is torn at the seam, in the region of maximum strain, at the right shoulder; there is something like cotton wool in his ear. He is studying from nature and attending to his *sensations*. He is at one with Horace. They are the bees of the Invisible, as Rilke put it in a remarkable statement on his own project—a project steeped in the Cézannian. Rilke spoke the language of "vibrations," but Rilke's vibrations are closely related to Cézanne's sensations.

Nature, the things we move among and use, are provisional and perishable; but they are, for as long as we are here, *our* possession and our friendship, sharers in our trouble and our happiness, just as they were once the confidants of our ancestors. Therefore it is crucial not only that we do not corrupt and degrade what constitutes the here and now, but, precisely because of the provisionality it shares with us, that these appearances and objects be comprehended by us in a most fervent understanding and transformed. Transformed? Yes, for our task is to stamp this provisional, perishing earth into ourselves so deeply, so painfully and passionately, that its being may rise again, "invisibly," in us. *We are the bees of the Invisible. Nous butinons éperdument le miel du visible, pour l'accumuler dans la grande ruche d'or de l'Invisible.* [We frantically gather the honey of the visible, in order to store it in the great golden hive of the Invisible.] The [*Duino*] *Elegies* show us at this work, this work of the continual conversion of the dear visible and tangible into the invisible vibration and agitation of our nature, which introduces new vibration-numbers into the vibration-spheres of the universe. (For, since the various materials in the cosmos are only different vibration-rates, we are preparing in this way, not only intensities of a spiritual kind, but— who knows?—new bodies, metals, nebulae, and constellations.)[19]

Cézanne is frantically gathering. He is fervently understanding. He is passionately transforming. He is painting. This is it. The photograph records a dream, or a vision, of the exemplary artist-creator of the modern age, caught in the act. That singular image is Renoir's unforgettable sight, as recounted in Geffroy's seminal article, which Denis and Roussel surely read: "Cézanne at his easel, painting, looking at the countryside: he was truly alone in the world, ardent, focused, alert, respectful."[20]

Cézanne for his part seems to have enjoyed himself. Contrary to expectation,

he was remarkably loquacious. He talked and painted, painted and talked. His visitors were entranced. "He talks very well," Denis wrote to his wife that evening, "he knows what he's doing, what he's worth, he is unaffected and highly intelligent." Afterwards he took them to the studio, then to the apartment, then to a café, where they drank his health. By way of a thank-you, Roussel sent him a copy of Delacroix's journal, published in three volumes in 1893–95, a well-chosen gift. "Delacroix, above all," he had told them.[21]

So far from solving the puzzle, however, the mystery remains. "He takes his secret to the grave," Bernard remarked to his wife. "He wrote to me that he wanted *to tell me everything,* and I don't know what he meant by that."[22] The photographs are no help. A photograph is a secret about a secret, said the photographer Diane Arbus. The photographs of Cézanne painting are just that. "How does he do it . . . ?" A century after his death, Renoir's question is still unanswered, and perhaps unanswerable. Elizabeth Murray spoke for artists everywhere: "The thing about Cézanne is, you can't quite figure out how he did it. . . . You can look and look, and it looks very simple, but go home and try to do it . . . it's really magic."[23]

Typically, Cézanne is not daubing but *looking.* In Rilke's parlance, he is stamping the visible into himself. The camera has frozen, not the decisive moment when the mark is made, but the mythical interval between strokes. We are not privy to the application of the paint; we glimpse the application of the painter, as the painter himself glimpsed the Promised Land. Valéry called the poem a prolonged hesitation between sound and sense. We might call the painting a prolonged hesitation between mark and meaning.

"What was going on in Cézanne's mind during the famous endless minutes he sometimes spent between brushstrokes," we long to know, between one mark and the next? Would he have had any sympathy with Simone Weil's impulse "to see a landscape as it is when I am not there . . . "?[24] There was a certain logic to that. And yet, as the photographs show, he was always intensely present, his eyes glued to a tree trunk or a lump of earth, as he put it. "There's such a strong pull, it's painful tearing them away. . . . My wife tells me they pop out of my head, all bloodshot. . . . When I get up from the painting, I feel a kind of giddiness, an ecstasy, as if I were stumbling around in a fog."[25] It has been well said that his art exposes the process of seeing. At the core of the Cézannian revolution is a decisive shift in the emphasis of observation, from the description of the thing apprehended to the process of apprehension itself. Cézanne insisted that he painted things as they are, for what they are, as he saw them. The issue is what he saw—how he saw. "He never wanted to let the logic

of the painting take precedence over the continuity of perception," argued John Berger: "after each brushstroke he had to re-establish his innocence as perceiver."[26] But perceptual innocence was a chimera. Cézanne's late painting testifies to his recognition that fanatic attentiveness did not yield any greater clarity or immediacy. On the contrary, long fixation led to perceptual disintegration. The harder he looked, the more he became aware of dispersion, dissolution, destabilization . . . doubt. After 1900, as Gowing noted, "separable physical objects in Cézanne's work increasingly merge into the flux of color."

We cannot know what was going on in his mind, but of this we can be reasonably sure: things were in flux. Out *sur le motif* he mused on the fundamental. "All that we see dissipates and disappears, does it not? Nature is always the same, but nothing remains of what we see of it. It is our art that must convey the sense of permanence, capture the elements in all their changing forms. It should give us a taste of the eternal. What lies beneath? Perhaps nothing. Perhaps everything. Everything, you understand?"[27] Baudelaire's speculations on color may have given him some moral support. "Imagine a beautiful natural space where everything is greening, reddening, clouding, and shimmering in complete freedom, where all things are in constant vibration, variously colored according to their molecular constitution, changed from one second to another by the movement of shadow and light, stirred by an inner energy, that makes the lines flicker and fulfills the law of eternal and universal movement. . . ."[28] The struggle for *réalisation* embraced the molecular and the molar, the elemental and the eternal. This may be part of the process involved in coming to terms with his painting. *Réalisation* entailed defamiliarization. "Unlike the classical constructions of Renaissance perspective—which determine a single ideal viewing position from which the whole composition comes into focus—Cézanne's paintings project two distinct 'viewpoints'—nose-close and ten feet away—which are rigorously incommensurable and discontinuous, and which can never fold together in some unified hierarchical visual experience."[29]

Nose-close, the brushstroke is sovereign. In his bid to reconcile transience and permanence, Cézanne committed himself, body and soul, to the integrity of the brushstroke. The act of mark making was an act of faith in its transformative potential. Each stroke testified to an ongoing revision of intention. Intrinsic to the power of the painting is his willingness to show the working. Perhaps Gertrude Stein was onto something after all: "In this way Cézanne nearly did nearly did and nearly did."[30] He set out to paint nature-in-its-becoming before his bloodshot eye. The *non finito* is a metaphor for becoming.

All the while, the picture was taking shape inside him. "He was 'germinating' with the landscape," said Merleau-Ponty.[31] The brushstroke is not simply a record. It is a unit of experience: calibrated, targeted, cogitated, yet pulsing, vexing, responding to its neighbor like a rhythm or a beat. The building of the painting is both planned and extemporized. The sensations are in sync.

The brushstrokes are investigative, but also retentive. "As he makes his mark, the Rubens he forgets he knows is as important as the river he knows he is remembering."[32] The mark is a trace—a trace of history or memory. "What gives truth to a Cézanne is not the pseudo-likeness to the model," argued the director Eric Rohmer, "it is the trace it carries within it of the process by which the painter perceives it." Cézanne's brush was loaded with emotion. *Réalisation* touched on temperament, embracing the internal, or perhaps the intestinal, as he indicated in one of his last letters to his young friend Louis Aurenche: "In your letter you speak to me of my *réalisation* in art. I believe I attain it more each day, if a little laboriously. For if the keen sensation of nature—and I certainly have that—is the necessary basis for all artistic conception, on which rests the grandeur and beauty of future work, *knowledge of the means of expressing our emotion* is no less essential, and is acquired only through very long experience." The emotional element emerged fully only at the end of his life, "as if his demon had visited him (as it visited Socrates shortly before his death) and ordered him to drop all rationalist aspirations and realize his inner struggle in form and color as immediately as possible."[33]

These were high stakes. "At each stroke, I risk my life," Bresson has him say. Braque, too, underlined the extremity. "He risked everything—yes, even his life—each time he embarked on a picture."[34] That is what Cézanne meant to his successors.

When Allen Ginsberg discovered Cézanne, as a student in 1948–49, he got "a strange shuddering impression looking at his canvases, partly the effect when someone pulls a Venetian blind, reverses the Venetian—there's a sudden shift, a flashing." Ginsberg's expression for this was "eyeball kicks." The effect was produced, he thought, from the "space gaps" in the painting and the juxtaposition of the brushstrokes; it was enhanced by marijuana. The talk of juxtaposition was inspired by Erle Loran's arresting treatment of *Cézanne's Composition* (1943), a work recommended by his professor, Meyer Schapiro. Ginsberg was vastly impressed by this explication of Cézanne's method, "the juxtaposition of multicolored spots that created atmosphere and light."[35] The poet sought a verbal equivalent. He embarked on a period of intensive study and experimentation; he read Cézanne's letters until he could paraphrase them

from memory: "I'm an old man and . . . my senses are not coarsened by passions like some *other* old men I know, and I have worked for years trying to . . . *reconstitute* the *petites sensations* that I get from nature, and I could stand on a hill and merely by moving my head half an inch the composition of the landscape was totally changed."

Ginsberg was especially taken with Cézanne's reference to "the spectacle that the *Pater Omnipotens Aeterne Deus* spreads before our eyes." He felt that he had found the key to the eyeball kicks. Later he told an interviewer:

Everybody knows his workmanlike, artisanlike, prettified-like painting method that is so great, but the really romanticistic motif behind it is absolutely marvelous, so you realize that he's really a saint! Working on his form of yoga, all that time, in obviously saintly circumstances of retirement in a small village, leading a relatively nonsociable life, going through the motions of going to church or not, but really containing in his skull these supernatural phenomena, and observations, you know, and it's very humble actually, because he didn't know if he was crazy or not—that is a flash of the physical, miracle dimensions of existence, trying to reduce that to canvas in two dimensions, and then trying to do it in such a way [that] if the observer looked at it long enough it would look like as much as three dimensions as the actual world of optical phenomena when one looks through one's eyes. Actually, he's reconstituted the whole fucking universe in his canvases.[36]

In 1956 Ginsberg delivered himself of *Howl,* the last part of which he characterized as a homage to Cézanne, complete with quotations from the letters:

Who dreamt and made incarnate gaps in Time & Space through
images juxtaposed, and trapped the archangel of the soul
between 2 visual images and joined the elemental verbs
and set the noun and dash of consciousness together
jumping with sensation of Pater Omnipotens Aeterna
Deus[37]

Howl offered verbal juxtapositions, with "gaps" in between, for the mind jumping with Cézannian sensations. Ginsberg's favorite example was "hydrogen jukebox."

A few years later, in 1961, Ginsberg made a pilgrimage of his own. "Yes-

terday in Aix," he wrote in his journal, "comparing postcard Cézanne repro-
duction with Sainte-Victoire and measuring each brushstroke to a geological
epoch. Went to Avenue Paul-Cézanne & stole into his studio—the cracked
white hat & green cloak—(modeled in photos and paintings)—his skulls and
thighbone—rosary—wooden puppet in a drawer—his easel and palette & the
shining slippery polished wood floor of the vast room."[38] Ginsberg stood on
the very spot where Denis and Roussel had stood, half a century before: the
hallowed ground where the man communed with the mountain.

Cézanne painted at least eleven oils and nineteen watercolors of the
Sainte-Victoire on that spot, from the time he acquired his land in November
1901 until his death in October 1906. Most of these works probably date
from the last three years of his life—late works in which he is in dialogue with
his inner self, in the artist André Masson's phrase, regardless of convention
or expectation, poles apart from decorum. "The result is a sovereign free-
dom, that of the last quartets of Beethoven, the uncarved block of Zen monks.
Offerings to eternity."[39]

Late Cézanne is a conscious summation—"like a confession before nature in
which one man accounts for his creative power and his weakness"—at once a
set of radical simplifications and a densely populated ethical universe, painted
in "the style of old age" that has been characterized as a kind of *abstractism*
in which the expression relies less and less on conventional vocabulary, which
is finally reduced to a few prime symbols: a juicy blue on a blank sheet, a new
cosmos of color patches.[40] "It can even happen that the poet comes late to
birth in a man who, until then, was simply a great painter," says Valéry. "Rem-
brandt, for instance, after attaining perfection in his early works, rises, later on,
to the sublime level, to the point where art itself grows imperceptible, and is
forgotten: having attained its supreme object without any apparent transition,
its success absorbs, dismisses, or consumes the sense of wonder, the question
of how it was done."[41] As with Rembrandt, so with Cézanne.

Adorno's analysis of the late work "refusing to reconcile in a single image
what is not reconciled" speaks eloquently to Cézanne's late paintings.[42] These
works are unreconciled, and so was he. They often come in sequence—the
mountains, the bathers, the apples, the pots, the skulls—like the persistent
repetitions of Samuel Beckett. "All of old. Nothing else ever. Ever tried. Ever
failed. No matter. Try again. Fail again. Fail better."[43] They make demands on
the spectator. "The maturity of the late works of significant artists does not
resemble the kind one finds in fruit," as Adorno has it. "They are, for the most

part, not round, but furrowed, even ravaged. Devoid of sweetness, bitter and spiny, they do not surrender themselves to mere delectation."[44]

According to Brice Marden, he looked so hard at the mountain he made it disappear. Cézanne's sensations of the Sainte-Victoire are endlessly astonishing. The strokes become shreds; appearance is transmuted into apparition. Merleau-Ponty told Sartre that he was impressed by a line in Alfred North Whitehead: "Nature is in tatters." Merleau-Ponty's last testament, "Eye and Mind," was composed at Le Tholonet in the summer of 1960, in the shadow of Cézanne. "How, he says more or less, does that mountain in the distance announce itself to us?" wrote Sartre after his friend's death. "By discontinuous and, at times, intermittent signals, sparse, insubstantial phantasms, shimmering, shadowplay; this dusty thing strikes us by its sheer insubstantiality."[45] It was a sympathetic evocation. The paintings seem to suggest that there is more to see than we can at present see. "However often I dined out," Proust found, "I did not see the other guests, because when I thought I was looking at them, I was in fact radiographing them." Cézanne was doing something similar. "The copiable he does not see. He searches for a relation, a common factor, substrata." He excavates from within. "With art you go into your very selfmost straits. And set yourself free." Deep in his selfmost straits, Cézanne discovered a new world. "An original painter or an original writer follows the path of the oculist," says Proust. "Their painting or their prose acts upon us like a course of treatment which is not always agreeable. When it is over, the practitioner says to us: 'Now look.' And at this point the world (which was not created once and for all, but as often as an original artist is born) appears utterly different from the one we knew, but perfectly clear."[46] Such is the Cézanne world.

As far as we can tell from the photographs, when Denis and Roussel came to call, he was working on the stupendous offering acquired by Sergei Shchukin from Vollard, in 1911, and now in the Pushkin Museum in Moscow.[47] Of the many versions of *The Mont Sainte-Victoire Seen from Les Lauves,* the Moscow version (color plate 79), a very late work, has a degree of urgency and intensity unequaled in Cézanne's landscapes. "Chaos seems imminent," writes one authority.

> The exaltation of the struggle for any vestige of stability is rapturous. The agitation and density of the brushstrokes and the ridges of layered paint are extraordinary even for Cézanne's late work. Intense dashes of orange, seeded with vivid strokes of red, dominate the plain; over which also play

the sharp greens that gain the upper hand in the strip of meadow and trees in the foreground. Similar but less densely applied greens reappear in the sky amid purples and dark blues. There, against the white of the canvas showing through, the crisp strokes are more visible than they are in the foreground, where they seem smothered under thick pigment. In comparison to the cold, bright splendor of the sky and the foreboding darkness of the plain, the mountain seems extremely sensual. Opaque strokes of lavender, pink and violet sit among more transparent blues and greens. For all this encrustation and dark compression, this painting is neither a despairing vision nor Cézanne's Götterdämmerung. He has given it too much energy, too much passion.[48]

"In the history of art," says Adorno, "late works are the catastrophes."[49] The late Sainte-Victoires are Cézanne's catastrophes. "With Cézanne landscape itself comes to an end," proclaimed the artist Robert Motherwell in the 1940s.[50] Meanwhile the seeds of something different continued to germinate. The legendary avant-garde filmmaker Stan Brakhage set out to film, not the world, but the act of seeing the world. In 1969 he made *My Mountain Song 27*.[51] Cézannian inspiration takes many forms. According to the poet Anne Carson, in *The Beauty of the Husband* (2001),

Ray was no Mont Sainte-Victoire
but his curiously crystalline little body
did set up a wise and fleshy relation
between world and retina.
His world your retina.[52]

Photographs of Cézanne are rare but revealing. More famous still than the snap of him painting the Sainte-Victoire is the portrait of him sitting in front of an enormous canvas-in-progress in the studio. This photograph was taken by Émile Bernard, most probably in March 1904. According to Bernard, Cézanne had been laboring for a month on a painting of three skulls on an oriental rug. "What it lacks," he said, "is *réalisation*. I'll get there, perhaps, but I'm old and it may be that I'll die without having reached that supreme goal: to realize like the Venetians!" Then he took up his old lament: "I should like to be admitted to the Salon de Bouguereau. I know very well what the problem is, I just don't seem to get there. Optics has nothing to do with it."[53] The following year Bernard found the painting tacked to the wall, abandoned.

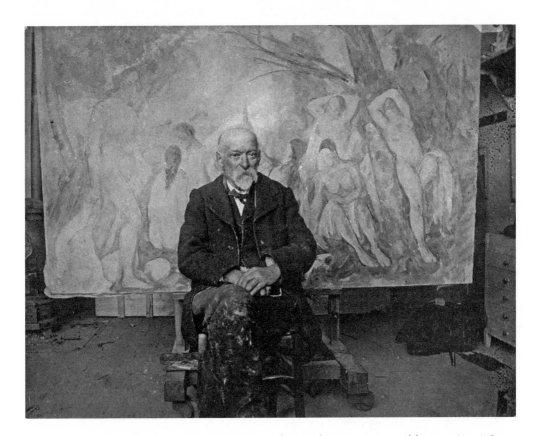

The other work in progress in the studio was impossible to miss. "On a mechanical easel that had just been set up, there was a big canvas of nude women bathing, which was in a complete state of chaos," remembered Bernard. "The drawing seemed to me rather deformed. I asked Cézanne why he didn't use models for his nudes. He replied that at his age one should refrain from stripping women in order to paint them; he might be permitted to address himself to someone of fifty or so, but he was pretty sure that he would not find anyone in Aix. He went over to some boxes and showed me the drawings that he had made at the Atelier Suisse in his youth. 'I've always made use of these drawings,' he told me, 'they're hardly sufficient, but at my age one must make do.' " Bernard wrote to his mother of this first acquaintance with the master: "He is an old man, unaffected, a little suspicious and strange. . . . I saw some of his paintings, among others a big canvas of nude women that is a magnificent thing, as much for the forms as for the power of the whole and the human anatomy. It seems he's been working on it for ten years."[54]

The canvas in question was one of the three *Large Bathers*. All three passed through Vollard's hands. Two were bought by Auguste Pellerin (and exhibited in the 1907 retrospective); one of these is now in the Philadelphia Museum

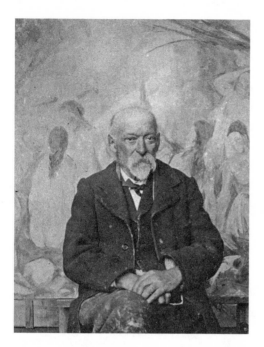

of Art, the other in the National Gallery in London. The third was bought by Dr. Albert C. Barnes and is now in the foundation that bears his name, together with dozens of other Cézannes. The canvas on the easel in the photograph is the Barnes painting (color plate 73). It is big—nearly one and a half meters wide and over two meters long (five by seven feet)—though the Philadelphia one is even bigger, as high as the Barnes canvas is wide, and half a meter longer.[55] If the Barnes painting is a diorama, the Philadelphia one is a cathedral. The sculptor Henry Moore recalled his first sight of it as one of the most intense experiences of his life: "What had a tremendous impact on me was the big Cézanne, the triangular bathing composition with the nudes in perspective, lying on the ground as if they'd been sliced out of mountain rock. For me this was like seeing Chartres Cathedral."[56] These were the canvases that Cézanne had in mind when he had the slot built in the studio wall.

Evidently Cézanne obliged Bernard by agreeing to pose for a photograph, which was rarer even than seeing him at work. His mien has been much studied. According to one recent commentator, "Cézanne's shy pride and discomfort registers . . . in his stately carriage," a fancy that may owe something to T. J. Clark's notion of the artist as "a sheepish and proud collaborator" in the image making. The same commentator goes on to posit a sort of double life (or double image): the "masterful, vigorous" Cézanne outside, *sur le motif*, and the "melancholic, diminished" Cézanne inside, in the studio.[57] This seems overdrawn, not to say far-fetched. In fact, for one who was not used to having his picture taken, Cézanne appears surprisingly composed, neither stately nor discomforted, but compact and catlike, in watchful repose.

The photography itself may have taken some time. Bernard took at least two different shots (possibly more, never recovered). The mise-en-scène is almost identical. Bewhiskered and bespattered in his working clothes, Cézanne sits on one of his wooden chairs, directly in front of the *Large Bathers*. He is dwarfed yet superimposed. One variant is not exactly a close-up, but is somewhat closer-to. The other reveals a little more of the paraphernalia of the stu-

dio beyond the canvas, at the margins of the print—the all-important stove, the debris on the floor, a wooden box, a chest of drawers, a coat rack—though these details are often cropped in reproduction. In the former, he is still talking; his mouth is open and he is not looking directly at the camera. In the latter, he calmly meets the camera's gaze. Here in his own habitat is the sublime little grimalkin himself, "small, timorous, yet sometimes bantam defiant, sensitive, full of grand ambition, yet ruled still deeper by a naïve, Mediterranean sense of truth or reality, imagination, call it what you will"—D. H. Lawrence's bravura description. "He is not a big figure. Yet his struggle is truly heroic."[58]

This small Cézanne became a talisman. All over the world, artists wedged that photograph in the corner of a mirror in the studio, or pinned it on the wall with the other icons: the battered postcards of Emperaire or Vallier, the still life, the Sainte-Victoire, and the yellowing reproductions of the *Large Bathers*.[59]

A year after the photograph was taken, he had more visitors. They found "a big painting of bathers with eight figures, almost life-size, on which Cézanne was still working." Their host was apologetic. "I hardly dare admit it," he told them, "I've been working on it since 1894. I'd like to be able to lay it on thick like Courbet." Courbet was "a real animal."[60] It seems clear that Cézanne continued to rework this painting until the end, and that the final reworking was a radical departure from the earlier states—radical enough to endow it with the capacity to disquiet, or possibly to embarrass, a capacity it retains to this day. The *Large Bathers* has a mystic potency.

Cézanne's *Bathers* have always been disquieting. Coping with the two other *Large Bathers* at the 1907 retrospective was too much for some. "Cézanne does not understand the human body and has not worked out its laws," complained Émile Bernard, the apostate. "He presses on innocently, weaving his patient logical strokes into forms that are illogical, because ignorant and baseless." Others went further. "Cézanne is everywhere at the Salon d'automne," wrote Remy de Gourmont. "Everywhere his raw earth greys and baked earth reds, his washed-out greens, his dirty whites; everywhere his women like rotting flesh"—the *Bathers* as carcasses, a touch of Baudelaire.[61]

The Barnes *Bathers* was still under wraps, which is perhaps just as well. In the period after Cézanne's portrait was taken, the painting went through further mutations. The grand design remained unchanged: a gang of six women, depicted so as to "establish a mirage of extraordinary self-sufficiency," flanked by two separate figures, differentiated from the rest anatomically and physiognomically.[62] But the bathers themselves were much altered. All of the figures in the painting loom larger in earlier states; they submitted to a process of

reduction and concealment. "My figures got too big," Cézanne told Denis, in 1906, as they stood in front of the painting, "so I reduced them by this much (a hand)." Here was an insight into the mysterious process of making. Denis reflected:

> What is most surprising in Cézanne's work is surely his search for form, or more precisely, his deformations: it is here that one discovers the greatest hesitations and *pentimenti* in the artist's work. The large painting of bathers left unfinished in his studio in Aix [the Barnes painting] is typical from this point of view. Taken up countless times over the course of many years, it has varied little in aspect or color, and even the placement of strokes of paint remained almost the same. On the other hand, he reworked the dimensions of the figures many times. Sometimes they attained natural height, sometimes they shrank to half-size: arms, torsos and legs were augmented and reduced to impossible proportions. This was the variable element in his work: his sense of form included neither silhouette nor fixed proportions.[63]

The flanking figures were transformed, if not transgendered. On the left, irrupting into the scene as if about to bear witness, is a misshapen figure with a woman's body and a head that seems to anticipate the biomorphic forms beloved of the surrealists. The head has been construed as a phallus. Traditionally identified as "the striding woman," her posture suggests that she will stop striding and start testifying at any moment; the others wait on her word. On the right, reclining against an accommodating tree, is a bather at rest. The naked body is shown more or less full frontal, but the head is effaced (or impenetrably shadowed) and the groin is blackened and blued—gouged out, as Clark says, by the ferocity of the mark making. Violence has been done to these transgressive figures on the margins. They bear the scars, or the deformities. Their separateness is enforced by an arête of paint; they are practically walled off from the central group. As so often in Cézanne's work, the relief map of the painted surface is full of surprises.

Sexing the bathers is not a task for the squeamish. If the strider is positively surreal, the recliner is "insecurely sexed." There is a rudimentary ambiguity to the body so displayed; in Clark's formulation, "gender is not fixed or self-evident." Several of Cézanne's bathers are androgynous. Among the forebears of the recliner in the *Large Bathers* is the indeterminate figure stretched out on the grass in *Bathers at Rest* (color plate 47), and even further back,

"the gloomy hermaphrodite" in *The Temptation of Saint Anthony* (color plate 49).[64] The idea was not so outlandish. As Cézanne would have known, Baudelaire himself recognized a similar quality in Flaubert's Madame Bovary. His celebrated panegyric "M. Gustave Flaubert—*Madame Bovary—The Temptation of Saint Anthony*" (1868) was full of ideas for the artist. A suggestive passage ran as follows: "In order fully to achieve his tour de force, it remained for the author to strip himself (as far as possible) of his sex and make himself a woman. The result is a marvel; notwithstanding all his zeal as an actor, he couldn't help infusing male blood into his creature's veins, and in her boundless energy and ambition, even in her dreaming, Madame Bovary remained a man. Like Pallas, sprung fully armed from the brain of Zeus, this strange androgyne retained all the charms of a masculine soul in a delightful feminine body."[65]

In the case of the *Large Bathers,* there may be a further sign, if not a floating signifier. As if to recall the equivocal interpretations of the 1870s, a shadowy blue form extends more or less vertically from the recliner's crotch. When Jasper Johns turned to this painting as the source for a series of ink-on-plastic *Tracings After Cézanne,* in 1994, he imagined that bather indulging in a sexual reverie, and made the equivocal unequivocal. In some of the tracings, the blue form has become an erect penis (color plate 74).[66]

Cézanne's *Bathers* are dreamscapes. They have occasioned a good deal of profitless psychoanalysis, linked to his supposed phobias and pathologies, about women, about men, about nudity, about sex, about sexuality, about the father, about the mother, about being touched, mocked, exploited, maltreated, persecuted, molested, and traumatized—the full spectrum of sociopathy, eccentricity, abnormality, instability, and insanity. According to one authority, "Cézanne returned time and again to the *Bathers* as a way of confronting, expressing, and finally controlling his changing attitude towards women and resolving his other psychological complexities, particularly his doubts about his own sexual identity."[67] Such speculations take us back to Meyer Schapiro and the psychobiography of repression and sublimation. Schapiro held that Cézanne came to understand his need for some sort of serenity, and managed to keep a lid on his unruly psyche; but "the will to order and objectivity" of the 1880s did not last—could not last—because it rested on "a deliberate repression of a part of himself which breaks through from time to time."[68] That part, the part that dare not speak its name, had to do with his homoerotic impulses, targeted in particular on Zola (the former bather), and on his disobedient libido more generally. Fortunately, the psychoanalysts have paid no attention

to his diabetes and the possibility of impotence. But they do not lack for foundation myths. Bernard's much-recycled account of Cézanne's phobia about being touched, allegedly rooted in the childhood memory of being kicked from behind, is music to their ears. Bernard reports Cézanne remembering as follows: "I was going quietly down a staircase, when a kid who was sliding down the banister, at full speed, gave me such a kick up the arse as he went by that I almost fell over; the shock was so unexpected and unlooked-for, it hit me so hard that for years I've been obsessed by its happening again, to the point that I can't abide being touched or brushed by anyone."[69]

"One can almost hear the analyst breathing a discreet sigh of relief," adds Clark disarmingly, as he makes the most of the story. "This patient's phantasies are close to the surface." For the psychoanalytically inclined, the triumph over youthful excess, palette-knife exuberance, and black despair is nothing but "a fragile, fraught truce, indeed a magnificent defense against trauma."[70] As the reclining bather could testify, the effort to discipline the libido was doomed. The will to order gave way to the will to blue.

For analysts like these, the gloomy hermaphrodite is a self-portrait (with a head like Zola's), awash with guilt or remorse. The ubiquitous *Bather with Outstretched Arms* is "a projection of Cézanne himself, an image of his own solitary condition"; more specifically, "an expression of anxiety and guilt about masturbation." The Barnes *Bathers* is "a staging of that moment in the dissolution of the Oedipus complex at which the threat of castration is so intense and overwhelming that the male child is unable to take the exit into repression; and instead remains frozen in a world where, in spite of everything, the father is absent and the phallic mother's return is awaited. She will possess the phallus and restore it to her son. And everyone will have the same sexuality." In other words, the *Large Bathers* is a kind of regression—a painting cure—"his attempt to reconstitute a world of sexuality which, at some level, he had never left." Once again, the reclining bather is a surrogate for the mourning painter. "There has never been a subject so constituted under the sign of loss and despondency as the figure leaning on the tree. Maybe he does not even see the phallic mother arriving. Maybe in a sense he does not want to. He is content to spend his life grieving for the body he once had."[71]

The brushstroke itself has been recruited to the cause. According to Theodore Reff, "by systematizing even the size and direction of the brushstroke, he affirms a desire for complete consciousness of all that enters the work, leaving nothing to accident or whim. And this in turn reflects, I believe, an effort to master within himself the turbulent impulses that had led him to choose such

themes of struggle, temptation and ironic adoration in the first place. It is as if he strove to incorporate these hidden feelings into the domain of constructive professional activity, submitting them to strict aesthetic requirements through which he might ultimately neutralize them." The constructive stroke was a means to self-control. As Reff acknowledged, this line derived from Schapiro's interpretation of the Philadelphia *Bathers* as an "over-determined" composition. "In freeing himself from his troubled fantasy," wrote Schapiro, "Cézanne transposed the early erotic themes into less disturbing 'classic' objects, nudes whose set postures and unerotic surface, taken from the frozen world of the art school and the museum, make them seem purely instruments of his art. But something of the original anxiety is reflected in the arbitrariness and intensity of the means of control."[72] Re-enter Saint-Anthony-Cézanne, carnal temptation and philosophical doubt. A twitch of the brush is all it takes. Another bugger unmanned; another hussy floored. The hermaphrodites frolic by the river. The sluts flit between the trees. The *Large Bathers* are not innocent: they are machines for haunted memories.

It is but a short step from the overdetermined painting to the overdetermined reading.[73] There are other explanations. An earlier large bather with arms akimbo had a photographic source (an academic model).[74] The bather with outstretched arms had an artistic source—and ultimately a classical one—Leander, in Rubens's *Hero and Leander* (1604–05), a work taking its inspiration from Ovid's *Heroides*.

> Leander often swam the strait to Hero
> Until the last blind night brought tragedy.[75]

Cézanne had a feel for Rubens; he was a sort of honorary Venetian. In his "Confidences," Rubens appears as his favorite painter. If Gasquet is to be believed, under certain Rubens purples Cézanne caught a whisper of Ronsard.

Perhaps the franker responses are the best. Stan Brakhage did not care for the *Bathers*, but he had a notion of their place on the artistic journey:

> When you make those marks, you're leaving little bread crumbs so you can find your way back through the forest—and you're hoping some little bird doesn't come along and eat them up. Humanly, the individual maker . . . has grounds that are essentially neurotic. Usually these are the cross-wires of being a teenager, there's no way around that. The kinky *Bather* paintings of Cézanne are absolutely essential in order for him to

get to the Mont Sainte-Victoire, or at least to the apples, let's go that far. At some point he had to go back to that again [the erotic early work], those really embarrassing slimy sexual distresses of Cézanne. Of peasant Cézanne, getting his rocks off.[76]

Franker still is Michael Snow's outsize photograph *Paris de jugement Le and/or State of the Arts* (color plate 75), in which three women stand naked in front of the Philadelphia *Bathers,* their backs to the camera, contemplating the painting—or complexifying the fantasizing—as if to turn the tables on Émile Bernard, the talismanic photograph, the solitary condition, the deliberate repression, and all the fast talk of staging and dreaming and grieving.

With Cézanne, the personal was intertwined with the classical. As so often, the clues to a deeper understanding may lie in Virgil.

Still wrestling with the *Large Bathers* in the high summer of 1906, Cézanne tried to escape the stifling heat by taking a carriage to the Pont des Trois-Sautets over the Arc, a few miles southeast of Aix. In order not to be too much encumbered, he carried only his bag of watercolors. He wrote to his son: "Here on the riverbank the *motifs* multiply, the same subject seen from a different angle offers a subject of study of the most compelling interest, and so varied that I think I could occupy myself for months without moving, leaning now more to the right, now more to the left."[77] In that *locus amoenus* he occupied himself making hallucinatory watercolors (color plate 76), with more bathers; dreaming "passing spirit-troops," as Seamus Heaney writes, after Virgil, "*animae, quibus altera fato / Corpora debentur,* 'spirits,' that is, / 'To whom second bodies are owed by fate.' "[78]

It would have been hard for Cézanne not to think of Virgil in that place, and then to conjure the shade of the swimmer, "as if we had commingled / Among shades and shadows stirring on the brink / And stood there waiting, watching, / Needy and ever needier for translation" across to the other side.[79] Did he also conjure the shade of *le papa*? The tenor of his talk suggests unfinished business—remorse—a feeling that he had not given the paternal authority his due, or found a way to express his gratitude for what he owed to the author of his days. In the *Aeneid,* Virgil brings Aeneas to the shade of his father, Anchises, in the Elysian Fields. One of the mysteries disclosed by the ghost to his living son is that of the return of souls in new incarnations ("second bodies") and their drinking of forgetfulness from the river Lethe. When he sees the throng of ghosts on the riverbank, Aeneas asks Anchises, "*Quae lucis miseris tam dira cupido*"—why this unnatural longing for the light of mortal life again?

Anchises' reply makes it clear that, if they are to return to earth, the souls of the dead must be *immemores,* without memory:

All these presences
Once they have rolled time's wheel a thousand years
Are summoned here to drink the river water
So that memories of this underworld are shed
And soul is longing to dwell in flesh and blood
Under the dome of the sky.[80]

Did Cézanne see a throng of ghosts on the riverbank? Was there a Virgilian strain to the late *Bathers,* feeding their longing, under the dome of the sky? The *Aeneid* was a constant reference. "Never forget your art, *sic itur ad astra.*" Cézanne's advice to Louis Aurenche echoed Aeneas giving heart to his son Ascanius: "*Macte nova virtute, puer; sic itur ad astra.*" (Blessings on your young courage, boy; thus one reaches the stars.)[81] He was well versed in the underworld and its secrets. The Delacroix he had copied half a century earlier was *Dante and Virgil Crossing the Styx*; he owned an engraving after that painting.[82] He knew that if memory was a way of meeting the paternal shade again, it was at the same time confirmation of the ultimate parting.

But that was not all he knew. He had grown in self-knowledge. Once upon a time, he might have liked a gang of his own. After the Inseparables, he had been excluded; more to the point, he had excluded himself. When the time came for the *Large Bathers,* he knew where he stood. He was powerful and solitary. Male or female, or in-between, the *Bathers* cannot be reduced to an exercise in repression. Cézanne was alert to the slippage between the living and the dead. He himself was a specter at the feast, "the man who does not exist," as he put it to Gasquet. "Besides, I am as good as dead."[83] The existential status of those who meant most to him was almost immaterial. Pissarro the burner of the necropolises of art was a living presence three years after his death; Zola the swimmer still swam in the mind's eye half a century after he first took to water. "How far away it all is, and yet how close."[84] As Rilke wrote:

. . . Strange,
to see all that was once so interconnected
now floating in space. And death demands a labor,
a tying up of loose ends, before one has

that first inkling of eternity.—But the living
all make the same mistake: they distinguish too sharply.
Angels (it's said) often don't know whether they move among
the living or the dead. The eternal current
bears all the ages with it through both kingdoms
forever and drowns their voices in both.[85]

In September, the heat began to abate. Cézanne sent Paul a letter full of pathos:

> The weather is magnificent, the countryside superb. Carlos Camoin is here, he comes to see me from time to time. I'm reading Baudelaire's treatments of the work of Delacroix. As for me, I must remain alone. People are so crafty, there's no escaping them, their thieving, their self-importance, their conceit, their violations, their hands on your work, and yet, nature is very beautiful. I still see Vallier, but I'm so slow in *réalisation* that it makes me very sad. Only you can console me in my sad state. So I commend myself to you, I embrace you and Maman with all my heart.[86]

"Seeing Vallier" meant only one thing. Cézanne painted six oil portraits of *The Gardener Vallier,* plus three large watercolors, the culmination of the late work. There is Vallier in summer and Vallier in winter: he is a man for all seasons.[87] One of those portraits was the last oil painting he ever worked on. Evidently he set a lot of store by them. Visitors to his studio in February 1905 saw two works in progress: the Barnes *Bathers* and a portrait of a man, in profile, wearing a cap—Vallier's winter attribute. Cézanne attached great importance to that portrait. "If I succeed with this fellow," he told them, "it means that the theory will be true."[88]

Vallier was more than a gardener. Legend has it that he had been to sea (traditionally, some of the portraits are known by the alternative title *The Sailor*). Cézanne relied upon him for practically everything, even a massage. His presence was providential. With age, the painter and the gardener achieved an uncanny complicity. Vallier became an "other self," a double. Gowing found that "the gardener in profile has not only a look of Cézanne himself but the look of a Michelangelesque Moses," and it may well be that these portraits are in some sense symbiotic self-portraits.[89] Vallier was Cézanne's secret sharer.

The nobility of their complicity is deeply moving. It is there in the

blank-spaced summery canvases (color plate 84) as well as in the heavily worked wintry ones (color plate 83). These latter are consciously textured. The paint has been applied slowly and deliberately, in thick layers reminiscent of geological strata, with a final inklike layer of blue-black.[90] The old gardener has a kind of specific gravity. And yet, for all his substantiality, he has an almost unbearable lightness of being—his legs seem to fade away, and his crabbed hands have a shadow-life of their own, as if caught in slow motion. His eyes are dark sockets. "Here, look at this portrait!" Cézanne exclaimed to the young poet Jean Royère. "Those aren't eyes yet: they haven't been brought out yet!" And then his constant refrain: "*Je ne me suis pas réalisé!*"[91] It was justly said that "Cézanne paints as Sisyphus rolls his rock."[92]

One of the most intriguing responses to the portraits of Vallier came from an unexpected quarter, in an unexpected form. The philosopher Martin Heidegger was moved to write a poem.

> The thoughtfully serene, the urgent
> stillness of the form of the old gardener
> Vallier, who tends the inconspicuous on the
> *Chemin des Lauves.*
>
> In the late work of the painter the twofoldness
> of what is present and of presence has become
> one, "realized" and overcome at the same time,
> transformed into a mystery-filled identity.
>
> Is a path revealed here, which leads to
> a belonging-together of poetry and thought?[93]

Heidegger had come late to Cézanne. In the course of preparing a memorial address for the twentieth anniversary of Rilke's death, in 1946, he immersed himself in the poet's letters (the ones that became *Letters on Cézanne*). He read to friends the passages that spoke most directly to him, giving special emphasis to a matchless encapsulation of the transformative project: "This labor which no longer knew any preferences or biases or fastidious predilections, whose minutest component had been tested on the scales of an infinitely responsive conscience, and which so incorruptibly reduced a reality to its color content that it resumed a new existence in a beyond of color, without any previous memories."[94] At around the same time he discovered the Cézannes in

the Beyeler Collection and the Kunstmuseum in Basel, in particular the last of the great catastrophes—the final Sainte-Victoire.[95] Heidegger was hooked. He saw more and more Cézannes; he read the artist's published letters; he studied some of the literature, notably a dense treatise on *The Art of Cézanne* by Kurt Badt, with whom he corresponded; and in 1956 he made his first pilgrimage to Aix and the surrounding region, which he came to regard as his "second homeland." He was still going back ten years later.

In Aix he struck up a conversation with André Masson:

AM: How to find Cézanne the man? A good biography? For want of that: the letters.

MH: In those of van Gogh, there is more than van Gogh.

AM: By contrast, in those of Cézanne, there seems to be less . . .

MH: In those of Cézanne there is little, but in that little there is a lot.

AM: The testimony also. The importance of that of Émile Bernard: the panic in front of the gardener's daughter, the haunting memory of ridiculous abuse experienced in his youth, his horror of Bernard's helping hand across a ditch. The "hook" . . .

MH: Cézanne had a horror of all human contact.

AM: He countered that fear with a style: his own. Just as his suffering and bitterness were his own. He was the greatest painter in Europe, and he knew it.[96]

Heidegger fell under the spell of the magic mountain. There is a photograph of him sitting heavily on a rock, contemplating the Sainte-Victoire, meditating on Cézanne. He would commend the experience to others. "The wondrous mountain with which Cézanne struggled ought to show its wandering light to you too." *What Is Called Thinking?* (1968) introduced the mountain into the teaching. "We give our attention to the mountains that are there, not in respect of their geological structure or geographical location, but only in respect of their being present. What is present has risen from unconcealment." Cézanne was the agent of unconcealment. Heidegger's confession of faith was complete. "These days in Cézanne's home country are worth more than a whole library of philosophy books. If only one could think as directly as Cézanne painted."[97]

Fittingly, Heidegger made a connection between Cézanne and Heraclitus (another lodestar), citing one of the fragments: "He who does not expect will not find out the unexpected, for it is trackless and unexplored." Heraclitus

holds that wisdom is not simply there for the taking, as if panning for gold. It demands an openness on the part of the percipient, an outlook, often translated as "hope" or "expectation"; more accurately, perhaps, as "expectancy." This calls for a lengthy process of self-examination and reflection. "You will not find out the limits of the soul by going," cautions Heraclitus, "even if you travel over every way." His own voyage of discovery sailed inwards. If the inner world was uncharted, the outer world was unfathomable. "Nature loves to hide," says Heraclitus, sounding very like Cézanne. According to Heidegger: "Cézanne *sur le motif,* as he would say, in front of the Sainte-Victoire, knew something, since he had never finally learnt the unfindable. For his painting engaged not with being, but with becoming."[98] For Cézanne, there was no end to expectancy, and no end to the unexpected.

Heidegger's poem, or "thing-thought," as he called it, was consistent with his philosophical position. Vallier is "serene" (*gelassene*); in Heidegger's parlance, the German word *Gelassenheit* represents a sort of ideal state. It suggests not only serenity or equanimity, but also a sense of "releasing" or "letting be." Similarly, "the inconspicuous" (*der Unscheinbares*) in his usage carries more than the common meaning. It connotes "the ground" of all things—perhaps even the ground of the painting—something that is not itself noticed, but is the condition of there being anything to notice. For the thinker, therefore, the thing-thought had a certain poignancy. The gardener achieves *Gelassenheit*. The painter succeeds in "realizing," not only what is present, but presence itself; that is to say, not only the thing, but the "thinging"—the thing becoming thing, the world becoming world—the destination and the journey. Cézanne enables us to grasp the ungraspable in its intractable ungraspability. In Heidegger's terms, he is a poet—a poet for "needy times."

In October, the rain came. Cézanne sent Paul a Beckettian bulletin:

I continue to work with difficulty, but in the end there is something. That's the important thing, I think. Since sensations are my stock in trade, I believe I'm impervious. . . .

Everything goes by with frightening speed, I'm not doing too badly. I look after myself, I eat well.

Would you be kind enough to order me two dozen mongoose-hair brushes, like those we ordered last year?

Mon cher Paul, to give you the satisfactory news you want, I would have to be twenty years younger. I repeat, I eat well, and a little boost to morale would do me a power of good, but only work can give me that.

All my compatriots are arseholes beside me. I should tell you that I've received the cocoa.[99]

He must have written that letter early on 15 October. Later that day, he was caught in a thunderstorm out *sur le motif.* As he made his way back to the road, he collapsed; he was out in the rain for several hours, unconscious. A passing laundryman brought him back to the Rue Boulegon on his cart. It took two men to lift him upstairs into bed.

The following morning, impervious, he was back at work on a portrait of Vallier, on the terrace at Les Lauves, under the linden tree: the gardener in profile, like Moses, the early morning sun illuminating his forehead under the brim of the hat (color plate 86).[100]

When he returned to the apartment it was clear that his condition had worsened. The doctor suggested a male nurse, but Cézanne would not hear of it. The next day he felt strong enough to send a sharp remonstrance to an errant paint supplier:

A week has gone by since I asked you for ten burnt lakes no. 7, and I have had no reply. What is going on?

A reply, and a speedy one, I beg you.[101]

Three days later, on 20 October, his sister Marie bestirred herself to write her fateful letter to Paul, in Paris, requesting his presence while putting off Hortense, on account of Cézanne's commandeering her dressing room for a studio.[102]

Confined to bed under doctor's orders, he would get up every so often to add a few touches to a watercolor stationed nearby, *Still Life with Carafe, Bottle, and Fruit* (color plate 81).

On 22 October, Madame Brémond sent a telegram: COME IMMEDIATELY BOTH OF YOU FATHER VERY ILL.

It was too late. Paul Cézanne passed away at seven in the morning on 23 October 1906.[103] He is variously said to have contracted pleurisy or congestion of the lung. The death certificate provides no details. He had vowed to die painting, and he did. Madame Brémond alone was present. She called his neighbor Rougier, who came over and closed his eyes. His wife and son arrived just in time for the funeral. "Who cares anything today for a finely finished death?" asked Rilke.[104] The death, like the canvas, was *non finito.*

At the Salon de Bouguereau, they broke out the black crêpe.

Epilogue: Cézanne by Numbers

According to the catalogue raisonné of his paintings, his lifetime production was 954. There are over a hundred still lifes, of which about half feature apples. There are at least eighty *Bathers,* almost equally divided between male and female. There are over forty Mont Sainte-Victoires. To these should be added 645 watercolors and around 1,400 drawings, most of them from eighteen sketchbooks. Many of the sketchbooks have since been broken up and dispersed. There are extant 56 drawings of his wife, and no fewer than 136 of his son (often asleep). The catalogue raisonné of the drawings is the work of Adrien Chappuis, a connoisseur and collector—his collection of drawings the second-largest after that of the Kunstmuseum Basel. When Chappuis's heirs decided to sell the remaining sixty or so drawings and watercolors from his estate, in 2002, the French state selected a single watercolor in return for an export license for the remainder of the collection—a decision reminiscent of the selection from the Caillebotte bequest—despite the fact that there are hardly any Cézanne drawings in French national museums.

Immediately after Cézanne's death, Vollard and Bernheim-Jeune jointly acquired twenty-nine "studies" (oil paintings) for 213,000 francs and 187 watercolors for 62,000 francs from Cézanne's son, who received his first payment on 13 February 1907: checks for 81,000 francs and 50,000 francs. Further payments followed on 15 March (16,000 francs), 4 April (8,000 francs), 15 June (8,000 francs), and 26 June (8,000 francs). Regular sales and regular payments continued thereafter. In 1912, for example, he received 40,000 francs for *The Feast,* otherwise known as *The Orgy*; in 1913, 100,000 francs for *The Card Players* (sold by Vollard to Barnes for ten times that figure in 1925). So dissipated his inheritance.

According to Renoir, he had only to put two strokes of color on the canvas and it was already something. According to Picasso, it took only one. "A big

thing about modern painting is this. A painter like Tintoretto, for example, starts on his canvas, and then continues, and at the end when he has filled in and worked over everywhere, only then is the picture finished. Now if we take a painting by Cézanne (and this is even more obvious in the watercolors), the painting already exists the moment he paints the first stroke."[1] According to Manny Farber, in the watercolors, "more than half the event is elided to allow energy to move in and out of vague landscape notations."[2] According to Alfred Stieglitz, "there's nothing there but empty paper with a few splashes of color."[3] In the watercolors on white paper, it is the white paper that organizes the watercolors. The pathos of the paper was one of his great discoveries.

According to E. E. Cummings, the watercolors speak of love.

Pausing, I lift my eyes as best I can,
Where twain frail candles close their single arc
Upon a water-color by Cézanne.
But you, love thirsty, breathe across the gleam;
For total terror of the actual dark
Changing the shy equivalents of dream.[4]

According to Rilke, the watercolors are like an echo of a melody.[5]

According to Vollard, Cézanne needed one hundred and fifteen sittings for his portrait, before it was abandoned. According to Merleau-Ponty, "he needed one hundred sessions for a still life, one hundred and fifty sittings for a portrait." According to the standard translation of Merleau-Ponty, he needed *five hundred* sittings for a portrait.[6]

According to Gasquet, Cézanne said: "One minute in the life of the world is going by. Paint it as it is!" This became one of John Berger's favorite quotations.[7] According to Bernard, "his method of study was a meditation with a brush in his hand." Bernard was allowed to paint in one of the ground-floor rooms of the Les Lauves studio. "I got an idea of the slow pace of his work when he installed me in the studio outside Aix. While I worked on a still life that he had arranged for me in the room below, I could hear him pacing to and fro in the studio above; it was like a meditative walk the length and breadth of the room; also he would frequently come downstairs, go into the garden to sit down, and rush back upstairs."[8] According to Gasquet, twenty minutes in the life of the world could go by in the interval between strokes.[9] According to Merleau-Ponty, it could be an hour. According to Merleau-Ponty's translators, it could be several hours.[10]

According to X-rays of his paintings, Cézanne the slow coach is part of the legend. He could also paint *fast*.

According to Le Bail, the still life was arranged with great care, and a trade secret: he used coins to wedge the fruit—one- or two-sou pieces—tipping them forward, as if eager for inspection. The apple, too, strikes a pose. According to the poet W. S. Di Piero, a Cézanne painting is an object offering. "The objects are not in repose; they press themselves forward, ingenuously disposed, at once defiant and inviting. . . . In Cézanne's still lifes the canvas is a field that discloses the actual *activity* of the form-making imagination, not only the products of it. . . . He paints the action of the desirous imagination as it seeks to know its object."[11]

According to Vollard, he thought live models expensive—especially female models: four francs per session in the 1890s, twenty sous more than before the Franco-Prussian War. According to Léontine Paulet, daughter of the gardener and card player Paulin Paulet, who was the model for the girl in the largest of the *Card Players,* she and her father were paid three francs and five francs, respectively, per session. Léontine remembered interminable sittings. To begin with, she was very scared when Cézanne stared at her, but on the day of her first communion he gave her a two-franc piece and told her to go and buy whatever she wanted.

According to his correspondence, he used to go all the way to the Château Noir by carriage for five francs. When the coachman raised the price of a return journey to the Pont des Trois-Sautets to three francs, in 1906, Cézanne dispensed with his services. After paying additional postage on a letter from Zola in 1878, he asked his friend to economize on the number of sheets of paper in the envelope. When he wrote to the impoverished Emperaire, however, he enclosed a stamp for the reply, "in order to save you going into town." He also offered to send him some tubes of paint.[12] According to his niece Marthe Conil, he always gave a five-franc piece to the beggar at the cathedral door. One day, when his nieces began to mock the beggar, Cézanne quieted them: "But you don't know, it's Germain Nouveau, professor and poet, he was my classmate at the Collège Bourbon."[13]

According to technical studies of his work, he used more cobalt blue in his landscapes after his father's death, in 1886, when he became financially secure. According to Marcel Provence, who restored his studio, he considered it the height of luxury (*"un luxe de nabab"*) to buy his materials from a supplier to museums. "I paint as if I were Rothschild!"[14] A vertical stripe of light on the milk jug in the late *Still Life with Milk Jug and Fruit* (color plate 82) is a product of cadmium yellow, then very expensive, mixed with lead white. Remarkably, the highlights on the fruit emerge from underneath. Most highlights are painted last. Cézanne's highlights were painted first. He applied chrome yellow directly to the white ground; then he built up the piece of fruit. For the shadows under the plate he mixed iron oxide and red or yellow lake; it was unusual to use the lake in the mix rather than as a glaze. He knew his pigments. X-ray photography shows that the paint was applied slowly and meticulously; the lower layers are allowed to show through the upper ones. There are few changes in the composition. On the fruit, the oranges in particular, the blue paint is carefully exposed.[15]

According to Heidegger, his philosophy was at once coherent and parsimonious. "Cézanne was not a philosopher, but he understood all of philosophy. In a few words he summed up everything I have tried to express. He said: 'Life is terrifying.' [*C'est effrayant, la vie.*] I have been saying just that for forty years."[16]

According to Bresson, Cézanne said: "I paint, I work, I am free of thought."[17]

I paint, therefore I am.

According to Madame Brémond, he got up at three. According to the former controller of tolls Olivier, he was often to be seen at four, on his way to the studio. He would light the stove, make coffee, and read. According to a former

apprentice of the master mason Viguier, he would bring the artist a bottle of milk at five. Cézanne would boil the milk, have breakfast, and set to work. According to Bernard, he began painting at six. According to Le Bail, he left for the *motif* at seven. As like as not, he would say: "We're going to put our absurd theories into practice."[18]

According to the jottings in his sketchbook, he ate as follows:

Wednesday	morning	60 [centimes]	beef and kidneys
	evening	50	cutlets
Thursday	morning	75	cutlets
	evening		six sausages
Friday	morning	70	
	evening		nothing
Saturday	morning	1 [franc]	beef and kidney paid
Sunday	morning	1	beef and [?] slice
	evening	35	beef
Monday	-		
Sunday	morning	1	
Monday	morning	70	cutlet[19]

According to his granddaughter, Aline (the apple of the Little Dumpling's eye), two recipes for cutlets came down to her: lamb cutlets in breadcrumbs and lamb cutlets with truffles—the latter perhaps not entirely to Cézanne's taste. She also had two recipes for baked tomatoes. Both of them prescribed three tablespoons of olive oil.[20] The recipe for "juicy blue" has not survived.

According to the menu of the Dada-inspired dBFoundation of New York artists, "Cézanne Salad" consists of apples, oranges, and drapery.

According to his bill from the Hôtel Baudy in Giverny, in 1894, he regularly ordered a bottle of Mâcon (1.5 francs), sometimes a whisky (75 centimes), occasionally a cognac (40 centimes), and, unusually, a pair of braces (3 francs).

According to Ernest Hemingway, Cézanne's work is best seen on an empty stomach. "I learned to understand Cézanne much better and to see truly how he made landscapes when I was hungry," he recalled in *A Moveable Feast* (1964). "I used to wonder if he were hungry too when he painted; but I thought possibly it was only that he had forgotten to eat. It was one of those unsound but illuminating thoughts you have when you have been sleepless or hungry. Later I thought Cézanne was probably hungry in a different way." As a struggling writer, Hemingway went nearly every day to see the Cézannes in

the Luxembourg. "I was learning something from the painting of Cézanne that made writing simple true sentences far from enough to make the stories have the dimensions that I was trying to put in them. I was learning very much from him but I was not articulate enough to explain it to anyone. Besides, it was a secret."[21]

According to Bernard, his palette had three blue pigments: cobalt blue, ultramarine, and Prussian blue. According to Le Bail, when beginning a canvas, "he drew with a brush of ultramarine, diluted with lots of turpentine, laying in with a will, unhesitatingly." Asked why he was so fond of ultramarine, he replied: "Because the sky is blue."[22] According to Eric Rohmer, for Cézanne "the sky is *blue* before it is sky."[23] According to an unpublished bill, on 18 October 1888 Tanguy supplied him with ultramarine by Guimet. According to a recently discovered letter to an unnamed color merchant, on 14 July 1905 he ordered five tubes of Prussian blue by Bourgeois.[24] According to technical studies of his work, Prussian blue is found only in his oils and indigo only in his watercolors; mixed greens made of cobalt blue and chrome yellow have been identified in several of the watercolors. According to Huysmans, a certain painter of the impressionist persuasion favored a wigmaker blue. According to Bridget Riley, the *Large Bathers* present us with a great thundering blue. According to Rilke, Cézanne used at least sixteen shades of blue. Some of them are familiar (sky blue, sea blue, blue-green), but for the most part these were no ordinary blues. Among his blues: a barely blue, a waxy blue, a listening blue, a blue dove-gray, a wet dark blue, a juicy blue, a light cloudy blue, a thunderstorm blue, a bourgeois cotton blue, a densely quilted blue, an ancient Egyptian shadow-blue, a self-contained blue, and a completely supportless blue. "As if these colors could heal one of indecision after all. The good conscience of these reds, these blues, their simple truthfulness, it educates you; and if you stand among them as ready as possible, you get the impression that they are doing something for you."[25] According to Bresson, there is Cézanne blue, like Brueghel red. According to Mirbeau, there is a blue hour in the day, which Cézanne succeeds in capturing. According to Merleau-Ponty, the phenomenologist, there is blue being. Titian is supposed to have said that a painter needed only three colors: white, black, and red. Cézanne needed blue.

According to Cézanne, "we men experience nature more in terms of depth than surface, hence the need to introduce into our vibrations of light, represented by reds and yellows, a sufficient quantity of bluishness, to give the

feeling of air."[26] According to Sergei Makovsky, editor-in-chief of the journal *Apollon*, the Russian collector Morozov determined to buy a blue Cézanne. Makovsky remembered a visit to Morozov's gallery: "I was surprised to see a blank spot on a wall otherwise completely covered with Cézanne's works.

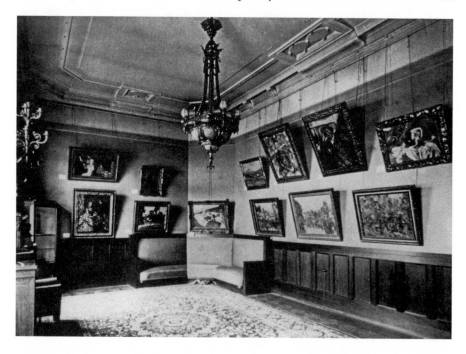

'That place is intended for a "blue Cézanne." . . . I have had my eye on it for a long time but haven't been able to make a selection.' "[27] Finally, in Vollard's shop, he found what he was looking for: *Blue Landscape* (color plate 77), which became his favorite painting. Some years later, in 1926, Walter Benjamin had his own epiphany in front of it, in what was then the Museum of Modern Western Art in Moscow:

> As I was looking at an extraordinarily beautiful Cézanne, it suddenly occurred to me that to the extent that one grasps a painting, one does not in any way enter into its space; rather, this space thrusts itself forward, especially in various specific spots. It opens up to us in corners and angles in which we believe we can localize crucial experiences of the past; there is something inexplicably familiar about these spots.[28]

Like many others, Benjamin continued to refine his Cézanne encounter in his own work. "The true image of the past flits by," he mused prophetically in

"On the Concept of History" (1940), only months before he committed suicide. "The past can be seized only as an image which flashes up at the moment of its recognizability, and is never seen again."[29]

Bluescapes (as Fredric Jameson calls them) meet their match in bluelifes. The late watercolors continue to echo. In these rapturous still lifes, broken blue contours convey a sense of air circulating around and through objects. According to his young visitors R. P. Rivière and J. F. Schnerb, "he did not seek to represent forms by a line. The outline existed for him only as the place where one form ended and another began. . . . In principle there is no line, a form exists only in relation to the neighboring forms."[30] The ubiquitous blue pot vibrates, bluishly, in sympathy with the blue fruit that keeps it company.[31]

Cézanne breaks the skin of things, in Henri Michaux's phrase, "to show how the things become things, how the world becomes world." According to Heidegger, what goes on in a Cézanne is "worlding."[32] Rilke captures it perfectly:

Soundless living, endless opening out,
space being used without space being taken
from that space adjacent things diminish,
existence almost uncontoured, like ground left blank
and pure within-ness, much so strangely soft
and self-illuminating—out to the edge:
is there anything we know like this?[33]

Countless people have had a Cézanne epiphany. According to Kenneth Clark, when he went to see a loan exhibition at the Victoria Art Gallery in Bath as a teenager during the First World War, "the Manets meant nothing to me; and Monet's cathedrals left me as baffled then as they do now; but the Cézannes were a knock-out blow. One landscape, in particular, gave me the strongest aesthetic shock I had ever received from a picture. I could not keep away from it, and went down the hill to see it almost every day." Samuel Courtauld saw the same painting a few years later, in 1922, on loan to the Burlington Fine Arts Club. "A young friend who was a painter of conventional portraits, and had been serving in the RFC [Royal Flying Corps], led me up to Cézanne's *Provençal Landscape*. . . . Though genuinely moved he was not very lucid, and finished by saying, in typical airman's language, 'It makes you go this way, and that way, and then off the deep-end altogether!' At that moment I felt the magic, and I have felt it in Cézanne's work ever since."[34]

"I could imagine someone not prepared . . . who had no experience of external ecstasy [that is, marijuana], passing in front of a Cézanne canvas, distracted and without noticing it, his eye traveling in, to, through the canvas into the space and suddenly stopping with his hair standing on end, dead in his tracks seeing a whole universe," said Allen Ginsberg. "And I think that's what Cézanne really does, to a lot of people."[35] The philosopher Henri Maldiney saw *space,* in an instant, in front of the Moscow *Mont Sainte-Victoire Seen from Les Lauves,* at the Cézanne exhibition in Paris in 1936. But a live canvas may not be necessary. For Robert Motherwell, it was love at first sight, at age fourteen, when he saw his first late Cézanne, in reproduction.

According to Fredric Jameson, it has become impossible to have a direct or unmediated experience of a Cézanne painting, "because the value of Cézanne has become a functional component of the ideology of establishment modernism."[36] We are engaging, not a canvas, but a cultural institution. "Everyman loves everyman's Cézanne and rolls his eyes: 'That paaynting! Ooo that paaynting!' " spouted Max Ernst, in his Dada phase. "I don't give a damn about Cézanne, for he is an enormous hunk of painting."[37] According to John Berger, consciously or unconsciously echoing Roger Fry, "millions of words have been written in psychological and aesthetic studies about Cézanne yet their conclusions lack the gravity of the work. Everyone is agreed that Cézanne's paintings appear to be different from those of any painter who preceded him; whilst the works of those who came after seem scarcely comparable, for they were produced out of the profound crisis which Cézanne . . . half foresaw and helped to provoke."[38] Hemingway's secret remains secret. It sometimes seems as if no advance has been made on Gertrude Stein:

> The apples looked like apples the chairs looked like chairs and it all had nothing to do with anything because if they did not look like apples or chairs or landscape or people they were apples and chairs and landscapes and people. They were so entirely these things that they were not an oil painting and yet that is just what the Cézannes were they were an oil painting. They were so entirely an oil painting that it was all there whether they were finished, the paintings, or whether they were not finished. Finished or unfinished it always was what it looked like the very essence of an oil painting because everything was always there, really there.[39]

"Why do we feel a momentary completeness of being when we look at his work," asked W. S. Di Piero, "with all his constant self-confessed failures, his

endlessly unsatisfactory 'researches' . . . , the grinding habitual unhappy inadequacy of it all? Despite all that, which in Cézanne's case is to say because of it, *the all is there.*"[40] According to van Gogh, "you must feel the whole of a country—isn't that what distinguishes a Cézanne from anything else?"[41]

According to Rilke, his poetry spoke for itself. "I believe that no poem in the *Sonnets to Orpheus* means anything that is not fully written out there, often, it is true, with its most secret name," he wrote to a friend, not entirely reassuringly. "All 'allusion' I am convinced would be contradictory to the indescribable 'being-there' of the poem." On another occasion he suggested that his most recalcitrant obscurities might require not elucidation so much as "submitting-to."[42]

Surely Cézanne requires submitting-to.

Yet there is an impulsion to say more. The best explanation so far has been offered by the critic David Sylvester: "In our lives nothing troubles us more than our inability to deal with those contradictions which we recognize in ourselves, in our feelings, our desires, our consciences—our inability to accept them and reconcile them. We tend to deal with such contradictions by closing our minds to the essence of one side or another or by evading them with some feeble compromise. Perhaps it is because Cézanne's art accepts contradictions to the full and finds a means to reconcile them that we always feel instinctively that it means so infinitely more than its ostensible subject. What it means is a moral grandeur which we cannot find in ourselves."[43]

Worlding is at the same time grounding and elevating.

According to the Dadaist house journal and Surrealist incubation unit, *Littérature,* edited by Louis Aragon, André Breton, and Philippe Soupault, Cézanne is more or less harmless. In 1921 the journal published approval ratings of the high-and-mighty throughout history—not to classify but to declassify, as they said—on a scale from +20 to –25, where +20 indicated complete approval, –25 extreme aversion, and 0 absolute indifference. Cézanne emerged with –3.36, a mild aversion, on the level of Corot (–4.90). This was far behind Baudelaire (+9.00) and Freud (+8.60), but well ahead of Delacroix (–8.54) and Debussy (–9.18). In that circle, it was a creditable achievement. The average concealed a surprisingly enthusiastic +13 from Paul Éluard, a studiously indifferent –1 from Breton, and an annihilating –25 from Tristan Tzara, the Dadaist commander-in-chief.[44]

According to Jean-Luc Godard, in *Histoire(s) du cinéma* (1988), "there are perhaps ten thousand people who haven't forgotten Cézanne's apples, but

there must be a billion viewers who will remember the cigarette lighter of *Strangers on a Train*." For Godard, a Cézanne was a painting that you could put in the cell of a condemned man without its being an outrage. Even in his own medium, however, he underestimated the pulling power of the apples. According to Woody Allen's alter ego Isaac Davis, in *Manhattan* (1979), there are eleven things that make life worth living: "Groucho Marx, Willie Mays, the second movement of the 'Jupiter' Symphony, Louis Armstrong's 'Potato Head Blues,' Swedish movies, *A Sentimental Education* by Flaubert, Marlon Brando, Frank Sinatra, and of course those incredible apples and pears by Cézanne. . . ."[45]

According to his son, he would say: "Politicians, there are two thousand of them in every legislature, but a Cézanne, there is only one every two centuries."[46]

According to Roland Barthes, there is in a single painter a whole history of painting. The whole of Nicolas de Staël is in three square centimeters of Cézanne. Then he scaled it down even further. The whole of Nicolas de Staël is in one square centimeter of Cézanne.[47] According to László Moholy-Nagy, supposedly abstract formal elements in certain compositions by Kandinsky or Matisse can be conceived of as "close-ups" or enlargements of details in Cézanne's paintings.[48]

They are all there, somewhere, in one square centimeter or another. Picasso and Braque, Matisse and Modigliani, Kandinsky and Klee, Giacometti and Morandi, Johns and Kelly, De Kooning and Lichtenstein, Gorky and Kossoff, Marden and Kitaj, Freud and Auerbach, Strand and Wall. The sublime little grimalkin is large. He contains multitudes. According to Klee, "he is the teacher par excellence." According to the writer Peter Handke, he is the teacher of mankind in the here and now.[49]

According to sages of every stripe—Louis Vauxcelles, Clement Greenberg, Merleau-Ponty—he was the great exemplar.[50] Asked to name the formative influences on his poetry, Rilke said that Cézanne had been his supreme example, and that "after the master's death, I followed his traces everywhere." Gertrude Stein, who began her creative life under the spell of the woman with a long face and a fan, and who did not lightly confess to influences, testified that "everything I have done has been influenced by Flaubert and Cézanne, and this gave me a new feeling about composition. Up to that time composition had consisted of a certain idea, to which everything else was an accompaniment

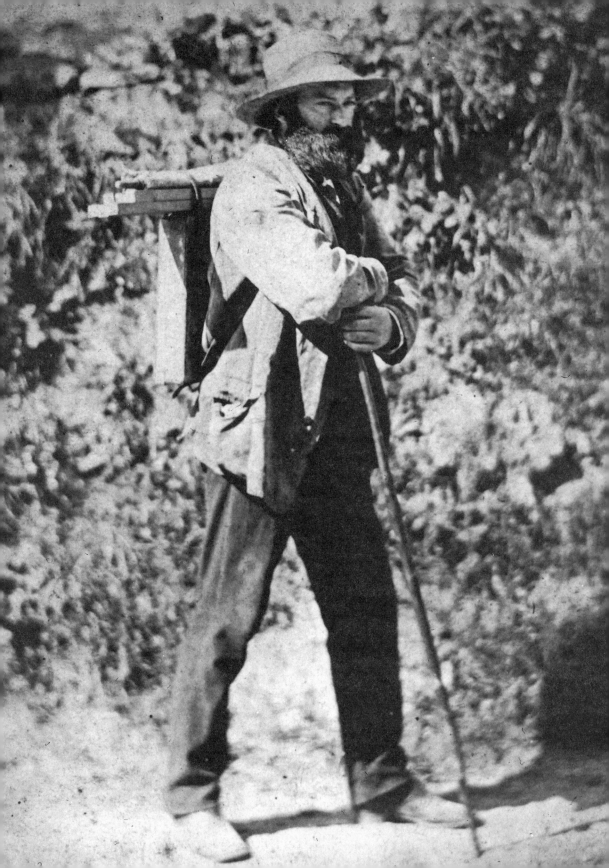

and separate but was not an end in itself, and Cézanne conceived the idea that in composition one thing was as important as another thing. Each part is as important as the whole, and that impressed me enormously."[51]

He was not merely influential. He has a much rarer distinction. He won for himself the kind of glory beautifully described by Paul Valéry: "To become for someone else the example of the dedicated life, being secretly invoked, pictured, and placed by a stranger in a sanctum of his thoughts, so as to serve him as a witness, a judge, a father, a hallowed mentor."[52] For Liliane Brion-Guerry, he was the great sustainer. She began work on her study of Cézanne as a conscious act of resistance, "a testimony of faith in certain values," in 1943. In the black years of the Occupation, moral values and color values coalesced.[53] For Picasso, he was the great protector: mother, father, grandfather, and spiritual advisor. *Still Life with Hat,* otherwise known as *Cézanne's Hat* (1909), is a portrait of a Kronstadt hat—a characteristic tribute—impudent, rivalrous, slightly comic, deadly serious, and a dig in the ribs for brother Braque, who supplied the hat.[54] For Seamus Heaney, he is an agent of equilibration, a kind of moral spirit level:

> Sitting there *sur le motif,* his grumpy contrary old back turned on us as he faces the humpy countervailing mountain. The first time I went to London I came back with a Cézanne print of the Mont Sainte-Victoire. The first art book I bought for myself was about Cézanne. When I wrote [the poem] "An Artist" I was reading Rilke's letters about his infatuation with Cézanne and some of Rilke's words are included. What I love is the doggedness, the courage to face into the job, the generation of what Hopkins would have called "self-yeast"—but in a positive sense: the miller gristing his own mill. This may or may not be the Cézanne known to art critics and historians, but he's the one I've lived with, the one rewarded with those incontrovertible paintings, so steady in themselves they steady you and the world—and you in the world.[55]

A century on, fortitude outbids *inquiétude.*

The pilgrimages to Aix that began in his lifetime continued after his death. They were not confined to artists. Heidegger was there in 1956, 1957, and 1958. On 20 March 1958, he prefaced a lecture on Hegel and the Greeks with a description of the way into the Bibémus quarry, to a place where the Sainte-Victoire comes into sight. There, he said, he had found Cézanne's path, "the path to which, from beginning to end, my own path as a thinker cor-

responds in its way."[56] Merleau-Ponty was there in 1960, writing "Eye and Mind." He took his epigraph from Cézanne, by way of Gasquet: "What I am trying to convey to you is more mysterious, entangled in the very roots of being, the impalpable source of sensations." He concluded with a Cézannian meditation on progress and completion, the life and the afterlife:

> If we cannot establish a hierarchy of civilizations or speak of progress— either in painting or in anything else that matters—it is not because some fate holds us back; it is, rather, because the very first painting in some sense went to the farthest reach of the future. If no painting comes to be *the* painting, if no work is ever absolutely completed and done with, still each creation changes, alters, enlightens, deepens, confirms, exalts, re-creates or pre-creates all the others. If creations are not established advances, this is not only because, like all things, they pass away; it is also that they have almost all their lives still before them.[57]

His creations have colonized our consciousness. His impact on our world, and our conception of our world, is comparable to that of Marx or Freud. According to Charles Taylor in *Sources of the Self,* Cézanne "brought to expression the meaningful forms and relationships which under-gird our ordinary perception, as they emerge and take shape from the materiality of things. To do this he had to forge a new language, abandoning linear and aerial perspective and making the spatial dispositions arise from the modulations of color. He 'recaptures and converts into visible objects what would, without him, remain walled up in the separate life of each consciousness: the vibration of appearances which is the cradle of things.' "[58]

Cézanne is a life changer.

Robert Bresson stopped painting and turned to filmmaking because of Cézanne. "Painting is over," he told an interviewer in 1996. "There is nowhere to go. I don't mean after Picasso, but after Cézanne. He went to the brink of what could not be done."[59] At the very same moment, after seeing a centenary retrospective at the Tate, Lucian Freud said that what affected him most was Cézanne's "being able to do things which I thought were undoable. It's heartening." Three years later, Freud bought himself a small Cézanne, the brothel picture entitled *Afternoon in Naples* (1876–77), and set about painting his own, much larger version, *After Cézanne* (2000).[60] After Cézanne, he declared his intention to paint himself to death. In 2011 he succeeded.

R. B. Kitaj persevered because of Cézanne. For Kitaj, Cézanne was the Man.

"When you fall in love with one person above all others, that love makes special claims on you. In that way, the mysterious way of love, Cézanne singles me out. Artists create their precursors, said a sage. Cézanne's last three great *Bather* pictures excite me more than any other art except Kafka's three novels. Both of these trios were left unfinished/finished at the death of their makers. Cézanne's lessons appear endless to me, encyclopedic like, say, Shakespeare or Beethoven."[61]

We shall never have done with Cézanne. I can think of no higher praise.

Acknowledgments

In the course of this adventure I have accumulated many debts. I am grateful to the following:

For encouragement and assistance in the quest: Wayne Andersen, Aline d'Aquilante, Stephen Bann, Alice Bellony, Jed Boardman, Ruth Butler, Faya Causey, Blandine Chambost, Harry Cooper, Denis Coutagne, Elizabeth Cowling, Ann Dumas, John Elderfield, Bruno Ely, Walter Feilchenfeldt, Jack Flam, Catherine Gegout, the late John Golding, Christine Guth, Michael Howard, the late John House, Polly Howells, Jasper Johns, Richard Kendall, Ross King, Debbie Lisle, Christopher Lloyd, Pavel Machotka, Marilyn McCully, Aya Louisa McDonald, Patrick McGuinness, Sandy Nairne, Anne Norton, Jorgelina Orfila, Michael Peppiatt, Joachim Pissarro, Lionel Pissarro, Michael Raeburn, Malika Rahal, Daphne Ratcliffe, Elisabeth Reissner, Bettina Renz, Christopher Riopelle, Adelheid Scholten, Michael Sheringham, Richard Shiff, Patterson Sims, Paul Smith, Michael Snow, Paul Stoop, Michael Sullivan, Kathryn Tuma, Alicia Volk, Jayne Warman, and Eric Werthman.

For permission to quote from their work: Alfred A. Knopf, for an extract from *The Beauty of the Husband* by Anne Carson, copyright © 2001 by Anne Carson. Used by permission of Alfred A. Knopf, a division of Random House, Inc.; the Trustees of the E. E. Cummings Trust, for an extract from "After your poppied hair inaugurates" © 1973, 1983, 1991, in E. E. Cummings, *Erotic Poems* © 1973, 1983, edited by George James Firmage, used by permission of Liveright Publishing Corporation; Michael Fried, for his poem "Cézanne," in *The Next Bend in the Road* (Chicago University Press, 2004); The Allen Ginsberg Trust and the Wylie Agency (UK) Limited, for an excerpt from *Howl*, taken from *Collected Poems 1947–1997* by Allen Ginsberg; Faber & Faber and Random House, for extracts from Seamus Heaney, "An Artist" and "The Riverbank Field," in *Opened Ground* (1998) and *The Human Chain* (2010);

Cambridge University Press, for Martin Heidegger's poem "Cézanne," translated by Julian Young in *Heidegger's Philosophy of Art* (2001); Pan Macmillan, for Arthur Rimbaud's "Vowels," in Graham Robb, *Rimbaud: A Biography* (Picador, 2000); Carcanet, for an extract from Charles Tomlinson, "The Pupil," in *New Collected Poems* (2009); Faber & Faber, for an extract from Derek Walcott, *Tiepolo's Hound* (2000); Faber & Faber and Alfred A. Knopf, for extracts from "Man with a Blue Guitar" in *Collected Poems* by Wallace Stevens, copyright © 1954 by Wallace Stevens and renewed 1982 by Holly Stevens; and "Someone puts a pineapple together," in *The Necessary Angel* by Wallace Stevens, copyright © 1951 by Wallace Stevens and renewed 1979 by Holly Stevens. Used by permission of Alfred A. Knopf, a division of Random House, Inc.; Farrar, Straus and Giroux, for extracts from Rilke's *Duino Elegies* (North Point, 2000) and "The Bowl of Roses," in *New Poems 1907* (North Point, 1984), translated by Edward Snow; Oxford University Press, for extracts from Baudelaire, *The Flowers of Evil* (1998), translated by James McGowan, Lucretius, *On the Nature of the Universe* (1999), translated by Ronald Melville, Ovid, *Metamorphoses* (1998), translated by A. D. Melville, and Virgil, *The Aeneid* (1998) and *The Eclogues* (1999), translated by C. Day Lewis; Princeton University Press, for extracts from *Horace: The Odes* (2002), edited by J. D. McClatchy, translated by Rachel Hadas and Stephen Yenser.

Among scholars, curators, archivists, and librarians: Jean Edmonson of the Acquavella Galleries, New York; Christine Ekelhart at the Albertina, Vienna; the staff of the Archives nationales, Paris; Liz Kirtulik at Art Resource, New York; Colin Harrison and his colleagues at the Ashmolean Museum, Oxford; the staff of the Barnes Foundation, Philadelphia; Henri Cousseau at the École nationale supérieure des beaux-arts, Paris; the staff of the Bibliothèque nationale de France, Paris; the staff of the Bodleian Library, Oxford; Charlotte Heyman at the Bridgeman Art Library, London; the staff of the Bührle Collection, Zurich; Stephanie Buck, Nancy Ireson, and Barnaby Wright at the Courtauld Institute, London; the staff of the Fondation Custodia, Paris; the staff of the Musée Maurice Denis, Saint-Germain-en-Laye; Peter Greenhalgh and his colleagues at the Fitzwilliam Museum, Cambridge; the staff of the Villa Flora, Winterthur; the staff of the Getty Research Institute, Los Angeles; Bruno Ely, Bernard Terlay, and their colleagues at the Musée Granet, Aix; the staff of the Hallward Library, University of Nottingham; Anne Dulau and her colleagues at the Hunterian Art Gallery, Glasgow; Maria Kalligerou at the Institute for Conservation, Oxford; Sandra Gianfreda at the Kunstmuseum Winterthur; the staff of the Musée des lettres et manuscrits in Brussels and Paris; the staff of

the Archives du Louvre, Paris; Philippe Ferrand and his colleagues at the Bibliothèque Méjanes, Aix-en-Provence; Asher Miller, Gary Tinterow, and their colleagues at the Metropolitan Museum of Art, New York; Matthias Herold, Cora Rosevear, Jennifer Schauer, and their colleagues at the Museum of Modern Art, New York; the staff of the National Art Library, London; Beth McIntyre at the National Museum of Wales, Cardiff; Christopher Riopelle and his colleagues at the National Gallery, London; Anne Halpern, Jean Henry, Ann Hoenigswald, Kimberly Jones, and their colleagues at the National Gallery of Art, Washington, D.C.; Sandy Nairne and his colleagues at the National Portrait Gallery, London; the staff of the Musée d'Orsay, Paris; the staff of the Pavillon de Vendôme, Aix-en-Provence; Susan Anderson, Adrianne Bratis, Joe Rishel, Kathy Sachs, Jenny Thompson, and John Vick at the Philadelphia Museum of Art, Philadelphia; Renée Maurer, Eliza Rathbone, and Karen Schneider at the Phillips Collection, Washington, D.C.; Alyssia Banon at the Lionel and Sandrine Pissarro Archives, Paris; the staff of the Musée Pissarro, Pontoise; the staff of the Harry Ransom Research Center for the Humanities, Austin, Texas; Madeleine Gerber and her colleagues at the Oskar Reinhart Collection, Winterthur; the staff of the Rosengart Collection, Lucerne; the staff of the Hyman Kreitman Research Centre at the Tate, London; the staff of the Wildenstein Institute, Paris; Françoise Antiquario at the Centre d'Études sur Zola et le naturalisme, Paris.

Caroline Girard for research assistance in Paris.

Andrew Gordon and Bruce Hunter, at David Higham Associates in London, and Michael Carlisle at Inkwell Management in New York, for professional counsel and moral support.

Deborah Garrison at Pantheon in New York and Daniel Crewe at Profile in London, for the personal interest they have taken in this book, their close reading, and their sympathetic editing. Caroline Zancan at Pantheon for expert assistance with the manuscript and the illustrations.

The Warden and Fellows of St. Antony's College, Oxford, in particular Margaret MacMillan, Alex Pravda, and Avi Shlaim, for election to the Warden's Fellowship for 2009–10, an invaluable period of writing and reflection.

My colleagues in the School of Politics and International Relations at the University of Nottingham, for bearing with this project over a number of years, especially during my periodic absences.

My friend Paul Edson, a professional translator, who supervised translations from the French (and the Provençal), and did his level best to save me from extravagances in the English. I have tried as far as possible to work from

the original documents throughout, in particular Cézanne's own letters. In the standard edition of his published correspondence the transcription is unreliable and the translation often wanting. A selection of letters recently transcribed and annotated by Jean-Claude Lebensztejn is scrupulously done but hard to find, published by a museum journal in 2010 and a small press in 2011, in French. I am preparing an edition of the complete correspondence, in English, including a number of new discoveries. Meanwhile, much of the firsthand testimony in this book has been translated afresh, not least, Cézanne himself. Needless to say, the final responsibility for all of this remains mine alone.

My ideal readers, Dee Danchev, Paul Edson, and John Golding, who read the whole work in manuscript. For this labor—truly a labor of love—I am deeply grateful.

And an acknowledgment of a different sort: Paul Valéry, on Stendhal, whose concluding flourish I have borrowed for my own.

Abbreviations

AN	Archives nationales, Paris
Andersen	Wayne Andersen, *Cézanne's Portrait Drawings* (Cambridge, MA: MIT, 1970)
BL	British Library, London
BM	British Museum, London
BM	*The Burlington Magazine*
BN	Bibliothèque nationale, Paris
C/Chappuis	Adrien Chappuis, *The Drawings of Paul Cézanne: A Catalogue Raisonné* (Greenwich, CT: New York Graphic Society, 1973)
Cézanne & Pissarro	Joachim Pissarro, *Pioneering Modern Painting: Cézanne & Pissarro, 1865–1885* (New York: MoMA, 2005)
Conversations	Michael Doran (ed.), *Conversations avec Cézanne* (Paris: Macula, 1978)
Corr.	Paul Cézanne, *Correspondance,* ed. John Rewald [1937] (Paris: Grasset, 1978)
Courtauld	Stephanie Buck et al., *The Courtauld Cézannes* (London: Courtauld, 2008)
GBA	*Gazette des beaux-arts*
Granet	Musée Granet, Aix-en-Provence
Letters	Paul Cézanne, *Letters,* ed. John Rewald [1941] (New York: Da Capo, 1976)
Lettres	Paul Cézanne, *Cinquante-trois lettres,* ed. Jean-Claude Lebensztejn (Paris: L'Échoppe, 2011)
Louis-Auguste	Louis-Auguste Cézanne (his father)
Marie	Marie Cézanne (his elder sister)
Méjanes	Bibliothèque Méjanes, Aix-en-Provence
Met	Metropolitan Museum of Art, New York
MFA	Museum of Fine Arts, Boston
MNAM	Musée national d'art moderne, Paris
MoMA	Museum of Modern Art, New York

Monsieur Paul Cézanne	Archives départmentales des Bouches-du-Rhône, *Monsieur Paul Cézanne, rentier, artiste-peintre* (Marseille: Images en Manœuvres, 2006)
NAF	Nouvelles Acquisitions françaises (BN manuscripts)
NG	National Gallery, London
NGA	National Gallery of Art, Washington, D.C.
NRF	*Nouvelle revue française*
NYRB	*New York Review of Books*
OC	*Œuvres complètes*
Orsay	Musée d'Orsay, Paris
Paul	Paul Cézanne *fils* (his son)
P/*Pissarro*	Joachim Pissarro and Claire Durand-Ruel Snollaerts, *Pissarro: Critical Catalogue of Paintings,* 3 vols. (Milan: Skira, 2005)
Pavillon	Pavillon de Vendôme, Aix-en-Provence
Phillips	Phillips Collection, Washington, D.C.
Pissarro, *Corr.*	*Correspondance de Camille Pissarro,* ed. Janine Bailly-Herzberg, 5 vols. (Paris: Presses universitaires de France, 1980–91)
PMA	Philadelphia Museum of Art
RA	Royal Academy, London
R/Rewald	John Rewald, *The Paintings of Paul Cézanne: A Catalogue Raisonné* (New York: Abrams, 1996)
Rewald, *Cézanne-Zola*	*Cézanne: sa vie, son œuvre, son amitié pour Zola* (Paris: Albin Michel, 1939)
Rilke, *Letters*	*Letters on Cézanne,* trans. Joel Agee (New York: North Point Press, 2002)
Rose	Rose Cézanne (his younger sister)
RWC	John Rewald, *Paul Cézanne: The Watercolors* (Boston: Little, Brown, 1983)
Tate	*Cézanne* (London: Tate, 1996)
V/Venturi	Lionello Venturi, *Cézanne: son art—son œuvre* [1936] (San Francisco: Wofsy, 1989)
Zola, *Corr.*	Émile Zola, *Correspondance,* ed. B. H. Bakker, 10 vols. (Montréal: Presses de l'université de Montréal/Paris: Éditions du CRNS, 1978–95)

Notes

Short titles in the Notes are shown in full in the Bibliography. The most commonly used of these short titles are listed in the Abbreviations. They refer to the original French editions, as for example Cézanne's *Correspondance* (*Corr.*) or his *Conversations*. All translations by the author, unless otherwise indicated.

Prologue: The Right Eyes

1. Renard diary, 21 October 1904, in *Journal* (Arles: Actes Sud, 2008), p. 908. Cf. Louis Vauxcelles, "Le Salon d'automne," *Gil Blas,* 14 October 1904.
2. Ratcliffe, "Working Methods," p. 135.
3. See Salmon, *Souvenirs,* vol. 3, p. 176.
4. "The Salon d'automne" [1907], in *Apollinaire on Art,* p. 20. Rouault was a member of the selection committee.
5. Maurice Denis, "Cézanne" [1907], in *Conversations,* p. 167. This article was originally published in *L'Occident* (September 1907) and reprinted in his *Théories* (1912, 1920, 1964). It first appeared in English in two parts in *BM* (January and February 1910), translated and introduced by Roger Fry. It also appears in *Conversations* in English, pp. 166–79, in a different translation.
6. Fry, *Cézanne* [1927], p. 84.
7. *Apollinaire on Art,* p. 21.
8. Ibid. p. 23. Jean-Henri Jansen, of Maison Jansen, interior design, was executive director of the Salon d'automne.
9. Camille Mauclair, "Le Salon d'automne," *La Revue bleue,* 12 October 1907. And again, in *L'Art décoratif* (November 1907), p. 163.
10. *Apollinaire on Art,* p. 18.
11. See, e.g., André Pérate, "Le Salon d'automne," *GBA* (November 1907), pp. 387–88. This article is itself illustrated by a number of Druet photographs.
12. Matisse to Marquet, n.d. [September 1904], in *Matisse-Marquet*; Bernard, "Cézanne" [1904], in *Conversations,* pp. 38–39.
13. In *Mercure de France,* 1 August 1905, pp. 353–54.
14. Bernard, "Memories," in *Conversations,* pp. 51–79. First published as "Souve-

nirs de Paul Cézanne" in *Mercure de France*, 1 and 16 October 1907, and much reprinted (1912, 1921, 1925 or 1926); and in *Conversations*, pp. 49–80.

15. Zola, *Correspondance*, vol. 1, *Lettres de jeunesse* (Paris: Fasquelle, 1907), comprising letters to Cézanne, Baille, and Roux. Vol. 2, *Les Lettres et les arts* (1908), contains further news of Cézanne in the letters to Coste, Guillemet, and Valabrègue.

16. Cf. Vollard, *Écoutant*, p. 102, quoting Cézanne on Clemenceau: *"Il a du 'temmpérammennte,' mais . . .".* Cézanne himself was not above playing on his accent: see, e.g., *"Ingres, malgré son estyle (pronunciation aixoise) . . . n'est qu'un très petit peintre."* Cézanne to Bernard, 25 July 1904, in *Corr.*, p. 381.

17. Cézanne to Camoin, 22 February 1903, in *Corr.*, p. 367. Couched as part of his credo.

18. Cézanne to Bernard and Roger Marx, 25 July 1904 and 23 January 1905, in *Corr.*, pp. 381, 390–91.

19. Maurice Sterne, *Shadow and Light* (New York: Harcourt, Brace, 1952), p. 43 (giving the exclamations in French).

20. See Rewald, *Cézanne and America*, p. 98, citing Abraham Walkowitz.

21. Max Weber interviewed by Carol S. Gruber, 1958, Columbia University Oral History Research Office, no. 324, pp. 118–20.

22. Ibid., p. 230. This was one of three *Large Bathers* (R857), now in the PMA. Also in the retrospective was R855, now in the NG. See ch. 12.

23. Huneker to Charles G. Rosebault, 25 December 1907, in *Letters of James Gibbons Huneker* (New York: Scribner's, 1922), p. 76.

24. Sickert, "Post-Impressionists" [1911], in Anna Gruetzner Robins (ed.), *Walter Sickert: The Complete Writings* (Oxford: Oxford University Press, 2000), p. 278.

25. Rilke to Clara, 10 October 1907, in Rilke, *Letters*, pp. 38–39.

26. Rilke to Clara, 12 October 1907, in Rilke, *Letters*, p. 42.

27. See Geffroy, *Monet*, p. 328, dating from 1895–96. Among other things a jest by Cézanne, who was steeped in the classics, punning on Priam's lost son Paris and the golden apple of Greek myth; at the same time, perhaps, a comment on lack of recognition in official circles, and an acknowledgment of how closely he was identified with apples—and how much they meant to him. Cf. Cézanne's *Amorous Shepherd* (*The Judgment of Paris*, c. 1883–85).

28. Léger to André Mare, 1907, in Dorothy Kosminski (ed.), *Fernand Léger* (New York: Prestel, 1994), p. 40, of R710; Léger to Léonce Rosenberg, 6 September 1919, in *Les Cahiers du MNAM, hors-série* (1996), p. 59; Georges Banquier, "L'Atelier Léger," in François Mathey, *Fernand Léger* (Paris: Hazan, 1956), p. 20. On the *Card Players*, see ch. 7.

29. Braque interviewed by André Verdet, "Rencontre," p. 14.

30. Arishima, "The Painter Paul Cézanne," *Shirakaba* 1 (1910), esp. p. 41.

31. Gertrude Stein, *Lectures in America*, p. 76.

32. D. S. MacColl, *Life, Work and Setting of Philip Wilson Steer* (London: Faber, 1945), p. 142. On *The Black Clock* (R136), see ch. 4.

33. On Shchukin's pastime, "Matisse Speaks" [1951] in *Matisse on Art*, p. 203. Giacometti saw a similar parallel.

34. Blanche, *Propos de peintre,* p. 191.

35. Christian Zervos, "Conversation avec Picasso" [1935], in Picasso, *Propos sur l'art* (Paris: Gallimard, 1998), p. 36. Picasso had been studying Cézanne for at least thirty years, as he himself insisted.

36. Merleau-Ponty, "Le doute de Cézanne" [1945], in *Sens et non-sens,* pp. 15–49. "Cézanne's Doubt" has achieved classic status. It entered the Anglo-American literature in *Sense and Nonsense* (1964). Merleau-Ponty speaks variously of *"une constitution morbide," "la constitution schizoïde,"* and *"l'être schizoïde."*

37. Daniel Rothman, *Cézanne's Doubt* (New World Records, 1997), a chamber opera for solo voice, clarinet, trumpet, and cello, with audio and video processing. According to Rothman, the work was inspired by Merleau-Ponty's essay; it draws on Rilke's *Letters on Cézanne,* the artist's own letters, and Baudelaire's poem "Une Charogne," which Cézanne knew by heart. See ch. 1.

38. Denis, "Cézanne," and Bernard, "Souvenirs," in *Conversations,* pp. 167 and 51; Zola, *Le Ventre,* p. 50; Geffroy, "Paul Cézanne," in *La Vie artistique,* vol. 6, p. 218.

39. See, e.g., André Salmon, *La Jeune Peinture française* (Paris: Trente, 1912), p. 43.

40. Lawrence, "Introduction" [1929], in *Selected Critical Writings,* p. 261.

41. Matisse to Raymond Escholier, 10 November 1936, in *Matisse on Art,* p. 124. *Three Bathers* (R360) is dated c. 1876–77. For more on the *Bathers,* see ch. 12.

42. Interviews with Jacques Guenne (1925) and André Marchand (1947), in *Matisse on Art,* pp. 80 and 175.

43. Rilke to Clara, 23 October 1907, in Rilke, *Letters,* pp. 74–75. See Self-Portrait 3 in this book.

1: The Dauber and the Scribbler

1. Gasquet, *Cézanne,* p. 35.

2. Zola entered the Collège Bourbon as a boarder in the eighth grade in 1852; the following year he leapt a grade and entered the sixth grade as a half-boarder.

3. Zola, *La Confession,* p. 140.

4. Gasquet, *Cézanne,* p. 35. Gasquet's *Cézanne* is one of the prime sources on the life of the artist, and also one of the most problematical. Slippages in time, smuggled borrowings from other sources, and the author's own intrusive voice combine to raise serious questions about authenticity and veracity. Clearly it should be treated with caution. Here, for example, *"un chic type"* does not ring true, either as a sample of Cézanne's vernacular or as a description he would offer of Zola. For the mature Cézanne, *chic* was not a compliment or a casual figure of speech but a term of abuse—picked up, perhaps, from his beloved Baudelaire—an understanding he shared with Zola. In other words, Gasquet's *Cézanne* is indeed *Gasquet's* Cézanne. Yet it seems to me that it cannot be ignored, as testimony, as a document of its time, and as part of the foundations of the afterlife. Gasquet's acquaintance with the artist dated from 1896. Over the next three years he saw a lot of Cézanne, but not thereafter. According to his wife, his account was written in 1912–13. It was published in 1921 and reprinted in 1926. It has been pillaged ever since. It was belatedly translated

into English as *Joachim Gasquet's Cézanne* in 1991, subtitled "a memoir with conversations." The conversations are extensive (fueling the evidentiary controversy); they appear in *Conversations* in English, pp. 108–60, in a different translation.

5. Lawrence, "Introduction," pp. 267, 278 (his emphasis).

6. Zola, *Madeleine Ferat*, in *OC*, vol. 1, pp. 727–28.

7. Zola, *La Confession*, p. 134.

8. Zola, *L'Œuvre*, pp. 93–94, corroborated in general terms by his letter to his mother of 13 April 1856. See Brown, *Zola*, p. 38.

9. Brown, *Zola*, p. 21.

10. Alexis, *Zola*, p. 23.

11. Cézanne to Zola, 7 December 1858, in *Corr.*, p. 50. "Boileau! A eunuch! A poet who sees nothing in a verse but a caesura and a rhyme." Zola to Cézanne, 16 January 1860, in Zola, *Corr.*, p. 131. Zola was fond of this trope: later, Monet was a man in a crowd of eunuchs (*Écrits*, p. 122).

12. Borély, "Cézanne à Aix," in *Conversations*, p. 21; Cézanne to Aurenche, 3 February 1902, in *Corr.*, p. 355.

13. Virgil, *Aeneid*, book 6: 566–69.

14. Zola, *L'Œuvre*, p. 93.

15. Cézanne to Zola, 9 July 1858, in *Corr.*, p. 37. See also 3 May 1858.

16. Zola, "Alfred de Musset," in *Documents littéraires* [1881], pp. 87–90; Alexis, *Zola*, p. 32. For the mature Cézanne on Hugo, see Bernard, "Souvenirs," in *Conversations*, p. 71.

17. Zola, "Musset," pp. 91, 94.

18. Musset, "Ballade à la lune," in *Poésies complètes* (Paris: Gallimard, 1957), pp. 183–85.

19. Borély, "Cézanne à Aix," in *Conversations*, p. 20. See ch. 11.

20. Samuel Beckett, trans. David Wheatley, *Selected Poems* (London: Faber, 2009), pp. 69–105. The *mirlitonnades* date from the 1970s. On Beckett and Cézanne, see ch. 11.

21. Cézanne to Zola, 13 April (continued from 9 April) 1858, in *Corr.*, pp. 23–25, correcting the punctuation from the original. This rather literal version follows Wayne Andersen's translation in *Youth*, pp. 39–41, with a few modifications. Cézanne's meaning is abundantly clear, but his word *sapière* seems to be either a pun or a misspelling (*rapière* is rapier, *sapience* is wisdom, *sapinière* is a tree plantation or nursery). Lindsay, *Cézanne*, p. 24, offers a rhymed version, deliberately archaic.

22. Cézanne to Paul, 13 September 1906, in *Corr.*, p. 408.

23. It also contained the article on Wagner and *Tannhäuser*. Cezanne was especially fond of the pieces on Delacroix. Cf. Cézanne to Paul, 28 September 1906, in *Corr.*, p. 412.

24. Larguier, *Le Dimanche* [1925], in *Conversations*, pp. 13–14. Larguier got to know Cézanne during his military service in Aix in 1900–02. The edition he mentions was a paperback published in 1899. Cézanne's taste in literature was not automatically shared, even with Zola, who was no fan of Baudelaire.

25. Baudelaire, *Flowers*, pp. 22–23.

26. Marie to Paul, 16 March 1911, in Mack, *Cézanne*, p. 21; Cézanne to Paul, 12 August 1906, in *Corr.*, p. 401.

27. Gasquet, *Cézanne*, pp. 338–39. Renoir did a portrait of Wagner.

28. Cézanne, "Mes Confidences," in *Conversations*, p. 24; Mack, *Cézanne*, p. 23, who had it from Marie Gasquet herself. Cézanne's friend Marion would have been familiar with Weber through his own friend Heinrich Morstatt, a German musician (and an admirer of Wagner, who was in his turn an admirer of Weber). A voluminous life of Weber by his son appeared in 1864–66, at the very time of Cézanne's purported interest in Wagner. *Young Girl at the Piano* is R149. Cf. Andersen, *Youth*, pp. 400–05; Lewis, *Early Imagery*, pp. 186–92.

29. Bernard, "Souvenirs," in *Conversations*, p. 64.

30. Ibid., pp. 64–65; Vollard, *Écoutant*, p. 51; Aurenche, *Souvenirs*, p. 63.

31. Alexis, *Zola*, p. 31; Lindsay, *Cézanne*, p. 13, citing Henri Gasquet; Gasquet, *Cézanne*, pp. 34–35.

32. *Monsieur Paul Cézanne*, pp. 36–47; Provence, "Cézanne collégien," pp. 824–27. This list corrects Provence's account in one or two particulars, from the records of the Collège Bourbon.

33. Zola to Cézanne, 30 December 1859, in Zola, *Corr.*, vol. 1, p. 119. See also the interesting letter of 1 August 1860, on Cézanne as poet.

34. Rilke to Lou Andreas-Salomé, 10 August 1903, in Rainer Maria Rilke and Lou Andreas-Salomé, trans. Edward Snow and Michael Winkler, *The Correspondence* (New York: Norton, 2006), p. 78.

35. Elder, *Giverny*, p. 49. Fry, too, was impressed by the affinity between them: see his *Cézanne*, p. 83. Cézanne mentions rereading Flaubert in the 1890s; and if Gasquet is to be relied upon, he frequently adverted to Flaubert in his conversation.

36. Francis Steegmuller, *Maupassant* (London: Collins, 1950), p. 62; Guy de Maupassant, "Étude sur Gustave Flaubert," in *Oeuvres posthumes* (Paris: Conard, 1930), p. 96.

37. Cézanne to Zola, 19 November [?] 1858, in *Corr.*, p. 44 (variously dated 17 and 23 November by Rewald); Bernard, "Souvenirs," in *Conversations*, p. 65.

38. Zola to Cézanne, 16 April 1860, in *Corr.*, p. 91.

39. Cézanne to Zola, quoted in Zola to Baille, 14 January 1860, and Zola to Cezanne, 16 January 1860, in Zola, *Corr.*, pp. 128 and 130. Michelet's *L'Amour* exercised a powerful influence. The full title must have appealed to Cézanne: *L'Affranchissement moral par le véritable Amour* (Moral emancipation through true Love).

40. Cézanne to Zola, 20 November 1878, in *Corr.*, p. 223. He also read Balzac's celebrated panegyric "Études sur M. Beyle," in the *Revue parisienne*, 25 September 1840, reprinted in *Œuvres diverses*, vol. 3 (Paris: Conard, 1910), pp. 371–405; and Zola's own study, "Stendhal," in *Le Messager de l'Europe*, May 1880, reprinted in *OC*, vol. 11, pp. 67–95, which he pronounced "very fine." See Cézanne to Coste, July 1868, and to Zola, June 1881, in *Corr.*, pp. 167 and 252.

41. Valéry, "Stendhal" [1927], in *Masters and Friends*, pp. 185–87.

42. Gasquet, *Cézanne*, pp. 337, 340.

43. See, e.g., Zola to Cézanne, 25 June 1860, in *Corr.*, p. 103.

44. Cézanne to Bernard, 25 July 1904, in *Corr.*, p. 381. He followed Delacroix in this assessment. Cf. Delacroix journal, 26 May 1858, in *Journal* [1893–95], vol. 2, pp. 1243–44, a work Cézanne must have known well.

45. Zola, "Les Peintres impressionistes" [1877] and "Le Naturalisme au Salon" [1880], in *Écrits*, pp. 358 and 423.

46. Zola to Cézanne, 25 June 1860, in Zola, *Corr.*, p. 191. Zola to Cézanne, 16 April 1860, suggests things withheld, or at least unwritten ("Again you say that sometimes you don't have the courage to write to me . . . "). Zola, *Corr.*, vol. 1, p. 146.

47. Zola to Cézanne, 14 June 1858, in *Corr.*, vol. 1, p. 96.

48. Valéry, "About Corot," in *Masters and Friends*, p. 140.

49. Cézanne to Zola, 9 April 1858, in *Corr.*, p. 22.

50. Cézanne to Zola, 9 April 1858, in *Corr.*, p. 21.

51. See Cézanne to Roux, n.d. [a draft, c. 1878], in *Corr.*, p. 226.

52. Zola to Cézanne, n.d. [c. 20 July 1858], in Mitterand, *Zola*, vol. 1, pp. 839–41. This letter also contains examples of Zola's versifying and rhyming, in response to the offerings in Cézanne's letter of 9 July 1858, in *Corr.*, pp. 35–40. They are indeed inferior, as Zola himself concedes.

53. Virgil, *Eclogues*, 1: 36–39. See also ch. 11.

54. *Eclogues*, 1: 67–68.

55. Cézanne to Alexis, 15 February 1882, in *Corr.*, pp. 256–57 (my emphasis).

56. Zola to Léon Hennique, 29 June 1877, in Zola, *Corr.*, vol. 3, p. 74.

57. Cézanne to Zola, 9 July and 19 November 1858, in *Corr.*, pp. 38 and 46. The couplet is from the lengthy poem "Dream of Hannibal." For *Infandum* in Virgil, see, e.g., *Aeneid*, book 2: 3–6.

58. Zola to Cézanne, 30 December 1859, in Zola, *Corr.*, vol. 1, p. 120. Cézanne's reply has not survived.

59. Zola to Cézanne, 25 March 1860, in *Corr.*, pp. 88–89.

60. Zola to Cézanne, 9 February and 25 June 1860, in *Corr.*, pp. 81 and 103.

61. Zola to Cézanne, 20 May 1866, in *Corr.*, pp. 148–49.

62. Caillot, vol. 1, is inscribed, *"1er prix de version Latine 1854"*; vol. 2, *"Souvenir de jeunesse de Cézanne trouvé chez sa sœur Marie."*

63. See Loran, "Cézanne's Country" [1930], p. 536. The author collected these stories in Aix in 1926–29. Jayne Warman confirms that his widow and son had removed all works of art from his studio at Les Lauves within five weeks of his death. There remained, however, 29 paintings and 187 watercolors (and an unknown number of books) in his house in Aix. "Natures mortes," in *Jas de Bouffan*, p. 16.

64. Provence, "Les prix," pp. 821–22; Reff, "Reproductions and Books," p. 307; Ely, "The Studio," in *Atelier Cézanne*, pp. 108–09. There is also a sketchbook, preserved in his studio in Aix, which contains some drawings in a similar style.

65. Valabrègue to Zola, 2 October 1866, in R99 (translation modified). For Valabrègue's experience, see ch. 4.

2: *Le Papa*

1. Rougier in Charensol, "Aix et Cezanne" [1925], p. 8; "Témoinage Cézanne," Pavillon, testimony gathered by Marcel Provence, in this instance from the daughter of Madame Décanis, proprietor of the Magasin des Vins in the Place des Trois Ormeaux, frequented by Cézanne's housekeeper. Rougier lived opposite Cézanne in the Rue Boulegon. That bonfire followed the forced sale of the Jas de Bouffan: see ch. 11. Gasquet mentions a (different?) bonfire of some thirty works.

2. Cézanne to Zola, 19 December 1878, in *Corr.*, p. 224.

3. The mock signature summoned a majestic Ingres in the Musée Granet in Aix, *Jupiter and Thetis* (1811). Poussin had done *The Four Seasons* two centuries earlier, in 1660–64.

4. Coquiot, *Cézanne* [1914], p. 42. Contrary to this account, it was in fact a male nude. Coquiot is not always reliable, but he was quick on the scene, and pertinacious, and able thereby to secure some choice scraps of reminiscence.

5. Bénédite report, 25 November 1907, Archives du Louvre, P30, translated in Mack, *Cézanne*, pp. 145–47. In the order mentioned: *Portrait of Louis-Auguste Cézanne* (R95), *The Four Seasons* (R4–7), *The Game of Hide-and-Seek, after Lancret* (R23), *Romantic Landscape with Fishermen* (R34–41), *The Bather by the Rock* (R29), *Christ in Limbo* (R145, a copy after Sebastiano del Piombo—even Bénédite nods), *Contrast* (R155), *Misery* (R146), *Portrait of Achille Emperaire* (R141). They were executed at different times over a period of several years; according to Rewald, between 1860 and 1870, though the dating of individual works is for the most part very uncertain, as Rewald himself indicates. The Jas was owned, not by the Maréchal de Villars, the regional governor in the second half of the eighteenth century, but by several generations of the Truphème family, whose arms appear in stucco work in the house. Joseph Julien Gaspard Truphème occupied the position of regional muster master, or military enrollment officer, in the same period, whence perhaps the confusion. See Boyer, "True Story."

6. Fry to Vanessa Bell, 29 November 1919, in Denys Sutton (ed.), *Letters of Roger Fry* (London: Chatto & Windus, 1972), vol. 1, pp. 473–74. Vollard bought *The Four Seasons* from Georges Bernheim for 75,000 francs in 1923, and left them to the Petit Palais in Paris.

7. Quinn to Arthur B. Davies, 2 October 1923, in R95. Later still—after the Second World War—the young Richard Hamilton was told by his teacher at the Royal Academy Schools, "Augustus John knocks spots off Cézanne!"

8. Gasquet, *Cézanne*, p. 27.

9. Coquiot, *Cézanne*, p. 14.

10. Guillemet to Zola, 2 November 1866, in Baligand, "Lettres inédites," pp. 179–80. See also Guillemet to Pissarro, in Cézanne to Pissarro, 23 October 1866, in *Corr.*, p. 161. This portrait is R101. There is a cryptic reference to the Pope and *Le Siècle* in a letter from Zola to Cézanne six years earlier (Zola, *Corr.*, vol. 1, p. 119). It is tempting to think that they shared a joke about Cézanne's father, but this seems to be a reference to contemporary politics.

11. Valabrègue to Zola, [September 1865], in Rewald, *Cézanne-Zola,* p. 103, reporting Cézanne's conversation.

12. Vollard, *Écoutant,* p. 105. It is impossible to be sure of the veracity of such an exchange. Louis-Auguste's remark sounds absolutely authentic; Vollard himself notes that the riposte was a little out of character for Cézanne.

13. Zola, "Le Jury" [27 April 1866] and "M. Manet" [7 May 1866], in *Écrits,* pp. 95 and 118. "Mediocrity" is a key term in Flaubert.

14. Zola, "À mon ami" [20 May 1866], in *Écrits,* p. 90.

15. Vollard, *Écoutant,* p. 40.

16. Cézanne to Pissarro and Zola, 23 and c. 19 October 1866, in *Corr.,* pp. 159 and 158.

17. Guillemet to Zola, 2 November 1866, in Baligand, "Lettres inédites," p. 180. Coquiot records more vituperation directed at passers-by while he painted (p. 131).

18. R93, dated 1865–66, measuring 30 x 41 cm. This painting appears to have been owned by Zola (a gift from the artist), though the inventory of Zola's collection of Cézannes is marvelously unclear.

19. See Zola to Solari, 30 August 1869, in Zola, *Corr.,* vol. 2, p. 204.

20. Antonini and Flippe, *La Famille Cézanne,* p. 15.

21. Mack, *Cézanne,* p. 6; *Histoire d'Aix,* in Ely, "Pater Omnipotens," p. 28.

22. Acte de mariage, 29 January 1844, in *Monsieur Paul Cézanne,* pp. 20–22. Louis-Auguste is still identified as a hatter in documents of 1839.

23. Contrat de mariage, 10 January 1844, in *Monsieur Paul Cézanne,* pp. 24–28.

24. Cézanne to Zola, n.d. [c. 19 October 1866], in *Corr.,* pp. 156, 158. The full page of the letter is reproduced in Chappuis (C151); the sketch in Rewald (R100), who suggests that the painting was probably destroyed by the artist.

25. Coquiot, *Cézanne,* p. 16.

26. Ely, "Pater Omnipotens," p. 38; Coquiot, *Cézanne,* p. 98.

27. Louis-Auguste to Gachet, 10 August 1873, in *Corr.,* pp. 182–83. Gachet had studied medicine in Montpellier; apparently he met Louis-Auguste on a visit to Aix in 1858. He saw a good deal of Cézanne in Pontoise with Pissarro in the early 1870s. This translation follows Andy Millar's sympathetic rendition in Ely, "Pater Omnipotens," p. 26, with one or two minor alterations.

28. Alexis to Zola, 13 February 1891, in *Naturalisme pas morte,* p. 400, reporting a conversation with Cézanne.

29. See Zola to Cézanne, 30 December 1859, in Zola, *Corr.,* vol. 1, p. 120. This has been taken as straight quotation from Louis-Auguste, but it is more likely to be Zola "voicing" Louis-Auguste.

30. Zola, *Rougons,* pp. 85, 88.

31. Zola manuscripts, BN NAF 10280, folios 4 and 19.

32. Flaubert to Zola, 3 June [1874], in Flaubert, *Corr.,* vol. 4, p. 805.

33. Zola, *Conquête,* pp. 114–15. Especially given Zola's precoccupation with heredity, it is interesting to find Marthe saddled with *"une inquiétude nerveuse,"* à la Lantier.

34. Ibid., p. 147.

35. Vollard, *Écoutant,* p. 79.

36. Ibid., p. 95. It is now clear that many of Cézanne's copies and studies were from reproductions or illustrations, rather than the works themselves, even where the original was readily accessible in Paris. He also consulted the *Musée des Familles* and the *Journal des Demoiselles* (taken by his sister); several volumes of these remain in his studio. It is equally clear that he drew inspiration from the text as well as the images; Flaubert, for example, was serialized in *L'Artiste* (see ch. 3).

37. Vollard, *Écoutant,* p. 220. On one visit, something evidently went wrong, and Renoir left suddenly, complaining of the atmosphere that prevailed in the house. See Renoir to Monet, February 1888, in Renoir, *Écrits,* p. 138.

38. Marchutz to Rewald, 21 January 1936, Rewald Papers, 51–6, NGA. This letter is a detailed account (in a mixture of French and German) of Marchutz's interview with Marthe Conil (1882–1969): a rare statement, offering compelling insights into the outlook and influence of Cézanne's mother.

39. M.C. [Marthe Conil], "Quelques Souvenirs," p. 301.

40. See Cézanne to Zola, 14 September 1878, in *Corr.,* p. 219. Louis-Auguste was then eighty.

41. *Kiss of the Muse* was exhibited at the Salon of 1857. Cézanne's copy (R9) is dated c. 1860.

42. Marie to Paul, 16 March 1911, translated in Mack, *Cézanne,* p. 16. Rembrandt was not called Paul. This appears to be Marie's mistake rather than her mother's.

43. Coquiot, *Cézanne,* p. 159. At this time, Coquiot apparently spotted three Cézannes in the dining room: the Sainte-Victoire, a youthful copy, and a picture of a young girl looking at a bird in a cage.

44. Marie to Paul, loc. cit., pp. 15–16.

45. Couture, *Méthode,* p. 266. Cézanne mentioned Couture approvingly to a number of visitors, and quoted his precepts in a letter to Camoin (13 September 1903, in *Corr.,* p. 371).

46. Cézanne to Camoin, 3 February 1902, in *Corr.,* p. 353. See also his reminiscence of Henri Gasquet's mother, and the family resemblance or transmission ("*la mère de la sagesse que tu représentes*"): Cézanne to Gasquet, 23 December 1898, ibid., pp. 334–35. In Cézanne's circle an encomium to one's mother was quite normal (e.g., Zola to Baille, 17 March [1861], in Zola, *Corr.,* vol. 1, p. 274).

47. Vollard, *Écoutant,* p. 57.

48. Coquiot, *Cézanne,* pp. 13–14.

49. The "Dream of Hannibal" is in Cézanne to Zola, 23 [19] November 1858, in *Corr.,* pp. 45–47.

50. Cézanne to Zola, 20 June [1859], in *Corr.,* pp. 59–61.

51. Cf. Cézanne to Zola, 30 November 1859, in *Corr.,* pp. 67–68.

52. The notes read: "14. Only the galleys entailed no fine; all the others entailed one. The fine was intended to reimburse the costs of the trial. The penalty of a fine is essentially divisible. 2ndly. Restorable; if an innocent man has been condemned, his money can be refunded. Equable and appreciable, i.e. it can be proportioned according to the income of the delinquent. How is this fine to be proportioned . . . " (translated in C46).

53. Contrary to the existing literature, he re-registered on 9 January 1860. Extracts

from the original documents are reproduced in *Monsieur Paul Cézanne*, pp. 58–59. On this subject the excellent chronology in the catalogue of the 1995–96 retrospective goes astray, adding to confusion over the timing of Cézanne's first visit to Paris. See below.

54. Zola to Cézanne, 25 June 1860, in Zola, *Corr.*, vol. 1, p. 192–93.

55. Several of his studies (or studies attributed to him) are reproduced in Ely, "L'école de dessin," together with examples by other students; two others are in Rewald, *Cézanne-Zola*, fig. 3 and 4. See also C73–78, R8, and *Impressionism*, pp. 62–63. Given the nature of the genre and the market in doubtful attributions, it is difficult to be certain about the authenticity of all this apprentice work.

56. Zola to Baille and Cézanne, 24 October 1860, and to Cézanne, 5 February 1861, in Zola, *Corr.*, vol. 1, pp. 249 and 259.

57. Kafka, *Letter to His Father*, p. 23.

58. Zola, "Manet" [1867], in *Écrits*, pp. 143–44.

59. Zola to Cézanne, 5 May 1860, in Zola, *Corr.*, vol. 1, p. 161. It is Dante's *Inferno*; but it is also a commonplace in Musset. Aurélien Houchart wrote to Zola on 19 April 1858 about "the grave and austere Pitot," of whom Zola had evidently asked for news (ibid., p. 162).

60. For the allegory of Hercules' choice, from Prodicus, see Robin Waterfield, *The First Philosophers* (Oxford: World's Classics, 2000), pp. 246–49. It was taken up in Cicero, *De Officiis*, Lucian, *The Dream*, and Xenophon, *Memorabilia*, all readily available in school editions; in Hugo and Musset; and, most conveniently, in "Le Choix d'Hercule," *Magasin pittoresque* 12 (1844), pp. 49ff., with a translation of Xenophon's text by J.-V. Le Clerc, illustrated with a woodcut after Gérard de Lairesse. The illustration is reproduced in Reff, "Cézanne and Hercules," fig. 2, together with Cézanne's treatments of Hercules. The same volume of the *Magasin pittoresque* contains two articles on the Musée d'Aix.

61. Cézanne to Zola, 7 December 1858, in *Corr.*, pp. 48–49. "The Mathematician" is probably a reference to Baille.

62. In Zola to Cézanne, 5 May 1860, in Zola, *Corr.*, vol. 1, p. 161.

63. In Zola to Cézanne, n.d. [July 1860], ibid., p. 214.

64. Zola to Cézanne, 3 March [1861], ibid., p. 271. Zola himself speculated that the visit might therefore be postponed until August. This letter, and a number of other letters, are misdated 1860 in the published edition of Cézanne's correspondence—which has led to considerable confusion about the proposed date of his long-awaited visit to Paris. The forecast date of March always referred to 1861, not 1860. The relevant letters are correctly dated in the published edition of Zola's correspondence, cited here. Gasquet purports to relate some of Gibert's conversation with Louis-Auguste, most probably invented (*Cézanne*, p. 64).

65. In Zola to Cézanne and Baille, 2 October 1860, in Zola, *Corr.*, vol. 1, p. 242.

66. Zola to Cézanne, 25 March, 16 April, 25 June, n.d. [July], and 1 August 1860, ibid., pp. 142, 146, 191, 212, and 216–17; Zola to Baille, n.d. [August 1860], ibid., p. 234.

67. Cicero, *De Officiis*, book 1, sections 21 and 32–33.

68. Zola to Cézanne, 3 March [1861], in Zola, *Corr.*, vol. 1, p. 272.

Self-Portrait: The Brooder

1. Berger, *Fictions of the Pose,* p. 359; Chapman, *Rembrandt's Self-Portraits,* p. xvii.

2. *Portrait of Paul Cézanne* (R72), dated 1862–64 by Rewald, c. 1861–62 by Gowing, possibly 1861 by Ratcliffe.

3. *Self-Portrait with Green Background* (R587), dated c. 1885, now in the Carnegie Museum of Art, Pittsburgh.

4. Gowing, *Early Years,* p. 72. Cf. Platzman, *Cézanne,* pp. 29–31. Machotka, *Cézanne,* vol. 1, p. 54, is more cautious.

3: All Excesses Are Brothers

1. Zola to Baille, 22 April 1861, in Zola, *Corr.,* vol. 1, pp. 284–85. The slight delay from March to April was caused by Rose Cézanne's illness.

2. On arrival, Louis-Auguste installed himself and his offspring (Marie came too) in a small hotel in the Rue Coquillière, in the First Arrondissement, near the Bourse.

3. Zola to Cézanne, 3 March [1861], in Zola, *Corr.,* vol. 1, p. 272; Cézanne to Huot, 4 June 1861, in *Corr.,* p. 121.

4. Zola to Baille and Cézanne, 2 October 1860, in Zola, *Corr.,* vol. 1, p. 242.

5. A. Gobin, *Fernande, histoire d'un modèle,* a work he sent to Zola in 1879, in *Les Rougon-Macquart,* vol. 4, p. 1415.

6. Zola to Cézanne, 26 April 1860, in Zola, *Corr.,* vol. 1, pp. 150–51.

7. Zola to Baille, 10 June 1861, in Zola, *Corr.,* vol. 1, pp. 293–94.

8. Cézanne to Huot, 4 June 1861, in *Corr.,* pp. 121–23 (his emphases).

9. Paul de Saint-Victor, "Salon de 1857," *La Presse,* 11 August 1857; Zola, "L'École française de peinture à l'exposition de 1878," in *Écrits,* p. 384.

10. Baudelaire, "Le chic et le poncif," *Salon de 1846,* in *Critique d'art,* vol. 1, pp. 145–46.

11. *Jacques Vingtras* was a trilogy comprising *L'Enfant* (1879), *Le Bachelier* (1881), and *L'Insurgé* (1886). *Le Bachelier,* p. 7. Cézanne was clearly stirred by this work, as he makes clear in a letter to Zola, 23 June 1879, in *Corr.,* p. 233. In the published edition of the letters, the force of his words is lost: the title is mistaken for the author, and the work itself is ignored. Zola had known Vallès since the early 1860s; he wrote an article on *Jacques Vingtras* in *Le Voltaire,* 24 June 1879, which Cézanne sought out and read.

12. Zola to Baille, n.d. [early July 1861], in Zola, *Corr.,* vol. 1, p. 299.

13. Ibid., pp. 299–303.

14. Diderot, trans. John Goodman, "The Salon of 1765," in *Diderot on Art,* vol. 1, p. 5.

15. Zola to Baille, n.d. [early July 1861], in Zola, *Corr.,* vol. 1, p. 300.

16. Quoted in Marie to Paul, 16 March 1911, in Mack, *Cézanne,* p. 434. The verse was evidently well known in the family. Vollard, *Écoutant,* p. 32, gives a variant.

17. Cézanne to Coste and Villevieille, 5 January 1863, in *Corr.,* p. 138.

18. Quoted in *Les Rougon-Macquart*, vol. 4, p. 1414, from the reminiscences of Antonin Proust.

19. Gasquet, *Cézanne*, p. 63 (and 207). Couture's *Romans* was in the Louvre. Cézanne later copied a figure from it, or a reproduction of it (C638 and 639), and kept a photograph of it in his studio.

20. See Cézanne to Coste and Villevieille, 5 January 1863, in *Corr.*, p. 137.

21. Registres des cartes d'élèves, 20 November 1863, no. 2097, and 13 February 1868, no. 278, Archives du Louvre. The registers are incomplete. We cannot tell, for example, which works from the French School were copied between 1871 and 1893; and we cannot be certain that Cézanne did not register on other occasions to make copies.

22. Chesneau, *L'Art et l'artistes*, p. 195; *Paris-Journal*, 7 May 1874, on Monet's *Boulevard des Capucines* (1873).

23. Chesneau, "L'art contemporain," *L'Artiste*, 1 April 1863, and *L'Éducation*, p. 163; Vollard, *Écoutant*, p. 85. Chesneau's quip was itself inspired by Taine's definition of a lion: "a jaw on four paws."

24. Cézanne to Zola, 7 December 1858, in *Corr.*, p. 50.

25. Zola to Cézanne, 29 September 1862, in Zola, *Corr.*, vol. 1, p. 324.

26. Rivière and Schnerb, "L'Atelier" [1905], in *Conversations*, p. 87. See also ch. 12.

27. Demande admission, 6 February 1863, AN cote AJ/52/912. I am grateful to Henri Cousseau for guidance on the documentation.

28. Vollard, *Écoutant*, p. 33, attributed to "M. Mottez" (Victor Mottez, a pupil of Ingres?).

29. Ibid., p. 57.

30. Cézanne to Coste, 27 February 1864, in *Corr.*, p. 141 (*galette* is the missing word in the published letter); Bernard, "Souvenirs," in *Conversations*, p. 55. A year earlier, he had made fun of Truphème competing for the Prix de Rome: "Don't think that I envy him" (Cézanne to Coste, 5 January 1863). Lombard was another of their circle from Aix, studying at the Atelier Signol. Cézanne is probably referring to his copy, *The Barque of Dante* (R172).

31. Vollard, *Écoutant*, p. 75, combining three of his favorite insults (*salaud*, *châtré*, and *jean-foutre*). Cf. Renoir, *Mon Père*, p. 127.

32. Rewald, *Impressionism*, p. 62. Rewald had this from Matisse, who had it from Monet.

33. Gimpel diary, 1 February, 1920, in *Journal*, p. 155; Elder, *Giverny*, p. 49; Wildenstein, *Monet*, vol. 5, p. 222. *The Abduction* (R121), dated 1867, is now in the Keynes Collection, on loan to the Fitzwilliam Museum, Cambridge; *The Negro Scipio* (R120) is now in the Museu de Arte de São Paulo. Cf. Gowing, *Early Years*, cat. 28, 30. Scipio also seems to have been the model for Solari's *Sleeping Negro*, exhibited at the Salon of 1868 and singled out for special praise by Zola in *Mon Salon*. See *Écrits*, pp. 226–27.

34. Baudelaire, "Delacroix" [1863], p. 272.

35. Alternatively, Hercules rescuing Alcestis from the Underworld. Herculean speculation notwithstanding, it seems to me that the case for Persephone is more convincing. Cf. Geist, *Interpreting Cézanne*, pp. 227–28.

36. Ovid, *Metamorphoses*, book 5: 385–93. Cayster is a river in Lydia, a country in

Asia Minor, famous for its swans. Persephone also crops up in one of Cézanne's favorite poems in Baudelaire's *Flowers of Evil,* "Sed non satiata."

37. Walter Scott, *Anne of Geierstein* [1829] (Oxford: Clarendon, 1920), p. 411. See ch. 10.

38. Cézanne is registered as copying *Shepherds of Arcadia* in the Louvre on 19 April 1864; characteristically, the later studies are parts of the whole, in this instance individual figures (C1011 and 1012). He had a photograph of this painting in his studio. His attention to Rubens's *Apotheosis of Henri IV,* also in the Louvre, follows a similar pattern. He made an early study of the figures on the left of the painting (C102), and over the next thirty-five years at least ten studies of the central figure of Bellona (C489, 489 bis, 490, 598, 627, 1007, 1138, 1139, 1140, 1215).

39. Ovid, *Metamorphoses,* book 10, 86–108. Cézanne would have known Poussin's *Landscape with Orpheus and Eurydice* (c. 1650) in the Louvre. Ovid was one of Poussin's staple sources.

40. Cézanne made studies of Delacroix's *Rebecca Abducted by the Templar* (1846), an episode in Walter Scott's *Ivanhoe,* from an engraving by Hédouin in *L'Artiste* 33 (1847), p. 224 (C117c and d); he would have been familiar with a later version (1858) in the Louvre. He also copied Delacroix's *Entombment* (1843), from another engraving by Hédouin in *L'Artiste* 31 (1845), p. 80 (C167); it has been suggested that he had the arm and head of Christ in this work in mind when he came to do his own painting. Other candidates: dell'Abbate's *The Abduction of Persephone* (c. 1560), in the Louvre; most plausibly, Cabanel's *Nymph Abducted by a Faun* (1860), one of the highlights of the Salon of 1861, featuring violence and dramatically contrasting complexions. Cabanel is mentioned in Cézanne's verse roundup of the salon in his letter to Huot (4 June 1861).

41. The preparatory drawing is C199, dated c. 1866–67; there is also a small watercolor figure study (RWC30), which has its own preparatory drawing (C200b), in which Pluto does seem to be wrestling with Proserpine, a little like Jacob with the Angel. Ovid's "Narcissus and Echo" is in *Metamorphoses,* book 3: 343–513. Poussin's painting is in the Louvre.

42. Zola, *L'Œuvre,* p. 153.

43. Zola, *Conquête,* pp. 196–97.

44. Zola was keenly aware of Ovid. In the second of the Rougon-Macquart series, *La Curée* (1871), he attempted to modernize the myth of Narcissus from the *Metamorphoses* (book 3, 343–513). The novel is not well known in English; see Arthur Goldhammer's translation, *The Kill* (New York: Modern Library, 2005).

45. Scipio appears to have posed in Cezanne's studio (or room) rather than at the Suisse; but the rule applies in the first instance to women.

46. Jean Renoir, *Renoir, mon père* [1962], p. 128; trans. Randolph and Dorothy Weaver, *Renoir, My Father,* p. 104. The book was conceived in the 1950s, the reminiscences drawn chiefly from conversations in 1915–19. Renoir *père* lived from 1841 to 1919; Renoir *fils* from 1894 to 1979.

47. Schapiro, "Apples," p. 10. The quotation from Renoir is on p. 30. See also ch. 12.

48. In another conversation, according to Vollard, he spoke of women as "cows"

and "calculating creatures," wanting to "get their hooks into him" (one of his favorite expressions). As reported, this lengthy conversation does not ring true—it sounds as though it has been stitched together by Vollard, and improved in the telling—though elements of it may well be authentic. *Écoutant,* pp. 45–47. Cézanne would have known Baudelaire's "Femmes damnées" (Condemned Women), which opens with an arresting image of women "like pensive cattle lying on the sands."

49. Zola, BN NAF 10316, "Notes Guillemet," folios 375–76.

50. Vollard, *Écoutant,* p. 88; Denis diary, 21 October 1899, in *Journal,* vol. 1, p. 157.

51. Zola, *L'Œuvre,* p. 32. Gasquet enlarges on this passage in his *Cézanne,* p. 39.

52. Zola, *L'Œuvre,* pp. 41, 70–71, 137.

53. Zola, BN NAF 10316, L'ébauche, folio 265. See ch. 9.

54. Zola, *Le Ventre,* p. 363. Following Rewald, this passage is often elided with passages from *L'Œuvre.* In his notes Zola underlined its importance. See Rewald, *Cézanne,* p. 62. Cf. *L'Œuvre,* p. 30.

55. Gasquet, *Cézanne,* pp. 100–01. Typically, the literary reference also appears to be an importation of Gasquet's. Barbey was a Catholic reactionary who often crossed swords with Zola. Of *Le Ventre,* he wrote: "The import of his books is this: one makes art as one makes sausage."

56. Lewis, *Early Imagery,* p. 75. "The vehemence of the brushwork," she adds, "suggests the artist's violent attitude toward that sexual image as much as it does his appreciation of Delacroix's style." *Lot and His Daughters* (R78), previously unknown, emerged from a private collection in Aix in the 1980s. It was authenticated by Gowing (who dated it as early as c. 1861) and accepted by Rewald (c. 1865, possibly earlier). These attributions have been vigorously disputed by Andersen, on stylistic grounds (and also sexual position). It seems to me that Andersen's objections have force. Cf. Gowing, *Early Years,* cat. 3; Andersen, *Youth,* pp. 508–09.

57. Mack, *Cézanne,* p. 172. Cf. Rivière, *Le Maître,* p. 144; Rewald, *Cézanne,* p. 78. Venturi dissented, writing in his catalogue raisonné of "the legend" of Cézanne's phobia of women; but crediting the origins of the legend to Cézanne's concerns about one particular woman extorting money from him in his last years in Aix—another fable from Gasquet, about a defrocked nun, supposedly the model for *Old Woman with a Rosary* (R808). Venturi, vol. 1, p. 60; Gasquet, *Cézanne* [1921], p. 67.

58. Melville, *Moby-Dick* [1851], p. 106.

59. Flaubert, *Temptation,* pp. 155–56, 194. His last words here are from the penultimate manuscript draft. Three excerpts from the second version of the novel were serialized in *L'Artiste* in 1856–57, centering on Anthony's temptation by the Queen of Sheba, his encounter with the ascetic Apollonius, and (most interestingly) the feast of Nebuchadnezzar. (Cf. *Temptation,* pp. 33–34, 36–43, 97–115.) The teenage Cézanne can hardly have missed them; it is possible that the last was a source for his painting.

60. Later in life, he advised the young poet Léo Larguier to reread Balzac, in particular the *Comédie humaine,* and talked to him of Rastignac, the protagonist of

Père Goriot (1835). With Émile Bernard's children he seems to have identified himself as Goriot. The novel feasts on death obsession; his gesture has been interpreted as reinforcing his own preoccupation with it. Cézanne was acutely aware of mortality, and failing health; but in this instance it seems to me that the identification was more playful. Among other things, Goriot was a vermicelli maker, which would have appealed to Cézanne's sense of humor, in connection with his fictional alter ego Claude Lantier. See Larguier, *Cézanne*, pp. 128, 131; Cézanne to Bernard, 15 April and 12 May 1904, in *Corr.*, pp. 376 and 378.

61. See Gasquet, *Cézanne*, p. 131. *Études philosophiques* first appeared in this form in 1855.

62. Balzac, *Peau,* pp. 227–28. "Megalomaniac philosophizing" is from Graham Robb, *Balzac,* p. 178, and before him, Hippolyte Taine, a significant influence on Zola.

63. "The profound life of still life" is Proust, trans. James Grieve, *In Search of Lost Time,* vol. 2, p. 448.

64. Gasquet, *Cézanne,* pp. 135, 367, quoting from *Peau,* p. 79 (the feast/orgy). Veronese was high praise in Cézanne's book. *The Feast* (R128) was reworked over time; it is all the more difficult to date (c. 1867–72?). There are also a study (RWC23) and at least four related drawings (C135–138). Orgies were everywhere in the middle of the nineteenth century, even in Offenbach.

65. Gasquet, *Cézanne,* p. 367. Gowing's essay takes as its text this formulation, "the logic of organized sensations."

66. Balzac, *Peau,* pp. 127–30.

67. Matilda Lewis, [November 1894], typescript, object file 1955.29.1, Yale University Art Gallery. This letter was previously ascribed to Mary Cassatt. The original title of the first of Daudet's series of novels, *Barbarin de Tarascon* (1869), seems to be what she had in mind.

68. Vollard, *Recollections,* p. 95. The exchange sounds a little off-key, the witticism more authentic than the idiom.

69. Creuset, *Ravaisou,* p. 70. Germain was then in her twenties, Ravaisou in his thirties.

70. Elder, *Giverny,* p. 47; Roux to Zola, 24 [August 1867?], in Thomson, "Roux-Zola," p. 344.

71. Vollard, *Écoutant,* p. 94; Denis diary, n.d. [1906], in *Journal,* vol. 2, p. 46, reporting what Cézanne said to Francis Jourdain, who visited him in 1905. Denis's *Journal* was not published until much later (1957), but he did on occasion talk to Vollard about Cézanne.

72. Renoir, *Mon Père,* p. 127.

73. Louis Étienne, *Le Jury et les exposants—Salon des refusés* [1863], in *Manet* (Paris: RMN, 1983), p. 166. "Facingness" is Michael Fried's term. See *Manet's Modernism* (Chicago: University of Chicago Press, 1996).

74. "The wan, wasted courtesan" is Mallarmé, who defended the painter and his project. "The Impressionists and Édouard Manet," *Art Monthly Review,* 30 September 1876, in Rubin, *Manet's Silence,* p. 233.

75. Daumier, too, is said to have observed ironically that Manet's painting had the virtue of reducing us to figures on playing cards (Vollard, *Écoutant,* p. 45). Bal-

zac's Frenhofer had made a very similar criticism of a painting of a woman by Porbus: "At first sight she seems admirable, but look again and you can tell that she's pasted onto the canvas . . . ; she's only a silhouette, a cutout who couldn't turn round or change position."

76. Baudelaire to Manet, 11 May 1865, in Baudelaire, *Corr.,* vol. 2, pp. 496–97 (his emphases).

77. Vollard, *Écoutant,* p. 229.

78. Duranty, "M. Manet et l'imagerie," *Paris-Journal,* 5 May 1870.

79. Vollard, *Écoutant,* p. 244; Valéry, *Degas, Danse, Dessin* [1938], p. 61 (his emphases).

80. Vollard, *Écoutant,* p. 36; Denis, "Cézanne" [1907], in *Conversations,* p. 176. Denis visited Cézanne in 1906. Delacroix emphasized laying-in.

81. Zola, "Manet" [1867], in *Écrits,* pp. 147, 152.

82. Valabrègue to Marion, in Marion to Morstatt, 12 April 1866, in Barr, "Marion," p. 51.

83. Zola, *L'Œuvre,* p. 145; Zola to Baille, 2 June 1860, in Zola, *Corr.,* vol. 1, pp. 172–73. Cézanne himself did not exhibit at the Salon des refusés, as is sometimes suggested.

84. Plato, *Theaetetus,* 183e, in Anthony Gottlieb, *The Dream of Reason* (London: Penguin, 2000), p. 59. Manet was born in 1832.

85. Gasquet, *Cézanne,* pp. 310–11; Vollard, *Écoutant,* p. 36.

86. Zola, "Lettre de Paris," *Le Messager de L'Europe* (July 1879), in *Écrits,* p. 400.

87. Also known as *The Barque of Dante, after Delacroix* (R172). In later years, the Virgilian underworld became more important to him. See ch. 12.

88. Julien Levy, *Memoir of an Art Gallery* (New York: Putnam's, 1977), p. 283.

89. Vallès, *Littérature et revolution,* pp. 393–94.

90. Valéry, "Situation de Baudelaire" [1930], in *Variété I et II* (Paris: Gallimard, 2005) p. 233.

91. Elder, *Giverny,* p. 48, based on interviews conducted c. 1920–22. There is an earlier variant of Cézanne's greeting in Octave Maus, "Salon d'automne" [1907], pp. 66–67, the text of a lecture delivered on 15 November 1906. Maus says that the anecdote was told to him by "someone who was present"—Monet, no doubt. "*Ah! Monsieur Manet, permettez-moi de ne pas vous tendre la main. Je ne me la suis lavée depuis huit jours!*" The Café Guerbois was in the Grand-Rue des Batignolles, now the Avenue de Clichy.

4: I Dare

1. Vollard, *Écoutant,* pp. 40 and 46 (reporting what Guillemet told him).

2. Zola, *Le Ventre,* pp. 49–50 (and 420 for the sash); reprised in *L'Œuvre,* p. 34. Cf. the description of Lantier *père* in *L'Assommoir,* p. 25.

3. Rivière, *Cézanne,* p. 76. Rivière was familiar with the artist all his life. In 1913 his daughter married Cézanne's son.

4. Duranty to Zola, [c. October 1877], BN NAF 24518, folio 224, partially quoted in Zola, *Corr.,* vol. 3, p. 137.

5. Duranty, "Le Peintre Louis Martin" [1872], in *Le Pays* [1881], pp. 316–20.

6. Duranty, "Le peintre Marsabiel," *La Rue*, 20 July 1867. In later versions the germ of the idea survives in the reaction of Maillobert and his band to the offerings at the Salon des refusés: "It's weakling [*faiblot*], it's bourgeois," they chorus. ("Louis Martin," p. 330.)

7. Duranty, "Louis Martin," p. 320.

8. "Painted, not only with a knife, but even a pistol" ("*peint, non seulement au couteau, mais encore au pistolet*"), the dismissive verdict of a salon juror of 1866 on Cézanne's portrait of Valabrègue (R94). Cf. Vollard, *Écoutant*, p. 36. The association with strangeness ("*C'est un drôle de pistolet*") would have been familiar to Cézanne (and others) from Balzac, e.g., *Illusions perdues*. A century later Barnett Newman remarked on his cannonball apples: "Interview with Émile de Antonio" [1970], in *Selected Writings*, p. 303.

9. Duranty, "Louis Martin," p. 320. Cf. Vollard, "*Écoutant*, p. 36; Guillemet to Oller, 12 September 1866, in *Francisco Oller*, p. 227.

10. Gasquet, *Cézanne*, p. 243. The sketchbook, the "Carnet de Jeunesse," is in the Cabinet des Dessins of the Louvre (RF 29949). See pp. 11v (C19) and 12 (C18); and for more diagrams, without annotations, pp. 21 (C24), 21v (C33), and 27 (C35). The original drawings are dated c. 1858; the geological material, c. 1866. C18 and 19 are also reproduced in Athanassoglou-Kallmyer, *Provence*, pp. 160–61.

11. Guillemet to Zola, 2 November [1866], in Baligand, "Lettres inédites," p. 181. The text of this letter as published in Cézanne's *Correspondance* is incomplete.

12. Geffroy, "Cézanne" [1894], in *La Vie artistique*, vol. 3, pp. 256–57.

13. Jules Bernex, "Souvenirs sur Cézanne," *L'Art sacré* (March-April 1956), p. 29.

14. Marion to Zola, n.d., BN NAF 24522, folio 19.

15. Zola's notes on Lucas alone take up BN Ms. 10345, folios 57–115. That work was described as "the fullest and best on this subject" by Darwin himself. *On the Origin of Species* (1859) was translated into French in 1865.

16. Zola, *Rougon-Macquart*, vol. 5, p. 1737.

17. Zola, "Les Rougon-Machard" [*sic*], OC, vol. 2, p. 297. The conception of 1868–69, first published in 1884.

18. Zola, *L'Œuvre*, p. 74.

19. Zola, trans. Margaret Mauldon, *L'Assommoir* (Oxford: World's Classics, 1995), p. 439.

20. Stendhal, *Histoire*, pp. 264 ff.

21. Ibid., p. 269.

22. Ibid., p. 270. This temperament also featured in *Le Rouge et le Noir*.

23. Goncourts, *Manette*, pp. 224–25, 421. The terms in which Delacroix is presented in *Manette* foreshadow the terms in which Lantier is presented in *L'Œuvre*.

24. *Manette*, pp. 140–41 (their emphasis). Cézanne must also have read the Goncourts' *Idées et sensations* (1866), an early selection from the journals. Many years later, in a letter to his son, he made reference to their ideas about color.

25. Goncourt journal, 21 January 1866, in *Journals*, p. 115.

26. Zola, "Introduction" [27 May 1866] and "Taine," *Mes Haines*, in *Écrits*, pp. 35 and 70–71, originally published as "L'esthétique professée à L'École des beaux-arts," *Revue contemporaine*, 15 February 1866. Cf. Taine, *Philosophie*,

vol. 1, p. 14. Taine wrote to thank him, emphasizing his own belief in *"la personnalité, la force et l'élan individuel"*—all grist to Zola's mill.

27. Gasquet, *Cézanne*, pp. 293–94. In Gasquet, Cézanne's talk is shot through with Taine. This is surely a prime case for skepticism—there are hints that Gasquet fancied himself as a latter-day Taine, e.g., when Cézanne is made to suggest that if he had a school of his own, Gasquet could come and lecture, "like Taine" (p. 191); and some of the allusions seem forced, e.g., "You know what Taine says about the classical spirit in the *Origines*" (p. 304), i.e., *Origines de la France contemporaine* (1876–91). Yet other citations ring true, and the turn of speech sounds absolutely authentic. The opinions on the Venetians square very well with what Cézanne read and marked and inwardly digested. (There is a copy of *Voyage en Italie* in his studio.) When he spoke of "the Venetians," as he often did, he meant above all Tintoretto (1518–94), Titian (1487–1576), Veronese (c. 1528–88), and perhaps by association Rubens (1577–1640).

28. Zola, "Proudhon et Courbet" [1865], in *Mes Haines* [1866], and "Les réalistes du Salon" [11 May 1866], in *Écrits*, pp. 44 and 122. What exactly did Cézanne mean to convey when he wrote to Zola, a few months later, "Imagine, I hardly read any more. I don't know if you're of the same mind, and on this I won't budge, but I'm beginning to think that art for art's sake is a bad joke; this *entre nous*." (*Corr.*, p. 159)? This was the tailpiece to a letter confessing to *"un peu de marasme"* (stagnation or depression); if the statement about reading was seriously meant, it did not hold good for long. Andersen thinks that he was talking about literature rather than painting (*Youth*, p. 500); he may well be right.

29. Delacroix, *Journal*, 8 June 1850, vol. 1, p. 514, apropos Rubens.

30. Zola to Taine, 13 January 1865, in Zola, *Corr.*, vol. 10, p. 442.

31. Taine, *Philosophie*, vol. 1, p. 62.

32. Taine, "Balzac" [1858], in *Nouveaux Essais* [1865], pp. 78–79.

33. Renoir, *Mon Père*, pp. 37–38.

34. Taine, *Philosophie*, vol. 1, pp. 44–45. Cf. Voltaire, trans. Roger Pearson, *Candide* [1759] (Oxford: World's Classics, 1990), p. 100. Coincidentally or otherwise, Voltaire also deals in sheep ("from that fine country of Eldorado").

35. Zola to Valabrègue, 21 April 1864, in Zola, *Corr.*, vol. 1, p. 360; Marion to Morstatt, August 1866, in Barr, "Marion," p. 53; Guillemet to Zola, 2 November 1866, in Baligand, "Lettres inédites," pp. 179–80. How Cézanne wore his beard had always been a subject of interest to his friends. Cf. Zola to Cézanne, 13 June 1860, in Zola, *Corr.*, vol. 1, p. 178. His refrain ran *"Il est bien noir pour moi, le ciel de l'avenir."* Cf. Zola to Valabrègue, 10 December 1866, in ibid., p. 464.

36. Marion to Morstatt, June 1866, in Barr, "Marion," p. 57; and also the letters of January 1866 and autumn 1868. Morstatt himself knew Cézanne from a sojourn in Marseille in 1864–66. See Cézanne to Morstatt, 23 December 1865 and 24 May 1868, in *Corr.*, pp. 144–45 and 166.

37. Jourdain, *Sans Remords*, p. 51. *The Stove in the Studio* (R90), dated c. 1865, is now in the NG. It has been related to a celebrated work by Chardin (1699–1779), *The Copper Cistern* (c. 1735). Cézanne clearly studied Chardin, and rated him very highly, but that came later, I think, after a major accession of

Chardins (including *The Copper Cistern*) to the Louvre in 1869; see ch. 11. Baudelaire's mistress had lived at the same address in the Rue Beautreillis a few years before, as Cézanne would have heard tell; Baudelaire, too, temporarily.

38. Cézanne to Pissarro, 15 March 1865, in *Corr.*, p. 144; Stendhal to Madame Jules Gaulthier, 21 March 1839, in Stendhal, *Salons*, p. 30. Stendhal's *Correspondance inédite* appeared in 1855. The Institut de France was the governing body of the fine arts.

39. Following Rewald's speculation, *Bread and Eggs* (R82) is usually said to have been submitted to the Salon of 1866. I believe Henri Loyrette is right in thinking that it would have made no sense for Cézanne to date it 1865 and then submit it in 1866. See Tate cat. 3. It is now in the Cincinnati Art Museum.

40. This work is R137, dated c. 1867–69, now in the Musée d'Orsay.

41. Woolf, *Fry*, pp. 111–12, quoting from Fry's review of the exhibition in the *Athenaeum*, 13 January 1906. The landscape was *The Pool of the Jas de Bouffan in Winter* (R350), from c. 1878. Cf. Fry, "Retrospect" [1920], in *Vision and Design* [1920] (Harmondsworth: Penguin, 1961), p. 226.

42. P114, perhaps the most impressive of Pissarro's rare still lifes. Apparently done while staying with Guillemet at La Roche-Guyon.

43. Gasquet, *Cézanne*, pp. 362, 369. Cézanne was friendly with Monticelli (1824–86), and even went on painting expeditions with him in the countryside around Marseille.

44. Wallace Stevens, "Someone puts a pineapple together," in *The Necessary Angel* (New York: Knopf, 1951), p. 87.

45. Wassily Kandinsky, trans. Michael Sadler, *Concerning the Spiritual in Art* (London: Tate, 2006), pp. 36–37. On the equality of things, see also ch. 10.

46. The epigraph to Stendhal's *Salons* [of 1822, 1824, and 1827], p. 21, dated 1855, from Baudelaire's *Exposition universelle* (his emphasis). Stendhal's *Correspondance inédite* included the preface to his Salon of 1824.

47. Rilke to Clara, 24 October 1907, in Rilke, *Letters*, pp. 77–78. *The Black Clock* (R136) is dated c. 1867–69 by Rewald and c. 1870 by Gowing; earlier rather than later in this bracket seems very plausible. Evidently Cézanne himself thought well of it: ten years on, he asked Zola about borrowing it back for an exhibition (*Corr.*, p. 205). It is now in an anonymous private collection.

48. Vollard, *Écoutant*, p. 40.

49. Ibid., p. 37.

50. Marion to Morstatt, 28 March 1866, in Barr, "Marion," p. 45, reporting what he heard from Valabrègue; Rivière, *Cézanne*, p. 29.

51. Marion to Morstatt, 12 April 1866, in Barr, "Marion," p. 46, reporting what he heard from Valabrègue; Zola to Coste, 14 June 1866, in Zola, *Corr.*, vol. 1, p. 451. Cf. Daubigny to Madame F., sister of Jules Lecoeur, 6 June 1866, in Rewald, *Cézanne-Zola*, p. 110, on the wrangling over Renoir's rejection.

52. Valabrègue to Zola, 2 October and November 1866, trans. Rewald in R99.

53. Zola, "Un Suicide" [19 April 1866], in *Écrits*, p. 88. This prefatory open letter is often omitted from editions of *Mon Salon*. The suicide of the painter Jalos Holtzhapfel had been attributed to his rejection by the jury. The case was not proven, and Zola mentioned no name.

54. Cézanne to Nieuwerkerke, 19 April 1866, in *Corr.*, pp. 146–47, correcting various errors of transcription. The original letter, with the annotation, is reproduced in Rewald, *Cézanne*, pp. 58–59. Cézanne's expression "serious workers" (*travailleurs sérieux*) was repeated a few days later in Zola's attack on the jury ("Le Jury," 27 April 1866, in *Écrits*, p. 97); in years to come it became part of the shared language with Pissarro (see ch. 5). He originally wrote "open to all" (*ouverte à tout le monde*).

55. *Le Figaro*, 8 and 12 April 1867, in Zola, *Corr.*, vol. 1, pp. 490–92.

56. Vollard, *Écoutant*, pp. 35–36. Vollard plays fast and loose with dates. He dates the original study of the waste collector to 1863, which is presumably several years too early, if it was indeed the one submitted to the Salon of 1867 (R115); but that painting is lost, presumed destroyed. The others on the theme (R289, 290, and 291), plus associated preparatory studies (C275, 276, 279, 280, 284, 285), seem to be securely dated to the 1870s, probably sometime after 1874. Cézanne's friend Guillaumin was at one time a night waste collector.

57. Valabrègue to Zola, November 1866, in R102 (translation modified).

58. The Uncle Dominique series is R102–11. One of these works (R110), now in the Oskar Reinhart Collection, was originally owned by Monet, who is said to have acquired it from Père Martin, a small, venturesome Paris dealer, in 1868, very soon after it was painted. Martin may have bought it (or had it to sell) from Cézanne himself—he was interested in Pissarro, who could have introduced them. Apparently Monet in effect exchanged it for one of his own paintings, plus 50 francs from Martin, who valued Monets at 100 francs, Cézannes at 50, and Pissarros at 40. Rewald, *Impressionism*, p. 214, citing *Bulletin de la vie artistique*, 1 July 1925; *Pissarro*, vol. 1, pp. 119–20.

59. *The Lawyer (Uncle Dominique)* (R106), formerly in the Pellerin Collection, now in the Musée d'Orsay.

60. Gowing, *Early Years*, p. 112, referring in the first instance to some of the smaller heads—perhaps R102 or R108.

61. Roux to Zola, 24 [c. June 1867/1868], in Thomson, "Roux-Zola," p. 344.

62. Zola, *L'Œuvre*, p. 84. Lantier's studio is nearby, at the junction with the Quai de Bourbon (see p. 29).

63. Zola, *L'Assommoir*, p. 297; Cezanne to Zola, 24 September 1878, in *Corr.*, p. 219.

64. Karl Madsen review in *Politiken* [1889], trans. Merete Bodelsen, in "Gauguin's Cézannes," p. 208. This is *Nude Woman* (R140). Both Denis and Bernard recalled seeing a painting answering to that description in Tanguy's shop a few years later; cf. Bernard, "Souvenirs," in *Conversations*, p. 68. Evidently Gauguin could have brought it back in 1891. After that it disappears from view. Tanguy saved other paintings from destruction by the artist; perhaps, as Rewald suggests, he could not save this one. Andersen proposes C82 as a study for it (*Youth*, pp. 368–69). Cézanne's more explicit rejoinder to Manet, *A Modern Olympia* (R171), came slightly later.

65. Rewald, "Emperaire" [1938], p. 60.

66. Gasquet, *Cézanne*, p. 73; Bernard, "Souvenirs," in *Conversations*, p. 68.

67. C229, in the Kunstmuseum, Basel, and 230, in the Cabinet des dessins of the

Louvre (RF 31 778). Also reproduced in Tate, cat. 20 and 21. The portrait is R139.

68. The Tintoretto self-portrait was (and is) in the Louvre. Cf. Gasquet, in *Conversations*, p. 138; Cézanne to Bernard, 23 December 1904, in *Corr.*, p. 385. He signed an earlier letter "Pictor P. Cézanne" (p. 379).

69. *La Grenouille et le bœuf*, in *La Revue comique*, 2 December 1848; *La Lanterne*, 31 October 1868. See Athanassoglou-Kallmyer, *Provence*, pp. 84–85. Cézanne was certainly familiar with anti-imperial and satirical publications like *La Lanterne* and *Le Galoubet* in this period: see Cézanne to Coste, [July and November 1868], in *Corr.*, pp. 168 and 170.

70. Bernard, "Souvenirs," in *Conversations*, pp. 68–69; "Tanguy," p. 609.

71. Bernheim-Jeune and Anna Boch to Eugène Boch, trans. Rewald, in R139.

72. "Le Salon par Stock," *Album Stock*, in Rewald, "Un article inédite."

Self-Portrait: The Desperado

1. This one is R116. Rochefort, "L'Amour du laid," *L'Intransigeant*, 9 March 1903. See ch. 10.

2. Lawrence, "Introduction," p. 266.

3. Zola, "Le Moment artistique," 4 May 1866, in *Écrits*, pp. 107–08.

4. Stevens, "The Man with the Blue Guitar," in *Collected Poems*, p. 165.

5: Anarchist Painting

1. Cézanne to Gabet, 7 June 1870, in *Corr.*, pp. 172–73.

2. Duret to Zola, and Zola to Duret, 30 May 1870, in Zola, *Corr.*, vol. 2, p. 219.

3. Valabrègue to Zola, [April 1867], in Rewald, *Cézanne-Zola*, pp. 137–38.

4. Bernard, "Souvenirs," records Cézanne's reliance on Blanc's works on the Spanish and Flemish schools. Three volumes remain in his studio.

5. Zola, "Édouard Manet" [10 May 1868], in *Écrits*, p. 199. The painting is described in detail in Reff, "Manet's Portrait of Zola." It is now in the Musée d'Orsay.

6. Fantin to Edwards, 15 June 1871, in Rewald, *Impressionism*, p. 205; Tabarant, *Manet*, p. 175. This painting is now in the Louvre.

7. Cézanne to Marion, in Marion to Morstatt, April 1868, in Barr, "Marion," p. 48.

8. According to Vollard (p. 79), there was no love lost between Cézanne and Fantin. He was probably right: Fantin disparaged Pissarro and considered the impressionists dilettantes who produced more noise than art. Cf. Pissarro to Lucien, 28 December 1883, in Pissarro, *Corr.*, vol. 1, p. 267.

9. Zola to Manet, 7 April 1868, in Zola, *Corr.*, vol. 2, pp. 116–17.

10. Duret to Pissarro, and Pissarro to Duret, 6 and 8 December 1873, in Pissarro, *Corr.*, vol. 1, p. 88. This formulation, *"des moutons à cinq pattes,"* may owe something to Taine's definition of a lion, *"une machoir sur quatre pattes."*

11. Duret, *Histoire* [1922], pp. 127–48, esp. 146–48. He owned six landscapes, one still life, and a portrait of Madame Cézanne (R198, 301, 397, 417, 490, 528,

653, and 716). In his criticism Duret adopted the formula of "finding himself" as the goal of the original artist. See his *Critique d'avant garde* (1885).

12. Guillemet to Oller, 12 September 1866, in Taylor, *Oller,* pp. 226–27. The painting in question was probably the portrait of his father reading *L'Événement.*

13. Madame Monet wanting to cover up the Cézannes: Denis diary, n.d. [1906], in *Journal,* vol. 2, p. 46.

14. Gauguin, trans. Van Wyck Brooks, *Gauguin's Intimate Journals* (New York: Dover, 1997), p. 23.

15. See Gide to Denis, [24 April 1901], in Denis, *Journal,* vol. 1, p. 169. Cézanne's *Still Life* (R418, dated 1879–80) is now in MoMA; Denis's *Homage* is now in the Musée d'Orsay. Gauguin also owned R140, 301, 391, 409, and 437.

16. In the bedroom: *Château Noir* (R940), now in MoMA; *L'Estaque* (R443), bought from Vollard for 600 francs in 1896, now in MoMA; *Bathers* (R666), now in the St. Louis Art Museum. *Snow Melting* is R413, now in MoMA. Monet also owned R110, 120, 245, 382, 443, 490, 657, 666, 680, 735, 849, 891, and 940.

17. See Pissarro to Lucien, 4 December 1895, in Pissarro, *Corr.,* vol. 4, p. 128. Cf. Julie Manet diary, 29 November 1895, in *Growing Up,* p. 76. *Three Pears* (RWC298, dated c. 1888–90) is now in the Met. Degas owned seven paintings (R297, 346, 369, 374, 416, 424, and 557) and a drawing; Renoir owned four paintings (R188, 456, 485, and 539) and two watercolors.

18. Julie Manet diary, 1 July 1899, in *Growing Up,* p. 177. "Durand-Ruel bought it for only 3,500," she added, "but M. Degas was afraid that [Count] Camondo would get it." That portrait was R296, now in the Columbus Museum of Art; Degas owned R297, now in the Virginia Museum of Fine Arts.

19. Denis, *Théories,* in *Conversations,* p. 176 (my emphasis), from a conversation of 1906, recorded in his diary.

20. Reff, "Cézanne's Bather," p. 173. This one is R369. For the others: R252, 253, 255, and 370, and the related drawings C378–89. Degas copied from R261; see *The Notebooks of Edgar Degas* vol. 2 (Oxford: Clarendon, 1976), p. 129. Giacometti later copied the same figure, from a reproduction in Fritz Burger, *Cézanne und Hodler* (1913); see *Cézanne & Giacometti,* no. 165 (undated). For more on the bathers, see ch. 12.

21. Breton, trans. Mark Polizzotti, "Picabia" [1922] and "Characteristics of the Modern Evolution" [1922], in *The Lost Steps* [1924], pp. 97 and 117 (his emphasis).

22. Woolf to Nicholas Bagenal, 15 April 1918, in Woolf, *Letters,* vol. 2, p. 230. *Apples* is R346, c. 1878, still in the Keynes Collection, on loan to the Fitzwilliam Museum, Cambridge.

23. Renoir, *Mon Père,* p. 302.

24. Ibid., pp. 37–38; Jean Renoir to Saint-Exupéry, 2 June 1942, in Jean Renoir, *Letters,* p. 127.

25. Denis, "Cézanne," in *Conversations,* p. 172.

26. "As Renoir said to me very aptly there is something of a comparison with the things of Pompeii, so crude and so wonderful . . . nothing of [the Académie] Julian!" Pissarro to Lucien, 21 November 1895, in Pissarro, *Corr.,* vol. 4, p.

119. He also thought the colors in Cézanne's paintings of bathers would have delighted the makers of ancient earthenware [*anciens faïenciers*]. Vollard, *Écoutant,* p. 309.

27. Rewald, *Cézanne-Zola,* pp. 386–87; Gasquet, *Cézanne,* in *Conversations,* p. 121.

28. Vollard, *Écoutant,* pp. 37, 78–79, and 201 (his emphasis).

29. Pissarro to Esther, 22 December 1885; to Lucien, 8 July 1891 and 26 April 1892, in Pissarro, *Corr.,* vol. 1, p. 368; vol. 3, pp. 103 and 221 (trans. Rewald, *Lucien,* pp. 195–96).

30. Pissarro to Mirbeau, 16 March 1892, in Pissarro, *Corr.,* vol. 3, p. 208; Bataille, "L'impressionisme," pp. 375–76.

31. Vollard, *Écoutant,* p. 221; Renoir to Durand-Ruel, 26 February 1882 (draft), enclosed with a covering note from Edmond Renoir (his brother), in Venturi, *Les Archives,* vol. 1, p. 122.

32. Borély, "Cézanne à Aix," in *Conversations,* pp. 20–21. An account dated 1902, of a visit "last July," but first published in 1911 and republished in 1926. There may be room for doubt about the date—Cézanne clearly speaks of Pissarro as if he were dead, yet he died only in November 1903—but the tenor of the talk sounds absolutely authentic. A quarter of a century later, Matisse used almost exactly the same phrase of Cézanne: "a sort of God of painting" ("*une sorte de bon Dieu de la peinture*"): interview with Jacques Guenne [1925], in *Matisse on Art,* p. 80.

33. Zola, "Lettre à M. Félix Faure, Président de la République," *L'Aurore,* 13 January 1898, in Zola, *OC,* vol. 18, pp. 437–44.

34. Julie Manet diary, 15 January 1898, in *Growing Up,* p. 124 (see also pp. 126 and 129); Pissarro to Georges Pissarro, in Pissarro, *Corr.,* vol. 4, p. 431; Signac diary, 11 February 1898, in Rewald, "Excerpts," part 2, p. 301; Halévy diary, 25 November 1897, in *My Friend Degas,* p. 100. Expressions of sympathy and solidarity from Monet and Pissarro to Zola are printed in Rewald, *Cézanne-Zola,* pp. 363–64.

35. Gauguin, *Racontars de Rapin,* pp. 9–10. Joachim Pissarro is also struck by this text; my translation differs somewhat from his. Cf. *Cézanne/Pissarro,* pp. 124–25.

36. Rewald, *Cézanne-Zola,* p. 365, based on testimony from Le Bail; Brown, *Zola,* pp. 726–28; Zola, "M. Scheurer-Kestner," *Le Figaro,* 25 November 1897, in *La Vérité en marche* (1901), in *OC,* vol. 18, p. 416; see also his prefatory note to this article, as republished. Auguste Scheurer-Kestner was vice-president of the Senate.

37. Vollard, *Écoutant,* p. 118. In Vollard's account, Cézanne appears to think that Zola had something to prove—that his intervention in the *affaire* was less about Dreyfus than about his own reputation and standing. Elsewhere (p. 104), Vollard tries to explain Cézanne's anti-Dreyfusard stance in terms of his reverence for the French army.

38. Bernard, "Souvenirs," in *Conversations,* p. 56 (his emphasis), a conversation from 1904. Following Vollard, it has been suggested that Cézanne made a point of supporting "anti-Dreyfusard" art: putting up reproductions by Forain, sub-

scribing to a statue by Rodin. This seems at once simplistic and far-fetched. Cézanne was not given to gesture politics; his taste in reproductions was various, embracing the notorious Communard Courbet; and all manner of people subscribed to the Rodin, Pissarro included.

39. As far as can be ascertained, Pissarro owned R114 (?), 123, 162, 179, 196, 197, 250, 302, 307, 309, 311, 313 (?), 371, 385, 446, 455, 484, 494, 504 (?), 577 (?), and 616 (?), and at least four drawings (C201–04).

40. See Cézanne to Bernard, Friday [1905], in *Corr.*, p. 393.

41. Pissarro to Lucien, 4 December 1895, in Pissarro, *Corr.*, vol. 4, p. 128. Pissarro may have brought forward slightly the date of this first encounter.

42. Vollard, *Écoutant*, p. 218.

43. Cézanne to Pissarro, 15 March 1865, in *Corr.*, p. 144; Pissarro to Oller, 14 December 1865, in Pissarro, *Corr.*, vol. 3, p. 533.

44. Guillemet to Oller, 12 September 1866, in Taylor, *Oller*, p. 226.

45. Pissarro interviewed by Robert de la Villehervé, in Pissarro, *Corr.*, vol. 5, p. 369; Cézanne to Gasquet, 26 September [1897], in *Corr.*, p. 329, "parallel" here meaning something like "equivalent to"; Lucien to Paul-Émile Pissarro, n.d. [1912], in Thorold, *Artists*, pp. 8–9, underlining the significance of the phrase, attributed to Cézanne in Lucien's manuscript notes, in Sketchbook 52, p. 98, Pissarro Archive, Ashmolean Museum, Oxford. There was perhaps a half-conscious musical analogy to their idea of harmony. Delacroix for one had used the same term (*accord*) in that context in his diary, which Cézanne surely read; he received a copy as a present early in 1906, but he may well have seen it before that. It was first published whole in 1893–95, however, twenty years after Cézanne and Pissarro developed their own dialect. See, e.g., 7 April 1849, in Delacroix, *Journal*, vol. 1, p. 439.

46. Pissarro to Lucien, 21 November 1895, in Pissarro, *Corr.*, vol. 4, p. 119 (and pp. 113, 116, 121); Gasquet, in *Conversations*, p. 136. Cézanne avows a lot more than this, in words put into his mouth by Gasquet; but these particular remarks have an authentic ring, even an authentic argot, especially in the context of the dialogue with Pissarro.

47. See Coquiot, *Cézanne*, p. 61, attributed to a peasant from Pontoise.

48. Guillemet to Oller, 12 September 1866, in Taylor, *Oller*, p. 226; Vollard, *Écoutant*, p. 44; Pissarro interviewed by Villehervé, in Pissarro, *Corr.*, vol. 5, p. 369. Cézanne selected *A Modern Olympia* (R225) as one of his three paintings for the first impressionist exhibition of 1874. He had done an earlier version (R171, dated c. 1870).

49. Bernard, "Cézanne" [1904], in *Conversations*, p. 36. These opinions have a certain status, because Bernard is held (rightly) to be more reliable than Gasquet, and because Cézanne himself saw them in print and made no objection, though he did not explicitly approve them, as is sometimes suggested. Indeed, he took up some of Bernard's exposition, and tried to explain himself a little further; see below. Cézanne to Bernard, 26 May and 25 July 1904, in *Corr.*, pp. 378 and 381.

50. Pierre-Louis Bouvier, *Manuel des jeunes artistes et amateurs en peinture*, in Callen, *Art*, p. 172.

51. Théophile Thoré, *Salons de W. Bürger*, in Callen, *Art*, p. 172.

52. Baudelaire, "Le Peintre de la vie moderne," in *Romantisme,* p. 220. This celebrated essay, first published in *Le Figaro* in November and December 1863, was reprinted in Cézanne's beloved *L'Art romantique* (1868).

53. Huysmans, "L'Exposition des indépendants en 1880," in *L'Art moderne* [1883], in *Écrits,* pp. 165–66.

54. Adam, *Soi,* p. 422. Adam was well acquainted with Pissarro and his circle. Cézanne and Pissarro later saw green. See ch. 6.

55. The expression is used by Duret, "Cézanne," p. 146, borrowing, he says, from "a man of the world" of his acquaintance. The association, or accusation, pervaded the culture at the turn of the century.

56. Pissarro to Mirbeau and Lucien, 30 September 1892 and 20 April 1891, in Pissarro, *Corr,* vol. 3, pp. 261 and 66; Zola, "À mon ami" [20 May 1866], in *Écrits,* p. 91.

57. Cézanne to Pissarro, 2 July 1876, in *Corr.,* p. 194. Cf. Pissarro to Lucien, 19 October 1883, in Pissarro, *Corr.,* vol. 1, p. 240.

58. Friedrich Nietzsche, trans. R. G. Hollingdale, *Human, All Too Human* [1886] (Cambridge: Cambridge University Press, 1996), p. 83.

59. R. G. Collingwood, *An Autobiography* (Oxford: Oxford University Press, 1939), p. 2.

60. Gasquet, in *Conversations,* p. 136, following Cézanne to Bernard, Friday [1905], in *Corr.,* pp. 392–93, an echo of "a corner of creation seen through a temperament," and perhaps an indication of reading Delacroix, or Baudelaire on Delacroix. Some of Delacroix's writings were published well before his *Journal*: on Poussin (one of Cézanne's favorite artists), for example, in *Moniteur* (1853), reprinted in *Eugène Delacroix, sa vie et ses œuvres* (1865).

61. Bernard, "Paul Cézanne," in *Conversations,* p. 32; Proust, *Lost Time,* vol. 3, p. 325.

62. Cézanne to Nieuwerkerke, 19 April 1866, in *Corr.,* p. 147; Zola, "Le jury" [27 April 1866], in *Écrits,* p. 97; Alexis, "Paris qui travaille, III," *L'Avenir national,* 5 May 1873. "Workers of the world, unite" is the peroration of the *Communist Manifesto* (1848).

63. Pissarro to Murer, n.d. [April 1876], in Pissarro, *Corr.,* vol. 2, p. 383 (his emphasis).

64. Jürgen Habermas, trans. T. McCarthy, *The Theory of Communicative Action* (Cambridge: Polity, 1987), vol. 2, p. 99 (his emphasis).

65. Pissarro to Murer, Monday morning [1878], in Pissarro, *Corr.,* vol. 1, p. 123.

66. Walcott, *Tiepolo's Hound,* pp. 42–43, a meditation on Pissarro's quest, and an exploration of his own.

67. This version of the story follows Valéry, trans. Martin Turnell, "About Corot," p. 153.

68. Astruc, *Les Quatorze Stations du Salon,* Castagnary, "Salon des refusés," and Jean Ravenel, "Le Salon de 1865," in *Pissarro,* vol. 2, pp. 60, 115, and 118. *Donkey* (P37) is now in the Musée d'Orsay. The two landscapes were *Chennevières, on the Banks of the Marne* (P103, now in the National Gallery of Scotland) and *The Water's Edge* (unidentified).

69. Gasquet, *Cézanne,* in *Conversations,* p. 121.

70. Guillemet to Oller, 12 September 1866, in Taylor, *Oller,* p. 227; Cézanne to Paul, 26 September 1906, in *Corr.,* p. 411. Cf. Bataille, "L'Impressionisme," p. 376. Seventeen ninety-three was the defining year of "the Terror" in the French Revolution. The Latin quotation is the opening line of a famous ode by Horace, strictly "*Exegi monumentum aere perennius,*" *Complete Odes,* p. 108.

71. Zola, "Taine," in *Écrits,* p. 72. His praise of Pissarro in print was much more fulsome than anything he wrote of Cézanne. See, e.g., "Adieu d'un critique d'art" [20 May 1866] , "Les naturalistes" [19 May 1868] and "Les payagistes" [1 June 1868], ibid., pp. 133, 200–01, and 214. His study of Manet is replete with patches. See "Manet" [1867], ibid., p. 151.

72. The sketchbook was sold at auction in Paris in 2004. On Pissarro before Pissarro, with a selection of illustrations, see Brettell, "Pissarro and Melbye," in *Pissarro,* vol. 1, pp. 3–11.

73. Le Bail to Rewald, 19 March 1935, Rewald Papers, Box 50–1, NGA; quoted in Rewald, *Cézanne-Zola,* p. 283. The usual translation, "in 1870," seems to me misleading. It is true that Le Bail wrote *en* 1870, but the sense is clearly *jusqu'en* (up to or until). "In 1870" makes no sense: that was the very year painting was interrupted, on account of the Franco-Prussian War. Pissarro fled the advancing Prussian army and after some indecision decamped to England.

74. Denis diary, 26 January 1906, in *Conversations,* p. 94; Walcott, *Tiepolo's Hound,* p. 45.

75. Aristotle, trans. J. A. K. Thomson, "The Kinds of Friendship," in *Ethics* (London: Penguin, 1976), p. 258, quoting Homer's *Iliad.*

76. Pissarro to Lucien and Mirbeau, 28 December 1883 and 30 September 1892, in Pissarro, *Corr.,* vol. 1, p. 267 and vol. 3, p. 260. "*Il mourait d'envie*"—a pun or merely a figure of speech?

77. Gasquet remembered Cézanne reciting a quatrain from Verlaine as they walked along the banks of the Arc: "*Car dans ce monde léthargique / Toujours en proie au vieux remords / Le seul rire encore logique / Est celui des têtes de morts.*" Vollard showed him a deluxe edition of Verlaine's *Parallèlement,* illustrated by Bonnard. "That's good," said Cézanne. "It's drawn in keeping." Gasquet, *Cézanne,* p. 56; Vollard, *Recollections,* p. 90.

78. See Cézanne to Pissarro, 20 May 1881, in *Corr.,* p. 251. *En Ménage* is another work that deals in temperaments as humors, à la Stendhal, and the friendship between artist and writer (see, e.g., pp. 107–08). The character of the artist Cyprien draws on Degas and Forain, among others.

79. Pissarro to Lucien, 28 December 1883 and 23 January 1886, in Pissarro, *Corr.,* vol. 1, p. 266 and vol. 2, p. 19. See ch. 8.

80. Rilke notes the consonance between them, well conveyed in his characteristic terminology, in *Letters on Cézanne,* pp. 60–61.

81. Cézanne to Paul, 15 October 1906, in *Corr.,* p. 416.

82. Cézanne to Bernard, 26 May 1904, in *Corr.,* p. 379.

83. Cézanne to Gasquet, 30 April 1896, in *Corr.,* p. 312.

84. Gasquet, *Cézanne,* in *Conversations,* pp. 154–55.

85. Gasquet, *Cézanne,* in *Conversations,* p. 128. Constantin Guys is the exemplar of "The Painter of Modern Life."

86. Gasquet, *Cézanne,* in *Conversations,* p. 145. Cf. *Par les Champs,* p. 272–73. Cézanne's talk of the black and the hole in the painting is among other things a play on its composition: the black hole that is the grave has been dug at the foot of the canvas, as if disappearing out of the bottom of the frame. In the book, the burial takes place on a visit to Carnac, where Flaubert's description of the rocks would have reminded Cézanne of his geological discussions with Marion in the 1860s. He may even have read this section before, as an extract: "Des pierres de Carnac et de l'archéologie celtique," *L'Artiste,* 18 April 1858, reprinted in *Par les Champs,* pp. 819–24.

87. Gasquet, *Cézanne,* in *Conversations,* p. 111. This account has been greeted with some skepticism, though it is credited by Françoise Cachin (Tate, no. 171). It is rather literary—while disclaiming that very quality—but in the context of Cézanne's other remarks on Flaubert, it seems to me to be much more plausible than is often thought; moreover, the allusion is apt, as Cézanne's allusions usually are, and the proposed correspondence remarkably close. Cf. *Madame Bovary,* pp. 120–21. The reference to Apuleius is to *The Golden Ass. Old Woman with a Rosary* (R808) was given to Joachim Gasquet, who sold it soon after Cézanne's death. It is now in the NG.

88. See Solari to Zola, 18 February 1871, in Zola, *Corr.,* vol. 2, p. 278.

6: La Boule

1. Vollard, *Écoutant,* p. 126. Cf. Cézanne to Paul, 22 September 1906, in *Corr.,* p. 410.

2. See Alexis to Zola, 25 August 1881, in Rewald, *Cézanne-Zola,* p. 232, reporting Louis-Auguste's response to a questioner (his emphasis).

3. Beckett, "First Love" [1973], in *The Expelled,* p. 61.

4. See Perruchot, *Cézanne,* p. 229.

5. This suggestion seems to derive from Jean de Beucken, *Un Portrait de Cézanne* (1955), first published in *France Illustration,* 11 and 25 August 1951. As a biographer, de Beucken is rather novelistic, sometimes novelettish, but towards the end he was close to Cézanne's son (who died in 1947) and may have heard things that were common currency, at least in the family. Much of the flavor of his work is lost in the English "adaptation" by Lothian Small, *Cézanne* (1962).

6. *Portrait of Hortense Fiquet (Madame Cézanne Sewing)* (C729), dated c. 1880, is in the Courtauld (see no. 11). She is also sewing in an oil portrait (R323), dated c. 1877, and two unrelated drawings (C398 and 728).

7. It has been said that she modeled for Cézanne's friend Guillaumin, but I think this claim is not well founded. We do not know how she met Cézanne, or when exactly she first sat for him.

8. Butler, *Hidden,* p. 324; Cézanne to Zola, 19 December 1878, in *Corr.,* p. 224.

9. See Denis diary, 23 January–5 February 1913, in *Journal,* vol. 2, p. 150; interview with Aline Cézanne (the artist's granddaughter), in *Madame Figaro,* 23 September 1995.

10. Cézanne to Zola, 23 and 28 March and 4 April 1878, in *Corr.,* pp. 203–08. A crisis over his allowance may have been brewing for some time, whether or not

it was connected with Hortense: see Cézanne to Pissarro, 24 June 1874, in ibid., p. 187. Cézanne and Zola suspected Louis-Auguste of reading their correspondence during the arguments over his future in 1860: see, e.g., Zola to Cézanne, 5 May 1860, in Zola, *Corr.,* vol. 1, p. 161.

11. Rewald, *Cézanne-Zola,* p. 232; Cézanne to Zola, 1 June and 29 July 1878, in *Corr.,* pp. 211 and 214.

12. Kafka, *Letter to His Father,* pp. 7–8, 21, written in 1919, at the age of thirty-six. Probably realizing the futility of this gesture, his mother did not deliver it, but returned it to the author. Cf. Cézanne to his parents, [1874], in *Corr.,* pp. 185–86.

13. Cézanne to Zola, 14 September 1878, in *Corr.,* p. 219.

14. See Cézanne to Zola, 4 November and 19 December 1878, in *Corr.,* pp. 221 and 224.

15. A pencil drawing, on a single sheet (C406), tentatively dated c. 1880–84. For an example of his mother and fruit, see C397; for another page of studies including his own head and apple, see C405.

16. Cézanne to Bernard, 25 July 1904, in *Corr.,* p. 381. The parenthesis was an afterthought; but *sensations colorantes* were fundamental to his practice. See ch. 11.

17. Alexis to Zola, 13 February 1891, in Bakker, *Naturalisme,* p. 400; extracted in *Corr.,* pp. 294–95.

18. Coste to Zola, 5 March 1891 and April 1896 [1897?], in *Corr.,* pp. 295–96, and Rewald, *Cézanne-Zola,* pp. 340–41. Maxime Conil's reputation as a skirt chaser caused tension between the sisters: Marie made known her disapproval.

19. Balzac, *Physiologie du mariage* [1829] (Paris: Gallimard, 1987), p. 55.

20. Le Bail to Rewald, 19 March 1935, Rewald Papers, Box 50–1, NGA.

21. *Head of a Woman (Portrait of Madame Zola?)* (R75) was signed and dated (1864) and owned by Zola; it bears some resemblance to an undated photograph of Alexandrine, but the likeness has been disputed and the identification is not certain. The speculation about her relationship with Cézanne is severely dealt with by Rewald in that entry in the catalogue raisonné.

22. Alexandrine to Zola, 17 December 1870, in Zola, *Corr.,* vol. 2, p. 253. Further bulletins followed, on 19 and 22 December, one referring to Cézanne "*le malheureux.*"

23. In his letters to his son, she is always "Maman"; in his correspondence with others she usually appears as Paul's mother. See, e.g., Cézanne to Chocquet, 18 December 1889, in *Corr.,* p. 289.

24. Rewald, *Cézanne,* p. 78. This passage follows *Cézanne-Zola,* p. 157, to the letter, except that the final judgment is expressed more categorically in the earlier account. See also the commentary on R578.

25. Rewald to Sidney Geist, 9 March 1976, in Rewald Papers, 81–8, NGA. A response to "The Secret Life of Paul Cézanne," *Art International,* 20 November 1975. Geist's interpretations are indeed idiosyncratic, but he is one of the very few authors to take Hortense seriously, and also the significance of the relationship to Cézanne. See his *Interpreting Cézanne*; and more recently Butler, *Hidden,* and Sidlauskas, *Cézanne's Other.* Barbara Corrado Pope's novel *Cézanne's Quarry* (New York: Pegasus, 2008) has a believable Hortense character. On

Rewald, see Feilchenfeldt, *By Appointment,* p. 252. Rewald's ex-wife, Alice Bellony, makes a similar and wider point in a damaging memoir, *John Rewald* (Paris: L'Échoppe, 2005).

26. Rewald, *Cézanne,* pp. 264–65. Cf. Perruchot, *Cézanne,* p. 415; Lindsay, *Cézanne,* p. 342; Fauconnier, *Cézanne,* p. 256; and Tate, no. 138. The gossip can be traced back to de Beucken, who wrote of Madame Brémond's telegram summoning them both to his bedside: "It was Hortense who received it, but not wanting to postpone a fitting at her dressmaker's, she hid it in a drawer—where probably her son discovered it."

27. Marie to Paul, 20 October 1906, in *Corr.,* pp. 417–18. Cézanne had been seriously ill for five days. See ch. 12.

28. Rewald, *Cézanne,* p. 266, quoting Couturier diary, 23 June 1951, in Marie-Alain Couturier, *Se Garder libre* (Paris: Cerf, 1962), p. 116. Matisse was recounting a conversation over dinner at Jean Renoir's house, at least thirty years earlier.

29. Matisse to André Rouveyre, 3 June 1947, in Matisse, *Écrits,* p. 193.

30. Marie, according to Édouard Aude, in *Nouvelles littéraires,* 29 January 1928; Cézanne, according to Gasquet, in *Conversations,* p. 124.

31. Aline Cézanne in *Madame Figaro,* 23 September 1995. Marthe Conil remembered Cézanne's mother acknowledging Hortense's patience. See M.C., "Quelques souvenirs," p. 300.

32. Denis diary, November 1901, in *Journal,* vol. 1, pp. 175–76. Cf. Butler, *Hidden,* p. 80.

33. Rivière, *Renoir,* pp. 39–40.

34. The value of grey is emphasized in *Règles du paysage* (1841), by Jean-Pierre Thénot, an authority on perspective, whose work Cézanne read in the 1890s. See ch. 11.

35. Denis diary, 21 October 1899, in *Journal,* vol. 1, p. 157, reporting what Vollard told him at the time (his emphases); Vollard, *Écoutant,* pp. 87ff. Vollard embellishes his account with a comic misunderstanding over the phrase "as if placed randomly." "Wretch!" cries Cézanne menacingly, "how dare you say that Delacroix painted randomly!" He is then pacified. "I love Delacroix!" he says, by way of apology.

36. *Bouquet of Flowers, after Delacroix* (R894), dated 1902–04, was owned by Ivan Morozov, and is now in the Pushkin Museum in Moscow. The original watercolor is in the Louvre. Vollard maintained that it was not a gift but an exchange, to which the artist "generously consented"; Cézanne wrote nonspecifically of "the magnificent gift." See Rewald, "Chocquet," p. 187; Cézanne to Vollard, 23 January 1902, in *Corr.,* p. 351.

37. *Three Bathers* (R258), dated 1874–75, now in the Musée d'Orsay, after passing through the hands of Vollard, Bernheim-Jeune, and Pellerin.

38. The portraits are R292, 296, 297, 460, 461, and 671, together with the portrait drawings C394, 395, and 398a. R460, dated to the early 1880s, appears to have been done from a photograph, reproduced in the catalogue raisonné; C395 and 398 could be preliminary studies for that work.

39. Charles Bigot, "Causerie artistique," *La Revue politique et littéraire,* 28 April 1877; "Les Impressionistes," *La Petite Presse,* 9 April 1877, in Tate, p. 167.

This portrait is R292, dated 1876–77, now in a private collection. In terms of physiognomy and angularity, there is a certain resemblance to the Delacroix, which was originally a double portrait of Chopin and George Sand (1838). Cézanne had done a drawing of a face probably copied from a portrait of Chopin, according to Chappuis (C185a), c. 1866–70; a drawing of Chopin by Delacroix entered the Louvre in 1872. The Renoir is *Portrait of Victor Chocquet* (1875–76), in the Fogg Art Museum in Cambridge, MA.

40. This one is R296, dated 1877, now in the Columbus Museum of Art, Ohio.

41. Schapiro, *Cézanne,* p. 34; Gowing in Passantino, *Duncan Phillips,* p. 90.

42. Gasquet, *Cézanne,* in *Conversations,* pp. 151–52.

43. Zola, *L'Œuvre,* pp. 243–44.

44. *The Apotheosis of Delacroix* (R746), dated 1890–94, is now in the Musée Granet. There is also a watercolor study of the Chocquet figure, with angel (RWC69), from c. 1878–80. In a photograph probably taken by Bernard in 1904, Cézanne poses as a painter, armed with brushes, with the *Apotheosis* on the easel. But that does not necessarily resolve the dating: the state of the work is not entirely clear; and Cézanne could simply have chosen that painting as a kind of attribute, to complete the pose. Bernard claims that Cézanne spoke of replacing Chocquet with Bernard himself; there seems to have been some talk of photographs in that connection. Bernard, "Souvenirs," in *Conversations,* pp. 69, 76; Cézanne to Bernard, 12 May 1904, in *Corr.,* p. 377.

45. See Bernard, "Souvenirs," in *Conversations,* p. 72. The work in question is RWC68.

46. *The Peacock Basin* (R643) is now in a private collection; *The Barque and the Bathers* (R644) was at one time split into three, but is now whole, in the Orangerie. Painted in 1890, the panels are long and narrow (30 x 124 cm), probably to go above the doorway.

47. See, e.g., the highly unusual terms of Cézanne to Chocquet, 7 February 1879, in *Corr.,* p. 229.

48. Hortense to Marie Chocquet, 1 August 1890, in *Corr.,* pp. 291–93.

49. Hortense to Bernard, 10 September 1905, Archives Vollard, Musée d'Orsay (her emphasis).

50. Marchutz to Rewald, 21 January 1936, Rewald Papers, 51–6, NGA, reporting the views of Marthe Conil, who had spent a summer with Cézanne's mother, Cézanne, Hortense, and little Paul in L'Estaque. She also thought that any talk of tension between Cézanne's mother and Hortense had been overdone, not least because Élisabeth Cézanne was so fond of her grandson.

51. Cézanne to Paul, 25 July 1906, in *Corr.,* p. 397, not the sentiments of someone past caring for his spouse. In a letter to Aurenche, on 10 March 1902, he indicates that she is not very well.

52. Cézanne to Solari and Gasquet, 21 and 23 July 1896, in *Corr.,* pp. 316 and 319. *Lake Annecy* (R805) is now in the Courtauld.

53. Rilke to Clara, 16 October 1907, in Rilke, *Letters,* p. 52 (my emphasis).

54. Rilke to Clara, 22 October 1907, in in Rilke, *Letters,* pp. 70–72 (his emphasis), on R324, dated c. 1877, now in the MFA Boston. Gris made a fine drawing after a reproduction of it, *Seated Woman (After Cézanne)* (1916).

55. Kimmelman, *Portraits,* pp. 20–21, 23, on R655, dated c. 1888–90, now in the Met. See also the interview with Robert Storr in *Elizabeth Murray* (New York: MoMA, 2005), p. 172.

56. R651, 652, 653, and 655, all dated c. 1888–90. The free-standing one is *Madame Cézanne in a Red Dress* (R652), now in the Museo de Arte, São Paulo, Brazil.

57. R651, now in the Beyeler Collection, Basel.

58. Sidlauskas, *Cézanne's Other,* pp. 25, 166; Andersen, *Portrait Drawings,* p. 79, citing *Portrait of Madame Cézanne* (R532), now in the PMA; Rishel, *Cézanne in Philadelphia Collections,* p. 27; Forge, *Monet,* p. 61.

59. Kafka, trans. Martin Greenberg, 20 August 1912, in *The Diaries* (London: Secker & Warburg, 1976), p. 722.

60. Loran, *Cézanne's Composition,* p. 85, based on *Portrait of Madame Cézanne* (R683), now in the Barnes Foundation. Lichtenstein repeated the trick with another diagram (p. 91), based on *Man with Folded Arms* (R850). The philosopher is Arthur C. Danto, in *The Transfiguration of the Commonplace* (Cambridge, MA: Harvard University Press, 1981), pp. 194ff.

61. Reproduced in Kimmelman, *Portraits,* p. 22, from which I have purloined (and adapted) the description.

62. Murray interviewed by Robert Storr (2005), in *Elizabeth Murray,* p. 172.

63. Stein, *Toklas,* p. 38, apropos R606, begun 1878, reworked 1886–88, now in the Bührle Collection in Zurich. It was exhibited at the Salon d'automne of 1904 as *Woman with Fan*; hence perhaps Stein's description.

64. See, e.g., R583, dated c. 1885–87, now in the Musée Granet; or R685, dated c. 1890–92, now in the PMA.

65. A story retold in Martin Meisel, *How Plays Work* (New York: Oxford University Press, 2007), p. 41, of *Happy Days.*

66. Gasquet, *Cézanne,* in *Conversations,* pp. 152–54. *Portrait of Henri Gasquet* (R810), dated 1896, is now in the McNay Art Institute, San Antonio, Texas.

67. Proust, *Remembrance,* vol. 1, p. 978.

Self-Portrait: The Dogged

1. This one is R274. Pissarro's self-portrait (P283), now in the Musée d'Orsay, was painted in Pontoise in 1873 during Cézanne's sojourn there. For Pissarro's portrait of Cézanne (P326), see ch. 7.

2. Rilke to Clara, 23 October 1907, in Rilke, *Letters,* pp. 74–75.

3. Seamus Heaney, "An Artist" [1984], in *Opened Ground* (London: Faber, 1998), p. 283.

4. Adrian Stokes, "Cézanne" [1947], in *Critical Writings,* vol. 2, p. 272.

5. R182, dated c. 1875, now in the Musée d'Orsay; R219, dated c. 1875, now in the Hermitage; R383, dated c. 1877, now in the Phillips Collection; R385 (Pissarro's), dated c. 1877, now in the Musée d'Orsay; R386, dated 1877–78, now in the Villa Flora, Winterthur; R416 (Degas's), dated 1879–80, now in the Oskar Reinhart Collection, Winterthur.

6. Joseph Péladan, from *La Revue hebdomadaire,* in Tate, p. 146. This refers to R383.

7. Badt, *Art of Cézanne,* pp. 185–86, following Venturi's catalogue raisonné, p. 36.

8. Passantino, *Duncan Phillips,* p. 90, quoting Gowing's lecture at the Phillips Collection, "Self-Consciousness in Art: Cézanne's Self-Portraits" (1987).

9. Some of Giacometti's copies are illustrated in Baumann and Tøjner, *Cézanne and Giacometti,* p. 232. On Giacometti, Cézanne, and the head, see ch. 10.

7: The Lizard

1. Roux to Zola, n.d., in Rewald, *Cézanne-Zola,* p. 182.

2. Roux to Zola, 4 January 1871, in Rewald, *Cézanne-Zola,* pp. 178–80. See also Zola to Valabrègue, 7 January 1871, in Zola, *Corr.,* vol. 2, pp. 273–74.

3. Rewald, *Cézanne-Zola,* p. 180.

4. Mack, *Cézanne,* pp. 164–65, based on an interview with Conil in the 1930s; Faure, *Constructeurs,* p. 223; Denis to Gide, 21 June 1919, in *Correspondance André Gide–Maurice Denis* (Paris: Gallimard, 2006), p. 327. Gide's friend Jacques Raverat was engaged in a controversy with Clive Bell over Cézanne's reputation and record. Conil was not a member of the family at the time, as Mack points out, nor was he a reliable witness.

5. Alexis to Zola (his emphasis) and Zola to Alexis, 19 and 30 June 1871, in Zola, *Corr.,* vol. 2, pp. 287 and 289.

6. Zola to Cézanne, 4 July 1871, in Zola, *Corr.,* vol. 2, pp. 293–94; not in *Corr.,* but in *Letters,* pp. 129–30. The preface to *La Fortune des Rougon,* dated 1 July 1871 and criticized by Flaubert as too revealing, is in some fashion a public version of this letter.

7. The work set in the pavilion is known as *Paul Alexis Reading at Zola's House* (R150), now in a Swiss private collection, though the identification of the subjects remains doubtful; the work set in the garden is *Paul Alexis Reading to Émile Zola* (R151), now in the Museo de Arte, São Paulo, both dated 1869–70. "The pasha" is Gowing, in *Early Years,* p. 164.

8. Vollard, *Écoutant,* pp. 41–43. The letter was published, complete, as an appendix to Vollard's book. It is not clear how exactly it came to light. The reported conversation would date from the 1890s, that is to say after the supposed rift between Cézanne and Zola.

9. Gowing in *Early Years,* p. 166; Schapiro in *Cézanne,* p. 54; Loyrette in Tate, no. 25. *Melting Snow* (R157) is now in a Swiss private collection; *Landscape* (C121), now in the Art Institute of Chicago, may have been a study for *The Fishermen's Village at L'Estaque* (R134), but surely not for the *View of L'Estaque* (R514), a decade later, as stated by Chappuis. *L'Estaque, Evening Effect* (R170), sometimes dated to this period, seems to me to be a little later, perhaps c. 1876, as suggested by Rewald.

10. Respectively, R154, now in the Pushkin Museum in Moscow; R152, now in a private collection; and R153, also in a private collection. Cézanne was not necessarily responding to events linked to the dates of publication; apart from anything else, he would have received the relevant issue some time afterwards—in the case of R153, long afterwards.

11. *Allegory of the Republic* (C198), dated c. 1871, in a Zurich private collection,

and *The Temptation of Saint Anthony* [?] (C444), dated 1869–73, in the Kunstmuseum, Basel. The two sides of a sketchbook page are not necessarily contemporaneous; Cézanne used and reused different pages at different times.

12. Cézanne to Emperaire, 26 January 1872, in *Corr.*, p. 179.

13. Emperaire to a friend, 27 March 1872, in *Corr.*, p. 180. See also his other complaints, of 19 February and 17 March 1872, continued over a year later, in June 1873. Cézanne was soon helping him out again, notwithstanding. See Cézanne to Zola, [summer 1878], p. 216.

14. Baudelaire, "Spleen" (I), in *Flowers of Evil,* p. 145. The French Revolution established a new Republic with a new calendar, starting on 22 September 1792 (and abolished by Napoleon from 1 January 1806). Pluvius (*Pluviôse*) was the name given to the period from 21 January to 19 February; it also means rainy, but this would appear to be a reference to revolutionary times. *Quai de Bercy* (R179), once owned by Pissarro, is now in a private collection.

15. Pissarro to Guillemet, 3 September 1872, in Pissarro, *Corr.*, vol. 1, p. 77.

16. Cézanne and Lucien to Pissarro, 11 December 1872, in *Corr.*, p. 181. The reference is to Nestlé milk powder, prescribed by Dr. Gachet, a personal friend of Nestlé.

17. Lindsay, *Cézanne*, p. 104.

18. *Portrait of Madame Pissarro,* c. 1874, reproduced in *Cézanne & Pissarro,* p. 43 (William Woodward III Trust). He also copied Pissarro's *Woman Sewing* (1881).

19. Meadmore, *Lucien*, p. 26.

20. Chappuis, in his commentary on the drawing (C300), formerly owned by Pissarro, now in the Cabinet des Dessins of the Louvre; Marc de Montifaud [Marie-Émilie Chartroule], "Exposition du boulevard des Capucines," *L'Artiste,* 1 May 1874. See also ch. 12. *A Modern Olympia* (R225) was supposedly dashed off as a kind of dare, after a conversation with Gachet, according to the story told by the latter's son (born 1873), who was neither a firsthand witness nor a reliable source. The source photograph for the drawing is widely reproduced, e.g., in *Cézanne & Pissarro,* p. 237.

21. Delacroix, "Raphael," *Revue de Paris* XI (1830), p. 128.

22. Rewald, *Impressionism,* pp. 456–57, from Le Bail's unpublished notes of 1896–97.

23. Cf. Guillaumin, *The Seine at Bercy* (1873–75), and *The Seine at Bercy, after Guillaumin* (R293), dated 1876–78, now in the Kunsthalle, Hamburg. Cézanne's painting was bought by Vollard for 400 francs in 1899 and sold to Bernheim-Jeune for 2,000 francs in 1900.

24. *Louveciennes* (P207), measuring 90 cm x 116 cm, was bought by Caillebotte, and duly refused by the state; *View of Louveciennes, after Pissarro* (R184), measuring 73 cm x 92 cm, was owned by Gachet, and is now in a private collection.

25. Cézanne to Paule Conil, 1 September 1902, in *Corr.*, pp. 364–65; Gasquet, *Cézanne,* p. 34. Cézanne was not alone. As he would have read, Flaubert spoke witheringly of "the eternal desire of the featherless biped to want to discover some sort of meaning in everything," apropos the ancient stones of Carnac, in *Par les champs et par les grèves* (1886).

26. *Turning Road* was a favorite motif. This one is R488, dated c. 1881, now in a private collection.

27. Respectively, *Snow Effect, Rue de la Citadel* (R195, presumed destroyed during the Second World War) and *Rue de la Citadel* (P323); *The Clos des Mathurins* (R310) and *View of the Maison des Mathurins* (P408); *Pissarro's Kitchen Garden* (R311) and *The Jardin de Maubuisson* (P494); *Houses at Valhermeil Seen from the Direction of Auvers-sur-Oise* (R493) and *The Hills at Le Chou* (P673). Rewald was uncertain about the chronology of the second pair, as to whether Cézanne and Pissarro worked there together in 1875, or Cézanne went there alone in 1877.

28. *Camille Pissarro, Seen from Behind* (C301), dated 1874–77, originally owned by Pissarro, now in the Kunstmuseum, Basel. See also *Portrait of Pissarro* (C299), in a large straw hat, at the easel. Cézanne was fond of sketching from behind: cf. *Dr. Gachet* (C296), owned by Gachet; and an unidentified woman (C346).

29. Respectively, *The Bridge at Maincy* (R436), once owned by Chocquet, now in the Musée d'Orsay, and *Small Bridge* (P401); *Jalais Hill* (R410, as *La Côte du Galet at Pontoise*), now in a private collection, and *La Côte des Jalais* (P116); *The Mill on the Couleuvre* (R483), now in the Nationalgalerie, Berlin, and *The Hills at L'Hermitage* (P121). There is also *Little Houses near Auvers* (R220), dated 1873–74, now in the Fogg Art Museum, Harvard, and *Harvesting Potatoes, Pontoise* (P360); and *The Hamlet of Valhermeil, near Pontoise* (R489), dated 1881, now in a Japanese private collection, and *The Ploughman at Valhermeil* (P438). As for names, the hill behind the prominent house in R220 and P360 is the Côte Lézard at Pontoise.

30. Brettell, "Pioneering Modern Painting," p. 683.

31. Pissarro to Lucien, 17 February 1884, in Pissarro, *Corr.*, vol. 1, p. 285 (his emphasis).

32. Pissarro to Lucien, 8 April 1896, in Pissarro, *Corr.*, vol 4, p. 188; Cézanne to Paul, Friday [20] July 1906, in *Corr.*, p. 396. Pissarro's painting was *The Roofs of Old Rouen, Notre Dame Cathedral, Overcast Sky* (P1114). He and Cézanne had bumped into each other at the exhibition of Monet's *Cathedrals,* and agreed on their masterly quality: see Pissarro to Lucien, 26 March 1895, in ibid., p. 75.

33. Pissarro to Lucien, 22 November 1895, in Pissarro, *Corr.*, vol. 4, p. 121.

34. Braque for one was well read in the exemplary life of Cézanne, which he devotedly followed. As Cézanne had his bedside Delacroix, so Braque had his bedside Cézanne. See Danchev, *Braque*, pp. 235–36.

35. Charles Tomlinson, "The Pupil" [2006], in *New Collected Poems*, p. 667.

36. Gasquet, *Cézanne*, in *Conversations*, p. 121 (my emphasis). The source for the sentence in italics, one of his most famous declarations, is indeed Maurice Denis (*Conversations*, p. 170), who heard it from Cézanne on his visit of 1906, and published it first in *L'Occident* (1907) and then in his *Théories* (1912 and much reprinted). For some reason it is not in his *Journal*, but Denis is a reliable witness, with a good ear for Cézanne's speech, as far as we can tell. Renoir remembered Cézanne calling his compositions "memories of museums" (*souvenirs de musées*). Vollard, *Écoutant*, p. 291.

37. Callen, *Impressionism*, p. 145, on R202 and P380.

38. Bernard, "Souvenirs," in *Conversations*, pp. 61 and 72. Bernard's list corresponds closely with the latest technical studies of the Cézannes in the NG and the Courtauld. Cf. Reissner, "Ways of Making," pp. 9–10, and "Transparency of Means," pp. 63, 69. As Reissner points out, some discrepancies may be a matter of nomenclature. Naples yellow, for example, was not found in the NG study, but "brilliant yellow," also mentioned by Bernard, is listed in a contemporary catalogue as "a variety of Naples yellow prepared from chrome yellow and white lead."

39. Reissner, "Transparency of Means," p. 63. The paintings analyzed were *L'Étang des Sœurs, Osny* (R307), *Tall Trees at the Jas de Bouffan* (R547), *Montagne Sainte-Victoire with Large Pine* (R599), *Pot of Primroses and Fruit* (R639), *The Card Players* (R713), *Man with a Pipe* (R712), *Still Life with Plaster Cupid* (R786), and *Lac d'Annecy* (R805).

40. Gasquet, *Cézanne*, in *Conversations*, p. 124.

41. "Le Bouquet de roses: propos de Pierre Bonnard recueillis en 1943," *Verve* (August 1947), quoted in Sarah Whitfield, "Fragments of an Identical World," in *Bonnard* (London: Tate, 1998), p. 20. Bonnard owned a *Bather with Outstretched Arms* (R252), of c. 1876, and made a lithograph of it; in the 1940s a reproduction of *The Seine at Bercy, after Guillaumin* (R293) was pinned to the wall of his studio.

42. Cézanne to Marx, 23 January 1905, in *Corr.*, pp. 390–91. "Sensationism" was a contemporary term of art, coined by Albert Aurier, connoting both the external stimulus or "impression" of something (out there) and the internal process of receiving it and, as it were, converting it into sensory experience (in here)—which is roughly what Cézanne meant when he spoke of his *sensation*. See Albert d'Escorailles [Albert Aurier], "Sensationisme," *Le Décadent littéraire*, 13 November 1886. Cf. Shiff, *Cézanne*, pp. 42–43, 186–88.

43. Vollard, *Écoutant*, p. 44.

44. Matisse's recollections of a conversation with Pissarro, of c. 1897, in Barr, *Matisse*, p. 38, and Duthuit, *Les Fauves*, pp. 169–70; Pissarro to Lucien, 7 March 1898, in Pissarro, *Corr.*, vol. 4, p. 458.

45. Denis, *Charmes et leçons de l'Italie* (Paris: Colin, 1933), pp. 189–92. Matisse adopted or adapted some of this for himself: "After a certain time, Cézanne always painted the same canvas of the *Bathers*." Interview with Jacques Guenne (1925), in *Matisse on Art*, p. 80.

46. Lucien's notes, Sketchbook 52 (1912), pp. 95–99, Pissarro Papers, Ashmolean. Some of these notes, but not all, were used in Lucien to Paul-Émile Pissarro, [1912], in Thorold, *Artists*, p. 8.

47. Virgil, *Eclogues*, no. 6, 1ff. "C'est Théocrite aux Halles," said Zola, of Claude Lantier in *Le Ventre de Paris*, referring to the market Les Halles. See Denise Le Blond-Zola (his daughter), *Zola*, p. 79.

48. Leroy, "L'exposition des impressionistes," *Le Charivari*, 25 April 1874; Montifaud, "L'exposition du boulevard des Capucines," *L'Artiste*, 1 May 1874.

49. Latouche to Gachet, 26 April 1874, in Gachet, *Deux amis*, p. 58. *House of the Hanged Man* (R202) and *A Modern Olympia* (R225) are now in the Musée d'Orsay; *House of Père Lacroix* (R201) is in the NGA.

50. Cézanne to his mother, 26 November 1874, in *Corr.,* pp. 188–89. This letter is known only from Coquiot, *Cézanne,* pp. 70–72, who indicates that a few lines have been omitted (shown here [. . .]), perhaps because Cézanne mentioned people still alive when that book was first published (in 1914); the English edition of his correspondance does not indicate the omission. The date given by Coquiot and followed by Rewald, 26 September, does not square with the dates of Pissarro's movements, which suggest that September is a misreading of November. It is evident from other letters that "Girard" in Coquiot (and Rewald) is a misreading of Giraud.

51. Quoted in Mothe, *Cézanne à Auvers,* p. 37. See also Cézanne to Doria, Chocquet and Maus, 30 June, 18 December, and 21 December 1889, in *Corr.,* pp. 286–90.

52. Interview with Jacques Guenne (1925), in *Matisse on Art,* p. 80.

53. In fact there are several *Card Players* (R706, 707, 710, 713, and 714). Coincidentally, Camondo owned one (R714). The earliest of them (R706 and 707) have been dated to 1890–92. Matisse did not specify; Joachim Pissarro believes that he was thinking of R706, now in the Barnes Foundation (*Cezanne & Pissarro,* pp. 51–52), which seems very plausible. Giacometti did a pencil copy of the same painting. See *Cézanne & Giacometti,* no. 166 (undated).

54. Fry, *Cézanne,* p. 38, on the card players.

55. Ginsberg, "Art of Poetry," pp. 26–27.

56. Breton, *L'Amour fou,* pp. 155–57 (his emphases, trans. modified), making reference to *The Murder* (R165), dated to c. 1870, now in the Walker Art Gallery, Liverpool; *The Card Players* (R706?); and *Boy with Skull* (R825), usually dated to 1895–98, also in the Barnes Foundation.

57. *The Abandoned House* (R351), dated to 1878–79, is now in a New York private collection; *The Cracked House* (R760), dated to 1892–94, is now in the Met.

58. Auden, "As I Walked Out One Evening" [1937], in *Collected Poems,* p. 134.

59. Bernstein, "Cézanne and Johns," in *Cézanne and Beyond,* p. 463. Cf. Gasquet, *Cézanne,* p. 57.

60. Johns, *Writings,* p. 166, apropos *The Large Bather* (R555), dated to c. 1885, now in MoMA. See, e.g., *Diver* (1962) and *Land's End* (1963), reproduced in Varnedoe, *Johns,* nos. 98 and 102.

61. See Cézanne to Doria and Maus, 30 June and 21 December 1889, in *Corr.,* pp. 286 and 290.

62. Melot, *Impressionist Print,* p. 105.

63. Geist suggests that the title of the hanged man (*le pendu*) was in fact Cézanne's nickname, among his friends, because he or his getup reminded them of the rack (*le pendu*) suspended from the ceiling in pawnshops, on which were hung pawned clothes. Geist may overdo the wordplay and word association in Cézanne—in this context he points also to the famous black clock (*la pendule*)—but this is an ingenious suggestion.

64. *Guillaumin with the Hanged Man* (1873), in sepia, from the deluxe edition of Duret's *Histoire des peintres impressionistes* (1906), is in the Courtauld (see no. 18); another example is in the BM. His other etchings were *Barges on the Seine at Bercy,* copied from a painting by Guillaumin; *Landscape at Auvers,*

based on one of his own paintings (R196); *Garden at Bicêtre*; and *Head of a Girl*, who appears to be the model for another work by Guillaumin, a pastel of the same title. Cézanne's *Portrait of the Painter Guillaumin* (C233), dated to 1869–72, is in the Boymans–van Beuningen Museum, Rotterdam. Guillaumin's etching, *Three Men at Table* (1873), is reproduced in Mothe, *Cézanne à Auvers,* p. 39; the man on the left is supposed to be Cézanne, though he is most kindly described as indistinct.

65. See *Portrait of Camille Pissarro* (C298), dated c. 1873, originally owned by Pissarro, and later by John Rewald; *Portrait of Cézanne in a Felt Hat* (c. 1874), both in the Cabinet des Dessins of the Louvre. Reproduced in *Cézanne & Pissarro,* nos. 15 and 17.

66. Bernard, "Cézanne" [1891], reprinted in *Propos,* pp. 20–22. Cf. Pissarro to Lucien, 2 and 7 May 1891, in Pissarro, *Corr.,* vol. 3, pp. 70 and 76–77.

67. *Portrait of Paul Cézanne* (P326) is explored in Reff, "Pissarro's Portrait of Cézanne," who insists on Cézanne's fundamentally apolitical outlook, while emphasizing his increasingly conservative, even reactionary, stance as he grew older. It seems to me that this position is too narrowly based and dogmatic; and that it does not capture the range and depth (or fluctuation) of his political engagement. It also tends to be just as misleading about his father, conflating social and political attitudes to produce a picture or caricature of undifferentiated conservatism.

68. *Le Hanneton,* 13 June 1867, caricature by Léonce Petit.

69. Vollard, *Écoutant,* p. 88 (and 90 and 93).

70. Cézanne to Zola, 14 April and 1 June 1878, in *Corr.,* pp. 209 and 211–12; Fernand Gregh, *L'Age d'or* (Paris: Grasset, 1947), p. 294.

71. Cézanne to Zola, 24 September 1878, in *Corr.,* pp. 219–20. Almost alone, Paul Smith has drawn attention to this remarkable passage. See the introduction to Roux, *Substance and Shadow,* p. xliv.

72. Cézanne to Pissarro, 2 July 1876, in *Corr.,* p. 196. In this letter Cézanne tells Pissarro that he is awaiting the fall of Dufaure, the president of the Council, and the partial renewal of the Senate.

73. Horace, "Parentis olim," *Complete Odes,* p. 6.

74. Cézanne to Coste, [July] 1868 and Monday evening [November 1868], in *Corr.,* pp. 168 and 170; Roux to Zola, 1 December 1868, in Thomson, "Roux-Zola," p. 367; Valabrègue to Zola, September 1865, in Rewald, *Cézanne-Zola,* p. 102. He was still reading *La Lanterne* in 1879: see Cézanne to Zola, 3 June 1879, in *Corr.,* p. 232.

75. Courbet to Maurice Richard, 23 June 1870, in Nochlin, *Courbet,* p. 87.

76. Cézanne to Zola, Wednesday evening 1878, in *Corr.,* p. 206, apropos *Une Page d'amour.*

77. *Still Life with Soup Tureen* (R302) is now in the Musée d'Orsay. It is firmly dated 1877 by Rewald, relying in the first instance on circumstantial evidence from Lucien—too firmly, I think. Loyrette (Tate, no.32) does not hesitate to date it earlier, c. 1873–74, observing that other canvases executed in Auvers at that time, notably *House of the Hanged Man,* have the same facture and texture

(and noting pointedly that Rewald elaborated on Lucien's evidence only after his death). Joachim Pissarro agrees with Loyrette, dating it to c. 1874 (*Cézanne & Pissarro,* p. 90). That seems convincing.

78. Many years later he was persuaded to part with it, to the mighty Auguste Pellerin, through the good offices of Octave Mirbeau. Pellerin bequeathed it to the Louvre in 1929.

79. Cézanne to Pissarro, 24 June 1874 and 2 July 1876, in *Corr.,* pp. 186–87 and 193–94 (my emphasis). In the first letter Cézanne is referring to *The Railway Crossing at Les Pâtis, near Pontoise* (P306). In the second, he indicates a three-letter word pertaining to Guillemet (*con?*). One of his motifs became *The Sea at L'Estaque* (R279), known to Chocquet as *The Mediterranean,* now in the Fondation Rau in Zurich. *The Hills at L'Hermitage* (P121) measured 1.5 x 2.0 meters. It was acquired by Durand-Ruel in 1873 and sold the same day to Faure.

80. Pierre Boulez, trans. Susan Bradshaw and Richard Rodney Bennett, *Boulez on Music Today* [1963] (London: Faber, 1971), p. 131. See also Peter Handke, trans. Ralph Manheim, "The Lesson of Monte Sainte-Victoire" [1980] in *Slow Homecoming* (New York: NYRB, 2009), p. 144.

81. Cézanne to Bernard, 23 October 1905, in Courtauld, letter B8 (my emphasis). See Jacques Derrida, trans. Geoff Bennington, *The Truth in Painting* [1978] (1987); Denis Coutagne, *Cézanne en vérité(s)* (2006).

82. See Cézanne to Pissarro, 23 October 1866, in *Corr.,* pp. 159–60.

8: *Semper Virens*

1. Given the rudimentary titles of the works exhibited—*Still Life, Flower Study*—a definitive listing has proved difficult. Rewald identifies the following, by current title, most of them lent by Chocquet: *The Fishermen* (R137), *Bathers at Rest* (R261), *The Rococo Vase* (R265), *Chestnut Trees and Farm at the Jas de Bouffan* (R268), *The Road* (R275), *Auvers-sur-Oise* (R277), *The Sea at L'Estaque* (R279), *Portrait of Victor Chocquet* (R292), *Tiger, After Barye* (R298), *Flowers in a Vase* (R315), *Apples and Cakes* (R329), *A Dessert* (R337), and *Dish of Apples* (R348), plus three watercolors: *Flowers and Fruits* (RWC8), *Rocks* (RWC10), and *The Climbing Road* (RWC17).

2. Cézanne to Maus, 27 November 1889, in *Corr.,* p. 288, accepting the invitation to exhibit with Les XX in Brussels.

3. There are three *Bathers at Rest* (R259, 260, and 261), dated to 1875–77, and a controversy about which was exhibited in 1877: the first (R259, now in the Musée d'Art et d'Histoire, Geneva), which is indeed more of a preparatory study, or the last (R261, now in the Barnes Foundation), which appears to represent the finished painting, arduously worked over. Weighing the arguments, Rewald plumped for the latter, a verdict questioned in the catalogue raisonné by Feilchenfeldt, on the grounds of its provenance (see below). Rewald was right, I think.

4. Georges Rivière, "L'Exposition des impressionistes," *L'Impressioniste,* 14 April 1877.

5. Jean Renoir, *My Father,* p. 105.

6. Alexis, *Madame Meuriot*, pp. 311–12. "At once timid and violent" became part of the Cézanne mythology. See ch. 10.

7. See Cézanne to Paul, 3 August 1906, in *Corr.*, mentioning "le regretté Cabaner." Cf. Vollard, *Écoutant*, p. 50.

8. Lefrère and Pakenham, *Cabaner*; Robb, *Rimbaud*, pp. 132–34.

9. Goncourt, *Journal*, 6 January 1889, and Champsaur, *Dinah Samuel* (1882), in Robb, *Rimbaud*, p. 417. Cabaner is Rapere, Rimbaud is Cimber in Champsaur's novel. The painter's name is Paul Albreux. "Alb" suggests albino, from the Latin *albinus*, the opposite of black (*noir*); "reux" sounds like the "Re" from Renoir.

10. Rimbaud, trans. Robb, "Vowels," in *Rimbaud*, pp. 135–36.

11. Vollard, *Écoutant*, pp. 50–51.

12. Cézanne to Zola, 20 May 1881, in *Corr.*, p. 250. Sollers, *Le Paradis de Cézanne*, proposes a comparison or affinity between Cézanne and Rimbaud himself.

13. Gasquet, *Cézanne*, in *Conversations*, p. 110. He said more than this, according to Gasquet, but it begins to sound a little too much like Gasquet's embroidering on Cézanne.

14. Cézanne to Roux (undated draft), [1878–79], in *Corr.*, pp. 225–26; printed and translated by Smith in Roux, *Substance and Shadow*, p. 205. The draft original is on a sketch of bathers (C378). It includes an additional phrase below *Pictor semper virens*, not reproduced in the published versions, or subsumed in a bit of postscript politeness. It is almost illegible, but appears to be a qualification of some sort, probably jocular—"although not [illegible]" (*quoique n'*[illegible] *pas*). Cézanne's relations with Roux had cooled in 1870–71; Roux's companion was close to Zola's wife, and may have taken a similar view of Cézanne and Hortense. See ch. 7.

15. See Cézanne to Coste, Monday evening [November 1868], in *Corr.*, p. 170. Cézanne may have remembered Cicero's *alia semper virent*, but he may also have been inspired by the use of the phrase in Balzac's *Illusions perdues* (1843), of the melancholic Lucien de Rubempré.

16. Denis, *Journal*, 1906, in *Conversations*, p. 94.

17. Horace, *Odes*, 4:2, trans. Rachel Hadas.

18. Cézanne to Zola, 12 April (and 7 May) 1878, in *Corr.*, pp. 246–48.

19. Vollard, *Écoutant*, p. 309.

20. Pissarro to Huysmans, Huysmans to Pissarro, 15 May 1883, in Pissarro, *Corr.*, vol. 1, p. 208.

21. Huysmans, "Paul Cézanne" [1888], in *Écrits*, p. 360. I follow the translation in Tate, p. 27. Huysmans wrote of *baigneuses* rather than *baigneurs*, but his description of the nude bathers fits *Bathers at Rest* (which he may not have seen for some years).

22. Geffroy, "Paul Cézanne," *Le Journal*, 25 March 1894. See also his statements in G. L. [Gaston Lesaulx], "Pour le Luxembourg," *Le Mémorial artistique*, 24 March 1894.

23. See Druick, "Lithographs," in *Late Cézanne*, pp. 119–37. *Large Bathers*, measuring 41 cm x 51 cm (the original painting measuring 79 cm x 97 cm), dated to 1896–98, the first work of Cézanne's acquired by Barnes, in 1912. One of the

hand-colored impressions is in the NGA, Ottawa. Another (without watercolor), from Vollard's collection, was sold at auction by Sotheby's in Paris in 2010 for around 20,000 euros.

24. *Bathers at Rest* (RWC61), dated to 1875–77, bought by the Shirakaba Group in 1921 and illustrated in their journal in 1923; acquired by Marubeni Corporation, Osaka, in 1969; now in the Bridgestone Museum of Art, Tokyo.

25. Fry, *Development*, pp. 57–58.

26. Gasquet, *Cézanne*, in *Conversations*, p. 137. For the comparison with Manet, see ch. 3.

27. Stendhal, *Histoire*, pp. 281–83 (my emphasis); Cézanne to Zola, 20 November [1878], in *Corr.*, p. 223. For his earlier reading, see ch. 4. For Taine, too, artists had been elevated to the ranks of the melancholic, as Cézanne could have read (*Philosophie de l'art*, vol. 1, pp. 65ff.).

28. Stendhal, *Histoire*, p. 279, on the melancholic temperament (his emphasis).

29. Cézanne to Zola, 24 September 1878, in *Corr.*, p. 220. According to Gasquet, Cézanne and Marion remained friends in later life, and even painted together (*Cézanne*, pp. 151–52); in this account, Cézanne himself makes favourable reference to Marion in discussion in the 1890s (*Conversations*, p. 112).

30. Cézanne to Zola, 14 September 1878, in *Corr.*, p. 218; La Fontaine, "The Oak and the Reed," in *Complete Fables*, pp. 25–26. As Cézanne probably knew, Corot had illustrated this fable, asserting the vulnerability of the oak. Huot became architect of the city of Marseille.

31. Cézanne to Zola, 23 February 1884, in *Corr.*, pp. 268–69. Not everyone was found wanting. In the same letter, Cézanne asks Zola to send his regards to "his compatriot" Alexis, of whom he had heard nothing for ages; and Solari for one never came in for any censure.

32. Cézanne to Huot and Solari, 4 June 1861 and 23 July 1896, in *Corr.*, pp. 121 and 318; Baudelaire, "Anywhere out of the world," in *Paris Spleen* [1869], p. 99 (translation modified). Cf. ch. 3.

33. Cézanne to Zola, 19 [?] November 1858, quoting Virgil, *Georgics*, 1:145–46, and 20 May 1881, in *Corr.*, pp. 44 and 251.

34. Delacroix, *Journal*, 9 June 1823, 4 and 8 November 1854, vol. 1, pp. 104 and 862–63. See also 5 October 1854.

35. Delacroix, *Journal*, 1 July 1854, vol. 1, pp. 789–90.

36. Cézanne to Zola, 14 May 1885, in *Corr.*, p. 272, quoting Virgil, *Eclogues*, 2:65. In the published edition of Cézanne's correspondence, the quotation is translated "Everyone is swept away by his passion," which is certainly arresting, and possibly apropos, but also somewhat heightened or exaggerated. The Latin verb *traho* means to draw or drag (or trail or pull); and the seductive-sounding *voluptas* is more a term of endearment. Here and elsewhere I have followed the translation in *Eclogues*.

37. The speculation is de Beucken's (*Cézanne*, pp. 65–66). It seems to me at once overheated and misdirected. Again, it may reflect stories or folk memories in the family, relayed by Paul, in his own old age. His characterization of the relationship with Hortense as "a sorry liaison there was no apparent reason to bring to

an end" is also misleading, I think, though it has certainly been influential in the literature.

38. Gasquet, *Cézanne*, pp. 145–46. On another occasion he remarked of Monet that "he was a grand seigneur who treats himself to the haystacks he fancies" (p. 122).

39. Cézanne to unknown woman, undated draft, on the back of a work acquired by the Albertina, Vienna, in 1924; frustratingly, they have no provenance. The published text (*Corr.*, p. 271) contains one or two misreadings.

40. Zola to Cézanne, 2 July 1885, in Zola, *Corr.*, vol. 5, p. 276.

41. Cézanne to Zola, 19 July 1885, in *Corr.*, pp. 277–78. His trail can be followed in the letters of 15 June, 27 June, 3 July, 6 July, 11 July, 13 July, and 15 July. A minor mystery attaches to a phrase in the letter of 3 July from La Roche-Guyon—"Owing to chance circumstances, life here is becoming rather difficult for me"—unless this was simply an allusion to the affair.

42. The two unfinished paintings: *La Roche-Guyon* (R539), now in the Smith College Museum of Art, Northampton, MA, and *Médan* (R542), now in a Zurich private collection.

43. Cézanne to Zola, 20 and 25 August 1885, in *Corr.*, pp. 278–79.

44. Lucretius, *On the Nature of the Universe*, 4.966–70 and 1145.

45. Ibid., 4.1061–73.

46. Jean-Jacques Rousseau, trans. Peter France, *Reveries of a Solitary Walker* (London: Penguin, 1979), p. 107.

47. Verdet, "Autour," p. 18 (my emphasis); Matisse, "Testimony Against Gertrude Stein," *Transition* 23 (1934–35), supplement, p. 6.

48. The horizontal one is R569 (painted in the morning, judging by the shadows), now in the Barnes Foundation; the unambiguously vertical one (also unfinished) is R570 (painted around midday), now in the Met; the change of mind is R571 (painted in the afternoon), now in the Booklyn Museum, where Gorky studied it. There is also a preliminary sketch (C902), bringing out the construction, now in MoMA.

49. *The Artist's Son, Full-Length Study* (C850) is in the Hillman Family Foundation, New York. A similar study (C849) is in a private collection. See also *The Artist's Son, writing* (C853) and *sleeping* (C854). Cf. *The Boy in the Red Waistcoat* (R659), one of a group dated 1890–95, now in the NGA; not Paul but (unusually) a professional model, Michelangelo de Rossi. Giacometti was much taken by the proportions of these paintings. See ch. 11.

50. R576, dated 1886–87 by Rewald, once owned by Matisse, now in the PMA; R580, dated c. 1885 by Rewald, now in the Nationalgalerie, Berlin, on loan from Bettina Berggruen. These paintings were small (c. 48 x 40 cm.). There is also a striking portrait drawing (C1065) in the same outfit.

51. Gasquet, *Cézanne*, in *Conversations*, p. 153.

52. *Madame Cézanne with Hydrangeas* (RWC209), dated c. 1885, now in a Zurich private collection. See also *Portrait of Madame Cézanne* (C1065), a slightly later drawing, dated to c. 1890–92, now in the Boymans Museum, Rotterdam.

53. Diderot, *Salons*, vol. 2, pp. 153–54.

54. Acte de mariage, 28 April 1886, in *Monsieur Paul Cézanne*, pp. 74–75. According to this, Cézanne resided at the Jas and Hortense in Gardanne; the census of 30 May 1886 records Cézanne, *rentier*, in Gardanne. The portraits of Jules Peyron (R577 and 578) are now in a New York private collection and the Fogg Art Museum, respectively.

55. Van Gogh to Bernard, c. 4 August 1888, in Tate chronology, trans. Isabelle Cahn, pp. 547–48. The Van Gogh Letters Web site (http://www.webexhibits .org/vangogh/letter/18/B14.htm) offers a more decorous (or euphemistic) translation. Meier-Graefe heard from the collector Andries Bonger of "the influence of Cézanne on Vincent" (Vincent's brother, Theo, was married to Bonger's sister Jo).

56. According to de Beucken (*Cézanne*, p. 66), Marie told her. "When the story of her lover's infidelity reached Hortense there were fearful scenes." On this account, even the Renoirs knew. "The Renoirs did their utmost to prevent the irregular union of the Cézannes from breaking up; but there were frightful scenes." But de Beucken is unreliable; the action attributed to Marie implausible (and almost impossible for de Beucken to know); and the stance of the Renoirs uncharacteristic.

57. Cézanne to Zola, 27 November [1882], in *Corr.*, pp. 259–60 (his emphasis).

58. Cézanne to Zola, 19 and 24 May 1883, in *Corr.*, pp. 263–64; Zola to Cézanne, 20 May 1883, in Zola, *Corr.*, vol. 4, p. 393.

59. Gasquet, *Cézanne*, p. 219.

60. Oliver Sacks, "A Summer of Madness," *NYRB*, 25 September 2008.

61. Geffroy, *Le Cœur*, p. 127. Cf. Vollard, *Écoutant*, p. 102. Cézanne would not have missed the undertow of art and the afterlife. Rewald believed that another story in this collection, "Le Viveur," reflected some of Cézanne's ideas—ideas he might even have discussed with Geffroy when they were introduced by Monet in 1894. The timing was too tight for direct transmission, I think (the book was published the following month), though Geffroy could certainly have made use of what he had already heard of Cézanne from other sources, Monet among them. However, the thoughts voiced in the story do not seem especially Cézanne-like, notwithstanding "the brain . . . as the rendezvous for our sensations" (p. 215); and the passage adduced by Rewald is misquoted.

62. Cf. Delacroix, *Journal*, 9 June 1823, vol. 1, p. 104.

63. Beckett, "First Love," p. 80.

64. Cézanne to Chocquet, 11 May 1886, in *Corr.*, pp. 283–84. As published, this letter contains a number of misreadings or mistranscriptions.

Self-Portrait: The Plasterer

1. Rewald in R510 sees it as nightcap; Rishel in Tate, no. 77, sees it as a plasterer's cap.

2. Respectively, R219, dated c. 1875, in the Hermitage; R384, dated 1878–79, in MoMA; R415, dated 1879–80, in the Kunstmuseum, Bern; R585, dated 1885–86, in a private collection; R774, dated 1894, in the Bridgestone Museum of Art, Tokyo; and R834, dated 1898–1900, in the MFA, Boston. See Kitschen,

"Cézannes Hüte." Kitschen refers to this one simply as a white turban, or a painter's turban.

3. Michael Fried, "Cézanne," in *The Next Bend in the Road* (Chicago: University of Chicago Press, 2004), p. 12.

4. Proust, trans. Caroline Beamish, "Chardin" [1895], in Rosenberg, *Chardin,* p. 328. Chardin was in his seventies when he painted that portrait, fully thirty years older than Cézanne in his white cap.

5. Cézanne to Bernard, 27 June 1904, in *Corr.,* p. 380. See ch. 11.

6. *Still Life with Pitcher* (C958), dated 1887–91.

7. Cézanne to Roger Marx, 23 January 1905, in *Corr.,* p. 390.

8. Page of studies (C405), dated 1877–80 by Chappuis (1883–87 by Venturi, 1884–86 by Andersen). The Goya etching was originally the frontispiece of the *Caprichos* (1799). Chappuis speculates plausibly that it was drawn from the reproduction in Charles Blanc's *École espagnole* (1869).

9. Schapiro, "Apples," p. 11. On Schapiro's psychologizing and its biographical implications, see chs. 3 and 12.

10. Berger, *Fictions of the Pose,* p. 358.

9: *L'Œuvre*

1. Zola, *Masterpiece,* pp. 251–53.

2. Ibid., pp. 175 and 351–52.

3. Ibid., p. 355.

4. Geffroy in *La Justice,* in Brown, *Zola,* pp. 559–60.

5. See Zola to Léopold Arnaud, 2 February 1867, apropos *Mystères de Marseille,* and to Henri Céard, 22 March 1885, apropos *Germinal,* in Zola, *Corr.,* vol. 1, p. 476, and vol. 5, p. 249; BN NAF 10316, L'ébauche, folio 265.

6. Zola, *Masterpiece,* p. 7. See, e.g., the "Portrait of Cézanne" in Rewald, *Cézanne-Zola,* pp. 123ff., and Rewald, *Cézanne,* pp. 97ff., the source of so many other portraits. According to a note in the earlier work, "This portrait is composed of quotations from *L'Œuvre,* pp. 12 and 19, manuscript notes for *L'Œuvre,* folder 220, and a passage from *Le Ventre de Paris,* p. 22." (The editions and therefore the page references differ.)

7. Zola, *Masterpiece,* p. 229.

8. Petrone, "La Double Vue." Oddly, Petrone speculates on the identity of the model, "*un Manet ou un Degas toujours inquiets?*" but makes no mention of "Paul" or Cézanne. For Duranty's other Cézanne variations, see ch. 4.

9. BN NAF 10316, L'ébauche, folio 265.

10. For Cézanne as "*un grand enfant,*" see Zola to Coste, 7 November 1897, in Zola, *Corr.,* vol. 9, p. 94, a response to Coste's bulletin from Aix. See ch. 6.

11. Zola, *Masterpiece,* pp. 238–39. Cf. R578.

12. Pissarro to Lucien, 23 January 1886, and Monet, [April 1886], in Pissarro, *Corr.,* vol. 2, pp. 19 and 37.

13. Monet to Zola, 5 April 1886, in Rewald, *Cézanne-Zola,* pp. 319–20; Monet to Pissarro, n.d., in Wildenstein, *Monet,* vol. 2, p. 274.

14. Pissarro to Lucien, 8 May 1886, in Pissarro, *Corr.,* vol. 2, p. 44.

15. Guillemet to Zola, n.d., in Rewald, *Cézanne-Zola,* p. 318. Renoir felt similarly about the mean-spiritedness of the work. See Vollard, *Écoutant,* p. 269.

16. Goncourt, *Journal,* 5 and 10 April 1886, in *Pages,* pp. 315–17.

17. Moore, *Impressions and Opinions,* p. 218.

18. Cézanne to Zola, 4 April 1886, in *Corr.,* p. 282. The concluding phrase is incorrect in the published edition of the correspondence: not "*sous l'impulsion*" but "*sous l'impression des temps [jours* crossed out] *écoulés.*"

19. Brassaï, "Braque," in *Artists,* p. 16. Cf. Picasso, apropos Cézanne, in Parmelin, *Picasso dit,* p. 114.

20. Cézanne to Oller, 5 July 1895, in *Corr.,* pp. 307–08. The letter to Zola is all "*tu*"; the letter to Oller is all "*vous.*"

21. See Gasquet, *Cézanne,* pp. 146–47.

22. Cézanne to Coste, 6 January 1883, in *Corr.,* p. 261.

23. Marcel Provence thought that Cézanne's relations with Coste later became strained, after the publication of *L'Œuvre,* because Coste was so thick with Zola; he has them making a kind of truce after mass at Saint-Sauveur, the Sunday after Zola's death. This sounds improbable. Marcel Provence was well informed about the goings-on in Aix, but he was misled about *L'Œuvre* ("Cézanne never forgave Zola for *L'Œuvre*"); his supposition about Cézanne and Coste is based on his assumption about Cézanne and Zola. See "Cézanne et ses amis," pp. 75–76.

24. Roux, *Substance and Shadow,* pp. 26 and 187. In Zola's *Thérèse Raquin* (1867), also, Laurent commits suicide, a failure, without comment from Cézanne.

25. Cf. Gasquet, *Cézanne,* p. 147.

26. Baudelaire, "A Phantom," in *Flowers of Evil,* p. 77.

27. Flaubert in Agamben, "Frenhofer and His Double," p. 9.

28. In fact he wrote "Frenhoffer." See "Mes Confidences" in *Conversations,* p. 103.

29. Balzac, *Unknown Masterpiece,* pp. 22, 38, 40–41, 44.

30. Ibid., pp. 24–25 (his emphasis). "Mabuse" was the nickname of the Flemish portraitist Jan Gossaert; in the story, Frenhofer claims to be his only pupil.

31. Bernard, "Souvenirs" and "Paul Cézanne" in *Conversations,* pp. 30 and 65, quoting Balzac, *Unknown Masterpiece,* p. 27 (Porbus's verdict).

32. Gasquet, *Cézanne,* in *Conversations,* p. 124.

33. The statement itself has been much mythologized. This form, possibly the original, was used by Camoin, quoting Cézanne, in his response to Morice's "Enquête" (1905); it is supported by Francis Jourdain, who accompanied Camoin on a visit to Cézanne early in 1905, and who clearly remembered the artist using that same form of words. Jourdain's account was published much later, in 1946 and 1950 (*Conversations,* p. 84), but it seems to capture an authentic Cézanne. The essential idea, *vivifier en soi au contact de la nature,* is firmly embedded in his letters. See Cézanne to Camoin, 22 February and 13 September 1903 (presented as a development of Couture's advice to his pupils), in *Corr.,* pp. 367 and 371.

34. His drawings of details from the painting (a shepherd and a shepherdess) are C1011 and 1012, roughly dated to 1887–90, now in the Kunstmuseum, Basel.

35. Rivière and Schnerb, "Cézanne's Studio," in *Conversations,* p. 90, a discerning account. It seems to me that the existing translation of this observation

("in whom reason guided a great natural facility") does not quite capture his meaning.

36. Gasquet, *Cézanne*, p. 174; Cézanne to Camoin, 13 September 1903, in *Corr.,* p. 371.

37. Gasquet, *Cézanne*, in *Conversations,* p. 150. Cf. Bernard, "Souvenirs," ibid., p. 80. In a later and more suspect text ("Une Conversation"), Bernard offered a fuller version of this statement, which helps to contextualize it but also sounds too labored and too programmatic to be fully authentic. After explaining the difficulties of finding nude models to pose outdoors, Cézanne concludes: "So I've been compelled to defer my project of redoing Poussin entirely from nature, without any help from notations, drawings or fragments of studies; that is, a real open-air Poussin, of color and light, instead of one of those works dreamed up in the studio."

38. Gasquet, *Cézanne*, in *Conversations,* pp. 150–51 (my emphasis). Cf. Cézanne to Bernard, 12 May 1904 and Friday [1905], in *Corr.,* pp. 377 and 393. Some of this also seems to have affinities with Gasquet's poetry: *Les Chants séculaires* (1903) contains verses on Poussin and on Descartes. *Discours de la méthode* is Descartes, in full *Discours de la méthode pour bien conduire sa raison, et chercher la vérité dans les sciences* (1637)—the truth, once more—containing the famous line "*Je pense, donc je suis.*" "Tears" suggests Virgil and "the tears of things" (*lacrimae rerum*). But the correct attribution is not straightforward. "A dream of reason" sounds like Gasquet in Platonic mode, yet Cézanne impressed on Rivière and Schnerb the absolute importance of reasoning and reflection.

39. Balzac, *Unknown Masterpiece,* pp. 23–24; *Chef-d'œuvre,* pp. 51–52. Delacroix said something similar. See his *Journal,* 15 July 1849, vol. 1, p. 452; emphasized by Baudelaire in his *Salon de 1846,* as Cézanne would have read.

40. Bernard, "Paul Cézanne," in *Conversations,* pp. 36–37.

41. Balzac, *Unknown Masterpiece,* p. 24; Matisse, interview with Jacques Guenne (1925), in *Matisse on Art,* p. 80.

42. Proust, *In Search of Lost Time,* vol. 5, pp. 348–49. Proust's character is speaking of Vermeer.

43. Marcel Provence notes, Archives Provence, Pavillon; *Gilais,* 9 April 1940.

44. Bernard, "Souvenirs," in *Conversations,* p. 56; Stone, *Lust for Life,* p. 294. In the same passage, the references to Baille are also inaccurate.

45. Gasquet, *Cézanne*, in *Conversations,* pp. 116 and 128. The suggestion is that Proudhon had made Courbet a kind of poster boy for social theory, thereby neutering his painting.

46. Vollard, *Écoutant,* p. 116.

47. Gasquet, *Cézanne*, p. 146.

48. Sartre, "Camus," in *Modern Times,* p. 301 (his emphases).

49. House, "Cézanne's *Card Players,*" in Ireson and Wright, *Cézanne's Card Players,* p. 69; Schapiro, *Cézanne,* p. 16. Athenassoglou-Kallmyer has suggested the opposite: that Cézanne's card players are "shaking hands in spirit" with Zola's miners in *Germinal* (1885). Given the treatment, that seems improbable. Cf. *Jas de Bouffan,* p. 55.

50. Vollard, *Écoutant,* p. 124.

51. Zola, "Peinture," *Le Figaro,* 2 May 1896, in *Écrits,* p. 468. Gasquet also reports a conversation with Zola (*Cézanne,* p. 147), around 1900, in which he appears to make a qualified admission of error, insofar as he had underestimated Cézanne's painting.

52. Vollard, *Écoutant,* pp. 117–18. Cf. Coquiot, *Cézanne,* pp. 112–15. The Zolas spent a week in Aix in 1892; they were having marital problems at the time. While there Zola saw something of Coste. Could he have been the source of the gossip?

53. Brown, *Flaubert,* p. 85.

54. Goncourt, *Journal,* 3 April 1878 and 20 June 1881, in *Pages,* pp. 237 and 265.

55. Ibid., p. 237 (his emphasis).

56. Camoin, "Souvenirs," p. 26.

57. Vollard, *Écoutant,* p. 267. This anecdote might be called into question; but there are too many such stories, from a variety of sources, for it to be completely discounted. It comes originally from Vollard's work on Renoir, not on Cézanne.

58. Elder, *Giverny,* pp. 47–48, rendered in Cézanne's strong Provençal accent.

59. Deffeux and Zavie, *Le Groupe de Médan,* p. 92.

60. Goncourt, *Journal,* 20 June 1881, vol. 6, p. 109 (not in *Pages*); Camoin to Rewald, 6 May 1958, Rewald Papers, Box 30–11, NGA. Prosper Mérimée was the author of *Carmen* (1845) and, more relevantly, *Notes d'un voyage dans le midi de la France* (1835), which included an encounter with a well-known antiquity in the Musée d'Aix, *Hercule Gaulois,* an object to fire the imagination of the young Cézanne.

61. Vollard, *Écoutant,* pp. 115–17 (his emphasis).

62. Denise Le Blond-Zola, *Zola* [1931], pp. 142, 150. Complications arose in part because Zola also had a mistress (Denise's mother), in fact another family.

63. Ibid., p. 149; Alexandrine to Fasquelle, October 1906, in Bloch-Dano, *Madame Zola,* p. 140.

64. Zola, *Masterpiece,* pp. 32–33.

65. Proust, *Remembrance,* vol. 1, p. 462, the conclusion to *Swann's Way.*

66. Zola, "Proudhon et Courbet," *Mes Haines* [1866], in *Écrits,* p. 46. "I am going to live out loud" became the epigraph to the work.

67. Gasquet, *Cézanne,* p. 144; Faure to Gasquet, n.d. [1920?], Archives Gasquet, 1869 (1735), f413, Méjanes. Cf. Bernard, "Souvenirs," in *Conversations,* p. 75: "In Paris his best friend had been a cobbler. . . . " Cézanne had an apartment in the Rue Ballu in the early 1900s.

68. Vollard, *Écoutant,* p. 114; Provence, "Cézanne et ses amis," pp. 75–76. Provence compiled an account of the day, used here, relying chiefly on the recollections of Madame Brémond. Cf. Ely, "The Studio," p. 89.

10: *Homo Sum*

1. Cf. Adhémar, "Le Cabinet de travail," pp. 293–94.

2. Probably *Garden Wall* (R88) and *Ferry at Bonnières* (R96).

3. Rochefort, "L'Amour du laid," *L'Intransigeant,* 9 March 1903, printed in

extenso in Rewald, *Cézanne-Zola*, pp. 378–79, and extracted in *Corr.*, p. 368; Cézanne to Paul, [March 1903], loc. cit.; Marcel Provence notes, based on information from Madame Brémond. Cf. Gasquet, *Cézanne*, pp. 213–14.

4. See Cézanne to Zola, 14 April 1878, in *Corr.*, p. 209; Bernard, "Souvenirs," in *Conversations*, p. 54; Marcel Provence notes, based on information from Madame Brémond; Johnson, "Cézanne's Country," p. 545.

5. Vivès-Apy, "Pages d'album," *Le Mémorial d'Aix*, 16 February 1911. Bernard and Coquiot emphasized the abuse; Aude and Camoin, among others, thought it exaggerated. Cf. Mack, *Cézanne*, p. 362, citing an interview with Camoin. Weighing the evidence (and the authorities) Marcel Provence sided with Aude and against Coquiot; he was rightly suspicious of "*les histoires coquiotes.*" See also Rougier, below.

6. The six, with present-day titles: *Nereids and Tritons* (R122), *Landscape* (R130), *The Black Clock* (R136), *Portrait of the Artist* (R116), *Portrait of a Woman (Presumed to Be Madame Zola)* (R75), and *Sugar Bowl, Pears and Blue Cup* (R93). *The Abduction* (R121) and *The Stove in the Studio* (R90) were bought by Vollard for 4,200 francs and 2,050 francs respectively. *Paul Alexis Reading* (R150) was bought by Jos Hessel for 1,050 francs.

7. The three to the Louvre: *Still Life with Soup Tureen* (R302), *The Kitchen Table* (R636), and *Still Life with Onions* (R803).

8. Fry, *Development*, pp. 39–40.

9. The seven, with present-day titles: *Card Players* (R710), *Woman with Coffee Pot* (R781), *Madame Cézanne in a Yellow Chair* (R655), *Portrait of Madame Cézanne* (R683), *Young Italian Woman Leaning on her Elbow* (R812), *Portrait of Paul Cézanne* (R876), and *Portrait of Madame Cézanne* (R583).

10. This is the version now in the NG (R855). On Moore, see ch. 12.

11. Maximilien Gauthier, "Faux et repeints," *Rumeur*, 26 November and 1 December 1927. That *Large Pine* (R537) is now in the Galerie Yoshii, Japan. Schuffenecker claimed to have retouched several others, including *The Bay of L'Estaque* (R444), now in the PMA; he offered to buy *Still Life with Compotier* (R418), but Gauguin would not part with it.

12. Gauguin to Schuffenecker, n.d. [June 1888], in R418.

13. Fry, *Development*, pp. 46 and 49.

14. Lecomte, "L'Art contemporain," *La Revue indépendante*, April 1892. Cf. his reprise, "Paul Cézanne," *Revue d'art*, 9 December 1899.

15. This story is repeated by Fry, *Development*, p. 29.

16. See Cézanne to Tanguy, 4 March 1878, and Tanguy to Cézanne, 31 August 1885, in *Corr.*, pp. 203 and 280; Tanguy to Cézanne, 8 May 1887, in Ratcliffe, "Working Methods," p. 245 (not in *Corr.*). Cézanne's itemized account from Tanguy is in the Harry Ransom Humanities Research Center, Austin, Texas.

17. Bernard, "Tanguy," p. 605.

18. See Cézanne to Mirbeau (undated draft), [December 1894], in *Corr.*, p. 302.

19. Stein, *Toklas*, p. 35.

20. In 1909, three years after the artist's death, Vollard sent Cassirer thirteen albums containing 757 photographs of works by Cézanne.

21. Signac diary, 23 December 1898, in "Excerpts," part 3, p. 74. Thanks to his mother, Signac bought *The Valley of the Oise* (R434) from Tanguy in 1884, when he was only twenty-one. All his life he refused to part with it.

22. Pissarro to Lucien, 21 January 1894, in Pissarro, *Corr.*, vol. 3, p. 419.

23. Braque interviewed by Dora Vallier (1954), in Vallier, *L'Intérieur*, p. 33.

24. *Three Bathers* (R360), dated to c. 1876–77, donated to the Petit Palais by Matisse in 1936. See Prologue.

25. Stein, *Toklas*, pp. 34–37. Loeser left eight of his Cézannes to the president of the United States and his successors in his will, with specific instructions about how they should be hung (about five feet from the floor, reasonably spaced, uncluttered by furniture, like apertures in the wall, as if they were windows on the world outside). Among them was *Hamlet at Payennet near Gardanne* (R572), which might conceivably be something like the one Stein had in mind.

26. Alexandre, "Claude Lantier," *Le Figaro*, 9 December 1895; Natanson, "Paul Cézanne," *La Revue blanche*, 1 December 1895, printed in extenso in Tate, pp. 33–35.

27. *Leda and the Swan* (R447), dated to c. 1880–82, now in the Barnes Foundation, a painting with complex associations and sources, including Zola's *Nana* (1880)—Nana turning into Leda, as part of the call and response between Zola and Cézanne—and even the label of a certain champagne: Champagne Nana. See Lebensztejn, "Une source oubliée." Cf. Vollard, *Écoutant*, p. 71.

28. Cézanne to Geffroy, 26 March 1894, in *Corr.*, p. 299. Included in the Duret sale were *Apples and Napkin* (R417), now in the Yasuda Kasai Museum of Art, Tokyo; and *The Winding Road* (R490), later owned by Monet, now in the MFA, Boston.

29. Geffroy, "Paul Cézanne," *La Vie artistique*, vol. 3, pp. 249–60; printed in extenso in Tate, pp. 29–30. First published in *Le Journal*, 25 March 1894. Geffroy's analysis was close to Lecomte's.

30. Geffroy, *L'Enfermé* (Paris: Charpentier, 1897), pp. 441–42.

31. Monet to Geffroy, 23 November 1894, in Geffroy, *Monet*, p. 325.

32. Geffroy, *Monet*, p. 326.

33. Alexis, *Madame Meuriot* [1890], pp. 311–12; Bernard, "Tanguy" [1908], p. 607, at Tanguy's. For the Alexis passage, see ch. 8. Another fictitious encounter between Cézanne and van Gogh (and Gauguin) is staged by Irving Stone in *Lust for Life*, pp. 290–95.

34. Denis diary, n.d. [mid-1906], *Journal*, vol. 2, p. 46, quoting Mirbeau. Coquiot, *Cézanne*, pp. 202–03, also citing Mirbeau, has a still more elaborate version. "Ah! Ce Gauguin! J'avais une petite sensation, et me l'a prise. Il l'a menée en Bretagne, à la Martinique, à Tahiti, oui, dans tous les paque-bots! Ce Gauguin!"

35. Geffroy, *Monet*, p. 328.

36. See ch. 3. Cf. Vollard, *Écoutant*, p. 102.

37. Elder, *Giverny*, p. 48.

38. Rewald, *Cézanne-Zola*, p. 344, gives a version of Monet's words, and Cézanne's response.

39. Gsell, "Propos d'Auguste Rodin . . . ," *La Revue*, 1 May 1906.

40. Rilke, *Rodin* [1903], pp. 9–10, 13, 41; Edmond Claris, "L'Impressionisme en sculpture," *La Nouvelle revue*, 1 June 1901.

41. Gasquet, *Cézanne*, in *Conversations*, pp. 127–28. *Balzac* was first exhibited in plaster at the Salon of the Société nationale des artistes in 1898 (and cast in bronze only posthumously); Rodin organized a retrospective of his own work in a temporary pavilion close to the Exposition universelle in 1900. Of course, this account, too, may be contaminated, by Gasquet.

42. Cézanne to Geffroy, 4 April 1895, in *Corr.*, p. 305.

43. Ludovici, *An Artist's Life,* p. 200. He was still thinking of submitting something to the salon as late as 1902. See Cézanne to Vollard, 2 April 1902, in *Corr.*, p. 360.

44. Paul interviewed by Pierre Lorquet, 22 June 1945, quoted in Ratcliffe, "Working Methods," p. 430.

45. Aurélien Houchart was at the Collège Bourbon at the same time as Cézanne. Marcel Provence gives him a mini-biography in *Tholonet*, pp. 37–39. Cf. Cézanne to Zola, 9 July 1859 and 24 August 1877, in *Corr.*, pp. 65 and 201.

46. Borély, "Cézanne à Aix," in *Conversations*, pp. 21–22.

47. Rougier interviewed by Charensol, "Aix et Cézanne," p. 8. Aude addressed the Académie d'Aix in very similar terms on 16 June 1938.

48. Cézanne to Bernard, 15 April 1904, in *Corr.*, pp. 375–76. He inserted "*oeterne Deus*" [*sic*] as an afterthought. I follow John House's reading of this passage (*Courtauld*, p. 149). According to Rougier, Cézanne would sometimes remark on how a man or a woman resembled a cylinder: see Charensol, "Aix et Cézanne," p. 8; Coquiot, *Cézanne*, p. 136. Evidently he said something similar to Denis and Roussel.

49. Osthaus, "A Visit" [1920–21], in *Conversations*, pp. 97–98, a visit of April 1906. The verdict on Monet and Pissarro is in French in the German original; it is perhaps a direct quotation. Cézanne was sufficiently bonhomous to permit Gertrude Osthaus to take his photograph: a very natural one, carrying a chair. With Gasquet, apparently, his assessment of Holbein was more guarded (*Conversations*, p. 131). He enthused to Vollard about Courbet, "apart from the fact that he is a little heavy in expression" (*Écoutant*, p. 76).

50. Gauguin to Schuffenecker, 14 January 1885, in Gauguin, *Corr.*, p. 88; Pissarro to Lucien, 20 January 1896, in Pissarro, *Corr.*, vol. 4, p. 153, recounting what he heard from Oller.

51. Gauguin to Pissarro, [July 1881], in Gauguin, *Corr.*, p. 21 (his emphasis). "The Gauguin maids" are from T. S. Eliot's *Sweeney Agonistes*.

52. Cézanne to Bernard, Friday [1905], in *Corr.*, p. 392; "Confidences," in *Conversations*, p. 102. Rimbaud's "Vagabonds" was first published in *La Vogue* in 1886, then in the celebrated collection *Illuminations* (1887). The opening of the poem may also have interested Cézanne apropos Zola: "Pitiful brother! . . . He credited me with a very peculiar kind of bad luck and innocence, and gave disturbing reasons."

53. Geffroy, *Monet*, p. 327. The letter he mentions is Cézanne to Geffroy, 12 June 1885, in *Corr.*, p. 306. The portrait (R791) is now in the Musée d'Orsay.

54. Cézanne to Monet, 6 July 1895, in *Corr.*, pp. 308–09.

55. Vollard, *Écoutant*, p. 97.

56. On the occasion of her marriage to Joachim Gasquet, in 1896, Cézanne gave her a small *Bathers* (R668), inscribed to "the Queen of the Félibriges." The Félibrige was founded in 1854 as a society of Provençal intellectuals, led by the poet Frédéric Mistral, dedicated to the rehabilitation of the native idiom, the *langue d'oc*, and the preservation of regional customs and culture. Joachim Gasquet was a crusader for the cause, publishing a kind of manifesto, "Le Réveil," *Le Mémorial d'Aix*, 3 August 1899. Cézanne was a sympathizer, for a while. See below.

57. Cézanne to Émile Solari, 25 February [1899?], in *Corr.*, p. 336; Vollard, *Écoutant*, p. 95.

58. Lord, *A Giacometti Portrait*, pp. 10–11.

59. Vollard, *Écoutant*, p. 97.

60. Newman, "Remarks at Artists' Sessions at Studio 35" [1952], in *Selected Writings*, p. 240.

61. Cézanne to Gasquet, 30 April 1896, in *Corr.*, p. 312; Cézanne to Vollard, 9 January 1903, in *Lettres*, p. 58. The deleted passage was never restored in the published correspondence; the letter was first published in its entirety in 1993. Vollard transposed the safe part of it into a conversation with Cézanne (*Écoutant*, p. 102). There is another (gratuitous) slighting reference to Geffroy in a letter to Gasquet of 22 June 1898, so perhaps Gasquet's version is not much exaggerated after all (*Cézanne*, p. 128).

62. See "Matisse Speaks" (1951), in *Matisse on Art*, p. 203.

63. Geffroy, "Le Sarcophage égyptien" [1891], in *La Vie artistique*, vol. 1, pp. 8–10. Cf. Gasquet, *Cézanne*, pp. 175–76.

64. Geffroy, "Paul Cézanne" and "L'Hommage à Cézanne," in *La Vie artistique*, vols. 6 and 8, pp. 214–20 and 374–80. Monet, for one, thought the review was excellent. Monet to Geffroy, 17 November 1895, in Rewald, *Cézanne and America*, p. 28.

65. Vollard, *Écoutant*, p. 102. The story that Cézanne began and abandoned a portrait of Clemenceau himself is a fiction.

66. See Cézanne to Mirbeau, undated draft [December 1894], in *Corr.*, pp. 302–03; and 11 July 1903, in *Lettres*, p. 62 (a letter first published in 2007). Cf. Gasquet, *Cézanne*, p. 128. See, e.g., Mirbeau's *L'Abbé Jules* (1888), or *Dans le ciel* (1892–93).

67. For the Boers, see Vollard, *Écoutant*, p. 88.

68. Bernard, "Souvenirs," in *Conversations*, p. 64; Cézanne to Paul, 24 July and 12 August 1906, in *Corr.*, pp. 397 and 401. See also the letter of 26 August 1906.

69. *Old Woman with a Rosary* (R808), dated c. 1895–96, now in the NG. See Gasquet, "Le Sang Provençal," *Les Mois dorés* (March-April 1898), p. 373, and *Cézanne*, pp. 202–06; Cézanne to Gasquet, 12 May 1902, in *Corr.*, pp. 361–62. As a reminder that Gasquet can never be dismissed out of hand, however, the equally fantastic tale of finding the canvas on the floor, under a coal scuttle by the stove, with a leaky pipe steaming and dripping on it, may well be true: conservators have identified water or steam damage to the lower left of the painting.

70. "No symbols where none intended" are the closing words of Samuel Beckett's *Watt* (1953).

71. Cézanne to Gasquet and Camoin, 13 June 1896 and 22 February 1903, in *Corr.*, pp. 316 and 367 (his emphasis).

72. Cézanne made reference to the Gasquets' superior attitude in a letter to Aurenche of November 1901: "*Les Jo paraissent (nescio cur) avoir quelque peu éteint leur superbe peu dangereuse d'ailleurs.*" Demolins is described as "completely bogus" (*joliment factice*) in a letter to his son of September 1906. *Corr.*, pp. 348 and 405.

73. Cézanne to Gasquet, 29 September 1896 and 30 January 1897, in *Corr.*, pp. 320 and 325. Before distaste set in, his enthusiasm ran as far as the racist preface to Gasquet's *Les Chants séculaires* (1903), by Louis Bertrand. See Cézanne to Gasquet, 22 June 1898 and 25 June 1903, in *Corr.*, pp. 332–33 and 369.

74. Cézanne to Vollard, 9 January 1903, in *Corr.*, pp. 366–67, the same letter that lamented Geffroy's castration of feeling. It may be that there is a certain parallel: in each case the first article was warmly welcomed, but perhaps the second was held to go too far. Vollard retained the passage about Gasquet and Demolins, but deleted the names.

75. Aurenche, "Souvenirs," p. 65. Before he was a monarchist, and a self-styled nationalist, Gasquet was indeed an anarchist, and a "Dreyfusien"—a further example of shifting loyalties. See his "De l'anarchisme dreyfusien au nationalisme intégral," *L'Action française*, 15 August 1901.

76. Cézanne to Paul, 8 September 1906, in *Corr.*, p. 406. He is referring to President Armand Fallières, elected earlier in the year. Interestingly, "the artificial and conventional" echoes a phrase in Gasquet's "Le Sang provençal"—which also invoked "the rustic and noble painting of Paul Cézanne"—for which Cézanne was full of praise at the time.

77. Cézanne to Aurenche, 20 November 1901, in *Corr.*, p. 348, apparently quoting from memory. Strictly, *Homo sum; humani nil a me alienum puto*—I count nothing human foreign to me. From Terence, *Heauton Timoroumenos* (*The Self-Tormentor*).

78. Borély, "Cézanne à Aix," in *Conversations*, p. 22.

79. Vollard, *Écoutant*, p. 119; Gasquet, *Cézanne*, p. 51. In fact Cézanne thought highly of Rosa Bonheur and her dedication to her craft—"*une sacrée femme*," he told Bernard, "she knew how to give herself totally to painting" ("Souvenirs," in *Conversations*, p. 71)—the verdict and the phrasing a reminder that he was not automatically dismissive of women.

80. David Sylvester, "Cézanne" [1996], in *About Modern Art*, p. 443 (his emphases).

81. *The Gulf of Marseille* (R390), dated 1876–79, now in the Musée d'Orsay, one of the two that survived the cull of Caillebotte's bequest. See Marden's Grove Group Notebook, in *Cézanne and Beyond*, p. 495, and the abstract paintings that resulted, *Grove Group IV* and *V* (1976).

82. Rilke to Clara, 12 October 1907, in Rilke, *Letters*, pp. 42–43. Rivière and Schnerb, "Cézanne's Studio," in *Conversations,* p. 89, remark on "his avid looking to seize the form and, as one might say, the weight of things."

83. Félix Vallotton, "Le Salon d'automne," *La Grande Revue*, 25 October 1907. Cf. Fry, *Development*, pp. 66–67.

84. Lord, *A Giacometti Portrait*, p. 72.

85. Vollard, *Écoutant*, p. 91.

86. Kessler diary, 14 February 1902, in Harry Kessler, trans. Laird M. Easton, *Journey to the Abyss* (New York: Knopf, 2011), p. 264.

87. See in particular R713 in the Courtauld, making use of the unpainted cream-primed canvas.

88. Gasquet, *Cézanne*, in *Conversations*, p. 108; Jaloux, "Souvenirs," dated to 1896 or 1897, and repeated (with variations) in his *Saisons littéraires*, p. 72. The gesture in Gasquet's account has been likened to Chocquet's in the portrait in the chair with the sawn-off legs (R296).

89. Vollard, "Souvenirs sur Cézanne," *Minotaure* 2, 6 (1935), p. 14.

90. Walser, "Thoughts" [1929], pp. 191–92; Rilke to Clara, 18 October 1907, in Rilke, *Letters,* pp. 58–59; Fry, *Development*, p. 26.

91. Giacometti interviewed by Georges Charbonnier, 16 April 1957, in *Le Monologue du peintre* [1959] (Paris: Durier, 1980), pp. 186–87. Was he thinking of the listing of "an orange, an apple, a ball, a head" in Cézanne to Bernard, 25 July 1904 (*Corr.,* p. 381)? The knob of the drawer in the table used by the card players undergoes a rather similar shattering or merging: see R706 and 707.

92. Bresson, *Notes*, p. 135 (his emphasis).

93. Vollard, *Écoutant*, p. 97.

94. *Portrait of Ambroise Vollard* (R811) is now in the Petit Palais in Paris; *Man with a Pipe* (R712), dated to c. 1892–95, in the Courtauld; *Seated Peasant* (R852), dated to c. 1900–04, in a private collection; *Woman in a Red Striped Dress* (R853), dated to c. 1898, in the Barnes Foundation.

95. Cézanne to Bernard, 23 October 1905, in *Corr.,* p. 394; Vollard, *Écoutant,* p. 291.

96. Émile Solari notes, in Mack, *Cézanne*, pp. 327–29. The first of these expeditions took place on 7 November 1895. Cézanne remembered them with great pleasure: see Cézanne to Solari, 23 July 1896, in *Corr.,* p. 318. According to Émile, Cézanne and Solari had climbed the mountain many times in their youth. In Walter Scott's *Anne of Geierstein* (1829), Provence is "the Arcadia of France."

Self-Portrait: The Inscrutable

1. In R834.

2. R182, dated c. 1875, and RWC486, dated c. 1895.

3. Beckett to McGreevy, 2 June 1958, in Knowlson, *Beckett,* p. 452. This was R584, a study for a self-portrait in a bowler hat (R585), dated 1885–86, now in the Glyptotek, Copenhagen.

4. Peter Gay, *Modernism* (New York: Norton, 2008), pp. 114–15.

5. T. J. Clark, "A House of Cards," a lecture at the Courtauld, 15 January 2011. Cf. R274 (Self-Portrait 3 in this book) and R383.

6. R809, dated 1896, now in the Národní Gallery, Prague.

7. Venturi, catalogue raisonné, p. 36.

11: A Scarecrow

1. Beckett, *Company,* pp. vii and 8. Cf. Beckett to McGreevy, 5 May 1935, in Beckett, *Letters,* vol. 1, p. 265.
2. Cézanne, "Confidences," in *Conversations,* p. 103.
3. Coste to Zola, April 1896 [1897?], in *Corr.,* p. 296.
4. Vollard, *Écoutant,* p. 74; Provence notes, based on information from Blanc. Cf. Ely, "A Place of Truth," p. 39.
5. Fabbri to Cézanne, 28 May, and Cézanne to Fabbri, 31 May 1899, in *Corr.,* p. 338.
6. There is some dispute about whether it was a *bastidon* or a *cabanon* (which would imply a smaller stone "cabin"). The building is still in place; given that it has an upper story, and an adjoining structure a little like an outhouse, it is known locally as a *bastidon.* Cézanne seems to have rented it from 1895 to 1899, or possibly 1902.
7. He rented the room in Couton's house from 1895 to 1899; and the room at the Château Noir from 1897 to 1902: that is, from the time of his mother's death to the construction of a new studio at Les Lauves: see below.
8. Johnson, "Cézanne's Country," pp. 532–35. According to Couton, a man sometimes posed nude for Cézanne in the woods nearby.
9. Creuset, *Ravaisou,* p. 69; Baille, *Petits Maîtres,* p. 56. He also painted with Bernard, and virtually insisted that Camoin come with him. See Cézanne to Camoin, 9 December 1904, in *Corr.,* p. 384.
10. Osthaus, "Une visite," and Jourdain, *Cézanne,* in *Conversations,* pp. 84 and 97.
11. Royère, "Paul Cézanne," p. 485. Cézanne was probably more widely read on the subject than is often supposed. His annotated copy of Jean-Pierre Thénot's *Les Règles de la perspective pratique* [1839] (1891) has recently come to light. Thénot's *Morphographie, ou L'Art de représenter . . . des corps solides* (1838) mentions the cylinder, the cone, and the sphere (in that order). Cf. Cézanne's celebrated letter to Bernard, 15 April 1904, in *Corr.,* p. 375, "*traitez la nature par le cylindre, la sphère, le cone, le tout mis en perspective.*"
12. Riley, "Cézanne in Provence," in *The Eye's Mind,* p. 253; Maldiney, *Regard, parole,* p. 150.
13. Osthaus, "Une visite," in *Conversations,* p. 97.
14. Cf. Rosalind Krauss, "The Motivation of the Sign," in *Picasso & Braque Symposium,* p. 268. *Lake d'Annecy* (R805) and *Plaster Cupid* (R786) are in the Courtauld. There is another, less disorientating *Plaster Cupid* (R782) in the Nationalmuseum, Stockholm.
15. Beckett to McGreevy and Mary Manning Howe, 9 October and 13 December 1936, in Beckett, *Letters,* vol. 1, pp. 374 and 397.
16. Geffroy, *Monet,* p. 330, as related by Monet; Rewald, "Cézanne and Guillaumin," pp. 117–18, as related by Signac. Rewald, *Cézanne-Zola,* p. 341, tells Signac's story in French. Cézanne apparently suspected Monet of trying to push his daughter into the arms of his son—perhaps another variant of people "getting their hooks into him." See Jourdain, *Cézanne,* in *Conversations,* p. 84.
17. Valéry, trans. Martin Turnell, "Stendhal," p. 187.

18. Cézanne to Gasquet, 30 April 1896, in *Corr.*, pp. 312–13. *Mont Sainte-Victoire with Large Pine* (R599) is now in the Courtauld; see below.

19. Kafka, "The Hunter Gracchus" [1931], in *Collected Short Stories*, p. 230.

20. Mellerio, *Le Mouvement idéaliste* [1896], p. 26; "Enquête sur les tendances actuelles des arts plastiques," *Mercure de France*, 1 and 15 August and 1 September 1905.

21. "Enquête," passim (emphasis in the original).

22. "Enquête," 1 September 1905.

23. Follain diary, 1 January 1942, in Jean Follain, *Agendas* (Paris: Paulhan, 1993), p. 89, from Denis.

24. *Le Mémorial d'Aix*, 15 October 1905; Cézanne to Paul, 15 October 1906, in *Corr.*, p. 416.

25. See Horace, *Odes*, 4:2, in *The Odes*, p. 259 (trans. Rachel Hadas): "My style is like the bees / That gather patiently from here and there."

26. Cézanne to Zola, Wednesday evening 1878, in *Corr.*, p. 207. Again quoting from memory, it seems, Cézanne has *incepte* rather than *incepto*. In full: "*Si quid inexpertum scaenae committis et audes personam formare nouam, seruetur ad imum qualis ab incepto processerit, et sibi constet.*" From *Ars Poetica*, 125–27. This passage was also part of the culture, deployed by Corneille and Diderot, among others. Larguier and Bernard both remark on Cézanne's knowledge of Horace. *Conversations*, pp. 12 and 56.

27. Another celebrated ode (3:30) is quoted in Guillemet's letter to Oller, of 12 September 1866, as from Cézanne and Pissarro: "*et monumentum exegi aere perennius.*" See ch. 5.

28. Horace, *Odes*, 3:16, in *The Odes*, p. 205, trans. Stephen Yenser (his emphasis). J. D. McClatchy, the editor of this collection, takes his cue from Auden, "The Horatians" (1968).

29. Gasquet, *Cézanne*, p. 167. Predictably, perhaps, the portrait (R809) is unfinished; it is now in the Národní Galerie, Prague.

30. Tattersall, *Diabetes*, p. 27, quoting from Pavy's "Introductory address to the discussion on the clinical aspect of glycosuria."

31. He complained of "*les douleurs neuralgiques*" to Zola, 11 March 1885; "*système nerveux très affaibli*" to Paul, 8 October 1906; "*troubles cérébraux*" to Aurenche (10 March 1902), Bernard (27 June 1904 and 21 September 1906), and Paul (22 September 1906).

32. As John House noted, "Cézanne seems to be making a subtle point by using this term rather than the more obvious *sensations colorées*, perhaps to suggest the active role of the *sensation* in generating the experience of color." Seeking to capture this, House translated the term as "colored sensory experiences" or "sensory experiences of color," rather than simply "color sensations" (as in the published correspondence). See "Cézanne's Letters to Émile Bernard," in Courtauld, pp. 147ff. In his "Opinions" (as recorded by Bernard), however, Cézanne did use "*sensations colorées*" (and "*organisées*"). See opinions 5, 6, and 7, in *Conversations*, p. 36.

33. Cézanne to Paul and Bernard, 8 October 1906 and 27 June 1904, in *Corr.*, pp. 413 and 379–80.

34. Bernard, "Souvenirs," in *Conversations*, p. 79; Cézanne to Bernard, 23 December 1904 and 23 October 1905, in *Corr.*, pp. 386 and 394. The postscript to the latter may help to clarify what he meant by "*l'optique*": "Optical experience, developing in us through study, teaches us to see." The parenthesis in the former is an afterthought inserted above the main text. Cézanne's use of "neo-impressionism" seems to be targeted at his correspondent—meaning what Gauguin or Bernard himself was doing.

35. See the exchange between Huysmans and Pissarro over *L'Art moderne* (1883), in Pissarro, *Corr.*, vol. 1, p. 208. "Retinal maladies" was first rehearsed in 1880 and definitively pinned on Cézanne in *Certains* (1899). See Huysmans, *Écrits*, pp. 164–65, 360.

36. Cézanne to Bernard, 27 June 1904, in *Corr.*, p. 380. Cf. Bernard, "Souvenirs," in *Conversations*, pp. 65 and 79. As Cézanne would have known, *Self-Portrait*, or *Portrait of Chardin Wearing an Eyeshade* (1775), was a late work, painted four years before his death; it was acquired by the Louvre in 1839. Cézanne applied the same epithet ("*un roublard*") to Vollard (Aurenche, "Souvenirs," p. 65).

37. Cézanne to Paul, 13 October 1906, in *Corr.*, p. 415.

38. Larguier, *Dimanche*, in *Conversations*, p. 12.

39. Ibid., p. 13.

40. Larguier, "Le Maître," in *La Maison du poète*, pp. 19ff. I follow the translation in Athanassoglou-Kallmyer, *Provence*, p. 228. See also "L'Heure du berger" and "Première toile," also dedicated to Cézanne.

41. Cézanne to Gasquet, 21 July 1896, in *Corr.*, p. 318; Gasquet, *Cézanne*, p. 170.

42. Cézanne to Émile Solari, 8 September 1897, in *Corr.*, p. 329.

43. Cézanne to Paul, 25 July and 3 August 1906, in *Corr.*, pp. 398–99. The published correspondence gives "ribs" for kidneys (*reins*). No more is known of Boissy's treatment, or of Dr. Guillaumont. A subsequent letter specifies the right foot.

44. Bernard, "Souvenirs," in *Conversations*, pp. 69–71. See also ch. 12.

45. Pissarro to Lucien, 3 December 1890 and 20 January 1896, in Pissarro, *Corr.*, vol. 2, p. 371, and vol. 4, p. 153; Lucien to Pissarro, 22 January 1896, in Lucien, *Letters*, p. 458.

46. "Restless" is in fact the primary sense of *inquiet*.

47. Jaloux, "Souvenirs" (his emphasis).

48. Morice, "Le Salon d'automne," *Mercure de France*, 1 December 1905. He makes a similar pun in "Le XXIe Salon des indépendants," *Mercure de France*, 15 April 1905.

49. See Cézanne to Bernard and Camoin, 23 October 1905 and 22 February 1903, in *Corr.*, pp. 394 and 368 (his emphases). Cézanne's vigorous underlining in the letter to Camoin is lost in the published edition of his correspondence.

50. Cf. Bann, *The True Vine*, p. 254, quoting from Saint John, 14:6.

51. Derrida, *Truth in Painting*, pp. 2 and 9. Characteristically, Derrida says that he takes the "saying" from someone else (Hubert Damisch).

52. Rilke, *Duino Elegies*, p. 55. Cf. the formulations in Rilke to Clara, 13 October 1907, in Rilke, *Letters*, p. 46, and "Requiem for a Friend" [1909], trans. Stephen Mitchell, at http://www.paratheatrical.com/requiemtext.html, p. 2.

53. Giacometti interviewed by David Sylvester, 1964, in Sylvester, *Looking at Giacometti,* p. 238. There are four oil paintings and two watercolors of *The Boy in the Red Waistcoat* (R656, 657, 658, and 659 and RWC375 and 376): a masterly group dated to 1888–90. They all have marvelous deformations; Giacometti is thinking of R658, from the Bührle Collection.

54. In this instance, R659, now in the NGA.

55. Beckett to McGreevy, 8 and 16 September 1934, in Beckett, *Letters,* vol. 1, pp. 222 and 227; J. M. Coetzee, "The Making of Samuel Beckett," *NYRB,* 30 April 2009.

56. Cf. Cézanne to Guillemet, 13 January 1897, in *Corr.,* p. 323. A fortnight (*"une quinzaine de jours"*), not a whole month as the standard chronology has it.

57. Baudelaire to his mother, 13 December 1862, in Baudelaire, *Corr.,* vol. 2, p. 274.

58. Clark, "Phenomenality," p. 111; Consibee in *Cézanne in Provence,* p. 195; Tuma, "Cézanne and Lucretius," p. 74. *The Red Rock* (R799), dated c. 1896–97, is in the Orangerie. *Mont Sainte-Victoire Seen from Bibémus* (R837), dated c. 1897, is in the Baltimore Museum of Art; a kind of companion piece, *The Bibémus Quarry* (R836), dated c. 1895, is in the Museum Folkwang, Essen. As so often, precise dating of these paintings is almost impossible. The campaigns were conducted between June 1895 and August 1896, between June 1897 and January 1898, and in the months after July 1899.

59. Gasquet, *Cézanne,* p. 252.

60. Schapiro, *Cézanne,* p. 118. *Rocks at Fontainebleau* (R775), dated c. 1893, now in the Met.

61. Flaubert, trans. Douglas Parmée, *A Sentimental Education,* pp. 352, 354–55. Cézanne mentions rereading Flaubert in a letter to Gasquet of 29 September 1896.

62. Cézanne to Monet, 6 July 1895, in *Corr.,* p. 308.

63. Provence, *Tholonet,* p. 16; Gasquet, *Cézanne,* pp. 177–78. The portrait drawing is C397, there dated 1877–80, reproduced in *Letters,* p. 201, dated c. 1885.

64. *Portrait of Madame Cézanne* is in Cézanne's studio in Aix; it is reproduced in *Jas de Bouffan,* p. 45.

65. Rilke to Baladine Klossovska, 1921, in Petzet, foreword to Rilke, *Letters,* p. xxii. Rilke probably read of this in Gasquet's *Cézanne* (p. 111), where it is interpreted as his "highest form of prayer."

66. The legal proceedings can be followed in the documents reproduced in *Monsieur Paul Cézanne*; the sale of the Cézannes in Vollard to Conil, 18 December 1899, Archives Vollard, 421 (4,1), p. 33, and Stockbook A, nos. 4127 and 4128, Musée d'Orsay. *House and Pigeon Tower* (R690) is now in the Museum Folkwang; *The Pigeon Tower* (R692) in the Cleveland Museum of Art. Vollard's price was 600, not 6,000, francs, as the standard chronology has it.

67. Rougier in Charensol, "Aix et Cézanne," p. 8. Conil apparently gambled away his money (and his wife's inheritance).

68. Gasquet, *Cézanne,* pp. 32–33.

69. Cézanne to Zola, 25 August 1885, in *Corr.,* p. 279. Cf. Cézanne to Pissarro and Bernard, 23 October 1866 and 23 October 1905, ibid., pp. 159 and 394. For the story of his mother's effects, see ch. 6.

70. See, e.g., Cézanne to Aurenche and Vollard, 10 March 1902 and 9 January 1903, in *Corr.*, p. 356, and *Lettres*, p. 58. In the published correspondence, the letter to Vollard is radically incomplete; the suppressions and omissions include a short paragraph relating to Hortense and Paul.

71. Acte d'achat in *Monsieur Paul Cézanne*, p. 192.

72. Girard's account, dating from the 1950s, in "Témoinages Cézanniens," extracted in *Atelier Cézanne*, p. 33; Loran, *Cézanne's Composition*, p. 136.

73. Cézanne to Vollard, 2 April 1902, in *Corr.*, pp. 360–61. He wrote similarly to Camoin the previous month.

74. Ely, "Place of Truth," pp. 34–35, drawing on testimony from Viguier, gathered by Marcel Provence; Coquiot, *Cézanne*, p. 127 (the estimate); *Déclaration de la succession de Paul Cézanne*, in *Monsieur Paul Cézanne*, p. 236.

75. Bernard, "Souvenirs" in *Conversations*, p. 58 (picked up by Rilke to Clara, 9 October 1907, in Rilke, *Letters*, p. 34); Coquiot, *Cézanne*, pp. 122 and 127, citing Rougier.

76. See Zola to Coste, 26 July 1866, and Cézanne to Pissarro, 2 July 1876, in *Corr.*, pp. 152 and 194.

77. Borély, "Cézanne à Aix," in *Conversations*, pp. 19–20. The easel paintings may be the *Large Bathers* (R855) in the NG and *The Gardener Vallier* (R948 or 949). See ch. 12.

78. Gasquet, *Cézanne*, p. 176. Here I follow Christopher Pemberton's translation (*Gasquet's Cézanne*, p. 118). The word used by Cézanne to describe the place is an obscure one: *le tubet*. There is a Maison de Retraite just outside Aix (but in a different direction) called "Le Tubet." That was evidently an old name for the house; perhaps there were others.

79. Virgil, *Eclogues,* 1:79–83. See also ch. 1.

80. Gasquet, *Cézanne*, pp. 176–77. Cézanne would have been familiar with a rather similar treatment of Tholonet and the surrounding countryside as a *lieu de mémoire* in *Evariste Plauchu* (1869), by his compatriot Marius Roux, whose very name was a remembrance of things past (the Roman general Marius defeated the armies of the Teutons and the Cimbri in the valley of the Arc). He would also have read an evocative series of articles in the same vein by Pierre Cheilan on "Le Tholonet: Le Petit Chemin" which ran in *Le Mémorial d'Aix* from March to May 1899. Gasquet could have drawn on the latter for his own account.

81. Gasquet, *Cézanne*, p. 127; Camoin to Rewald, 6 May 1958, Rewald Papers, Box 30–11, NGA. Cf. Brassaï, *Conversations*, p. 130. Neither remark can be dated with precision. The association with Gasquet was at its closest in 1896–97; Cézanne's expression as reported is rather oddly formulated. Camoin, like Larguier, did his military service in Aix. He arrived in late 1901 and was still visiting Cézanne in early 1905. The expression he recalled varies slightly as between the accounts of Brassaï and Rewald, but the sense is the same, and he was a very reliable witness (more reliable than Gasquet). Camoin for his part was surprised to see Gasquet's account and perhaps skeptical of it; he remarked on this to Rewald.

82. Cézanne to Paul, Friday [20?] July 1906, in *Lettres*, p. 71.

83. Gasquet, *Cézanne*, p. 140; Rilke, *Duino Elegies*, p. 5.

84. Lou Cadet d'Ais [Ravaisou], "Paul Cézanne," *Le National d'Aix*, 28 October 1906, reprinted in *La Provence libérée*, 13 August 1966; extracted in *Monsieur Paul Cézanne*, p. 287.

85. Lawrence, "Introduction," p. 279 (his emphases); Riley, "Color for the Painter" [1995], in *The Eye's Mind*, p. 237.

86. This *Large Pine* (R761) is dated to 1890–95 by Rewald, but Machotka has argued persuasively for a date closer to 1896 and the stylistic accomplishment of *The Lake d'Annecy*; it is now in the Hermitage. Cf. RWC285 and 286. Courbet's *Oak* was suggestively subtitled "Oak of Vercingétorix, Caesar's Camp near Alesia, Franche-Comté." Cézanne would have seen it at the exhibition of 1867.

87. Kelly's study of Cézanne—"how he did it"—his brushstrokes, his use of blues, grays, and greens together, and also the sense of affinity, emerges in conversations with Katherine Sachs and others in *Cézanne and Beyond*, pp. 433–45.

88. Gasquet, *Cézanne*, pp. 223–24. Cézanne as tree hugger may sound like one of Gasquet's flights of fancy, but Marcel Provence heard of his concern for this olive tree from the contractor and the mason who built the studio (they confirm exactly his instructions to protect it), and the reported speech sounds entirely authentic. See Ely, "Place of Truth," p. 39.

12: *Non Finito*

1. Cézanne to Vollard, 9 January 1903, in *Lettres*, p. 58. Cf. Cézanne to Aurenche, 25 September 1903, in *Corr.*, pp. 371–72, where he uses the same expression, "I work tenaciously," promising impishly that he and his son will come "as a choir" and say hello, "if the Austerlitz sun of painting should shine for me." (Austerlitz was the decisive battle of the War of the Third Coalition. Napoleon routed the Austrians and the Russians on 2 December 1805 under a brilliant winter sun.) The letter to Vollard does seem to speak to Cézanne's loneliness—he goes on to say that he lives alone—but it is also a reminder that he did not live alone all the time: Hortense and Paul were staying at the Rue Boulegon as he wrote. As published in his correspondence, the letter is incomplete, omitting the reference to his wife and son, among other things.

2. Gowing, "Logic," p. 198.

3. Bernard, "Souvenirs," in *Conversations*, p. 73, probably dating from his visit of March 1905. He said something similar to Rivière and Schnerb when they visited in January 1905. Rilke used the same expression, of Cézanne and his own creation Malte Laurids Brigge, "for Cézanne is nothing but the first primitive and bare achievement of that which in M.L. was not yet achieved" (Rilke to Clara, 8 September 1908).

4. F. M. Cornford, *Microcosmographia academica* (Cambridge: Cambridge University Press, 1933), p. 32.

5. Cézanne to a young artist (a friend of Joachim Gasquet's—Gustave Heiriès?), n.d., in *Corr.*, p. 321. Only fragments of this letter survive. Perhaps because of the connection with Gasquet, it is placed by Rewald at the end of the year 1896; given the preoccupation with time, it may be a little later.

6. Cézanne, "Confidences," in *Conversations*, p. 104. Was he also thinking of Michelangelo's *Moses* (1513–15), object of rhapsody in Stendhal's *Histoire* (p. 301)? Variations on the lines he quoted are a repeated refrain in the poem. The closest to Cézanne's version runs: "*Vous m'avez fait vieillir puissant et soli-taire / Laissez-moi m'endormir du sommeil de la terre.*" The preceding line clarifies the sense: "*Et cependant, Seigneur, je ne suis pas heureux.*" "Confidences" is reproduced in facsimile in Chappuis, vol. 1, pp. 26–27. Dating it has caused almost as much dispute as the paintings; Lebensztejn has argued convincingly for c. 1896. Recounting Cézanne's early life, Gasquet says that he "saw himself as different, solitary, marked by a sign" (*Cézanne*, p. 59), but this seems too knowing, too soon—a reading back from the later life—and also too much like striving for effect on Gasquet's part.

7. Cézanne to Gasquet, 4 January 1901, in *Corr.*, p. 344; Denis diary, 26 January 1906, in *Conversations*, pp. 93–94.

8. Rilke to Clara, 24 June 1907, in Rilke, *Letters*, p. 4.

9. Cézanne to Bernard, 21 September 1906, in *Corr.*, pp. 408–09. Could "macrobite" be an allusion to Macrobius, author of *Saturnalia* and the *Dream of Scipio*? The latter work may be appropriate to the circumstances: it is a commentary on the narrative by Cicero at the end of the *Republic*, in which the elder Scipio appears to his (adopted) grandson, and describes the life of the good after death, and the constitution of the universe. Macrobius is also known as one of the original readers of *The Golden Ass*, by Apuleius, which was said to be a favorite of Cézanne's. According to Gasquet (who had it from Lauzet), he read Apuleius aloud to Monticelli on their painting expeditions together, and reread it while painting the *Old Woman with Rosary* (*Cézanne*, pp. 144 and 201).

10. Cézanne to Gasquet, 5 September 1903, in *Corr.*, p. 370; Mirbeau, "L'Art, l'Institut et l'état," *La Revue*, 15 April 1905, in his *Combats esthétiques*, vol. 2, pp. 412–13. In Mirbeau's dialogue the petitioner is disguised as "a friend." This was the same Roujon who was responsible for the selection from the Caillebotte bequest (see ch. 8) and the rejection of the Cézanne murals from the Jas de Bouffan (see ch. 2). For an alternative version of his expostulations, see Vollard, *Écoutant*, p. 120.

11. Cézanne to Bernard, 25 July 1904, in *Corr.*, pp. 381–82.

12. Beckett, *The Unnamable* [1953] (London: Faber, 2010), p. 134, the concluding lines.

13. Couturier diary, 1952, in Marie-Alain Couturier, *Se garder libre* (Paris: Cerf, 1962), p. 148, to Louis Clayeux.

14. Denis diary, 26 January 1906, in *Conversations*, p. 93. Cf. his "Cézanne" in ibid., p. 176.

15. Denis diary, 26 January 1906, in *Conversations*, pp. 93–94. In Flaubert's *Salammbô* (1862), Mathô is the proud leader of a rebellion of mercenaries in the Carthaginian army, a barbarian in animal skins, obsessed with the luscious Salammbô. Another of Cézanne's favorite writers, Chateaubriand ("Chateau"), was fond of *le jalon*: "*Comme des jalons laissés en arrière, ils nous tracent le chemin que nous avons suivi dans le désert du passé*" (*Mémoires d'outre-tombe*).

16. The sketch is reproduced in Rewald, "Cézanne's theories about art," p. 32.

Apparently Cézanne's son accompanied them (a fourth figure edges into the frame of the painting); so it seems that he and perhaps Hortense were in Aix at the time. See Denis to Marthe (his wife), Sunday evening, in *Conversations*, p. 95.

17. See Sally Shafto, "Artistic Encounters: Jean-Marie Straub, Danièle Huillet and Paul Cézanne," *Senses of Cinema* 52 (2009), at http://www.sensesofcinema .com; Thierry Jousse and Dominique Païni, "Cézanne à Orsay: Entretien avec Virginie Herbin," *Cahiers du cinéma* 430 (1990), p. 530.

18. The three more familiar photographs are clearly printed in *Atelier Cézanne*, p. 48; two larger prints are in *Cézanne and Provence*, p. 288. Copies of all six are in the Rewald Papers, Box 58–2, NGA. In this setup, at least, the easel itself appears not to be on a slope or at a slant.

19. Rilke to Witold von Hulewicz (his Polish translator), 13 November 1925, in *Duino Elegies*, p. 70 (his emphases). Cézanne did speak of "vibrations of light": see Cézanne to Bernard, 15 April 1904, in *Corr.*, p. 376. The language of vibrations was taken up again by Merleau-Ponty in "Cézanne's Doubt." Through him it has spread to other influential accounts of Cézanne's significance for the culture and the self, e.g., Charles Taylor, *Sources of the Self* (Cambridge: Cambridge University Press, 1989). See Epilogue.

20. Geffroy, "Cézanne" [1894], in *La Vie artistique*, vol. 3, pp. 256–57. See ch. 5.

21. Denis to Marthe, Sunday evening, in *Conversations*, p. 95; Cézanne to Roussel, 22 February 1906, in *Lettres*, p. 70, cordially acknowledging the gift.

22. Bernard to his wife, 25 October 1906, in "Lettres inédites du peintre Émile Bernard à propos de la mort de son ami," *Arts-Documents* 33 (June 1953), p. 13 (his emphasis).

23. Murray interviewed by Robert Storr, in *Elizabeth Murray*, p. 171.

24. Clark, "Phenomenality," p. 109; Simone Weil, trans. Emma Craufurd, *Gravity and Grace* [1947] (London: Routledge, 2002), p. 42.

25. Gasquet, *Cézanne*, in *Conversations*, p. 124. According to Gasquet, Cézanne went on to link this fixation with Frenhofer and Balthasar Claës. See ch. 9.

26. Lehrer, "Cézanne," p. 98; Berger, "Sight of a Man," p. 227.

27. Gowing, "Logic," p. 181; Gasquet, *Cézanne*, in *Conversations*, p. 109, a passage highlighted by Loran in *Cézanne's Composition*, p. 15.

28. Baudelaire, "De la couleur," in *Salon de 1846*, in *Curiosités esthétiques* (Paris: Garnier, 1862), p. 105.

29. Jameson, "Towards a Libidinal Economy of Three Modern Painters" [1979], in *Modernist Papers*, p. 259. Baudelaire himself made use of "molecular," but the play of "molecular" and "molar" is from Deleuze and Guattari, *Anti-Oedipus*.

30. Stein, "Cézanne" [1923], in *Portraits and Prayers*, p. 11.

31. Merleau-Ponty, "Le Doute," p. 32.

32. Seamus Heaney, "Green Man," *Modern Painters* 13 (2000), p. 70, on Barrie Cooke. Why not "*refaire Rubens sur nature*," asked David Sylvester, noting Cézanne's hero worship. "Because Rubens was like a force of nature. Cézanne evoked the great Artificer [Poussin]." Sylvester, "Cézanne" [1996], in *About Modern Art*, p. 437. On Rubens, see below.

33. Cézanne to Aurenche, 25 January 1904, in *Corr.*, p. 373 (my emphasis); Max

Raphael, trans. Norbert Guterman, "The Work of Art" [1930], in *The Demands of Art*, p. 11, a study of another late Mont Sainte-Victoire seen from Les Lauves (R912, in the PMA).

34. Bresson, *Notes,* p. 135; Richardson, "Braque," p. 28. Bresson appears to have got this expression from Elgar, *Cézanne* (p. 244), who gives no source. It bears some resemblance to an expression in van Gogh's letter of 27 July 1890 to his brother, Theo.

35. Ginsberg, "Art of Poetry," p. 25; Loran, *Cézanne's Composition,* p. 14.

36. Ginsberg, "Art of Poetry," pp. 27–28. Cf. Cézanne to Bernard, 15 April 1904 and 21 September 1906, in *Corr.,* pp. 376 and 409.

37. Ginsberg, *Howl,* p. 7. In Ginsberg's parlance, it is "Aeterna." He also wrote a short poem, "Cézanne's Ports," collected in *Empty Mirror* (1961), about *The Gulf of Marseilles seen from L'Estaque* (R625), which he would have seen in the Met. William Carlos Williams's poem, "Cézanne," in *Poetry* 103 (1964), p. 253, makes a connection with Ginsberg.

38. Ginsberg journal, 30 May 1961, in *Journals* (New York: Grove, 1977), p. 207.

39. Masson, "Moralités esthétiques," p. 785 (his emphases).

40. Raphael, "The Work of Art," in *The Demands of Art*, p. 29; Broch, "The Style of the Mythical Age," p. 104.

41. Valéry, "The Triumph of Manet" [1932], in *Degas Manet Morisot,* p. 113.

42. Adorno, trans. Duncan Smith, modified by Richard Leppert, "Alienated Master-piece" [1959], in *Essays on Music,* p. 580.

43. Beckett, *Worstward Ho* [1983], in *Company etc.,* p. 81.

44. Adorno, trans. Susan H. Gillespie, "Late Style in Beethoven" [1937], in *Essays on Music,* p. 564.

45. Sartre, "Merleau-Ponty," pp. 387–88.

46. Proust, *In Search of Lost Time,* vol. 3, p. 325, and vol. 6, p. 25; Beckett, *Proust,* pp. 83–84, apropos "the radiographical quality of his imagination"; Celan, "The Meridian," in *Selected Poems and Prose,* p. 411. This edition of Proust has "occultist" for "oculist."

47. *Mont Sainte-Victoire Seen from Les Lauves* (R932), dated 1904–06. Cf. R931, now in the Kunstmuseum, Basel, perhaps the last in the sequence (and unfinished?). See also RWC587 and 589, which seem to relate to R932, without necessarily being studies as conventionally understood. The others in the sequence are R910–918 and RWC581a–599.

48. Rishel in Tate, p. 474.

49. Adorno, "Late Style," p. 567. "Catastrophe" in this sense is glossed in Said, *On Late Style,* pp. 13 and 16.

50. "The Modern Painter's World" (1944), in *The Collected Writings of Robert Motherwell* (Berkeley: University of California Press, 1999), p. 32.

51. *My Mountain Song 27* was made originally in 8mm and reissued in 1987 in 16mm. For Brakhage, it was a long work (20 minutes).

52. Anne Carson, *The Beauty of the Husband* (New York: Vintage, 2002), p. 105.

53. Bernard, "Souvenirs," in *Conversations,* p. 57, referring to *Three Skulls on an Oriental Rug* (R824), now in the Kunstmuseum, Solothurn. It is not easy to do full justice to *optique* in Cézanne's usage. (Cf. Cézanne to Bernard, 23 October

1905, in *Corr.,* p. 395.) Bernard remarked that "his *optique* was much more in his brain than his eye"; John House suggested that it seems to characterize the sum of the artist's optical experience, rather than any concept or science or technique. See also ch. 11, on his *optique* and his diabetes.

54. Bernard, "Souvenirs," and to his mother, 5 February 1904, in *Conversations,* pp. 58 and 24. Cf. Coquiot, *Cézanne,* pp. 144–45.

55. R855, in the National Gallery, measures 136 x 191 cm; R856, in the Barnes Foundation, 133 x 207 cm; R857, in the PMA, 208 x 249 cm.

56. *Henry Moore on Sculpture,* p. 190.

57. D'Souza, *Cézanne's Bathers,* pp. 1 and 4; Clark, "Freud's Cézanne," p. 423.

58. Lawrence, "Introduction," p. 269. Both shots are reproduced in Clark, "Freud's Cézanne," p. 148, the open mouth from Loran, *Cézanne's Composition,* p. 9, the calm gaze from the archives of the Musée d'Orsay.

59. Among others, Maurice Denis had a reproduction of the photograph; Henry Moore, *Three Bathers* (R361); Brice Marden, a postcard of the National Gallery *Bathers*; Leon Kossoff, a display of Cézannes, including a tattered reproduction of the Philadelphia *Bathers.* See Kossoff, *Drawing from Painting* (London: National Gallery, 2007), frontispiece. It has been suggested that the photograph could have been a source for Picasso's earliest work on the *Demoiselles d'Avignon,* though the evidence is not conclusive.

60. Rivière and Schnerb, "Cézanne's Studio," p. 91. In fact there are nine: another bather disppears behind the tree.

61. Bernard, "Réflexions à propos du Salon d'automne," p. 63; Remy de Gourmont, "Dialogues des amateurs—peinture d'automne," *Mercure de France,* 1 November 1907.

62. In the discussion that follows I have drawn on Stephen Bann's subtle interpretation of the *Bathers,* which in turn draws on René Girard's suggestive reading of Proust, in *Things Hidden Since the Foundation of the World* (1987); and T. J. Clark's penetrating observations on these works, but not the associated psychological speculations, nor the unquestioning acceptance of Cézanne's "horror of human contact," explained by an early kick from behind (a story that assumes tremendous importance in Clark's account). The mirage of self-sufficiency is Girard, on Proust's little band of girls, glimpsed by the narrator on the Balbec promenade. See Bann, *The True Vine,* pp. 172ff.; Clark, "Freud's Cézanne," pp. 143ff.

63. Denis diary, 1906, and "Théories," in *Conversations,* pp. 94 and 175–76.

64. Clark, "Freud's Cézanne," pp. 144 and 150. This *Temptation* (R167) was the first of three paintings and at least four drawings done around 1870–75. The gloomy hermaphrodite may be based on a figure by Delacroix, *Michelangelo in His Studio,* exhibited in Paris in 1864, in the same month Cézanne wrote that he was copying a Delacroix. Cézanne to Coste, 27 February 1864, in *Corr.,* p. 89. See ch. 3.

65. Baudelaire, "M. Gustave Flaubert—*Madame Bovary*—*La Tentation de Saint-Antoine,*" *L'Artiste,* 18 October 1857, reprinted in *L'Art romantique,* pp. 393–408. This article develops the link between *Madame Bovary* and *The Temptation of Saint Anthony* ("the secret chamber of his heart"), highlighting

"the prodigious feast of Nebuchadnezzar." In one of Cézanne's favorite books, Baudelaire also drew attention to Balzac's expression "the third sex": see "Le Peintre de la vie moderne," p. 226, quoting *La Dernière Incarnation de Vautrin* (1847).

66. See Bernstein, "Cézanne and Johns," in *Cézanne and Beyond,* where the tracings are reproduced on pp. 474–75. Johns has pointed out that Cézanne, too, made tracings. He owns an *Entombment, after Caravaggio* (c. 1877–80). Johns, "Flicker," p. 288. For earlier equivocal interpretations, see ch. 7.

67. Krumrine, *Bathers,* p. 33.

68. Schapiro, *Cézanne,* p. 29. See ch. 3. Dorival had seen the *Bathers* as a substitute for Cézanne's "suppressed libido."

69. Bernard, "Souvenirs," in *Conversations,* p. 71. See also ch. 11.

70. Clark, "Freud's Cézanne," p. 143; Garb, "Visuality and Sexuality," p. 47.

71. Reff, "Cézanne, Flaubert, Saint Anthony," p. 117, and "Cézanne's Bather with Outstretched Arms," p. 181; Clark, "Freud's Cézanne," p. 149.

72. Reff, "Constructive Stroke," pp. 224 and 226; Schapiro, *Cézanne,* p. 46. Cf. Reff, "Painting and Theory," p. 38.

73. Wayne Andersen has turned the tables with an interesting argument about the author's psychological investment in "his" Cézanne. "To possess Cézanne, one must first isolate him, kill his father, refuse him the love of a woman, and assert that he had difficulty making friends. . . . Surely Cézanne's father constituted a mortal threat to John Rewald's self-image as Cézanne's *guardien.*" *Cézanne and Zola,* p. xix.

74. See R555, dated c. 1885, now in MoMA; with source photograph reproduced.

75. Ovid, trans. A. D. Melville, *The Love Poems,* from *Amores,* 2:16:31–32. Strictly speaking, Cézanne probably worked from Heinrich Vosterman's copy of the original, in the Cabinet des Estampes of the Louvre. Rubens was inspired by the Greek poet Musaeus, who in his turn drew on Ovid. See Andersen, *Eternal Feminine,* pp. 115ff. Hero was the priestess of Aphrodite (Venus) at Sestos, on the other side of the Hellespont from Abydos, home of her lover Leander. He swam across the straits to her every night, guided by a lamp in the tower in which she lived, until a great storm extinguished the light and he drowned. Hero, seeing his body washed up on the rocks under the tower, threw herself to her death. The story is treated briefly and allusively by Virgil (*Georgics,* 3:258–63), as Cézanne would have known, and more extensively by Ovid in *Heroides* 18 and 19.

76. "A Conversation with Stan Brakhage," in Philip Taaffe, *Composite Nature* (New York: Peter Blum, 1998), at http://www.philiptaaffe.info/Interviews_State ments/CompositeNature.php.

77. Cézanne to Paul, 8 September 1906, in *Lettres,* pp. 84–85, one of the letters that inspired Ginsberg. See also the letters of 14 August and 13 September 1906.

78. Heaney, "The Riverbank Field," in *Human Chain,* p. 46, after Virgil, *Aeneid,* 6:704–15, 748–51. *Bathers Under a Bridge* (RWC601), now in the Met, is dated c. 1900 by Rewald, but 1906 by Simms and other authorities. Cf. *The Trois Sautets Bridge* (RWC644), now in the Cincinnati Art Museum, firmly dated 1906 by Rewald.

79. Heaney, "Route 110," in *Human Chain*, p. 58.

80. Heaney, "The Riverbank Field," in ibid., pp. 46–47. For Cézanne on his father, see Gasquet, *Cézanne*, p. 33.

81. Cézanne to Aurenche, 10 March 1902, in *Corr.*, p. 357, quoting Virgil, *Aeneid*, 9:641.

82. Also known as *The Barque of Dante, After Delacroix* (R172). See ch. 3. Cézanne would have read Baudelaire's discussions of the Delacroix original.

83. Cézanne to Gasquet, 30 April 1896, in *Corr.*, pp. 312–13. See ch. 11.

84. Cézanne to Paul, [20?] July 1906, *Lettres*, p. 71. On Pissarro, see also the letters of 3 August and 26 September 1906, *Lettres*, pp. 74 and 89. Cézanne gave swimming as his favorite form of relaxation in his "Confidences," and waxed lyrical about that *hygiénique distraction* in a letter to his niece Paule Conil in 1902 (*Corr.*, p. 365).

85. Rilke, *Duino Elegies*, p. 9.

86. Cézanne to Paul, 28 September 1906, *Lettres*, p. 91.

87. He wears a shirt and straw hat in three of the oils (R950, in the Tate; R953, in the Bürhle Collection; R954, in a private collection) and all of the watercolors (RWC639–41). In the other three oils he wears a jacket, an overcoat, and a cap (R948, formerly owned by Pellerin, now in a private collection; R949, in the NGA; R951, in a private collection).

88. Rivière and Schnerb, "L'Atelier," in *Conversations*, p. 91. Cézanne worked on one of the portraits throughout 1905–06. Camoin saw it in September 1906, looking "rather less worked up" (*plutôt moins fait*) than when he had last visited, the year before. Jourdain, *Cézanne*, in *Conversations*, p. 83 (where their visit is misdated to late 1904).

89. Gowing, "Logic," in *Conversations*, p. 212, of R954.

90. I am grateful to Ann Hoenigswald, senior conservator at the NGA, for discussing their Vallier (R949) and for allowing me to see her After Treatment Report.

91. Royère, "Erinnerungen," p. 482. Royère's "Memories" were published in German in 1912. I follow the translation by Melissa Thoron Hause in Baumann et al., *Finished/Unfinished*, p. 196. Cézanne may have been talking about R951.

92. Félix Valloton, "Au Salon d'automne," *La Grande Revue*, 25 October 1907.

93. Heidegger, "Cézanne" (1970), in Young, *Heidegger's Philosophy of Art*, p. 152, which also gives the original German. In the so-called later version, produced in 1974 and circulated privately to friends at Christmas 1975, Heidegger added the following comment, by way of explanation: "What Cézanne called '*la réalisation*' is the appearance of what is present in the clearing of presence—in such a way, indeed, that the duality of the two is overcome in the oneness of the pure radiance of his paintings. For thinking, this is the question of overcoming the ontological difference between Being and beings." Whether the recipients were any the wiser is a moot point.

94. Petzet, *Encounters*, p. 142, quoting Rilke to Clara, 18 October 1907, in Rilke, *Letters*, p. 58. Heidegger reinforced this statement with further extracts on Cézanne's personal use of color, and on the significance of Baudelaire's "La Charogne" (see Rilke, *Letters*, pp. 42 and 60).

95. The Basel one (R931) bears comparison with the Moscow one (R932). Beyeler owned another (R917), now in a Swiss private collection.

96. Masson, "Moralités," pp. 785–86.

97. Heidegger, trans. Fred D. Wieck and J. Glenn Gray, *What Is Called Thinking?* (New York: Harper & Row, 1968), p. 236; Jamme, "Cézanne, Rilke and Heidegger," p. 146. Cf. Fédier, "Voir sous le voile," p. 342.

98. Jean Beaufret, *Dialogue avec Heidegger*, vol. 3 (Paris: Minuit, 1974), p. 207. Beaufret was Heidegger's interlocutor and ambassador in France. His explanation here is patterned on fragment 18 in the traditional Diels edition of Heraclitus. In Beaufret: "*Si tu n'espères pas ce qui est hors d'espoir, tu ne trouveras pas, car il est introuvable et sans chemin menant à lui.*" In the modern French edition by Marcel Conche: "*S'il n'espère pas l'inespérable, il ne le découvrira pas, étant inexplorable et sans voie d'accès*" (fragment 66). I have followed the translation in Charles H. Kahn, *The Art and Thought of Heraclitus* (Cambridge: Cambridge University Press, 1979), p. 105 (fragment 7).

99. Cézanne to Paul, 15 October 1906, in *Lettres*, p. 95.

100. R954. See also RWC641.

101. Cézanne to a paint supplier, 17 October 1906, in *Corr.*, p. 417.

102. Marie to Paul, 20 October 1906, in *Corr.*, pp. 417–18; Rougier interviewed by Charensol, in "Aix and Cézanne." On the exclusion of Hortense, see ch. 6.

103. The death certificate is reproduced in *Monsieur Paul Cézanne*, p. 203. Some accounts give the time of death as 9:00 a.m.: a misreading of the time that the certificate itself was drawn up, by Isidore Baille.

104. Rilke, *Malte Laurids Brigge*, p. 17. Rivière identifies the last watercolor as *Still Life with Carafe, Bottle and Fruit* (RWC642, as *Bottle of Cognac*), now on loan from the Pearlman Foundation to the Princeton University Art Museum. See Duret, "Cézanne," p. 148; Rivière, *Le Maître*, p. 123.

Epilogue: Cézanne by Numbers

1. Hélène Parmelin, *Picasso dit . . .* (Paris: Gonthier, 1966), p. 85.

2. Manny Farber, "Kitchen Without Kitsch" [1977], in *Negative Space* (New York: Da Capo, 1998), p. 340.

3. Dorothy Norman, "From the Writings and Conversations of Alfred Stieglitz," *Twice a Year* 1 (fall–winter 1938), p. 81.

4. E. E. Cummings, *Erotic Poems* (New York: Norton, 2010), p. 47.

5. Rilke to Modersohn-Becker, 28 June 1907, in Rewald, *The Watercolors*, p. 39.

6. Merleau-Ponty, "Le Doute," in *Sens et non-sens*, p. 15; "Cézanne's Doubt," in *Sense and Nonsense*, p. 9 (my emphasis).

7. Gasquet, *Cézanne*, in *Conversations*, p. 113, quoted by Merleau-Ponty in "Le Doute" (p. 32), which is probably where Berger found it. See Berger, "Drawn to That Moment" [1976], in *Selected Essays*, p. 419. The same quotation is woven into his novel *G* [1972] (London: Bloomsbury, 1996). See p. 15.

8. Bernard, "Souvenirs," in *Conversations*, pp. 58, 62.

9. Gasquet, *Cézanne*, in *Conversations*, p. 124.

10. Merleau-Ponty, "Le Doute," p. 28; "Cézanne's Doubt," p. 15.

11. Di Piero, "Morandi of Bologna" and "Miscellany I," in *Out of Eden,* pp. 33 and 79 (his emphasis).

12. Cézanne to Zola and Emperaire, 28 March 1878 and January 1872, in *Corr.,* pp. 205 and 177–78. The postage in question was a 25-centime stamp.

13. M.C., "Quelques souvenirs," p. 302.

14. Larguier, *Cézanne,* p. 93.

15. This still life is R849, in the NGA. I am grateful to Ann Hoenigswald, senior conservator of paintings at the NGA, for discussing this painting with me, and for allowing me to see her After Treatment Report.

16. Heidegger in conversation with André Masson (1956), in Françoise Will-Levaillant (ed.), *Le Rebelle du surréalisme* (Paris: Hermann, 1976), pp. 138ff. "*C'est effrayant, la vie,*" was indeed a habitual refrain.

17. Bresson interviewed by Michel Ciment (1996), trans. Pierre Hodgson, in *Projections* 9 (London: Faber, 1999), p. 3. According to Henri Cartier-Bresson, it was: "If I'm painting and suddenly start to think everything goes to hell." Interview with Michel Nuridsany (1994), in "The Moment That Counts," *NYRB,* 2 March 1995. "What a slap in the face for the conceptualists!" added Cartier-Bresson.

18. Marcel Provence notes, in *Atelier Cézanne,* p. 91; Bernard, "Souvenirs," in *Conversations,* p. 57; Le Bail to Rewald, 19 March 1935, in Rewald Papers, Box 50-1, NGA.

19. *A Cézanne Sketchbook,* p. II. For "January," no date given. The sketchbook is thought to date from c. 1869–70 to c. 1885–86.

20. Aline Cézanne, *Le Carnet de recettes de Mamine Cézanne* (Paris: Lattès, 2006), pp. 38, 41, 48, 79. Aline was the elder child of Paul Cézanne *fils* and Renée Rivière ("Mamine"), daughter of Georges Rivière.

21. Ernest Hemingway, *A Moveable Feast* (Harmondsworth: Penguin, 1966), pp. 16, 53. Hemingway was in Paris in 1921.

22. Le Bail to Rewald, loc. cit.

23. Eric Rohmer, "Des goûtes et des couleurs" (1956), in *Le Goût de la beauté* (Paris: Cahiers du Cinéma, 2004), p. 110.

24. The bill is in the Fondation Custodia, 1977–A.1746, Paris; the letter is in *Lettres,* p. 69.

25. Rilke to Clara, 13 October 1907, in Rilke, *Letters,* pp. 45–46.

26. Cézanne to Bernard, 15 April 1904, in *Corr.,* p. 376, a continuation of the lesson on perspective.

27. Sergei Makovsky in *Apollon* (1912), in Rabinow, *Cézanne to Picasso,* p. 254.

28. Benjamin diary, 24 December 1926, in Walter Benjamin, trans. Richard Sieburth, *Moscow Diary* (Cambridge, MA: Harvard University Press, 1986), p. 42. *Blue Landscape* (R882), dated 1904–06, is now in the Hermitage.

29. Walter Benjamin, trans. Harry Zohn, "On the Concept of History," in *Selected Writings,* vol. 4 (Cambridge, MA: Harvard University Press, 2003), p. 390. These reflections were first published in 1950; they are perhaps better known as "Theses on the Philosophy of History," in the collection *Illuminations* (1973).

30. Rivière and Schnerb, "L'Atelier," in *Conversations,* p. 87.

31. See RWC554, 567, 571, and 572. The last is the focus of a detailed study, *Cézanne in the Studio* (2004), by Carol Armstrong.

32. Merleau-Ponty, "Eye and Mind," p. 181; Young, *Heidegger's Philosophy of Art,* p. 157, citing "On the Question of Being" (1955).

33. Rilke, "The Bowl of Roses," in *New Poems* [1907], p. 193.

34. Kenneth Clark, *Another Part of the Wood* (London: Murray, 1974), pp. 70–71; Anthony Blunt, "Samuel Courtauld as Collector and Benefactor," in Douglas Cooper, *The Courtauld Collection* (1954), in Courtauld, pp. 12–13. The painting was on loan from the Davies sisters' collection, now in the National Museum of Wales: *Mountains in Provence* (R391), dated c. 1879, once owned by Gauguin, who considered it "a marvel."

35. Ginsberg, "Art of Poetry," p. 29.

36. Jameson, "Towards a Libidinal Economy of Three Modern Painters" [1979], in *Modernist Papers,* p. 258.

37. Ernst, trans. Gabriele Bennett, "Über Cézanne" from *Bulletin D* (1919), in Lucy R. Lippard (ed.), *Dadas on Art* (Englewood Cliffs, NJ: Prentice-Hall, 1971), p. 125. "*Je m'en fous de Cézanne,*" in French in the original.

38. Berger, "Sight of a Man," p. 225.

39. Stein, *Lectures in America,* pp. 76–77.

40. Di Piero, "Miscellany 1," in *Out of Eden,* p. 79.

41. Van Gogh to Theo, 3 November 1889, van Gogh Letters, no. 816.

42. Rilke to the Countess Sizzo and to Clara, 1 June and 23 April 1923, in *Duino Elegies,* p. xii.

43. Sylvester, "Still Life" [1962], in *About Modern Art,* pp. 96–97.

44. *Littérature* 18 (1921), p. 1.

45. Plus crabs at Sam Wo's and (his girlfriend) Tracy's face.

46. Rewald, *Cézanne et Zola,* p. 416, citing information from Maxime Conil and Paul. According to Larguier (*Cézanne,* p. 78), "Politicians, there are over a thousand in France, and it's shit. Whereas there's only one Cézanne!"

47. Roland Barthes, trans. Richard Howard, "Réquichot and His Body" [1973] in *The Responsibility of Forms* (Berkeley: University of California Press, 1991), p. 229; "Pause," *Le Nouvel Observateur,* 26 March 1979, in OC, vol. 5, pp. 652–53. In between, it went up to five square centimeters. "Archimboldo ou Rhétoriqueur et magicien" [1978], in ibid., p. 505.

48. László Moholy-Nagy, trans. Daphne M. Hoffmann, *The New Vision* [1932] (London: Faber, 1939), p. 81.

49. Handke, *The Lesson,* in *Slow Homecoming,* p. 176; Klee diary, 1909, in *The Diaries of Paul Klee* (Berkeley: University of California Press, 1964), p. 237. "I am large, I contain multitudes" is from Walt Whitman, "Song of Myself," in *Leaves of Grass.*

50. Vauxcelles, "La légende de Cézanne," *Carnet de la semaine,* 19 January 1930; Greenberg, "Cézanne and the Unity of Modern Art" [1951], in *Collected Essays,* vol. 3, p. 91; Merleau-Ponty, *Sens et non-sens,* p. 11.

51. Rilke to Alfred Schaer, 20 February 1924, in Petzet, "Foreword" to Rilke, *Let-*

ters, p. ix; Gertrude Stein and Robert Haas, "A Transatlantic Interview" (1946), in R. Bruce Elder, *The Films of Stan Brakhage in the American Tradition* (Waterloo, Ontario: Wilfrid Laurier University Press, 1998), p. 279.

52. Valéry, *Analects*, p. 227.

53. Liliane Brion-Guerry, *Cézanne et l'expression de l'espace* (Paris: Albin Michel, 1966), p. 7; conversation with Denis Coutagne, 8 September 2008.

54. See Danchev, *Braque*, pp. 180–82.

55. Seamus Heaney interviewed by Dennis O'Driscoll, in *Stepping Stones* (London: Faber, 2008), pp. 262–63. "The Artist" is the poem quoted in Self-Portrait 3.

56. Beaufret, *Dialogue avec Heidegger*, vol. 3, p. 155, gives "*J'ai trouvé ici le chemin de Cézanne, auquel, de son début jusqu'à sa fin, mon propre chemin de pensée répond à sa façon.*" Fédier, "Voir sous le voile de l'interprétation," p. 331, gives a variant of the last phrase: "*mon propre chemin de pensée en une certain mesure correspond.*" Both men were present on this occasion; Fédier says that he has a copy of the text in front of him as he writes.

57. Merleau-Ponty, "Eye and Mind," pp. 159 and 190. The epigraph comes from one of his prime sources, Gasquet's *Cézanne* (and sounds more like Gasquet than Cézanne). For the conclusion, I have modified the translation by Chris Turner, in Sartre, "Merleau-Ponty," pp. 409–10.

58. Taylor, *Sources of the Self*, p. 468, quoting Merleau-Ponty (after Rilke), "Cézanne's Doubt," pp. 17–18.

59. Bresson interviewed by Ciment, loc. cit., p. 11.

60. William Feaver, *Lucian Freud* (London: Tate, 2002), p. 46. *After Cézanne* is now in the National Gallery of Australia.

61. Colin Wiggins, *Kitaj in the Aura of Cézanne and Other Masters* (London: National Gallery, 2001), pp. 43, 47. Artists creating their precursors is from Borges. Kafka's *The Castle, The Trial,* and *Amerika* were prepared for publication by Max Brod.

Bibliography

BOOKS

Adorno, Theodor W., trans. Susan H. Gillespie. *Essays on Music.* Berkeley: University of California Press, 2002.

Alexis, Paul. *Émile Zola.* Paris: Charpentier, 1882.

———. *Madame Meuriot.* Paris: Charpentier, 1890.

Andersen, Wayne. *Cézanne's Portrait Drawings.* Cambridge, MA: MIT Press, 1970.

———. *The Youth of Cézanne and Zola.* Geneva: Fabriart, 2003.

———. *Cézanne and the Eternal Feminine.* Cambridge: Cambridge University Press, 2004.

Antonini, Luc, and Nicolas Flippe. *La Famille Cézanne.* Colombelles: Corlet, 2006.

Apollinaire. *Chroniques d'art.* Paris: Gallimard, 1960.

———, trans. Susan Suleiman. *Apollinaire on Art.* New York: Viking Penguin, 1972.

Apuleius, trans. P. G. Walsh. *The Golden Ass.* Oxford: World's Classics, 1995.

Archives départmentales des Bouches-du-Rhône. *Monsieur Paul Cézanne, rentier, artiste-peintre.* Marseille: Images en Manœuvres, 2006.

Armstrong, Carol. *Cézanne in the Studio.* Los Angeles: Getty, 2004.

Arrouye, Jean, ed. *Cézanne, d'une siècle à l'autre.* Marseille: Parenthèses, 2006.

Athanassoglou-Kallmyer, Nina Maria. *Cézanne and Provence.* Chicago: University of Chicago Press, 2003.

Aude, Eduard, et al. *Tombeau de Cézanne.* Paris: Palais du Louvre, 1956.

Badt, Kurt, trans. Sheila Ann Ogilvie. *The Art of Cézanne.* [1956] London: Faber, 1966.

Baille, Franck. *Les Petits Maîtres d'Aix.* Aix: Roubaud, 1981.

Bakker, B. H., ed. *"Naturalisme pas mort": Lettres inédites de Paul Alexis à Émile Zola.* Toronto: University of Toronto Press, 1971.

Ballas, Giula. *Cézanne: Baigneuses et baigneurs.* Paris: Biro, 2002.

Balzac, Honoré de. *Le Chef-d'œuvre inconnu.* Paris: Gallimard, 1994.

———. *La Peau de chagrin.* Paris: Gallimard, 1974.

———. *La Recherche de l'absolu.* Paris: Gallimard, 1976.

———, trans. Richard Howard, *The Unknown Masterpiece.* New York: NYRB, 2001.

Bann, Stephen. *The True Vine.* Cambridge: Cambridge University Press, 1989.

Barthes, Roland, trans. Richard Howard. *The Responsibility of Forms.* [1982] Berkeley: University of California Press, 1991.

Baudelaire, Charles. *Curiosités esthétiques.* Paris: Garnier, 1962.

———. *Au-delà du romantisme*. Paris: Flammarion, 1998.

———, trans. James McGowan. *The Flowers of Evil*. Oxford: World's Classics, 1998.

Baumann, Felix, et al., eds. *Cézanne Finished/Unfinished*. Ostfildern: Hatje Cantz, 2000.

———. *Cézanne and the Dawn of Modern Art*. Ostfildern: Hatje Cantz, 2004.

Baumann, Felix, and Poul Erik Tøjner, eds. *Cézanne & Giacometti*. Ostfildern: Hatje Cantz, 2008.

Bazaine, Jean. *Notes sur la peinture d'aujourd'hui*. Paris: Seuil, 1953.

Bellony, Alice. *John Rewald*. Paris: L'Échoppe, 2005.

Berger, Harry. *Fictions of the Pose*. Palo Alto, CA: Stanford University Press, 2000.

Bernard, Émile. *Propos sur l'art*. Paris: Séguier, 1994.

Berthold, Gertrude. *Cézanne und die alten Meister*. Stuttgart: Kohlhammer, 1958.

Beucken, Jean de. *Un Portrait de Cézanne*. Paris: Gallimard, 1955.

Blanc, Charles. *Grammaire des arts du dessin*. Paris: Laurens, 1867.

Blanche, Jacques-Émile. *Propos de peintre*. Paris: Émile-Paul, 1919.

Bloch-Dano, Evelyne. *Madame Zola*. Paris: Grasset, 1997.

Boime, Albert. *Thomas Couture and the Eclectic Vision*. New Haven: Yale University Press, 1980.

Brady, Patrick. *"L'Œuvre" d'Émile Zola*. Geneva: Droz, 1967.

Brassaï, trans. Richard Miller. *The Artists of My Life*. London: Thames & Hudson, 1982.

Bresson, Robert. *Notes sur le cinématographe*. Paris: Gallimard, 1995.

Brettell, Richard R. *Pissarro's People*. New York: Prestel, 2011.

Brion-Guerry, Liliane. *Cézanne et l'expression de l'espace*. Paris: Albin Michel, 1966.

Brown, Frederick. *Zola*. London: Macmillan, 1996.

Buck, Stephanie, et al., eds. *The Courtauld Cézannes*. London: Courtauld Gallery, 2008.

Butler, Ruth. *Hidden in the Shadow of the Master*. New Haven: Yale University Press, 2008.

Cachin, Françoise, et al. *Cézanne*. London: Tate, 1996.

———. *Cézanne aujourd'hui*. Paris: RMN, 1997.

Callen, Anthea. *The Art of Impressionism*. New Haven: Yale University Press, 2000.

Callow, Philip. *Lost Earth*. London: Allison & Busby, 1995.

Cézanne, Aline. *Le Carnet de recettes de Mamine Cézanne*. Paris: Lattès, 2006.

Cézanne, Paul. *Correspondance*. [1937] Paris: Grasset, 2006.

———, trans. Marguerite Kay. *Letters*. [1941] New York: Da Capo, 1976.

———, trans. Seymour Hacker. *Letters*. New York: Hacker, 1984.

———. *Sketchbook*. [1951] New York: Dover, 1985.

———. *The Basel Sketchbooks*. New York: MoMA, 1988.

———. *Two Sketchbooks*. Philadelphia: PMA, 1989.

———. *Cinquante-trois lettres*. Paris: L'Échoppe, 2011.

Champsaur, Félicien. *Dinah Samuel*. [1882] Paris: Séguier, 1999.

Chapman, H. Perry. *Rembrandt's Self-Portraits*. Princeton: Princeton University Press, 1992.

Chappuis, Adrien. *The Drawings of Paul Cézanne*. Greenwich, CT: New York Graphic Society, 1973.

Clark, T. J. *Farewell to an Idea*. New Haven: Yale University Press, 1999.

Conisbee, Philip, and Denis Coutagne. *Cézanne in Provence*. Washington, DC: NGA, 2006.

Coquiot, Gustave. *Paul Cézanne*. Paris: Ollendorff, 1919.

Coutagne, Denis. *Cézanne en vérité(s)*. Arles: Actes Sud, 2006.

———, ed. *Sainte-Victoire Cézanne*. Aix: Roubaud, 1990.

————, ed. *Atelier Cézanne*. Aix: Société Paul Cézanne, 2002.

————, ed. *Jas de Bouffan*. Aix: Société Paul Cézanne, 2004.

————, ed. *Cézanne et Paris*. Paris: RMN, 2011.

Coutagne, Denis, et al. *Colloque Rewald Cézanne*. Aix: Hexagone, 1997.

————. *Ce que Cézanne donne à penser*. Paris: Gallimard, 2008.

Couture, Thomas. *Méthode et entretiens d'atelier*. Paris: Rue Vintimille, 1867.

Crary, Jonathan. *Suspensions of Perception*. Cambridge, MA: MIT Press, 1999.

Creuset, Geneviève. *Joseph Ravaisou*. Marseille: La Savoisienne, 1975.

Danchev, Alex. *Georges Braque*. London: Hamish Hamilton, 2005.

Deffeux, Léon, and Émile Zavie. *Le Groupe de Médan*. Paris: Payot, 1920.

Delacroix, Eugène. *Journal*. [1893–95] Paris: Corti, 2009.

Deleuze, Gilles, trans. Daniel W. Smith. *Francis Bacon*. [1981] London: Continuum, 2003.

Denis, Maurice. *Théories*. [1912] Paris: Rouart et Watelin, 1920.

————. *Journal*. Paris: La Colombe, 1957–59.

Di Piero, W. S. *Essays on Modern Art*. Berkeley: University of California Press, 1991.

Distel, Anne, and Susan Alyson Stein. *Cézanne to Van Gogh*. New York: Metropolitan Museum of Art, 1999.

Doran, Michael, ed. *Conversations avec Cézanne*. Paris: Macula, 1978.

————, trans. Julie Lawrence Cochran. *Conversations with Cézanne*. Berkeley: University of California Press, 2001.

Dorival, Bernard. *Cézanne*. Paris: Tisné, 1948.

D'Souza, Aruna. *Cézanne's Bathers*. University Park, PA: Pennsylvania State University Press, 2008.

Duranty, Edmond. *Le Pays des arts*. Paris: Charpentier, 1880.

Duret, Théodore. *Histoire des peintres impressionistes*. Paris: Floury, 1922.

————, et al. *Cézanne*. Paris: Bernheim-Jeune, 1914.

Ehrenzweig, Anton. *The Psychoanalysis of Artistic Vision and Hearing*. [1953] London: Sheldon, 1975.

Elder, Marc. *À Giverny, chez Claude Monet*. Paris: Bernheim-Jeune, 1924.

Elgar, Frank. *Cézanne*. London: Thames & Hudson, 1969.

Ely, Bruno, ed. *Picasso Cézanne*. Paris: RMN, 2009.

Fauconnier, Bernard. *L'Incendie de la Sainte-Victoire*. Paris: Grasset, 1995.

————. *Cézanne*. Paris: Gallimard, 2006.

Faure, Élie, *Les Constructeurs*. Paris: Crès, 1921.

Feilchenfeldt, Walter. *By Appointment Only*. London: Thames & Hudson, 2006.

Flaubert, Gustave, trans. Lafcadio Hearn. *The Temptation of Saint Anthony*. New York: Modern Library, 1992.

Fraisset, Michel. *Les Vies silencieuses de Cézanne*. Aix: Office du tourisme, 1999.

Fry, Roger. *Cézanne: A Study of His Development*. [1927] Chicago: University of Chicago Press, 1989.

Gachet, Paul. *Lettres impressionistes*. Paris: Grasset, 1957.

Gachet, Paul *fils*. *Deux Amis impressionistes*. Paris: Musées nationaux, 1956.

Gasquet, Joachim. *Cézanne*. [1921] Fougères: Encre marine, 2002.

————, trans. Christopher Pemberton. *Joachim Gasquet's Cézanne*. London: Thames & Hudson, 1991.

Gauguin, Paul. *Correspondance de Paul Gauguin*. Paris: Singer-Polignac, 1984.

Geffroy, Gustave. *La Vie artistique*. 8 vols. Paris: Dentu/Floury, 1894–1903.

———. *Le Cœur et l'esprit*. Paris: Charpentier, 1894.

———. *L'Enfermé*. Paris: Charpentier, 1897.

———. *Claude Monet*. [1922] Paris: Macula, 1980.

———. *Paul Cézanne et autres textes*. Paris: Séguier, 1995.

Geist, Sidney. *Interpreting Cézanne*. Cambridge, MA: Harvard University Press, 1988.

Gimpel, René. *Journal d'un collectionneur marchand de tableaux*. Paris: Calmann-Lévy, 1963.

Ginsberg, Allen. *"Howl," "Kaddish" and Other Poems*. London: Penguin, 2009.

Goncourt, Edmond, and Jules. *Manette Salomon*. Paris: Gallimard, 1996.

———, trans. Robert Baldick. *Pages from the Goncourt Journals*. New York: NYRB, 2007.

Gordon, Robert, and Andrew Forge. *Monet*. New York: Abrams, 1983.

Gowing, Lawrence. *Watercolor and Pencil Drawings by Cézanne*. London: Arts Council, 1973.

———. *Cézanne: The Early Years*. London: RA, 1988.

Handke, Peter, trans. Ralph Manheim. *Slow Homecoming*. New York: NYRB, 2009.

Heaney, Seamus. *The Human Chain*. London: Faber, 2010.

———. *Opened Ground*. London: Faber, 1998.

Héraclite, trans. Marcel Conche. *Fragments*. Paris: Presses universitaires de France, 1986.

Hesiod, trans. M. L. West. *Theogony* and *Works and Days*. Oxford: World's Classics, 1988.

Hindry, Ann. *Correspondances: Ellsworth Kelly/Paul Cézanne*. Paris: Argol, 2008.

Horace, trans. David West. *The Complete Odes and Epodes*. Oxford: World's Classics, 1997.

———, trans. contemporary poets. *The Odes*. Princeton: Princeton University Press, 2002.

House, John. *Impressionism: Paint and Politics*. New Haven: Yale University Press, 2004.

Huyghe, René. *Cézanne*. Paris: Plon, 1936.

Huysmans, J-K. *Écrits sur l'art*. Paris: Bartillat, 2006.

———. *En ménage*. Paris: Sillage, 2007.

Ireson, Nancy, and Barnaby Wright, eds. *Cézanne's Card Players*. London: Courtauld Gallery, 2010.

Jaloux, Edmond. *Fumées dans la campagne*. Paris: Fayard, 1918.

———. *Les Saisons littéraires*. Fribourg: Librairie de l'Université, 1942.

Janicaud, Dominique. *Heidegger en France*. Paris: Albin Michel, 2001.

Jean, Raymond. *Cézanne, la vie, l'espace*. Paris: Seuil, 1986.

Jourdain, Francis. *Cézanne*. Paris: Braun, 1950.

———. *Sans remords ni rancune*. Paris: Corrêa, 1953.

Jourdain, Frantz, and Robert Rey. *Le Salon d'automne*. Paris: Les Arts et Le Livre, 1926.

Juliet, Charles. *Shitao et Cézanne*. Paris: L'Échoppe, 2003.

———. *Cézanne un grand vivant*. Paris: POL, 2006.

Kahn, Charles H. *The Art and Thought of Heraclitus*. Cambridge: Cambridge University Press, 1979.

Kendall, Richard, ed. *Cézanne and Poussin*. Sheffield: Sheffield Academic Press, 1993.

Kimmelman, Michael. *Portraits*. New York: Modern Library, 1999.

Klingsor, Tristan. *Cézanne*. Paris: Rieder, 1923.

Krumrine, Mary Louise. *Paul Cézanne: The Bathers*. London: Thames & Hudson, 1990.

Laborde, Albert. *Trente-huit Années près de Zola*. Paris: Français Réunis, 1963.

La Fontaine, Jean de, trans. Norman R. Shapiro. *The Complete Fables*. Urbana: University of Illinois Press, 2007.

Lanoux, Armand. *Zola Vivant* in Zola, OC, vol. 1, pp. 9–346.

Larguier, Léo. *Le Dimanche avec Paul Cézanne*. Paris: L'Édition, 1925.

———. *Cézanne, ou le drame de la peinture*. Paris: Denoël, 1936.

———. *Cézanne, ou La Lutte avec l'ange de la peinture*. Paris: Julliard, 1947.

Lebensztejn, Jean-Claude. *Études Cézanniennes*. Paris: Flammarion, 2006.

Le Blond-Zola, Denise. *Émile Zola*. Paris: Fasquelle, 1931.

Lefrère, Jean-Jacques, and Michael Pakenham. *Cabaner, poète au piano*. Paris: L'Échoppe, 1994.

Lewis, Mary Tompkins. *Cézanne's Early Imagery*. Berkeley: University of California Press, 1989.

———. *Cézanne*. London: Phaidon, 2000.

Lindsay, Jack. *Cézanne*. London: Icon, 1972.

Lloyd, Christopher, ed. *Studies on Camille Pissarro*. London: RKP, 1986.

Loran, Erle. *Cézanne's Composition*. [1943] Berkeley: University of California Press, 2006.

Lord, James. *A Giacometti Portrait*. New York: Noonday, 1980.

Lucretius, trans. Ronald Melville. *On the Nature of the Universe*. Oxford: World's Classics, 1999.

Machotka, Pavel. *Cézanne: Landscape into Art*. New Haven: Yale University Press, 1996.

———. *Cézanne: The Eye and the Mind*. Marseille: Crès, 2008.

Mack, Gerstle. *Paul Cézanne*. New York: Knopf, 1935.

Manet, Julie, trans. Rosalind de Boland Roberts and Jane Roberts. *Growing Up with the Impressionists*. [1979] London: Sotheby's, 1987.

Matisse, Henri. *Écrits et propos sur l'art*. Paris: Hermann, 1992.

———, trans. Jack Flam. *Matisse on Art*. Berkeley: University of California Press, 1995.

Matisse, Henri, and Albert Marquet, ed. Claudine Grammont. *Correspondance*. Paris: Bibliothèque des Arts, 2008.

Meadmore, W. S. *Lucien Pissarro*. London: Constable, 1962.

Meier-Graefe, Julius, trans. J. Holroyd-Reece. *Cézanne*. [1910] London: Benn, 1927.

Mellerio, André. *Le Mouvement idéaliste en peinture*. Paris: Floury, 1896.

Merleau-Ponty, Maurice. *Sens et non-sens*. Paris: Gallimard, 1996.

———, trans. Hubert L. Dreyfus and Patricia Allen Dreyfus. *Sense and Nonsense*. Evanston, IL: Northwestern University Press, 1964.

Mirbeau, Octave. *L'Abbé Jules*. [1888] Paris: Ollendorff, 1901.

———. *Dans le ciel*. [1892–93] Paris: L'Échoppe, 1989.

———. *Combats esthétiques*. 2 vols. Paris: Séguier, 1993.

Mitterand, Henri. *Zola*. 3 vols. Paris: Fayard, 1999–2002.

Mitterand, Henri, and Jean Vidal. *Album Zola*. Paris: Gallimard, 1963.

Moholy-Nagy, Laszló, trans. Daphne M. Hoffmann. *The New Vision*. [1932] London: Faber, 1939.

Moore, George. *Impressions and Opinions*. London: Nutt, 1891.

———. *Memoirs of My Dead Life*. London: Heinemann, 1906.

Morel, Jean-Paul. *C'était Ambroise Vollard*. Paris: Fayard, 2007.

Mothe, Alain, et al. *Cézanne à Auvers-sur-Oise*. Paris: Valhermeil, n.d.

Niess, Robert J. *Zola, Cézanne and Manet: A Study of "L'Œuvre."* Ann Arbor: University of Michigan Press, 1968.

Novotny, Fritz. *Cézanne*. New York: Oxford University Press, 1937.

Ovid, trans. A. D. Melville. *Metamorphoses*. Oxford: World's Classics, 1998.

———. *The Love Poems*. Oxford: World's Classics, 1990.

Passantino, Erika J. *Duncan Phillips*. New Haven: Yale University Press, 1999.

Perruchot, Henri. *La Vie de Cézanne*. Paris: Hachette, 1956.

Petzet, Heinrich Wiegand, trans. Parvis Emad and Kenneth Maly. *Encounters and Dialogues with Martin Heidegger*. Chicago: University of Chicago Press, 1993.

Pissarro, Camille, trans. Lionel Abel. *Letters to His Son Lucien*. [1943] Boston: MFA, 2002.

———. *Correspondance de Camille Pissarro*, ed. Janine Bailly-Herzberg. 5 vols. Paris: Presses universitaires de France, 1980–91.

Pissarro, Joachim. *Pioneering Modern Painting: Cézanne & Pissarro*. New York: MoMA, 2005.

———. *Cézanne/Pissarro, Johns/Rauschenberg*. Cambridge: Cambridge University Press, 2006.

Pissarro, Joachim, and Claire Durand-Ruel Snollaerts. *Pissarro: Critical Catalogue of Paintings*. 3 vols. Milan: Skira, 2005.

Platzman, Steven. *Cézanne: The Self-Portraits*. London: Thames & Hudson, 2001.

Pleynet, Marcelin. *Cézanne marginal*. Gémenos: Les Mauvais Jours, 2006.

———. *Cézanne*. Paris: Gallimard, 2010.

Pope, Barbara Corrado. *Cézanne's Quarry*. New York: Pegasus, 2008.

Proust, Marcel. *In Search of Lost Time*. 6 vols. London: Penguin, 2002.

Provence, Marcel. *Cézanne au Tholonet*. Aix: Mémorial d'Aix, 1939.

Rabinow, Rebecca A., ed. *Cézanne to Picasso*. New York: Metropolitan Museum of Art, 2006.

Ramuz, C. F. *L'Exemple de Cézanne*. Saint-Sébastien-sur-Loire: Séquences, 2005.

Raynal, Maurice, trans. James Emmons. *Cézanne*. Geneva: Skira, 1954.

Redon, Odilon. *À Soi-même*. Paris: Floury, 1922.

Renoir, Jean, trans. Randolph and Dorothy Weaver. *Renoir, My Father*. [1962] New York: NYRB, 2001.

Rewald, John. *Cézanne et Zola*. Paris: Sedrowski, 1936.

———. *Cézanne: Sa Vie, son œuvre, son amitié pour Zola*. Paris: Albin Michel, 1939.

———. *The History of Impressionism*. [1946] London: Secker & Warburg, 1973.

———. *Post-Impressionism*. [1956] New York: MoMA, 1978.

———. *Cézanne, Geffroy et Gasquet*. Paris: Quatre Chemins-Editart, 1959.

———. *Paul Cézanne: The Watercolors*. Boston: Little, Brown, 1983.

———. *Studies in Impressionism*. London: Thames & Hudson, 1985.

———. *Cézanne*. New York: Abrams, 1986.

———. *Cézanne and America*. London: Thames & Hudson, 1989.

———. *The Paintings of Paul Cézanne*. New York: Abrams, 1996.

Riley, Bridget. *The Eye's Mind*. London: Thames & Hudson, 2009.

Rilke, Rainer Maria. *Auguste Rodin*. [1903/1907] New York: Dover, 2006.

———, trans. M. D. Herter Norton. *The Notebooks of Malte Laurids Brigge*. [1910] New York: Norton, 1949.

————, trans. Joel Agee. *Letters on Cézanne.* [1952] New York: North Point Press, 2002.

————, trans. Edward Snow. *New Poems.* New York: North Point Press, 1984.

————, trans. Edward Snow. *Duino Elegies.* New York: North Point Press, 2000.

Rishel, Joseph J., and Katherine Sachs, eds. *Cézanne and Beyond.* Philadelphia: PMA, 2009.

Rivière, Georges. *Renoir et ses amis.* Paris: Floury, 1921.

————. *Le Maître Paul Cézanne.* Paris: Floury, 1923.

Robb, Graham. *Rimbaud.* London: Picador, 2000.

Robbins, Anne. *Cézanne in Britain.* London: National Gallery, 2006.

Romilly, Jacqueline de. *Sur les Chemins de Sainte-Victoire.* Paris: Julliard, 1987.

Roux, Marius, trans. Dick Collins and Fiona Cox. *The Substance and the Shadow.* University Park: Pennsylvania University Press, 2007.

Rubin, William, ed. *Cézanne: The Late Work.* New York: MoMA, 1977.

Said, Edward. *On Late Style.* London: Bloomsbury, 2006.

Salmon, André. *Souvenirs sans fin.* 3 vols. Paris: Gallimard, 1955–61.

Schapiro, Meyer. *Cézanne.* [1952] New York: Abrams, 2004.

Scott, Sir Walter. *Anne of Geierstein.* [1829] Oxford: Clarendon Press, 1920.

Semmer, Laure-Caroline. *Cézanne, une histoire française.* Paris: Scala, 2011.

Shiff, Richard. *Cézanne and the End of Impressionism.* Chicago: University of Chicago Press, 1984.

Sidlauskas, Susan. *Cézanne's Other.* Berkeley: University of California Press, 2009.

Simms, Matthew. *Cézanne's Watercolors.* New Haven: Yale University Press, 2008.

Smith, Paul. *Interpreting Cézanne.* London: Tate, 1996.

Sollers, Philippe. *Le Paradis de Cézanne.* Paris: Gallimard, 1995.

Stavitsky, Gail, and Katherine Rothkopf. *Cézanne and American Modernism.* New Haven: Yale University Press, 2009.

Stein, Gertrude. *The Autobiography of Alice B. Toklas.* [1933] London: Penguin, 1966.

————. *Lectures in America.* New York: Random House, 1935.

Stendhal. *Histoire de la peinture en Italie.* Paris: Gallimard, 1996.

————. *Salons.* Paris: Gallimard, 2000.

Stevens, Wallace. *Collected Poems.* London: Faber, 1984.

Stone, Irving. *Lust for Life.* [1935] London: Arrow, 2001.

————. *Depths of Glory.* London: Bodley Head, 1985.

Swan, Thomas. *The Cézanne Case.* New York: Onyx, 2001.

Taine, Hippolyte. *Nouveaux Essais de critique et d'histoire.* Paris: Hachette, 1901.

————. *Philosophie de l'art.* 2 vols. Paris: Hachette, 1904.

————. *De l'intelligence.* Paris: Hachette, 1880.

————. *Voyage en Italie.* Paris: Hachette, 1866.

Tattersall, Robert. *Diabetes.* Oxford: Oxford University Press, 2010.

Taylor, Charles. *Sources of the Self.* Cambridge: Cambridge University Press, 1989.

Taylor, René, et al. *Francisco Oller.* Ponce, Puerto Rico: Museo de Arte de Ponce, 1983.

Thorold, Anne, ed. *Artists, Writers, Politics: Camille Pissarro and His Friends.* Oxford: Ashmolean Museum, 1980.

————, ed. *The Letters of Lucien to Camille Pissarro.* Cambridge: Cambridge University Press, 1993.

————, and Kristen Erickson. *Camille Pissarro and His Family.* Oxford: Ashmolean Museum, 1993.

Tomlinson, Charles. *New Collected Poems*. Manchester: Carcanet, 2009.

Valéry, Paul, trans. Martin Turnell. *Masters and Friends*. London: RKP, 1968.

Vallès, Jules. *Jacques Vingtras*. 3 vols. Paris: Charpentier, 1879–86.

Venturi, Lionello. *Cézanne: Son Art—son œuvre*. [1936] San Francisco: Alan Wofsy, 1989.

———. *Les Archives de l'impressionisme*. 2 vols. Paris: Durand-Ruel, 1939.

Verdi, Richard. *Cézanne and Poussin*. Edinburgh: National Galleries of Scotland, 1990.

———. *Cézanne*. London: Thames & Hudson, 1992.

Virgil, trans. C. Day Lewis. *The Aeneid*. Oxford: World's Classics, 1998.

———. *The Eclogues; The Georgics*. Oxford: World's Classics, 1999.

Vizetelly, Ernest A. *Émile Zola*. London: Bodley Head, 1904.

Vollard, Ambroise, trans. Violet M. Macdonald. *Recollections of a Picture Dealer*. [1936] New York: Dover, 2002.

———. *En Écoutant Cézanne, Degas, Renoir*. [1938] Paris: Grasset, 2005.

Walcott, Derek. *Tiepolo's Hound*. London: Faber, 2000.

Wheelwright, Philip. *Heraclitus*. Oxford: Oxford University Press, 1959.

Wildenstein, Daniel. *Claude Monet*. 5 vols. Lausanne: Bibliothèque des Arts, 1974–91.

Young, Julian. *Heidegger's Philosophy of Art*. Cambridge: Cambridge University Press, 2001.

Zola, Émile, ed. B. H. Bakker. *Correspondance*. 10 vols. Montreal: Presse de l'université de Montréal, 1978–95.

———. *Écrits sur l'art*. Paris: Gallimard, 1991.

———. *L'Assommoir*. Paris: Gallimard, 1978.

———. *La Faute de l'abbé Mouret*. Paris: Gallimard, 1991.

———. *La Fortune des Rougons*. Paris: Gallimard, 1981.

———. *L'Œuvre*. Paris: Gallimard, 1983.

———. *Le Ventre de Paris*. Paris: Gallimard, 2002.

———. *La Confession de Claude*. Paris: Dodo, 2009.

———. *Madeleine Ferat*. Paris: Dodo, 2009.

———. *La Conquête de Plassans*. Paris: Gallimard, 1990.

———. *Nana*. Paris: Gallimard, 2002.

———. *Thérèse Raquin*. Paris: Gallimard, 2002.

———, trans. Arthur Goldhammer. *The Kill*. New York: Modern Library, 2005.

———, trans. Thomas Walton, revised Roger Pearson. *The Masterpiece*. Oxford: World's Classics, 2006.

ARTICLES

Adhémar, Jean. "Le Cabinet de travail de Zola." *GBA* 56 (1960), pp. 285–98.

Adler, Kathleen. "Cézanne's Bodies." *Art in America* 78 (1990), pp. 234–37.

Agamben, Giorgio, trans. Georgia Albert. "Frenhofer and His Double." In *The Man Without Content*, pp. 8–12. Palo Alto, CA: Stanford University Press, 1999.

Alexandre, Arsène. "Claude Lantier." *Le Figaro*, 9 December 1895.

———. "Paul Cézanne." *Le Figaro*, 25 October 1906.

Andersen, Wayne. "Cézanne's Sketchbook in the Art Institute of Chicago." *BM* 104 (1962), pp. 196–201.

———. "Cézanne's *carnet violet-moiré*." *BM* 747 (June 1965), pp. 313–18.

————. "Cézanne, Tanguy, Chocquet." *BM* 49 (June 1967), pp. 137–39.

Athanassoglou-Kallmyer, Nina Maria. "An Artistic and Political Manifesto for Cézanne." *Art Bulletin* 72 (1990), pp. 482–92.

————. "Cézanne and Delacroix's Posthumous Reputation." *Art Bulletin* 87 (2005), pp. 111–29.

Baligand, Renée, "Lettres inédites d'Antoine Guillemet à Émile Zola." *Les Cahiers naturalistes* 51 (1977), pp. 173–205.

Ballas, Guila. "Paul Cézanne et la revue *L'Artiste*." *GBA* 98 (1981), pp. 223–32.

Barr, Alfred. "Cézanne d'après les lettres de Marion à Morstatt." *GBA* 17 (1937), pp. 37–58.

Bataille, Georges. "L'Impressionisme" [1956]. In *Œuvres Complètes,* vol. 12, pp. 370–80.

Baudelaire, Charles. "M. Gustave Flaubert, *Madame Bovary* et *La Tentation de Saint-Antoine.*" *L'Artiste,* 18 October 1857. In *L'Art romantique,* pp. 393–408.

Beaufret, Jean. "Heidegger et la question de l'histoire." In *Dialogues avec Heidegger,* vol. 3, pp. 183–216. Paris: Minuit, 1974.

————. "En France." In *Erinnerung an Martin Heidegger,* pp. 9–13. Pfullingen: Neske, 1977.

Becker, Colette. "Jean-Baptistin Baille." *Les Cahiers naturalistes* 56 (1982), pp. 147–58.

Berger, John. "The Sight of a Man" [1970]. In *Selected Essays,* pp. 224–29. London: Bloomsbury, 2001.

Bernard, Émile. "Paul Cézanne." *Les Hommes d'aujourd'hui* 8 (1891), n.p.

————. "Paul Cézanne." *L'Occident* (July 1904), in *Conversations,* pp. 33–44.

————. "Souvenirs sur Paul Cézanne." *Mercure de France,* 1 and 16 October 1907. In *Conversations,* pp. 51–79.

————. "Réflexions apropos du Salon d'automne." *La Rénovation esthétique,* December 1907.

————. "Julien Tanguy." *Mercure de France,* 16 December 1908, pp. 600–16.

————. "La méthode de Paul Cézanne." *Mercure de France,* 1 March 1920, pp. 289–318.

————. "La technique de Paul Cézanne." *L'Amour de l'art* (December 1920, pp. 271–78.

————. "Une conversation avec Paul Cézanne." *Mercure de France,* 1 June 1921, pp. 272–97.

————. "Les aquarelles de Cézanne." *L'Amour de l'art* (February 1924), pp. 32–36.

————. "L'erreur de Cézanne." *Mercure de France,* 1 May 1926, pp. 513–28.

Bernex, Jules. "Paul Cézanne." *Le Feu* 4 (1907), pp. 179–83.

————. "Souvenirs sur Cézanne." *L'Art sacré* (March-April 1956), pp. 22–31.

Blanche, Jacques-Émile. "Les Techniques de Cézanne." In *Cézanne,* pp. 9–16. Paris: Musée de l'Orangerie, 1936.

Boardingham, Robert. "Cézanne and the 1904 Salon d'automne." *Apollo* 142 (1995), pp. 31–39.

Bodelsen, Merete. "Gauguin's Cézannes." *BM* 104 (1962), pp. 204–11.

Boime, Albert. "Cézanne's Real and Imaginary Estate" [1998]. At www.albertboime.com/articles/102.pdf.

Bois, Yve-Alain, trans. Rosalind Krauss. "Cézanne: Words and Deeds." *October* 84 (1998), pp. 31–43.

Borély, Jules. "Cézanne à Aix." *L'Art vivant,* 1 July 1926. In *Conversations,* pp. 19–24.

Bouillon, Jean-Paul. "Le modèle Cézannien de Maurice Denis." In *Cézanne aujourd'hui,* pp. 145–64.

Boyer, Jean, trans. A. J. F. Millar. "The true story of the Jas de Bouffan in the 18th and early 19th centuries." In *Jas de Bouffan,* pp. 10–14.

Brettell, Richard. "Cézanne/Pissarro: élève/élève." In *Cézanne aujourd'hui*, pp. 29–37.
———. "Pioneering Modern Painting." *BM* 147 (2005), pp. 680–84.
Bridge, Helen. "Rilke and the Modern Portrait." *Modern Language Review* 99 (2004), pp. 681–95.
Broch, Hermann. "The Style of the Mythical Age" [1947]. In Simone Weil and Rachel Bespaloff, *War and the Iliad*, pp. 103–21. New York: NYRB, 2005.
Buren, Daniel. "Cézanne" [1955]. In *Il faut rendre à Cézanne ce qui appartient à Cézanne*, pp. 18–25. Paris: Gallimard, 2006.
Burnstock, Aviva, et al. "Cézanne's Development of the *Card Players*." In Ireson and Wright, *Cézanne's Card Players*, pp. 35–54.
Butler, Marigene H. "An Investigation of Pigments and Technique in the Cézanne Painting *Chestnut Trees*." *Bulletin of the American Institute for Conservation* 13 (1973), pp. 77–85.
———. "An Investigation of the Materials and Technique used by Paul Cézanne." Preprints of papers presented at 12th annual meeting of American Institute for Conservation, Los Angeles (1984), pp. 20–33.
Cahn, Isabelle. "L'Exposition Cézanne chez Vollard en 1895." In *Cézanne aujourd'hui*, pp. 135–44.
Camoin, Charles. "Souvenirs sur Paul Cézanne." *L'Amour de l'art*, January 1921, pp. 25–26.
Cézanne, Paul. "Trente-quatre lettres." *Les Cahiers du Musée national d'art moderne* 111 (Spring 2010), pp. 82–107.
Charensol. "Aix et Cézanne." *L'Art vivant*, 1 December 1925.
Chervet, Henri. "Le Salon d'automne." *NRF*, November-December 1907.
Chun, Young-Paik. "Looking at Cézanne through his own eyes." *Art History* 25 (2002), pp. 392–97.
———. "Melancholia and Cézanne's Portraits." In Griselda Pollock, ed., *Psychoanalysis and the Image*, pp. 94–126. Oxford: Blackwell, 2006.
Clark, Kenneth. "The Enigma of Cézanne." *Apollo* 100 (1974), pp. 78–81.
Clark, T. J. "Freud's Cézanne." In *Farewell to an Idea*, pp. 139–68.
———. "Phenomenality and Materiality in Cézanne." In Tom Cohen, ed., *Material Events*, pp. 93–113. Minneapolis: University of Minnesota Press, 2001.
Cohen, Rachel. "Artist's Model." *New Yorker*, 7 November 2005.
Consibee, Philip. "Cézanne's Provence." In *Cézanne and Provence*, pp. 1–26.
Cooper, Douglas. "Two Cézanne Exhibitions." *BM* 96 (1954), pp. 344–49 and 378–83.
———. "Au Jas de Bouffan." *L'Œil*, 15 February 1955.
Coquiot, Gustave. "Cézanne et la nature." In *Vagabondages*, pp. 142–47. Paris: Ollendorff, 1921.
Corroy, Georges. "La montagne Sainte-Victoire." *Bulletin du Service de la Carte géologique de la France* 251 (1957).
Coutagne, Denis. "Cézanne, tradition et modernité." In Coutagne, *Sainte-Victoire Cézanne*, pp. 79–124.
———, trans. A. J. F. Millar. "The major works in the Lauves studio." In Coutagne, *Atelier Cézanne*, pp. 42–69.
———. "The Jas de Bouffan landscapes." In Coutagne, *Jas de Bouffan*, pp. 98–139.
Cranshaw, Roger, and Adrian Lewis. "Wilful Ineptitude." *Art History* 12 (1989), pp. 129–35.

DeLue, Rachael Ziady. "Pissarro, Landscape, Vision and Tradition." *Art Bulletin* 80 (1998), pp. 718–36.

Denis, Maurice. "Cézanne." *L'Occident*, September 1907. In *Conversations*, pp. 166–79.

———. "L'Influence de Cézanne." *L'Amour de l'art* (December 1920), pp. 279–84.

Dombrowski, André. "The Emperor's Last Clothes." *BM* 148 (2006), pp. 586–94.

Druick, Douglas. "Cézanne Lithographs." In Rubin, *Late Work*, pp. 119–38.

D'Souza, Aruna. "Paul Cezanne, Claude Lantier and Artistic Impotence." At http://www.19thc-artworldwide.org.

Duranty, Edmond. "Le Peintre Louis Martin" [1872]. In *Le Pays des arts*, pp. 315–50. Paris: Charpentier, 1881.

Duret, Théodore. "Cézanne." In *Histoire des peintres impressionistes* [1878], pp. 127–48. Paris: Floury, 1922.

Elderfield, John. "Cézanne: The Lesson of the Master." *Art in America* 78 (1985), pp. 86–93.

Ely, Bruno. "Cezanne, L'École de dessin et le Musée d'Aix." In *Cézanne au Musée d'Aix*, pp. 137–206. Aix: Granet, 1984.

———. " 'La plus haute sommité du department.' " In Coutagne, *Sainte-Victoire Cézanne*, pp. 133–96.

———, trans. A. J. F. Millar. "A Place of Truth." In Coutagne, *Atelier Cézanne*, pp. 26–41.

———. "The Studio in the Days of Marcel Provence." In *Atelier Cézanne*, pp. 78–117.

———. "From Sanctuary to Cultural Tourism." In *Atelier Cézanne*, pp. 152–65.

———. "*Pater Omnipotens Aeterne Deus.*" In Coutagne, *Jas de Bouffan*, pp. 22–48.

———, trans. Judith Terry. "Cézanne's Youth and the Intellectual and Artistic Milieu in Aix." In Conisbee and Coutagne, *Cézanne and Provence*, pp. 27–46.

Faure, Elie. "Paul Cézanne." *Portraits d'hier*, 1 May 1910.

———. "Paul Cézanne" [1910]. In *Les Constructeurs*, pp. 211–55. Paris: Crès, 1921.

Faxon, Alicia. "Cézanne's Sources for *Les Grandes Baigneuses.*" *Art Bulletin* 65 (1983), pp. 320–23.

Fédier, François. "Voir sous le viole de l'interprétation . . . Cézanne et Heidegger." In Walter Biemal and Friedrich-Wilhelm von Herrmann, eds., pp. 331–47. *Kunst und Technik.* Frankfurt: Klostermann, 1989.

Fry, Roger. "*Paul Cézanne* by Ambroise Vollard." *BM* 31 (1917), pp. 52–61.

Garb, Tamar. "Visuality and Sexuality in Cézanne's Late Bathers." *Oxford Art Journal* 19 (1996), pp. 46–60.

———. "Cézanne's Late Bathers." In *Bodies of Modernity*, pp. 196–218. London: Thames & Hudson, 1998.

———. "Touching Sexual Difference: *Madame Cézanne in a Red Dress.*" In *The Painted Face*, pp. 139–80. New Haven: Yale University Press, 2007.

Gauthier, Maximilien. "Faux et repeints." *Rumeur*, 26 November and 1 December 1927.

Geffroy, Gustave. "Le Sarcophage égyptien." In *La Vie artistique*, vol. 1, pp. 1–10.

———. "Paul Cézanne." *Le Journal*, 25 March 1894. In *La Vie artistique*, vol. 3, pp. 249–60.

———. "Paul Cézanne." *Le Journal*, 16 November 1895. In *La Vie artistique*, vol. 6, pp. 214–20.

———. "L'Hommage à Cézanne" [1901]. In *La Vie artistique*, vol. 8, pp. 374–80.

Girard, Marcel. "Cézanne et Zola: Les baignades au bord de l'Arc." *Les Cahiers naturalistes* 60 (1986), pp. 28–40.

Golding, John. "Under Cézanne's Spell." *New York Review of Books,* 11 January 1996.

Gowing, Lawrence. "Notes on the Development of Cézanne." *BM* 98 (June 1956), pp. 185–92.

———. "The Logic of Organized Sensations." In *Conversations,* pp. 180–212.

———, and John Rewald. "Les Maisons provençales: Cézanne and Puget." *BM* 132 (1990), pp. 637–39.

Greenberg, Clement. "Cézanne and the Unity of Modern Art" [1951]. In *The Collected Essays and Criticism,* vol. 3, pp. 82–91. Chicago: University of Chicago Press, 1993.

Harvey, Benjamin. "Cézanne and Zola: a reassessment of 'L'Éternel feminine.' " *BM* 140 (1998), pp. 312–18.

Heron, Patrick. "Is Cézanne Still Alive?" [1956]. In *Painter as Critic,* pp. 116–20. London: Tate, 1998.

———. "Solid Space in Cézanne." *Modern Painters* (Spring 1996), pp. 16–24.

House, John. "Impressionism and History: The Rewald Legacy." *Art History* 9 (1986), pp. 369–76.

———. "Cézanne's Project." In Buck, *Courtauld Cézannes,* pp. 26–47.

———. "Cézanne's *Card Players*: Art Without Anecdote." In Ireson and Wright, *Card Players,* pp. 55–72.

Huneker, James. "Paul Cezanne." In *Promenades of an Impressionist,* pp. 1–23. London: Werner Laurie, 1910.

Hutton, John. "Camille Pissarro's *Turpitudes sociales* and Late Nineteenth-Century French Anarchist Anti-Feminism." *History Workshop Journal* 24 (1987), pp. 32–61.

Huysmans, J-K. "Paul Cezanne" [1888]. In *Écrits sur l'art,* pp. 359–60.

Ireson, Nancy, and Barnaby Wright. "Cézanne's *Card Players*." In *Card Players,* pp. 15–34.

Isaacson, Joel. "Pissarro's Doubt." *Apollo* 136 (1992), pp. 320–24.

———. "Constable, Duranty, Mallarmé, Impressionism, Plein Air and Forgetting." *Art Bulletin* 76 (1994), pp. 427–50.

Jaloux, Edmond. "Souvenirs sur Paul Cézanne." *L'Amour de l'art,* December 1920.

Jameson, Fredric. "Towards a Libinal Economy of Three Modernist Painters" [1979]. In *The Modernist Papers,* pp. 255–68. London: Verso, 2007.

Jamme, Christoph, trans. David L. Simpson. "The Loss of Things: Cézanne, Rilke, Heidegger." In Karsten Harries and Christoph Jamme, eds., *Martin Heidegger: Politics, Art and Technology,* pp. 139–53. New York: Holmes & Meier, 1994.

Jenkins, David Fraser. "Baigneuses and Demoiselles." *Apollo* 145 (1997), pp. 39–44.

Johns, Jasper, in conversation with Richard Shiff. "Flicker in the Work." *Master Drawings* 44 (2006), pp. 275–91.

Johnson, Erle Loran. "Cézanne's Country." *The Arts* 16 (1930), pp. 521–55.

Kear, Jon. " 'Frenhofer, c'est moi.' " *Cambridge Quarterly* 35 (2006), pp. 345–60.

Kitschen, Friederike. "Cézannes Hüte." *Pantheon* 56 (1989), pp. 120–32.

Klingsor, Tristan. "Le Salon d'automne." *L'Humanité,* 3 October 1907.

Krumrine, Mary Louise. "Cézanne's Restricted Power." *BM* 134 (1992), pp. 586–95.

Kuenzli, Katherine Marie. "Aesthetics and cultural politics in the age of Dreyfus: Maurice Denis's *Homage to Cézanne*." *Art History* 30 (2007), pp. 683–711.

Lawrence, D. H. "Introduction to These Paintings" [1929]. In *Selected Critical Writings,* pp. 248–83. Oxford: World's Classics, 1998.

Le Blond-Zola, Denise. "Zola et Cézanne." *Mercure de France,* January–February 1931.

Lebensztejn, Jean-Claude. "Persistance de la mémoire" [1993]. In *Études,* pp. 25–45.

———. "Les Couilles de Cézanne" [1998]. In *Études,* pp. 7–23.

———. "Une source oubliée de Cézanne" [2003–04]. In *Études,* pp. 47–59.

———. "Études cézanniennes" [2004]. In *Études,* pp. 62–78.

———. "Prendre le dessus." In *Études,* pp. 81–92.

Leca, Benedict. "Sites of Forgetting: Cézanne and the Provençal Landscape Tradition." In Conisbee and Coutagne, *Cézanne and Provence,* pp. 47–58.

Lecomte, Georges. "L'Art contemporain." *La Revue indépendante* (April 1892), pp. 1–29.

———. "Paul Cézanne." *La Revue de l'art,* 9 December 1899.

Lehrer, Jonah. "Paul Cézanne." In *Proust Was a Neuroscientist,* pp. 96–119. Edinburgh: Canongate, 2011.

Lethbridge, Robert. "Zola and Contemporary Painting." *Dix-neuf* 1 (2003), pp. 43–56.

Lhote, André. "Cézanne l'incompris." *NRF,* 1 September 1936.

Lichtenstein, Sara. "Cézanne and Delacroix." *Art Bulletin* 46 (1964), pp. 55–67.

———. "Cézanne's Copies and Variants after Delacroix." *Apollo* 101 (1975), pp. 116–27.

Lloyd, Christopher. " 'Paul Cézanne, Pupil of Pissarro.' " *Apollo* 136 (1992), pp. 284–90.

Lord, Douglas [Douglas Cooper]. "Paul Cézanne." *BM* 69 (1936), pp. 32–35.

Lyotard, Jean-François. "Freud selon Cézanne" [1971]. In *Des Dispositifs pulsionnels,* pp. 67–88. Paris: Bourgois, 1980.

McPherson, Heather. "Cézanne." In *The Modern Portrait in Nineteenth-Century France,* pp. 117–44. Cambridge: Cambridge University Press, 2001.

Maldiney, Henri. "Cézanne et le paysage." In *Art et existence,* pp. 18–27. Paris: Klincksieck, 1986.

———. "Cézanne et Sainte-Victoire, peinture et vérité." In Coutagne, *Sainte-Victoire Cézanne,* pp. 273–88.

Malevich, Kasimir, trans. Xenia Glowacki-Prus and Arnold McMillin. "An Analysis of New and Imitative Art (Paul Cézanne)." In *Essays on Art* vol. 2, pp. 19–30. London: Rapp and Whiting, 1969.

Masson, André. "Moralités esthétiques." *NRF,* 1 May 1959.

M. C. [Marthe Conil]. "Quelques souvenirs sur Paul Cézanne, par une de ses nièces." *GBA* 56 (1960), pp. 299–302.

Meier-Graefe, Julius, trans. Florence Simmonds and George W. Chrystal. "Paul Cézanne" [1904]. In *Modern Art,* vol. 1, pp. 266–70. London: Heinemann, 1908.

Merleau-Ponty, Maurice. "Le doute de Cézanne" [1945]. In *Sens et non-sens,* pp. 15–49.

———, trans. Hubert L. Dreyfus and Patricia Allen Dreyfus. "Cézanne's Doubt." In *Sense and Nonsense,* pp. 9–25.

———, trans. Carleton Dallery. "Eye and Mind." In *The Primacy of Perception,* pp. 159–90. Evanston: Northwestern University Press, 1964.

Mirbeau, Octave. "L'Art, l'Institut et l'état." *La Revue,* 15 April 1905.

———. "Interview d'Octave Mirbeau par Paul Gsell." *La Revue,* 15 March 1907.

Mitterand, Henri. "Brothers in Art: Cézanne and Zola." In Coutagne, *Cézanne and Paris,* pp. 34–43.

Montifaud, Marc de [Marie-Émilie Chartroule]. "Exposition du boulevard des Capucines." *L'Artiste,* 1 May 1874.

Morice, Charles. "Les Aquarelles de Cézanne." *Mercure de France*, 1 July 1905.

———. "Paul Cézanne." *Mercure de France*, 15 February 1907. In *Quelques maîtres modernes*, pp. 94–122. Paris: Messein, 1914.

———. "Le Salon d'automne." *Mercure de France*, 1 November 1907.

———, ed. "Enquête sur les tendances actuelles des arts plastiques." *Mercure de France*, 1 and 15 August and 1 September 1905.

Nagaï, Takanori. "An Aspect of Cézanne's Reception in Japan." *Aesthetics International* 8 (1998), pp. 79–91.

Natanson, Thadée. "Paul Cézanne." *La Revue blanche*, 1 December 1895.

Newton, Joy. "La dernière toile de Claude." *Les Cahiers naturalistes* 74 (2000), pp. 239–45.

———. "The Atelier Novel." In Richard Hobbs, ed., *Impressions of French Modernity*, pp. 173–89. Manchester: Manchester University Press, 1998.

———. "Cézanne's Literary Incarnations." *French Studies* 61 (2007), pp. 36–46.

Nochlin, Linda. "Cézanne: Studies in Contrast." *Art in America* 84 (1996), pp. 56–67.

Osthaus, Karl Ernst. "A Visit to Paul Cézanne" [1920–21]. In *Conversations*, pp. 96–99.

Pératé, André. "Le Salon d'automne." *GBA* 38 (1907), pp. 385–407.

Perruchot, Henri. "Les quinze logis de Monsieur Cézanne." *L'Œil* (Christmas 1955), pp. 32–36.

Petrone, Mario. " 'La Double vue de Louis Séguin,' par Duranty." *GBA* 88 (1976), pp. 235–39.

Pleynet, Marcelin. "Cézanne sous l'œil paternel" [1979]. In *Les Modernes et la tradition*, pp. 121–43. Paris: Gallimard, 1990.

Pollock, Griselda. "What Can We Say About Cézanne These Days?" *Oxford Art Journal* 13 (1990), pp. 95–101.

Portugés, Paul. "Allen Ginsberg's Paul Cézanne and the Pater Omnipotens Aeterna Deus." *Contemporary Literature* 21 (1980), pp. 435–49.

Provence, Marcel. "Cézanne collégien." *Mercure de France*, 1 February and 1 August 1925.

———. "Cézanne et ses amis." *Mercure de France*, 1 April 1926.

Rapetti, Rodolphe. "L'inquiétude cézannienne." *Revue de l'art* 144 (2004), pp. 35–50.

Raphael, Max, trans. Norbert Guterman. "The Work of Art and the Model in Nature" [1930]. In *The Demands of Art*, pp. 7–43, London: RKP, 1968.

Ravaisou, Joseph. "Paul Cézanne." *Le National d'Aix*, 28 October 1906.

Reff, Theodore. "Cézanne's Drawings." *BM* 101 (1959), pp. 171–76.

———. "Cézanne and Poussin." *Journal of the Warburg and Courtauld Institutes* 23 (1960), pp. 150–74.

———. "Reproductions and Books in Cézanne's Studio." *GBA*, November 1960, pp. 303–09.

———. "Cézanne's Bather with Outstretched Arms." *GBA*, March 1962, pp. 173–90.

———. "Cézanne, Flaubert, Saint Anthony, and the Queen of Sheba." *Art Bulletin* 44 (1962), pp. 113–25.

———. "Cézanne's Constructive Stroke." *Art Quarterly* 25 (1962), pp. 214–26.

———. "Cézanne: The Logical Mystery." *Art News* 62 (1963), pp. 28–31.

———. "Cézanne's *Dream of Hannibal*." *Art Bulletin* 45 (1963), 148–52.

———. "Copyists in the Louvre, 1850–1870." *Art Bulletin* 46 (1964), pp. 552–59.

———. "Cézanne and Hercules." *Art Bulletin* 48 (1966), pp. 35–44.

———. "Pissarro's Portrait of Cézanne." *BM* 109 (1967), pp. 627–33.

———. "Cézanne's Drawings." *BM* 117 (1975), pp. 489–91.

———. "Manet's Portrait of Zola." *BM* 117 (1975), pp. 34–44.

———. "Cézanne on Solids and Spaces." *Artforum* 16 (1977), pp. 34–37.

———. "Cézanne's Late Bather Paintings." *Arts Magazine* 52 (1977), pp. 116–19.

———. "Painting and Theory in the Final Decade." In Rubin, *Late Work*, pp. 13–54.

———. "The Pictures within Cézanne's Pictures." *Arts Magazine* 53 (1979), pp. 90–104.

———. "Cézanne's *Card Players* and their Sources." *Arts Magazine* 55 (1980), pp. 104–17.

———. "Cézanne: The Severed Head and the Skull." *Arts Magazine* 58 (1983), pp. 84–100.

———. "Cézanne et Chardin." In Cachin, *Cézanne aujourd'hui*, pp. 11–28.

———. "Cézanne's early paravent at the Jas de Bouffan." In *Jas de Bouffan*, pp. 56–67.

———, trans. Jeanne Bouniort. "Cézanne et la perspective." *Revue de l'art* 86 (1989), pp. 8–15.

Reissner, Elisabeth. "Ways of Making: Practice and Innovation in Cézanne's Paintings in the National Gallery." *National Gallery Technical Bulletin* 29 (2008), pp. 4–30.

———. "Transparency of Means: Drawing and Color in Cézanne's Watercolors and Oil Paintings in the Courtauld Gallery." In *Courtauld Cézannes*, pp. 49–71.

Rewald, John. "Paul Cézanne: New documents for the years 1870–1871." *BM* 74 (1939), pp. 163–71.

———. "Cézanne's Theories about Art." *Art News* 47 (1936), pp. 31–36.

———. "Achille Emperaire and Cézanne" [1938]. In *Studies in Impressionism*, pp. 56–68.

———. "Un article inédit sur Paul Cézanne en 1870." *Arts*, 21–27 July 1954.

———. "Chocquet and Cézanne" [1969]. In *Studies*, pp. 121–87.

———. "Cézanne and His Father" [1971–72]. In *Studies*, pp. 69–101.

———. "Cézanne and Guillaumin" [1975]. In *Studies*, pp. 103–19.

———. "The Last Motifs at Aix." In Rubin, *Late Work*, pp. 83–106.

Rider, Jacques Le. "Rilke et Cézanne." In *Cézanne aujourd'hui*, pp. 125–34.

Riley, Bridget. "Cézanne in Provence" [2006]. In *The Eye's Mind*, pp. 249–65.

Rivière, Georges. "L'Exposition des impressionistes." *L'Impressioniste*, 14 April 1877.

Rivière, R. P., and J. F. Schnerb. "L'atelier de Cézanne." *La Grande Revue*, 25 December 1907. In *Conversations*, pp. 84–90.

Rochefort, Henri. "L'Amour du laid." *L'Intransigeant*, 9 March 1903.

Rosenthal, Norman. "Cézanne: The Early Years." *Modern Painters* (Autumn 1988), pp. 52–55.

Rouart, Louis. "Réflexions sur le Salon d'automne." *L'Occident* 12 (1907), pp. 230–41.

Royère, Jean. "Sur Paul Cézanne." *La Phalange*, 15 November 1906.

———. "Paul Cézanne: Erinnerungen." *Kunst und Künstler* 10 (1912), pp. 477–86.

Sartre, Jean-Paul, trans. Chris Turner. "Merleau-Ponty." In *Portraits* [1964], pp. 266–428. London: Seagull, 2009.

Schapiro, Meyer. "The Apples of Cézanne" [1968]. In *Modern Art*, pp. 1–38. New York: Braziller, 1979.

Schjeldahl, Peter. "Cézanne versus Pissarro" [2005]. In *Let's See*, pp. 190–92. London: Thames & Hudson, 2008.

Schubert, Karsten. "Cézanne, Chappuis and the limits of connoisseurship." *BM* 148 (2006), pp. 612–20.

Seubold, Günter. "Der Pfad ins Selbe: Zur Cézanne-Interpretation Martin Heideggers." *Philosophisches Jarhbuch* 94 (1987), pp. 64–78.

Shafto, Sally. "Artistic Encounters: Jean-Marie Straub, Danièle Huillet and Paul Cézanne." at http://www.sensesofcinema.com/2009/52/.

Shiff, Richard. "Cézanne's Physicality." In Salim Kemal and Ivan Gaskell, eds., *The Language of Art History*, pp. 129–80. Cambridge: Cambridge University Press, 1991.

———. "Cézanne and Poussin." In Kendall, *Cézanne and Poussin*, pp. 51–68.

———. "Dense Cézanne." *Apollo* 143 (1996), pp. 51–54.

———. "La touché de Cézanne." In Cachin, *Cézanne aujourd'hui*, pp. 117–24.

———. "Cézanne's Blur, Approximating Cézanne." In Richard Thomson, ed., *Framing France*, pp. 59–80. Manchester: Manchester University Press, 1998.

———. "Sensation, Movement, Cézanne." In Terence Maloon, ed., *Classic Cézanne*, pp. 13–28. Sydney: Art Gallery NSW, 1998.

———. "Mark, Motif, Materiality: The Cézanne Effect in the Twentieth Century." In Baumann, *Finished/Unfinished*, pp. 99–126.

———. "Cézanne in the Wild." *BM* 148 (2006), pp. 605–11.

———. "Risible Cézanne." In Eik Kahng, ed., *The Repeating Image*, pp. 127–71. Baltimore: Walters Art Museum, 2007.

———. "Lucky Cézanne (Cézanne *Tychique*)." In Rishel and Sachs, *Cézanne and Beyond*, pp. 55–102.

———. "He Painted." In Ireson and Wright, *Card Players*, pp. 73–91.

Simon, Robert. "Cézanne and the Subject of Violence." *Art in America* 79 (1991), pp. 120–35.

Smith, Paul. "Pictures and History: One Man's Truth." *Oxford Art Journal* 10 (1987), pp. 97–105.

———. "Paul Adam, *Soi* et les 'peintres impressionistes.'" *Revue de l'art* 82 (1988), pp. 39–50.

———. "'Parbleu': Pissarro and the Political Color of an Original Vision." *Art History* 15 (1992), pp. 223–47.

———. "Joachim Gasquet, Virgil and Cézanne's Landscape." *Apollo* 148 (1998), pp. 11–23.

———. "Cézanne's Maternal Landscape and Its Gender." In Steven Adams and Anna Greutzner Robins, eds., *Gendering Landscape Art*, pp. 116–32. New Brunswick, NJ: Rutgers University Press, 2001.

———. "Cézanne's Late Landscapes, or the Prospect of Death." In Conisbee and Coutagne, *Cézanne and Provence*, pp. 59–77.

———. "Literature and Art." *French Studies* 61 (2007), pp. 1–13.

———. "Paul Cézanne's Primitive Self and Related Fictions." In Charles G. Salas, ed., *The Life and the Work*, pp. 45–75. Los Angeles: Getty, 2007.

———. "Real Primitives: Cézanne, Wittgenstein and the nature of aesthetic quality." In Jonathan Harris, ed., *Value, Art, Politics*, pp. 93–122. Liverpool: Liverpool University Press, 2007.

Stein, Gertrude. "Cézanne" [1923]. In *Portraits and Prayers*, p. 11. New York: Random House, 1934.

Stock. "Le Salon par Stock." *Album Stock*, 20 March 1870.

Stokes, Adrian. "Cézanne" [1947]. In *The Critical Writings of Adrian Stokes*, vol. 2, pp. 259–72. London: Thames & Hudson, 1978.

Sutton, Denys. "The Paradoxes of Cézanne." *Apollo* 100 (1974), pp. 98–107.

Sylvester, David. "Cézanne" [1996]. In *About Modern Art,* pp. 437–44. London: Pimlico, 1997.

Takumi, Hideo. "Cézanne and Japan." In *Cézanne,* pp. 18–21. Tokyo: Tokyo Shimbun, 1986.

Tanaka, Hidemichi. "Cézanne and 'Japonisme.'" *Artibus et Historiae* 22 (2001), pp. 201–20.

Thomson, Clive. "Une Correspondence inédite: Roux–Zola." *University of Ottawa Quarterly* 48 (1978), pp. 335–70.

Thomson, Richard. "Sparing the Rod." *Art History* 31 (2008), pp. 412–18.

Tomlinson, Charles. "The Poet as Painter." *Essays by Divers Hands* 40 (1979), pp. 147–62.

Tuma, Kathryn. "Cézanne and Lucretius at the Red Rock." *Representations* 78 (2002), pp. 56–85.

Valloton, Félix. "Le Salon d'automne." *La Grande revue,* 25 October 1907.

Van Buren, Anne H. "Madame Cézanne's Fashions and the date of her portraits." *Art Quarterly* 29 (1966), pp. 111–27.

Vauxcelles, Louis. "Cézanne." *Gil Blas,* 18 March 1905.

———. "Le Salon d'automne." *Gil Blas,* 5 October 1906.

———. "La Mort de Paul Cézanne." *Gil Blas,* 25 October 1906.

———. "La Clôture du Salon d'automne." *Gil Blas,* 22 November 1906.

———. "À propos de Cézanne." *L'Art vivant,* 1 July 1926.

———. "La Légende de Cézanne." *Carnet de la semaine,* 19 January 1930.

Verdi, Richard. "Roger Fry's 'Cézanne, a study of his development,' 1927." *BM* 151 (2009), pp. 544–47.

Vivès-Apy, Charles. "Pages d'album." *Mémorial d'Aix,* 16 February 1911.

Waldfogel, Melvin. "A problem in Cézanne's *Grandes Baigneuses.*" *BM* 104 (1962), pp. 200–05.

———. "Caillebotte, Vollard et Cézanne's *Baigneurs au repos.*" *GBA* 65 (1965), pp. 113–20.

Walser, Robert, trans. Christopher Middleton. "Thoughts on Cézanne" [1929]. In *Selected Stories,* pp. 189–92. New York: NYRB, 2002.

Walter, Rodolphe. "Zola et ses amis à Bennecourt." *Les Cahiers naturalistes* 17 (1961), pp. 19–32.

———. "Cézanne à Bennecourt en 1866." *GBA* 59 (1962), 103–18.

Wechsler, Judith. "Cézanne: Sensation/perception." In Cachin, *Cézanne aujourd'hui,* pp. 109–16.

Williams, Forrest. "Cézanne and French Phenomenology." *Journal of Aesthetics and Art Criticism* 12 (1954), pp. 481–92.

Wright, Barnaby. "The Courtauld Cézannes." In Buck, *Courtauld Cézannes,* pp. 12–25.

Wright, Willard Huntington. "Paul Cézanne." In *Modern Painting,* pp. 129–63. New York: Lane, 1915.

Yasuhide, Shimbata. "A factual account of the introduction of Cézanne through Japanese art magazines in the Meji and Taisho periods." In *Cézanne and Japan,* pp. 213–16. Yokohama: Yokohama Museum of Art, 1999.

Zieske, Faith. "An Investigation of Paul Cézanne's Watercolors with Emphasis on Emerald Green." *The Book and Paper Group Annual* 14 (1995), pp. 105–15.

———. "Paul Cézanne's Watercolors." In Harriet K. Stratis and Britt Salveson, eds., *The Broad Spectrum,* pp. 89–100. London: Archetype, 2002.

THESES

Dombrowski, André. "Modernism and Extremism: The Early Works of Paul Cézanne." University of California, Berkeley, 2006.

Orfila, Jorgelina. "Paul Cézanne and the Making of Modern Art History." University of Maryland, College Park, 2007.

Ratcliffe, Robert W. "Cézanne's Working Methods and Their Theoretical Background." Courtauld Institute of Art, University of London, 1961.

Tuma, Kathryn A. "Cézanne, Lucretius and the Late Nineteenth-Century Crisis in Science." University of California, Berkeley, 2000.

Index

Page numbers in *italic* indicate
integrated illustrations

"safety in solitude," 225, 227–8, 319

self-definition and self-differentiation, 91, 104–6, 140–1

self-examination, 191, 225–6

synesthesia, 218, 219

temperament, 10, 85, 94–5, 99–100, 103, 106, 199, 225–7, 237

truth in painting, 317–18

truth-to-self, 200

early life

at the Académie Suisse, 67–8, 72, 75, 345

birth, 47

classical education, 33–5, 59, 61, 76–7, 200, 201, 352–3

at the Collège Bourbon, 17–21, 27–8, 33, 53, 131–2

at École Saint-Joseph, 53

evades military service, 60, 185–6

murals at the Jas de Bouffan, 37–41

resolves to become an artist, 57–62

returns to Aix-en-Provence, 71–2

returns to Paris, 72–5

studies art in Aix, 56–7, 72

studies law, 54, 55, 56, 59–60

works in his father's bank, 71–2

in the Franco-Prussian War, 151, 184–9

exhibitions

at Exposition universelle (1889), 203, 215

first one-man exhibition (1895), 196, 215, 222, 274–5, 279, 290, 299, 303

first posthumous retrospective exhibition (1907), 3, 7–8, 8, 10–13, 241, 271, 294, 347

at impressionist exhibitions, 201–3, 215

retrospective exhibition (1936), 249, 272, 367

retrospective exhibition (1954), 272

Salle Cézanne at the Salon d'automne (1904), 8, 8, 10

friendships

and Cabaner, 216–20

correspondence with Zola, 9, 32–5, 55–6, 266; *et passim*

and Geffroy, 279–94

and Joachim Gasquet, 291–2, 327–8

and Pissarro, 132, 135–7, 140–7, 206–7, 211–13, 262

rift with Zola, 249–52, 260–2, 264–9

and Zola, 28–30, 31–5, 123–4

and Zola's death, 269

influences, 196–7

admiration for Delacroix, 90–1, 165–6

admiration for Flaubert, 148–50

Baudelaire's influence on, 25–6

and Manet, 88–90

later life, 303–30, 331–58

brain trouble, 311, 331, 333

death, 10, 162–3, 358

and the death of friends, 327

diabetes, 86, 310–11, 312–13, 316, 350

at Les Lauves, 323–7, 330, 331, 342

sight problems, 98, 311–13

private life

appearance, 84, 92–3, 106, 181

conceals Hortense from his father, 153, 155–7

Dreyfus affair, 134–5

financial dependence on his father, 54, 62, 154–5, 157

and his father's death, 164, 266

and his mother's death, 135, 164, 321–2

homeopathic treatment, 314–15

inheritance from his father, 235–6, 266

in love with a mystery woman, 228–33, 234–5, 237

life in Paris, 66–71

makes his will, 235–6

marries Hortense, 153, 234–5, 237–8

massages, 315

Pissarro's portraits of, 206, 207, 207, 210–11

poetry, 24–5, 59, 72, 168–9

relationship with his father, 9, 43–4, 154–7, 335

relationship with his mother, 52, 53–4

relationship with his son, 152, 291–2

relationship with Hortense, 152–64, 172

and the sale of the Jas de Bouffan, 322–3

walks, 303, 313